Chinese
Art
& Culture

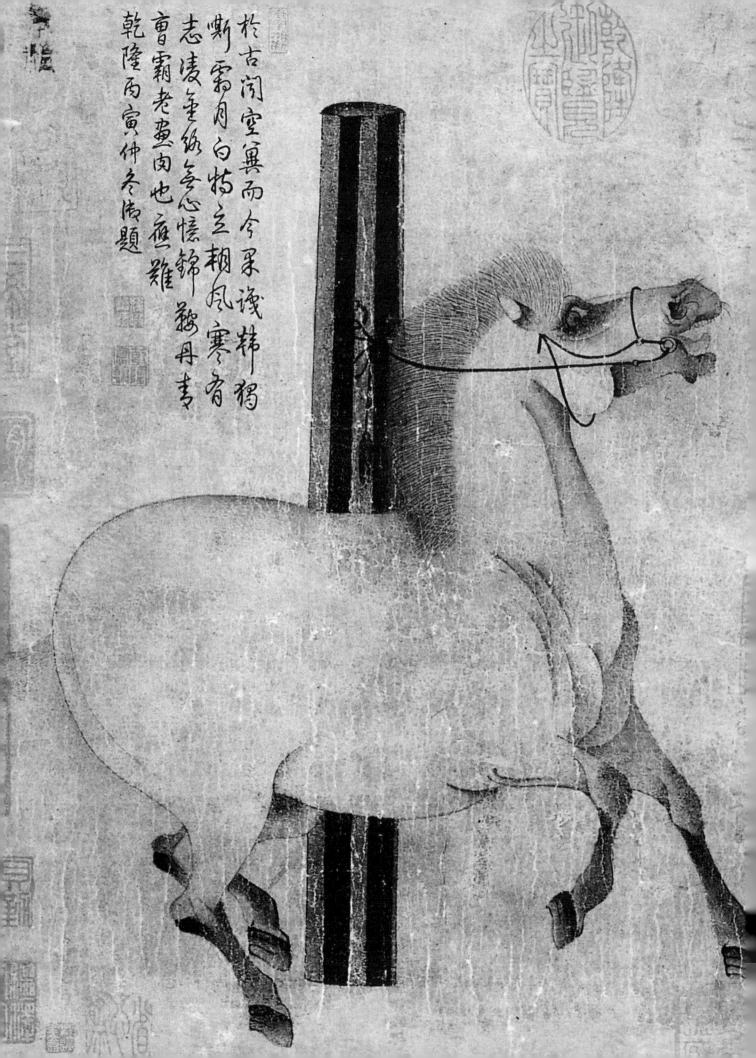

Chinese Art & Culture

ROBERT L. THORP

RICHARD ELLIS VINOGRAD

HARRY N. ABRAMS, INC., PUBLISHERS

For Harry N. Abrams, Inc.
 Project director: Julia Moore
 Jacket: Darilyn Lowe Carnes
For Calmann & King, Ltd.
 Editor: Kara Hattersley Smith
 Designer: Karen Stafford
 Picture research: Donald Dinwiddie, Julia Ruxton
 Maps: Eugene Fleury

This book was produced by Calmann & King, Ltd., London

Library of Congress Cataloging-in-Publication Data

 Thorp, Robert L., 1946–
 Chinese art and culture / Robert L. Thorp and Richard Ellis Vinograd.
 p. cm.
 Includes bibliographical references and index.
 ISBN 0-8109-4145-7 / ISBN 0-13-088969-5 (PH pb)
 1. Arts, Chinese. I. Vinograd, Richard Ellis. II. Title.

 NX583.A1 T49 2000
 306.4'89'0952–dc21

 00-058613

Printed and bound in Italy

Half-title page: Fu Shan (1607–1684/5), *Poem in Cursive Script*. Ming–Qing. Hanging scroll.
Shanghai Museum

Frontispiece: Att. to Han Gan, *Night-shining White*. Tang, 8th century CE. Handscroll. The
Metropolitan Museum of Art, New York

Title page: Kneeling bowman. Qin, c. 210 BCE. Earthenware. Museum of Qin Figures and
Horses, Lintong

 Harry N. Abrams, Inc.
100 Fifth Avenue
New York, N.Y. 10011
www.abramsbooks.com

Acknowledgments

All texts have their roots in others, and this book is no exception. The authors recognize their many debts to the thinking and expression of other scholars, starting with our pre-modern Chinese predecessors and continuing down to our immediate teachers and peers. Our teachers—James Cahill, Chu-tsing Li, and Laurence Sickman—played an especially large role in forming our sense of what "Chinese art and culture" might be. We are also grateful to respected colleagues and friends in China for invaluable experiences of art and culture, especially the Cultural Relics Bureau, Institute of Archaeology, and both Palace Museums.

This book has been a cooperative effort in more ways than one and we want to acknowledge, and express our gratitude for, the contributions of all those who have been a part of this project. Julia Moore, our executive editor at Abrams, kept us on track through many travails with her wise guidance. Kara Hattersley-Smith, our editor at Calmann & King Limited, saw us through the final editing and production stages with both patience and good humor. We are also most grateful to Donald Dinwiddie and Julia Ruxton for their extraordinary efforts in assembling the illustrations, quite literally from around the globe.

Robert Thorp, who wrote chapters 1–6, wishes particularly to thank Dr. Ellen Johnston Laing for reading the first chapters with great care at an early stage, and the students of his course "Chinese Art and Culture" for their many comments and corrections.

Richard Vinograd, who wrote chapters 7–10, extends his grateful appreciation to Dr. Suzanne Wright, who was instrumental in researching and editing the later chapters and who gathered much of the reference material for those sections. Dr. Britta Erickson generously provided many images and resources for contemporary art, and Marion Lee and Dr. Hsingyuan Tsao were also extremely helpful in acquiring illustrations. Melissa Abbe kindly shared her unpublished research on Chen Shizeng. Special thanks to Andrew Franklin CVO, CBE, of London, for his generosity.

We are most grateful also to the many colleagues who generously gave of their time and resources to help in securing illustrations. Special thanks to Professor Michael Sullivan at Oxford and Margaret Edwards at Birmingham; Bruce Doar, Susan Dewer, and Li Baoping of Artext in Beijing; James Harper in London; Mary Ann Rogers of Kaikodo in New York; Alex Chappell of the San Francisco Museum of Modern Art; and the staff of The French Embassy in Lisbon.

To Karen and to Meghan

TABLE OF CONTENTS

3 THE LATE BRONZE AGE: EASTERN ZHOU

4 THE FIRST EMPIRES: QIN AND HAN

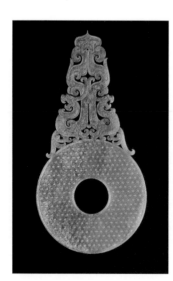

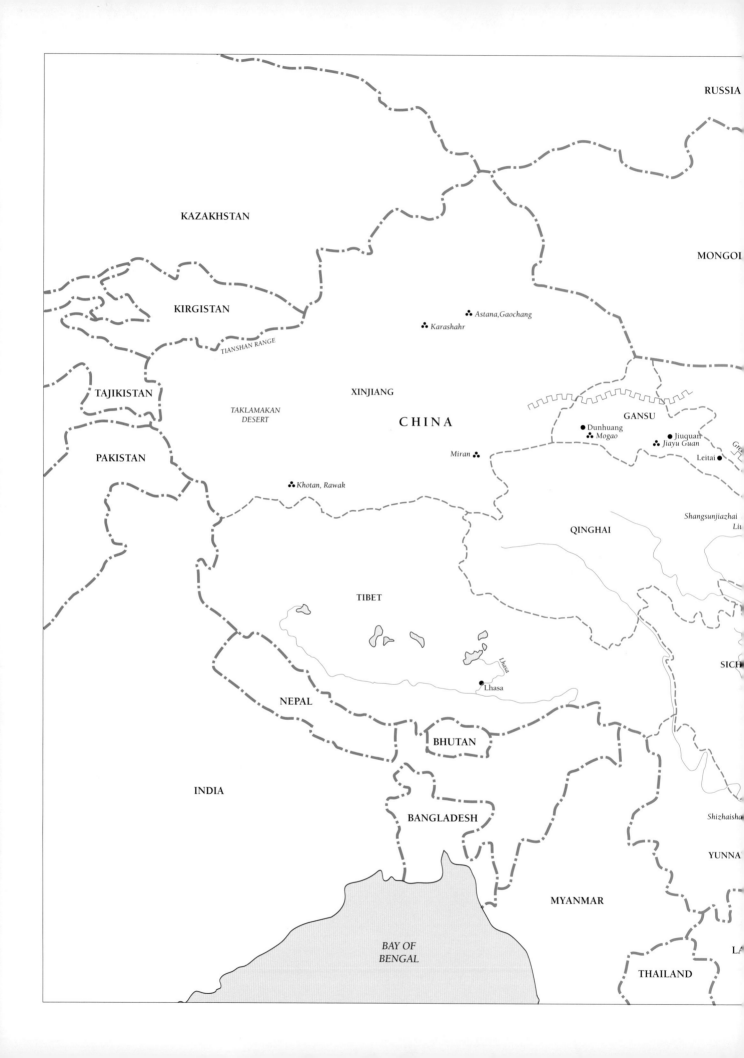

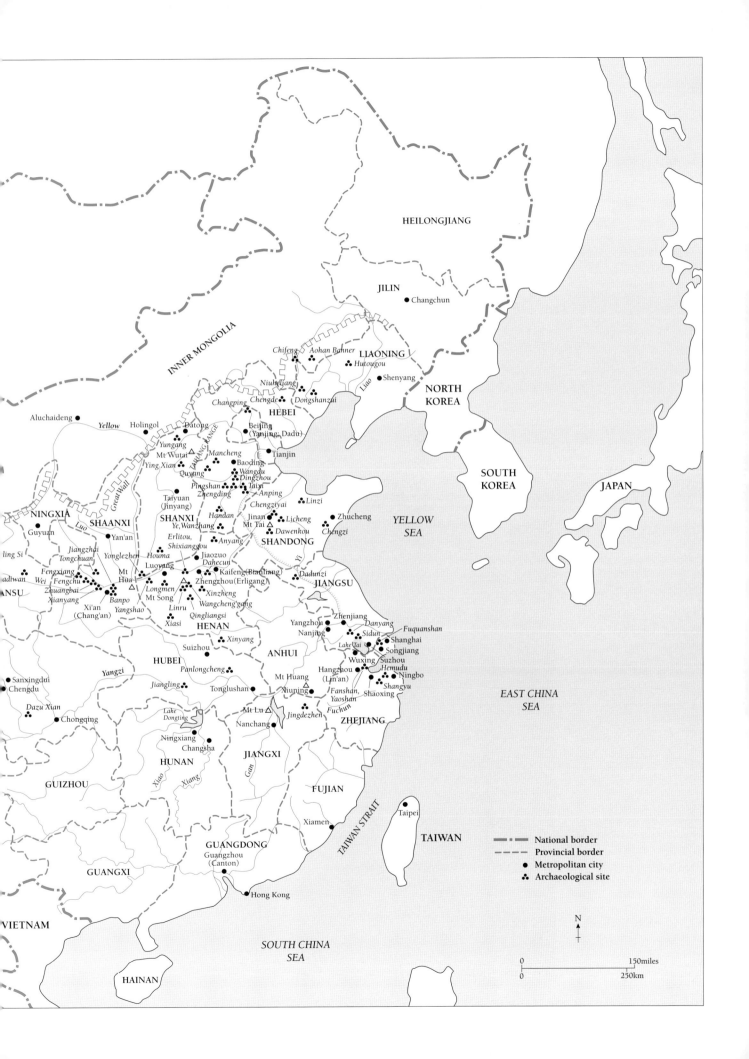

HEILONGJIANG

JILIN

● Changchun

INNER MONGOLIA

Chifeng *Aohan Banner*
LIAONING
Hutougou
Niuheliang
Changping *Chengde* *Dongshanzui*
Liao ● Shenyang
NORTH
KOREA

Aluchaideng ● *Yellow* Holingol ● Datong
Yungang
Mt Wutai △ TAIHANG RANGE
Ying Xian *Mancheng*
● Baoding
Quyang *Wangdu* *Dingzhou*
Pingshan *Taiyi*
Zhengding *Anping*
Taiyuan *Chengziyai*
(Jinyang) *Handan* ● ●*Linzi*

SOUTH
KOREA

JAPAN

YELLOW
SEA

NINGXIA
Guyuan ●
SHAANXI
ling Si
Yan'an ●
Jiangzhai
Tongchuan
adiwan
Fengxiang ●
Wei *Fengchu*
Zhuangbai
Xianyang
Xi'an
(Chang'an)
Banpo
Yangshao

SHANXI
Erlitou,
Shixianggou
Yonglezhen *Houma*
Mt △
Hua
Longmen
Mt Song
Linru
Xiasi
HENAN

Jinan ● ●*Licheng*
Mt Tai △ *Dawenkou*
SHANDONG
Anyang
Jiaozuo
Dahecun
Kaifeng (Bianliang) *Dadunzi*
Zhengzhou (Erligang)
Xinzheng
Wangcheng'gang
Qingliangsi

Ye, Wanzhang

● Zhucheng
Chengzi

JIANGSU

Suizhou ● *Xinyang*

HUBEI
Panlongcheng
Jiangling
Yangzi
Tonglushan

Sanxingdui ●
Chengdu ●
Dazu Xian
● Chongqing

Lake
Dongting

ANHUI

Mt Huang
(Lin'an)
△
Xiuning

Zhenjiang ●
Yangzhou ● *Danyang*
Nanjing ● *Sidun* *Fuquanshan*
Lake Tai *Shanghai*
Wuxing Suzhou ● Songjiang
Hangzhou ● *Hemudu*
● Ningbo
Fanshan, *Shangyu*
Yaoshan Shaoxing
Fuchun
ZHEJIANG

EAST CHINA
SEA

Mt Lu △
Nanchang ●
Jingdezhen

Ningxiang ●
Changsha ●
HUNAN
JIANGXI

FUJIAN

Xiao
Xiang
Gan

GUIZHOU

TAIWAN STRAIT

● Taipei

TAIWAN

Xiamen ●

VIETNAM

GUANGDONG
Guangzhou ●
(Canton)

GUANGXI

● Hong Kong

SOUTH CHINA
SEA

HAINAN

N

	National border
	Provincial border
●	Metropolitan city
❀	Archaeological site

0 150miles
0 250km

INTRODUCING CHINESE ART AND CULTURE

SCOPE AND APPROACH

Chinese art has a history of more than seven thousand years, from the pottery-making and jade-carving cultures of the Neolithic (or New Stone Age) down to contemporary Chinese video, installation, and performance artists working in international arenas. China has arguably been the most abundantly productive, continuous artistic culture in the history of the world. For that reason alone, writing a usefully comprehensive history of Chinese art means that one must condense that sheer wealth of material and also deal with the rapid expansion of information about it. While old chapters are revised at least monthly by archaeological discoveries and by new interpretations opened up by research, new chapters are written daily by the explorations of contemporary artists. Our approach in this book is to embrace that dynamism of Chinese art studies, seeing it as an opportunity to convey the richness and interest of this field. Our text offers a guide to Chinese art not only through major monuments and their historical and cultural contexts but also through the insights and approaches of recent discovery and scholarship. We recognize—as should the reader—the contingent nature of our account, and the openness of our conclusions to argument, debate, and revision. Where appropriate, we discuss unresolved questions and controversies, and the suggested readings at the end of this book offer many expanded and alternative views of our topics. The story that is told in the following pages is open-ended and still evolving.

We have kept a few other guiding principles in mind throughout. We wanted this not to be a presentation of isolated museum masterpieces but, as much as possible, a history of art in active engagement with societies, economies, and wider fields of culture (FIG. 0-1). In our choice of examples we have favored art in original archaeological or monumental settings as much as possible and, for the many cases where original contexts are lost to view, we have tried to resituate art through its diverse interconnections to social, political,

0-1 Great Pagoda of the Fogong (Buddha's Palace) Temple
Yingxian, Shanxi. Liao, datable to 1056. Height 221′ (67.3 m)

This pagoda, a memorial tower to the Buddha, is the tallest surviving wooden building in the world. Innovative concentric rings of columns made the interior space more accessible for worship than in earlier designs, evidence of the high technical achievements of architectural designers and craftsmen. Built under the patronage of the Liao regime, ruled by the Qidan people from the northern border lands, the pagoda exemplifies multicultural contributions to the arts of China.

economic, and religious events or institutions. At the same time, we recognize that works of visual art operate through specific properties of material, form, and motif, and we offer many examples of detailed analysis as a guide to unfolding the complexity of particular monuments. For clarity's sake we follow a historical chronology but have tried to make chapter divisions meaningful in terms of socioeconomic changes and cultural shifts rather than accepting fixed dynastic divisions. Our chapters introduce relevant contexts and themes for each era, so that art is always discussed within larger narratives.

One important effect of recent research is that scholars now question ideas of essential, permanent characteristics of Chinese art and culture. Many long-held conceptions of Chinese art turn out to be based on the tastes and values of ruling and literate (mostly male) elite patrons and audiences of certain periods. Often left out of such accounts are features of popular, religious, or craft arts, or the cultural activities and values of women. Even the idea of an enduring Chinese cultural identity has been destabilized by an increasing awareness of the interactions and cross-borrowings between multiple regional cultures in the pre-imperial age (before the late third century BCE), between China and so-called barbarian cultures and states of the periphery and borderlands during the two millennia of the imperial age, and ultimately between China and its international trading partners. In view of this outlook, we have tried to include art from diverse social and cultural settings and to represent the cultural activities of women as patrons, practitioners, and consumers of art. This is not due to any simplistic notion of fairness, but because the more inclusive account is the fuller and more interesting one. Even the traditionally elite arts patronized by rulers and educated gentlemen, which remain the majority of those discussed, stand out in greater clarity and complexity by contrast with the kinds of art, tastes, and values they rejected.

Even while we question ideas of essentialism, it is worth asking what remains of cultural distinctiveness. In what ways were Chinese arts special and noteworthy within the broad history of world art? A few long-term characteristics

stand out although, as important as these culturally distinctive elements were in the history of Chinese art, they still leave out much of significance and interest.

Productivity and Technical Accomplishment in Craft Arts

China is unique among the great cultures of the world in the degree to which its civilization was identified with its craft products. For the ancient Greeks and Romans, China was Seres, "the land of silk." In early modern Europe, "China" was as likely to refer to Chinaware porcelains as to their country of origin (FIG. 0-2). There is good reason for this, because Chinese productivity and technical excellence in many crafts were unrivaled for centuries or even millennia. Ceramic production and the carving of the hardstones known collectively as jade are part of the earliest horizons of Chinese cultures in the Neolithic period, and the products of these activities have been made continuously in large numbers, sometimes approaching an industrial scale, down to the present. Chinese silks were prized luxury items for both domestic and international consumption for nearly two millennia. Chinese lacquerware factories employed an early version of mass production more than two thousand years ago. Bronze vessel

0-2 "Ceramic processes" 19th century. Four watercolor prints on paper from a series of twenty-four scenes; 15½ × 20″ (39.5 × 51 cm). The British Museum, London

The volume and high quality of craft production in pre-modern China remain impressive even by today's standards. Whether in bronze casting or ceramics, timber-frame building or block printing, artisan workshops capitalized on several basic principles. Tasks were broken into a sequence of independent steps; individual units derived from master models were easily replicated, while managers coordinated the input of resources and output at each step. These watercolors show such a workshop system in operation in Canton.

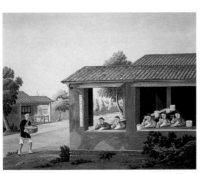
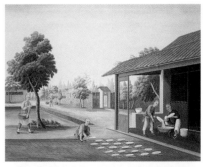
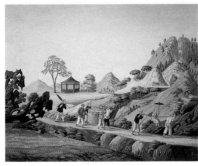
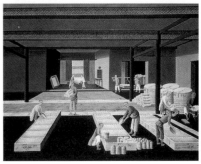

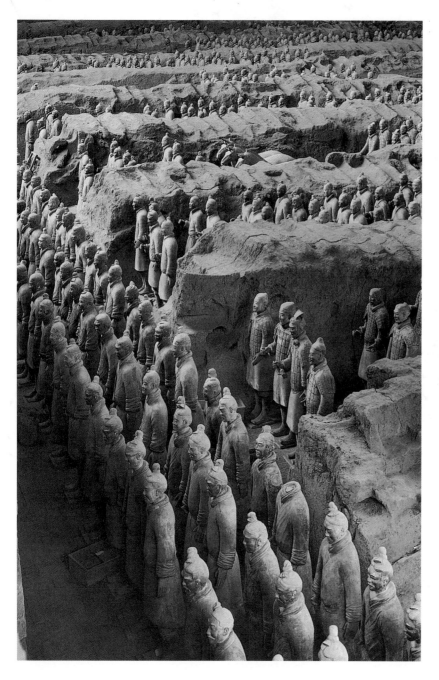

0-3 Warriors
Qin, c. 210 BCE.
Earthenware. Trench 1,
Lishan, Lintong, Shaanxi

This view shows only a portion of the terracotta army buried to the east of the Qin First Emperor's tomb. Depressions on the top of the earthern baulks mark the positions of roof beams that once covered each column.

casting, gold and silver metalworking, woodblock printing of books and pictures, and hardwood furniture making are among many other media with long histories of large-scale, technically distinguished production. Far from being mere cultural embellishments, such craft industries were major economic and social forces.

Thus the use of terms such as "craft arts," "craft skills," and "craft production" throughout this book points to major traditions of highly accomplished technique and organization, and should not convey the negative evaluations often implied

by distinctions between fine arts and crafts in the modern West. Critical traditions in China do indicate distinctions between literate arts—especially those such as calligraphy, painting, and architecture that acquired an accompanying theoretical, historical, and critical literature—and art forms that depended more on specialized skills and sometimes on laborious or cooperative production. Such distinctions were fluid over time, however, as antique ceramics were prized and inscribed by imperial collectors, ancient ritual bronze vessels attracted the interest of antiquarian scholars, and individual potters, carvers, and metalworkers achieved independent renown.

Ancestral Veneration and Associated Arts

Ritual performances of respect for ancestors are a Chinese cultural feature with roots that extend at least as far back as the Shang dynasty, around 1200 BCE, and continue down to the present. Among the artistic products directly associated with ancestor veneration are monuments of tomb architecture and memorial sculpture, and a wide array of ritual and grave goods: bronze offering vessels, along with tomb furnishings of stone and ceramic sculpture, metalwork, lacquer, and jade (FIG. 0-3). More generally, the importance of ancestral cult practices contributed to a strong historical consciousness in Chinese culture and to such artistic by-products as antiquarian tastes, retrospective calligraphy and painting styles, and an art-historical literature.

The Authority of the Written Text

The Chinese written language has been a unifying cultural force since the Shang period, enabling communication across temporal and geographical divides (FIG. 0-4). At the same time, writing was in some ways exclusionary, since it was limited to literate elites who were always a distinct minority of the population until the recent past. Nevertheless, writing has been a powerful vehicle for forging cultural identity, and the high status accorded the written text, at times verging on the divine or magical, lent prestige to the arts of calligraphy, monumental inscribed

stone steles, printed and illustrated books, and paintings inscribed with written texts.

GEOGRAPHICAL SETTING

China today is an area far larger than Europe and the nearby lands bordering the Mediterranean, those regions most commonly construed as "Western civilization." It is more diverse in climate, terrain, and human populations than that same European and Mediterranean cultural realm, with a history as long and complex as that of the "West" or any large portion of Earth's crust, be it the Indian subcontinent or sub-Saharan Africa. A simple-minded equation of China, a twenty-first century nation state, with other nations—France or Greece, Egypt or Mexico—misses these crucial points. China is among the few modern-day nations—others being Australia, Russia, and the United States—that occupy territory of truly continental proportions. Its total area of 3.7 million square miles (c. 9.6 million sq. km) is slightly more than that of the United States. The People's Republic of China (hereafter abbreviated as PRC) today stretches from subarctic northern latitudes (Heilongjiang is on the same parallel as Hudson Bay, Canada) to tropical ones (Hainan is on the same parallel as Havana, Cuba). This physical domain is exceptionally diverse, changing from jungles and hardwood forests to vast grasslands and barren plateaus, from mountain ranges high and low to great river basins, lake systems, and deserts of shifting sands.

However, it is misleading to take this map of the present-day PRC (see map, pages 12–13) as our mental image of an enduring "China." Its boundaries are actually an artifact of late imperial history. The Manchu expansion of the 18th century under the Qianlong emperor (r. 1736–1795) had been achieved through the forcible submission of diverse peoples, many of whom had rather little to do with Chinese states for most of their own earlier history. By adding on the regions of Manchuria, Mongolia, Xinjiang, and Tibet, the Manchu–Qing armies created a more multiethnic and multicultural empire than any earlier, Chinese dynasty had ever done. Throughout its

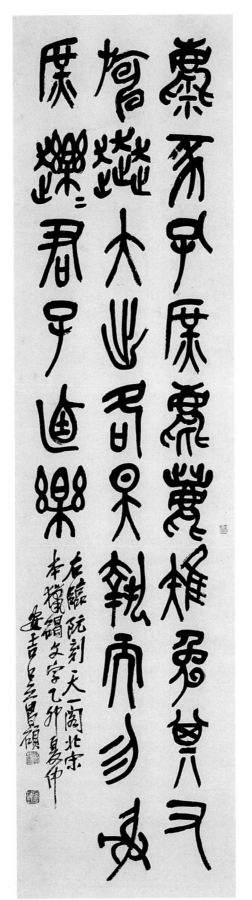

0-4 Wu Changshi (1844–1927), Stone Drum Script
1915. One of a set of four hanging scrolls, ink on paper; 59 × 15¾″ (150 × 40 cm). Shanghai Institute of Chinese Painting

This modern work of calligraphy was based on an archaic script style, more than 2,000 years old, the most famous examples of which are the inscriptions on ten cylindrical granite boulders known as the "Stone Drums" (see FIG. 3-2 below). Wu Changshi's scrolls testify to the centrality of the writing system as a unifying force in Chinese culture, often accompanied by a veneration of the past and a strong historical consciousness. Modern-era calligraphers added an archaeological interest in the origins and early history of writing.

Macroregions of China

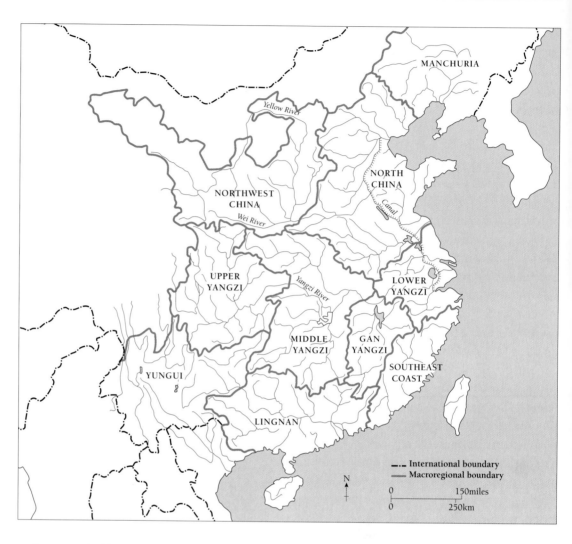

earlier recorded history, by contrast, China was much smaller in physical extent, a core geographers usually call "China proper," "Inner China," or "agrarian China." Shorn of the dependencies tacked on by the Manchus, China proper was nonetheless large and diverse, but something less than half the area of the modern-day PRC. Until fairly recently, 95 per cent of the population lived in China proper, with only 5 per cent residing in the outer regions.

In this book we deal primarily with China proper, but even then only selectively with many of its southern and border regions. We have adopted the concept of "macroregions" as our basic frame of reference for breaking down this vast entity on a continental scale. G. William Skinner defined macroregions as physiographic units tied together internally by river systems and delimited from each other at their margins by natural barriers, principally mountain ranges (see map above).

Each macroregion on our map has approximate boundaries established by natural terrain rather than by administrative (human) fiat, unlike today's provinces or their predecessors. Indeed most macroregions include more than one present-day province, and their boundaries sometimes transect traditional provincial-level units. Nonetheless, some macroregional boundaries remain conventional, as where the huge Yangzi River drainage area is divided into Upper, Middle, and Lower macroregions. Each macroregion has a core, a zone defined by a major river and its tributaries, with adjacent high-quality land available for human exploitation. Each macroregion also has a periphery, a zone surrounding the core characterized by its less desirable land, lower rates of cultivation, and smaller population. Urban development has always been concentrated in regional cores.

Dividing China proper into macroregions creates units of analysis more comparable to European

nation-states in size, internal range of climate and physical terrain, and population. Leaving aside **Manchuria**—the three northeastern provinces of Liaoning, Jilin, and Heilongjiang—there are nine macroregions. **North China** extends from the approximate line of the Great Wall south to the Huai River and from the eastern foothills of the Taihang range to the Bohai Gulf (Pacific Ocean). It is dominated by the Yellow River (Huang he). The North China plain of river alluvium has filled in the continental shelf between the Taihang Mountains and the Shandong massif (modern Hebei, Henan, and Shandong). This macroregion corresponds in large measure to the "central plains" (*zhongyuan*) of traditional Chinese historiography, the heartland of ancient "central states" (*zhong guo*). That term, in fact, became the appellation for China in Chinese only from the late seventeenth century.

Northwest China comprises the loess (wind-blown, fine particle soil) highlands of the upper Yellow River and its major tributaries, especially the Wei River (Shaanxi) and the Fen River (Shanxi). This macroregion is well delimited on the south by the Qinling range and on the east by the Taihang but is more arbitrarily defined on the north and west, where it meets the steppe and desert zones of Inner Mongolia, Ningxia, and Gansu. The Wei River valley of modern-day Shaanxi supported a succession of ancient capitals, starting with the (Western) Zhou (c. 1050–771 BCE) near the Feng River, southeast of modern Xi'an, and continuing through the Qin (221–206 BCE), Han (206 BCE–220 CE), various small states during the period of division, and the Tang (618–907 CE). No other region (see maps, pages 56, 124) played such a decisive role in ancient and medieval times.

The drainage of the Yangzi ("winding river"), also called the Changjiang ("long river"), can be defined as four macroregions. The **Upper Yangzi** macroregion corresponds in large part to modern Sichuan ("four rivers") province, a high basin rimmed with mountainous terrain on all sides. At least since the establishment of the first empire in 221 BCE, this macroregion has been one of the most populous and prosperous in all of China proper, as remains true today. The **Middle Yangzi**, on the other hand, is defined as the tributaries and lakes that occupy the central reaches of the river's drainage, approximately the traditional provinces of Hubei and Hunan ("north of the lake" and "south of the lake," respectively). Lake Dongting still acts as a huge catchment basin for this part of central China; in ancient times it was even more vast. The high dam (now under construction) near the Three Gorges is an effort, among other things, to control the water issuing from the Upper Yangzi and hence protect the Middle Yangzi from devastating floods. The **Lower Yangzi** macroregion corresponds approximately to the traditional area called "south of the river" (Jiangnan), the low-lying provinces of Jiangsu and Zhejiang along with Shanghai, where the great river meets the ocean. In the history of later imperial China this region became the most prosperous in all the realm, the home of elites that dominated government service and the arts. A fourth macroregion—the **Gan-Yangzi**—can be defined as the drainage of the Gan River, a major tributary that runs north through modern Jiangxi province.

Along the coast and further south are three other macroregions: the **Southeast Coast**, comprising parts of Zhejiang and all of Fujian, cut off from the interior by mountainous zones and facing the ocean; **Lingnan**, the coastal lowlands drained by the West River and tributaries, the traditional Guangdong and Guangxi ("broad east" and "broad west"); and **Yungui**, the plateaus of the southwest, modern Yunnan and Guizhou. Peoples from the north began to move into these southern macroregions only in the Qin–Han periods, and this immigration continued throughout much of later history. These regions not only support distinctive "dialects" (actually individual languages such as Cantonese), they are also the homelands of many of the fifty or so officially recognized "national minorities," including such large groups as the Zhuang and Miao.

Macroregions held political, economic, and cultural importance throughout China's history, but other kinds of geographical dynamics involving urban centers operated at various times as well. In early China until the late first millennium CE, the most important geopolitical axis was from west to east, as political capitals alternated between the strategic Xi'an region in the northwest and

the area around Luoyang in north-central China, which was closer to population and economic centers. Beginning with the period of division in the mid-first millennium CE, a north–south axis became increasingly important as refugee populations moved south, political capitals were established in the Nanjing region, and a long-term shift to the southeast as the engine of economic development gained momentum. Starting from the end of the first millennium CE, the region of Beijing in the far northeast became a political center for the northern Liao and Jin regimes of partially sedentarized, formerly nomadic peoples. Beijing continued as a primary political capital under the Mongol Yuan regime (thirteenth–fourteenth centuries) and thereafter, attesting to the ongoing importance of the northern borderlands and inner Asian strategic relations in later Chinese history (FIG. 0-5). Hangzhou in the southeast became a capital city for the refugee Southern Song regime (1127–1279) in the twelfth century, and Nanjing, briefly a capital in the early Ming (fourteenth–fifteenth centuries), continued as a secondary capital throughout that dynasty. Other major cities in the southeast, such as Suzhou, Yangzhou, and Shanghai, were primarily commercial and cultural centers, as were both Hangzhou and Nanjing. These cities were advantageously located near water transport or other trade routes, especially on the network of rivers, lakes, and canals (including the famous Grand Canal system that linked southeastern and north-central China) that was so beneficial to the commercial prosperity of southern China.

For administrative purposes, the contemporary map of China (map, pages 12–13) is divided into first-, second-, and third-order units.

First-order divisions:

(1) Provinces. Large-scale administrative units akin to provinces have been in existence since at least the time of the First Emperor of Qin (c. 221–210 BCE) when thirty-six "commanderies" were established. The modern-day provinces of the PRC differ somewhat from their immediate predecessors of the Qing (1644–1911) and Republican (1912–1949) periods, although some of their names extend back to early periods. Today there are twenty-three provinces.

(2) In addition, much territory is administered as five Autonomous Regions, areas where sizable so-called minority populations (for example, Hui–Muslims, Uighurs, Zhuang, Mongols, and Tibetans) once predominated.

(3) Finally, four large, centrally administered cities share first-order status, being represented in national affairs in much the same way as the provinces and autonomous regions. These cities are: Beijing (Peking), Tianjin (Tientsin), Chongqing (Chungking), and Shanghai.

Second-order divisions: Although various intermediate administrative districts exist, the usual second-order unit is the county (*xian*). The county administration system predates even the commanderies of the First Emperor. Throughout most of Chinese history, county magistrates ran China.

Third-order divisions: Most archaeological sites are named after a local place, be it a city, village, or natural feature within a county.

CHINESE LANGUAGES

Chinese is a language family. The spoken languages (speech) of various regions, in English by custom called "dialects," are actually more accurately considered separate languages. Thus "common speech" (*putong hua*) and "national language" (*guo yu*) are adaptations of a language called Mandarin (*guan hua*), so named because it was once the speech of imperial officials. The spoken languages of Guangdong (Canton), Shanghai, Fujian–Taiwan, and many other regions are in reality distinct languages. Speakers of Cantonese and Mandarin cannot communicate; the gap between them is as great as that between speakers of German and Italian. *In this book all terms are rendered in their standard, modern Romanized Mandarin spelling.*

The regional and historical diversity of spoken language in China made standardization of written language all the more important. The earliest politically imposed efforts at script standardization were mandated by the founding emperor of the Qin, China's first imperial dynasty, and were a crucial instrument of political unification. Perhaps no factor was more important to long-term political and cultural unity than the common

written language, accessible to the educated whatever their spoken language or ethnicity. Various forms of official scripts linked writing with political authority, along with its basic communicative functions. Writing was associated with elite status and cultural authority as well, since only a small minority of the population was educated in the classical literary and philosophical texts that were the prerequisite curriculum for civil-service examinations and prestigious official careers. That base of classical literacy expanded over time, with increased educational opportunities and more widespread competition for official positions. The development of printing technologies in the late first millennium CE also aided the standardization and dissemination of writing. A lower level of functional literacy, that allowed comprehension of shop signs, primers, and almanacs, was more widespread.

Chinese written characters were normally written or printed from right to left and from top to bottom in unpunctuated columns. Various categories of script forms developed over time and for different cultural functions, including official forms such as the seal or clerical scripts, a standard script most often used for printed texts, and various cursive scripts. Handwritten texts could be produced at different speeds and with varying degrees of formality, using pliable animal-hair brushes. The distinctions between regular, running, and "draft" scripts could be roughly analogous to those between printed writing, cursive script styles, and barely legible personal scrawls in handwritten English (see "Script Types," page 175). A small minority of individual characters were pictographic or represented abstract concepts, but most were compound characters including a significant classifying element, or "radical" (water, metal, hand, bird, and grass are examples), along with a phonetic component that conveyed pronunciation.

Functions of writing thus included representing spoken language, providing a unifying vehicle of communication, and conveying political, religious, or social authority. From early times writing was also appreciated for its aesthetic values. A critical and theoretical literature about calligraphy developed from the third century CE, paralleling texts on the aesthetics of literature, music, and painting. Almost any kind of writing can be appreciated in aesthetic terms, but some modes of writing consciously emphasized visual interest over content. In most texts that go beyond mere notation or practical function, evaluation and response involve an interplay between aesthetics of form, content of the message, status of the occasion of writing, and the medium or format of the text. An official text written in a formal style and engraved on a stone monument (for example, see FIG. 6-32 below) had a very different purpose and impact than an autobiographical essay brush-written on a scroll in an idiosyncratic, extreme cursive style (for example, see FIG. 6-33 below).

Romanization

Since all Chinese languages use a logographic writing system, often referred to as "Chinese characters," one way to represent the sounds of Chinese words is by "Romanizing," that is, using the letters of the Roman alphabet. That alphabet was not, however, created for this purpose, and many of the accommodations are less than ideal. Two systems are in common use. The first is Wade–Giles, a system created in the nineteenth century by two redoubtable English scholars, Thomas Wade and Herbert Giles. Until the 1970s, this was standard in English-language publications of all kinds. The second is Pinyin (literally, "spelling" or "put together sounds"), a system promulgated by the PRC for all official purposes and employed by many users outside China since the 1980s. *Pinyin has been followed in this text.* Since Pinyin was created recently, it employs some conventions of the International Phonetic Alphabet (IPA); unlike Wade–Giles, it was not created expressly for the convenience of English speakers.

The following examples illustrate some of the contrasts between Wade–Giles and Pinyin: Wade–Giles links multisyllable words with hyphens, while Pinyin simply runs the syllables together, e.g. (Wade–Giles) Ho-mu-tu, (Pinyin) Hemudu; Wade–Giles employs several diacritical marks, while Pinyin does not, e.g. (Wade–Giles)

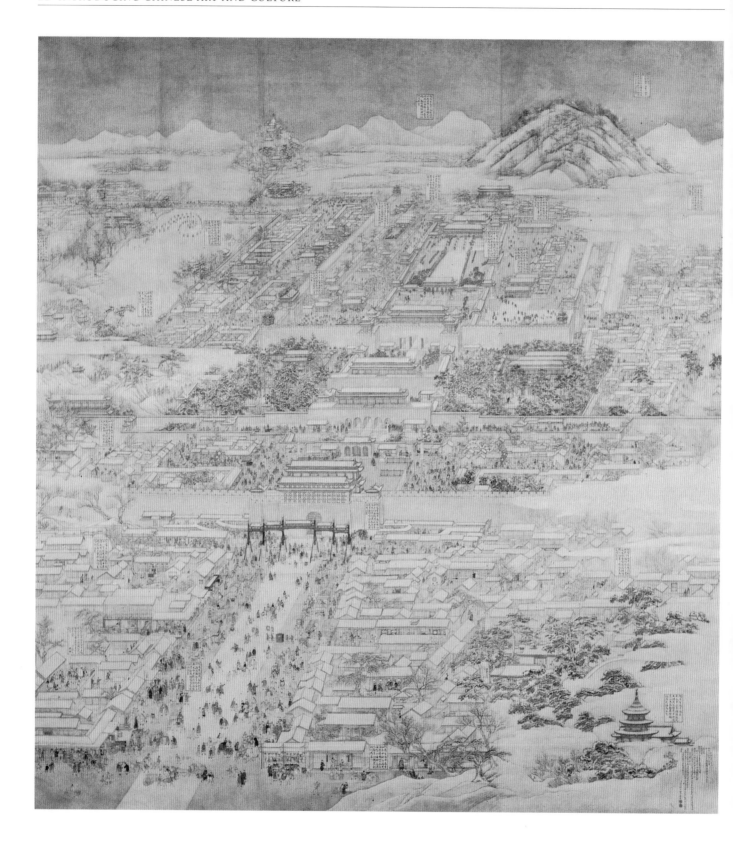

Yin-hsü, (Pinyin) Yinxu; in Wade–Giles, initial consonants that are aspirated are marked by an apostrophe, while in Pinyin different letters are used to represent the aspirated and unaspirated sounds, e.g. (Wade–Giles) *pan, p'an, tan, t'an, kan, k'an,* (Pinyin) *ban, pan, dan, tan, gan, kan.*

CHRONOLOGY

This book begins ostensibly at 5000 BCE with "Late Neolithic" cultures of seven thousand years ago. How to label and understand such long spans of time are not simple questions long ago resolved by specialists. One of the main thrusts of modern-day archaeology in China is to extend our knowledge back into earlier periods, often redating cultural phenomena and the labels we apply to them in the process. Several conventional divisions of time are perpetuated here, but with certain qualifications.

History and Prehistory

In premodern Chinese culture there was no "prehistory." The oldest stages of the human story were accounted for by narratives (now considered myths). Sima Qian's *Historical Records (Shi ji,* c. 100 BCE), for example, retells a history of the world from the beginning of human time. Embedded in received literary sources were all the vital details: from the creation of humankind by Fu Xi and Nu Wa (see FIG. 4-21 below) through such notable human inventions as cultivated plants (by Shen Nong) or writing (by Cang Jie). On the other hand, critical scholars devoted enormous efforts to examining historiographical traditions with searching text criticism, determining in the process that the oldest firm date was merely 841 BCE, during the Western Zhou period. Prior to that date, all traditional and modern chronologies vary, depending on sources adduced and decisions on various issues. The most often debated of key early dates—the founding of the (Western) Zhou—continues to engage scholars, who in our time consult radiocarbon datings, eclipse records, and a variety of other sources.

Since the discovery of the oracle-bone inscriptions at the turn of the twentieth century, primary historical sources have been available for study back to the period of the Late Shang kings, beginning probably with Wu Ding (variously estimated at c. 1300 or 1200 BCE). In this volume we regard the period from Wu Ding's era onward as "historical" in the simple sense that primary records are at hand. The centuries leading up to Late Shang "documented" in some transmitted sources are regarded as "proto-history," in the sense that, while some of their data may in fact illuminate the past, it cannot be confirmed from authentic ancient records of the period. Where to establish a boundary between "prehistory" and "proto-history" is more arbitrary. Here we suggest the end of the third millennium BCE as a workable approximation, knowing full well that developments in Chinese archaeology may require revision. Thus the inception of the first of the Three Dynasties of traditional historiography—the Xia—marks the boundary of prehistory and proto-history in this volume (chapter 2).

Imperial China

Strictly speaking, the imperial age begins in 221 BCE with the success of the Qin armies against their final rival (see chapter 4) and concludes with the demise of the (Manchu) Qing dynasty in 1911 CE (see chapter 10). In spite of the biases of many generations of earlier scholars, Chinese society and culture were by no means unchanging during that long span, nor were the breaks at 221 BCE and 1911 CE absolutely clear-cut. The essential components of Qin's new regime were created in the centuries prior to 221, while other vital elements of an imperial state were crafted only in the Han or still later. The abdication of the last emperor, likewise, did not change the structure and functioning of Chinese society overnight. The two rival modern Chinese states, the PRC and Republic of China (ROC), both perpetuate long-established imperial customs and usages.

Our chapters recognize many, but not all, of the major dynastic divisions. Whether or not we follow the historian's periodizations, we are convinced that social, economic, ideological, and

0-5 Xu Yang (active c. 1750–after 1776), Bird's-Eye View of the Capital 1770. Hanging scroll, ink and color on paper; 8'4¼" × 7'8" (2.55 × 2.34 m). The Palace Museum, Beijing

The ceremonial north–south axis of the capital city of Beijing is the major organizing feature of this maplike overview. The large gate and wall across the center of the painting mark the boundary between the commercial Outer City and the residential Inner City. Farther back are gates and walls of the Imperial City government buildings and temples, surrounding the walled Forbidden City of the imperial palace and central throne halls. The Temple of Heaven is depicted at lower right. Although organized around a series of enclosures, with power focused at the center, Beijing, like other great urban centers, had spaces for commerce and leisure and reached out to a wider world, here including the European sources of perspectival rendering techniques.

cultural phenomena cannot be usefully distinguished by following political chronology. Our seven chapters covering the imperial period are both a matter of practical convenience and statements about more meaningful periodizations from the standpoint of our topic—art and culture. The lumping together of complete dynasties in chapters 4 to 7 is more or less conventional, the sorting of topics across dynastic divisions in chapters 8 to 10 less so. Our rationalizations are explained in each chapter.

Dynasties

Until the Yuan, dynastic appellations derived from traditional names of regions, ancient states, or the fief of the founding emperor. Liu Bang, founder of (Former) Han, had been a lord of Han; Li Yuan, founder of Tang, was Duke of Tang. Each dynasty had an imperial family, but their surname is rarely used in this connection; one exception is the "Cao Wei," used to distinguish Cao Cao's Wei dynasty (220–265 CE) from the Tuoba (Tabgatch) Wei (386–535 CE). Some dynasties are designated, after the fact, as Former or Later, Western or Eastern, when distinctions are required. Western Zhou is so named because its capital was in the west (near modern Xi'an), while Eastern Zhou shifted its capital east to Luoyang. The last three dynasties followed a new naming custom, selecting terms of auspicious import (Yuan, "primal"; Ming, "brilliant"; Qing, "pure"); two of the three were founded by non-Han Chinese rulers. In premodern times, the inhabitants of China used the current dynastic name as the name of their nation. Such phrases as "people of Han" or "people of Tang" were perpetuated in later periods as names for the "Chinese."

Dates

The successive kingdoms and dynasties of the historical period generally kept track of dates by enumerating years in the reign of the present ruler, king or emperor. Late Shang oracle-bone and bronze inscriptions make reference to a certain year of a certain "sacrificial cycle," thought to be approximately the same as a year. Likewise, late imperial documents and paintings are dated, for example, to the "22nd year of the Qianlong emperor" (1757; see FIG. 9-33 below). For the period from Former Han through Yuan, era names were promulgated by the court and changed as circumstances required. Events are dated to a certain year of a certain era. In Ming and Qing times, however, a single reign name was adopted for each ruling emperor instead. (Thus, "Qianlong" is the reign name, not the emperor's own name.) Some historians prefer to call emperors by their family and personal name (the Song emperor Huizong thus becomes Zhao Ji, with Zhao the family name), but more often these rulers are referred to either by their ancestral title such as Tang Taizong ("grand ancestor"), or by their posthumous honorific name, such as Emperor Wu (Han Wu di, the "martial emperor"). The equivalent of the Western surname always comes first by custom; hence Mao Zedong was Comrade Mao.

Time chart of periods and dynasties

Late Neolithic period	c. 5000–2000 BCE		**Sui dynasty**	581–617
Yangshao Culture (Henan, Shaanxi)	c. 5000–2750		**Tang dynasty**	618–907
Majiayao Culture (Gansu, Qinghai)	c. 4000–2250		**Five (Northern) dynasties**	907–960
Dawenkou Culture (Shandong, Jiangsu)	c. 5000–2250		Later Liang	907–922
Hongshan Culture	c. 4500–2750		Later Tang	923–936
Liangzhu Culture (Jiangsu, Shanghai, Zhejiang)			Later Jin	937–948
	c. 3300–2250		Later Han	946–950
Longshan Culture (Shandong)	c. 3000–1700		Later Zhou	951–960
Xia dynasty	c. 2000–1600?		**Ten Kingdoms**	902–979
Shang dynasty	c. 1500–c. 1050		Wu	902–937
Zhou dynasty	c. 1050–256		Southern Tang	937–975
Western Zhou	c. 1050–771		Wu Yue	907–978
Eastern Zhou	770–256		Former Shu	903–925
Spring and Autumn period	c. 770–450		Later Shu	934–965
Warring States period	c. 450–221		Min	909–945
Qin dynasty	221–206		Northern Han	951–979
Han dynasty	202 BCE–220 CE		Southern Han	917–971
Former (Western) Han	202 BCE–9 CE		Jingnan	907–963
Usurpation of Wang Mang	9–23		Chu	927–951
Later (Eastern) Han	25–220		**China Periphery**	
Period of Division	220–581		South (Yungui macroregion)	
Three Kingdoms	220–265		*Nan Zhao*	649–937
Wei	220–280		*Dali*	937–1254
Shu	221–263		North/Northwest	
Wu	222–280		*Liao dynasty (Qidan)*	947–1125
Western Jin dynasty	265–316		*Xi Xia (Tangut)*	1038–1227
Eastern Jin dynasty	317–420		*Jin dynasty (Jurchen)*	1115–1234
Southern dynasties			**Song dynasty**	960–1279
Liu Song	420–479		Northern Song	960–1127
Southern Qi	479–502		Southern Song	1127–1279
Liang	502–557		**Yuan dynasty (Mongol)**	1279–1368
Chen	557–589		**Ming dynasty**	1368–1644
Northern dynasties			**Qing dynasty (Manchu)**	1644–1911
Northern Wei (Tagbatch/Tuoba)	386–534		**Republic of China**	1912–1949
Eastern Wei	534–549		**People's Republic of China**	1949–present
Western Wei	535–556			
Northern Qi	550–577			
Northern Zhou	557–581			

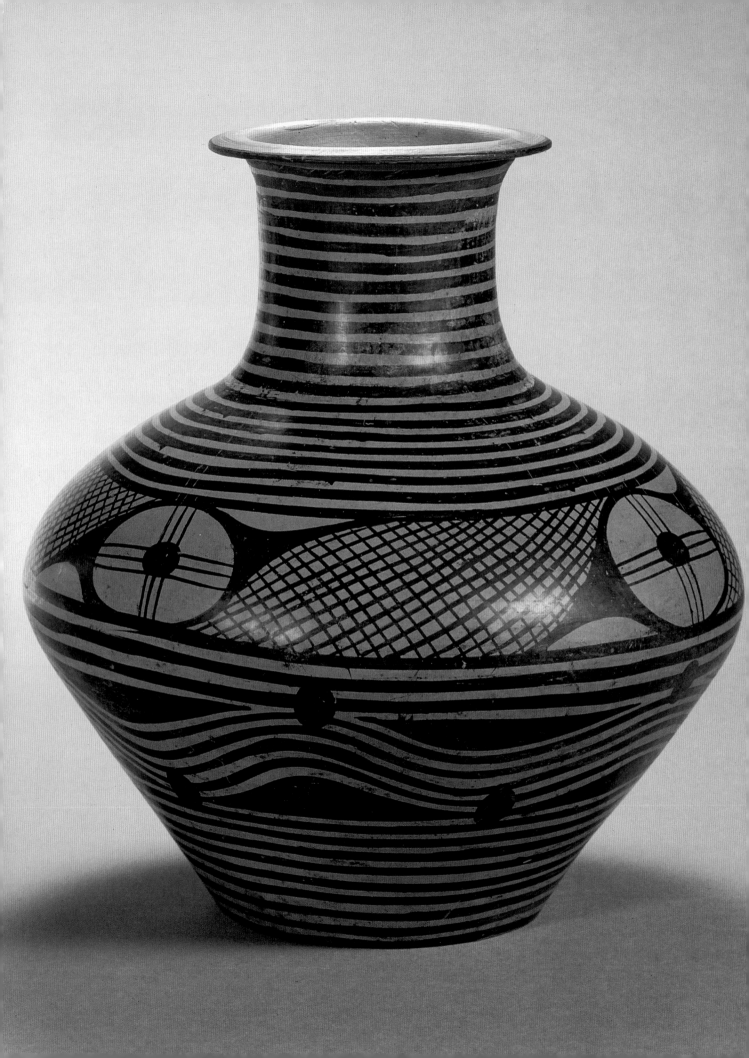

1 PREHISTORIC ROOTS: LATE NEOLITHIC CULTURES

W ELL-DEVELOPED VILLAGE societies had appeared in many macroregions of China by about 5000 BCE. This volume begins with this "Late Neolithic" period (c. 5000–2000 BCE) and with a focus on the working of two abundant materials: stone and clay. These topics represent the artistic roots of historic cultures we call "Chinese." Some archaeologists in modern-day China see all of the archaeological cultures of that vast geographical area as "Chinese." It is probably more accurate to say that, while some cultures contributed significantly to later Chinese civilization, others had little impact. We should also remember that we nowadays have more knowledge of the distant past than earlier generations did; indeed, some of the cultures featured in the first chapters of this book could not have been known to the people of later historic periods. It would not be true to the evidence to assume automatically that all that came before contributed to a grand narrative of Chinese civilization.

Knowledge of this period of some three thousand years comes from the material record and the various kinds of reasoning applied to it. Just as gaps in that record make some questions difficult to investigate, so too certain types of reasoning may lead our discussion in one direction at the expense of others. Many statements below are necessarily inferential. Many of them are drawn from analogy, from more secure knowledge of how humans have acted and made things in historic or contemporary societies, including China.

Inferences and analogies, including Chinese ones, are not inevitable. One can find many alternative models in comparative data, so our interpretations of this prehistoric material must remain tentative and subject to continual revision.

VILLAGE SOCIETIES

Archaeologists have employed the term "Neolithic" to characterize archaeological cultures that made stone tools by grinding or polishing. The regular shapes and smooth surfaces of such tools are readily recognized. Indeed polished stone celts (axes) first led J.G. Andersson to investigate the Yangshao site, the namesake for the Yangshao or "Painted Pottery" Culture, in 1912. Ground or polished tools contrast with those made by percussion, in which the shape, edge, and surface reveal that they were struck by a hammer stone or had pressure applied from a point (as in the Palaeolithic). Classifying societies by technological yardsticks marked an important conceptual advance in the history of European archaeology. Such terms, however, tell us little about how human groups actually lived. The making of stone tools cannot in itself serve as an index of social complexity or economic organization.

In China, as in other parts of the world, the appearance of ground and polished tools figures in a larger complex of interrelated changes that can be isolated in the archaeological record

1-1 Bottle with painted decoration
Yangshao Culture, Majiayao phase, 4th millennium BCE. Earthenware, height 11″ (28 cm). Minhe, Qinghai. Qinghai Institute of Archaeology, Xining

after the last Ice Age. These changes often, but to a varying degree, include a settled life in which people built villages with semi-permanent houses. Village populations relied on cultivated plants and domesticated animals as food sources to complement gathering and hunting. This shift in diet is attested from storage pits and the vessels needed for food, from stone tools (such as querns—stone hand mills—and rollers) used to process foodstuffs, and from the animal bones (both their kind and quantity) found in refuse pits. These changes often, but not always, included the making of pottery, generally the most abundant artifacts at a site of this kind.

In combination, these changes suggest a social organism larger than family groups. Local societies of this kind comprise several lineage groups that find it beneficial to live together and to share resources and labor for such activities as agriculture and mutual defense. By at least 5000 BCE, the landscape of North China supported many villages with populations of several hundred people. These villages may have been occupied for a limited time, only to be abandoned and perhaps later reoccupied. Discontinuous occupation could reflect instability in these communities; it might also result from the rapid exhaustion of arable fields if, for example, slash-and-burn agriculture was practiced. Most of the objects described in this chapter (with the exception of the Liangzhu jades and Longshan "eggshell" wares) came from village-level, local societies.

1-2 Plan of Jiangzhai village
Lintong, Shaanxi. Yangshao Culture, 5th millennium BCE

Like its neighbor, Banpo, the Jiangzhai site may have supported several hundred people within its encircling ditch, their 120 houses clustered in several groups, each with a large "clan house" for communal gatherings. The central open area held graves (not shown on this plan), in addition to those outside the ditch on the east and southeast. Four kilns near the Lin River on the southwest served village potters.

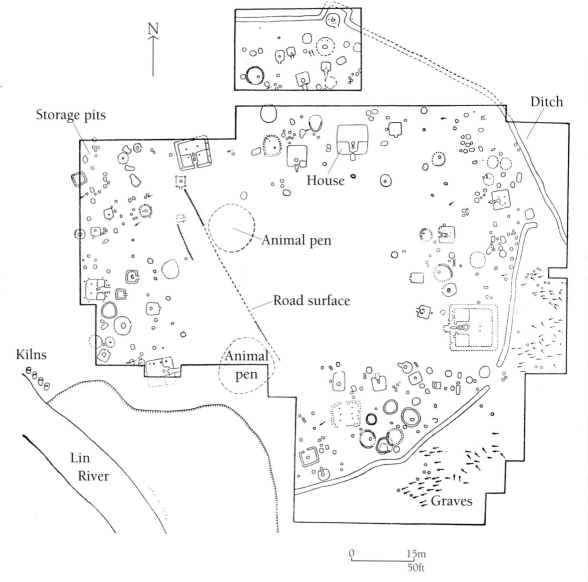

Archaeologists in the People's Republic of China (PRC) generally employ a terminology to describe these societies that they derived from nineteenth-century European and American social scientists, especially the writings of Karl Marx, Friedrich Engels, and Lewis Henry Morgan. In their parlance, early societies changed over time from a matrilineal (or matriarchal) organization, in which women occupied a privileged place in the community and descent was reckoned through mothers, to a patrilineal (or patriarchal) one in which men became socially dominant and descent was reckoned through fathers. Unfortunately, little if any archaeological data as such unambiguously support the existence of either social organization or a transition from one to the other.

Village Life

While hundreds of Neolithic village sites have been investigated, only a handful have been well preserved, thoroughly explored, and thoroughly reported. Two sites east of modern-day Xi'an (Shaanxi), representing the Yangshao Culture, provide our best picture of villages at the beginning of the Late Neolithic. The first site, named Banpo, was discovered in 1953 and excavated for five seasons from 1954 to 1957. The description and analysis of this one site have set the tone for many subsequent discussions of the Neolithic in China. The second site, Jiangzhai, nearby in Lintong County, further east from Xi'an, was excavated over eleven seasons between 1972 and 1979. Their points in common far outweigh their differences, and the present discussion depends on both. However, the excavators cleared only about a fifth of the Banpo area, whereas nearly all the Jiangzhai site was exposed.

Both sites occupy terraces above streams, in each case tributaries of the Wei River. The high ground afforded safety from flooding, while the streams provided reliable water. Both sites were surrounded by large ditches several yards or meters deep and wide (see FIG. 1-2). Unexcavated sections in the ditches facilitated entering and leaving. Traces of a wooden palisade at Jiangzhai suggest the ditch had a defensive role. Inside the ditch

enclosure at Jiangzhai, about one hundred houses were grouped into five clusters, each cluster including a single, much larger house. This leads to the inference that the village consisted of five lineages or clans living in distinct areas. The large houses could have served as clan lodges. Similarities at Banpo and other sites suggest that Yangshao communities shared this village plan and social structure. At Jiangzhai, the large open area near the center of the village functioned as a cemetery, and house doors generally opened onto this central area.

Both villages also had hundreds of subterranean pits for storage and refuse, traces of pens for holding livestock, as well as several pottery kilns at one edge of the site. Thus it appears that agricultural resources were kept within the defensible village, while pottery production took place on the margin with kilns used in common. The villages depended on cultivated millet as their main cereal food. Many of the ground stone tools must have been used to clear and till the fields and to harvest grain. Other domesticated grains and vegetables (including what we call Chinese cabbage!) figured in the diet, as did seasonal wild nuts and berries. Domesticated pigs and dogs furnished animal protein, supplemented by wild animals such as deer and by fish. Stone points for spears and arrows confirm game hunting, as do skeletal remains, and the quantity of carved bone hooks points to a reliance on fishing.

Houses at Banpo and Jiangzhai stood either on the surface or slightly below ground level and were either rectangular or circular in plan (see FIG. 1-3). There may have been a trend over time to build more houses at ground level and to favor rectangular plans. These houses were constructed around several large posts set into the ground and covered with a skin of wattle and daub, with tree branches woven together for the walls and roof and coated with mud plaster. The tamped floors and walls sometimes show signs of burning. A hearth near the center of the floor allowed indoor cooking, and presumably a smoke hole pierced the roof. A raised threshold at the doorway protected the interior from water running in. The interiors of these houses

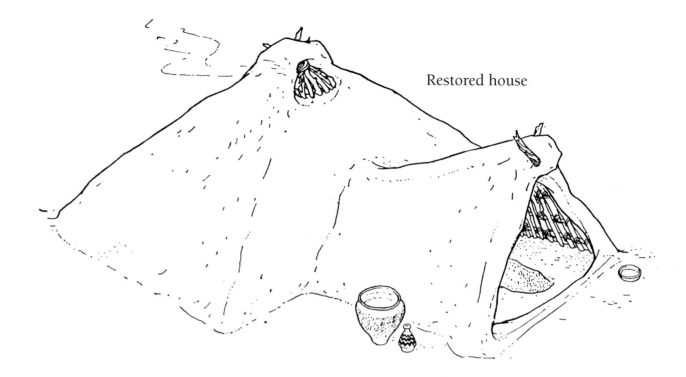

Restored house

1-3 Wattle-and-daub house
Banpo, Xi'an, Shaanxi.
Yangshao Culture, 5th
millennium BCE. Rendering by
Yang Hongxun

Semi-subterranean houses
like this one were common-
place throughout North
China during the Late
Neolithic. A tentlike canopy
of mud on a frame of inter-
woven small branches (wattle
and daub) was carried by a
few larger tree trunks
anchored in the ground. The
hearth provided warmth and
a cooking fire, but many
activities must have been pur-
sued out of doors.

Cross section

End to end section

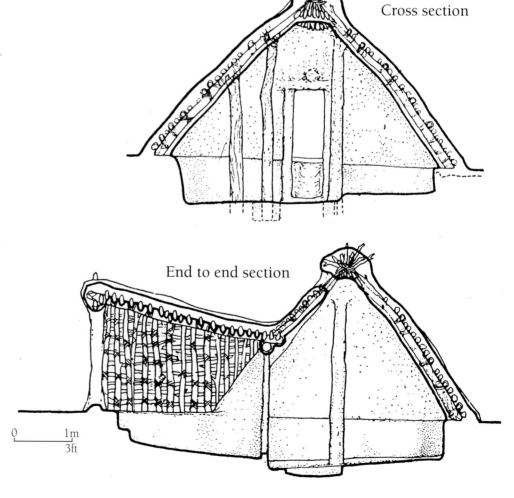

0 1m
 3ft

vary from 140 to 320 square feet (10–30 sq. m). Larger ones might be adequate for a family group of five or more individuals. If a village such as Jiangzhai had as many as one hundred houses at one time, as many as five hundred people could have lived there.

These villages at Banpo and Jiangzhai were occupied for much of the period from 5000 to 4000 BCE. We have much less evidence concerning village plans for other archaeological cultures of this same period, such as the Dawenkou Culture of the lower Yellow River and the East Coast of China, where traces of similar houses have been documented. At the Hemudu site south of Hangzhou Bay (Zhejiang), remains of wooden stilt houses indicate that here people lived on the wet margins of a marsh or lake. In some high elevations of the middle Yellow River, traces of cave dwellings seem to anticipate peasant housing of the loess lands—wind-blown, fine clay and silt deposits—in historic times. In the Northeast macroregion (Inner Mongolia and Liaoning), stone played an important role in housing, as at Xinglongwa. Fragmentary data from these other regions leave open the question of how those villages were laid out and hence limit our inferences about social organization. Substantial cemeteries characterize many cultures for which we lack data on villages, especially those of the East Coast. The sizable numbers of graves could be explained as the result of large village populations or lengthy occupation, or perhaps because several neighboring villages shared a common cemetery. The existence of large settlements or clusters of villages therefore seems plausible during the later fifth and fourth millennia.

By c. 3000–2000 BCE, several macroregions yield evidence of large, walled settlements. Neolithic walled sites have been known since the excavations at Chengziyai (Shandong) and Hougang (Henan) in the 1930s. Walled sites can now be documented across the middle and lower Yellow River drainage areas and in the Middle and Lower Yangzi macroregions. None of these sites, except Wangcheng'gang (Dengfeng County, Henan), has been presented in a formal report, and this actually ranks among the smallest. Here two fragmentary walled compounds measuring less than 330 feet (100 m) on a side survive. Other sites in Henan and Shandong are known only from brief reports and news items, as are several sites of the Qujialing Culture in Hubei. In addition archaeologists have discovered a large earthen platform with walls in the center of the Liangzhu Culture sites discussed below (see pages 34–39). The construction of these sites implies a social organization that could marshall large labor forces, probably a chiefdom, perhaps even an incipient state. A better understanding of these walled sites will require regional settlement analyses that determine how sites of various sizes are related within regional domains, as well as more detailed investigations of the contents of the sites themselves. Such efforts represent the cutting edge of prehistoric research today.

Death and Burial

While villagers buried young children near houses in urns within the ditch enclosures at both Banpo and Jiangzhai, they buried adults in cemetery tracts. At Banpo, 174 adult burials were excavated, most north of the village. At Jiangzhai a similar number were found in several directions around the ditch as well as at the center of the village. Most burials are single graves: one person interred with a few grave goods such as stone tools, pottery, and personal ornaments. Somewhat later in time, secondary burials, graves with many skeletons reinterred after their initial burial, appear at Yangshao sites. At both Banpo and Jiangzhai rich graves do not figure in the excavations. There are no reported finds of putative chiefs' graves or burials that suggest one clan was richer or of higher status than another. From the grave goods, Banpo and Jiangzhai appear to be egalitarian societies.

At other Neolithic cemeteries, however, disparities in grave construction and furnishings do suggest social differentiation. Contrasts in burials suggest that some members of these villages enjoyed higher status and greater wealth in life than did others. But treatment of the dead need not be dictated simply by status in life. The Dawenkou site (Tai'an and Ningyang Counties, Shandong) affords one of the best examples of

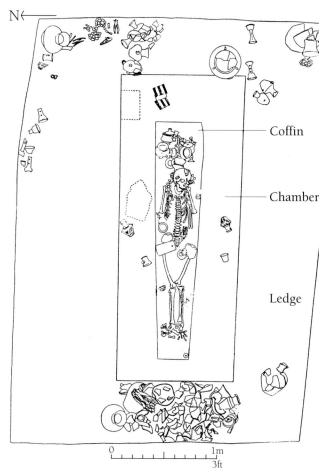

Coffin

Chamber

Ledge

1-4 Plan of Grave 10 with grave goods
Dawenkou cemetery site, Tai'an, Shandong. Dawenkou Culture, 4th millennium BCE

The plan (right) shows a rectangular coffin with skeletal remains placed within a larger trench, the latter surrounded by a ledge for displaying grave goods (pictured at left). The woman buried here had dozens of pottery vessels, including storage crocks and drinking goblets, as well as hardstone axe heads and several necklaces. One painted pot (left, top center) complements the others.

contrasts in grave sizes and furnishings. Excavated in summer 1959, this large cemetery contained at least 133 graves that could be classified in three successive periods. Grave 10 (FIG. 1-4), located in a cluster of twelve burials at the north edge of the cemetery, can be dated to the late period. It held the skeletal remains of a woman aged 50–55, a very advanced age. The skeleton occupied a large rectangular pit more than 13 feet long and 10 feet wide (4 x 3 m). Placed around her on ledges were several dozen white, black, and painted pottery vessels, as well as hardstone axe heads and a carved ivory tube. She herself wore three stone necklaces as well as other jewelry. These furnishings may indicate an elaborate funeral rite. Together the grave goods constitute a considerable amount of wealth consigned to the ground upon this woman's death. Only a few of the many graves are so large and none so richly furnished.

While most of the objects discussed below came from graves, most were not made specifically for burial. Stone tools and pottery are of course common in the dwelling areas of Neolithic villages, but they are rarely so well preserved if recovered there. For the best specimens we rely on goods placed with the dead, but even so, much of the pottery has been restored. This kind of sampling has its drawbacks. We illustrate and discuss objects deemed suitable for a grave rather than the whole range of object types in actual use. On the other hand, whole vessels tell us much more about shape and surface treatment than sherds alone can and must be examined if we wish to understand the full accomplishments of Neolithic potters.

MATERIAL CULTURE: MAKING THINGS

The people who lived in these villages created complex material cultures utilizing the abundant resources of their environment. They carved the bones from hunted and domesticated animals

into a variety of tools and ornaments and utilized animal hides for shelter, clothing, and for vessels to hold water. They used wood and bamboo for constructing houses and for a variety of other purposes including palisades, fencing, bows, arrows, spears, digging sticks, and containers. Mats and baskets could be made from plant materials; their impressions can be seen on pottery and on daub from houses. Woven cloth is documented, again on the basis of impressions found in clay.

Of all of the natural materials worked by human hands, hardstone and clay have particular qualities of endurance; even when pottery is smashed into pieces, the sherds survive. As a result stone and clay artifacts account for the great bulk of material recovered from both habitation sites and burials. Moreover, quite early, these societies worked stone and clay with exceptional skill. Shapes and surfaces elicited considerable attention, sometimes far beyond that required purely by practical requirements. Finely worked stones and decorated pottery carry much information in addition to what physical traits suggest about manufacture or shapes suggest about function. Stone carving and pottery decoration link us imaginatively to these ancient people (see pages 46–53 below). Like them, we find interest and pleasure in contemplating these well-made things.

In China, the oldest stone tools so far known have been found in southern Shanxi, near the Yellow River at a site called Xihoudu dated to 1.8 million years ago. Developed grinding techniques appeared much later but never entirely supplanted the percussion methods used to make flakes

Working Hardstones and Jade

Hard minerals must have been the most challenging materials to work for the prehistoric lapidary or stone cutter. They required grinding with a medium like sand (such as quartzite or carborundum), harder than the mineral to be worked. In order to hold the abrasive sand in place, some kind of a matrix—such as a paste or glue—was needed. The work of shaping, smoothing, and decorating hardstones also required distinct tools to guide the sand. A bamboo tube, for example, could hold the abrasive against a surface and gradually (after many tubes) produce a drilled perforation. Sand imbedded in a twisted bowstring could incise a straight line or even saw through a slab. The most impressive prehistoric hardstones required several techniques: slicing and shaping, making perforations of large diameter (such as bi disks) and great depth (such as cong tubes; see FIG. 1-9 below), removing surface to leave delicate relief bands, and, not least, incising extraordinarily fine line patterns within exceedingly small areas (see FIG.

1-10). These techniques, in turn, imply a secure method to hold or mount the object being worked, a ready power source for the tool guiding the abrasive sand, and possibly even magnification to permit the jade worker to see minute designs.

In the Northeast and Lower Yangzi macroregions, from the fourth millennium onward, we find a selective appropriation of certain minerals (all considered yu, "jade," by the later Chinese) distinguished by their colors, surface, and especially their extraordinary toughness. These hardstones are generally nephrite, in mineralogical terms an amphibole with a microstructure of "randomly-oriented bundles of felted and twisted fibers" (Wen and Jing, "Chinese Neolithic Jades," p. 254). The toughness of nephrite, second in the natural world only to carbonado ("black diamond"), derives from this structure. The smaller the bundles of fibers and the higher the degree of their misorientation, the more difficult the nephrite is to work. The

minerals most often found in the Chinese Neolithic are actinolite and tremolite, especially in the Lower Yangzi. While only one source for these minerals can be confirmed in this region (Liyang, Jiangsu), most Chinese researchers believe local sources must have been worked during this period. Perhaps they are now exhausted. (It is interesting that prehistoric cultures closest to the Xinjiang sources of nephrite have so far not produced evidence of working this kind of hardstone.) The coloration of these nephrites results from their chemical composition. They range from various greens and yellows to white, but the whiter, milkier shades seem to have been preferred by many Neolithic lapidaries. The other stone commonly called "jade" in English is the mineral jadeite (in Chinese feicui), never found in any ancient Chinese context. Jadeite—a sodium pyroxene with a different microstructure—actually has greater toughness and a different range of colors than nephrite. Its glassy appearance also contrasts with the cloudy nephrites.

1-5 Bird
Hongshan Culture, 4th millennium BCE. Turquoise, height 1″ (2.5 cm). Dongshanzui, Kezuo, Liaoning. Liaoning Museum, Shenyang

(see "Working Hardstones and Jade," page 33, for an introduction to the techniques of working stone). Around the beginning of the recent geological age (the Holocene), twelve to ten thousand years ago, gatherers and hunters in several parts of China began to experiment with making ground stone tools. Such stone working continued well into historic times when both prestige objects and practical ones were predominantly bronze. Ground stone knives, sickles, points, and other forms continued in use as important parts of tool kits throughout the Bronze Age.

Hardstones of the Hongshan and Liangzhu Cultures

Objects made of nephritic hardstones have been recovered from a great variety of Neolithic sites, but only in the 1980s did scholars focus on two regions especially rich in these products. The quantities of hardstones and their fine quality have prompted discussions of an "Age of Jade" as a developmental stage after the Late Neolithic and prior to the Bronze Age. However, hardstones did not play as prominent a role in Late Neolithic cultures in general as they did in the Northeast and East Coast cultures in particular, so the

concept seems ill-suited for general use. The prominence of hardstones in these cultures nonetheless suggests increasing social complexity. Indeed, chiefdoms may have appeared in these regions by this time. Differential distribution of wealth, specialized labor, luxury goods production, and control over precious resources all characterize such societies, and all these traits seem to fit the archaeological cultures discussed below.

Excavations have documented an early jade-using culture in the Liao River drainage of the Northeast macroregion (specifically Inner Mongolia and Liaoning). Named after a site in Inner Mongolia, the Hongshan Culture is dated to the fifth to early third millennia BCE, contemporaneous with Yangshao in the North and Northwest. Some Hongshan sites exhibit stone architectural features, including putative ritual structures and graves. A certain amount of painted pottery has been found, but only hardstone carvings concern us here. At sites such as Hutougou and Niuheliang (both in Liaoning), small pieces of hardstone shaped as birds (FIG. 1-5), tortoises, and as abstract curl or cloud forms (FIG. 1-6) have been found in cist graves. Two other characteristic artifacts—the so-called "pig–dragons" (FIG. 1-7) and "cuffs"—have been noted in several burials. Found near the waists and heads of skeletons, respectively, they could have been worn as a part of the dress or headgear. In general, jades of the Hongshan Culture have rather simple shapes and minimal surface detail. Small animal plaques present a typical silhouette with few additional details. The pig–dragons—a thick disk with a slit—usually have restrained linework suggestive of rudimentary facial features. The name is clumsy; beyond the snout or nose and large eye circles, this design lacks recognizable animal features. To call it a pig or dragon requires a leap of the imagination.

The Liangzhu Culture of the Lower Yangzi centered on Lake Tai (in modern Jiangsu, Shanghai, and Zhejiang) utilized hardstones in large quantities. Its name derives from a site first found in the 1930s. Major excavations of the 1970s–1980s uncovered numerous burials, but as yet no villages have been reported. Some of the graves yielded exceptional quantities of hardstones,

1-6 Hooked-cloud ornament
Front view. Hongshan Culture, 4th millennium BCE. Hardstone, length 8⅞″ (22.5 cm). Niuheliang, Jianping, Liaoning. Liaoning Museum, Shenyang

literally hundreds of items in a single burial. This culture seems to be the successor to a lengthy local sequence and dates to the late fourth and third millennia BCE, contemporaneous with the late Dawenkou Culture in Shandong. The well developed jade-working industry cannot have depended on household production. Minerals had to be prospected, mined, and transported over some distance. The volume of production itself required workshops with a considerable labor force. Highly skilled workers must have engaged in their craft for lengthy periods. A craft-producing population, in turn, demanded the support of others. Like the "eggshell" wares from the Shandong Longshan Culture discussed below (see FIG. 1-18), Liangzhu jades most probably emanated from a chiefdom.

We can infer functions for many Liangzhu jades from several dozen well-preserved, rich burials. Small beads and tubes arrayed near the heads and necks were probably necklaces. Large rings on wrists and arms presumably were bracelets. Flat plaques of several shapes, a fitting with three prongs, and awl-shaped jades also appear near skulls. It has been suggested they were part of headdresses, possibly differing for men and women. Elaborate headdresses appear in the composite motif found on the most impressively worked Liangzhu Culture jades (see FIG. 1-10 below).

Other forms found in the Liangzhu Culture most probably had ceremonial uses. Large axe

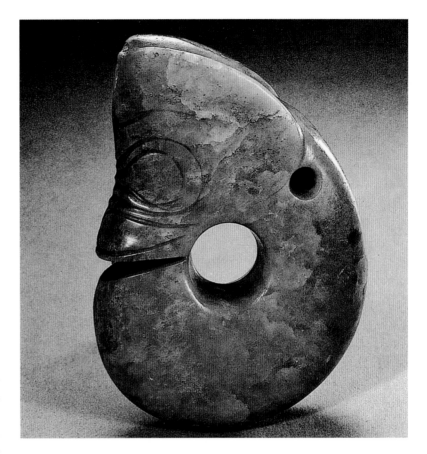

blades with perforations have been found at one side of skeletons in several graves at the Fanshan site northwest of Hangzhou (Zhejiang). The blades are accompanied by a fitting that ornamented the butt end of the axe handle and another piece that served as a finial (FIG. 1-8). The axe measured about 32 inches (80 cm) in length. Excavators found minute pieces of jade in the area where the now decayed handle lay. These axes may have been limited to male burials. At the Fuquanshan site (in rural Shanghai), excavators found several graves with many axe heads, although none are as elaborate as the examples found at Fanshan. Such axes could have been tokens of chiefly rank or warrior status. Although hafted and shaped much like the more common stone axes found in many other Neolithic cultures (and depicted among the Dawenkou emblems; compare FIG. 1-21 below), their cutting edges are not sharpened, and the stone is too brittle to withstand vigorous use, either as a tool or in combat. The blade from Fanshan also bears a complex composite image (see FIG. 1-10). This too suggests its owner had a special status.

1-7 Pig–dragon
Hongshan Culture, 4th millennium BCE. Hardstone, height 6½″ (16.5 cm). Niuheliang, Jianping, Liaoning. Shanghai Museum

1-8 Axe blade with handle fittings
Liangzhu Culture, 3rd millennium BCE. Hardstone. Fanshan, Yuhang, Zhejiang. Zhejiang Institute of Cultural Relics and Archaeology, Hangzhou

Found in one of the richest of the Fanshan graves (M12), this "ceremonial" axe originally consisted of a wooden handle (itself inlaid with small stones) and top and bottom fittings made from the same mottled purple-brown nephrite. The blade, tied in place, was made from a different stone with green bands in its creamy white matrix. (Compare with FIG. 2-24)

1-9 Squared tube, *cong*
Liangzhu Culture, 3rd
millennium BCE. Hardstone,
height 11½" (29.6 cm).
Sidun, Wujin, Jiangsu. Nanjing
Museum

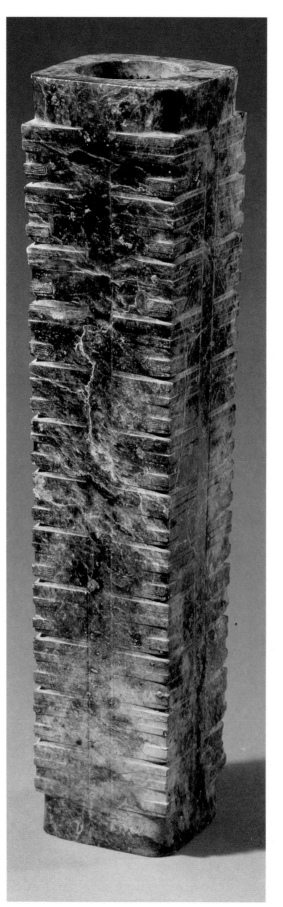

Other distinctive types cannot be linked readily to any obvious use either as adornment or as weaponry. Antiquarian scholars have long known about flat disks with perforations, *bi*, and squared tubes, *cong*, but the proper origin and dating of these objects remained obscure. A series of burials reported in the 1980s verified their attribution to the Liangzhu Culture. One grave near Sidun, Changzhou (Jiangsu), for example, contained no less than 24 disks and 33 tubes arrayed under, around, and on the skeleton of a 20-year-old male. The disks and tubes showed discoloration and fractures, perhaps caused by fire. The excavators hypothesize that there was a funeral rite in which the disks were laid down in the grave, burned, the corpse placed on the fire, and then tubes added around the body. Pre-modern scholars associated *bi* disks with the round dome of heaven and *cong* tubes with the square earth. These concepts and associations, however, only developed in the Warring States and early imperial periods (fifth–first centuries BCE), and there is no particular reason to believe that prehistoric peoples of the Lower Yangzi associated similar ideas with these types. The frequent pairing of these two forms may have significance. *Bi* disks look like enlarged renderings of spindle whorls used in weaving, and not unlike some axe heads with large perforations. To some modern scholars, the regular horizontal bands on the *cong* tubes suggest a concern with measuring. Whatever utilitarian forms and functions lie behind the shape and decoration of these objects, by the time the Liangzhu Culture flourished these hardstones had acquired special functions.

Disks in Liangzhu burials usually lack decoration, but other forms display extraordinarily complex and miniaturized surface detail. The *cong* tubes range from 1–2 (2.5–5 cm) to 12–16 inches (30–40 cm) in height. They are divided into two to fifteen superimposed registers of repeated patterns oriented at the four squared corners (FIG. 1-9). The pattern often consists of little more than a raised horizontal ribbon with drilled or raised circles placed above it on adjoining faces of the tube. Each register is delimited by undercutting below the ribbon and a pair of raised bands above the circles. Some smaller tubes, more like

rings or bracelets, suggest that the patterns found on taller tubes may actually be reduced renderings of a more complex motif: a mask that combines both human and animal elements. An animal mask generally appears below a less elaborate pattern register such as that on taller tubes. Its drilled concentric circles (read here as "eyes") have a raised area with fine engraved lines surrounding them. These relief areas are connected by a crimped band (a nose ridge?) bearing similar line work, so that the horizontal ribbon below seems to represent a mouth. Many dozens of these smaller tubes have come from burials, their patterns given greater or lesser elaboration through relief and fine lines. Some scholars now propose that the small braceletlike forms with elaborate masks actually represent the beginning of a lengthy devel-

opment and attribute the taller *cong* with simplified multiple registers to a later period.

Even more elaborate mask motifs, in turn, play a central role in the most complex imagery found on the Liangzhu Culture jades (FIG. 1-10). This motif seems to be restricted to certain large and impressive forms: axe blades, large *cong*, and plaques used as headdresses or hair fittings. As on the more common small forms, the mouth, eye sockets, and bridge linking them are rendered in relief, complemented by a broad "nose." Above these features lies another relief area consisting of a rudimentary miniature face within a trapezoidal head bearing a wide headdress resembling feathers. Indeed the simplified features of this face suggest the upper register pattern of small tubes. The two areas of relief are integrated by fine incised

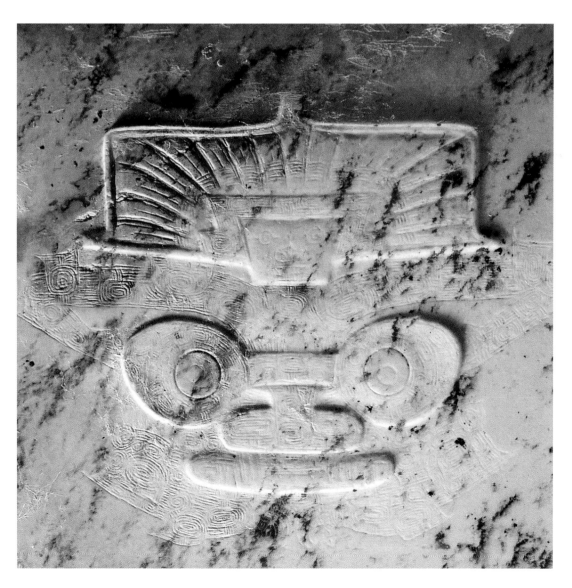

1-10 Mask motif from axe
Detail of FIG. 1-8

lines that delineate a torso, arms, and legs. Seen in this way, a body surrounds the raised eyes of the lower mask. Its hands meet the mask's eyes, while its clawed feet curl up under the mouth. The more common two-tier mask motifs found on small tubes and the radically simplified repeated patterns on tall tubes may both be references to this complex, fully elaborated form.

Scholars debate the possible identification and meaning of the composite mask figure. Since masks serve in many cultures as attributes of shamans and shamanesses, some suppose these motifs connect to a shamanic cult. The human-like figure of the composite motif could be either a deity served by a shaman or the shaman himself. In this view, many of the richest Liangzhu Culture burials should be attributed to shamans, presumably attired in their most impressive costume with jewelry and headgear. Indeed, one Liangzhu burial site at Yaoshan (Zhejiang) lies within an artificial earthen platform (or "altar") to which Chinese archaeologists ascribe religious ceremonies. This interpretive strategy deserves attention, but unfortunately much of the context for this cult remains unknown. Some writers see the mask-figure motif as the spirit or totem of

Working with Clay

Pots have been made in remarkably consistent ways throughout the world, perhaps because their basic ingredients and characteristics are also uniform. Clay fired at relatively low temperatures (c. 900°C) is called earthenware. It is relatively soft, easily broken, and porous. The ceramics discussed in this chapter would be placed in this category. When fired at higher temperatures (c. 1200°C), clay becomes harder and less porous; this is stoneware. According to present evidence, stonewares appeared only in the Bronze Age (see chapter 2). Firing clay requires a special oven or kiln where the raw vessels can be baked for a period of time. Kilns at the Banpo and Dawenkou sites have separate chambers for burning fuel and for baking vessels. When the air within the latter is oxygen-rich, combustion changes the iron in the clay to a reddish color. This is an oxidizing atmosphere. On the other hand, when the air in the kiln lacks oxygen, combustion draws oxygen out of the clay, turning it gray; this is a reducing atmosphere. The red wares described below came from oxidizing kilns, while gray wares and the "eggshell" black wares were made in reducing atmospheres.

The clay used for potting was common loess, the fine-particle soil deposited over much of North China by winds and rivers since the last Ice Age. The clay may be processed (levigated) before use to make its particles fine and regular. When dampened, the sticky quality of the clay allows it to be modeled plastically. Using slabs and coils of clay to construct shapes was the most common technique. Coils can be built up to make walls of vessels of any size and then melded by paddling. For this the potter holds the vessel in the hand or on a stand and beats the surface with a tool that is covered with twine so that it will not stick to the surface. Paddling reduces the visibility of the coils on the exterior as it strengthens the walls, but one can usually still feel the coils on the inside of a vessel. Larger jars had to be made in two halves and then joined together with wet clay (luting). Similarly, small filaments of clay can be luted to the surface for lugs. Potters finished many vessels on a slow wheel or turntable. By rotating the vessel, surfaces and shape could be made more regular, and some painting was also done in this way (see FIG. 1-1). The true fast wheel appeared rather late, notably in the regional Long-shan cultures. In vessels actually turned on a fast wheel, one can feel where the clay has been worked up. Only the "eggshell" black wares (see FIG. 1-18) discussed below required a true fast wheel.

The great majority of pots were given some surface treatment, such as cordmarking, scratching, and comb patterns. Cordmarking uses a paddle wrapped with cord or a stick wound with cord and then applied as a roller. Painted pottery of the Yangshao and East Coast cultures was burnished prior to painting. A piece of shell or smooth stone was used to polish the surface, imparting a glossy appearance. Paint can be applied either before or after firing. If applied before firing, the decoration will be less prone to flake. The painting utilizes slip, a liquid suspension of clay, with minerals that burn to various colors when baked. Some pots have a slip coating as a ground on which additional painting was then applied (see FIG. 1-16). Many materials could have been used to apply pigment. From the appearance of strokes and lines, it seems that some brushes consisted of pliant plant material.

the Liangzhu Culture people. Another bird motif, so far less often found in excavated objects than in objects in collections without provenance, has been linked to a sun cult or sun-bird totem. In a few rare instances the composite mask and bird images occur together. More discoveries and research will no doubt lead to renewed thinking on these topics.

Pottery

While pottery can be found at Early Neolithic sites that date before 7500 BCE, only after that date, in Middle Neolithic cultures, does it become truly abundant. In subsequent times and places, pottery marks the spot where prehistoric human groups lived. For most of the Neolithic period, part-time, perhaps seasonal, potters, both women and men, made pottery. Household production could achieve large output and high levels of quality. At Banpo and Jiangzhai, kilns clustered at one edge of the village suggest that all households had access to the kilns in order to fire their wares. Obtaining fuel and firing up the kilns may have been group tasks. Skilled, full-time potters supported by others probably appeared by the end of the Late Neolithic (c. 3000–2000 BCE), perhaps in chiefdoms such as the Shandong Longshan Culture.

Excavators analyze pottery to create convenient yardsticks for estimating time. This is made possible by the large quantities of pottery produced and by the everyday breakage that requires potters to produce new vessels continually. Pottery changes shape gradually but steadily over time, and decoration also undergoes a continuous long-term modification. By sorting sherds and whole vessels with these visible changes in mind, archaeologists establish relative sequences (seriations) that then become a standard for dating other deposits wherever they are found. Relative datings based on pottery seriations have been useful for comparing sites in different regions and for tracking long-term trends. Pottery also serves

archaeologists as a marker for recognizing "archaeological cultures" and their phases. Within sites occupied for relatively short times, pottery exhibits considerable consistency in its wares, shapes, and surface. At sites inhabited for longer periods or on several occasions, on the other hand, archaeologists can recognize the presence of one or more phases (or even cultures) from sherds in stratified deposits. Surveys and trial excavations that plot the areal distribution of a culture or its phases over space generally depend on such diagnostic sherds.

Moreover, pottery can be a source of data about cognitive processes and symbolic communication. Surface decoration, especially painting, offers the possibility of insight into the mind of an ancient potter. Yangshao potters decorated their basins and bottles with a variety of representational and non-representational designs. For modern researchers, the non-representational designs—common among many potters through

1-11 Bowl with painted decoration
Yangshao Culture, Banpo phase, 5th millennium BCE. Earthenware, diameter 15½″ (39.5 cm). Banpo, Xi'an, Shaanxi. Historical Museum, Beijing

the ages—serve as a point of entry into such questions as group identity. Representational designs, on the other hand, while less common in real numbers, are equally inviting (see pages 47–53 below). Speculations about symbolic connotations, however, are regarded here as the proverbial "slippery slope." How can we be confident that our assertions about a design we see as a "flower" or a "shaman's mask" correspond to what the ancient potters themselves saw or wished to make?

Pottery vessels served practical purposes for their makers and users, but by Late Neolithic times some pottery production fulfilled certain non-utilitarian purposes as well. Any vessel can be analyzed initially by mentally taking it apart and describing each of its attributes or features. For example, a vessel with a small flat base, wide ovoid body, open mouth, and everted rim (such as FIG. 1-11) may be common both in burials and in dwelling sites. It could have served a variety of purposes within the span of a day and over its life. Holding raw vegetables, serving cooked grain, holding water for washing hands, or covering a large crock as a lid would all be possible functions. A consistent combination of attributes, like those listed above, defines a type, but a single type could serve several functions, and many types probably shared common functions. Modern scholars have no choice but to call vessels such as this one (FIG. 1-11) "bowls," but it should not be assumed that such names designate their actual roles in all contexts.

We can be more confident about functions if the context or contents provide specific clues. Residues such as the dregs of a liquid or the charred remains of cooked grain or meat indicate contents, while tripods recovered from a hearth with carbon on their legs clearly served as cooking pots. Attributes that fulfill a specific purpose in themselves—such as legs, ring feet, lugs, spouts, lids, and knobs—also help to isolate functions. If lugs surround the mouth of a vessel, especially one with a large capacity, it may be that a lid or cover was tied down with a perishable material to seal the vessel and protect its contents. An argument about whether some pottery was non-utilitarian or "ceremonial" often depends on clues derived from its attributes and context. For exam-

ple, vessels with especially large pedestal bases, elaborate lids, and other features that make them inconvenient to handle may have been display wares and thus tokens of wealth or rank. Vessels like the "eggshell" cups (see FIG. 1-18) that only appear in burials may also be classed as ceremonial with some assurance.

Yangshao Cultures

Since J. Gunnar Andersson's initial work at the Yangshao type site, this culture has often been equated with painted pottery. In fact, painted vessels make up a small percentage of the total ceramic inventory at any excavation and within any context (except for burials of the Banshan and Machang phases). At Banpo the excavators collected five hundred thousand sherds and restored a thousand whole vessels. Of this total, only a few dozen whole vessels carried painted decoration. At Banpo potters painted vessels made from a fine hard red clay (accounting for 35 per cent of the sherds) with a burnished surface. Such red wares were primarily to hold water and food and appear in fairly high percentages in burials. Therefore it seems that the painted pottery at Banpo was of better than average quality and was preferred for both eating and burial uses.

The development of pottery shape and decoration within the Yangshao Cultures can be examined using wide-mouth bowls or basins, *pen*. At Banpo in the fifth millennium BCE, these basins were built up by coiling from a flat base. They have a gently swelling silhouette, but the upper register of the body contracts slightly below an everted rim (see FIG. 1-11). Painting may appear on the exterior upper register, on the rim itself, and inside the basin. Black and red slips (liquid suspensions of clay) were used to apply a variety of motifs. Among the more distinctive are: a fish in silhouette with alternating infilled and reserved (unpainted) areas; a "mask" with slit eyes, nose, and mouth, sometimes with flanking fish; and such creatures as deer and frogs. These representational motifs are of a piece with an abundant repertoire of geometric patterns, such as rectangular panels with infill reminiscent of fish bodies. Several early analyses of these motifs suggested that the "representational" fish came

1-12 Basin with painted decoration
Yangshao Culture, Miaodigou phase, 4th millennium BCE. Earthenware, height 14¼″ (36.5 cm). Miaodigou, Sanmenxia, Henan. National Museum of History, Beijing

earlier and that "non-representational" forms derived from them—an overall trend toward abstraction. While this makes for a logical formal sequence, it cannot be supported from the stratigraphy of the finds at Banpo and other sites, or from the shapes of the vessels with decoration. Abstract motifs can be found at lower (earlier) levels, while representational ones persist in upper (later) strata. Vessels of the same shape and hence same relative position in a seriation may carry either kind of design. The common animal motifs of Banpo and other Yangshao sites (Jiangzhai, Beishouling) did not, however, persist in later Yangshao phases.

In the Miaodigou phase, in the fourth millennium BCE, as exemplified by its type site in northwestern Henan, potters continued to make basins, but their shapes changed (FIG. 1-12). Although constructed on a small flat base, the slope of the vessel wall now angles sharply and the upper wall curves smoothly back to the mouth, so that the vessel's widest diameter is below the rim at the curve in the wall. Painting appears on the upper half of the outer wall and rim, but never on the interior. The most common motifs might be called abstract, unless one instead identifies reserved areas as "leaves" or "petals" and sees them as arrayed around infilled dots, the centers of "flowers." Some vessels have neatly composed patterns of five "petals" disposed around the surface so that individual petals serve two adjacent "flowers." Many examples, however, are anything but static. Potters pulled and stretched reserved areas, creating a constantly changing flow of motifs looking rather like sails filled by a strong gust of wind. Like the Banpo potters, the people of Miaodigou exploited the potential of painted and unpainted areas to create strong effects with only a single color of slip.

Similar basins are found in the Majiayao Culture of Gansu and Qinghai to the northwest of the Wei and Yellow River heartlands (fourth millennium BCE). This culture coexisted with Miaodigou to its east and the Dawenkou Culture (see below) of the eastern coast. Motifs of both the Banpo and Miaodigou phases are found on pottery from early strata at sites in Gansu. The local Majiayao

1-13 Basin with painted decoration

Yangshao Culture, Majiayao phase, 4th millennium BCE. Earthenware, diameter 11¾" (30 cm). Minhe, Qinghai. Qinghai Institute of Archaeology, Xining

1-14 Basin with painted decoration

Dawenkou Culture, 4th millennium BCE. Earthenware, height 4½" (11.3 cm). Dadunzi, Pi County, Jiangsu. Nanjing Museum

potters, even while retaining the early Yangshao basin shape, developed a distinctive repertoire of painted motifs not found in Shaanxi and Henan. A beautiful basin from Minhe County (Qinghai), painted both on the exterior and interior of its burnished, buff-colored body, shows the local style (FIG. 1-13). Contrasting infill and reserve areas are played off through undulating, modulated lines held in place at intervals by solid dots and set off by elongated, infilled "petal" forms that recall Miaodigou motifs. Inside this basin, the potter subdivided the area into equal segments using dots and then disposed dots at equal intervals around the rim. Majiayao designs generally exhibit careful geometry, but their outstanding characteristic must be their flowing lines gracefully moving around the vessel. In many cases it appears the vessel was painted on a turntable (see FIG. 1-1). A brush held stationary at right angles to the vessel surface could create evenly spaced, parallel lines while the vessel itself was rotated. Most of the surfaces of Majiayao basins are covered with monochrome designs, as are large bottles and jars.

These brief descriptions illustrate how vessel forms and painted decoration developed differently over both space and time. Archaeologists working at sites from Henan westward to Gansu and Qinghai recognize these wares and their cultural identities from just a few sherds due to the formal traits of such basins and their decoration. Cataloguing such data and systematically synthesizing it constitutes one of the main achievements of Chinese archaeologists since the 1950s.

The time-and-space framework for Chinese Neolithic cultures derives in large measure from such analyses.

East Coast Cultures

The Yangshao and Majiayao Cultures of Henan, Shaanxi, Gansu, and Qinghai did not have a monopoly on painted pottery. Impressive painted wares occur in the east, especially in the modern-day coastal provinces of Shandong and Jiangsu, where

the Dawenkou Culture flourished from the late fifth to mid-third millennium BCE. The excavation of extensive cemeteries at Dadunzi (northern Jiangsu) and at Dawenkou (southern Shandong) has supplied much of the data for studying this pottery. Like the Yangshao, the Dawenkou Culture existed for a lengthy period; many regional variations and chronological phases can be recognized. Here too, painted pottery was relatively rare even when it flourished; it is almost unknown in later phases.

Basins found in northern Jiangsu have shapes very much like Miaodigou vessels and feature similar painted designs. For example, the decoration on several basins from the Dadunzi site (Pi County, Jiangsu) reproduces extremely accomplished renderings of the same kinds of dots and "petals" (FIG. 1-14). Here, however, the decoration requires three colors of slip: reddish orange, brown-black, and white. Patterns are painted onto a ground that has previously been covered with slip, a practice not common in Miaodigou pottery. When redrawn, the pattern resembles either four circles created from petals and then filled with paired dots connected by horizontal lines or four flowers consisting of four petals each. Some examples also parallel Miaodigou pottery by replacing a regular, highly patterned disposition of these elements by distorted shapes and varied, dynamic placement. Dawenkou painted pottery carries other motifs, such as an eight-pointed star outlined in dark slip (FIG. 1-15) and filled in white with a reserved red square (the actual body color).

Many scholars argue for contact between the Miaodigou Culture of Henan and the Dawenkou Culture of Jiangsu and Shandong as the best explanation for their similar shapes and decor. Absolute dates from carbon-14 dating tests place the two phases within the same chronological range, and indeed the western periphery of the Dawenkou distribution overlaps the eastern periphery of the Miaodigou. A site north of Zhengzhou (Henan) called Dahecun revealed a lengthy occupation. Its pottery in turn represents a gradual transition from earlier to later Yangshao phases, including impressive painted pottery utilizing several slips (FIG. 1-16) that suggests contact with Dawenkou. The vessel shown

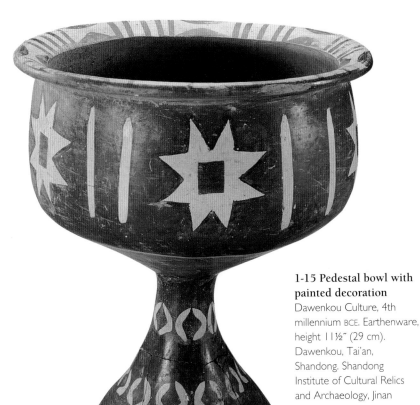

1-15 Pedestal bowl with painted decoration
Dawenkou Culture, 4th millennium BCE. Earthenware, height 11½" (29 cm). Dawenkou, Tai'an, Shandong. Shandong Institute of Cultural Relics and Archaeology, Jinan

1-16 Basin with painted decoration
Yangshao Culture, 4th millennium BCE. Earthenware, height 8¼" (21 cm). Dahecun, Zhengzhou, Henan. Zhengzhou City Museum

in this figure descends from the short, wide-mouthed basin first encountered at Banpo and later developed in both Miaodigou and Dawenkou. Its decoration consists of a white ground with other pigments played off against it, known earlier from the east. Movement back and forth from the Henan interior to the east coast was feasible and must have been increasingly common over time. Throughout the Late Neolithic such regional interaction became more and more powerful and must be considered one of the essential mechanisms for gradually creating a supra-regional, "Chinese" culture.

In addition to the three regions discussed above, painted pottery has been found in other cultures, including the Banshan and Machang of Gansu and Qinghai, the Hongshan Culture of the Northeast, the Daxi Culture of the Middle Yangzi, and the Taosi Culture of Shanxi. It is still too early to demonstrate that sustained interaction with adjacent Yangshao or Dawenkou Cultures had a decisive impact on these painted wares. The Taosi Culture is still known only from preliminary reports, and very little of its painted pottery has been published. In its own time period (c. 2500–1500 BCE), Taosi painted pottery was a rarity, except for the Northwest macroregion (the Banshan, Machang, and subsequent cultures). In the early Bronze Age painted wares also appear in the Xiajiadian Culture of the Northeast (see chapter 2).

The Shandong Longshan Culture

For several decades, "Longshan" has been a general term for a host of regional cultures in North China and the Yangzi drainage zone that share certain features and fall chronologically in the third millennium BCE. This meaning exceeds the initial use of this term, when it applied only to the culture first recognized at a site called Chengziyai (east of Jinan, Shandong). Pottery found at that site by G.D. Wu and others in 1930–1931 included a range of gray, dull black, and lustrous lacquer black wares. Some were wheel-made. Excavations at earlier Dawenkou sites have demonstrated that Shandong Longshan wares descend from shapes that evolved over a long term in that culture. Both in their earlier Dawenkou incarnations and in their later, Longshan ones, these vessels do not exhibit much, if any, surface embellishment except for raised ridges and incised lines made while turning on a wheel. The Shandong Longshan wares were among the earliest pottery made by specialists rather than part-time or seasonal potters. The Shandong Longshan Culture with its walled settlements certainly exceeded a village-level society, and, as with the Liangzhu Culture to the south, the term "chiefdom" probably fits.

Two kinds of pottery from this culture deserve special attention. A distinctive spouted pitcher, *gui* (FIG. 1-17), made from red, gray, or white clays has been found throughout its distribution. The white clay used for these vessels (but rarely for any other) is called *ganzi tu*, a porcellaneous clay (kaolin) that burns to a yellow-white color when fired at high temperatures. This may be the earliest instance in North China of such a clay being used for ceramics. (White clay is an indispensable ingredient in much later true porcelain.) The tripod body (called a *li*) consists of three bulbous, hollow legs terminating in solid, conical feet. Above the level at which these three legs join is a round neck with a turned rim. One portion of that rim is drawn out to create a large, troughlike spout. Directly opposite, attached below the neck and onto one leg, the potter affixed a strap handle. The form of the vessel, especially its aligned spout and handle, favored a pouring function, presumably for liquid contents warmed in the bulbous legs. Function and shape anticipate (or parallel) several bronze pouring vessels of the early Bronze Age (for example, see FIG. 2-13 below).

Taking into account their physical characteristics, find spots, and associations, the finest Shandong Longshan wares must have served ritual functions. This ware has been called "eggshell" black (FIG. 1-18) because it compares in thickness to a chicken's eggshell. Characteristic vessels are small goblets, *bei,* consisting of a round base, thin stem, and cuplike body with a flaring rim; they weigh only 1.5–2.5 ounces (50–70 g). Each component shows traces of having been thrown on a fast wheel. Some vessels actually have a separate cup cradled by the stem. The amazing thinness of the walls required a very fine clay

1-17 Pitcher
Longshan Culture, 3rd millennium BCE. White pottery, height 11½" (29.7 cm). Yaoguanzhuang, Weifang, Shandong. Shandong Museum, Jinan

Representative of a type that survived for several thousand years in the East Coast Neolithic (Dawenkou and Long-shan) cultures, this *gui* was designed to permit its liquid contents to be heated rapidly and then poured with precision. It stands near the inception of a long tradition of wine service vessels that served ritual needs throughout later times (compare the early bronze *jue*, see FIG. 2-13).

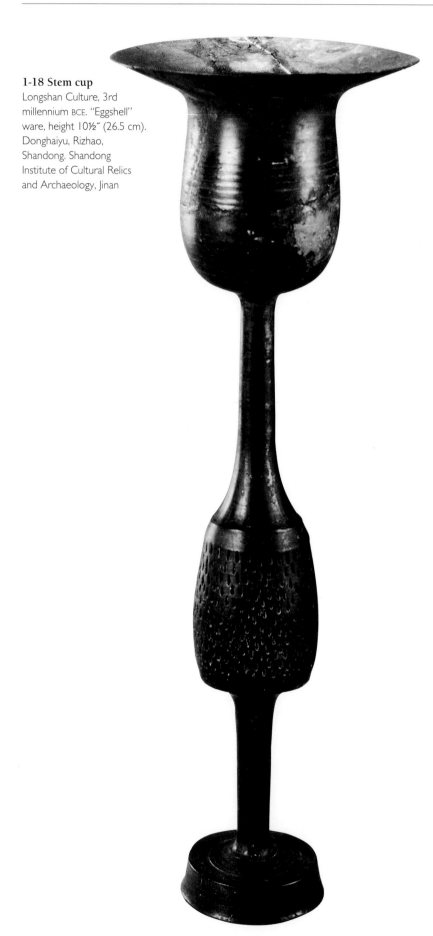

1-18 Stem cup
Longshan Culture, 3rd
millennium BCE. "Eggshell"
ware, height 10½" (26.5 cm).
Donghaiyu, Rizhao,
Shandong. Shandong
Institute of Cultural Relics
and Archaeology, Jinan

without impurities or temper (inclusions added by the potter). The paste is a uniform black throughout, although burnishing enhanced the luster of the surfaces. Making walls so thin may have necessitated scraping the exteriors with a sharp cutting tool while the half-dry vessel rotated on the wheel. Two formidable challenges thus faced potters making such objects. The power train driving the wheel had to be steady, more so than a kick wheel. Secondly, unfired vessels had to be able to withstand high temperatures inside the kiln without collapsing.

The functional role of this ware can be seen at a Longshan cemetery site near Chengzi (Zhucheng, Shandong; not to be confused with the more famous Chengziyai). Here only 6 per cent of the graves contained "eggshell" black ware cups. All of those graves, in turn, were large trenches with traces of wooden chambers and an assortment of other pottery, including some *gui* pouring vessels. A single cup was found near the upper torso or head of the skeleton or, in a few cases, near the hand. When compared to other graves of the same phase in the same cemetery, these few instances with cups seem richly endowed, and we infer both that their occupants had some special status and that cups and associated pottery figured in a rite at the burial. Like painted wares from Taosi, the "eggshell" wares from Shandong were probably made in limited quantities for special persons and functions. As with fine Liangzhu hardstones, some portion of society dedicated itself to specialized craft production for the needs of the elite.

MIND IN MATTER

It may seem presumptuous to study prehistoric artifacts for an understanding of abstract and complex notions. Our assumption, however, is that modes of thinking can be in some sense "visible." Visible, if and when data can be brought together to inform the deductions and speculations required to "see" them. An object utterly without context—without any clue to its time or place of origin, the human group that made it, or its function—becomes a blank slate on which an observer

can inscribe virtually any meaning. Interpretations of this kind must inevitably be idiosyncratic and, since they cannot be tested, may or may not be persuasive. On the other hand, observations and deductions about objects situated within contexts—as is generally the case for archaeological artifacts—lead beyond mere description and classification. With some measure of imagination and plausible speculation, interpretations of objects do in fact offer access to such topics as how people conceptualized themselves and their world.

Images of Animals and Humans

Several of the cultures surveyed above produced pottery vessels with the shape or attributes of real animals. For example, pouring vessels in the shape of boars and dogs (see, for example, FIG. 1-19) from the Dawenkou Culture of Shandong served as utilitarian objects and were essentially pod-based containers with spouts and loop handles. Legs and bodies were given feet, necks, and tails, while spouts were modeled with a mouth, snout and nostrils, eyes and ears. These vessels have been recovered from graves furnished with other, more common pottery and such items as roebuck tusks or the jaws of a pig. Animal offerings at graves are far more common than vessels shaped like animals, but correlating the two customs might be meaningful. Pigs and dogs were domesticated animals in this culture. Both animals presumably figured as significant food sources for at least some of the population. Each animal may also have been linked to hunting (wild boars were hunted, dogs were used in hunting). Both animals, moreover, supplied the tusks, bone, and ivory found in graves.

A modern observer created the pattern of associations sketched here from among all of the possible facts included in an archaeological description of grave contents. Nonetheless some of these associations could have been in the minds of the people who made such animal-shaped vessels. Hypothetical associations can be revised as more examples of graves and vessels are found. To date, all of the animal-shaped vessels in the Dawenkou Culture have been found with the asso-

ciated grave goods mentioned above. One grave was a mature female's burial, while the rest were males. It is not unusual to associate mature males with hunting and the task of procuring valuable food. Many societies past and present have assigned roles of this general kind to men. If we carry this line of thinking still further we raise many questions: were boars and dogs "fierce" or "powerful" animals? Was the hunter who killed such an animal or used such an animal likewise fierce or powerful? Did social prestige accrue to successful hunters? Did grave rituals and grave goods commemorate prowess as hunters or status as powerful figures within the village? When such artifacts and grave goods are found in a female's burial, can we extrapolate that she too

1-19 Pig
Dawenkou Culture, 4th millennium BCE. Earthenware, height 8½″ (21.5 cm). Dawenkou, Tai'an, Shandong. Shandong Museum, Jinan

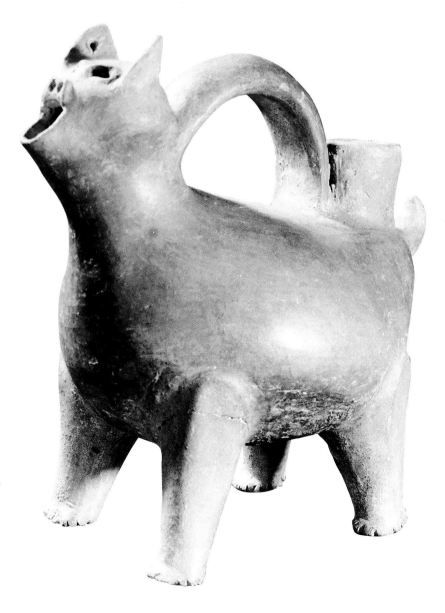

1-20 Owl
Yangshao Culture, 4th
millennium BCE. Earthenware,
height 14″ (36 cm).
Quanhucun, Hua County,
Shaanxi. Institute of
Archaeology, Beijing

was a potent hunter or otherwise powerful?
One can adduce ethnographic data from societies
in which hunting a boar becomes a source of social
prestige; however, an analogy only demonstrates
the possibility of such a linkage in the prehistoric
case. It does not establish a fact for a prehis-
toric society such as this one.

Other vessels in the shape of animals cannot,
however, be related to hunting; a gray pottery owl
from Quanhucun (Hua County, Shaanxi; FIG.
1-20) serves as a convenient example. Here no
published data on the excavation context has been
made available. Although a related owl's head has
been found in the same county, the species does
not correlate with other grave goods (such as
the Dawenkou tusks or pig jaws). Moreover, given
its shape, the Quanhucun owl actually serves less
well as a vessel. Although suitable perhaps for

storage, it would be hard to handle, especially
when filled. The owl's features—especially beak
and eyes—incorporate well-observed details
that distinguish it from generic bird representa-
tions. Without additional clues such as the status
of pigs as domesticated or the grave goods of
the Dawenkou Culture, however, it becomes
impossible to theorize the significance of the
owl. Is this vessel exceptional? Whose owl was it?
Later associations of birds in historic and literate
Chinese cultures, for example as the voices of
omens, have little value here, except as yet an-
other fund of comparative data that could be
invoked when more circumstantial informa-
tion becomes available. Owl-shaped vessels
are an appealing feature of Late Shang bronze
casting and marble carving (see FIGS. 2-10, 2-1,
below).

Precursors to Writing?

Some scholars see the origins of the characteristic Chinese logographic script in scratches on the rims of Banpo pottery sherds from the fifth millennium BCE. These marks were made by intention and did serve some purpose for potters or users. Some marks recur within a site or across sites, but they are generally so rudimentary (such as two parallel lines) that attributing specific meaning, much less linguistic function, to them seems ill advised. In order to be a precursor of proper writing, a mark must have had a demonstrable linguistic role representing sound (phonemes) and meaning (morphemes). It is possible that marks signifying meanings without sound values pre-dated true logographs, which convey both. Numerals would be a likely case in point. Other signs may have been employed as emblems—symbols that stand for something by conventional association. The earliest true Chinese writing system, the script of the Shang (c. 1200 BCE; see FIG. 2-5 below), already utilizes true logographs that carry both phonemic and morphemic value through several techniques of graphic representation and combination (see "Divination: Communicating with the Ancestors," page 61).

Sherds at sites such as Banpo, Jiangzhai, and Liuwan offer abundant evidence for marks made by potters. The assortment of marks in a given excavation can be quite extensive. At the Liuwan cemetery (Qinghai, c. 2400–2000 BCE), Machang Culture vessels bore thirty-eight distinguishable marks painted onto the lower portion of vessels. These marks systematize some 679 examples recovered from the graves of this one culture. If each household was making its own pottery, these marks could approximate the number of makers (households) at

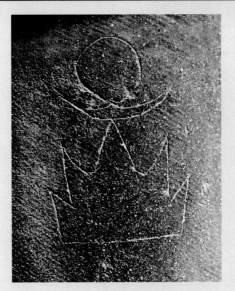

1-21 Detail of emblem incised on vessel
Dawenkou Culture, 4th millennium BCE. Lingyanghe, Ju County, Shandong. Ju County Museum

the time. On the other hand, if a few potters were producing wares for a larger community of users, different marks might indicate users or owners instead. The excavators of the Liuwan cemetery found a significant correlation between certain marks and certain graves, and some marks were found in multiple graves. If marks designated family identity, the association of the burials with identical marks might tell us about social organization.

More complex signs are found in the late Dawenkou Culture, datable to c. 3000–2000 BCE (FIG. 1-21). These marks consist of incised line drawings of a few repeated kinds: for example, a stone axe head on a handle, or a combination of a disk (sun?) and a crescent (moon?), sometimes with a pointed shape (mountain?). At present eight or more distinct signs have been collected, albeit in very limited numbers. They can be found only

on the exterior of large containers and have been documented at several sites distributed over the Shandong peninsula. In describing the line drawings, the words in parentheses above (namely sun, moon, and mountain) give possible readings proposed by Chinese archaeologists. Once we acknowledge these readings, however, it becomes difficult to see the drawings as anything else. By the same token these identifications are not strained. Some logographs of the Shang period in fact parallel them and provide one basis for such identifications. Perhaps these marks were emblems of groups (as small as a family or as large as a tribe) that had spread across the area documented by their archaeological distribution. This would be a matter of some importance for later periods, especially the early Bronze Age, when "clan emblems" figure prominently in many inscriptions on bronze ritual vessels.

Isolated potters' marks or emblems notwithstanding, there has been little evidence for a sequence of signs (logographs) that might represent a phrase or sentence. If efforts at writing employed perishable materials such as wood, bamboo, or leaves, their one-time existence would necessarily be absent from the archaeological record. The sophistication of Shang writing argues for a period of development in which principles for constructing logographs were devised. That development has yet to be rediscovered.

1-22 Vessel with human head

Yangshao Culture, 4th millennium BCE. Earthenware, height 12½″ (32 cm). Dadiwan, Qin'an, Gansu. Gansu Museum, Lanzhou

Most Neolithic cultures also yield some evidence for human representation. The best known examples come from the Yangshao Culture of the Wei River and the Majiayao Culture of the Gansu corridor. J.G. Andersson first collected pottery human images in the Gansu corridor during the 1920s, but his specimens could never be linked to specific archaeological contexts. Analogues have been rare in controlled excavations since that time. A fine example of this type is a tall painted bottle with human head from the important Dadiwan site in Gansu (FIG. 1-22). Here the potter finished off a burnished and painted red ware bottle with a modeled head. The face, a flat plane built out from the neck, has a raised nose ridge and rudimentary loop ears at either side. The facial features are generalized and masklike. The painted decoration on the body, a rendition of characteristic Miaodigou motifs (compare FIG. 1-12), does not extend to the head. By contrast, several examples collected by Andersson show painting on both heads and necks. Moreover, their zigzag edges suggest these heads were cut from the upper part of large vessels (perhaps only when they were collected for Andersson?). Two comparable vessels with heads attached come from the Machang Culture. These large pots, recovered at the Liuwan cemetery (Ledu, Qinghai), have painting on the face and head, like Andersson's examples, but the decoration on the vessel body does not relate to the heads. Painting on the faces has led scholars to speculate that the heads represent shamans or some other special status within the village, or possibly a custom like tattooing.

One vessel collected (not excavated) from the Liuwan cemetery integrates elements of a human figure with the characteristic Machang "frog" or stick-figure painted motif (FIG. 1-23). Except for the treatment of its surface, this tall pot matches hundreds of Machang vessels excavated at this site. The potter pinched clay at the neck and shaped it into nose, ear, and mouth ridges. There are crudely shaped arms, legs, nipples, belly button, and phallus on the vessel body. Touches of black slip reinforce some of these features, while the bent lower limbs of a stick-figure motif bracket the design at the bottom. A fully realized stick figure occupies the opposite surface. The Liuwan

vessel remains a true rarity, and once again, because it lacks context, it cannot be associated in any specific way with the extensive burials documented at the Liuwan site. As an "ithyphallic" image— one that presents the male generative organ—this design could also be associated with cult or shamanic activity, but what exactly did it represent? Some writers see the design as androgynous, with both male and female secondary sexual characteristics. A Machang Culture site at Shangsunjiazhai (in Datong County, Qinghai) is the find spot for a large basin with a procession of stick figures painted inside the bowl. The figures, rendered in profile, are also ithyphallic. Moreover, at the earlier Dadiwan site (Majiayao Culture), a hard-packed house floor had painted designs of ithyphallic type. These several examples establish at best a limited regional context for interpreting this imagery. Chinese scholars have generally used phallic imagery as evidence supporting the claim that Late Neolithic society became patrilineal, as well as in an argument asserting the early origins of ancestor worship.

Two Hongshan Culture sites in Liaoning, Dongshanzui and Niuheliang (see the discussion of hardstones above), present another unusual case. These sites have in common soft-baked clay images of nude female figurines, ranging in size from miniatures to fragments that are life-sized or larger. The torsos reveal only generalized modeling, but several figurines with distended stomachs have been described as pregnant females. A well-preserved head from Niuheliang (FIG. 1-24) with inlaid stones as eyes is almost life-sized. Compared to the much smaller modeled heads from the northwest sites discussed above, the features are more fully described, with nostrils and eye sockets. The surface is covered with a white slip, and the eyes are turquoise. This fair-skinned, blue-eyed figure might be evidence for a population group with similar traits on the steppe margins of North China. Small female figurines are known from several Neolithic cultures, but no other sites have as yet revealed such a quantity of figurines and body parts. The published accounts remain too incomplete to facilitate more informed speculation, but some scholars already hypothesize a "goddess" cult something

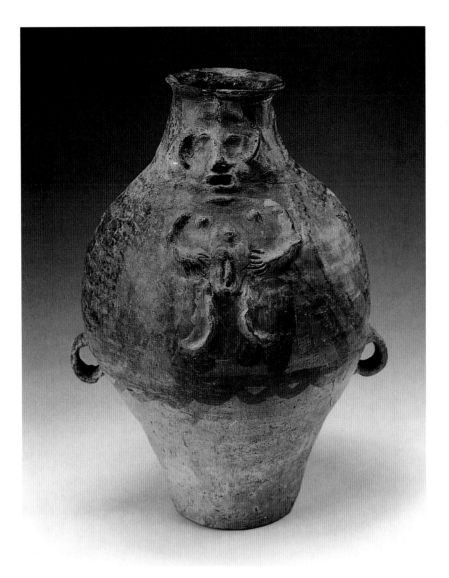

like the Venus figurines of prehistoric Europe as the context for their creation.

All properly documented animal and human images were recovered from burial contexts or putative ritual ones. As the earliest relatively sophisticated representations from these regions, they stand near the beginning of attempts to represent the world of the people who made them. But these ideas—"images" and "representation"—come from our modern-day categories of description and analysis. We should not assume that their makers regarded these objects this way. Were such images somehow endowed with life spirit or power as effigies or fetishes? Were they parts of a larger cultic and ritual context that incorporated perishable objects long decayed as well as various activities (music, dance, life-cycle rites) that do

1-23 Vessel with modeled ithyphallic design
Yangshao Culture, Machang phase, 3rd millennium BCE. Earthenware, height 13″ (33 cm). Liuwan, Ledu, Qinghai. Historical Museum, Beijing

1-24 Head
Niuheliang site, Lingyuan, Liaoning. Hongshan Culture, 4th millennium BCE. Clay, height 8¾″ (22.5 cm)

not leave behind durable traces? (For example, the stick figures painted inside the bowl from Qinghai may actually be dancers.) Contemporary scholars aspire to understand the cultural contexts and significance of this imagery, but until more pieces of evidence can be gathered the questions scholars can pose far exceed the confident answers they can deliver.

In historical retrospect, and until earlier examples become known, many scholars will see these artifacts as the beginnings of Chinese art. Yet such an evaluation has limited validity. In this discussion, "China" can only stand for a modern-day geographical entity; it did not exist at the time. Most later, historic cultures within China probably did not know of these artifacts. Nor can we assert unproblematically that later artistic traditions can be connected seamlessly back over the millennia to these examples. While in later times Chinese culture occupied some of these regions,

this does not mean that they should necessarily be included within the history of that culture.

This chapter emphasizes features of the current archaeological record that in many cases can be plausibly connected to later cultures. Pride of place has gone to such topics as working hardstones, pottery and its painted decoration, the earliest representational sculpture, and possible steps toward writing. Each of these categories of making things has a history that links prehistoric human groups with cultures that flourished from the second millennium BCE onward and to which we attach the label "Chinese." A different picture of prehistory in North China and neighboring regions could be assembled from present archaeological data, perhaps one emphasizing linkages to the north, to the Japanese islands, or to Central and Western Asia. Moreover, the material actually described above is the tip of a proverbial iceberg of data. More data accumulate year by year through the untiring efforts of field archaeologists and research scholars. The Liangzhu Culture *cong* tubes were misattributed to a late, historic period within recent memory and have been correctly identified only recently. Other examples of wholesale rethinking will also be necessary in the future. Here perhaps, more than in any other field, the future holds great promise for breakthroughs that will allow us to reinvent the past.

2 THE EARLY BRONZE AGE: SHANG AND WESTERN ZHOU

WHILE MODERN FIELD archaeology in China started with excavations at prehistoric sites, its theory and many of its practices took shape during two episodes related to the Bronze Age: premodern antiquarianism, starting as long ago as the eleventh century CE, and the excavations at Anyang (Henan) prior to World War II. In the Northern Song period (960–1127 CE), scholars began to investigate bronze ritual vessels with inscriptions as a means of supplementing and correcting the testimony of the Confucian classics and histories. By consulting ancient texts, scholars created a vocabulary to name these vessels and their decoration, a lexicon still used today. Scholars and emperors also began to collect and catalogue these objects in ways that presaged modern-day habits. All of these activities contributed to an expanded view of the past, the "Three Dynasties" (Xia, Shang, and Zhou). It became known that many ritual vessels had been recovered in the northern part of Henan at a locale known as Yinxu ("the ruins of Yin"), the traditional location of the last Shang capital.

Scientific excavations at Anyang actually began as a legacy of such enthusiasms. The discovery that archaic inscriptions on shell and bone ("oracle bones"; see "Divination: Communicating with the Ancestors," page 61) emanated from a hamlet near Anyang triggered fifteen seasons of large-scale excavations (1928–1937). As work progressed, the excavators realized they were unearthing the palaces, tombs, ritual vessels, and divination inscriptions of the Shang kings. The understandings that emerged over time have yielded a many-sided portrait of what we now call the Late Shang culture. Thus, for the pioneers of Chinese archaeology, their vocation was a pursuit contiguous with the study of history in every way.

Today, most Chinese archaeologists argue that "history" begins c. 2000 BCE or even earlier. In this chapter we consider a wide range of archaeological data in relation to the received picture of ancient Chinese history: a sequence of dynasties exercising political power over portions of North China and neighboring areas. However, the present authors regard most of the second millennium BCE (until c. 1200) as in fact a protohistoric period—a prelude to proper history but not itself historical. In particular, we maintain a reserved attitude toward the historicity—the historical reality—of the first of the Three Dynasties, the Xia (c. 2000–1600?), even though today most Chinese archaeologists not only assume its existence but also believe they have found its archaeological traces at a site called Erlitou (Henan).

THE EARLY STATE AND SOCIETY

Whether one consults the archaeological record or the literary canon, the human landscape of the second millennium BCE changed in fundamental

2-1 Owl-shaped wine container, *zun*
Shang period, Yinxu II, c. 1200 BCE. Bronze, height 18¼″ (46.3 cm). Tomb 5, Xiaotun Locus North, Anyang. Institute of Archaeology, Beijing

Shang and Zhou Sites in Henan and Shaanxi

ways. Changes resulted only in part from population growth; more importantly, they were the consequence of increased social complexity. Small villages—much like their antecedents at Banpo and Jiangzhai (see FIG. 1-2 above)—still existed in great numbers, but larger, more densely populated settlements also appeared for the first time. In addition to these nucleated settlements (called *yi* in the oracle-bone inscriptions), a few widely dispersed major settlements served a range of new purposes, required by a stratified social order. These major sites were the centers of chieftains or kings. Some chieftains and kings have left their traces in the literary record: possibly the Xia, most certainly the Shang and Zhou. How much before the Late Shang period (c. 1200–1050 BCE) such powerful figures could properly be called "kings," *wang*, remains debatable, but there can be little doubt that the first true states appeared in North China during this protohistoric period. By the Late Shang period, the Shang and Zhou kings engaged in both friendly and hostile relations with each other and with chiefdoms bordering their territory.

Settlements

Even if the identification of specific sites can be debated, physical traces of widespread social change are readable in the ground. Few nucleated *yi* settlements of this period have actually been

reported, but many likely candidates exist, usually suggested by cemeteries for which adjacent habitation zones have not yet been excavated. Among the best preserved settlements is a site in Hebei Province called Taixi (in Gaocheng County). This site occupied at least 2400 square yards (2000 sq. m) of a raised terrace, itself several yards or meters higher than the adjoining terrain. Within the terrace were the floors and wall footings of some fourteen houses, twelve of them from a single period of occupation. The houses were mostly built at ground level with thick pounded-earth walls forming one- or two-room chambers. Excavators also recovered traces of sun-dried adobe. Wooden frames probably carried mud plaster or thatch roofs. The houses were aligned either on a north–south axis or at right angles to it. Many chambers shared common walls, and several met at neat right angles. Several of the chambers lacked one wall and thus functioned like open sheds. These may have been workshops for the pottery, bone carving, or even the lacquer wares found at this site. In addition, two deep water wells were found. The Shang oracle-bone inscriptions contain frequent references to the king commanding the construction of *yi* "settlements." Sites such as Taixi suggest what such a settlement might have been like. No traces of a surrounding wall or ditch have yet been reported at Taixi, but over a hundred graves were unearthed to the east of the houses. Of these, eighteen contained bronze vessels and weapons and thus may represent the elite segment of the local population.

During the middle of the second millennium BCE, much larger settlements also appeared in the North China macroregion. The two best known and largest lie in Henan Province: at Zhengzhou, where the Erligang type site was first investigated in the 1950s, and in Yanshi County to the west, where a site called Shixianggou has been excavated extensively since the 1980s. These walled sites enclose areas in the neighborhood of 0.95 and 0.74 square miles (2.5 and 1.9 sq. km) respectively. The Zhengzhou wall runs partially under a late (Ming-period) wall but is longer overall: about 5500–6200 feet (1700–1900 m) for each side of its roughly square plan. The wall was

Building with Pounded Earth

Archaeologists digging at Anyang in the early 1930s came upon densely packed earth which they mistook initially as flood deposits. After the recognition of the Longshan-period earthen wall at Chengziyai (Shandong), however, the excavators identified such features as the products of human labor. The term *hang-tu*, an expression native to the Anyang region, was adopted for this important building technique.

The fundamentals of the process have not changed in several thousand years, and indeed people living in the countryside of the North China loess lands still use compacted earth, *banzhu*, to make farmyard walls and houses. The technique today requires wooden forms, typically spindly tree trunks lashed together to create a simple frame. Loose soil is dumped into that frame and then made hard using pounders, such as river cobbles lifted by a wooden shaft. The pounding reduces the loose earth to much thinner, compact layers. In ancient times, these layers were so tightly packed that they survive today with a hardness almost like that of concrete. Impressions from the pounders are often visible on the top surfaces of these layers; it appears that bundles of sticks may have been used for pounding in Shang and Zhou times.

The modern-day excavators of the Zhengzhou wall calculate that it would have required 1.14 million cubic yards (870,000 cubic meters) of pounded earth. If one assumes that twice that volume of soil must first be dug before compacting, then more than 2 million cubic yards of earth were required. If, again, one assumes that a single laborer (equipped with a stone spade and woven basket) could dig, move, and then tamp 0.26 cubic yards (0.2 cubic meters) a day with a pounder, the approximate time and labor force can be calculated. If that labor force were 10,000 workers, about eight years of effort would have been expended. Of course, all these numbers are estimates. How many hours of work a day and days a week should one assume? Whatever refinements these crude estimates may require, they help us imagine the magnitude of such tasks. Projects like this became more common as the Bronze Age unfolded. Massive walls and large foundations characterize all Bronze Age and imperial-period city sites. A ruler who could command thousands of laborers for many seasons must have been a powerful figure indeed, such as the king of a state.

constructed from layers of pounded earth and in some stretches still rises to a height of as much as 30 feet (9 m). (See "Building with Pounded Earth", above) The base dimensions of the wall range up to 65 feet (over 20 m). By contrast the wall at Shixianggou is an irregular rectangle measuring about 5500 feet (1700 m) north–south by at most 3900 feet (1200 m) east–west. While this wall is sometimes as wide at the base as that at Zhengzhou, at present its height nowhere exceeds more than 10 feet (3 m). Both walls have a number of gaps interpreted as gates, and within each walled area are traces of roadways issuing from those supposed gates.

Each of these sites could well be termed a "city." Indeed the modern Chinese word for "city" is the logograph for a large wall, *cheng*. The extended meaning of the graph derives from the key role of walls as a defining attribute of major sites. Walls enclose and exclude; their gates control access. Palaces and government offices were usually located within walls. Even if we equate these walled sites with archaic cities, we have not resolved their identification. Were they early Shang capitals … cult centers … military strong points? Data now suggest there may have been a hierarchy of sites. Smaller walled sites contemporaneous with Zhengzhou and Shixianggou are known from Shanxi (Gucheng), Hubei (Panlongcheng), Jiangxi (Wucheng), and Sichuan (Sanxingdui). The status of these sites would depend on how they actually functioned. According to definitions of the Zhou period, a thousand years later, a settlement with ancestral temples was considered a "capital," *du*. Some of these sites, both large and small, could have fulfilled that role for an elite lineage that occupied them, while others presumably functioned as satellite outposts to control territories, resources, or communication routes.

The rulers of large settlements, whether chiefs or kings, exercised their authority in courtyard complexes ancestral to later palace and temple

N

Hall

Yard

Gallery

Gate

Wattle-and-daub walls
Pounded-earth walls
P Pits
SG Shang graves
HG Eastern Han graves
RP Recent pits

0 10m
 33ft

2-2 Plan of palace–temple no. 2
Erlitou, Yanshi, Henan. Erlitou Culture,
2000–1600 BCE.

2-3 Courtyard compound
Fengchu, Qishan, Shaanxi. Late
Shang–Early Western Zhou,
c. 1100–1000 BCE. Rendering by
Yang Hongxun

designs. In ancient texts, these courtyards, *ting*, function as the setting for rituals and gatherings that satisfied the needs of the ruler, his clan, and his polity or people. Modern scholars refer to these complexes as "palace–temples" to signify their multiple roles and the multiple roles of rulers. A main hall, *tang*, a large roofed structure on an elevated platform, occupied the heart of a courtyard. This *tang* was the stage on which rites were acted out. An encircling wall, often with a gallery, defined the space of the courtyard, especially an open area before the main hall. In ancient texts the ruler is described as addressing gatherings assembled in such spaces. A gate house, again with a roof, controlled access to this precinct. Placed opposite the main hall, it determined a central axis. In general, courtyards are symmetrical about their axis; site permitting, the axis is aligned with the northern direction, with the entrance at the south. Together the wall and gate house separate the space and activities of the courtyard from the surrounding settlement, so that whatever happened within was off limits and hence mysterious. The mysterious aura created by such spaces adheres to almost all later Chinese architectural complexes, secular or sacred.

The two earliest palace–temples known survive only as foundations at the Erlitou site (FIG. 2-2). The larger of the two occupies a raised, pounded-earth terrace roughly 330 feet (100 m) square and aligned with magnetic north. The main hall stood on a large rectangular block of pounded earth, its broad dimension facing south. Unfortunately, the surface had been scraped clean throughout this site, so details remain conjectural. The smaller site (only about 230 by 200 ft, 70 x 60 m) was better preserved in every way, revealing more about its hall, gate house, and walls. Here the main hall had three large chambers of wattle-and-daub construction. A circuit of post holes around the perimeter suggests a roof with four slopes or overhanging eaves. The gate house of this courtyard consisted of a central passage and two flanking (guard?) chambers. Perimeter walls of pounded earth had galleries on the interior. Altogether the Erlitou site may have had

as many as several dozen compounds of this kind. If they served as ancestral temples, the site could well have been a capital, *du*, as defined above. Unlike Zhengzhou and Shixianggou, however, the Erlitou site had no massive wall or other enclosing feature. In view of its proximity to the Shixianggou site, Erlitou may have been a cult center linked to that larger site.

Compounds with this complex plan were not among the fifty-plus foundations partially unearthed and recorded in the 1928–1937 excavations at Anyang, nor did their condition permit careful restorations. A courtyard of Late Shang date in Qishan County (Shaanxi) shows how this basic design developed. Located near the village of Fengchu, the courtyard was built on a raised terrace in such a way that its perimeter walls and chambers were elevated above the yard (FIG. 2-3). The main hall was linked at each end to these chambers, but its floor was higher still. Behind the main hall was a divided rear yard. The gate house consisted of two large chambers connected to the sides; they frame a passageway leading into the yard. That entrance lay aligned on the central axis and was fronted by a freestanding screen wall. This courtyard was a compact, well-integrated unit, each part scaled to fit neatly with adjacent components. The overall size is significantly smaller than the two courtyards at Erlitou, merely 150 by 100 or so feet (45 by 32 m). Because of its location in Qishan County, ancestral home of the Zhou kings, Chinese scholars associate this courtyard with the royal Zhou lineage. A pit containing oracle bones reinforces this association.

The preference for certain building materials—pounded earth, mud plaster and daub, timber, thatch—largely determined the incomplete preservation of these most ancient structures. The advent of architectural pottery, roof tiles and water pipes for example, added a new, more durable ingredient into the built environment but did not materially improve the preservation of the structures themselves. It is thus quite difficult for us to understand the appearance of these sites. No pictorial art survives from this period, and ancient graphs suggest at most such generalized features as pitched roofs or two-panel doors. Almost

the only evidence for the details of these elite structures comes from a few ritual vessels that incorporate "walls," "windows," and "doors." *Ding* vessels from Shaanxi, for example, suggest that doors were divided into upper and lower panels and that windows may have had latticework. A kneeling figure lacking feet is often attached to one door panel on such vessels. (Zhou penal law prescribed chopping off the feet for certain crimes; such punishment could lead to a career as a palace doorkeeper.)

The Shang Royal Cult

Who occupied these structures, and how did they dominate society? Answers to these questions depend partially on material data but primarily on the interpretation of the oracle-bone inscriptions from Anyang. Whatever we can say today about the Shang royal lineage, its kings, and its cult derives in large measure from reading the inscriptions cut into turtle shells and ox scapulas (shoulder blades) for the divinations (plastromancy, scapulimancy) that were conducted daily during the reigns of the Late Shang kings. The Shang royal cult functioned in many ways as the glue that held society together. The living king's position in the cult as a unique intermediary between the people and the spirits validated his claims to worldly as well as spiritual authority. The practice of divination and sacrifice, both conducted by the king, served the needs of the royal lineage and of the larger society. The status and obligations of one lineage to another and of non-Shang groups to the Shang were determined through cult obligations. Much of the economy was regulated for and channeled toward this purpose. Craft production for the elite (see pages 64–81 below), in particular, centered on cult needs and activities. Many physical vestiges of the Shang are traces of cult activity, from oracle-bone inscriptions to bronze vessels and royal tombs.

The oracle-bone inscriptions found at Anyang were unexpected. Although various methods of forecasting the future were known in ancient China, most famously casting milfoil stalks in consultation with the *Book of Changes* (*Yi jing*), the specific materials and process of divination as practiced

2-4 Ox shoulder blade
Shang period, Yinxu phase,
1200–1050 BCE. Height 15¾"
(40 cm). Xiaotun Locus
West, Anyang. Institute of
Archaeology, Beijing

by the Shang kings were not recorded in transmitted texts and evidently did not continue much beyond the expiration of that dynasty. The materials employed, however, can be found in earlier Neolithic societies, especially ox scapulas. The use of both oxen and female turtles may indicate that the practices of the Shang cult had roots in several different mantic (divinatory) traditions. In any event, little is known about why such raw materials were chosen or what significance they may have had. Ox scapulas offered a large, relatively smooth and flat surface for making cracks, but the bones found at Anyang were first prepared by a tedious process of cutting and trimming (FIG. 2-4). Similarly, plastrons (the lower shells of turtles) required extensive work to cut away interior ridges and polish the surface. Notations on oracle bones suggest both oxen and turtles may have been raised for use in divination and sent to the Shang cult center at Anyang from outlying regions. Over the Late Shang period, bones and shells were used in roughly equal numbers. David N. Keightley has estimated that at least six oxen and twelve turtles were needed for this purpose during every ten-day week.

After the bones and shells had been prepared, hollows were carved on their back surfaces, usually in two parts. Columns of lentoid hollows were cut on the axis with the long dimension of the bone or shell, and smaller, round areas were cut away at right angles to them. This pair of depressions thus created two zones where the bone or shell was very thin and could easily crack when a hot point was applied. The resulting cracks, one long and vertical, and the other short and at an angle to the first, were the physical manifestation of the "oracle." The sound —something like "puk"— that issued from this process has been termed "the voice of the turtle." Interpreting these cracks, or more usually paired sets of cracks, was the arcane specialty of the king—his channel of communication with the ancestors.

Today scholars know of more than two hundred thousand "inscriptions on bone and shell," *jiagu wen*, recovered both from looting and from controlled excavations. Keightley suggests this

may be some 5 to 10 per cent of the original corpus of inscribed pieces. The vocabulary of these inscriptions has been estimated at about five thousand logographs, of which perhaps 40 per cent are recognized. The remainder are undeciphered, many assumed to be names or graphs for which there is no later descendant. Within these inscriptions are many formulaic phrases, most often paired positive and negative statements. The subjects addressed in the inscriptions are remarkably wide-ranging, although a majority have to do with details of cult, especially sacrifices. Who should receive offerings? When should the rite be performed? The most common subject is the outlook for the upcoming ten-day week, but the weather, celestial events, harvests, hunting, childbirth, warfare, and many other topics also merit attention.

The Shang king and cult served a hierarchy of powers through divination and sacrifice. Supreme among these powerful spirits was Di, the High God (also sometimes called Shang Di). It is possible that Di was a deified Shang ancestor (or even originally a collective term for deceased ancestors). Di was impersonal and all-powerful but remote, accessible only through the intercession of the royal ancestor spirits. Di controlled the natural and human worlds, causing both fortuitous outcomes, such as a bountiful harvest, and calamitous ones, such as drought or pestilence. As the supreme power, Di may have been ancestral or equivalent to the Zhou deity Tian ("Heaven"). Like Di, Tian was impersonal, able to bestow both good and ill fortune, and accessible via rites performed by the king. While it is unlikely that the Shang kings addressed Di or sacrificed to him directly, the Zhou king did maintain direct regular communication with Tian and in fact ruled by virtue of Tian's sanction (the "Mandate of Heaven").

Less powerful than Di was an array of nature powers and remote ancestors. The former included the spirits of the sun and moon and the winds of the four directions. Nature spirits found in the inscriptions include He, the spirit of the river (in this instance a reference to the Yellow River), and Yue, the spirit of the marchmount (holy mountain), possibly embodied by Mount Song (between Zhengzhou and Luoyang, in Henan). These nature

Divination: Communicating with the Ancestors

**2-5 Rubbing of
Bingbian 247**
Shang period, Yinxu II,
c. 1200 BCE. Academia
Sinica, Taiwan

Lengthy inscriptions encompass the following parts (using the terminology of David N. Keightley; see FIG. 2-5 and translation below):

(1) **Preface**. The day of divination is indicated by a two-graph combination (from among sixty pairs, the sexagenary cycle), and the diviner is named. About one hundred and twenty diviners are known.

(2) **Charge**. The topic being tested is stated, usually in antithetical, positive–negative statements. Diviners tested many charges five times by burning five pairs of cracks arrayed on opposite sides of bones or shells.

(3) **Prognostication**. The king inscribes his judgment as a restatement of the charge.

(4) **Crack numbers and notations**. Paired sets of cracks are usually numbered 1–5, and sometimes a comment like "Greatly auspicious" is noted.

(5) **Verification**. Another restatement of the charge at a later date confirming that the prognosticated result did transpire. It should be remembered, however, that most inscriptions consist only of preface and charge.

Full-length inscriptions offer a number of criteria for internal dating, and scholars have been able to place inscriptions in a relative chronology tied to the reigns of the Late Shang kings. The key element in such dating is the terminology used to refer to the royal ancestors. The use of generational terms (brother, father, grandfather) places the king conducting the divination in relation to his ancestors. Scholars have also associated diviners with certain reigns, and there are other criteria, including script style. The periodization of the inscriptions has also been correlated with archaeological phases recognized at Anyang.

Translation of *Bingbian* 247 by David N. Keightley (FIG. 2-5)
Positive Charge (right side of shell):
[Preface] Crack-making on *jiashen* [day 21], Que divined.
[Charge] Lady Hao will give birth and it will be good.
[Prognostication] The king read the cracks and said: "If it be on a *ding*-day that she gives birth, it will be good. If it be on a *geng*-day that she gives birth, it will be prolonged auspiciousness."
[Verification] After thirty-one days, *jiayin* [day 51], she gave birth. It was not good. It was a girl.

Negative Charge (left side of shell):
[Preface] Crack-making on *jiashen* [day 21], Que divined.
[Charge] Lady Hao will give birth and it may not be good.
[Verification] After thirty-one days, *jiayin* [day 51], she gave birth. It really was not good. It was a girl.

powers were the objects of specific sacrificial offerings; in the case of He, it has been suggested that offerings were made by throwing pieces of jade into the river. Remote ancestors also received cult worship. Some may have been one-time animal spirits made human or co-opted ancestors of lineages later subsumed within the Shang royal clan. Some were associated with mythical feats and attributes and later became part of the large group of culture bearers recognized in legend. The Zhou royal lineage honored a similar figure, Hou Ji, the Lord of Millet, as their own ultimate ancestor. Mythic events associated with Hou Ji form part of the earliest Zhou poetry, the *Book of Songs* (*Shi jing*).

The most powerful spirits affecting the living Shang king and his people were recent royal ancestors. The inscriptions document a genealogy starting with the dynastic founder, Cheng Tang, down through twenty reigns until the time that Anyang was occupied as a cult center. An additional eight or nine kings certainly divined at Anyang and so are taken to be true historical personages. The royal ancestors included both kings (fathers, grandfathers) and queens or consorts (mothers, grandmothers). Their ability to monitor the workings of the world of the living and to respond to human actions meant the king had to make frequent divinations so that his acts were not displeasing. The ancestors became more powerful as their generational distance from the king increased. The Zhou ancestral cult also demanded regular attention from descendants, who maintained family altars and performed scheduled sacrifices for at least a certain number of generations. This family-based cult, much modified over time, remained a feature of normative Chinese society throughout later history.

The Shang preoccupation with propitiating the ancestor spirits anticipated the Zhou practice of regular rites to Heaven, which also somehow monitored the king's conduct. Both the Shang and Zhou cults assumed that the ancestors had needs very like those of humans. The regular sustenance offered to these powerful spirits necessitated the ritual vessels that have been the focus of so much Shang and Zhou art history (see pages 69–81 below). Sacrifices were much like a meal for the living, with the exception of blood rites and human victims. Although the ancestor spirits themselves required attention and offerings, their greatest value to the king was as intermediaries to Di. The offerings were a kind of contractual bribe, in David Keightley's formulation, by which the Shang king obtained certain outcomes for himself and his people. Again, the types of Shang offerings—meat, grain, alcoholic drink, human—anticipate Zhou practices. Over the Late Shang period there was a shift from an open and flexible system of sacrifices to a rigidly scheduled and stereotyped set of rites. Early Western Zhou practices were evidently built on the Late Shang system but manifest considerable change, with less need for alcohol

and human blood. The changing repertoire of Western Zhou bronze vessels attests to these changing ritual habits.

The King and the Political Order

As the head of both the royal lineage and the larger polity, the Shang king performed a variety of duties that can be separated into distinct secular/political and religious/familial categories. Every aspect of the king's duties was tied both to his family (living and dead) and to the state. In the Western Zhou period, a similar combination of roles and duties characterizes kings. Many scholars refer to the Shang king's rule as "patrimonialism." While state organization might be termed proto-bureaucratic, the way in which roles were assigned and the relationship between ruler and subordinates was more akin to a family structure. A powerful father or patriarch presided over an extended, multigenerational family. Service within this patrimonial organization was a matter of personal obligation to the king, and kinship figured as the key qualification for service.

The oracle-bone inscriptions describe the Shang king giving orders or commands, such as to build a new settlement or launch a punitive military campaign against an adversary. The king is continually informed of developments within Shang territory, both near and far, and he himself frequently travels through that domain, manifesting his authority by, perhaps literally, "showing the flag." He attends to the weather and harvest but also engages in large-scale royal hunts. The copious divinations about sacrifice were simply the first phase of the king's ritual responsibilities. Daily, weekly, and other, less frequent sacrifices to royal ancestors and nature spirits occupied a significant part of the king's time. In all of these activities, an elite (or nobility?) composed of members of the royal lineage and other powerful clans served him. A staff (a nascent bureaucracy) of ritual specialists, diviners, scribes, and military officers met his immediate requirements. The over one hundred and twenty diviners named in the inscriptions may have been drawn from cadet branches of the royal lineage and from other clans. The king was also aided by the royal consorts,

fu, who performed a number of the same duties.

The Shang king's place of residence functioned as a capital of sorts, and this location changed repeatedly during the dynasty, perhaps even from one time of year to another. The cult center where the last Shang kings were buried, and hence the site of divination and cult offerings, located near modern Anyang, may have been the center of the Late Shang domain. Other lords ruled territories surrounding the king's and probably received him when he was on hunts or circuits. They provided resources for the royal domains including grain and other commodities, as well as people when labor or military service was required. The effective area of the Late Shang king's domain was much of Henan and parts of southern Hebei, western Shandong, and southern Shanxi. A wider area ruled by lords of statelets, *fang-guo*, not within the ramified Shang lineage, surrounded this zone. Some statelets were brought into the Shang state, while others maintained autonomy, and relations with them might be peaceful or hostile.

In similar ways, the Western Zhou kings presided over a structure of authority. After the conquest of Shang, the Zhou king was careful to place blood relations in key locations throughout the state in a system that has frequently been likened to medieval European feudalism. In some respects this is appropriate—obligations to the Zhou king included military service and taxes—but there were few of the explicit contractual obligations that were a feature of European feudalism. Ranks and titles were elaborated in the Western Zhou and are usually rendered in English equivalents such as Earl, Marquis, Duke. In the Western Zhou period the local nobles also interacted with outlying statelets and chiefdoms.

We know little of the rationale for the Shang king's rule except what we can infer about a king's role as the link to the ancestors and spirit world. The Zhou kings, however, left documents that more explicitly justify their rule and elaborate its ideology. Some of the texts in the *Book of Documents* (*Shang shu*) are presented as announcements made by the Zhou king to a defeated Shang people. They accuse the last Shang king of immoral conduct and claim that their deity, Heaven, had sanctioned their armed overthrow of this despicable ruler. The last Shang king's ritual excesses were part of his alleged misdeeds. Early Zhou propaganda, by contrast, proclaims a more moderate approach. Heaven has sanctioned their rule, and they must live up to its requirements.

The testimony of such sources, after several thousand years of scribal transmission, has been substantiated to some degree by a small corpus of Late Shang and Early Western Zhou inscriptions using much the same language and assumptions. For example, the traditional account of the Zhou defeat of Shang is dated to the morning of an auspicious day (*jiazi*). An Early Western Zhou *gui* vessel (FIG. 2-6) from Shaanxi unearthed in 1977 repeats that exact dating in its text, which had been composed a mere seven days after the event.

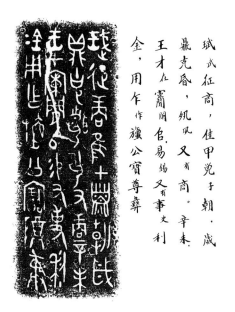

2-6 **Rubbing and transcription of inscription on Li *gui***
Western Zhou period, c. 1050 BCE. Lintong, Shaanxi. Shaanxi History Museum, Xi'an

> King Wu campaigned against Shang. It was *jiazi* [day 1], in the morning. King Wu performed *su* and *ding* sacrifices and was able to make known that he had routed the Shang. On *xinwei* [day 8], the King was at Jian encampment and awarded chargé d'affaires Li metal, with which Li herewith makes for the Duke of Zhan this treasured sacrificial vessel.
>
> Shaughnessy, *Sources* (pp. 89, 105)

With the Western Zhou, we enter a historical period in which received historical accounts can be verified from excavated materials, albeit sometimes with modest qualifications.

Warfare

The Shang and Zhou kings were warriors, able to enforce their will by commanding other warriors to do their bidding. The strongest of the Late Shang kings, Wu Ding, was probably an able commander himself, and his consort Lady Hao may also have played a role in raising men at arms,

2-7 Ceremonial dagger–axe, *ge*
Shang period, Yinxu phase, 1200–1050 BCE. Bronze with jade blade and turquoise inlay, length 13½″ (34.5 cm). Freer Gallery of Art, Smithsonian Institution, Washington, D.C. (40.10)

if not actually leading them in battle. The Early Western Zhou rulers, Wu Wang the "Martial King" and his brother the Duke of Zhou, likewise had military force at their disposal and employed it effectively. The martial tradition of these early kings tended to be down-played in later writings about the "Golden Age" that the Zhou was thought to exemplify. Confucius (551–479 BCE) stresses the civil virtues and dedication to ritual of the early Zhou era rather than its martial aspects. And in later times military valor is often paired with civil virtue in a sub-ordinate relationship.

The Shang kings regularly fought statelets or chiefdoms on their borders. All groups had access to weaponry made from bronze, especially a blade mounted at right angles on a shaft (the so-called "dagger–axe," *ge*) used for hacking and stabbing. Many thousands of these weapons are known, but only a few have any special features to sug-gest high-ranking warriors or lords, or even the king, carried them as tokens of status. An example in the Freer Gallery of Art (FIG. 2-7) has a bronze hilt that holds a jade blade; the hilt is inlaid with small pieces of turquoise. Finials at top and bottom resemble birds or drag-ons. The blade itself bears double-line incised drawing, while its top margin is fretted something like the flanges on Late Shang vessels. This token of rank should be considered a descendant of the Liangzhu blade discussed in chapter 1 (see FIGS. 1-8, 1-10 above). Other weapons include wide-blade axes, *yue* or *qi*, a form known as early as the Erlitou Culture; a few axes even have meteoritic iron blades. Some *ge* and other axes were rendered in jade. Like the deluxe specimen shown here, these would have been too fragile for any use other than ceremonial display. At least some Shang and Zhou warriors may have gone into battle in bronze helmets, although these are relatively rare, and shields may have had bronze fittings. Body armor, if it existed, has not survived.

The key weapon in the Shang and Zhou arsenal may have been the *ge*, but the most awe-inspiring component of an army must surely have been chariots. Many scholars now regard these two-wheeled carts as a technology brought into North China during the Shang period. Antecedents are known in Western Asia, and considerable evidence for their use in the intermediary Siber-ian and Central Asian zones can be cited. The Shang and Zhou war chariot was pulled by either two or four horses. The wooden cab, axles, wheels, tongue, and yoke were complemented by bronze fittings, and considerable numbers have been recovered from burial pits at Anyang and else-where. A Western Zhou chariot with a team of four horses and bronze regalia must have been a most impressive sight (FIG. 2-8). The artist's reconstruction shown here derives both from literary sources and from specimens excavated in Shaanxi. Bronze inscriptions frequently describe the bestowal of such chariots and their gear on meritorious recipients, and these accounts accord with textual traditions. As command vehicles these chariots must have been very useful, but how effective they were in combat on rugged terrain is an open question.

Although scholars over the centuries have given most of their attention to ritual vessels, both as the medium for inscriptions and as art objects, bronze casting for military purposes was a major industry during the Bronze Age. As long as the Shang and Zhou kings had exclusive control over ore resources and casting technology, their power was unassailable. Bronze production thus was a key component of the security and survival of the state.

CRAFT PRODUCTION FOR THE ELITE

Jade and bronze were only two of a variety of crafts exploited for the use of the Shang and Zhou elite, especially for the king's own person and his ritual obligations. Jades and bronzes had in common the virtues of durability: consigned to royal or elite tombs, they had a better chance of survival than objects that remained above ground in the hands

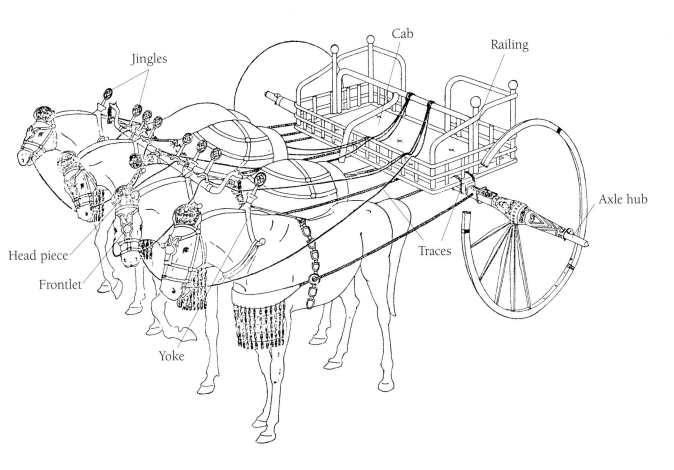

Jingles

Cab

Railing

Head piece

Frontlet

Yoke

Traces

Axle hub

of their users. Other craft products that did not share these traits—perishable silk cloth, fragile lacquer wares, breakable stonewares—have survived only in more limited quantities. Their attrition makes it that much more difficult to understand the achievements of their makers, the extent of their use, and their impact on the working of jade and bronze.

Artisans crafted all of these materials in workshops linked to the Shang and Zhou kings and nobility. Inscriptional data suggest a considerable range of skilled crafts during this time, but material evidence is less extensive. A late Eastern Zhou text, *The Artificer's Record (Kaogong ji)*, lists many craft specialties perpetuated among hereditary lineages, each with their own special knowledge. Similar family-based skills and knowledge may have been characteristic of Shang and Western Zhou times as well. A few actual workshop sites are known, such as a jade-carving site northwest of Xiaotun and the bronze foundry at Miaopu North, both at Anyang, but we do not know if craft workers enjoyed a social or economic status superior to other laborers. A case for

favored status has been built on the discovery of a few substantial houses that seem to have been workshops for the production of pottery, jade, and even alcoholic spirits (as at the Taixi site discussed above), but the evidence is inconclusive. These crafts were apparently not available to the larger society. Craft production for the elite, however, could not have existed without a diversified and developed economic base, one regulated or controlled by the king who supplied craft workers with food and shelter and perhaps even freed them from other obligations. Houses and pits excavated around the palace–temple foundations at Xiaotun suggest some craft workshops were located in actual physical proximity to the kings. Their maintenance from royal granaries and resources would have been easily sustained.

Carving in the Shang period reached high levels, and many features of Shang style originate in the act of carving. Bone carving (not to mention the preparation of scapulas and plastrons for divination) flourished. Bone was the material of choice for pins to gather the long hair of men and women. Fragments of bone objects were recovered from

2-8 Chariot and four-horse team
Western Zhou period, c. 1050–771 BCE

The plethora of technical terms for the parts of this war chariot emphasizes the complexities of this most imposing of war machines. Derived from many Western Zhou finds, this drawing displays the basic engineering of chariots and the array of bronze fittings that had developed since the Late Shang period, when the first chariots appeared.

2-9 Goblet

Shang, Yinxu period, c. 1200 BCE. Ivory with turquoise inlay, height 11¾" (30.3 cm). Tomb 5, Xiaotun Locus North, Anyang. Institute of Archaeology, Beijing

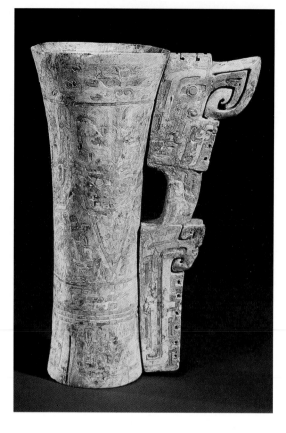

2-10 Owl

Shang period, Yinxu II, c. 1200 BCE. Marble, height 13¾" (33.6 cm). Tomb 1001, Xibeigang, Anyang. Academia Sinica, Taiwan

This owl and a kneeling tiger of similar size were the first large Shang stone carvings excavated scientifically. Their rear slots suggest a functional role as supports, perhaps at the entry to the burial chamber or for tomb furniture. Although masks and dragons supplement the surface decoration, they are less prominent than comparable motifs on the bronze owl wine container from the tomb of Lady Hao (see FIG. 2-1).

the Anyang royal tombs, but the carved ivory goblets from the tomb of Lady Hao best exemplify this aspect of Shang carving (FIG. 2-9). The entire surface was worked with designs interchangeable with those of bronze decoration (see below). Inlaid turquoise teeth, nostrils, eyes, and brows play off against the dense surface patterns, a technique seen in the ceremonial *ge* (see FIG. 2-7 above). Tusks needed for these goblets may have derived from royal elephants or may have been tribute. Elephant bones were found at Anyang in the 1930s and 1960s; tusks also figure prominently at Sanxingdui, the contemporaneous site in Sichuan (see pages 86–87 below).

Compared to ivory, blocks of nephrite were obdurate indeed. Most Shang and Western Zhou jade carvings are small in scale. A high percentage comprise a menagerie of real-world animals of land, water, and air, with an assortment of more fantastic creatures, including the crested birds and dragons also found in bronze decoration. Several hundred of the most pleasing Shang jades, most of them easily held in the palm, were found in the tomb of Lady Hao, consort of King Wu Ding, whose unlooted tomb southwest of the palace foundations also yielded miniature human and humanlike figures (see FIG. 2-23 below). Several writers have noted the similarity of Shang jades to prehistoric predecessors. For example, the so-called pig–dragons of the Hongshan Culture (see FIG. 1-7) seem to presage coiled dragons of the Shang, although the latter are flat rather than round in section. Similarly, the ubiquitous mask motifs of Shang bronzes and other media are akin in general terms to the motifs found on Liangzhu Culture jades (see FIG. 1-10). Comparable materials and designs must make us ponder the possibility of a relationship. However, long stretches of time and space separate the Shang from each of these prehistoric cultures, and only a few examples of prehistoric objects have been found in Shang contexts.

The prewar excavations unearthed a number of marble images in the round at the Anyang royal tombs, and, more recently, the discovery of the tomb of Lady Hao has added to that evidence. A marble owl from Tomb 1001 (FIG. 2-10) represents work of the period. Only some 13 inches (34 cm) in height, this carving nonetheless ranks among the largest works of Shang-period sculpture from the north. The vertical slot in its back

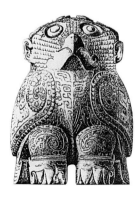
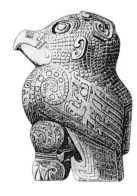
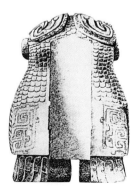
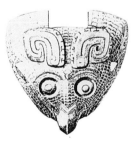

Piece-mold Bronze Casting

The molds used in Shang and Zhou times were ceramic, a hard gray earthenware, made from two kinds of clay: a finer clay on their interior surfaces and a coarser backing. Molds were prepared from templates or models and made in sections that could be assembled with keys or mortises to hold them in position. The molds for the largest Shang vessel yet known, the *Si mu wu fangding* (FIG. 2-11), would have consisted of multiple slabs, perhaps with several subsections for each of the four sides of the vessel. Vessels circular in cross section were created from two- or three-part assemblies. Making sectional or piece molds offered a great advantage. A model or template could be made once and many clay slabs impressed onto it to create identical mold sections. Individual molds could be stamped while moist, and then baked before carving. Carving could be assigned to many hands working separately; thus individual pieces vary considerably in small details. A core to occupy the intended interior space of the vessel also had to be made. Many writers have hypothesized that a positive model was trimmed down on all surfaces and then reused as a core. However, cores could also be cast from molds. Whatever the case, the space left between the core and reassembled outer piece molds determined the thickness of the vessel. Proper distance and hence thickness could be assured by carving keys into the mold sections and core (in order to support a lower core or suspend an upper core), or by introducing metal

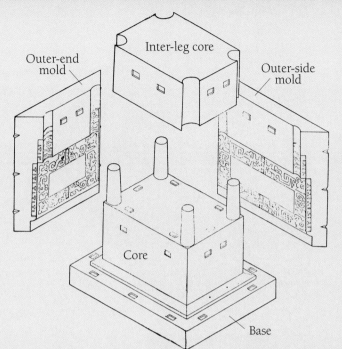

2-11 Mold assembly for the *Si mu wu fangding*

The vessel made using this (reconstructed) mold assembly remains the largest ever recovered from the Shang period, weighing nearly one ton (875 kg). The dedication to a "Mother Wu" (*mu wu*) may indicate the *fangding* was cast for a consort of King Wu Ding and contemporary of Lady Hao.

Labels in figure: Outer-end mold, Inter-leg core, Outer-side mold, Core, Base

spacers (chaplets) between core and molds.

Casting must have been a laborious and tricky process. The mold assembly had to be invested with a mass of clay to hold it together. This was probably placed in a sand pit in the ground and probably was itself heated so that hot metal was not introduced into cold molds, causing cracking. Many vessels seem to have been cast upside down with a leg (or spout attached to the ring foot) used to pour in the alloy. Part of a mold assembly for a large *fangding* vessel was found in the foundry at Miaopu North (see again FIG. 2-11). A sprue—an outlet—also had to be attached to another leg or similar feature to allow hot gases and air trapped within to escape as the molten metal was poured

in. The whole assembly filled with metal from bottom to top, finally topping off at the pouring spout and outlet sprue. After the whole had cooled for a short time, the assembly was retrieved from its bed of sand, and the molds were broken off the new vessel. Thousands of broken mold fragments were recovered at the Miaopu North foundry site.

The freshly cast object usually needed extensive cold working. Fins of metal that had seeped into the seams between adjoining mold pieces had to be trimmed or filed off and smoothed. Core material trapped in relief features had to be carved out, as did the core matrix filling the interior space of the vessel. Polishing and buffing would also have been needed.

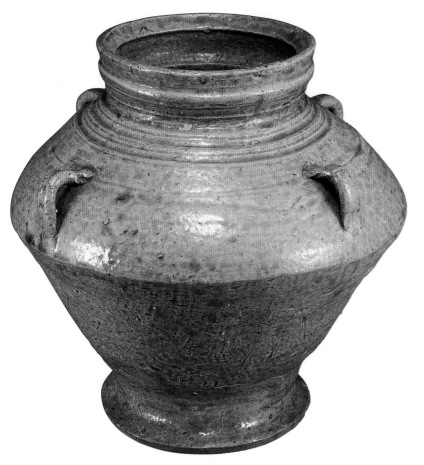

2-12 Large storage vessel, *hu*

Western Zhou period, c. 1000–900 BCE. Glazed stoneware, height 7¼" (18.7 cm). Liutaizicun, Jiyang, Shandong. Shandong Institute of Cultural Relics and Archaeology, Jinan

that could withstand high-temperature firing were used to produce stonewares (FIG. 2-12; for the basic techiques of working clay, see page 38). Feldspathic glazing on these vessels is attested in northern and southern regions from both the Shang and Western Zhou but may have been more common in the Yangzi drainage zones of modern-day Jiangxi and Anhui provinces. Potters applied the glazes over the surfaces of large container vessels (usually *zun* and *lei*) and burned them to either a soft gray-green or chocolate brown. Such vessels are thinly potted and carry at most a sparing decoration of incised lines or stamped cordmarkings. Uneven pooling of the glaze creates dark glassy spots; while perhaps accidental, it is much admired by modern connoisseurs. Examples unearthed from such northern sites as Zhengzhou, Anyang, and Luoyang (all in Henan) as well as the Xi'an region (Shaanxi), suggest stonewares traveled regularly from southern kilns to northern consumers. The high-temperature kilns and the control over firing needed for this kind of production were analogous to the furnaces and equipment used in bronze foundries.

Bronze Ritual Vessels

Defining attributes of Shang and Zhou kingship included the abilities to exploit ore resources, to maintain foundries, and to utilize precious metal for cult ritual and state ceremony. It has even been suggested that the Shang capitals moved in order to secure the copper ores necessary for this technology. Ritual vessels employed in the royal cult were symbols of royal status and authority. The "nine *ding* tripods" utilized in the royal ancestral temple became tokens of legitimacy. In the Zhou, a new king would claim to have received the nine *ding* as positive evidence that he enjoyed Heaven's Mandate. The requirements of bronze casting (see "Piece-mold Bronze Casting," page 67) included a skilled labor force whose many separate efforts could be coordinated for high-volume production. Ore sources had to be found and mined. Laborers smelted raw ore into metal ingots that were then transported to foundries. Potters adept at model and mold making, and at firing up kilns to heat the alloy, needed their

suggests that it anchored some object inserted there. The owl is a plump bird resting on its two thick, drumstick legs and hooked tail feathers. Grooves cut across the bottom define the two claws and tail but leave a substantial base. The bird's features are compact, accentuating the prominent, curved beak. Inset circular eyes, simple C-shaped ears, and flattened horns at the top of the head are rendered in relief or incised line but do not break from the mass. Incised lines cover all surfaces: scales on the back and head, coiled serpents and dragons placed as backswept wings, and a mask motif on the chest. The design and conception are strikingly similar to a pair of bronze vessels in the shape of owls from the tomb of Lady Hao (see FIG. 2-1). Their only important differences are their projecting features—such as ears and horns—made possible by the stronger metal. The owl enjoyed a considerable vogue in the crafts of the early reigns of Late Shang, appearing often in jades and bronzes.

Shang and Zhou bronze casting was indebted in significant ways to ceramic technology. Clays

own raw materials and fuel. The casting process itself required specific expertise so that the melt could be properly mixed, the pour carefully controlled, the furnace closely monitored. Final cold working (filing, polishing) to finish objects imposed its own requirements of skill. The products of this high technology must have elicited awe among the general population, which perhaps was complemented by rituals performed by the founders during production.

All aspects of bronze casting as practiced in ancient China seem to have grown from local traditions, in spite of its relatively late appearance and the best efforts of some scholars to identify it as an imported technology like the horse-drawn chariot. Early European studies of Chinese bronzes simply assumed they were made by a version of the lost-wax technique known from ancient Mesopotamia. The study of ceramic outer molds recovered from Anyang sites as early as the 1930s disproved this assumption. (We know now that a lost-wax casting procedure was used by the Spring and Autumn period; see chapter 3.) Some scholars argue in favor of a smithy stage preceding casting in the history of Chinese metallurgy, primarily because of details on some early ceramic vessels that can be interpreted as evidence for rivets and other sheet metal features. This viewpoint is not generally accepted.

Bronze is an alloy of copper and tin that does not occur in nature. In ancient China lead was almost always used as well. A ternary (three-part) alloy has several virtues directly related to the proportions of the three metals in the recipe. The addition of tin to copper increases hardness, although a high tin alloy will be brittle. Tin also lowers the melting temperature of the alloy and promotes fluidity, thus improving the ability to fill in all parts of the mold assembly. Lead, on the other hand, improves the ability of the cold metal to take finishing and also affects color, turning the casting gray. While lead is consistent in Early and Late Shang castings, it may have been present initially simply as an impurity in copper ores. All of these ores were available in central and north China. Both copper and tin were mined within 190 miles (300 km) of Anyang.

Ore was rendered into ingots at or near the mines. Ingots have been found at the Miaopu North foundry site at Anyang and at an important mine of the Eastern Zhou period near the Yangzi River in Hubei. The crucibles—large vessels for melting ingots—found at Shang sites lack pouring troughs, which suggests that the materials being heated were already reasonably pure and did not produce much slag to be poured off. Crucibles typically are made of a hard earthenware with thickened walls (and even air chambers) to retain heat. They often have solid bases shaped as plugs that could be inserted into a socket as they were heated in the furnace. Such furnaces did not differ fundamentally from ceramic kilns. In order to melt the alloy, temperatures above 1000°C were necessary, but this is less than the temperatures needed for the production of stonewares. Once the melt was ready, it had to be poured into a waiting mold assembly. Few details of this step are known, but one site at Anyang seems to have had a charcoal-lined trough in the ground leading from furnace to casting pit.

Terms of Analysis

Function

Like many ancient objects that now repose in museums, Shang and Western Zhou bronze vessels were not made simply for display or aesthetic appreciation. Many vessel types have lengthy histories in Chinese cultures before the use of bronze, and some continued long after the Bronze Age. While specific functions cannot always be determined, several large classes are represented:

(1) vessels for holding alcoholic beverages, e.g. FIGS. 2-1, 2-16, 2-18, and for heating, pouring, and drinking the same, e.g. FIGS. 2-13, 2-15, 2-17;

(2) vessels for steaming and serving grain, e.g. FIGS. 2-19 and 2-20;

(3) tripod vessels for cooking meat, e.g. FIG. 2-14;

(4) shallow basins for holding water, perhaps for ablutions, e.g. FIG. 2-22.

Moreover, as more intact assemblages have been analyzed, it is quite clear that many vessels were part of sets or ensembles of different types. Members of such sets often share a common decoration. For all of these reasons, it is misleading to analyze bronze ritual vessels as if they were individual creations.

Unfortunately, there is no direct evidence for how a group of vessels was used on a royal altar prior to the literary sources of later Zhou centuries. If the rites performed at a Shang funeral were representative, sets of vessels might be cast as a group at one time or, alternatively, might be composed of disparate pieces gathered together from different sources, sometimes of different ages and hence rather different appearance. The tomb of Lady Hao, the richest burial ever excavated at Anyang, held over two hundred ritual vessels. About half bore inscriptions naming her and hence were produced for her use (for example, FIGS. 2-17, 2-1, 2-21 below), perhaps by a single foundry at Anyang. An almost equal number of vessels, however, bear inscriptions naming other owners, which might mean that they were donated (with their contents?) at the funeral. On the other hand, some elite burials west of the Xiaotun cult center contained vessels that clearly pre-date the period of the burial. They were probably culled from ancestral altars or other sources in order to satisfy the needs of the funeral rites. A large cache of Western Zhou vessels recovered at Zhuangbai in Shaanxi consisted of bronzes made for a single family over several generations. The fact that they were cached at one time indicates the family held onto many vessels used by their ancestors. Both patterns of use and the status or wealth of the users determined ritual sets.

The names by which the various types are designated today were for the most part derived from ancient Chinese writings by antiquarian scholars of the Song dynasty (960–1279 CE). Some types—such as *ding, gui, hu, jia, jue, li, yan (xian), yu*—are also found in oracle-bone or bronze inscriptions. However, the most common terms employed in bronze inscriptions of the Late Shang and Western Zhou periods are broader phrases: for example, "precious revered sacrificial vessel," *bao zun yi.* This phrase may be found on virtually any type.

Only some of the Shang- and Zhou-period terminology has been reconstructed, and clearly it did not entirely correspond to later antiquarian and archaeological usages.

Individual vessel types match different kinds of handling and use. Vessels with pod supports are an important component of Shang bronze assemblages. The earliest common type, the pouring cup, *jue* (see FIG. 2-13 below), is one of several types with a tripod base. The three legs allowed the container to be placed into the coals or flames of a fire, or onto any irregular surface, without tipping over. Surface deposits of soot attest to this use. The pouring trough and strap handle of the *jue* made it suitable for a libation or for emptying the alcoholic beverage into a goblet (such as the ivory cup, see FIG. 2-9 above). Moreover, the *jue* was differentiated from a related type called a *jia*, which has a round mouth but no modifications to facilitate pouring (see FIG. 2-15). Since *jia* are also usually larger than *jue*, we may deduce they were used to heat a large quantity of beverage, which was then ladled out. The most numerous pod type is the tripod, *ding*, used in cooking meat stews, the "main courses" of any ritual repast. Late Zhou- and Han-period ritual texts describe elaborate nine- or even eleven-course meals prepared for important ritual offerings. This actual function is reasonably well supported by discoveries of charred bones (even fossilized meat) within the bowls of Shang and Zhou *ding*. The loop handles of *ding* allowed the cooks to set them on and off the fire, but clearly these vessels were not handled as much as the smaller *jue*. The repertoire of types, and varieties within types, was finely tuned to meet the real needs of those officiating at the rites.

While Late Shang assemblages have a functional logic, a syntax that facilitated performance of a certain rite with certain offerings, it is unlikely that ritual sets were entirely stable. The most common syntax throughout the Shang period is a pouring cup, *jue*, and drinking goblet, *gu*. This in turn suggests that many rites involved individuals consuming alcoholic beverages. Next most frequent is the addition of a meat-cooking vessel, *ding*, and the larger beverage-warming type, the *jia*, to the *jue*–*gu* pair which allowed a meat offering and warming of the drink for *jue* and

gu. An extraordinary burial like that of Lady Hao contained about fifty pairs of *jue* and *gu.* This large number was perhaps dictated by the number of mourners who attended her funeral rite. By the Middle and Late Western Zhou periods, prescribed sets of vessels correlated with noble rank were taking shape. According to ritual texts, a Zhou "Son of Heaven" was entitled to a complement of nine meat-cooking tripods, *ding,* and eight grain-serving bowls, *gui.* Lesser noble ranks were given reduced complements—seven *ding* and six *gui,* five *ding* and three *gui* etc.—as an expression of ritual and sumptuary conventions. Many Zhou excavations bear out at least these general patterns. As yet, no known Western Zhou royal burials to confirm the highest levels of this system have been discovered.

Typology and Decoration

We can learn a good deal about bronze vessels by considering their changing appearance from the Erlitou Culture (Xia?) through the Western Zhou. This lengthy period unfolds as several stages in the early history of this industry (see chapter 3 for Eastern Zhou). From a few small, thin, and simple types based on ceramics characteristic of the Erlitou Culture and early Erligang phase, we can trace a continuous record of experimentation and elaboration. Foundries revised the oldest types and created entirely new ones. An extensive repertoire of large, thickly cast, complex, and floridly decorated vessels characterized the incep-

tion of the Late Shang period, as with the vessels from Lady Hao's tomb. Many new types, especially wine containers, flourished, but only a few of them survived beyond the Early Western Zhou period. The range of types in the Early Western Zhou reigns clearly draws on mature Shang practices, but by the Middle Western Zhou one can track changes in the array of types and their relative importance. By the last reigns of Western Zhou, some long-lived types have been dropped from ritual sets, while new approaches to surface decoration have also appeared.

The earliest vessels, the *jue* cups from the Erlitou and a few other sites, already show the mixture of standardization and variation that would ever afterwards characterize bronze production. *Jue* cups (FIG. 2-13) were standardized: three bladelike legs; a flat-bottomed, bi-conical body; an extended trough spout balanced by an opposite lip; and a strap handle midway between trough and lip at right angles to them. These attributes define the type. Ceramic prototypes both pre-dated and coexisted with these metal renderings. At this stage, all *jue* share these attributes; all are well designed to heat and pour liquid. Yet these vessels clearly were not produced from the same molds or after one prototype. They range in size from about 5 to 10 inches (12–25 cm), and their parts differ considerably in proportions. The short legs and attenuated trough of the example shown here contrast with longer legs and shorter troughs on others. Moreover, even in this small sample, two variations appear with some regularity. About half of the vessels have perforations in their strap handles. Others have short posts near the juncture of rim and trough spout. Predictable, standard features combined with minor variations characterize every type throughout the Shang and Western Zhou periods.

Vessels of the Early Shang period, the Lower and Upper Erligang phases in archaeological parlance, are far more numerous. More than a dozen standard types are found over a wide territory extending from northern Hebei to central Hunan, and from the Shandong peninsula to the Wei River valley of Shaanxi (the North and Northwest

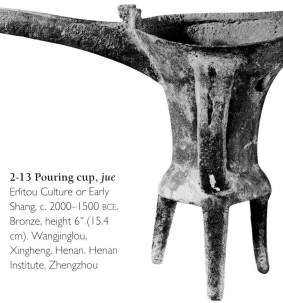

2-13 Pouring cup, *jue*
Erlitou Culture or Early Shang, c. 2000–1500 BCE. Bronze, height 6" (15.4 cm). Wangjinglou, Xingheng, Henan. Henan Institute, Zhengzhou

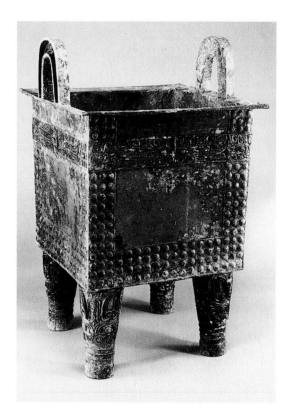

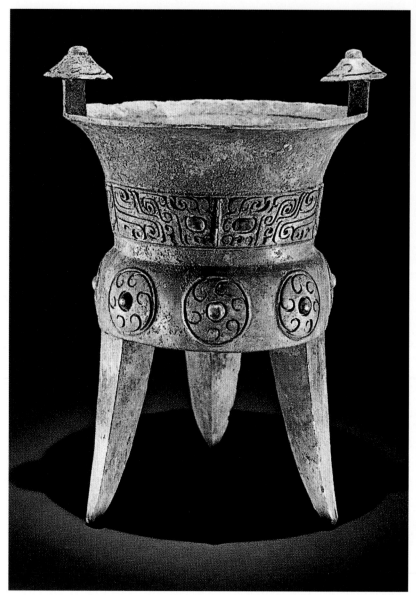

2-14 Cooking vessel, *fangding*
Shang period, Erligang phase, 1600–1400 BCE. Bronze,
height 32½″ (83 cm). Zhengzhou, Henan. Zhengzhou
Institute of Cultural Relics and Archaeology

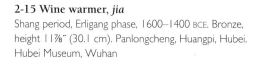

2-15 Wine warmer, *jia*
Shang period, Erligang phase, 1600–1400 BCE. Bronze,
height 11⅞″ (30.1 cm). Panlongcheng, Huangpi, Hubei.
Hubei Museum, Wuhan

macroregions and Middle Yangzi). This distribution of find spots contrasts sharply with the narrow range of find spots in the previous Erlitou Culture period (Henan, Shanxi). Vessels with pod bases were elaborated into several types for heating and pouring liquid (*jue, jia, he*), cooking meat stews (*ding* and *li*), and steaming (*yan* or *xian*). Vessels with ring bases, again modeled closely on ceramic forms, vary mainly in the treatment of their bodies, from shallow basins (*pan*), to deeper bowls (*gui*), to shouldered containers (*lei, zun, pou, hu,* and *you*). Drinking goblets (*gu*) are also ubiquitous. Within this repertoire of types, many features—legs, necks, rims, handles—are common property. If we make an analogy

with objects actually assembled from separately made parts kept on a shelf, then Erligang-phase foundries needed only a few basic parts in different combinations to create this array of specialized forms. Moreover, in spite of their wide geographical distribution, there are no obvious regional variations. Almost all types and varieties are found in all macroregions. In archaeological perspective, this kind of homogeneous distribution would be strong evidence for a widespread cultural horizon, the Early Shang Culture.

One notable innovation of this period is the first appearance of very large vessels, especially the rectangular *ding*, the *fangding*. Several pairs of these imposing vessels have been recovered from pits

and may have been sacrificial offerings (FIG. 2-14). In the case of several pairs found at Zhengzhou the rendering of the type is consistent, but dimensions vary (32–39 inches; 80–100 cm). Four thick, cylindrical legs support the large, rectangular box. The walls of the box angle slightly outward and the lip is sharply everted. Large hollow loop handles rise from the two short ends. The surface decoration blends bands of typical "zoomorphic" motifs (see pages 77–81 below) with bands of raised bosses, which frame an undecorated central panel but leave a bare register under the lip on each face. This formulaic approach to covering the four broad faces of such *fangding* was to have a long life, surviving into the Western Zhou period. Scholars refer to such conventional approaches to decoration on types as "orders" of decoration.

Most vessels produced in the Erligang phase have one or more bands of decoration on a prominent segment of the body (FIG. 2-15). This decoration was produced as motifs either carved or stamped into outer mold segments. Thus, a typical vessel with a circular section like the *jia* shown here will have a band in three segments corresponding to the three outer molds needed for casting. The rendition of these motifs ranges from a thin relief line (requiring incised lines in the outer molds) to wider ribbons against intaglio areas (requiring carved or stamped relief on the outer mold to hold the space for intaglio passages). In fact, the actual renderings of the common motifs constitute a spectrum of variations, rather than two, dichotomized renderings. Many vessels have both thin relief lines and wide ribbons on their surfaces. From the standpoint of the artisans carving the molds, the choice was largely a matter of introducing more or less carving and detail. Vessels of the Erligang phase share a repertoire of established motifs.

Elaborate surface treatments characterize the transitional period bridging the height of activity at such Erligang-phase centers as Zhengzhou and the first reigns of the Anyang occupation. The settlement at Taixi (Gaocheng, Hebei), discussed for its surface houses above (see page 56), represents

this period well. Several vessels at Taixi exhibit surface coverage more extensive than narrow bands, with a more complex rendering of Erligang-phase motifs. A kind of quill, filling densely packed areas that surround the elements of the mask motif, characterizes this stage of decoration. An unprovenanced wine container, *pou*, now in the collection of the Palace Museum, Beijing, represents this decoration (FIG. 2-16). Supported by a relatively high ring base, the body of this vessel is divided by a sharply carinated (keel-like) shoulder into rising, swelling surfaces and the slanting ledge below the cylindrical neck. Large rams' heads placed equidistantly on the shoulder overlap the edge. Finely drawn and crisply cut patterns cover most of the vessel. Plain bands separate the several stacked zones of decoration, while three raised lines ("bowstrings") encircle

2-16 Wine container, *pou*
Shang period, 1400–1200 BCE. Bronze, height 20½" (52 cm). The Palace Museum, Beijing

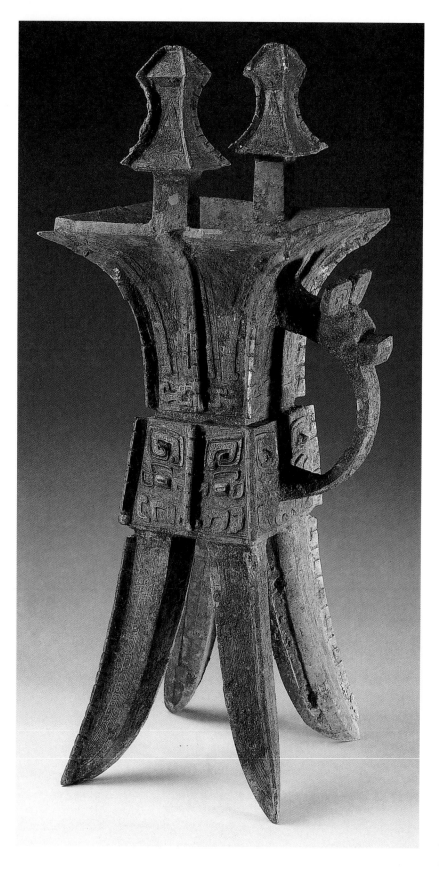

the neck. The five different bands are exercises in manipulating spirals and quills punctuated by relief "eyes" (or bosses). This patterning is so dense that it becomes difficult to discriminate between motifs. During this same transitional period other innovations in decoration appear. On some vessels an undulating relief separates select elements from the dense quills, perhaps to enhance their readability. The first recognizable animal motifs (turtles, fish, cicadas) appear on vessels, and a small percentage of vessels display fields of bosses or other geometric patterning. From this stage forward, several trends in decoration coexist.

Few discoveries have affected studies of bronze vessels as much as the undisturbed tomb of Lady Hao at Anyang. This assemblage offers a window through which to observe the range and quality of bronze casting produced for a royal patron at the beginning of the dynastic occupation (c. 1200 BCE). While some eight hundred to a thousand vessels have been scientifically excavated at Anyang sites since the 1928–1937 campaigns, about a quarter of that number come from this one tomb. As a result, we have a far better idea of all aspects of Shang bronze production and usage at this time (the period archaeologists call Yinxu II) than at any other. In Lady Hao's tomb assemblage alone, archaeologists recovered virtually every type and variety known for this period, as well as others not seen before.

Refinements and considerable experimentation characterize this phase. The tall *jia* (*fangjia*), one of a pair from Lady Hao's tomb, bears an inscription with her name (FIG. 2-17). While the basic components of the *jia* type had been stable since the Erligang phase (compare FIG. 2-15), here the form is rendered as a container with a square (*fang*) cross section, including each of its four legs. The artisan refined the silhouette to accentuate a concave arc ascending from the point of each leg to the everted lip. Flanges on the legs, body, and neck emphasize this continuous, taut profile. Incised line decoration on the two outer surfaces of each leg contrasts with relief motifs on the body and neck. An animal head surmounts the strap handle. Two large caps on posts rise from the rim and echo, in reverse, the trumpetlike mouth and profile of the vessel body. This

jia is one of many types rendered for Lady Hao in daring new ways. The assemblage also held *fangding, fanglei, fangzun, fanghu*, and unusual renderings of the *fangyi* wine container and the steamer, *yan*. Each of these innovative varieties derives from an established type. This interest in square- and rectangular-section bronze vessels may demonstrate a new bronze aesthetic in which foundries emphasized qualities specific to bronze vessels and downplayed the debts to ceramic prototypes.

Another striking innovation of this period is animal sculptures in bronze that also served as usable vessels. Most impressive is an owl-shaped container, one of a pair (owl *zun*; see FIG. 2-1), also inscribed with the name of Lady Hao. These two birds share much in common with the carved marble owl (see FIG. 2-10 above) retrieved from Tomb 1001 at the royal cemetery. (Some scholars believe this tomb was that of King Wu Ding.) In the bronze owls, the design exploits the greater strength of metal to lessen the bulk of the legs and tail feathers and to realize horns standing atop the head. Like the marble owl, the bronze vessels play host to a variety of animal and zoomorphic motifs, including a bird and bottle-horn dragon in the round on the lid, coiled serpents as the wings, and an owl mask over the tail feathers. Animal-shaped vessels continued to appear within Late Shang and Western Zhou bronze casting but never became very numerous. The animal shape of the vessel and the more or less real animals applied to the vessels are styled as precisely as the zoomorphs (masks and dragons) that also characterize this period but at the same time establish a connection to the natural world.

The architectonic forms and carefully orchestrated, boldly rendered decoration of the vessels from Lady Hao's tomb foretell a longlasting tradition. This tradition continued during the late reigns at Anyang and flourished into the Western Zhou period. A fine example, possibly from a foundry at Luoyang, where some of the Shang populace were resettled after the Zhou conquest of the mid-eleventh century, is a *fangyi* in the Freer Gallery of Art, Washington, D.C. (FIG. 2-18). Known as the "Ling *fangyi*" after the individual named in its lengthy inscription, this square, boxlike vessel on a low base has a bulging silhouette and a convex lid similar to a hipped roof. A thick flange with prominent, undercut hooks accentuates each corner and marks the midline of each face. Large masks with hooks similar to the silhouettes of the flanges decorate each face, while on the lid this same mask is oriented upside down. Small animal heads with split bodies cover the band under the lip. Vessels with a comparable debt to a Late Shang aesthetic are attested at find spots in the Wei River valley as well. Like this example from Luoyang, these vessels take the earlier style several steps further toward bold, assertive statements and even baroque ornamentation.

This tradition of bronze vessel decoration, certainly the most privileged in modern art-historical writings, was by no means the only current within Early Western Zhou bronze casting. Even as early as the tomb of Lady Hao, a small percentage of vessels perpetuated a more restrained manner and body forms more obviously tied to ceramic prototypes and Erligang-phase bronze types. A goblet, *gu*, excavated from the rich cache of Western Zhou vessels at the village of Zhuangbai (Fufeng County, Shaanxi) features a remarkable, uncorroded, copper-colored surface, as well as archaistic decoration. The term "archaistic" is invoked here because the shape of the goblet is itself late in the overall development of *gu*, while the motifs on the foot quote earlier decoration. The motifs combine raised bosses and a squared-spiral ground pattern to bracket a wider band with a flower-petal motif in relief lines. A number of vessels from late contexts at Anyang and from Early Western Zhou finds have a decoration that appropriates earlier styles. Their designers had thus jumped back over some generations of bronze production in search of a stylistic model.

Most studies of Western Zhou bronze vessels and their inscriptions employ a three-part periodization. While there are disagreements about how exactly to assign some vessels and inscriptions, there is also considerable consensus. Early Western Zhou vessels (made in the first reigns from the kings Wu through Kang or Zhao) are notably diverse in stylistic features. This is generally interpreted as testimony to several coexisting casting traditions. Both the much-praised "Anyang style" (again, see FIG. 2-18) and the alternative

2-17 Wine warmer, *fangjia*
Shang period, Yinxu II, c. 1200 BCE. Bronze, height 26¼″ (66.8 cm). Tomb 5, Xiaotun Locus North, Anyang. Institute of Archaeology, Beijing

2-18 Ling *fangyi* wine container

Early Western Zhou (King Zhao, c. 977/975–957 BCE). Bronze, height 14″ (35 cm). Freer Gallery of Art, Smithsonian Institution, Washington, D.C. (30.54)

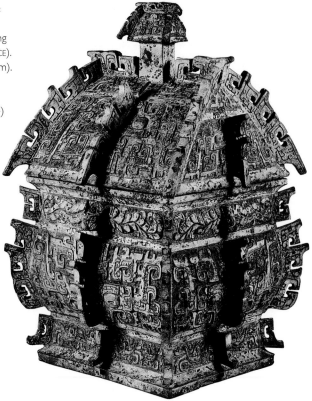

2-19 Meng *gui* grain vessel

Middle Western Zhou, c. 950–850 BCE. Bronze, height 10″ (25 cm). Zhangjiapo, Chang'an, Shaanxi. Institute of Archaeology, Beijing

large-scale profile birds, for example on the bellies of *you* wine containers. The elaboration of these bird motifs is what distinguishes Middle Western Zhou vessels. The birds are now grand creatures with profuse crests and tail feathers that sweep from head and rump in extravagant cascades (as, for example, in FIG. 2-19). Paired birds may confront or turn away from each other, their plumage ribbons that overlap and curl back to fill the surface. At the same time, these Middle Western Zhou vessels as a rule have smooth shapes and flowing profiles. Art historian Jessica Rawson has characterized the changing assortment of vessel types as part of a "ritual revolution." Changes in shape and decoration, on the other hand, would seem to register pronounced differences in the tastes of patrons and new demands on foundries.

By contrast, more striking developments occurred in the Late Western Zhou period, the reigns from King Yi to King You. The Hu *gui* shown here (FIG. 2-20) bears a lengthy inscription in the voice of King Li (r. 857/853–842/828). In addition to its considerable size, the vessel impresses with vertical fluting on both the square base and round bowl. The bands that encircle the foot and neck are composed of repeated hooked curls derived from the evolution of earlier dragon and bird motifs. Impressive statements in themselves, the vertical handles display curls and ribbons that allude to animal tusks or horns and crests. Only the eyes and jaws of the animal heads retain a naturalistic quality.

taste of the *gu* from Zhuangbai are part of this diversity. Significant changes begin to appear in the following several reigns, usually called Middle Western Zhou (King Mu through the kings Yi or Xiao). These include the demise of some long-lived types (such as *jue*), greater emphasis on *ding* and *gui*, the modification of certain types and varieties (such as *zun* and *you* wine containers), and the appearance of new decoration, principally bird motifs.

Birds are part of Shang-period bronze decoration from the transitional period prior to the Anyang occupation, both as motifs that complement the mask and dragon designs and as relief features that ornament handles, shoulders, and rims (compare the lid of the owl vessel, FIG. 2-1). Some Late Shang vessels give considerable prominence to

Motifs and Meanings

Art historians working outside of China have devoted most of their energy to understanding the history of rendering decoration. Some scholars, by no means all, have posited this decoration as "pure ornament," one without an ascertainable meaning. Questions about meaning are assumed here to be interesting and sometimes pertinent to other topics. At the same time these questions are not simply problems of isolating a specific motif and then linking it to a specific spirit or deity. Habits integral to casting vessels governed decoration. With the exception of water basins, *pan*, the decoration was placed on the exterior

where it was most readily seen by users and their associates. (If *pan* held water, even a full basin would have had readable decoration; see FIG. 2-22 below). Relatively narrow bands characterize early decorated vessels (as in FIG. 2-15 above). The major developmental trend over time was the addition of registers over ring bases, bodies, shoulders, and necks. In coordinating these superimposed bands, some now quite tall in their own right, the mold makers observed the divisions between outer mold segments and generally repeated the same motif in each mold segment. By aligning these motifs on common vertical coordinates, parallel to the edges of mold segments, the designers created a powerful organization of the surfaces. The *pou* from the Palace Museum is a fine example (see FIG. 2-16). Expenditure of energy made such vessels special, akin to more perishable objects of high value such as ivory carvings and lacquer wares.

The definition of an elaborate mask motif distinguished from ground patterns marked a watershed in the history of bronze decoration. The motif (FIG. 2-21; see also FIG. 2-17) was common to other media and objects (compare FIGS. 2-7, 2-9, 2-10). The mask could be realized by true relief, by inlay, or by graphic renderings with a dense ground pattern (usually squared spirals) for contrast. The inception of this motif roughly coincides with the early dynastic occupation of the sites at Anyang, the reign of Wu Ding

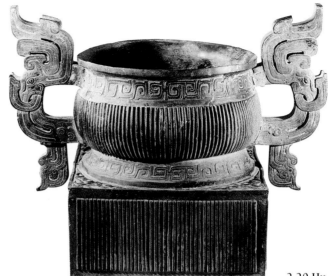

2-20 Hu *gui* grain vessel
Late Western Zhou (King Li, c. 857/53–842/28 BCE). Bronze, height 22¾" (58 cm). Qicun, Fufeng, Shaanxi. Shaanxi Historical Museum, Xi'an

"Although I am but a young boy, I have no leisure day or night. I always support the former kings, in order to match August Heaven; I broadly embroider my heart so that it drops down to the four quarters…" Thus begins the inscription of this vessel, transmitting the voice of King Li himself. (Shaughnessy, *Sources*, p. 171)

and Lady Hao. Vessels inscribed with the latter's name carry both graphic and relief renditions of a repertoire of mask motifs. Since the functional context of these objects was always offerings linked to the ancestors, the royal cult would be the best place in which to discuss possible meanings.

The cult must have changed over time (and varied across space), just as Shang-period society itself did. With the exception of the large *fangding* from Zhengzhou (see FIG. 2-14), it is unlikely that we have any royal vessels prior to the time of Lady Hao. On the other hand, from the Late Shang, we have examples of royal castings and non-royal elite castings, as well as vessels made outside the Anyang cult center. Likewise, only with the

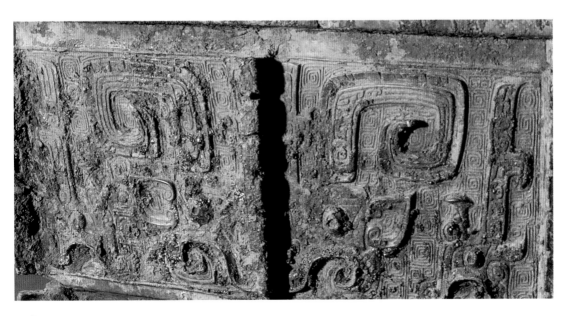

2-21 Mask motif, *taotie*, from a *fangding* vessel
Shang period, Yinxu II, c. 1200 BCE. Tomb 5, Xiaotun Locus North, Anyang. Institute of Archaeology, Beijing

oracle-bone texts can we begin to talk in specifics about Shang religious beliefs and sacrificial practices associated with the kings who utilized the cult center at Anyang. The discussion below focuses on Late Shang materials (c. 1200–1050 BCE) in relation to contemporary inscriptions and archaeological contexts from Anyang. (For different traditions of imagery and cult, see pages 81–87 below.)

Three groups of motifs can be distinguished on the thousands of Late Shang vessels: (1) imaginary, animal-like motifs (zoomorphs); (2) motifs that may be real animals; and (3) human motifs.

The great majority of motifs fall into the first broad category, in which frontal masks and profile renderings dominate. The former (again, see FIG. 2-21) were usually displayed on prominent surfaces, while profile creatures may flank them or fill bases, shoulders, and necks. One could easily subdivide both groups into many subcategories. One obvious subcategory is renderings of the mask with different horns or other sec-ondary features linked to real-world animals. For example, a pair of *fangding* from Tomb 1004 at the Anyang royal cemetery have well-defined masks on their four faces, one with a deerlike rack of tined antlers, the other featuring bovine horns. In each case a single graph cast in the interior wall represents the same animal. Variations of the profile creature are less pronounced, but two large groups are abundant: birdlike motifs, so called because of their beaks, plumes, or tail feathers; and dragonlike motifs with "bottle horns," sinuous bodies, and sometimes diamond backs or curling tails.

In pursuing this kind of classification, some scholars attempt to match these groups of animal-like creatures with graphs from textual sources. The graph *long*, now conventionally translated as "dragon," appears in oracle-bone texts and bears a strong visual resemblance to one of these motifs is (FIG. 2-22). But even if Shang-period viewers used this word for these motifs, we are no closer to understanding the meaning of "dragons" in the

2-22 Dragon, *long*, motif interior of a water basin, *pan*
Shang period, Yinxu II, c. 1200 BCE. Tomb 5, Xiaotun Locus North, Anyang. Institute of Archaeology, Beijing

Shang cult. Later literary sources, while much richer in concepts and terminology regarding dragons, cannot be applied to the Shang period. Song antiquarians favored the term *kui*, a kind of one-legged, dragonlike creature from mythology, for this same motif, but that association cannot be validated since the sources in which the term is found long postdate Shang times. There may be other terms in the oracle-bone inscriptions that might similarly be linked to mask or bird motifs, but none of these associations is as strong as that between the graph *long* and the dragonlike creatures featured on bronze vessels.

The mask motifs would seem to have very ancient roots in prehistoric traditions, most notably the Liangzhu Culture of the Lower Yangzi macro-region (see FIG. 1-10). We cannot yet draw a clear line of descent from Liangzhu imagery to the earliest Shang-period motifs, much less to the mature motifs considered here. Shang burials have yet to reveal more than a few Liangzhu objects, so we cannot even be confident that Late Shang people actually knew much about this artistic tradition. On the other hand, masks were common in many cultures. Masks have the property of being animated or made powerful by the fixed stare of their eyes and the ferocity of open jaws and wicked fangs (see FIG. 2-21). Representations of ferocious real animals do appear in Late Shang art, especially tigers or other large felines, but the variation inherent in the mask imagery argues against its simple derivation from any one natural animal. On the contrary, the mask had a lengthy development. Only in the Late Shang period does it share some details, such as specific renderings of horns, with real-world animals.

As consistent, favored choices, mask images must have played a role in the minds of makers and users alike, perhaps as "markers." This is not a claim for a specific, iconic identity. Rather, the realm and role of the spirits—both ancestral spirits and nature powers—may have been evoked by well defined designs made a part of ritual objects and their settings. Access to these spirits was limited to a small group of specialists, notably the king, diviners, and other officiants, but knowledge of them and awe inspired by them must have been widely acknowledged, even pervasive.

Masks invoked the realm of the powers and the king's circle. They reinforced the fundamental social and political gulf between those who could communicate with the spirits and those who could not. In this interpretation, mask imagery played a role in validating the definitions, practices, and social consequences of royal authority. Ideological justification of this sort is a commonplace function of art making.

The second group or fund of imagery, while less extensive, was by no means confined to the cult center at Anyang in the Late Shang period. Real animals or birds populate many objects, including stone and jade carvings (see FIG. 2-10) and bronze vessels (see FIG. 2-1). This attention to the natural world contrasts with evidence for the Erlitou Culture (Xia) and the Early Shang period, when such references are notably lacking. It coincides once again with the transitional period prior to the royal occupation of Anyang, the definition of distinctive mask imagery, and the epigraphic and cult practices exemplified by the evidence from Anyang. Recognizable as these real animals sometimes are, they are rendered in such a way that they are stylistically consistent with the imaginary, zoomorphic creatures that otherwise dominate Shang decoration. We know that animals played important roles in Shang cult, for example the ox shoulder blades and turtle shells for divination and the animals, including oxen, offered in ritual repasts for ancestors.

A scholarly vogue for totemism in the early twentieth century linked these motifs to animal spirits in Shang and Zhou origin myths. Oxen, rams, elephants, tigers, cicadas, birds, and turtles and tortoises have all been considered as possible clan totems. Unfortunately, oracle-bone inscriptions hardly justify this approach. Divinations and cult offerings seem not to be addressed to animal spirits or made for such spirits. Moreover, the myths associated with the origins of the Shang and Zhou people are known only through much later texts; it is difficult to establish their antiquity. A second way of interpreting these motifs may have some merit but must be applied with care. It is possible that certain real animals were selected on the principle of the rebus, in this case a punning reference to a concept using a thing

with a name having a similar pronunciation. Thus a depiction of a ram (modern *yang*, ancient pronunciation *ziang*) might as a pun invoke the concept of auspiciousness (modern *xiang*, ancient pronunciation *dziang*). This kind of punning association is quite common in later periods, both in lexicons and decoration. Since Shang graphs often incorporate animal forms as markers of either meaning (significs) or sound (phonetics), the general principle would seem to have been in use by this early period. It is intriguing to consider vessels, such as *pan* basins (see FIG. 2-22), that orchestrate a selection of real and imaginary animals. Could the repetition of several motifs in a particular sequence (such as fish–bird–tiger) have carried a linguistic charge or symbolic code?

The third fund of imagery, the smallest, incorporates humans (compare FIGS. 1-22 and 1-23). Like real-world animals, human faces and complete figures appear only in the Late Shang period.

2-23 Kneeling figure
Shang period, Yinxu II, c. 1200 BCE. Hardstone, height 2¾″ (6.9 cm). Tomb 5, Xiaotun Locus North, Anyang. Institute of Archaeology, Beijing

2-24 "Man and beast" motif on ceremonial axe
Shang period, Yinxu II, c. 1200 BCE. Tomb 5, Xiaotun Locus North, Anyang. Institute of Archaeology, Beijing

This axe may have been both a token of rank and an instrument of death for human sacrifice. The innocent face flanked by a pair of animals, usually identified as tigers, seems blissfully unaware of any unhappy outcome, and the tigers, most ferocious of beasts, are surprisingly benign. The great *Si mu wu fangding* (compare FIG. 2-11) had a similar motif on its loop handles.

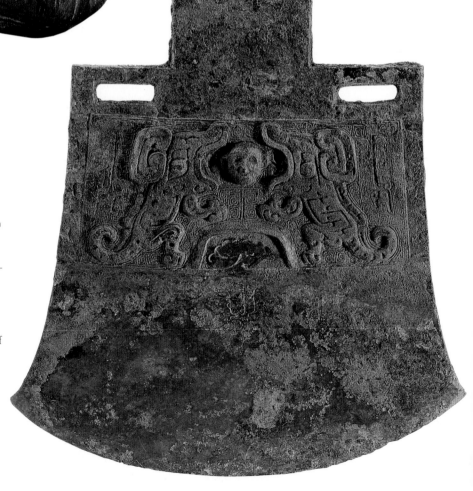

In bronze decoration, they are at present more commonly found outside of Anyang (see pages 81–87 below). Small stone and jade carvings from Tomb 5 at Anyang are important examples of figural subjects (FIG. 2-23). All but one of these carvings in the round are shown kneeling. They vary in attire: one is well clothed, another seemingly nude, a third perhaps tattooed, while a fourth standing figure may be male on one face and female on the reverse. Within the field of bronze objects, only human faces are seen at Anyang find spots. These include a bronze face mask from a royal tomb and two instances of the motif of a face flanked by two rather benign tigerlike creatures (FIG. 2-24). A *fangding* from Hunan is a well known example found outside Anyang, each flat side carrying a large, well-modeled face (see FIG. 2-25 below). There is not enough evidence from Anyang to argue that human imagery was of great consequence in the Shang royal cult.

Recent discoveries in the southwest (the Upper Yangzi macroregion; see pages 86–87) place this discussion in a new context. The large-as-life human figure cast in bronze (see FIG. 2-28 below) and the many masks and heads with human features from the Sanxingdui site make quite the opposite argument for the cultic needs and practices of this culture, which seems to have flourished contemporaneously with the Late Shang period at Anyang. Unlike the Anyang cult, in the Upper Yangzi macroregion human actors (shamans?) or anthropomorphic recipients of offerings (deities, ancestors?) may have been quite significant. One should ponder the possibility that similar imagery may once have existed at Anyang but was not rendered in durable materials, excepting the small stone and jade carvings.

Unlike the prehistoric cultures surveyed in chapter 1, we understand the Late Shang period in part through contemporaneous documents created for the Shang kings. There is an implicit challenge to harmonize the evidence of these texts with the manifold archaeological data, including the visual properties of objects. Questions about ideology and world view documented in the divination records (the existence of the High God, the role of ancestors) can be further investigated through a careful analysis of visual culture.

If Shang society and its world view were imbued with the values of hierarchy, order, and balance, it is not surprising that vessels and their decoration share these qualities. It is tempting to see the symmetries of decoration as analogues to the symmetries of living and dead hierarchies, or positive and negative charges on oracle bones. If spirits and nature powers preoccupied the king and his divinations, it is surely not out of bounds to consider the spirits and powers in relation to the powerful visual culture of ritual vessels.

BEYOND SHANG AND ZHOU

Two models govern most discussions of the early Bronze Age, especially the Shang state and its relations with surrounding peoples. In the received historiographic model, that of the "Three Dynasties," the Shang kings held power over a wide territory following the demise of the Xia and prior to their conquest by the Zhou. Other, culturally less advanced peoples existed on the margins of these three states, sometimes in conflict, sometimes peacefully. This Three Dynasties model prefigures power relations in historic periods, projecting traits of much later times onto the earliest states. It also posits a large measure of cultural homogeneity among the people of Xia, Shang, and Zhou. Most discussions of the Erlitou Culture within China today assume it represents the culture of the Xia. The archaeological continuities between Erlitou and Erligang, between Erligang and Anyang, and between Anyang and Western Zhou therefore constitute an important argument for long-term cultural unity.

More modern interpretations apply a center and periphery model, often expressed in terms of "metropolitan" and "provincial" cultures. Much of the archaeological activity of the last five decades has surveyed cultures in the regions surrounding North China in the period contemporaneous with the Shang occupation of Zhengzhou and Anyang. Finds in other macroregions are generally described as offshoots or parallel developments with regional characteristics. One liability of this model is the implicit assumption of cultural superiority

2-25 Cooking vessel,
fangding
Late Shang period,
1200–1050 BCE. Bronze,
height 15″ (38.5 cm).
Ningxiang, Hunan. Hunan
Museum, Changsha

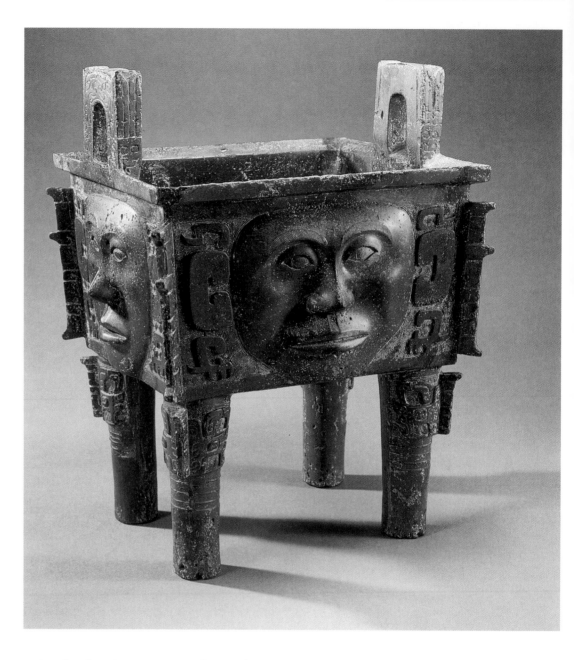

assigned to the cultures in Henan, the initial "metropolitan" center. In this model, many features of the regional cultures are explicitly or implicitly denigrated by comparison to sites in Henan. Another limitation to the center/periphery model is the nature of the Shang capitals and the activities of the Shang kings. The "capitals" moved with some frequency, and the king himself moved around his domains regularly.

A third model, adopted here, posits large geographical regions, the macroregions already described in the Introduction. Each macroregion has boundaries determined by physiographic features; river systems within regions tie them together,

and prehistoric and protohistoric archaeological cultures in fact tended to cluster along river systems. During the middle and late second millennium BCE, bronze-using cultures flourished in the Upper and Middle Yangzi, the Gan Yangzi, and the Northwest, in addition to the North China macroregion. It may well be that the Shang state known from Zhengzhou and Anyang sometimes actively expanded into adjacent macroregions, notably the Middle Yangzi and the Wei River valley of the Northwest. But it seems very unlikely that, even at its most expansive, the Shang state actually controlled much territory outside the North China macroregion and its margins. The

oracle-bone inscriptions refer to many non-Shang statelets across the north and in nearby zones. These qualifications are especially germane to some of the most important discoveries in recent archaeology.

On present evidence, the most extensive traces of advanced cultures are documented in the North-west (modern Shanxi and Shaanxi), the Upper Yangzi (modern Sichuan), the Middle Yangzi (modern Hubei and Hunan), and Gan Yangzi (modern Jiangxi) macroregions. How should these cultures be viewed? Since both oracle-bone texts and received histories name the people of the Wei River as the Zhou, some of the archaeological cultures of the Northwest contemporaneous with Late Shang must represent that group. But what of the finds at Sanxingdui in Sichuan (see, for example, FIG. 2-28), or in the Yangzi River lake country of modern Hunan (see FIG. 2-26)? Here neither oracle-bone inscriptions nor traditional historiography give us identifications. Moreover, the material record is complex. Many features of material culture as known at Anyang and other northern sites are found, but so too are bronze vessels, weapons, and sculptures that are exceptional or unknown in North China. In the discussion below, these regional bronze-using cultures are interpreted as the products of interaction both within and across macroregions. The process involved the interaction of local traditions with new technologies and the interaction of local cultures with more distant ones. In this interaction model, we do not assume the priority of one region over all others. Nor do we assume that effects flow in one direction only, or necessarily move from one advanced center outward to all others. In fact evidence is mounting for a variety of interaction patterns: between North and Northwest, between Northwest and Upper Yangzi, between Middle and Upper Yangzi, and so on.

On the northern margins of the North China macroregion the local culture exhibits some of the technologies of their Shang neighbors without, however, a comparable social structure. The oracle-bone inscriptions attest to a variety of names for non-Shang peoples and some may be ancestral to the groups known in later texts as the Hu, Di, and Rong. The people of the Xiajiadian

Culture probably did not depend on a pastoral economy at this early date, in as much as they built walled settlements and permanent houses out of unfired adobe and stone. A weapon kit notable for its daggers, socketed axe heads, and small knives distinguishes their archaeological traces. The daggers, many with animal heads worked into their pommels, are best known. Such daggers have been found in Late Shang contexts at Anyang sites but are intrusive there. In fact both the weapons known from Anyang and those found in these northern sites exemplify a complex process of interaction: the exchange of goods, mutual borrowing of features from each tradition, and selective imitation of one tradition by the other. These processes are also represented by pottery from the Dadianzi site

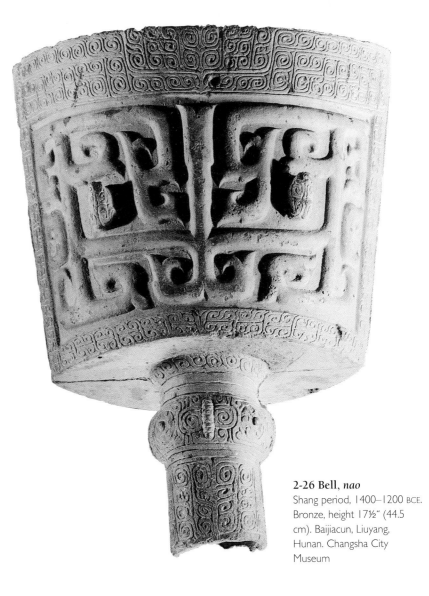

2-26 Bell, *nao*
Shang period, 1400–1200 BCE. Bronze, height 17½" (44.5 cm). Baijiacun, Liuyang, Hunan. Changsha City Museum

2-27 Container vessel, lei
Lower Xiajiadian Culture, c. 1500 BCE. Painted pottery, height 11¾" (30 cm). Dadianzi, Chifeng, Inner Mongolia. Institute of Archaeology, Beijing

The Lower Xiajiadian Culture occupied the northern frontier contemporary with the Shang. Its pottery is a mix of local shapes and decoration and a few types (such as *jue* and *gui* pouring vessels) that call to mind the Erlitou Culture. This *lei* carries painted decoration that reworks familiar Shang mask motifs in bold red and white pigments.

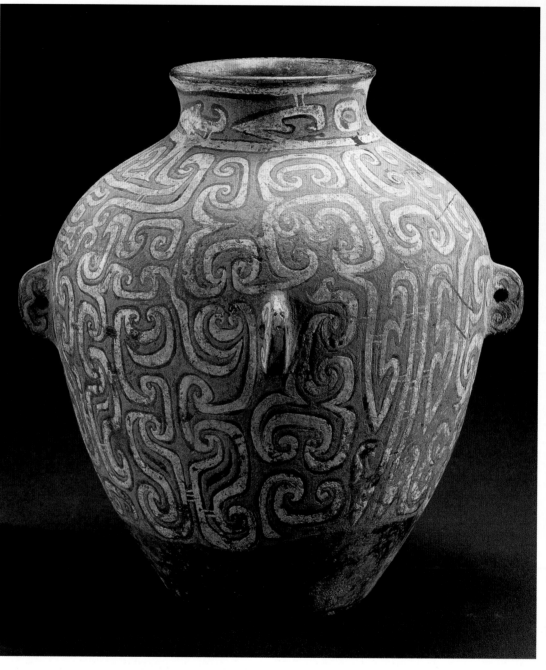

2-28 Standing figure
Late Shang period, 1200–1050 BCE. Bronze, height 8'7" (2.62 m). Sanxingdui Pit No. 2, Guanghan, Sichuan. Sichuan Institute of Cultural Relics and Archaeology, Chengdu

in Aohan Banner near Chifeng City in the Inner Mongolian Autonomous Region (FIG. 2-27). The large shouldered container vessel (similar to a Shang *lei*) was painted over most of its surface with designs delineated in black lines and infill in red and white pigments. Upon close inspection, the motifs include clear quotations from the mask motif and profile creatures known on Late Shang bronzes. More than on bronze objects found in the southern macroregions (compare FIG. 2-26), however, here Shang motifs are radically reworked, abstracted into conventional

forms such as connected C-shaped hooks. To anyone familiar with Shang motifs the allusions are perceptible, but the vocabulary has been remade.

Excavators have recovered many bronze vessels, bells, and weapons from a variety of contexts in the middle of the Yangzi River, the marshy lake country of Hubei and Hunan. Several walled sites are known; the best reported is a site at Panlongcheng north of modern Wuhan that flourished in the Early Shang period. Late Shang-period deposits with bells or vessels in apparent isolation from habitation zones

or cemeteries are common. Many of these objects might have been carried over long distances and could in fact have emanated from a northern foundry. A striking number of unusual vessels are also reported, such as the *fangding* with a human face on each side from an undocumented context in Ningxiang County, Hunan (FIG. 2-25). The vessel's shape and proportions would place it into the Late Shang or even early Western Zhou period. Its decoration, however, blends habits well known in northern foundries, like the crisp squared-spiral ground pattern, with other features that are rarely, if ever, seen elsewhere. The softly modeled faces are akin to the face on the lid of a pouring vessel, *he*, said to come from Anyang and to a bronze mask recovered at Anyang during the pre-World War II excavations. On the other hand, the raised motifs—claws, ears, and horns—have smooth surfaces without inset lines or other embellishment. For those who investigate meanings associated with cult, the faces also pose an important question. If here the cult vessel functioned quite well without a conventional mask motif, what does that imply about requisites for ritual vessels in general and the needs of the local cult in particular?

The large bells, *nao*, of Hunan are even more distinctive (FIG. 2-26). Many of the most impressive have been found in groups in a shallow deposit on the slope of a mountain. *Nao* are known from Anyang sites, but only as small-scale objects in sets of three. As hand-held bells meant to be struck on their upturned lips, *nao* presage the chimes of suspended bells that developed in the Western Zhou period. This example from Hunan, like many of its cousins, is of considerable size, fully 17 inches (45 cm) in height. It must have required a considerable stand for support and can hardly have been carried around easily. The striking of this *nao* would have been an awe-inspiring part of ceremonial displays or rites. The main field of the bell is given over to assertive relief that is only tenuously readable as a mask. Thick ribbons trace out the rudiments of a pair of eyes, crest, jaws, and displayed body against the plain recessed ground. Pronged spirals fill the surrounding surfaces.

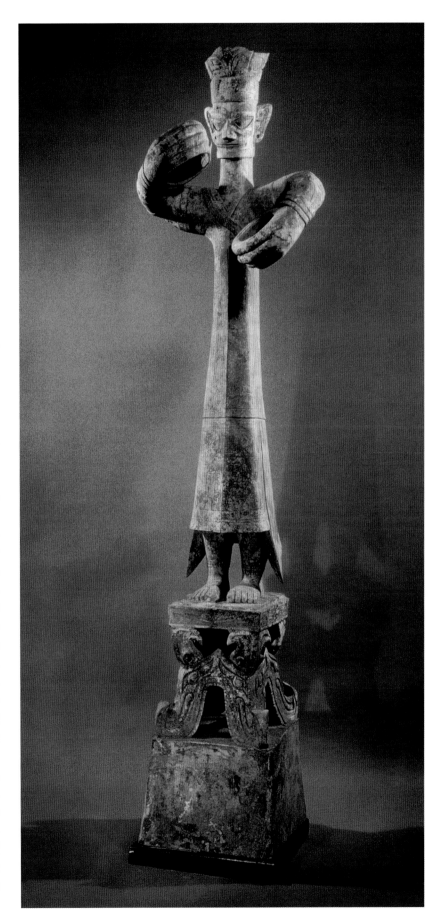

In the Upper Yangzi macroregion another recent discovery has challenged previous expectations even more seriously. Two large sacrificial pits found near a walled site called Sanxingdui, north of Chengdu in Guanghan County, Sichuan, have yielded a rich harvest of bronze objects, jades, gold, and even elephant tusks. All were seemingly consigned to the pits as part of rites that involved a large conflagration, which consumed many of the offerings. The bronze vessels taken from these two pits have close relations discovered at sites in several parts of the downstream Middle Yangzi macroregion. The pits also contained over fifty nearly life-sized bronze heads, more than twenty bronze masks, and a variety of figures, one of them as large as life on a high pedestal (FIG. 2-28). This sculpture from Pit No. 2 is a frontally posed standing figure atop a base nearly a yard or meter high. A plain block serves as a pedestal, but the figure actually stands on a smaller square plinth carried by four heads with long noses, bulging eyes, and horns that meet the four corners of the plinth. The figure, erect and static, is cloaked in a long gown with pointed hem at the rear, long sleeves, and a lapel that crosses from right to left. A second inner garment like a skirt is visible at the front, and there are designs on both garments that suggest motifs in the cloth. Thick arms extend from the shoulders and terminate in oversized hands that form circles, presumably to hold something, now absent, such as an elephant tusk.

The figure's head and face share many features with other bronze heads and masks. The head seems to be surmounted by headgear, with petals rising from a band. The square chin and straight mouth are parallel, but without expression or visible teeth. The nose and cheeks are sharply defined; the are eyes bulging, almond-shaped slits. The brows resemble knife blades over the eyes. Large ears stick out from each side of the head, with holes for ear rings in each lobe. Most of the bronze heads are similar in essential features, but most lack head band or headdress. Their necks extend downward to points in front and back but do not form complete cylinders. Several heads had gold foil applied to their surfaces. Most of the masks are also similar in their facial details.

They differ in that they were cast as sheets shaped to represent only the sides and front. Otherwise they are incomplete, without necks and headgear.

If the evidence from North China were still the only data available for protohistoric China, we could comment on the relative insignificance of human imagery in general, and the total lack of large-scale figural images in particular (compare the diminutive jade figure from Tomb 5, FIG. 2-23). The images, heads, and masks from Sanxingdui force a fundamental revision in our thinking, but our comprehension of why they were made remains minimal. If, as seems plausible, the heads and masks were themselves mounted on figures or stands made of perishable materials, one can imagine a temple or ritual precinct with a host of large effigies or icons. This is contrary to all of our expectations about Shang and Zhou temples, but akin to other cultures. Even if this speculation is accepted, we still have no means as yet to identify the figures. Are they one image, repeated, or are they a cast of divine, mythological characters? The quantities of jade and ivory consigned to the sacrificial pits where these images were recovered suggests rites not known from the Shang oracle-bone texts or from the earliest Zhou documents. This culture, and its cult, are "foreign" to received notions of nascent "Chinese" civilization.

Like the finds in Inner Mongolia or Hunan, the materials from Sichuan testify to the transfer of material culture. The best datings for the Sanxingdui evidence would make most of it contemporary with the transitional period and early Anyang occupation. Its local roots are still not well documented, but the walled site was certainly occupied long before the sacrificial pits. Only at relatively high levels of generalization do the cultures discussed in this section have much in common. If we use a term such as "Shang civilization" to designate all of these cultures, it becomes imprecise and less useful. If instead we reserve that term for the dynasty of kings attested at Anyang, as recommended at the beginning of this chapter, then we must create a new terminology for the other bronze-using peoples of today's China. Even though this terminology can be wordy (the Upper

Yangzi Sanxingdui culture), the benefits to clearer thinking pay off.

In selecting topics and images for this chapter, we have worked within a conceptual framework that blends traditional Chinese and European historiography (the Three Dynasties, the Bronze Age) and contemporary archaeological approaches (macroregions, interaction models). The picture evoked is not an inevitable one, but rather a consequence of these choices. The selection of particular figures has been driven by the need to illustrate characteristic objects and styles that in turn complement general ideas about how to interpret them. Any single illustration could be replaced, but, given our goals, the textual commentary would not vary greatly. Readers are encouraged to take the "lessons" laid out here and to apply them to other, similar objects that are more readily accessible. Certainly we have not exhausted ways of describing or interpreting these classes of objects, any more than we have discussed all relevant aspects of the cultures that made them.

Even with all appropriate words of caution well in mind, by the time of the Late Shang and Early Western Zhou kings a "Chinese" culture had taken shape in the north. In addition to the striking phenomena of a writing system ancestral to later Chinese script, scholars have detected the germs of many key concepts and social practices that would inform human society in this part of Asia for millennia to come. The origins of Chinese civilization can never be pinpointed to one particular time. At the same time, by the end of the second millennium BCE a critical conjunction of elements exists in the Bronze Age cultures of North and Northwest China. These cultures can be seen as the progenitors of Chinese civilization.

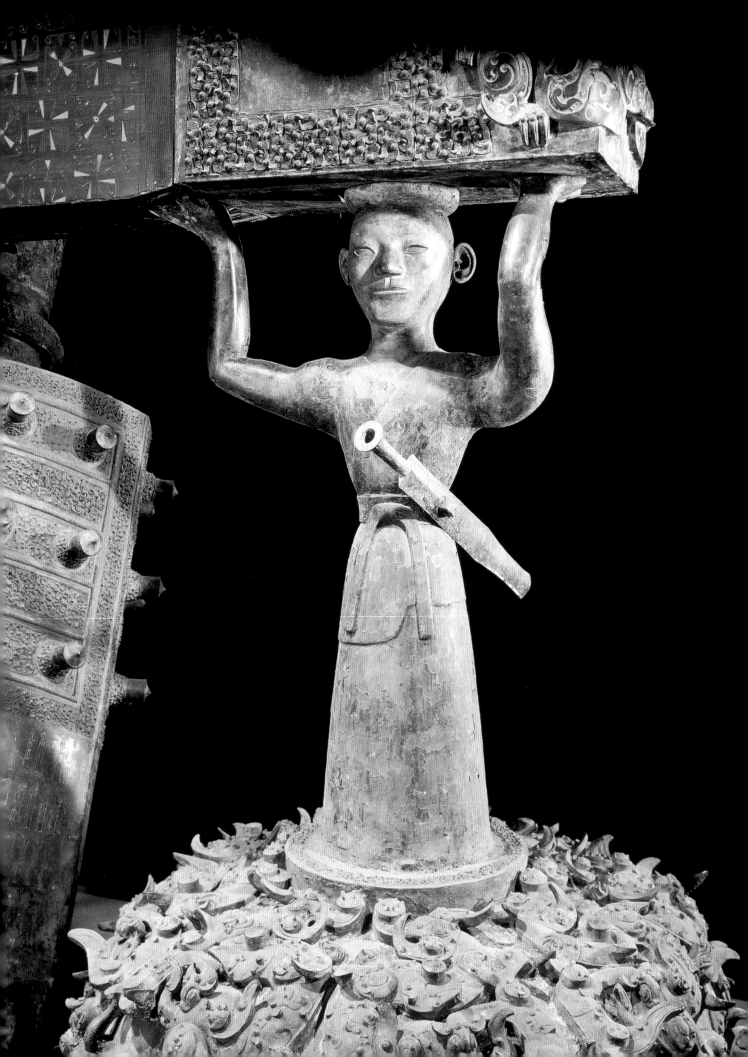

3 THE LATE BRONZE AGE: EASTERN ZHOU

PROTOHISTORIC CULTURES created in the North and Northwest macroregions became the foundation for historic cultures of the Eastern Zhou period (770–256 BCE). This period takes its name from a watershed event: the displacement of the royal Zhou capital from west (the Wei River valley, modern Shaanxi) to east (Luoyang, modern Henan). The removal of the capital resulted in the temporary loss of the Zhou heartland to a non-Zhou people, the Quan Rong, who had lived on the borders and whose depredations had become increasingly bold and costly. By shifting his center of rule to the ancient secondary capital of Luoyang, the Zhou king Ping Wang and his advisors hoped to create a more secure realm. In fact, this shift also signaled the rise of powerful regional lords who eventually took the privileges and even the title of "king" (wang) for themselves. They practiced de facto sovereignty over their domains while maintaining a semblance of their obligations to the Zhou Son of Heaven. Later historians have subdivided Eastern Zhou into two periods: the "Spring and Autumn" period (roughly 770–450 BCE) and the "Warring States" period (roughly 450–221 BCE). Both terms derive from texts. The so-called *Spring and Autumn Annals* (*Chun qiu*), traditionally attributed to Confucius, records events at the court of Lu. The *Intrigues (or Stratagems) of the Warring States* (*Zhan guo ce*), on the other hand, is a collection of anecdotes emphasizing the persuasive arguments of court advisors during that era of great turmoil.

The royal Zhou domain never exceeded a thin strip of land bordering the capital. The domains of the great regional powers, however, grew steadily at the expense of weaker states. As these regional powers became stronger economically and politically, they spread the ancient culture of the Zhou over an ever wider territory. Modeling their states on the royal Zhou court and their rituals on the royal Zhou rites, they came to dominate much of the North, Northwest, Middle Yangzi, and Lower Yangzi macroregions by the fifth century BCE. This expanded area became the crucible in which a common culture was alloyed. Gradually the strong states forged the apparatus that would be necessary for imperial unification under the Qin during the third century BCE (see chapter 4).

STATE AND SOCIETY

The lords who ruled the territories of eighth-century BCE China were members of a hereditary aristocracy, the scions of branches of the royal Zhou lineage. Their birthright to rule was unchallenged, even if their separate ambitions frequently led to diplomatic and military maneuvers against one another. Serving these lords were high-ranking ministers (*qing* and *daifu*), also hereditary elites. At a lower level were men of warrior (*shi*) status. Over the course of the period, the rise of ministers and warriors changed the social and political structure of Zhou society. Noble

Writing Tools and Scripts

The earliest extensive evidence for brush writing dates from the Warring States period, as do the oldest writing implements. Oracle-bone graphs and a few specimens of actual writing on shell and stone indicate that pliant brushes were already used in Shang times. Hair brush tips affixed to wooden or bamboo tubes are known from several late Zhou burials. The brushes recovered archaeologically do not differ in principle from writing brushes used continuously until modern times. The flexible tip can carry a considerable load of fluid ink or pigment and is sufficiently pliable to form strokes of any shape or thickness. Cakes of carbon black ink are also known, along with knives and other tools in a scribe's writing kit. Specimens of Warring States writing run the gamut from laboriously rendered graphs with elaborate flourishes to rapidly brushed, unembellished forms.

Specimens of brush writing on stone, wood, bamboo, and silk survive in some numbers. Many burials in the Middle Yangzi macroregion hold bundles of bamboo slips, originally tied together as rolls. While their silk ties often have not survived, notches cut into the slips clearly indicate their position. These rolls have texts written on the smooth yellow inner surface of the bamboo, which was cut and trimmed with knives. Slips range in size from 4 to 32 inches (10–80 cm). Although writings on strips are not punctuated, they are often formatted as blocks of text with top and bottom margins or indentations to divide text. Many bamboo rolls are inventories of the goods interred at the time of burial, but other known texts include prognostications, legal documents, and almanacs.

Regional script variants flourished, as did stylized scripts for special purposes.

The "Six Scripts" mentioned by some ancient texts correspond to the writing of the major powers of the Warring States period (Yan, Qi, Chu, and the three states created by the dissolution of Jin—Han, Wei, and Zhao). The modern Chinese scholar Li Xueqin believes that there were two major traditions, the eastern "Six Scripts" and a western tradition exemplified by the writing of Qin. The best example of writing in the area of Qin are the famous "Stone Drums" (FIG. 3-2), ten cylindrical granite boulders discovered during Tang times. The texts cut into these stones, akin to poetry found in the *Book of Songs*, are the oldest extant examples of the long-lived tradition of stone inscriptions. Their dating is much debated, with suggestions

3-2 Rubbing from "Stone Drum"
Eastern Zhou (state of Qin), 7th–6th century BCE. The Palace Museum, Beijing

3-3 Rubbing of inscription on *ding* vessel
Eastern Zhou (state of Chu), c. 550 BCE. Tomb 2, Xiasi, Xichuan, Henan. Henan Cultural Relics Institute, Zhengzhou

ranging from the Spring and Autumn to the Warring States period. The best preserved portions of the Stone Drums show characters in seal script, written with lines of even thickness and rounded endings. Individual graphs are generally symmetrical and balanced as much as structure allows. Open spaces separate adjacent graphs so that there is no overlapping top to bottom or side to side. The general shape of these graphs recalls earlier, Western Zhou bronze script (see FIG. 2-6 above).

The inscriptions cast into the sixth-century tripods found at Xiasi (Xichuan, Henan) are fine examples of an ornamented "bird" script associated with the state of Chu (FIG. 3-3). Here calligraphers rendered individual characters in thin, elongated lines with small flourishes that echo each other from graph to graph and from column to column. Thickened waists and junctures contrast with wispy tails. The shaping of certain strokes, with a little imagination, evokes the silhouette of long-legged or long-necked birds. The inscription on the Xiasi *ding* was styled quite consciously for visual effect, the grace and delicacy of the characters distinguishing them from more utilitarian writing and the seal script of Qin.

houses of local lords were deposed by assertive minister families, and in parallel fashion warriors also gained power. This process continued unabated into the Warring States period. The social transition in progress was observed, critiqued, and often opposed by the thinkers of the age, and many of their writings focus on remedies to this instability. The putative links between the Son of Heaven and the nobility may have become more form than substance, but newly powerful segments of this society nonetheless promoted the practices and material manifestations of ritualized social interaction. The shift in social prestige and political power to second- and third-tier elites enhanced their economic base, with a consequent increase in all manner of elite craft production.

The elite comprised at most a very small percentage of the society as a whole. Some estimates of the population of the seven strong states during the third century BCE are as high as 50 to 60 million. Less than one per cent could qualify as "elite," something in the order of half a million persons of all ages and both genders. To be a member of this segment of society meant that one was born to a noble lineage: either the Zhou house and its cadet branches, or other ancient lineages which owed their high status to the early Zhou kings. As society changed, however, more and more members of the elite were actually offspring of ministers and warriors who had improved their status amid the flux of the time. Again, admission was through birth, a legacy of the deeds and blood of one's ancestors. To be of elite status also meant residence in a city, large or small, as described below, and hence a life-style with the daily routines and pleasures that being removed from the countryside and the demands of farming allowed. Elite status conferred a range of material benefits, from dress and household furnishings to diet and entertainment, which were simultaneously status markers and so were carefully regulated. To be elite also entailed social and ritual obligations: for males, within the family as a head of household and within the state as a warrior, court officer, or attendant to a lord. The elite also commanded the tools of writing, and their works provide much of the literary legacy of antiquity.

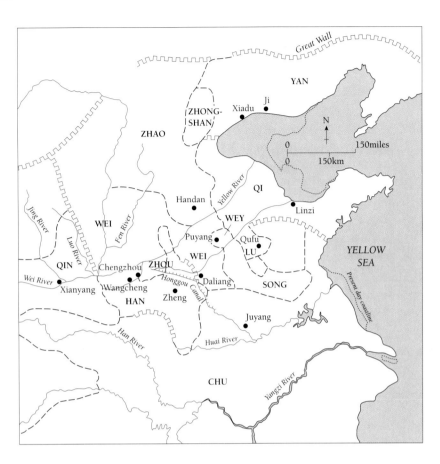

Zhou Urbanism

Over the six centuries of the Eastern Zhou period, the number of states declined dramatically, from more than one hundred initially to a small group of seven strong states by the third century BCE. During this period many cities were built over much of North China in a three-level hierarchy. At the pinnacle of each state was its capital, *guo du*, the seat of its lord and locus of his ancestral temples. These seats became the major urban centers of their day, and a few, like Linzi of Qi, had a sizable population. (Its population is estimated to have been about 280,000.) State capitals featured royal palaces within their own small walled city, as well as extensive markets and workshops. At an intermediate level were the seats of lesser nobles who served the lord of each state. Their settlements, *du yi*, also had lineage temples. At the lowest level were rural settlements, *yi*, with clustered houses and some small-scale market activity and craft production. The archaeology of this period has been focused on the several dozen best-preserved state capitals, and traces

States of the Warring States Period

3-4 Plan of Linzi of Qi

of intermediate and lower level settlements have rarely been identified.

Most Eastern Zhou cities were situated on flat terrain with good water resources such as a nearby river that could fill the moats and provide reliable drinking water. Walls were often aligned in relation to magnetic north to create more or less regular four-sided figures. Many cities were expanded over time by adding additional walled tracts. Entry was controlled by gates in the walls, and these in turn determined the path of major arteries across cities. Within the walled area were residential and workshop zones, although the population also clustered outside. The lord's palace was generally segregated from the rest of the city by its own walls. Large, raised terraces of hard, pounded earth used for palace structures often survive. By the Warring States period, large cities were well-fortified citadels, able to contain and protect their residents and resources against a siege.

The capital of the state of Qi, at Linzi in modern-day Shandong, lies on the west bank of the Zi River (FIG. 3-4). It was established in the mid-ninth century and occupied for more than six hundred years until Qi surrendered to Qin in 221 BCE. The main walls of the city describe an irregular rectangle with long dimensions running

3-5 Plan of Lower Capital of Yan

The "Royal City" Plan

This extract from the *Artificer's Record* (*Kao gong ji*) gives the canonical description of a "royal city" (*wang cheng*). Its insistence on spatial order and numerical symbolism is consistent with a date in the late Zhou or early Han, and most contemporary scholars assign the text to that period. Some scholars link the text more specifically with the state of Qi (modern Shandong).

3-6 "Royal City" (*wang cheng*) plan after *San li tu*, 1676

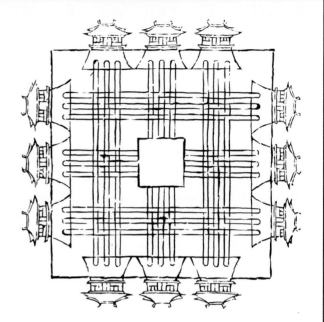

The artisans demarcated the [ruler's] capital as a square with sides of nine *li*, each side having three gates. Within the capital were nine meridional [north–south] avenues and nine latitudinal [east–west] avenues, each avenue being nine chariot-tracks in width. The ancestral temple was sited to the left [of the ruler's central position], while the altar of soil was sited to the right. The [ruler's] court faced south, while the market was sited [to its] rear. Both market and court are plots one hundred double-paces square.

Visualizing this terse text has challenged scholars for many generations (FIG. 3-6). If the ruler's palace is sited at the center of the nine-*li* square walled area, some crossing avenues will necessarily be blocked. Moreover, the city grid and its wards will be much affected by how the three gates allotted to each side are placed along the walls. Many commentators have assumed that each gate accommodated three portals, so that each avenue actually consisted of three roadways. Thus the nine avenues of the text are generally converted to three groups of three in diagrams. Several much later imperial cities took at least some of the prescriptions of this "royal city plan" to heart, for example the Sui-Tang capital Chang'an (see FIG. 6-2 below). The Yuan capital of Dadu, precursor of Beijing, also utilized an approximately square shape with three gates to east, south, and west, and two at the north. Its palace city was centrally located, but pulled forward, with temple and altars that also mimicked the "royal city" plan.

north–south parallel to the river. The palace, on higher ground to the southwest, had a smaller, separate wall, roughly square in plan. The walls were massive, with base dimensions ranging from 65 to 130 feet (20–40 m). The circumference of these joined walls exceeded 13 miles (21 km). The entire city was ringed by moats as much as 80–100 feet wide by 10 feet deep (25–30 m by 3 m), filled by water from the river. About a dozen gates gave access, and a network of major thoroughfares crossed the city. Water was also channeled into the city to supply the residents and connect the moats and river.

In the case of the Lower Capital of the state of Yan (in modern Yi County, Hebei), the city was located between two rivers on a plain (FIG. 3-5). The earlier (eastern) city had an irregular shape nearly 2.5 miles (4 km) square, defined by walls as much as 130 feet (40 m) wide at the base. This area was subdivided by an east–west wall that demarcated a palace precinct in the north. Clustered palace platforms dominated this area, while a royal tomb precinct occupied the northwest corner. The Wuyangtai, largest of the palace foundations, was 455 by 360 feet (140 by 110 m) at the base and rose through two levels to a height

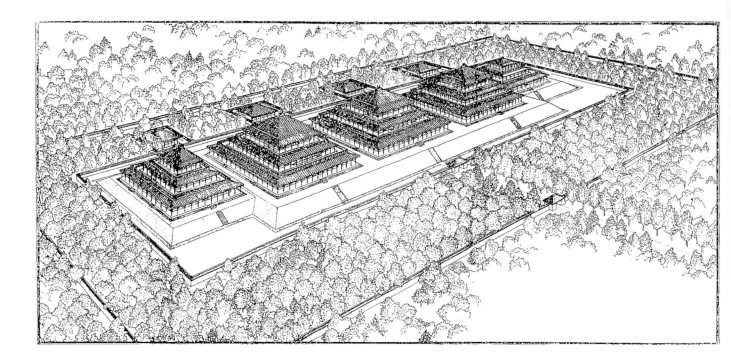

3-7 "Burial district" of Zhongshan kings
Eastern Zhou, c. 310 BCE. Rendering by Yang Hongxun

In making this restoration, the architectural historian Yang Hongxun has chosen to show the site heavily forested within the walls surrounding the raised terrace. Moreover, the stairs necessary to ascend to the upper offering halls atop each earthen core are assumed to be within the galleries that encircle each core, and hence not visible in this bird's-eye view.

3-8 Door escutcheon with knocker

Eastern Zhou (state of Yan), 3rd century BCE. Bronze, height 24½″ (62 cm). Lower Capital, Yi County, Hebei. Hebei Cultural Relics Institute, Shijiazhuang

of 36 feet (11 m). A second walled city was built at a later date to enclose an almost equal area to the west. Thus the Lower Capital enclosed extensive tracts for residential and workshop use. Large water channels within the eastern city and parallel to the wall dividing the east and west cities were connected to the moats and both rivers.

Literary sources lack specific descriptions of individual buildings to complement the prescriptive account quoted above. Some pictorial art does survive, mainly designs on bronze vessels (see FIG. 3-24 below) that incorporate schematic elements of architecture. Our best source for the design of structures is a plate of bronze recovered from a royal Zhongshan tomb in Pingshan (Hebei). This object records the plan of the necropolis constructed in the late fourth century BCE for the Zhongshan kings. Archaeologists and historians of architecture have been able to compare the specifications of this "Burial District Plan" with the actual dimensions at the site. The result is a tentative reconstruction of multilevel, earth-core structures characteristic of both palaces and burial complexes (FIG. 3-7). The Zhong-shan site was laid out as a rectangular compound running east–west, surrounded by two walls. Within was a raised terrace with sloping sides that held five large halls, three at the center and a smaller one at each end. While palace compounds at cities such as Linzi and the Lower Capital did not have such regular plans and symmetry, the Zhongshan plan is informative for the design and appearance of the structures themselves. A square earthen mound surmounted each burial. Galleries (timber-frame colonnades carrying tile roofs) wrapped around the base of each mound and possibly at an intermediate level above. At the top of each mound was a free-standing structure of

timber-frame construction with proportions that harmonized with the lower galleries to create a regular pyramid. Access from lower to upper levels was achieved by either interior or exterior stairs. The use of regular bays and uniform tiled roofs at each level increased the imposing effect. Viewed as a whole, each temple appeared to be a three-story structure, when in fact only the top level created usable space. The multiple terraces of the earthen platforms preserved at sites like the Yan Lower Capital were amenable to such designs; literary references to the "viewing terraces" (*tai*) of the Warring States lords also correlate well with such structures.

Archaeologists have retrieved little of the actual fabric of such buildings. Roof tiles of fired gray clay are abundant, as are floor tiles, water drainage pipes, and related architectural pottery. More rarely, other fittings are recovered, such as a finely rendered door pull found at the Yan Lower Capital (FIG. 3-8), created from bronze decorated in the highly embellished interlace characteristic of the late Spring and Autumn and early Warring States periods. The escutcheon was originally affixed to a door, while the ring within the loop of the animal mask served as a pull or knocker. Since doors customarily had two panels, one must assume that a mate for this fitting is missing. In addition to the use of metal accessories, literary sources suggest that carved stone was employed, and lacquer painting and textile hangings would have decorated a court hall or a lord's private chambers.

Warfare: "the great affair of state"

The conduct of warfare during the first centuries of Eastern Zhou, as portrayed in such early literary sources as the *Zuo Commentary* (*Zuo zhuan*), had an almost chivalric character. Before battle rival lords addressed one another in florid speeches, and in the heat of combat warriors resisted the opportunity to kill an adversary at a disadvantage. The vanquished might even be feasted after defeat. Engagements were brief, often concluded after one day's combat. By the end of the Eastern Zhou period, armies could be extremely large, with tens of thousands of foot soldiers commanded by officers in hundreds of war chariots, the result of a shift from small units dominated by nobles in chariots to infantry armies composed of peasant soldiers impressed into service by the state. This shift to infantry began around the sixth century; during the fourth century mounted archery—modeled on that of the horse-riding peoples on the northern frontier—also began to play a role. The need to maintain large armies was a serious strain on the economies of the smaller states. During the Warring States era, the strongest states boasted thousands or even tens of thousands of chariots as a way of quantifying their might. This was a remarkable investment in military hardware when one considers the four-horse teams, bronze fittings, and other gear required, as well as the complement of three armed warriors per chariot. Large infantry armies maneuvered for field position, besieged fortified cities, engaged in prolonged combat, and sometimes were slaughtered in horrendous postbattle orgies of killing. The armies of Qin, campaigning against their rivals in the third century, became notorious for large-scale slaughter, as when a Qin commander put four hundred thousand soldiers of Zhao to death after their defeat in 260 BCE. (Some scholars discount these large numbers as propaganda.)

The material culture of warfare changed to suit these practices. Many of the larger states built long walls during the Warring States period with the purpose of limiting the freedom of foot and chariot forces to cross a border or maneuver for advantage. Many royal burials of the period are flanked by pits in which large numbers of horses were put to death at the funeral and interred with chariots. Presumably many more chariots were retained, and new ones were outfitted regularly. Some warriors wore armor, but relatively little has survived. Striking examples are lacquered leather, lamellar (plate) body armor with helmets found in the tomb of Marquis Yi at Suizhou, and iron armor composed of small plates from the Lower Capital of Yan. Lacquered leather shields have been found; their value probably increased as swords and close combat became more common. A stand for the chime of bells from the Marquis Yi tomb provides a rendering of an armed warrior figure (FIG. 3-1). Cast as one piece with

the heavy base, this figure wears a long skirt and a close-fitting upper garment belted at the waist; a sword in its scabbard hangs at the left hip. Bronze helmets are also known, but, given the paucity of examples, it is by no means certain that many soldiers were actually protected in battle by such gear. This figure is also a rare instance of relatively large-scale human sculpture, a precursor of the "underground" army of the First Emperor of Qin.

The most common weapons were a variety of halberds and spears, designed for stabbing and hacking between warriors facing off. Pictorial designs on bronze vessels frequently show lines of warriors arrayed against one another. Again the tomb of Marquis Yi yielded extraordinary specimens, such as a halberd with three *ge* blades hafted one above the other, or pikes with spiked balls

at their ends. There were also bows and arrows, and the crossbow came into use at the end of the period. Swords intended for hand-to-hand combat are often a part of elite burials, and pictorial designs suggest they were used by infantry units as well as officers.

CRAFT PRODUCTION FOR THE ELITE

Neither the growth in cities nor the changes in warfare could have taken place without a strong economic base. The Eastern Zhou period is characterized by a shift from small-scale, self-sufficient local economies of elite fiefs and rural settlements to regional economies dependent in important ways on manufacturing and trade. Iron production began during this period, as did wide use of state-controlled metallic coinage. Both the larger and smaller states extended their control over the population by organizing the peasantry for warfare, on the one hand, and by exacting levies or taxes, on the other. Private land holdings also appeared at this time. Cities that had been established initially as fiefs and elite strongholds grew as marketing and manufacturing centers. These regional economies relied on the exploitation of available natural resources, large-scale manufacturing centered in cities, considerable specialized production, and interregional trade that moved products between the rival states. The state of Qi, for example, was known for lacquer, silk, hemp, linen, dyed fabrics, salt, sea food, even strange rocks. The southern state of Chu exported timber and animal products, as well as such ores as copper and gold. The states of Wu and Yue were noted for their swords.

Luxury Life-styles

Personal Attire
The attributes of elite status—dress, adornment, weapons, chariots, and the like—served to demarcate and make distinctions within stratified classes atop the great mass of the population. Texts of the time offer abundant evidence for these perquisites, and over time archaeology has brought

3-9 Man holding lamp
Eastern Zhou, c. 310 BCE. Bronze with inlay, head silver with stone inlay; height 26" (66.4 cm). Tomb 1, Pingshan, Hebei. Hebei Cultural Relics Institute, Shijiazhuang

many of these observations to life. Pictorial and sculptural art also represents some members of elite society, although non-elite persons are actually more common. The paradigmatic elite male came to be conceived as a "gentleman" (*junzi*), a superior man whose intellectual and moral character qualified him for elite status and hence entitled him to command others and profit by their labors. An emphasis on moral virtues flourishes from the time of Confucius (traditional dates, 551–479 BCE), but the idea is found in a variety of thinkers during subsequent centuries. A gentleman was schooled in the "six arts [skills]" (*liu yi*): social and ritual etiquette, music, archery, chariot driving, writing, and calculation. These six kinds of expertise encompass the norms of social life and ritual practice, the martial abilities required of a warrior, and the practical skills needed by a court officer.

Detailed renderings of costume are rare, but several small-scale sculptures give us an idea of the attire of the day. A lamp in the form of a standing male figure from one of the royal Zhongshan tombs is among the most complete renderings of dress and grooming (FIG. 3-9). Given the animals he tends, this figure can hardly be a high-ranking person, but he is nonetheless elegantly dressed. The figure stands on a large square base, shoes and skirt exposed by the split hem of a long, one-piece outer robe. This outer robe is worn folded across the chest from left to right and cinched at the waist by a belt with a hook. The sleeves are cut to hang with ample cuffs. The head, made from silver with black stones inlaid for eyes, shows the face as clean-shaven or plucked of any facial hair except a neat moustache. The man's long hair is pulled off the forehead and gathered at the back by a combination of hairpins and bows. A chin strap holds a small hat in place on top of the head.

This kind of attire was probably common among citified elites during the Warring States period, during which separate top (*yi*) and bottom (*shang*) garments were replaced by a single-piece outer robe (*shen yi*). There was considerable variety in the cut of these garments: robes could be straight or more ample, sleeves narrow or wide. Collars varied as well, and, like cuffs and lapels,

had borders of distinct fabric and color. Lords and ladies clothed in these long robes could not very well perform physical labor, surely one of the messages conveyed. Their garments, moreover, were a ready-made field for the display of rich colors and lavish patterns, and thus for registering additional messages about status and wealth. Some of this attire is known from a small tomb at Mashan near Jiangling (Hubei), the capital region of Chu. This burial, attributed to a woman of the warrior, *shi*, class, has been dated to the middle of the Warring States period, the late fourth century BCE. The deceased was dressed and wrapped in a large assortment of silk garments, including long outer robes, light inner robes, skirts, leggings, shoes, and cap. In addition to the tailored garments, hampers also contained pieces of silk fabric with extraordinary embroidery (FIG. 3-10). Fine stitching delineates complex patterns of birds and animals interlaced with abstract forms. The detail shown is taken from a light-weight robe covered with an overall interlace pattern and a contrasting motif of tigers. Upon closer inspection, the interlace itself is found to contain dragons and birds, their body parts rendered by varied stitches. The paired tigers stand out through their strong color and pattern and are placed onto the matrix of interlace at intervals in alternating confronting and addorsed (back to back) profiles. The taste for complex patterns composed of the bodies and parts of both real and imaginary animals is common to most of the arts of this period, including bronzes, lacquer wares, and jades.

Such finery was complemented by accessories such as hardstone necklaces, jade pendants,

3-10 Detail of embroidered sleeve
Eastern Zhou (state of Chu), 4th–3rd century BCE. Silk, length 44¾" (114 cm). Mashan, Jiangling, Hubei. Jingzhou Museum, Jingsha City

3-11 Garment hook
Eastern Zhou (state of Chu),
4th century BCE. Iron with
gold and silver inlay, length
18⅛″ (46.2 cm). Wangshan
Tomb 1, Jiangling, Hubei.
Hubei Museum, Wuhan

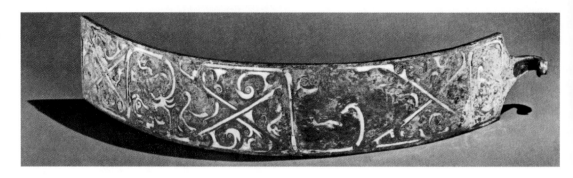

and metal hooks to fasten garments and belts. These hooks are ubiquitous in graves of the time and come in all shapes and sizes, from diminutive fasteners that probably secured lapels to much larger pieces for cinching a heavy belt. The use of leather belts increased during the Warring States period and is another debt of the peoples of the central plains to the "barbarians" on their margins. The example shown here is actually made of iron inlaid with gold and silver in another complex interlace of dragons and birds (FIG. 3-11). Weighing 1.5 pounds (0.7 kg) and fully 19 inches (48 cm) long, this hook would have crossed most

of the frontal girth of its wearer. Like the embroidery, it came from a tomb at Jiangling, in this instance that of a male of higher status. Bronze belt hooks were also frequently adorned with such stones as turquoise; some incorporate jade and gilt as well.

Lacquer
Lacquered furniture was as important as the more common cups, plates, and serving vessels used for food and drink. Several southern tombs contained large couches for sitting and sleeping as well as arm rests, low offering tables, and

Making Lacquer Wares

Lacquer wares flourished long before the Eastern Zhou, but this is the earliest period from which they survive in great quantities. The flowering of lacquerware production during the Eastern Zhou period was certainly real. However, preservation has depended on tomb chamber construction, especially techniques for sealing grave goods within chambers where they were protected from decay. In this respect, the tombs of the Middle Yangzi, modern Hubei and Hunan provinces, have been the best repositories of lacquer objects as well as other perishable goods such as silk.

Lac is the sap of a tree native to southern and central China—a natural polymer. When it dries, the sap is lightweight and strong, and it renders anything it covers nearly impervious to decay.

Making lacquered objects starts with heating and purifying this sap. This is an unpleasant task because the fumes can be poisonous and may cause rashes on the skin. The fluid is then colored with carbon black, cinnabar red, or other pigments. Red designs on a black ground characterize most lacquer wares. Application requires a hair brush, like a writing brush, and a sure hand able to manipulate the obdurate, viscous medium. Lacquer is applied one coat at a time and then allowed to dry before sanding and application of a new coat. Most objects have many thin layers of lacquer built up on their surfaces.

Lacquer wares also require cores, and these generally fall into three types. Wooden cores carved from blocks were favored for heavy, durable objects

such as couches, arm rests, and tables. Wood could also be shaped with a cutting tool to achieve more regular forms and thinner dimensions. This kind of core was favored for such things as wine cups. A second type of core utilizes either wood or bamboo strips, bent into shape and joined with fasteners much like a bamboo steamer. Many circular boxes for cosmetics, mirrors, and other uses were made in this way. Finally, a "hollow-core" technique was devised in which coarse woven fabric, like hemp, was stiffened with lacquer. The intended shape was created by holding the fabric against a wooden or clay mold as the lacquer dried. Once the fabric was sufficiently stiff to hold its shape, the mold could be removed. This technique made extremely light objects possible.

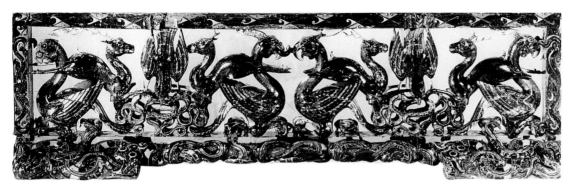

3-12 Miniature screen
Eastern Zhou (state of
Chu), 4th century BCE.
Lacquered wood, length
20¼" (51.8 cm). Wangshan
Tomb 1, Jiangling, Hubei.
Hubei Museum, Wuhan

3-13 Disk, *bi*
Eastern Zhou, 4th–3rd
century BCE. Hardstone,
diameter 8⅝" (22 cm).
The Nelson-Atkins
Museum of Art, Kansas
City (33.81)

miniature screens. The example of the latter shown here (FIG. 3-12) is a marvel of carving and painting from the large fourth-century tomb at Wangshan, near Jiangling (Hubei), that also yielded the iron belt hook discussed above. About 20 inches long by 6 inches high (52 by 15 cm), the frame and its myriad creatures are linked by mortise-and-tenon joinery. The composition consists of two identical units, each centered on a descending bird grasping plaited snakes in its beak. Confronting deer and addorsed birds flank this central element. Snakes and amphibians carved in relief inhabit the base and vertical supports of the frame, while abstract scrolls cover the top. The motifs are at the descriptive end of a spectrum of real animals and derivative decorative motifs pervasive in all Eastern Zhou media. Rendered here as three-dimensional forms, the motifs and their composition are comparable to the two-dimensional embroidery of tigers against dragon interlace on the robe from Mashan (see FIG. 3-10 above).

Jades

Yet another category of luxury goods produced for noble lords and ladies during this period is jade carving (see "Working Hardstones and Jade," page 33). The finest Eastern Zhou jades date to the Warring States period. These objects include nephrite from sources in Central Asia (modern Xinjiang). Only more mineralogical studies will determine if sources within China proper were exhausted by this time. The most important factor affecting the look of Warring States jades was probably the use of iron tools to guide the abrasive grinding powders combined with an improved power-train for drill points. The consequence was a style of crafting jade that emphasized

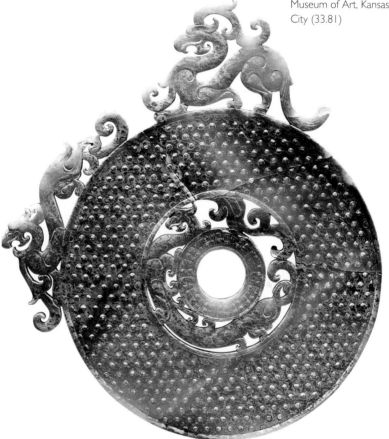

complex silhouettes and challenging relief. Representative of this style is a large disk, *bi*, with rampant dragons in the Nelson-Atkins Museum of Art, Kansas City (FIG. 3-13). The disk is said to come from looted tombs at Jincun near ancient Luoyang that are commonly thought to be royal Zhou burials. The thin slab of stone consists of a small ring held within a larger, wider disk by a twisting feline. Two dragons at top and at left perch on the outer margin of the disk, posed to suggest great potential energy. The disk is covered with a pattern of raised spirals in neat rows that

necessitated grinding out much of the surface. Features of the dragons and feline are rendered by incised lines. Many examples of this style of jade working are associated with Jincun, as are a number of excavated objects from Former (or Western) Han contexts such as princely tombs at Mancheng (Hebei; see FIG. 4-1 below) and Canton or Guangzhou (Guangdong; see FIG. 4-15). Are the excavated examples archaic pieces buried in Han times, or is a Warring States dating of the style mistaken? It is possible that a Warring States jade workshop continued under imperial patronage during the early Former Han. This is one of several continuities in craft production that will be examined further in chapter 4.

The Bronze Industry

The industry most essential to the support of the state, the elite, and their life-style was the production of bronze. The use of bronze vessels and musical chimes in ancestral temples and at court in banquets and other ceremonies was integral to an active process of legitimation. By continually demonstrating their right to rule, the nobles of the Eastern Zhou strengthened their control over society. Bronze weapons were the key to furthering the aims of the state when diplomacy failed. Other bronze objects, from chariot fittings to mirrors and garment hooks, formed part of displays of social status. Bronze was also the medium for coinage that promoted the integration of the various state economies. Not least, agricultural production was dependent on the use of bronze implements.

Direct evidence of mining comes from several sites in the Middle and Lower Yangzi macroregions. On the Yangzi River to the east of the great lake system lie extensive remains of a major mining and smelting site at Tonglu Shan (Daye, Hubei). The place-names suggest a long-standing connection with ore deposits and smelting. Tonglu Shan, for example, might be translated as "Verdigris Mountain," and local records attest native copper on the surface that "flowered after rain." Daye County might be rendered as "Great Smelter." This archaeological site lies within an active modern open-pit mining complex producing iron ore. Huge quantities of slag from ancient smelters at Tonglu Shan bearing traces of copper are rich in iron. Thus, ore bodies first exploited for their copper became valuable for their iron. At Tonglu Shan, the mining required open trenches, vertical shafts, and horizontal underground galleries. Digging followed the ore bodies from surface exposures into the earth, sometimes as much as 200 feet (60 m) below ground level. Early shafts were generally small, many less than a yard square. Over time, as the deposits were followed further and further

3-14 Reconstructed casting assembly for bell

As shown here, a *bo* bell required outer molds for the suspension loop at bottom, and for its top, a pair for the sides, and a core to occupy the interior, all locked together with keys fitted to mortises.

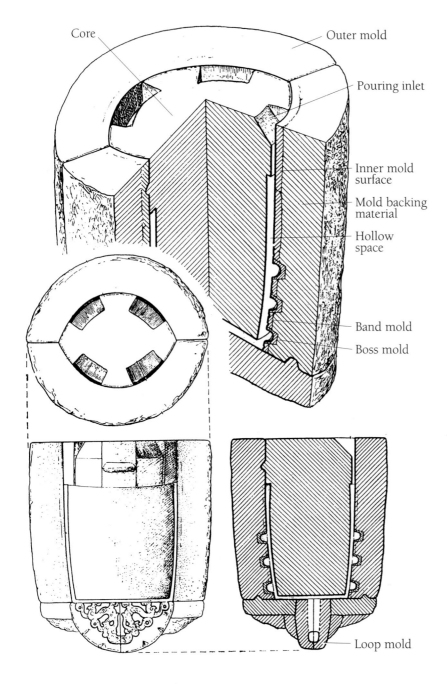

Core
Outer mold
Pouring inlet
Inner mold surface
Mold backing material
Hollow space
Band mold
Boss mold
Loop mold

underground, shafts and galleries were enlarged, and winches were employed to haul ore to the top. Both the volume of ore extracted and its richness are impressive. The 400,000 metric tons of slag from copper smelting were the residue of an iron-rich ore with about 10 per cent copper. This alone suggests production of at least 40,000 tons of copper. Furnaces for smelting ore also operated at the site. Ingots of more than 90 per cent pure copper have in fact been recovered near the mine close to the Yangzi River. Shipment up river supported the foundries of Chu and its neighboring states.

The preeminent foundry site of the Eastern Zhou is near the capital of the state of Jin, a city called Xintian (Houma, Shanxi). This foundry flourished for about two centuries, from the early sixth to the early fourth century BCE. Two localities have yielded a staggering amount of evidence for ceramic molds (some fifty thousand fragments) used in the production of ritual vessels, tools, chariot fittings, belt hooks, and coinage. Locality II at Houma had many roughly made subterranean and semi-subterranean houses that served as workshops. The site was also littered with fragments of crucibles used for preparing alloy and blow pipes needed to heat the charge within the crucible. Molds utilized the common clay available at the site, but it was generally very fine and was mixed with a fine local sand. The kinds of clay used for mold sections, cores, and other purposes varied, especially in the amount of temper, in order to promote porosity or strength as required. The mold-making process incorporated several techniques: models to which clay sheets for mold sections could be applied, modeling and carving, and ceramic molds to form the sections needed for casting. Molds had a fine-particle clay for their inner surfaces and a coarser clay as backing. Fine details required laborious hand work, but completely decorated master stamps or pattern blocks could be used for many molds. Clay molds were fired prior to casting.

The great bulk of the Houma finds are fragments of outer mold sections. Flat objects such as tools were cast from bivalve molds, and these were the most abundant at the site (three thousand fragments for spades, ten thousand for belt hooks). Larger, dimensional objects such as vessels required a more complex set of molds and often used precast elements. Metalworkers cast larger objects from sets of mold sections in tiers, each tier consisting of multiple sections. These sections could be produced rapidly using a master mold or similar replication process. In order to cast a bell, for example, as many as ninety-four mold sections and two cores were assembled (FIG. 3-14), but the number of models or master molds needed was far less. Sections were joined with keys and then plastered together with additional clay. Cores were fixed in place, and spacing was maintained by keys and similar methods of joining. Pouring cups were placed on the assembled mold sections prior to casting or made as part of the mold assembly.

3-15 Altar table
Eastern Zhou (state of Chu), c. 550 BCE. Bronze. Tomb 2, Xiasi, Xichuan, Henan. Henan Cultural Relics Institute, Zhengzhou

Archaeological artifacts from bronze foundries are rarely unique, but this altar table may truly warrant that distinction. Densely interlaced filaments of bronze were cast in blocks using the lost-wax method and then assembled by soldering to create the framing top margins and sides of this table. A dozen dragons climb the sides, tongues lolling on the table top.

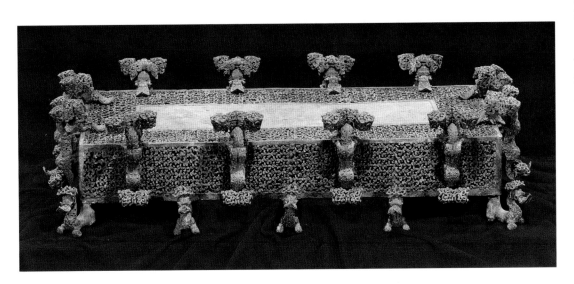

Casting technology also changed during this period in ways that complemented the traditional section mold process (see "Piece-mold Bronze Casting," page 67). Most objects were still cast in a single pour using an assembly of many sectional molds of the kinds found at the Houma foundry. To create appendages, precasting (casting on) was used; a small element—such as a knob, handle, or flange—was first cast separately, often in a bivalve mold. The component was then installed into the ceramic mold assembly for the vessel itself and locked onto that vessel when the pour took place. (Components were also soldered onto vessel bodies, but this was less common.) A second technique for achieving inlay effects also emerged, initially in southern foundries. Pure copper was cast as thin sheets in the shape of an inlay pattern. The element was then mounted in the outer mold so that, when the vessel was cast, the copper was locked into place. The effect achieved was comparable to a mechanical inlay of copper in sheets or wire, but the inlay could not fall out as one using a fixative might.

A third process now known from the middle and late Spring and Autumn period (late seventh–early sixth century), originating in southern foundries, is the "lost-wax" technique. Complex three-dimensional interlace appendages on a number of vessels found at the Xiasi site in southern Henan could only be created using this technique. Even more extensive utilization of lost wax is documented in the late fifth-century tomb of Marquis Yi at Suizhou. Strands of wax were shaped into the desired component, such as the many panels of twisting filaments used for the altar table found in Tomb 2 at Xiasi (FIG. 3-15). After these filaments were invested with a clay matrix, completely filling all of the interstices, the mold could be baked. The wax filaments themselves dissolved, and molten alloy was then poured into the cavities. Most lost-wax appendages were subsequently soldered on.

The powerful states of the Eastern Zhou period maintained their own foundries, but evidence remains scant, with the notable exception of Houma in the state of Jin. Both "commercial" transactions and ritualized gift-giving circulated vessels between states and across regions. Comparable vessels and bells were being produced at the same time in several regions. The states of the central plains, including Jin, represent one such regional tradition. In fact, many vessels found at sites in Henan, Shanxi, and neighboring zones could well have emanated from Houma. Likewise many vessels recovered in the north (states of Yan, Zhongshan, and Zhao), east (states of Qi and Lu), south (Chu), and west (Qin) are distinctive. Any discussion of Eastern Zhou bronze casting therefore must distinguish regional traditions as well as assess broader developments.

Chinese archaeologists have studied excavated assemblages of bronze vessels dated by grave goods and inscriptions. This approach has created a framework that continually grows and can be revised as more material comes to light. Excavated assemblages that can be attributed to specific states and their lords are rooted in history and can help us track regional traditions. The repertoire of vessel types shows substantial changes over this period. There is no mistaking early Spring and Autumn assemblages and Warring States ones. Certain types endured, notably caldrons, *ding*, used for cooking and serving meat courses, wine containers, *hu*, and *pan* and *yi* water basins and ewers. Several sets of *ding*, varying in size and number, with or without lids, normally constituted the core of a ritual set. Other food-serving types changed considerably. The *gui* of late Western Zhou and early Eastern Zhou were complemented and then superceded over time by other types such as *dou*, *fu*, *dui*, and their variants. All were covered containers, and their proliferation suggests a greater emphasis on grain offerings. Both *fu* and *dui* comprise two identical parts, serving as top lid and bottom container respectively. Thus four *fu* vessels could actually be used to serve eight grain offerings. Wine containers were generally represented in pairs. *Hu* in particular were often monumental, and some were enhanced with elaborate appendages that make them the most striking vessels of a set. Other vessels used as wine containers include various *guan* and *fou*, lidded jars of rather simple form and decoration.

The Spring and Autumn Period

Vessels made during the early and middle Spring

and Autumn period (eighth through seventh centuries BCE) derive their shapes and decoration from late Western Zhou vessels. Early seventh-century vessels from tombs in Guangshan County (Henan), representing the small state of Huang, are unusually well preserved and serve here as a benchmark assemblage for this period. The Guangshan vessels comprised two sets, one for a lord, the other for his consort. Each set consisted of a core group of paired *ding*, *dou*, *hu*, *ling* (wine containers), *pan*, and *yi*. Each set was consistent in every way, including inscriptions. This consistency suggests the vessels were made at one time. At 12 inches (30 cm) high, a *hu* container from this assemblage was easily manipulated by using two hands, and the small, animal-shaped handles were useful as grips (FIG. 3-16). Some of the vessel surface is plain, but three registers of dense patterns cover the belly and shoulder. The pattern unit on the belly is derived from a dragon head and body of the kind developed during the late Western Zhou, here standardized and repeated. Excavators have recovered many hundreds of vessels with similar decoration from tombs throughout the central plains. Their simple silhouettes and dense surface decoration were a characteristic choice during this period.

Against this large grouping stand other, exceptional vessels, in which their large scale, complex appendages, fine detail in the decoration, and naturalistic elements all play a role. The rich tombs at Xiasi (Xichuan County, Henan) afford a selection of vessels made for, among others, a Chu prince. The tombs date to the middle and late Spring and Autumn period, spanning the sixth century. A pair of wine containers, *hu*, from Tomb I exemplify this approach (FIG. 3-17). Each vessel is almost 32 inches (80 cm) in height and quite heavy, weighing 56 pounds (25 kg), not a size that permits easy manipulation. The *hu* are rounded squares in cross section, with tall necks and bulging bellies. Horizontal and vertical relief bands that create panels on the belly and shoulder augment the surfaces and demarcate those zones from the neck above. The lower panels are left plain, but the shoulder panels, neck, and foot are all covered with small-scale relief patterns. Some of these are akin to patterns on the Guangshan vessel above

and again derive from late Western Zhou motifs. Additional features distinguish these vessels from most of their contemporaries: three-dimensional dragons as feet and handles, and elaborate lids with everted profiles and openwork. The effect of these appendages is to enhance the silhouette so that the shape is partially obscured. These vessels dominate their space as sculptural monuments in a way that the self-contained Guangshan *hu* vessels did not.

Other pairs of *hu* made for high-ranking lords share some of these same devices (banding and

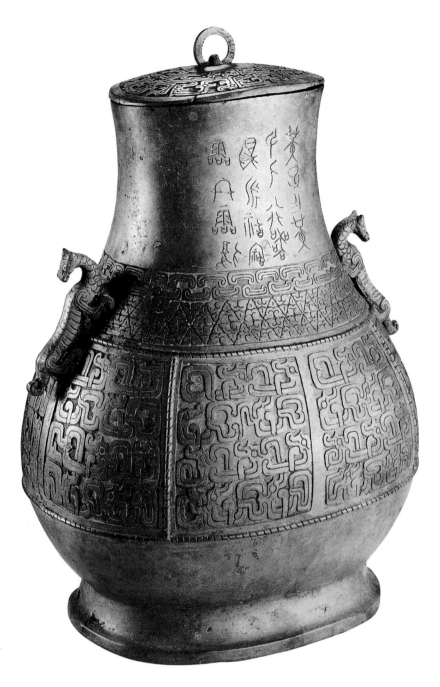

3-16 Wine vessel, *hu*
Eastern Zhou (state of Huang), c. 650 BCE. Bronze, height 12½" (32 cm). Baoxiangsi, Guangshan, Henan. Henan Cultural Relics Institute, Zhengzhou

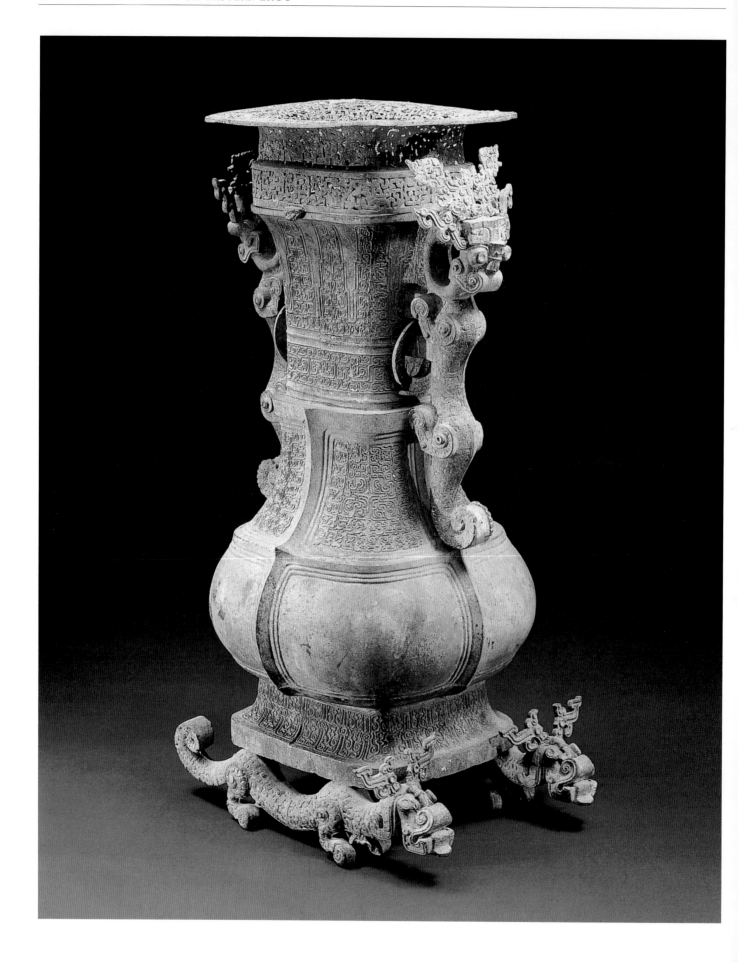

3-17 Wine vessel, *hu*
Eastern Zhou (state of Chu),
c. 550 BCE. Bronze, height
31″ (79 cm). Tomb 1, Xiasi,
Xichuan, Henan. Henan
Cultural Relics Institute,
Zhengzhou

3-18 Detail of bell, *bo*
Eastern Zhou (state of Jin),
5th century BCE. Tomb 251,
Jinshengcun, Taiyuan, Shanxi.
Shanxi Archaeology Institute,
Taiyuan

panels, dragon handles, openwork lids). *Hu* from the looted Xinzheng tomb (Henan) even add a naturalistically rendered crane to the lid. The design devised for these monumental *hu*, which might be termed an "order" of decoration following the usage suggested in chapter 2, is documented in assemblages of such states as Jin (Shangmacun, Jinshengcun), Zheng (Xinzheng), Chu (Xiasi), and Cai (Shou County). Large container vessels perhaps invite this kind of elaboration. A cooking tripod or food-serving vessel cannot grow too large before it becomes impossible to handle.

An assemblage of late Spring and Autumn vessels exhibits still other choices in design. Tomb 251 at Jinshengcun, near Taiyuan (Shanxi), has been attributed to a high minister of the state of Jin. The vessels are clearly products of the Houma foundry and have much in common with the better-known find at Liyu in northern Shanxi of the 1920s. Most of the vessels, such as the twenty-five *ding* and the musical bells, are decorated with a dragon interlace pattern that required fine detail in the preparation of the molds. Although dragon elements are discernible, the borders, striations, and scales on the ribbons and the many raised curls and spirals that grow from them together create a rich relief surface in which recognizable animal elements are downplayed. The dragon motif itself can be seen more clearly in the loops of bells and in a frontal mask motif (FIG. 3-18).

Amazing detail and craft were lavished on vessels with sleek silhouettes and low-slung, compact forms. The several sets of covered *ding*, for example, have smooth, rounded profiles with well-integrated lids and cabriole legs mounted onto the belly in such a way that the vessels hang between them. The streamlined silhouettes of these *ding* contrast with the prickly and varied contours of many southern vessels, such as examples from Xiasi. These Jin vessels also accommodated naturalistic animals such as recumbent bulls on their lids; there is even a bird-shaped wine container.

These three assemblages together span most of the Spring and Autumn period. Their vessels have much in common, including shapes and dragon and interlace patterns derived from late Western Zhou motifs. Many types, especially *fu*, *guan*, *pan*, and *yi*, are relatively constant over time and space. Little energy seems to have been invested in devising new versions or in elaborating these types. Even so, each region also produced some vessels that present distinctive appearances: for example, the *sheng ding* of the Xiasi tombs (discussed below) with their flat bases, constricted waists, flaring handles, and many appendages. Sorting these vessels by the patterns employed, or charting the development of interlace patterns, is not an adequate way of ordering them. Patterns are only one element in a more

complex product resulting from considerations of function, status, scale, shape, and the use of appendages and sculptural forms.

The Warring States Period

The options evident in rich assemblages of the late Spring and Autumn period were perpetuated during the early Warring States era. As it happens, there is now more evidence for casting in several regions surrounding the central plains, especially the north (states of Yan and Zhongshan), south (Chu and smaller states), and west (Qin), during this period than for the center. Among the options were fantastic applications of the lost-wax technique; more traditional relief-covered vessels; vessels with metallic and stone inlay; vessels with pictorial designs (see pages 112–114); or sober, unembellished vessels. Vessel types transcend these distinctions based on surface treatment. Thus a rounded *ding* with thick cabriole legs and a tight-fitting lid may be rendered with relief, with inlay, or with unadorned surfaces. By the

middle and late Warring States period, more vessels of sumptuous design were used away from the ritual altars than ever before. Foundries producing sets for such use may have been more prone to experiment and to seek visual effects. Patrons commissioning such equipment for their courts may have felt entitled to indulge a taste for stone or metal inlay or other attractive features.

The bronze vessels from the tomb at Suizhou (Hubei) constitute the largest assemblage of its kind ever recovered. The excavators calculate that almost ten tons of bronze were invested in the vessels, musical chime, weaponry, and other paraphernalia of the obscure Marquis Yi of Zeng. A high percentage of these objects have inscriptions naming him. Most of these objects must have been created in a Chu foundry, and an inscribed bell explicitly documents Marquis Yi's relationship to the king of Chu. Since the date of this inscription can be fixed at 433 BCE, this assemblage is confidently assigned to the late fifth century. In most respects the Suizhou vessels and their designs are based on norms evident in earlier assemblages as at Xiasi and Jinshengcun. Sets of *ding*, both the characteristic southern *sheng ding* variety and the covered variety associated with the central plains, are present in great number. However, the surface treatments include not only typical relief patterns but also an extensive use of stone inlay not common elsewhere. The many different sets of vessels required for food preparation and food service are each stylistically consistent, but wine vessels differed from them. Two large wine containers, *fou*, are the largest Eastern Zhou vessels ever recovered, weighing 650 and 720 pounds (292 and 327 kg) respectively. These containers and other wine vessels generally have relief decoration that exploits plastically rendered curls and spirals erupting from a dense dragon interlace ground.

A paired *zun* and *pan* originally crafted for another marquis are probably the most extravagant, complex, and technically challenging vessels within this formidable assemblage (FIG. 3-19). Each vessel was cast using piece molds, and each carries fields of relief decoration. Artisans then augmented each body with a variety of appendages that were first cast separately and then

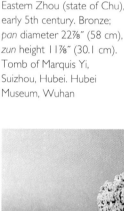

3-19 Water basin, *pan* and wine vessel, *zun*
Eastern Zhou (state of Chu), early 5th century. Bronze; *pan* diameter 22⅞" (58 cm), *zun* height 11⅞" (30.1 cm). Tomb of Marquis Yi, Suizhou, Hubei. Hubei Museum, Wuhan

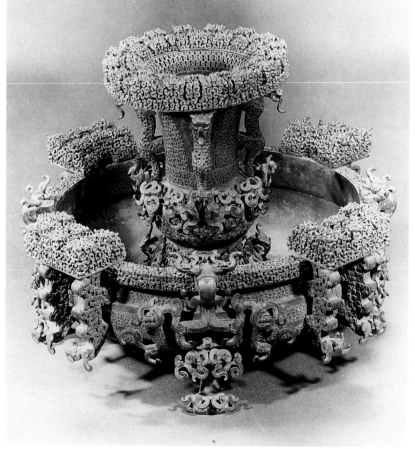

joined to the vessel. Altogether fifty-six components were assembled for the *zun*, while forty-four components were needed for the *pan*. These appendages were themselves made of several parts soldered together. The rim of the *zun* consists of sixteen units, each made using a lost-wax process. The *pan* vessel is crowned with equally complex units of lost-wax manufacture, soldered together to encircle the rim and to serve as grips. The writhing, three-dimensional interlace seen in these units is reminiscent of the panels on the unusual altar table from Tomb 2 at Xiasi (see FIG. 3-15 above), one of the earliest examples of the lost-wax process. The use of large appendages on a vessel, already a trend in the mid to late Spring and Autumn period, is taken several steps further in this pair.

Vessels from the royal Zhongshan tombs (Pingshan, Hebei) could not differ more from those made for Marquis Yi. The Zhongshan state was first established by a non-Zhou people, the Bai Di. By the late fifth century BCE their state was occupied by the prince of Wei (one of the three states formed after the partition of Jin) and for a time was a fief of Wei. Bai Di rulers reestablished control over Zhongshan by 378, and the state continued under their rule until its final demise at the hands of Zhao in 296. Given this political history, the Zhongshan kingdom became a laboratory of cultural interaction between Zhou and non-Zhou cultural practices. The contents of two royal tombs dating from the late fourth century illustrate this experimentation. The principal ritual vessels, such as the nine lidded *ding*, are compact

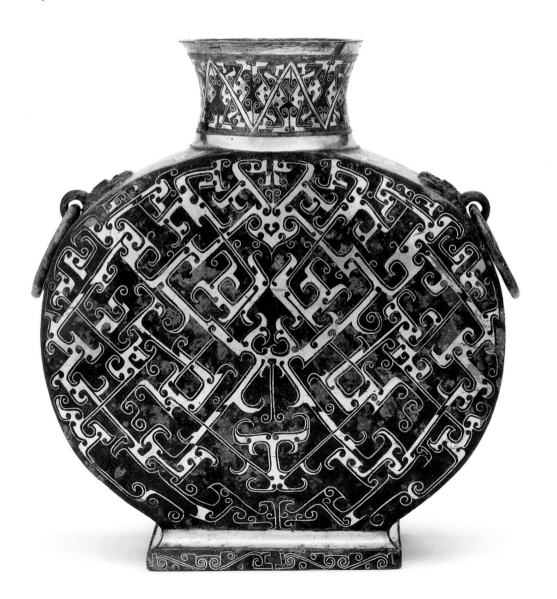

3-20 Flat *hu* vessel
Eastern Zhou, 5th–4th century BCE. Bronze with silver inlay, height 12¼″ (31.1 cm). Freer Gallery of Art, Smithsonian Institution, Washington, D.C. (15.103)

3-21 Wine vessel, *hu*
Eastern Zhou (state of Zhongshan), c. 310 BCE. Bronze, height 24¾″ (63 cm). Tomb 1, Pingshan, Hebei. Hebei Cultural Relics Institute, Shijiazhuang

and undecorated, although the largest tripod bears an incised inscription of 469 characters dated 314 BCE. This vessel also features cast iron legs. An inscribed *hu* vessel (FIG. 3-21) also has a sleek, unadorned body. Lively profile dragons attached to the four edges of this square-section vessel, on the other hand, recall the large dragon handles on several of the monumental *hu* discussed above. The bulk of the meat, grain, and wine vessels recovered from these tombs are similarly restrained in shape and lack surface decoration. Other vessels, however, display a markedly different taste. It is likely that the tomb inventory derives from several regions and foundries.

Other Zhongshan vessels utilized metal inlay to fill the otherwise smooth surfaces with intricate interlace designs of contrasting color. Silver, gold, copper, and stones such as turquoise all figure prominently in Warring States inlay objects. Renewed interest in inlay is evident already in the late Spring and Autumn period, as shown by the cast copper inlay on wine containers at Xiasi (Henan) or the gold inlay of *dou* vessels at Jinshengcun (Shanxi). It may be that foundries in the central plains were a major source of inlay vessels and other objects found in the Zhongshan tombs. (Compare the lamp of FIG. 3-9.) A fine example of inlay decoration from the period is a flattened *hu* vessel now in the Freer Gallery of Art (FIG. 3-20). Without the silver inlay, this container would be a simple round shape with flat walls mounted on a rectangular foot and surmounted by a cylindrical neck. The reddish-bronze color of the body contrasts with the silvery sheen of the inlay, created by hammering strips of silver into depressions cast in the surface. The decoration is generally symmetrical around

an axis at the center of each flat side. The wider bands and the thin lines that complement them create diagonally disposed patterns derived from bird and dragon motifs common in textiles (see FIG. 3-10 above) and lacquer wares (see FIG. 3-12). Here, however, all traces of head, claw, or wing have been erased. A square *hu* in the Zhongshan tomb exhibits similar decoration, although its diagonal motifs are more densely rendered.

RITUAL AND REPRESENTATION

"Ritual" (*li*) informed Zhou society. The concept of *li* embraced the solemn choreography essential for a state ceremony or sacrifice, dictated the chivalric norms regulating the conduct of warfare, and determined the etiquette when entertaining an emissary from a neighbor state. Not least, it defined the ordinary social interactions of individuals. Ritual determined the relations between the Son of Heaven and the lord, the living and the dead, and throughout the social fabric. Three compendia assembled much of this traditional ritual and etiquette.

The *Zhou li* (*Rituals of Zhou*) describes in considerable detail the organization of the early royal Zhou court and the duties that governed every rank and office. Most scholars now regard this text as a synthesis produced in the late Zhou period that expounds an idealized vision of Western Zhou. The sixth section of this text, missing in Han times, was replaced by the present *Artificer's Record* (see "The 'Royal City' Plan," page 93).

The *Yi li* (*Ceremonial and Ritual*) is an encyclopedia of ritual usage for the *shi* class, generally attributed to the late Zhou period as well. Early versions of this text are preserved among fragments of the so-called Han "Stone Classics" of 175 CE (see chapter 4, FIG. 4-3).

The *Li ji* (*Record of Ritual*), attributed to the disciples of Confucius, surveys a wide range of life-cycle events and rituals. It is a redaction of the Han period from disparate sources.

It is a cliché of modern social science that ritual reproduces culture and legitimates social and political structures. According to *li*, only ranking male members of the elite could preside at the

solemn rites before the ancestral altars or at the open-air altar of the local god. Their ability to assume this role set them apart. More specifically, their control over sacrifice, the ritualized feeding of the spirits, maintained the social order. During the upheavals of the Eastern Zhou these roles were claimed, in sequence, first by local lords, then by ministers, and finally by members of the lesser warrior, *shi*, class. Each of these social groups thus claimed both real and symbolic power. Each in turn patronized the artisans and industries charged with producing ritual equipment. *Li* was implicit in many features of elite material culture. In principle, if not always practice, its norms governed the size and attributes of cities and palaces, dress and regalia, chariots and banners, music and dance. Not least, ritual regulated burial, from the number of chambers and coffins to the words authorized to designate "death."

The ritual theater *par excellence* was the ancestral temple of a great lineage. The best-preserved example now known was constructed during the middle of the Spring and Autumn period (c. seventh–sixth centuries BCE). Located in the capital of the state of Qin, Yong, this site (in Fengxiang, Shaanxi) was explored systematically during the 1980s. The temple at Majiazhuang was enclosed by a thick pounded-earth wall that defined a compound about 290 feet from side to side by at least 230 feet deep (88 by 71 m). A central axis from south to north was marked by a gate house and the main hall. A large courtyard (about 112 by 98 ft; 35 by 30 m) occupied the center. Two halls of similar plan, both facing inward, flanked the courtyard. Aerial photographs show

the "footprint" of these three structures, especially their thick wall footings, traces of a stone splash slope surrounding each structure, and many sacrificial pits in the yard. This ritual precinct corresponds to the kind of temple setting described or assumed in the three ritual texts. Space is ordered, so the position of celebrants and participants may be carefully specified. The lord presided within the main hall, sometimes facing the yard and those gathered there. Ceremonies could be conducted in the yard (hence the sacrificial pits) within the front area of the hall, or within the enclosed building, out of sight. Ceremonies for lesser-ranking ancestors could be performed in the flanking halls.

Ritual vessels were essential equipment for the altar of a Zhou noble. The three ritual canons project a schematic system which correlated social rank and ritual sets. The most common system assumes the Son of Heaven required an ensemble of nine *ding* cauldrons complemented by eight grain vessels (initially *gui*, later *fu*). A local lord would employ seven *ding* and six *gui*, a high minister five *ding* and four *gui*, a lesser minister three and two, and a low-ranking *shi* merely a single *ding*. The numerology of this scheme starts with nine, later the symbolic imperial number, and matches decreasing odd and even numbers for the two basic foods within a ritual repast. The key vessel type, the *ding*, was dedicated to the preparation and service of meat offerings, a privilege reserved for the elite and symbolic of their life and death power. Inscriptions on cauldrons (see FIG. 3-3 above) specify several functional subtypes: *huo ding* for cooking, *sheng ding* sets

3-22 Chime of bells, *bianzhong*
Eastern Zhou (state of Chu), c. 433 BCE. Length 24½" (7.5 m), height 8′10″ (2.7 m). Tomb of Marquis Yi, Suizhou, Hubei. Hubei Museum, Wuhan

"Suspended music," the Zhou-period term for such chimebells, was a perquisite of noble rank, and in this instance also a gift bestowed by the King of Chu on his vassal, Marquis Yi of Zeng. The chime of 65 bells was recovered, intact and installed as seen here, in Marquis Yi's tomb. Half a dozen musicians, standing and kneeling at both sides, were required for performance.

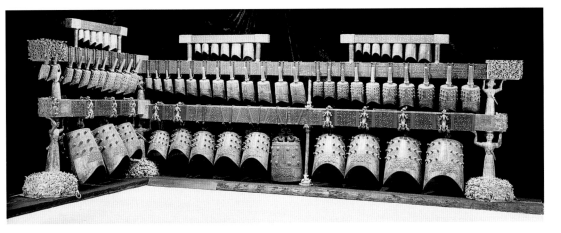

for presenting the different courses, and small *cha ding* for preparing condiments to flavor the roasted meats and fish. Precise equivalents of this scheme are not yet known for the Western Zhou period, owing to the lack of high-ranking tombs and complete assemblages, but for the Eastern Zhou many more intact assemblages are documented. Many Chinese writers believe that lords of lesser rank with larger numbers of *ding* than authorized manifest the decline and ultimate demise of ritual norms and stable social structure.

The Suizhou tomb of Marquis Yi (c. 433 BCE) and an earlier tomb at Xiasi (mid-sixth century) both held large chimes of bells (FIG. 3-22). Both chimes required several musicians to strike the large number of bells, sixty-five and twenty-six respectively. The Suizhou bells were suspended from a three-tier frame with a short arm meeting the main frame at a right angle at one end. The chime stand was in place and intact at the time of excavation. The Xiasi chime was not found on its frame, although metal cables used to suspend the bells were found attached to their shanks. Each chime consisted of several small sets of bells. Artisans tuned every bell in turn in the process of casting so that it produced a specific note in the musical scale. Moreover, because of their crimped elliptical cross sections, these bells actually produced two distinct musical notes depending on where they were struck. These two notes generally vary by a major or minor third. As in the pictorial scene seen in figure 3-24 below, stone chimes or lithophones complemented the bronze bell chimes, and many sets are known, some with racks for suspension. These chimes were only part of an Eastern Zhou orchestra. The Suizhou tomb was also outfitted with a variety of string instruments (ancestors of later lutes or zithers), wind instruments (pitch pipes and reeds), as well as drums. It may be that many of the women put to death at the time of the burial of Marquis Yi were musicians who performed for his pleasure (see below).

Funerary Ritual

Ritualized disposal of the dead was a major intellectual preoccupation and a significant aspect of the economy during the Eastern Zhou. In addition to the ritual canons compiled during this period, other thinkers (Xunzi, Mozi, Zhuangzi) addressed these issues, and a few, like Mozi, questioned the wisdom of assigning so much wealth to this purpose. In spite of such criticisms, the lords and ladies of the period invested considerable assets in their preparations for eternity. Burial tracts became prominent features of larger cities. The mounded royal tombs of the lords of Qi were constructed on low hills overlooking Linzi from the south. The precinct for the tombs of the kings of Zhongshan dominated the landscape outside their capital (see FIG. 3-7 above). Extensive mounds are associated with the capital of Zhao at Handan (Hebei) and the capital of Chu near modern Jiangling (Hubei). The Qin necropolis at Fengxiang (Shaanxi) was some 8 square miles (21 sq. km) in area, with 18 clusters of tombs defined by ditches rather than mounds. To these remains of royal lords and ladies must be added thousands of other elite burials in cemeteries near every major urban center. Most of the objects illustrated in this chapter derive from burials.

Burial chambers were by this time elaborate underground structures. Some were designed to approximate the above-ground residences enjoyed in life. Chambers were installed in bedrock or surrounded with protective stone and an envelope of charcoal and sticky clay impervious to water. All tomb chambers seem to have been entered and their furnishings installed from above, with or without a convenient ramp. The chamber at Suizhou was 69 feet wide by 55 feet long (21 by 17 m), making it larger than any of the Shang royal tombs near Anyang. Its central room was large enough to accommodate the massive bell frame seen in figure 3-22 above and numerous ritual vessels with space to spare. The coffin chamber on the east side held both the double coffin of the marquis and those of eight women and a dog. Thirteen more coffins of other attendants (musicians?) were found in the west chamber. A veritable armory with 4500 weapons was installed in the smallest, north chamber. Burial chambers this large and this well preserved were by no means the norm. Instead, for most

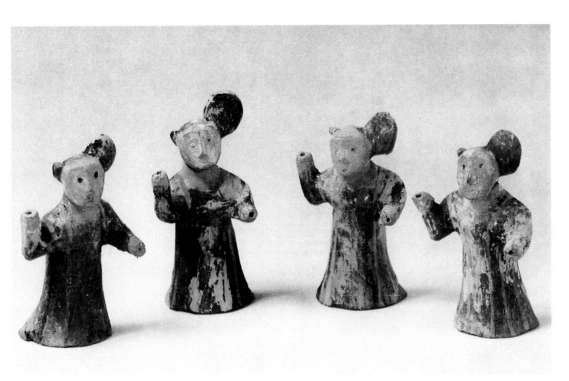

3-23 Clay figurines
Eastern Zhou (state of Qi), 4th century BCE. Earthenware with pigment, height 3″ (7.6 cm). Zhangqiu, Shandong. Shandong Institute of Cultural Relics and Archaeology, Jinan

of elite society, burials required an outer chamber holding a nested coffin or two and a few side compartments tightly packed with burial goods.

An increasing emphasis on a full complement of grave goods matching actual bronze altar vessels but made from inexpensive clay characterizes the Eastern Zhou period. Tombs at the Yan Lower Capital (Yi County, Hebei), at the Qi capital near Linzi (Shandong), at the Chu capital near Jiangling (Hubei), and at the Qin necropolis near Fengxiang (Shaanxi) are furnished with extensive sets of surrogate ceramic vessels. These are generally gray wares that mimic in their number, shape, and decoration the standard components of bronze vessel sets. Ritual texts refer to such vessels as "inauspicious" or "spirit" objects (*xiong qi*, *ming qi*). These objects actually predominate in the burials of the lower-ranking members of the elite. Another ancient custom was to bury attendants of a lord at his funeral ("following in death"). Although Confucius and others railed against it, this fate was common for male and female servants such as drivers, musicians, and personal attendants. Ceramic figurines seem to begin in burials by the late Spring and Autumn period. They first appear as grave furnishings for attendants. The best known examples are from Qi tombs in Shandong and Jin tombs in Shanxi

dated to the early or middle Warring States. In each instance, burials of attendants included small (3 inch; 8 cm) clay figurines (FIG. 3-23). Modeled from soft clay, low fired, and painted, these figurines enact the roles of dancers and musicians, and in some cases instruments are provided. Although there is growing evidence for these simple clay figurines in several regions, and many carved wooden figurines in the south, most tombs linked to high-ranking nobles do not contain such surrogates.

Representational Art

Our understanding of early Chinese art is based upon physical preservation. Perishable goods, from textiles to wall paintings, from bamboo documents to wood carvings, complemented the ceramics, jades, and bronze vessels. Thus the status of representational art remains unsettled. It is inaccurate to say that "representation" is unknown; more properly, representation was not essential to decoration on ritual bronzes and jades during the protohistoric period. Striking renderings of a face (for example, see FIGS. 1-24 and 2-25 above) belie any notion of inability. The scarcity of human figures and activities, on the other hand, demands that we consider the purposes of such subject

3-24 Detail of ritual

Redrawn from a pictorial bronze

This drawing reproduces designs cast into the surface of a *hu* vessel dated to the 4th century BCE. At left a ritual encounter takes place above a musical performance replete with bells, a stone chime, and a standing drum. At right are two scenes involving archery: bowmen aim their tethered arrows at birds in flight, while archers in long robes take aim at the target at far right.

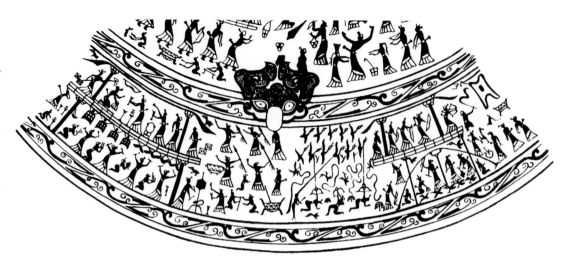

matter. By the Eastern Zhou period, new purposes seem to be in play, and representational art becomes more common. Moreover, the range of media preserved also increases, now including perishable items such as lacquer wares that are rare from earlier periods.

The earliest pictorial designs appear during the sixth and fifth centuries—the late Spring and Autumn and early Warring States periods. This material emanates from find spots spread over most of the central states from north to south, with many examples in the center itself. The evidence at hand does not support the notion that the representation of these subjects required an external stimulus. Pictorial designs are found on thin-walled copper vessels (usually water basins, *pan,* and ewers, *yi*) rendered in engraved lines, on various food and wine vessel types (*dou, hu, jian*) where copper was inlaid into cast depressions, and among various lacquerware hampers and boxes. The common denominator among the objects is use outside an altar or other ritual setting. All could have been employed in the palace for the daily ablutions, eating, and drinking of a noble. As such they were luxury goods and hence suitable for decoration of a kind not deemed appropriate in solemn rites. There was no inherent difference between a lacquerware box and a metal ewer as a vehicle to carry representational designs. Pictorial subject matter embraces many aspects of elite life, including several of the "six arts" mentioned above as the accomplishments of a gentleman. Scenes of warfare on land and water, hunting on foot and with chariots, fowling with arrows on

cords, archery contests, music making, and ritualized events account for most examples.

Several *hu* vessels, such as this example from Baihuatan near Chengdu (Sichuan), display a structure with two stories and overhanging eaves (FIG. 3-24) as if seen in elevation or cross section. Within the columns of the lower level kneeling musicians strike stone chimes and suspended bells. A kneeling figure (of high rank?) faces several standing ones in a scene above. An attendant holds a fan over the former. Stands or footed vessels are in evidence, and the standing figures hold goblets or the like in their hands. This scene could represent a guest ritual or perhaps a rite associated with the archery, hunting, and warfare depicted on other registers. In any event, the consumption of food and wine is suggested, as is the ritualized interaction of host or lord kneeling and guests or servitors standing within a palace.

The pictorial style of these and other scenes is remarkably consistent. Figures are depicted as simple silhouettes in profile. Usually two or three types of figures are juxtaposed—warriors, musicians, hunters, for example—each type with its own standard poses and attributes. Figures are generally confined to one scale, but exceptions exist side by side. Rarely is any single figure differentiated by scale, attributes, pose, or placement. Figures act and interact by their gestures and groupings: several face several others; a group of warriors in file move toward their opponents. Symmetry is often present but need not be exact. Figures share a common base line, and sometimes one is supplied; they may also be stacked in superimposed

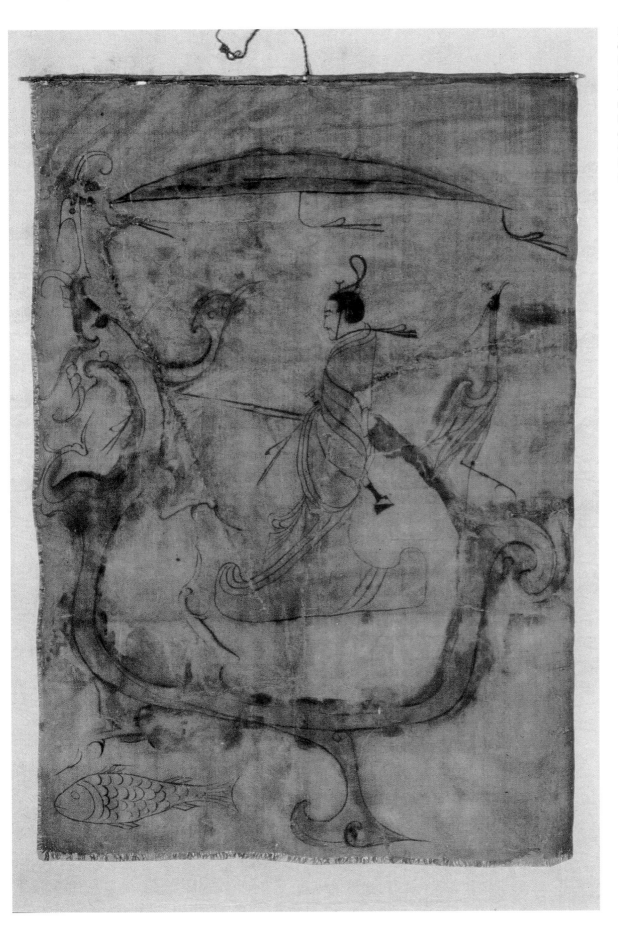

3-25 "Man and dragon"
Eastern Zhou (state of Chu), 4th–3rd century BCE. Silk painting, height 14¼" (37.5 cm). Zitanku, Changsha, Hunan. Hunan Museum, Changsha

registers within a single field. Little setting is included, but much can be suggested by a few lines—a hill or a pond edge—or by a building in elevation. In spite of their miniaturization, there is no reason to suppose that larger surfaces would have been any different. Now lost wall paintings probably looked much the same.

While designs on copper and bronze vessels are best known, lacquer wares and silk were also important media for representational art. The tombs at Suizhou and Baoshan (Jiangling, Hubei) and Xinyang (Henan) contained lacquered objects with examples of figural scenes in the style described above. Two paintings on silk also survive from this period, both from Changsha (Hunan), a southern center of the Chu realm. The example illustrated (FIG. 3-25) is a rectangle of darkened silk about 15 by 11 inches (38 by 28 cm) sewn to a stave at the top. A male figure in a long robe stands at the center, in profile, facing the left. His robe is drawn in line only, with some attention to collar, cuff, and elbow folds; a sword in its scabbard hangs at his waist. Under the man is a large dragon, also facing left, with its body in a U-shape and a canopy above. The dragon's body was filled in with ink wash, as was the canopy. Presumably dragon and canopy together are a kind of vehicle, and the man is driving it (note the reins). To suggest motion, tassles hanging from the canopy and the man's chin strap are shown blown to the right by a strong breeze. A second painting on silk depicting a woman was recovered from another Chu grave near Changsha. These small silk paintings most probably were part of the funeral gear carried in procession from the home of the deceased to the grave. Thus they anticipate the most important early paintings on silk, the banners from Mawangdui, east of Changsha, dated to the Former Han (see FIG. 4-24).

A WIDER VIEW: PEOPLES OF THE NORTH AND SOUTHWEST

The powerful states that dominated the central plains during the Warring States period shared much of a common culture. The royal Zhou domain and its immediate neighbors—Han, Wei, and Zhao—occupied the center, but states flanking them were by no means "provincial." Qi to the east and Qin to the west were advanced societies whose economies were intimately linked with the center. Important thinkers of the day moved back and forth among these states and recognized them as basically similar in important institutions and practices, including their devotion to Zhou ritual. Customs might vary between regions—music, food, or script—but itinerant scholars and royal emissaries were reasonably at home in these different states. The term "Hua–Xia" was used to designate these states and their common culture.

With the great northern and southern states, however, the situation was more complex. Yan and Zhongshan to the north and Chu, Wu, and Yue to the south stood apart. In the eyes of their own people there were distinctions between their cultures and that of the central plains. Most scholars see this dichotomy as an artifact of a process of "sinification," by which elites adopted Hua–Xia customs as they consolidated power over the local populace. For example, it is likely that Chinese script and northern dialect were used by only some of the population of a southern state such as Chu. Religious customs also differed, and such literary compilations as *The Songs of the South (Chu ci)* testify to a mythology and to religious practices that may have no counterparts among the Hua–Xia cultures.

A variety of names were applied to tribal peoples who lived at the margins of the Warring States. Across the west and north the most common epithets were Rong, Di, and Hu. The state of Zhao, when it adopted horse-back archery, called the clothing necessary "barbarian clothing," *hu fu*. It may be that *hu* specified horse riders, a culture trait that did not characterize the Rong and Di. The founders of the state of Zhongshan were themselves Bai Di, who, like the elite of Chu, seem to have consciously adopted the trappings of Hua–Xia culture. The people of Chu encountered local tribal peoples whom they lumped into the general category of *man* ("southern barbarian"). Such peoples wore different clothing, worshipped different gods, and produced different arts and crafts from the Hua–Xia. They were

non-literate, and their speech may have been ancestral to such modern language families as the Miao–Yao or Tai.

This overview suggests a three-part classification of peoples and cultures in the late Zhou period. Within the central plains were a group of states that considered themselves Hua–Xia, heirs of the "Three Dynasties," an advanced civilization in many respects. Sharing much but not all of this Hua–Xia culture were powerful states on the north and south. These states had local populations who did not share the Hua–Xia culture of the elite. On their margins were yet other peoples known by a variety of terms as "barbarians." The powerful states whose elites shared the Hua–Xia culture constituted the "central kingdoms," *zhong guo*, a term that only in modern times became the standard word for "China."

A nomadic life based on horse riding seems to have developed early in the first millennium BCE on the steppes west and north of modern-day China. The earliest incursions of such nomads into the central states date to the late Western Zhou, and indeed the move of the Zhou capital eastward was a consequence of these attacks. One truly nomadic people appeared in the northern territories of modern Hebei, Shanxi, and Shaanxi and the Inner Mongolian Autonomous Region by the fourth century BCE. These were the Xiongnu, a horse-riding culture that later became a major threat to the Qin and Han empires. With origins further north, perhaps in modern-day Mongolia, the Xiongnu appear first in the histories of the northern states of Qin, Yan, and Zhao. From their graves in the Ordos region, a desert contained within the great loop of the Yellow River, it appears

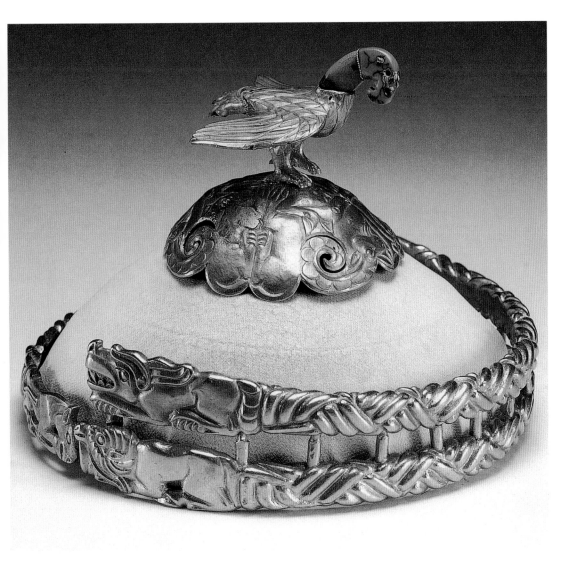

3-26 Headdress
Eastern Zhou (Xiongnu Culture), 5th–3rd century BCE. Gold with turquoise, diameter 6½″ (16.5 cm). Aluchaideng, Hangjin Banner, Inner Mongolia. Inner Mongolia Museum, Huhehaote

these people traded regularly with their neighbors and adopted the technology of the central states. The Xiongnu used both iron and bronze to create distinctive tools and weapons, as well as various metal plaques and ornaments.

One of the most impressive finds linked to the Xiongnu is a group of gold and silver objects recovered at Aluchaideng in Hangjin Banner of Inner Mongolia (southwest of Baotou), now a desert region. This find probably came from a Warring States era burial. The headgear we illustrate consists of two parts, both made from soft, hammered gold weighing altogether over 2.5 pounds (some 1200 g; FIG. 3-26). An eagle with its neck and head made from turquoise stands with spread wings on a gold skull cap. Both neck and tail feathers are flexible so they swayed when the cap was worn. The skull cap in turn is decorated with designs of recumbent wolves and sheep repeated four times. The second part of this headdress is a circlet of gold about 6.5 inches (17 cm) in diameter. It has two bands on one side and a single band on the other, both rendered as twisted rope. These bands terminate in animal heads: tiger, ram, and horse. This is most probably a crown for a tribal leader, even a ranking chieftain of the Xiongnu. Working gold is associated with steppe

cultures across Eurasia and was characteristic of such western peoples as the Scythians. The animals represented, both wild and domesticated, are found in the art of many cultures of the first millennium BCE. Their most characteristic use is in "animal combats" in which predators attack prey. That does not seem to be what is shown here, although the eagle may be imagined as circling above prey. Cloth or leather once connected the cap and bands.

Southwest of the states of Chu, Ba, and Shu was another powerful kingdom, one that did not maintain relations with the central states. Known as Dian, and centered around the lake of that name, this culture flourished in the plateau of modern-day Yunnan from the Spring and Autumn period into the Han. The Dian may have been ancestral to Tai peoples of recent times. Indeed, many customs represented in their pictorial and sculptural art suggest similarities to the many "minority nationalities," *shaoshu minzu*, of the present-day People's Republic of China. The altar table (FIG. 3-27) comes from a cemetery site of the Warring States period on Mount Lijia (Jiangchuan, Yunnan). The long-horned bulls are characteristic of much early Dian art, as is the device of a predator, especially a tiger. The table

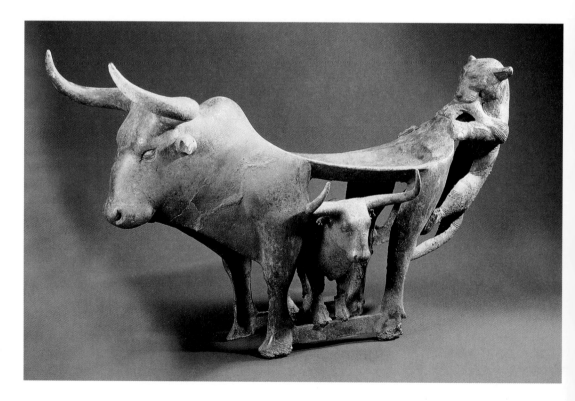

3-27 Table
Eastern Zhou (Dian Culture), 5th–3rd century BCE. Bronze, length 30″ (76 cm). Mount Lijia, Jiangchuan, Yunnan. Yunnan Museum, Kunming

is 30 inches (76 cm) in length. The maker created a flat surface by cutting away the back of the larger bull, and created room for the smaller animal placed at right angles by removing the belly of the same bull. In spite of these practical abridgments, the animals are carefully observed and tellingly rendered. This high naturalism contrasts with the more stylized animal motifs typical of northern steppe peoples.

Both on the steppe margins and the Yunnan plateau of the southwest, sophisticated cultures developed among peoples distinct from the Hua–Xia peoples of the central states. Their histories are part of a survey of Chinese art and culture both because their homelands today fall within the modern boundaries of China and, more importantly, because their interactions with the central states contribute to later history. The expansion of the Hua–Xia peoples (called "Han" in modern times) over the map of China proper is a fundamental long-term trend in Chinese history. This expansion had an impact on all of the native peoples who confronted that advancing Han Chinese population, a story still being written today in the Autonomous Regions of the People's Republic of China.

This chapter treats a shorter period than the prehistoric and protohistoric chapters above. In each successive period, the evidence increases geometrically. The Eastern Zhou period is a fully historic one, with literary sources that overwhelm us with detail when compared to what is known from authentic Shang and Western Zhou inscriptions. Moreover, the number of sites, quantity of artifacts, range of media, and types of objects surpass the material record of preceding periods. The evidence represents more different people in more different places spread over a greater geographical terrain. Simple story lines are consequently that much more difficult to discern.

One important story was the fundamental transformation of Eastern Zhou society within the central states. The aristocratic nobility established by the Zhou founders was gradually supplanted by a new social order. In this new society, men of lesser rank usurped status and power with great regularity, but the legitimating roles of ritual and cult remained significant. The steady consolidation of the more than one hundred states of early Eastern Zhou into a handful was, in retrospect, preparation for another story, that of Qin unification. Until the late third century, however, that outcome could not have been foretold. Even as the small states were disappearing, regional economies grew increasingly productive and ever more integrated. A widespread, common culture was in the making. This common culture was the initial stage of the Chinese civilization that has survived into our own century. Later chapters will track the growth of that culture and chronicle some of its interactions with neighboring peoples both near and far.

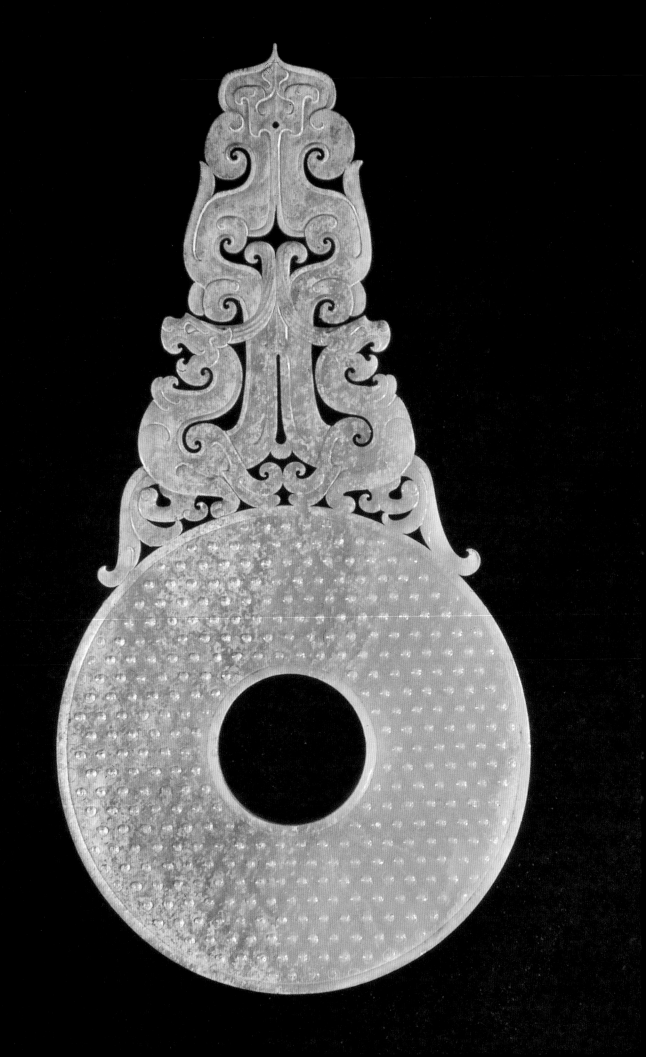

4 THE FIRST EMPIRES: QIN AND HAN

THE SUCCESS OF the Qin armies in 221 BCE marks a fundamental turning point in Chinese history. From that date forward China would normally be unified under one central regime. In periods when central rule was weakened, the ideal of a centralized state nonetheless remained potent. And even in periods of actual political division (the Northern and Southern Dynasties, or Liao, Jin, and early Yuan), the goal of a unified state still preoccupied the minds of statesmen and motivated their actions. What Qin accomplished took several decades of intense warfare against the other "strong states" of the late Zhou period. But warfare was only one part of this story, and arguably not the most important. Qin created a state organized in pursuit of its own goals—political, economic, social, and military—that became a model for all later authoritarian, centralized imperial regimes. The notion that the state, as manifest in the emperor, his court, and bureaucracy, could control and direct all aspects of society proved to be far more important for later Chinese history than the strategies of Qin generals. Qin's contributions cannot be underestimated, even if its rule did not endure.

The two Han regimes, by contrast, were long lived, and they successfully institutionalized and elaborated much of what Qin initiated. The Former (or Western) Han dynasty ruled from Liu Bang's victory over his rivals in 202 BCE until usurpation by a high court official, Wang Mang, in 9 CE. By most accounts, this dynasty was a time of general prosperity, of growing central power, and of military expansion in several directions: northeast, southwest, and northwest. The Later (or Eastern) Han that followed the demise of Wang Mang was a "restoration" in name only. Although the Liu family was again ascendant, in fact the former imperial line was replaced by a distantly related branch. This period from 25 to 220 CE differed from its earlier namesake. Central power was more and more in question. Struggles within the court and capital among distaff relatives and eunuchs polarized elite society. Prosperity in the countryside did not mean greater wealth for the state, as local magnates gained de facto autonomy. Scholars (the class from which officials were drawn) were often alienated. The peasantry suffered and sometimes rebelled. Contacts with foreign cultures grew, and Buddhism made its initial appearance within China proper. While on the whole the two Han dynasties were relatively stable, they were nonetheless dynamic societies.

THE IMPERIAL STATE AND SOCIETY

The achievements of the Qin dynasty were the subject of analysis and debate soon after its fall, c. 206 BCE. Han writers often vilified the First Emperor of Qin (*Qin shi huangdi*; on this term see page 137 below) and his ministers for their

4-1 Disk, *bi*
Former Han, 2nd century BCE. Nephrite, height 10″ (25.9 cm). Tomb of Liu Sheng, Mancheng, Hebei. Hebei Cultural Relics Institute, Shijiazhuang

According to *Huai nan zi* (*The Book of the Prince of Huianan*; 2nd century BCE): "A shoreline divided the primordial *qi*. That which was pure and bright spread out to form Heaven; the heavy and turbid congealed to form Earth… The conjoined essences of Heaven and Earth produced *yin* and *yang*…" (Major, *Heaven and Earth*, p. 62.) To Han thinkers this disk symbolized not only Heaven but also the origins of the cosmos.

4-2 "Small seal" script
Qin, c. 219 BCE. Detail of
rubbing, Yishan Stone.
National Museum of History,
Beijing

Sima Qian reports: "In his
28th year, the First Emperor
went eastward to inspect the
commanderies and counties
and climbed Mount Yi in
Zou, where he erected a
stone monument." (Nien-
hauser, *Grand Scribe's
Records*, vol. 1, p. 138.) The
Yishan Stone was lost by the
Tang period (618–906 CE),
but rubbings like this one
were made using a replica
created in 993 CE from rub-
bings then available.

harsh policies and immoral acts: the burning of the books and killing of scholars, for example. This tendentious writing continued as memories of Qin faded. Qin has been used as a handy negative example by writers addressing government policies and problems up to recent decades. More often than not the First Emperor has been seen as a villain, although in the political campaigns of the 1970s he was remade into a progressive. The new order imposed by the Qin was revised under the Former Han, but many features survived intact. Never again would China break up into a collection of warring states ruled by hereditary nobles. The new empire redefined many of the terms of society and of life for the millions of people living within its bounds.

Qin Unification

The First Emperor promulgated an administrative system in which his realm was divided into thirty-six commanderies. All were governed by a trio of appointees sent out from the capital at Xianyang (near modern Xianyang, Shaanxi): a civil governor, a military commander, and an inspector who reported to the court. These officials shared authority locally but were closely controlled by the court, which placed strict limits on their power. The court also required the local population to pay taxes and provide labor service (corvée). Law governed all aspects of this system, and excavated documents testify to the implementation of the Qin statutes at the local level. To consolidate his power over the defeated six states, the First Emperor ordered the destruction of defensive "long walls" and city walls. He kept a strong army in the field along the northern frontier and used it and other laborers to construct large-scale public works such as defensive lines (see "The Myth of the Great Wall," page 121), roads, and canals. The best known of the First Emperor's measures were designed to integrate regional economies. Axle widths were standardized so that carts could move smoothly along the rutted roads. Officially issued weights and measures for commodities were made uniform so that all markets operated with a common set of standards. Standardized script replaced the several regional writing systems that had flourished in the Warring States period (compare FIGS. 3-2 and 3-3).

The First Emperor made several long circuits of his realm during the decade (221–210 BCE) he ruled. Most included lengthy sojourns near the eastern coast in modern-day Shandong and Zhejiang. *Historical Records* (*Shi ji*, c. 100 BCE) contains transcriptions of some of the texts carved in stones set up to memorialize the emperor's achievements. Only two stones with inscriptions, the Taishan and Langye Tai stones, have survived. They and four others are actually studied through rubbings of later date, such as the one reproduced here (FIG. 4-2). The calligraphy is traditionally attributed to Li Si, a chancellor who presided over the Qin victory. The graphs on these stones are elegant renderings derived from the Eastern Zhou "small seal" (*xiao zhuan*) script that, in turn, grew from script employed on Western Zhou bronzes (see FIGS. 2-6 and 3-2). The text is written in vertical columns so that each character is

separated from its neighbors by even spacing. In fact, the graphs appear to be contained within imaginary grids or rectangles. Individual characters are taller than they are wide, with a strong central axis and a composition carefully balanced around that axis. The two characters for "emperor" (*huang* and *di*; see first column top right in FIG. 4-2), for example, are completely symmetrical side to side. The spacing of parallel horizontal strokes is also regular. Strokes are even in width throughout their length and begin and end as slightly rounded forms. There are no flourishes that might reveal the actions of a pliant brush tip. This script was the model for texts incised on the weights and measures issued under imperial command.

The Myth of the Great Wall

The best-known achievement of the First Emperor is surely the Great Wall. *Historical Records* documents the emperor's charge to his general, Meng Tian, to construct defensive lines across much of the northern frontier (modern-day Ningxia, Inner Mongolia, Shaanxi, Shanxi, and Hebei). The general in turn mobilized impressed laborers, convicts, and soldiers. Their work was a combination of repairing and connecting existing walls constructed by the preunification states of Qin, Zhao, and Yan and of building new segments. These lines were for the most part made from pounded earth (see "Building with Pounded Earth," page 57), but in some areas stone was also used. In spite of the wall's later fame, *Historical Records* merely states:

> After Qin had unified the world, Meng Tian was sent to command a host of three hundred thousand to drive out the Rong and Di along the north. He took from them the territory to the south of the Yellow River, and built a long wall, constructing its defiles and passes in accordance with the configurations of the terrain. It started at Lintao and extended to Liaodong, reaching a distance of more than ten thousand *li*. After crossing the Yellow River, it wound northward, touching Mount Yang.
>
> (Waldron, *The Great Wall of China*, p.17, modified)

The text links the construction to campaigns against the steppe peoples on Qin's northern frontier. The term "long wall" (*chang cheng*) is found in early accounts of defensive walls built by several states as early as the seventh century BCE. The distance, expressed as "ten thousand" *li*, seems to connote simply "a great number" or "myriad."

After the Qin, other walls were built, but the "long wall" associated with Meng Tian and the First Emperor accrued specific symbolic associations. In political writings, the project became an example of over-reaching ambition and grandiose schemes associated with a megalomanic ruler. In popular literature, the suffering of the workers under Meng Tian became a recurring motif, exemplified by the account of a worker who died on the job. His body was interred in the wall rather than given a proper funeral. It is well known that Marco Polo never mentions the Great Wall, but early European visitors such as the Jesuits reported its existence and linked what they saw to the Qin. What they and other more recent visitors observed, however, was actually a series of much larger, stone and brick-clad walls erected under the Ming (1368–1644 CE), most during the sixteenth century. The Ming Great Wall was a response to a failed frontier policy and the continuing threat posed by the Mongols, then only recently evicted from China. This structure, in turn, has been the source for more modern myths. As early as the 1930s, the cartoon series "Ripley's Believe-It-or-Not" asserted that the Great Wall was the only man-made structure visible from outer space. More recently it has been claimed that astronauts observed the wall from their spacecraft or from the moon. None of this is true, any more than one can see the American interstate highways from outer space. More fundamentally, writings about China have employed the Great Wall to symbolize a perceived boundary between sedentary, agricultural Chinese civilization and nomadic, pastoral cultures of steppe peoples. It is thus thought to demarcate the realm of civilization from its opposite, the barbarian peoples who preyed on China and sometimes overran it. In fact, in traditional societies, state boundaries were much less fixed and far more permeable than in modern states. Many non-Han (non-Hua–Xia) people lived within the lines of the Qin "long wall" or Ming Great Wall. Likewise Chinese authority was extended beyond those limits from time to time as well. As a cultural divide, the Great Wall was always more myth than reality.

4-3 "Clerical" script
Later Han, 2nd century CE.
Detail of rubbing, Han
"Stone Classics." Institute of
Archaeology, Beijing

kingdoms was gradually reduced, and, moreover, the kings (or "princes") were replaced with sons from the imperial family. Although these kingdoms never altogether disappeared, their real power had been decisively reduced by about 100 BCE. Their actual administration and status came to differ only in name from that of commanderies. Within both commanderies and kingdoms, the next and lowest level of imperial administration was the county, *xian*, still the basic unit in China today, the number and size of which fluctuated in response to growth and shifts in population. In Later (Eastern) Han times there were about 1500 of them. The magistrates who administered these counties were charged with an awesome array of tasks, including population registration, tax collection, public works, and public security. The local, commoner population of the realm interacted with the imperial government by submitting taxes and participating in public works.

The officials who staffed the imperial government, both at the center and in the counties, were drawn from the educated male population. The court instituted various measures to bring men into government service, the most common being a recommendation system in which officials nominated candidates as "filial and incorrupt." Candidates were sent to the capital, where they served for a time as gentlemen attached to the palace before being posted to an office. By the middle of Former Han a state-sponsored Academy had been established at the capital, offering instruction in the "Five Classics": *Book of Documents*, *Book of Poetry*, *Book of Changes*, ritual canons, and *Spring and Autumn Annals*. The number of students in this institution increased in the Later Han period, and the state established a second school late in the second century CE. In 175 CE, the court ordered that authorized versions of the "classics" be carved into stone slabs set up inside the Academy at Luoyang (Henan), capital of the Later Han. These definitive editions were to be used as the basis for all government education and examinations, and they attracted an enormous number of students.

The Han "Stone Classics" survive today both as fragments of stone in various collections and

Structure of the Han Realm

Like the Qin, the Former Han regime was divided into commanderies administered by appointees sent from the imperial capital, Chang'an (Xi'an, Shaanxi). However, the court gave a significant portion of the eastern territories to loyal followers and allies of the founding emperor in the form of "kingdoms," which in principle were practically independent fiefs. Officials served the rulers of these fiefs in a system modeled on the imperial court and owed the imperial court yearly visits and tax revenues. Over the course of the first century of Han rule the number of

as a corpus of rubbings (FIG. 4-3). The principal scholar in charge, Cai Yong (133–192 CE), was a noted calligrapher. His hand may have been the basis for the scribes who wrote out the many thousands of characters. The texts are written in a recently developed script known as "clerical" (li shu). Thoroughly indebted to the use of a brush, this manner of writing takes its name from the clerks who developed it. The extract from the "Stone Classics" illustrates some of its most characteristic features. The traits of regular spacing and characters contained within imaginary boundaries are also found in the small seal script discussed above (see FIG. 4-2). The composition of individual graphs is less symmetrical, however, even when this is encouraged by the structure of the graphs. The main reason for this decreased symmetry is the emphasis on flourishes at the end of strokes. The diagonal stroke moving from top left to bottom right is consistently rendered so that the brush flares. Strokes that terminate at lower left as well as horizontal strokes that end to the right achieved a similar emphasis. These flourishes, which required applying more pressure to spread the brush hairs, show the debt to utilitarian brush writing of the day. The same trait can be seen on Han documents written on bamboo slips found in the northwest and documents from tombs in the heart of the Han realm. The "Stone Classics" were influential for centuries to come, primarily through rubbings. The great calligrapher Wang Xizhi (307–379 CE) was much influenced by them (see FIGS. 5-23 and 5-24 below). Since he lived in the south, he must have studied either careful copies or rubbings.

The Qin and Han Capitals

The Wei River valley had served as the capital of the Western Zhou kings. The Qin appreciated its strategic value when they mounted their sustained offensive against the eastern powers. After 221 BCE, Xianyang grew steadily as imperial projects were pursued on a grand scale and as officials and artisans from throughout the empire congregated around the court. These two processes—imperial commissions and the centripetal attraction of the imperial capital—continued during the Former Han and account for much of the grandeur of Chang'an. Remains from Qin Xianyang are less well known than their Han counterparts. The depredations of the army that overran the region account, in part, for their absence. It is also the result of the shifting course of the Wei River, which moved northward, scouring out areas that had been occupied. By contrast, the site of Han Chang'an was neglected by later ages and never inundated by the river. The Han capital is still reasonably well preserved, its walls and foundations clearly visible even today. Extensive excavations continue on a regular basis.

The overall plan of Xianyang is not completely understood. The greatest concentration of palace foundations known at present is a stretch of high terraces north of the river between modern-day Xianyang (to the west) and modern-day Xi'an (across the river and to the south). It is not certain if this palace district was enclosed by walls, or even if the capital had any proper walls. Xianyang was developed over a period of almost a century and a half, but during the First Emperor's reign major projects were sited to the south of the river. These included the famous Ebang Palace, an enormous structure never completed, the Shanglin imperial park, and the First Emperor's own tomb at Lishan (FIG. 4-4) far to the east. *Historical Records*

4-4 Lishan, tomb of the First Emperor
Tumulus, Lintong, Shaanxi. Qin, late 3rd century BCE

Xi'an Region

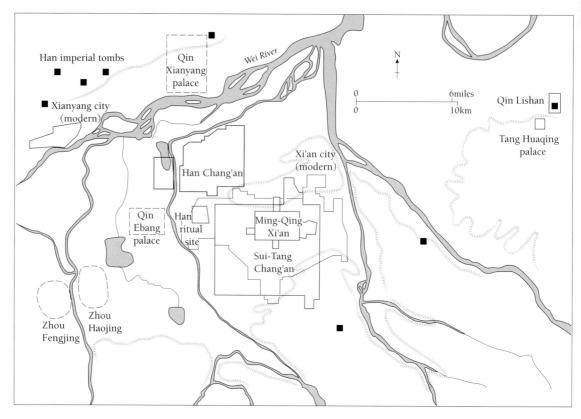

4-5 Plan of Han Chang'an

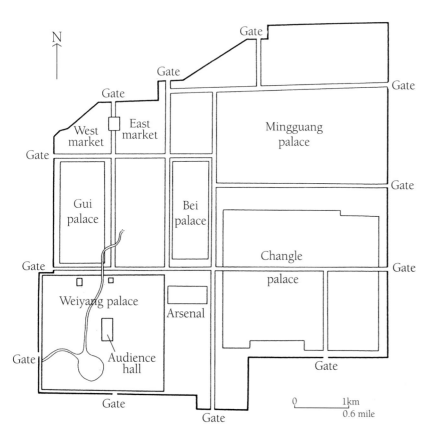

claims that the First Emperor of Qin had hundreds of detached palaces spread around the valley on both sides of the river, connected by highways and bridges spanning the river. Thus the entire area served as the capital district, and mountain ranges at north and south took the place of city walls.

Han Chang'an, located immediately northwest of modern Xi'an, has been surveyed in some detail (FIG. 4-5) and its major structures have been investigated. After some debate, the founding emperor's advisors recommended the continued use of the "land within the passes" as the imperial capital. Planners sited the new city around the remains of a one-time Qin palace, which was renamed the Palace of Everlasting Joy (Changle Gong) and became the residence of the empress. It was flanked on the west by the Eternal Palace (Weiyang Gong), where the reigning emperor held court and lived. Only toward the end of the 190s BCE did concerted efforts begin to erect city walls around the palaces. The position of the two main palaces and the irregular course of a small river on the northwest determined the layout of these walls, each about 3.7 miles (6 km) in length. As a result the shape of the

city is highly irregular: a straight east wall, a south wall that jogs south to enclose the Eternal Palace at the west, a fairly straight west wall only 2.8 miles (4.5 km) in length, and a stair-step north wall parallel to the river. The number of gates, three per wall, was more in keeping with the canonical prescriptions of the "royal city" plan (see "The 'Royal City' Plan," page 93). Each gate had three portals, the center one being reserved for imperial chariots. All roads were twelve chariots wide (four chariots per lane). The city site was lower on the north and higher to the south, where the palaces were located. Chang'an was primarily a "palace city," with little area left within the walls for other purposes. The imperial arsenal was located between the two main palaces, just west of the main north–south artery. Markets were sited inside the northwest corner, and the northwest was also a center for workshops of many kinds. Other important sites were developed outside the walls. A major palace was built to the west of the city within Shanglin Park, which in turn was augmented by a large artificial lake, Kunming Chi. A precinct for ritual structures was also constructed due south of the city. This site was the locus of the Bright Hall, the center of imperial rites. By the time of the first census in 2 CE, the population of Chang'an was between 250,000 and 500,000.

Luoyang, the capital of Later Han, was built on preexisting foundations. The city lies about 9 miles (15 km) east of the modern city of the same name (in Henan). A rectangular city, its long dimension ran from the Luo River in the south to the Mang Mountains in the north. In area the city was only about a third the size of Chang'an. As in Chang'an, palaces occupied a high percentage of the land within the walls. The north and south palaces were not aligned on the same axis, and many other irregularities are evident in the walls, gates, and road grid. As at Chang'an, the practical decisions made by the builders considerably muted the power of the "royal city" prescriptive model. Markets were located outside the city walls. Extensive residential wards adjoined the city on both east and west. A ritual precinct was created south of the city in an area that has since been reclaimed by the Luo River. This was

the location of another Bright Hall, the Spiritual Terrace, and the Academy mentioned above.

Although several important architectural sites at the two capitals have been well studied, their details remain cloudy. The Qin palaces built north of the Wei River were constructed around earthen cores, rather like the mortuary temples of the pre-imperial kings of Zhongshan (see FIG. 3-7 above). This kind of core was also employed for the Spiritual Terrace (Lingtai) at Luoyang. The grandest Han earthen core structure, however, was the audience hall of the Eternal Palace at Chang'an. Its pounded-earth platform extends about 1140 feet (350 m) north–south and is about 490 feet (150 m) wide. The platform rises in three steps from a low terrace on the south to a higher intermediate one and then to an extremely high (49 ft; 15 m) but shallow foundation block at the north. This block carried the main hall of state, which not only overlooked the terraces ascending from the south but also loomed over the northern areas of the city behind. This extensive terrace and core is reminiscent of palace buildings at several of the capitals of the Warring States. More common, however, were structures built on low platforms and thick wall footings made from pounded earth. This construction characterizes several compounds excavated within the Eternal Palace, as well as the arsenal at Chang'an, and an imperial granary located east of the capital at Huayin (Shaanxi). In these buildings, deep wall footings, piers, and low foundation blocks supported timber-frame structures that did not depend on an earthen core. Many aspects of their column grids, walls and doors, paving, and the like can be deduced from the remains unearthed at these sites.

The restorations proposed for the Bright Hall (Ming *tang*) at Chang'an (FIG. 4-6) tell us much about the evidence available but rather less about the realities of imperial architecture. This observation is not meant to disparage the contributions of architectural historians who have synthesized the data. More obviously than in many statements made by scholars, however, their restorations are examples of a chain of assumptions and inferences. Their suggestions are logical, but logic does not guarantee historical accuracy, and in many cases alternative logic is equally

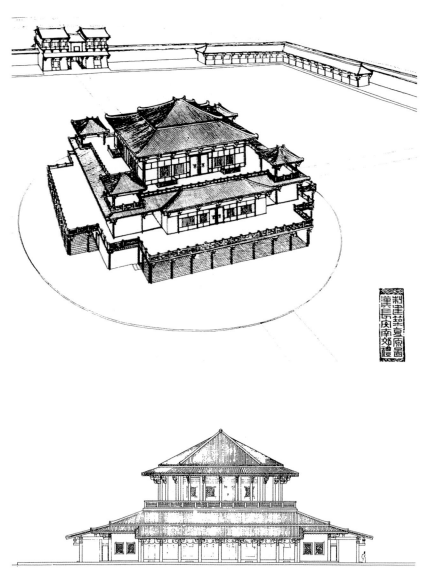

level remain hypothetical. They are derived from a combination of assumptions, such as Han texts and comparative evidence. For the elevations of such structures, we are largely dependent on Han pictorial art and ceramic models. The key differences between the two renderings concern the presence of an intermediate level of chambers and the top-level hall, which could have had either a pyramidal or a conical roof. Since the base of that level was not preserved at the time of excavation, the choice of one over another hinges on other data. (For the symbolism of the Ming *tang*, see page 137 below.)

The only standing architecture that actually survives are several dozen stone monuments—paired towers, *que*—at tomb sites in Henan and Sichuan, most dating from the Later Han. (Three of Former Han date are located near Mount Song, Henan.) In addition, several stone offering shrines survive in Shandong, the best preserved being the Xiaotang Shan shrine and the shrine of Wu Liang. These stone monuments mimic the ordinary architecture of their day in details such as roofs and bracketing. The right tower at the tomb of Gao Yi dated 209 CE in Ya'an County (Sichuan)

4-7 Gao Yi tower, *que*
Ya'an, Sichuan. Later Han, c. 209 CE. Red sandstone, height 19′4″ (5.9 m)

4-6 Bright Hall (Ming tang)
Renderings by Wang Shiren and Yang Hongxun

acceptable. In fact, architectural historians have suggested several variant renderings that reinforce the contingent nature of their projects. The foundation of the Bright Hall was only partially preserved at excavation. A channel dug through the site in Tang times (618–907) had demolished the eastern half. Thus restorations start by assuming that the overall plan was essentially symmetrical and that features noted and measured on the west were repeated on the east. In addition, the top levels were not intact. Much less can be said about any feature above ground level than can be determined about the base. The four ground-level chambers set against the core are known in considerable detail because of paving, column bases, and many other preserved features. On the other hand, renderings of the second (and possible third)

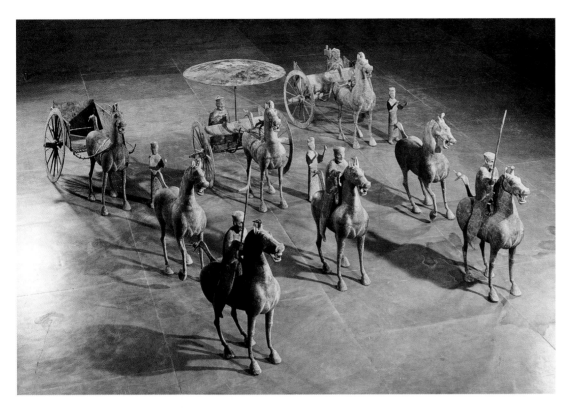

4-8 General's entourage
Later Han, 2nd century CE.
Bronze. Leitai tomb, Wuwei,
Gansu. Gansu Museum,
Lanzhou

Best known for the "Flying
Horse," the tomb at Leitai
held an ensemble of 38
bronze horses, an ox, 14
chariots and carts, 17 spear-
carrying warriors, and 28
attendants on foot, thought
to represent the entourage
of a leading general of the
region, whose tomb they
furnished. In this view, three
files of cavalry with long
pikes lead the procession.

consists of a main pillar with an abutting smaller pillar to one side (FIG. 4-7). Each pillar is surmounted by several tiers of carving that reproduce the interlocked tie beams found at the top of the walls in frame structures, as well as bracket arms and blocks (*dou gong*) designed to carry the eaves. The eaves, roof, and ridges are also carved in stone to imitate tilework. The details of joinery, bracket arms, and ridge ornaments are probably accurate for the architectural vocabulary of the day. This tower rises to almost 20 feet (6 m) in height. The offering shrines in Shandong, best known for the engravings and low reliefs, give us a general idea of the basic elements of a simple gabled building. It is not certain that their heavy proportions are in fact accurate reproductions of timber structures.

Han Society

The emperor and members of the imperial house stood, unchallenged, at the pinnacle of Han-period society. Families that supplied consorts and empresses were often of rather humble status in the Former (Western) Han, but the selection of a daughter benefitted her relations; not surpris-ingly, in Later (Eastern) Han, consort families were generally of high status. In spite of the kingdoms and a large number of marquisates, honorary noble titles with fiefs bestowed on worthy persons by the emperor, there was no large entrenched nobility in Han times that could challenge the imperial house. Sumptuary regulations and social privileges set these high-status persons apart from the great bulk of society. In fact, the tombs of several imperial princes and their consorts have proven to be the richest repositories in all of Han archaeology.

At the top of the commoner classes were scholars and officials. The administration of the Han empire required the services of about 120,000 officials, a number which probably does not include county-level subordinate positions. Officials had special privileges and were exempt from the kinds of punishments administered to the rest of society. With an official position came a fixed income, expressed in bushels of grain but actually given out as a combination of grain and cash. Officials moved about the realm in chariots, and the number of chariots and their types varied in proportion to the rank of the official (FIG. 4-8). A very high-ranking person could command

an entourage of outriders, plus soldiers on foot who cleared the road, and accompanying subordinates in smaller vehicles. While scholars were in effect "officials in waiting," they nonetheless could be quite poor. Many famous scholars at some point worked with their hands to support themselves. The close connection between scholarly activities and official position helped bolster the prestige of scholars, and through an official appointment they could achieve financial security or even great wealth.

In theory, the other commoner classes were ranked in descending order as farmers, artisans, and merchants. This conventional pecking order comes from Confucian admonitions that agriculture fulfills a primary need of society and that the suppliers of food should be honored. On the other hand, since mental work was valued over manual labor, farmers could never be part of the elite. Surely the great majority of the 50–60 million Han population were engaged in agriculture and living in rural communities. Artisans, while esteemed to some degree for their work, were not given much status. They might be independent producers or work within state-operated factories. Many laborers in these state shops were either soldiers or slaves. Merchants, the least esteemed social class, had become

increasingly influential during the Warring States era. Their lack of social prestige was offset by the considerable wealth many amassed. Indeed some scholar–officials made fortunes as merchants, any qualms about merchant status overcome, it would seem, by the appeal of rewards. Farmers, the most honored segment of society, were often impoverished, while low-status merchants enjoyed great wealth and large land holdings. Thus the economic realities of the time were often at odds with social norms.

High-ranking officials, both civil and military, could become large land owners. The growth of powerful local families with extensive lands and large numbers of dependent laborers reached a peak in the Later Han. Their manors or estates are depicted frequently both in tomb paintings and in ceramic models. An estate was both a manor house for its lord and a defensible outpost if bandits or "barbarians" threatened. Many estates had "guests" or private armies who were supported by the lord to provide security.

Picturing Elite Life

By Later Han times we have extensive pictorial evidence of elite life. No wall paintings survive from the Han period except those made for tomb decoration or deposited in a tomb among grave goods. It is our assumption here that these works share at least a common pictorial vocabulary with murals and other formats in everyday life. At the same time, we should not assume that the limitations of tomb art are also those of Han art generally. Tomb 3 at Mawangdui (Changsha, Hunan) contained a great collection of manuscripts written out on silk, as well as several maps and various charts or diagrams (see "The Land of Silk," page 131, for further discussion of the silk objects found in the Mawangdui tombs). At present these are the only extant examples of these important categories of pictorial art. The qualities found in these illustrated texts are identical to the silk wall hangings mounted on the walls of the burial chamber that served in effect as murals. In this instance, there seems to be no appreciable difference between works made for the living and those painted for the tomb. The

4-9 Entertainers
Later Han, 2nd century CE. Rubbing from impressed brick, 15¾ × 18¾" (40 × 48 cm). Chengdu, Sichuan. Chengdu Museum

energy and expertise invested in tomb decoration, however, must often have fallen below the level expected from artisans enlisted to paint in a palace.

Pictorial decoration within tombs dates to no earlier than the first century BCE (see FIG. 4-21 below), and most examples are found in burials of metropolitan officials at Luoyang. These early paintings are executed on the smooth surfaces of large hollow bricks used for tomb chambers. Lintels and pediment bricks are the favored locations for decoration. Tomb structures changed to small bricks and vaulted construction by the end of the Former Han, and the painting process was altered accordingly. A plaster ground spread over these bricks then became the surface on which painting was produced, as in the Holingol tomb below (see FIG. 4-11). At much the same time, in regions where stone was favored as a building material, such as southern Henan, northern Shaanxi, and parts of Shandong and Jiangsu, artisans cut low reliefs into the blocks used for jambs, lintels, pediments, door panels, and the like.

Some of the most accomplished pictorial designs from the Han are actually close analogs to true painting: impressed bricks placed in the walls of tombs constructed during the second century CE in the Sichuan basin. Better regarded as tiles, since they are flat rectangular slabs of clay, they generally measure about 10–15 by 15–20 inches (25–38 cm by 38–50 cm). Artisans carved boards in intaglio to produce the designs. A clay slab was then impressed onto the board which served as a draw mold, peeled from the mold, and fired. The virtue of these impressed designs is that they survive intact and can produce accurate rubbings (see FIG. 4-9). Since these tiles were first collected and published in the 1940s, art historians have used them both as evidence for pictorial art and for their wide-ranging content. In spite of several dozen painted tombs more recently published, none can yet match the range of subject matter and fine condition of the best tiles.

The subjects illustrated cover many aspects of Han life: seasonal activities of rural society, chariot processions of officials and wealthy land owners, feasting and entertainments suitable for a grand household, the architectural environment, mythological figures, and didactic narratives. A scene of entertainment is typical of many compositions with its carefully constructed groupings, lively activities, and attention to detail (FIG. 4-9). On the left, two pairs of seated figures sit on low couches: the two men at lower left hold panpipes to their mouths, while the man and woman above could be spectators or additional musicians. Four performers seem to be displaying their talents on the right: male and female dancers facing each other at the bottom and two male jugglers at the top. Except for the duplicated panpipe players, each figure in this scene is different from the others, and each epitomizes a characteristic activity. The juggler at top right balances a vase on his elbow while brandishing a long sword at a ball in mid-air. The female dancer at lower right swirls her long sleeves and rotates her head and body while moving further right. The scene is animated and full of entertaining detail. The elements are also evenly disposed across the rectangular tile with plenty of open surface separating the figures and their props. The kinds of performances shown were known in Han times as the "hundred entertainments" or "sundry shows." Like depictions of farming on painted bricks from Jiayu Guan (Gansu), they introduce the experiences of common folk and suggest something of the richness of Han popular culture.

Ceramic figurines also illustrate the life-style of the wealthy by representing their household staff. One of the most accomplished figurines from Sichuan is a performer caught in a vibrant moment (FIG. 4-10). The bare chest and baggy trousers are typical of entertainers, also seen in tiles. He sways forward as he energetically strikes the small drum held in his left hand. For such a heavy-set figure, he is remarkably limber. His open mouth and furrowed forehead suggest he is calling out or singing. Such performers were gifted at both singing and storytelling. Many other occupations are included among Han figurines, but most are more generic renderings

4-10 Singer with drum
Later Han, 2nd century CE. Earthenware, height 26¼" (67 cm). Pi County, Sichuan. Sichuan Museum, Chengdu

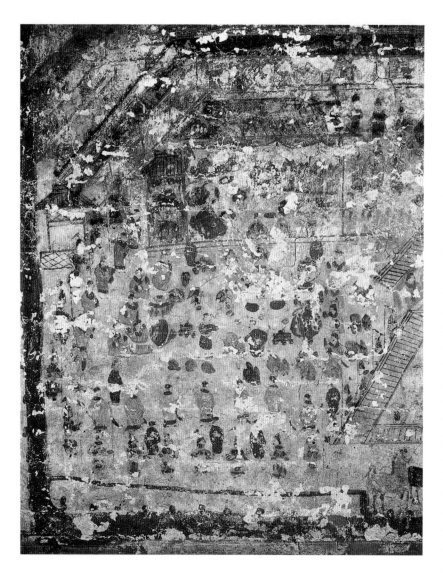

4-11 Commandant's headquarters at Ningcheng
Detail of wall painting, tomb at Holingol, Inner Mongolia. Later Han, 2nd century CE

of standing and kneeling attendants that functioned well enough without such active poses. Produced in two-part molds, they are generally distinguished only by the treatment of their limbs, which could be modified while the clay was soft.

A number of brick-chamber tombs with fine wall paintings attributed to Later Han grandees have been excavated, especially around Luoyang and in Hebei (such as Wangdu and Anping). These paintings depict the official staff of the deceased, as at Wangdu, or the chariot processions that were a perquisite of his rank, as at Anping. The latter tomb even contains a "portrait" of the deceased in the rear chamber (see FIG. 4-22 below). But a tomb at Holingol (in Chinese: Helinge'er) in Inner Mongolia, while less impressive for the quality of its painting, is notable for its subject matter

(FIG. 4-11). The paintings on the ceilings of the front chamber chronicle the official career of the deceased. This "biography" begins on the west ceiling with a single chariot and the cartouche "raised as filial and incorrupt" in clerical script. This marks the man's initial recommendation as a candidate for official position. At the time, the minimum age was forty, and only one candidate from each commandery could be recommended in each three-year period. The middle of the vault includes a chariot with the inscription "gentleman," probably an abbreviation for Gentleman of the Palace, a post at court in Luoyang that paid 300 bushels. This was the most common initial appointment, usually for a minimum of three years as a member of the imperial bodyguard. Another group of chariots at the left end of this panel includes the inscription "Chief Clerk of He Xi," a region west of the Yellow River in modern-day Shaanxi. This post, which paid 600 bushels, was subordinate to the commandery's governor. A related painting in the tomb's middle chamber shows the headquarters of the commandery at Lishi (modern Lishi, Shanxi). In contrast to the chaotic groups of riders and chariots moving in all directions seen on the west ceiling, the south vault shows a large field with many chariots moving right to left, accompanied by outriders. The cartouche reads "Acting Chief Commandant of Shang commandery dependent state." This was a temporary position with military duties that paid 2000 bushels. Here the entire company of mounted figures and several chariots represents the commandant's entourage. The east vault, by contrast, bears the inscription "Magistrate of Fanyang," a county-level position in northeastern Henan. After a series of frontier military posts, the official was placed in charge of civil administration of a peaceful, interior locality. The salary for this post was 600–1000 bushels of grain, and his perquisites were also reduced.

The climax of this man's career was his appointment as "Colonel-Protector of the Wuhuan carrying a staff of authority." This was once again a frontier post dealing with a non-Han people. An extensive chariot and cavalry entourage is painted on the north ceiling vault, a prominent position immediately visible upon entering the tomb.

The Land of Silk

In the Mediterranean world of the first century CE, the "Seres" were known as a people living at the far ends of the earth. They produced silk, a textile much in demand among Roman consumers. China thus comes into view in the Eurocentric world as the source of a rare and valuable commodity obtained by overland or seaborne trade over immense distances. Unlike the better known Indian subcontinent, ideas about China changed little until the great land travelers of the late Middle Ages, such as Marco Polo. For much of that time, the Chinese had a virtual monopoly on the production of silk. Silk weaving in particular reached great heights during the early empire. The silks that went west were the products of an advanced weaving technology without parallel in the world at that time.

Silk is the natural filament extruded by the silk worm (*Bombyx mori*) for its cocoon. Silkworms had been domesticated in China in early times, probably prior to the Shang. The worms were killed before emerging from the cocoon by drying in sunlight or by steaming—processes which also weaken the sticky gum (sericin) that holds the coiled filament together. Perhaps the most extraordinary feature of these filaments is their length, as much as 2600–3250 feet (800–1000 m) each. This silk is also amazingly fine and extremely strong. Measured in *mu*-diameters (0.001 mm), a filament is only 20–30 *mu* (0.020–030 mm). Thread was made by reeling filaments together. The silk weaves of the Han period utilized many different structures of warp (vertical) and weft (horizontal) threads

woven on treadle looms. Plain weaves such as tabby or taffeta have roughly equal numbers of lengthwise (warp) threads and threads carried by the shuttle (weft), usually 50–60 per cm. A much looser gauze will have only 20–25 threads per cm. More complicated fabrics such as damask and brocade necessitated separating specific arrays of warp threads in order to weave the weft-thread patterns. This kind of work requires a draw loom, but the date of this invention in China is not certain. Late Zhou textiles from Jiangling (see FIG. 3-10 above) are evidence of such a loom. Many Han-period textiles are monochromes with woven patterns. Others are polychromes, some woven, others with printed or even painted patterns.

The tombs at Mawangdui (Changsha, Hunan) held the possessions and grave goods of a marquis, his wife, and son, all buried in the first part of the second century BCE. Their riches are featured throughout this chapter. They contained an extensive selection of silk textiles (forty-six rolls in Tomb I alone): plain-weave silk, gauze, monochrome damask, complex gauze, polychrome "brocade," and embroideries. A pair of mittens from Tomb I (FIG. 4-12) was sewn from two kinds of plain-weave silk and then decorated in chain-stitch embroidery with designs of flying birds. Many robes were made of an unlined, sheer gauze suitable for the hot climate of Hunan. Silk pillows, sachets, and covers for lacquered boxes, musical instruments, and other personal possessions were also present. Both the lady interred in Tomb I and her son in Tomb 3 were dressed in multiple

4-12 Mittens
Former Han, 2nd century BCE. Silk with embroidery, length 9¾″ (24.8 cm). Mawangdui Tomb I, Changsha, Hunan. Hunan Museum, Changsha

garments and then wrapped in several layers of shrouds prior to their placement in the coffin. Both tombs also contained banner paintings on silk (see FIG. 4-24).

Silk of the Han period has been recovered from many sites outside China proper. In addition to the tombs of colonists in the northern Korean peninsula, Han silks are known from sites on both the southern and northern fringes of the Tarim Basin (modern-day Xinjiang Autonomous Region). They are also reported from sites in Mongolia (Noin-ula), Russia, and even Palmyra (Syria). Although the term "Silk Road"—designating the land routes across Central Asia—was coined only in the late nineteenth century by the German geographer Ferdinand von Richthofen, the Han knew about the peoples living in the far west through trade and the military expeditions carried out during the reign of Emperor Wu.

The colonel's headquarters were located in modern Huailai (Hebei; see FIG. 4-11), but the territory over which he presided included a major horse market at Ningcheng and perhaps even the territory where the tomb itself was located. This post paid 2000 bushels once again. Many subordinates are shown in this painting, including clerks in charge of several bureaus and aides-de-camp. These four ceilings and the related wall panels comprise the oldest extant Chinese pictorial biography. Using a series of chariot processions as he ascends the official ladder of success, the work summarizes the official's career, from the time of his initial recommendation to his highest post. Each step up is noted by inscriptions. The probable dates of this official can be estimated as between 140 and 220 CE.

COURT PATRONAGE AND LUXURY ARTS

The Former Han was an era of economic recovery and growing prosperity. Tax rates on farmers were reduced to a modest level, and the commercial and manufacturing economies flourished. Although the campaigns of Emperor Wu (r. 140–87 BCE) became a costly burden, the realm was able to sustain them by interventionist policies that targeted commerce and manufacturing as sources of state revenue. Statesmen debated the role of the government in the economy, most famously in the *Debates on Salt and Iron* (*Yan tie lun*, c. 81 BCE). This account of a court conference provides a glimpse into the economic thinking of the time, especially positive and negative attitudes toward the state's role in the economy and the consumption characteristic of Han society. In spite of changes from one reign to another, the state generally played a major role in the economy. Indeed, state-controlled offices administered most of the projects and categories of production featured in this chapter.

At court several offices were directly concerned with projects on behalf of the emperor. The Lesser Treasury, led by one of the nine ministers who managed the central government, was in charge of collecting revenue for the emperor and of managing all the goods and services needed to sustain his court. The revenues available to the emperor included taxes on natural products of the mountains, oceans, rivers, lakes, forests, and marshes (such as fish and timber), as well as on merchants, and tribute in gold offered by the kingdoms and marquisates. The Lesser Treasury supervised an elaborate secretariat, as well as the harem and eunuchs of the inner court, the court physician, the kitchens, and the offices engaged in specialized production. For example, two Weaving Offices were responsible for preparing the imperial wardrobe. The Office for Manufactures produced all kinds of useful objects, including weapons. The Office for Arts and Crafts created luxury goods of many kinds, some of which are discussed below. The court established a separate agency, the Artisans of the Eastern Garden, to manufacture furnishings necessary for imperial burials. Imperial construction projects—such as palaces, temples, tombs, and parks—were in the hands of the Court Architect. His office was staffed by subordinates who controlled bureaus for acquiring and working stone, timber, and other building materials. Captains, who managed the large labor forces employed in such projects, also served the Court Architect. These workers included soldiers, corvée labor, convicts, and even government slaves. Chang'an and Luoyang were the centers of much economic production on behalf of the court. The volume of that output and the scope of other court projects must have had an immense impact on the economies of those two regions.

In addition, the government administered workshops dedicated to specialized production. The most famous were forty-eight iron workshops and thirty-six salt workshops established in the commanderies. By this time, iron was an essential ingredient in many aspects of life, most especially agricultural and industrial tools. Archaeologists have uncovered state iron workshops that produced farming implements by complex multiple-mold assemblies at several sites in Henan. It has been suggested that the volume of iron production during the Han period was far greater than that in Rome at the same time; indeed European economies reached comparable

levels of production only during the Industrial Revolution. Salt, while sold by the state, was actually made by private producers licensed by the government. Revenues from these two workshop systems went to the imperial treasury, not the emperor's own purse. Other workshops included ones for gold production in Guiyang, lacquer and precious metals in Sichuan, and silk in Shandong and Henan. These workshops in many cases grew from local centers first developed during the Warring States era. Government administration thus integrated their production into the national economy in a way that profited the state and the needs of the court.

Objects produced at official workshops generally bear stamps or marks designating where they were made. Some objects, especially lacquer wares and metal vessels, have lengthy inscriptions that detail their manufacture. This inscription was taken from a lacquer cup:

> In the third year of the Yuanshi reign period [3 CE], the Guanghan Commandery official workshop manufactured this *chenyu* lacquered, incised, painted, wood-core cup with gilt handle, with a capacity of one *sheng*, sixteen *yue*. Manufactured by the core-maker artisan Chang, the lacquer artisan Li, the lacquer artisan Jie, the gilding artisan Chang, the painter Fang, the polisher Ping, the inspector Kuang, and the foreman Zhong. Overseen by supervisor Hui, chief Yin, assistant Feng, executive officer Lin, and clerk Tan.
>
> (Wang, *Han Civilization*, p. 86)

This kind of inscription gives a full bill of particulars, from the date and place of manufacture to the object's capacity. Each artisan involved in its production is listed by surname. Other inscribed objects suggest that these families served in such roles for generations. Petty officials supervising the workshop are also specified. These inscriptions provide the first significant collection of specific names linked to the production of arts and crafts; nothing similar is available for production prior to the early imperial era. Although we customarily think of these crafts as "anonymous," in its own time this cup was designated as the product of the skilled labor of a particular shop and

its staff. The real motivation behind such inscriptions was to assign responsibility and to control quality. After all, a large percentage of the output of this Guanghan lacquer workshop was destined for court consumption.

Lacquer Wares, Metalwork, and Jade

Denizens of the Han capitals and wealthy land owners ensconced in their rural manors enjoyed a deluxe life-style that rivaled that of the nobility of the Warring States period. Sumptuary norms restricted certain kinds of buildings, chariots, banners, and wardrobe to members of the imperial court and the highest officials. And as in the Eastern Zhou period, there was a sharp break, visible in every detail, between the elite and the bulk of the population. The silk robes of an official contrasted with the homespun or paper garments of a corvée laborer or peasant working in the fields. Wealth gave access to all manner of luxury goods, and their production and consumption were significant to the Han economy. Well-furnished tombs, like the two preserved at Mawangdui (Hunan), are quite literally catalogues of the material culture of the elite and of the kinds of goods they enjoyed in life. The Lady of Dai, interred in Tomb 1 at Mawangdui, was the wife of a marquis. Although he was posted to the kingdom of Changsha (modern Hunan), her husband's home fief and economic base was to the north, in southern Henan. The grave goods found in her tomb, especially the extensive selection of lacquer wares, suggest the real wealth at the disposal of a local notable.

Ubiquitous in elite Han-period tombs, lacquer wares represent a continuation of the regional industries that had flourished in Qi (Shandong), Chu (Hubei–Hunan–Anhui), and Shu (Sichuan). (See "Making Lacquer Wares," page 98.) Many lacquer wares from the Mawangdui tombs bear stamps identifying them as products of state factories in Sichuan. Local production must have continued as well, however, and the heavy lacquered coffins of the Mawangdui tombs were probably made locally (see FIG. 4-16 for detail). Lacquer ware was extremely costly and labor-intensive. One of the protagonists in the "Salt and

4-13 Wine vessel, *zhong*
Former Han, 2nd century
BCE. Lacquer, height 22½″
(57 cm). Mawangdui Tomb
3, Changsha, Hunan. Hunan
Museum, Changsha

Iron" court debate of 81 BCE claimed that "a painted lacquered cup was worth ten bronze cups" and that "a lacquered cup required the labor of one hundred artisans and a lacquered screen that of ten thousand hands." Against such claims, no doubt exaggerated for rhetorical effect, consider the one hundred and eighty-four lacquer objects in Mawangdui Tomb 1. The Lady of Dai was given a ritual service of seven *ding* tripods, four square wine vessels, two round wine vessels, and four covered boxes. In addition she had an extensive food and wine service including: two large tray-tables, eight cylindrical cups, forty "ear" cups, fifty food cups, thirty saucers, two round trays, six bowls, and two ewers. In addition, three food and cosmetic boxes and two pieces of lacquered wooden furniture—an arm rest and screen —filled out her grave goods. Many pieces were inscribed with the name of the Marquis of Dai.

Most of the lacquer vessels in Tomb 1 have a black ground with red designs. The round wine vessel, *zhong* (FIG. 4-13), is typical, one of a pair, each about 24 inches (60 cm) in height. The core is wood turned on a rotary cutting tool. The interior is covered by cinnabar red, while the exterior has a black ground. Painted red bands

**4-14 Rhino-shaped
vessel**
Former Han, 2nd century
BCE. Bronze, length 22⅞″ (58
cm). Maoling, Xingping
County, Shaanxi. National
Museum of History, Beijing

demarcate ring foot, body, and neck. Scroll or cloudlike motifs decorate each register in turn. The domical lid, also solid wood, is similarly painted. It has three painted yellow knobs, imitating the gilt fittings found on bronze vessels. This *zhong* lacks the kind of lengthy inscription cited above, perhaps because it was not destined for an imperial consumer. Produced as one of a pair, the *zhong* is also consistent in materials and style with the seven *ding* and four square-section wine containers, *fang*, from the ritual service. All must have issued from the same workshop.

Like silk and lacquer, bronze production flourished in the Qin and Han periods, but increasingly was aimed at secular uses. The great contrast, however, is in the decline of the large sets of ritual vessels that dominated earlier periods. The wealthiest of Han patrons, such as the Prince of Zhongshan buried at Mancheng (Hebei) or the King of Nanyue buried in Canton or Guangzhou (Guangdong), had bronze bells, bronze and iron weapons, and many kitchen vessels of bronze, but only the King of Nanyue—ruler of a vassal state—had the sets of bronze tripods and wine containers akin to those of a late Zhou lord. In the Former Han period, sets of ritual vessels found in tombs typically consist of *ding* tripods, *he* covered boxes, and *fang* or *zhong* wine vessels, but these are normally made of ceramic and presumably therefore were burial goods. (The lacquer vessels found in the Mawangdui tombs could not have served the original functions their shapes imply: a lacquer *ding* could not cook meat over a bed of coals.) Bronze vessels for use in the kitchen and larder, and for elegant service in the palace, on the other hand, are ubiquitous in Han burials and perpetuate many of the techniques of decoration noted in chapter 3. Inlaid metal and stone, glass paste, relief decoration, and undecorated types are all in evidence. One important new technique of decoration is flash gilding. In this process, intense heat bonded gold powder to the surface of a vessel using mercury. The mercury made the procedure a dangerous, even deadly, one. (Only a few Han objects are actually made from cast or hammered gold.)

Both the court bureaus supporting the emperor and regional workshops manufactured bronze

goods. In addition, inscriptions on vessels and references to wealthy merchants in historical sources sketch the workings of private workshops that sold their goods on the market. A number of the kitchen vessels from the Mancheng tombs were actually purchased in Luoyang from private vendors. Even some production for the imperial court, as indicated by the phrase *chenyu* found in the lengthy inscription quoted above, found its way onto the market. Lacquerware cups from local officials' graves in such outposts as Lelang (Korea) and Gansu bear this phrase. Rather than imagine these as imperial gifts bestowed on the officials, it is more probable that official workshops on occasion sold off some of their excess product.

Extraordinary objects transcend their practical functions. A large rhinoceros-shaped vessel found in an earthenware crock near the tomb of Emperor Wu (the Maoling) is a *tour de force* (FIG. 4-14). The vessel serves well enough as a pouring device when standing on the animal's four legs, holding liquid, presumably wine, in its ample belly. The server would dispense its contents through a small, cigarlike spout in the proper left jaw. A hinged lid on the back was made to look like a saddle. Cast as one piece, the rhinoceros also bears traces of gold-inlay cloud patterns on its skin. With its stocky legs, the animal rests confidently in an alert attitude, head cocked, neck folds rippling. The haunches and torso suggest real weight and powerful muscles under the skin. One can imagine the exclamations when a servant appeared holding the rhinoceros with an evening's wine course. This rhinoceros

4-15 Drinking cup
Former Han, 2nd century BCE. Nephrite, length 7¼" (18.4 cm). Tomb of King of Nanyue, Guangzhou, Guangdong. Tomb of King of Nanyue Museum, Guangzhou

is simultaneously a sculpture and a practical vessel, a combination of natural description and practical function, a carefully described real animal and a surface for decorative designs.

By Han times, jade had manifold associations, with many traditions of use and craft. Jade objects such as garment hooks, seals, and cups were common among personal accessories and adornment. Jades played an important role in burial, culminating in the jade shrouds of the Han imperial princes and princesses (see FIG. 4-23 below). Imperial ritual also employed jades as tokens to be manipulated in such ceremonial precincts as the Bright Hall. From the time of Emperor Wu (r. 140–87 BCE) onward, the Han armies sometimes occupied and controlled portions of the Tarim Basin and the Kunlun and Tianshan ranges where boulders of nephrite were found. Most Han jade carvings are true nephrite, most of it presumed to be from Xinjiang.

Many of the finest pieces recovered from the Mancheng tombs and the tomb of the King of Nanyue (both late second century BCE) exhibit material and workmanship nearly identical to that associated with the late Zhou site of Jincun (Luoyang). The disk, *bi*, now in Kansas City (see FIG. 3-13 above) has a traditional provenance of Jincun and presumably a late Zhou date. Several *bi* from Mancheng (FIG. 4-1) and Canton or Guangzhou must have emanated from the same shop working at the same time. The Mancheng disk shown here carries a pair of addorsed dragons or felines of the same "species" as the two rampant animals on the perimeter of the example now in Kansas City. In the Mancheng disk, however, they are held in check by lengthened bodies that establish a central crest rising above their heads, its height almost equal to the diameter of the disk. It is enlivened by many cut-away passages and incised lines. By contrast with the Kansas City *bi*, this disk is a single field of raised curls in regular rows, without a twisted animal holding a smaller inner ring in place. The color of the stone, the shaping of such details as animal jaws, and the treatment of the field of plastic curls all suggest that these works share a common origin. Further examples from the Nanyue tomb can

be cited. Some Former Han jades could actually be heirlooms. One can also imagine that an imperial jade workshop employing some of the same late Zhou families of artisans was still in production in the second century BCE. Jades found in the Mancheng tombs certainly emanated from capital workshops or other imperial factories. Those found in the tomb of the King of Nanyue could well derive from the same workshops if they were gifts from the Han court. Ritual texts of the imperial era claim the *bi* was the symbol of Heaven, conceived as round in Warring States and Han cosmology. Adding dragons to such disks asserted an imperial association, since by this time it was the emblematic imperial creature.

Jade as a luxury commodity is well represented in the tomb of the King of Nanyue (FIG. 4-15), perhaps the richest collection of jades from the Former Han period. An independent kingdom until 111 BCE, Canton was ruled by a line of northerners who took control of this region at the fall of Qin. Sufficiently strong to resist Han force, Nanyue had formal relations with the imperial court at Chang'an and exchanged emissaries and gifts. Thus many of the goods found in this unlooted tomb may have been produced in imperial Han workshops. The drinking cup could be among items offered to Zhao Mei, the second Nanyue king, who died c. 122 BCE. The cup is only some 7.5 inches (19 cm) in length and 2–2.5 inches (5–6 cm) in diameter at its mouth. The horn-shaped body ends in a split "tail" with a symmetrical curl to each side. Incised lines augment ridges on the tails and relief on the body. This is not a rhyton, an animal or human head (compare a Tang example, FIG. 6-37 below), but rather an elaboration of a horn. Easily grasped, the cup cannot hold liquid without a support. One should imagine it had a metal or lacquerware stand.

IMPERIAL IDEOLOGY AND WORLD VIEW

For a discussion of Qin–Han ideology and world view, explicit literary and visual statements amplify one other. Nonetheless, it is important to

remember the scope of various belief systems: their temporal, regional, and social limits. These generalities should not be assumed to have been unchallenged or to apply to all social groups, even if many were granted orthodox status by the imperial institution.

The Emperor

At the center of the world and at the pinnacle of human society stood the emperor, *huangdi*, a social class of one. In adopting this term, the First Emperor of Qin linked two ideas: the fabled "Three August Ones and Five Sovereigns" (*san huang wu di*) who reigned in antiquity, and supernatural powers (*di*) already the object of sacrifices in the Qin state. Thus a new term for a new role also recapitulated several ancient strains of thought. The ideal of the "Son of Heaven" (*Tian zi*), received from the Zhou, brought with it the notion of a charge or mandate bestowed by this impersonal power on a man of virtue. The First Emperor, as shown in his stone inscriptions (see FIG. 4-2), was convinced that his right to rule came from the might he possessed more than from a benediction of Heaven. In Han times, however, the role of Heaven's mandate as sanction became increasingly important. The emperor's position became integral to the structure and functioning of the natural world. His ritual duties played a key role in the maintenance of both natural processes and human welfare. In spite of a series of weak boy emperors, both in late Former Han and in Later Han, the institution was firmly established.

The physical shape and structure of the world as described by Han-period writers was interpreted according to several competing theories. Whatever the overall metaphor—a "dome of Heaven" or a yolk in an egg—Heaven was round and Earth square. The human realm was a land mass surrounded by water, and it in turn had both central and fringe zones. The Han empire occupied the center (as the "middle kingdom"), but no competing civilization coexisted with it. The margins were known imperfectly as the territories of bizarre peoples and strange creatures. Those nearest naturally tended to gravitate toward the center to submit to the Son of Heaven. The world was further understood as split into three fundamental components: Heaven, humankind, and Earth. Heaven presided over the human and natural worlds just as the emperor ruled human society. All under Heaven belonged to the emperor, who owed his position to Heaven's mandate and who ritually served Heaven and human society. These concepts—tripartite hierarchy, round and square, and centrality—were literally figured in the overall design of the Bright Hall for which alternative restorations were described (see FIG. 4-6 above). Whether it had two or three levels, its vertical divisions could be equated to the tripartite Heaven–humankind–Earth scheme. As a square yard surrounded by a round water course, it also epitomized the physical shape of the world. With its central and four directional chambers, it incorporated additional symbolic associations with the four cardinal directions and center, which correlated in turn with the "Five Phases" (*wu xing*). The walls of the four outer chambers were in fact painted with colors associated with each direction: east green, south red, west white, and north black. (Yellow, the color of the center, is not verified.) The round tiles that lined the eaves, moreover, carried relief designs of the numinous or divine creatures of each direction, color, and phase: east–green–dragon–wood; south–red–phoenix–fire; west–white–tiger–metal; and north–black–tortoise and snake–water. (The phase of the center was "earth," but a symbolical animal was not established for this direction.) Han texts suggest that the emperor came to each ritual chamber in its season for offerings to the powers, robed in regalia of suitable color and motif, and bearing ritual tokens. The *bi* disk from Mancheng (see FIG. 4-1), itself the shape of Heaven, may represent such a token.

The imperial court employed a considerable bureaucracy to monitor the workings of the world. They did so on the theory that both natural phenomena (stars, eclipses, the winds, and "ethers") and unnatural ones (omens and portents such as prodigies and disasters) relayed Heaven's evaluation of the ruling emperor. The Spiritual Terrace at Luoyang was the headquarters of court astronomers and astrologers. Their detailed observations catalogued eclipses, constellations, comets,

4-16 Detail of red-ground coffin
Former Han, after 168 BCE. Mawangdui Tomb 1, Changsha, Hunan. Hunan Museum, Changsha

and sun spots. Such records are preserved in the dynastic treatises and even in texts from Mawangdui. Omens and portents were also a subject for Han art. Auspicious beasts were depicted in paintings, reliefs, and other media (see FIGS. 4-16 and 4-25). For example, the animals depicted on the faces of the red inner coffin of Mawangdui Tomb 1 include tigers, dragons, horned animals, intertwined dragons, and an ensemble of four creatures with dragons: a winged immortal, long-tailed bird, feline, and white deer. This coffin, like its black mate, is among the pinnacles of extant Han lacquer painting. The horned and hoofed creatures on the end panel (FIG. 4-16) are drawn in a modified profile with heads turned in a three-quarter pose. Paired at each top corner of a square field defined by the border, they are nonetheless not identical, nor is the pulsating

ether that courses under and around their air-borne bodies. This ether or cloud matter is tied into the more regularized scrolls of the border bands. The creatures flank a central triangular form sometimes interpreted as a reference to a magic mountain such as Kunlun, the abode of the Queen Mother of the West. Like lacquer wares from Mawangdui, this is an art that blends description of real and imaginary creatures with a pervasive cosmic breath to exploit their decorative potential. That blend epitomizes Former Han compositions more generally, as we will see below (FIGS. 4-21 and 4-24). Illustrated portents are also found in Later Han reliefs. Scholars have recognized and studied the stone slabs associated with the shrine of Wu Liang (Jiaxiang, Shandong) since the Song period (960–1279).

The Tomb of the First Emperor

Although the future First Emperor became King of Qin in 246 BCE, he was then a minor and only achieved effective power in 238. Work on his tomb, called Lishan (see FIG. 4-4 above) after the nearby mountains, must have begun shortly after his accession and continued in several phases under the direction of his chancellors, Lu Buwei and Li Si. The emperor selected a site on the eastern edge of the capital district, near the tombs of his grandfather and father. The most active phase of construction probably began after unification in 221. At that period a massive force of military, corvée, and convict laborers worked both at the Ebang Palace and the Lishan site. The so-called underground army was most probably created during this phase. The final stage of work commenced after the emperor's death in 210 but must have been cut short by the rapidly deteriorating military situation. This monument has never been "lost"; its existence has always been known within China. Placed on the main route approaching Chang'an (Xi'an) from the east, generations of scholars have remarked on the site, and a considerable lore has developed about it. Contemporary attention dates from the extraordinary discoveries in 1974–1975 of three large trenches, some 3900 feet (1200 m) east of the tomb, containing life-size terra-cotta warriors.

The plan of the First Emperor's necropolis summarized the major traditions of burial current in the late Zhou era and was to become a model for Han and subsequent emperors. The site was a felicitous natural setting, sheltered by mountains on the south and drained by the Wei River to the north. The burial is a single tomb precinct of enormous scale, a plan that valorizes the First Emperor's unique status in his day and in history. Unlike the lords of Zhongshan, who were buried within a common precinct (see FIG. 3-7), the First Emperor was isolated in death much as he had been in life. The precinct is a long rectangle nearly 1.2 miles north–south by 0.6 miles wide (2 km by 1 km), with a smaller rectangular inner wall. It was oriented to face east and west, with gates for access from either direction. The pounded-earth mound dominated the southern half of the inner walled area. The mound today is about 1100 feet (350 m) square, with four distinct sides, two steps in its profile, and a flattened top about 80 by 33 feet (25 by 10 m). The height has been much disputed; the best current measurement is almost 250 feet (76 m). It seems unlikely that any structures were erected on the mound. However, the northern half of the inner walled area was subdivided into zones for structures and associated burials. These halls were most probably chambers for sacrifices and support services. Additional burials and pits were arrayed in several zones inside and outside the walls.

The underground components of the tomb are hinted at in several texts, but only a few details have been determined so far through actual probing and survey. The main chamber seems to have had a rectangular shape, 1500 by 1280 feet (460 by 390 m), with unfired-brick walls about 13 feet (4 m) high and thick. It may reach to a depth of more than 96 feet (30 m) below ground level. Several ramps lead into this chamber area, and there are five doors on the east, which may therefore be considered the proper approach. Details of the structure and plan are unknown, but a multiroom chamber of large timbers and stone construction is certainly possible. Textual accounts mention a sky map (painted?) on the ceiling and a topographical map (modeled?) on the floor with circulating mercury representing the waters of the earth. A geophysical survey in the 1980s determined that there were in fact unnaturally large concentrations of mercury under the mound.

Until the recent excavations at Lishan, artifacts directly associated with the First Emperor were limited to the many weights, measures, and weapons from his reign and the several stone inscriptions commemorating his peregrinations (see FIG. 4-2). Two chariots of bronze (FIG. 4-17) probably best represent the work and accomplishments of artisans in the First Emperor's service. Placed end to end in a pit near the west edge of the mound, they occupied merely one portion of a trench with several other as yet unreported compartments. The chariots, scaled at less than half life-size, were originally painted in lifelike colors like the terra-cotta army. Chariot

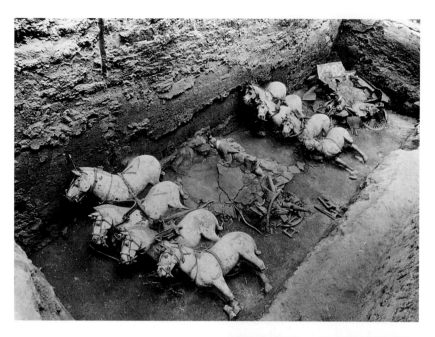

4-17 Chariots 1 and 2 at excavation
Qin, c. 210 BCE. Lishan, Lintong, Shaanxi.
Museum of Qin Figures and Horses, Lintong

4-18 Officer figure
Qin, c. 210 BCE. Earthenware, height 6′5″
(1.96 m). Trench 1, Lishan, Lintong, Shaanxi.
Museum of Qin Figures and Horses, Lintong

1 is an open cab with a large round canopy (compare the silk painting from Changsha in FIG. 3-25) driven by a standing warrior armed with a sword. Chariot 2 is a closed carriage with a kneeling driver. The two drivers are identical in style to the terra-cotta warriors, although reduced in scale. Likewise the sturdy four-horse teams that pull these chariots are the same stock as those represented in the trenches. The chariots, however, replicate in great detail all of the fittings and components of horse-drawn vehicles. This attention to specifics is a general characteristic of Qin work, a literal and complete rendering of reality. The two chariots most probably represent some portion of the First Emperor's chariot corps, the ancestor of all imperial entourages; the First Emperor's entourage could have had from nine to eighty-one chariots.

Farmers digging a well in an orchard first discovered the fragments of clay figures that led, in turn, to the many recent excavations around Lishan. The first trench is a rectangular construction nearly 750 feet long by 200 feet wide (230 m by 62 m), subdivided into eleven corridors separated by baulks of earth (see FIG. 0-3). Although only 16 feet (5 m) below ground level, no traces of this trench had been reported prior to 1974. In spite of some handsome smaller clay figures unearthed around the necropolis over the years, no one seems to have anticipated a project like this. The nine main corridors are filled with life-size warriors, four abreast, facing east; the two narrow side corridors have files of two warriors each, the outside file facing away from the main body of the army. A large open area at the east end was accessible by five ramps. More than two hundred warriors in three long ranks, probably the vanguard of the army, stand here. Two additional smaller trenches were discovered on the north side of Trench 1. The trench at the east end was mainly devoted to cavalry and archers (Trench 2); the other at the west end was a kind of headquarters detachment (Trench 3). The total number of warriors in all three trenches is estimated to surpass seven thousand figures.

Impressive as the formations are, the individual figures (FIGS. 4-18, 4-19) are no less intriguing as individual sculptures and as achievements of

the potter's craft. All the warriors, with the exception of the kneeling archers, stand on small clay plinths. (Horses stand on their rather thin, stiff legs without additional support.) Yet these figures weigh hundreds of pounds each. The stances are generally rigid, with both feet firmly planted and torso and arms balanced over the cylindrical legs. In this respect they resemble the vertical supports for the bell chime of Marquis Yi (see FIG. 3-1 above). Several types, however, vary the pose. Some charioteers extend their arms forward to grasp reins. Striding bowmen place one leg at right angles to the body and twist their shoulders to hold their weapons at one side. Kneeling archers crouch in a three-point pose resting on one knee (again, see FIG. 4-19). While all of the warriors seem to have come from the same population, they exhibit many variations, especially in renderings of facial features, hair, and other details. High-ranking officers, for example, wear special caps, a scarf tied at the neck, and tassels on their chest armor (again, see FIG. 4-18). Other figures wear different headgear and armor. Still others are not armored. By combining many finishing details—moustaches, chin whiskers, topknots, and plaited hair—the potters made the basic types into an array of individuals. Many writers assert that every warrior is unique. To the extent that each figure was finished by hand, this is literally true. Conceptually, however, this army is a catalogue of types rather than a collection of renderings of actual individuals.

The production of these warriors must have occupied many hands for some years, but no textual sources actually hint at the project. Impressed and scratched marks on the warriors and horses document the many workshops or gangs of workers drawn mostly from the capital region. These laborers were of necessity housed and fed at or near the site, they required supervision and control, and they and their work needed a variety of supplies and other support services. The management of the work must have been as demanding as the design and execution of the figures. Clay for sculpting and kilns for firing were among the most important parts of the production process, each entailing general laborers and more skilled artisans. The actual crafting of

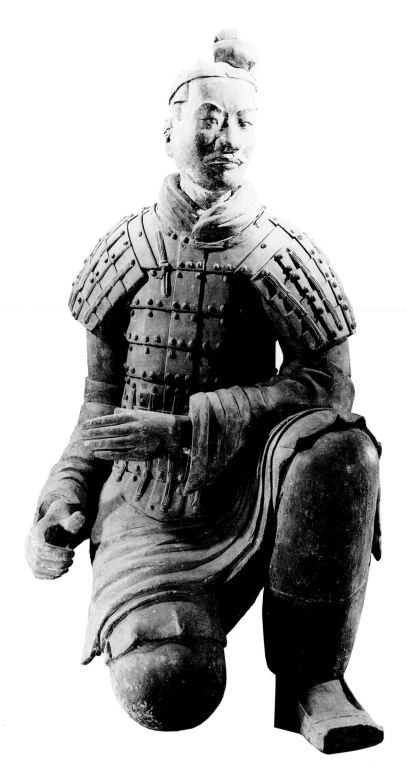

4-19 Kneeling bowman
Qin, c. 210 BCE. Earthenware, height 48″ (1.22 m). Trench 2, Lishan, Lintong, Shaanxi. Museum of Qin Figures and Horses, Lintong

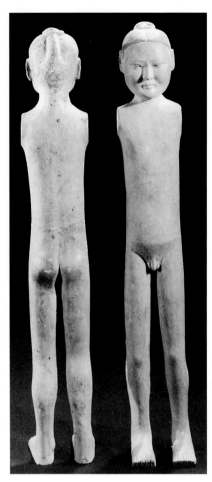

4-20 Nude figurines
Former Han, 2nd century
BCE. Earthenware, height
24½″ (62 cm). Yangling,
Xianyang, Shaanxi. Shaanxi
Archaeology Institute, Xi'an

figures and horses had to be divided into many steps, combining molds and free-hand work. The component parts had to be assembled in sequence, fired, and painted. The multiple stages in lacquer production recorded in the inscription cited above (see page 133) were certainly analogous to the many teams of workers who carried out each portion of this process. The achievements of the Lishan site are therefore collective ones. No single architect or designer is identified, although responsibility rested ultimately with the chancellors, the highest officials in the empire. Their success lay in bringing the project to completion—strong testimony to the ability of the Qin state to enforce its will and to ensure performance to its standards.

Han Imperial Tombs

Many early texts assert that "Han perpetuated the Qin system." This was no less true of imperial burials than government institutions and practice. The Former Han tombs near Chang'an and those from Later Han at Luoyang continued many features of Lishan. Each emperor established funerary parks during his reign, by convention starting in the second year. A large budget, perhaps as much as one-third of state revenues, was dedicated to this project. Labor forces under the supervision of the Court Architect worked on site; one instance records thirty thousand workers. The court employed other court bureaus, especially the Artisans of the Eastern Garden, to prepare burial furnishings of all kinds, including the jade suits discussed below (see FIG. 4-23). The Han emperors, unlike the First Emperor, were accompanied by their empresses, who had separate, smaller parks nearby. In addition, it was the custom in Former Han to have satellite burials with mounds in the same area as a reward to high officials and meritorious generals (see the sculpture from the tomb of General Huo Qubing, FIG. 4-26). Pits containing

valuables also continued Qin and pre-Qin practice. The rhinoceros discussed above (FIG. 4-14) is simply one of many fine objects from the vicinity of the tomb of Emperor Wu.

Workshops within the northwest corner of Han Chang'an produced ceramic figurines for use at the tombs. One of the largest examples consists of about 2500 warriors on foot and horseback from the tomb of a Han general near the Changling. More recently, about two dozen trenches have been probed in the area of the Yangling, the tomb of Emperor Jing (r. 157–141 BCE) and his consort, Empress Wang (d. 126 BCE). The figurines excavated here have gained attention because they are nude renderings (FIG. 4-20). The Yangling figurines are much smaller than their Qin prototypes at only 24 inches (60 cm). Unlike the former, they were made from two-part molds rather than assembled from parts. Several facial types are found, but other features are generalized: squared feet, thin torsos, a deep groove from shoulder blades to buttocks, and thick necks. Moreover, the figurines were completely painted, fully costumed, and armed. Thus these are mannequins that wore miniature armor and robes over their bodies, rather than proper nudes. Although the total number is not yet known, several thousand seems likely, and this is not a unique case. This was an ambitious, costly project, yet more modest than the Qin army and hence not a comparable drain on the economy.

Myths and Portraits

The cultures of ancient China exhibit many features also found among other ancient peoples, but a systematic mythology is not among them. Only during the Eastern Zhou period are traces of mythology found with any consistency in extant literary sources. Most of these works are compilations of the Warring States period such as the *Songs of the South (Chu ci)* and *Classic of Mountains and Oceans (Shan hai jing)*, anecdotes found in *Zhuangzi* (the writings attributed to the Eastern Zhou thinker of that name), or other fleeting references. It is possible that the culture heroes who crafted the basic elements of Chinese culture may not have been known prior to Han times. On the other

4-21 Fu Xi and Nu Wa
Details of painted hollow bricks. Former Han, 1st century BCE. Tomb of Bu Qianqiu, Luoyang, Henan. Luoyang Ancient Tombs Museum

4-22 Portrait of tomb lord
Wall painting. Tomb at Anping, Hebei. Later Han, c. 176 CE

This early "portrait," one of very few possible examples from the Han, can be dated by inscription to 176 CE and identified as the tomb's master, a man by the name of Zhao. The excavators speculate that a famous eunuch official of this area, one Zhao Zhong, might have been buried here.

hand, there is an obvious gap between what was preserved in texts made for the elite and a much larger body of ideas current in common society. One contribution of recent archaeological finds is toward a better understanding of Han mythology.

One of the most widespread mythological subjects in Han art is that of the twin beings Fu Xi and Nu Wa. Few pre-Han texts mention their names or variants of them. Nu Wa is credited with the creation of the human race and Fu Xi with such contributions as hunting and fishing, the Eight Trigrams, and time reckoning. As a complementary, male–female pair, they are also associated with the dualistic *yin–yang* concept, and pictorial renderings reinforce this. In the tomb of a certain Bu Qianqiu at Luoyang, for example, Fu Xi and Nu Wa are drawn on ceiling bricks at opposite ends of the gabled chamber (FIG. 4-21). Both assume three-quarter poses with simple robes over their upper torsos and serpentine bodies that curl upward. The drawing is thin and resilient, but wider strokes and touches of color augment the careful detail of facial features. Infill color is used on the robes: red for Fu Xi and purple for Nu Wa. Both in this tomb and in several others at Luoyang, the two figures

are physically separated and flanked by sun and moon, respectively.

Figures from human history also occupied a prominent place in Han pictorial art. If myths embody fundamental notions about the workings of the natural world, then didactic stories convey messages about the workings of human society. The Shandong reliefs and others from Henan, Shaanxi, and Sichuan often picture stories of brave warriors, chaste women, filial sons, and worthy officials. Tales are generally resolved into their most basic characters and props. Jing Ke's attempted assassination of the First Emperor requires little more than the two protagonists, a knife, and the column in which the misguided weapon lodged. For a filial son who plays for his aged parents, three figures and some toys will suffice. In the case of the "painted basket" from Lelang unearthed in Korea in the 1930s, brief cartouches identifying stereotyped seated figures were adequate. We know from textual accounts that many of these tales were painted on the walls of Han palaces, and some have been found in painted tombs as well.

Formal portraits were also a part of Han palace decoration. The Han emperors memorialized worthy figures for their achievements, and the same impulse figures in funerary art as well. A clear case is the Later Han tomb at Anping (Hebei) dated by inscription to 176 CE. This is a large and exceptionally well built tomb that has been attributed tentatively to a wealthy eunuch, one Zhao Zhong. The central chamber features a procession of eighty-two chariots, the entourage of a great man. A side chamber displays a large portrait 6 feet tall (1.8 m; FIG. 4-22) of an imposing man seated on a low couch within a canopy and screen. This is a static, frontal rendering: the peaked cap, symmetrical face, and rigid pose are iconic. One hand holds a fan, while the other gestures. A white and black collar and cuffs complement the bright red robes. The drawing here is springy and thin; the painter expended considerable energy on brows, whiskers, and moustache. Those details suffice to transform a generic seated figure type into a specific individual. His smaller scaled attendants stand only as tall as their seated master. Other Later Han murals match this work in conception, such as

the tomb at nearby Wangdu (Hebei) with its official staff and the tombs at Mi County (Henan) with their display of a lavish life-style. This type of portraiture presages the work of such noted painters as Gu Kaizhi (c. 344/345–406 CE) and Yan Liben (d. 673 CE; see chapters 5 and 6).

The Souls and the After-life

Death became an occasion to reaffirm important ideological values: the honor and respect due to seniors, the duties incumbent on juniors, the centrality of lineage and cult obligations. Tombs were objects of intense concern, although there are no treatises or essays by Han literati that explicitly detail their features and significance. Instead texts describe the ritualized behavior of family and community at death rites, especially mourning. The rationalizations of the Eastern Zhou thinker Xunzi were manifested in Han times by a large-scale commitment to "rich burials." While some policy discussions and social critics castigated society for the costs and superstitions associated with these burial practices, there was never any significant diminution in the social, economic, and ideological investment made in tombs and their furnishings.

Death was viewed by many writers as the separation of two souls. In life, these souls animated both the physical body and the mental faculties. An earthly soul, *po*, remained in or near the corpse at death and was commonly believed to be a recipient of the care and sustenance offered to the dead through burial rites. An ethereal or heavenly soul, *hun*, was thought to depart the body at death, ascending to extraterrestial realms, but its fate was obscure. An untended grave might cause the transformation of the *po*-soul into an evil, marauding spirit or ghost (*gui*) that caused harm. Several competing schema describing the fate of the ethereal soul are visible both in texts and material evidence. For some, there was the cult of the Eastern Isles in the ocean, inhabited by spirits or immortals (*shen* or *xian*) who enjoyed a blissful eternity. Both the First Emperor of Qin and Emperor Wu of Han sent expeditions by sea in search of these isles. For others, especially in the south, the wandering soul was, if

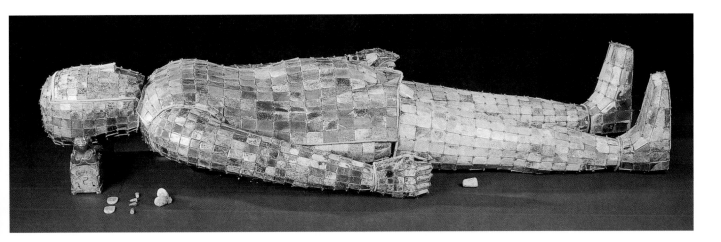

possible, to be summoned back to the bosom of the family. Poems in *The Songs of the South* (*Chu ci*) and rites described in the *Li ji* (*Record of Ritual*) summarize these views. In the last years of Former Han and especially in Later Han times, a newer cult arose to a divine spirit in a distant westerly realm, the Queen Mother of the West on Mount Kunlun. Tombs and their furnishings also suggest multiple agendas. Filial devotion, as exemplified in didactic tales and by great exertions at the death of a parent, was not incommensurate with a cautious respect for the evil potential of ghosts. An inventory of goods made explicitly for burial was both an economical alternative to consigning valuables to the grave and a symbolic statement of the deceased's status, real or imaginary. Wall paintings and impressed tiles recorded this life, but other grave goods suggest complex ideas about the after-life not well represented in existing literature.

The idea that various practices or elixirs could somehow prolong life, retard death, and/or achieve a physical immortality led to the creation of many artifacts associated with the tomb and constitutes a major theme in other arts. The Han emperors adopted the practice of jade burial shrouds, full-size body suits of jade plaques knitted together with wire of gold, silver, or bronze (FIG. 4-23). The "Treatise on Rites" of the *History of Later Han* (*Hou Han shu*) describes such suits, but not until 1968 did well-preserved examples come to light in two rock-cut tombs near Mancheng (Hebei). These were the burials of Prince Liu Sheng of Zhongshan (d. 113 BCE), a brother of Emperor Wu, and of Dou Wan, member of a prominent

consort family. More than a dozen other suits are now known, and several have been restored. Each corpse was actually prepared with plugs placed in or on the "nine bodily orifices," including eyes, ears, nostrils, and mouth. The jade suits, made to order by the Artisans of the Eastern Garden in Chang'an, consist of separate face masks and stocking caps, chest and back pieces, arms, gloves, legs, and boots. Although in principle gold wire was restricted to the Son of Heaven, it was used at Mancheng. The jade suits are merely one part of the goods and practices associated with longevity and immortality in the Zhongshan tombs. The rock-cut mountain site may have been associated with the mountainous realms of the immortals. The coffins holding the enshrouded remains were themselves lined with jade. A large number of auspicious disks, *bi*, were placed in and around the suits. Deluxe bronze vessels with extraordinary bird-script inlay in turn contained medicinal wine with special qualities. A deluxe incense burner inlaid with gold in the form of a mountain amid the waves depicts immortals amid the peaks and clouds of incense. The latter objects, while not made for burial, were no less linked to the cult of the immortals and elixirs.

Related ideas played a part in the design, construction, and furnishings of the two well-preserved tombs at Mawangdui. We have discussed objects from the tomb throughout this chapter. The burials are veritable time capsules of elite life in the early second century BCE. Silk garments and fabric, lacquer wares, musical instruments, food stuffs, and personal accessories were consigned to the grave as the personal effects of the Lady

4-23 Burial suit
Former Han, c. 113 BCE. Jade plaques with gold thread, overall length 6′2″ (1.88 m). Tomb of Liu Sheng, Mancheng, Hebei. Hebei Museum, Shijiazhuang

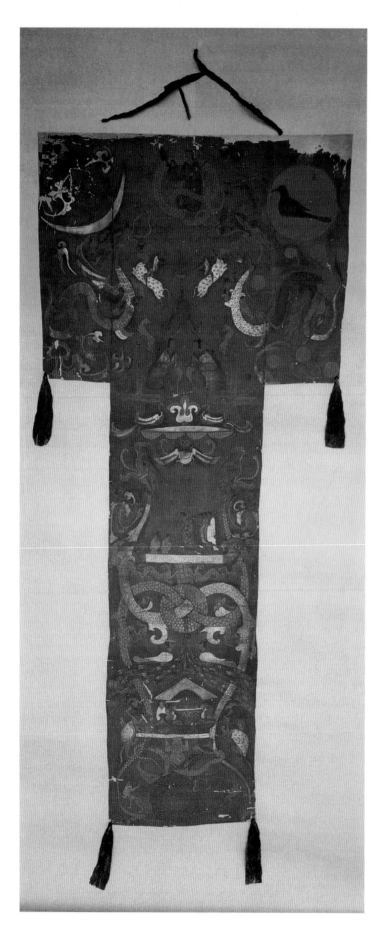

of Dai (d. 168 or after) and her son, respectively, but also as markers of their status. An inscribed wooden tablet in the son's tomb (Tomb 3) suggests that his earthly soul was turned over to the supervision of an underground bureaucracy that mirrored living society. Still other items were prepared for the funeral and burial, including wooden figurines of household servants, surrogate objects (wooden *bi* disks, clay coins, and vessels), and, not least, painted silk banners for the funeral procession.

The two banners from Mawangdui are among our richest visual sources for the Former Han period and the best preserved examples of painting from that period (FIG. 4-24). They correspond in function to the banners that carried an inscription with the name of the deceased flanked by the sun and moon that are described in ritual texts. Here heavenly and earthly realms are pictured schematically with the deceased. Both banners are long panels of silk with "arms" attached at the top. Their T-shape creates a two-part composition: a heavenly zone with sun and moon at the top and a vertical stem below, dominated by intertwined ascending dragons. The heavens display not only the two most important celestial orbs but also other dragons. In the case of the lady's banner, a serpent-bodied creature floats, coiled, at the top center. Identifications of this figure vary. Some writers favor a local diety known as the "Torch Dragon," ruler of the heavens who controlled night and day. A gate with figures depicted as Han officials wearing mortar-board hats marks the lower edge of the heavens in each banner. Ascending dragons, also a consistent feature of textual descriptions, fill the stem of each banner. Two dragons ascend for the lady and four for her son. Between the dragon necks in each case is a platform on which stands the deceased with attendants. These figures are portraits in the notional sense that specific details were intended to link the images to individuals. The lady, for example, leans forward on a staff of a kind found in her

4-24 Painted banner
Former Han, after 168 BCE. Silk, height 6´8¾˝ (2.05 m). Mawangdui Tomb 1, Changsha, Hunan. Hunan Museum, Changsha

tomb. Below the *bi* disk through which the dragon bodies are plaited is a second platform. Here a gathering of figures attends an ensemble of ritual vessels and a cloth-wrapped form that could be the corpse. This reading of the discrete images suggests a temporal dimension: the portrait above is either the lady or son in life, or ascending as a spirit, while the ritual scene below would represent the funeral. However specific identifications are argued, the total composition serves as a diagram relating Heaven and Earth, human and spirit realms.

The ideas discussed here were not stable during the entire span of the Qin–Han empires. Nor were they ever articulated definitively in a single authoritative text, although many Former Han writers attempted syntheses. The shadowy creatures of the Mawangdui banners were but a fraction of a larger natural and supernatural universe of peoples, animals, and spirits that recur in essays, poetry, and visual arts. Both words and images circulated throughout the empire, making regional traditions more widely known. In retrospect, these diverse strands of belief and imagination underlie many later traditions of Chinese culture.

BEYOND THE MIDDLE KINGDOM: PEOPLES OF THE FRONTIERS

Beyond the frontier commanderies of the Han realm lived many peoples who interacted with the empire. Han treatises describe some of these peoples and regions, especially those west of the Jade Gate in far western Gansu. After the investigations

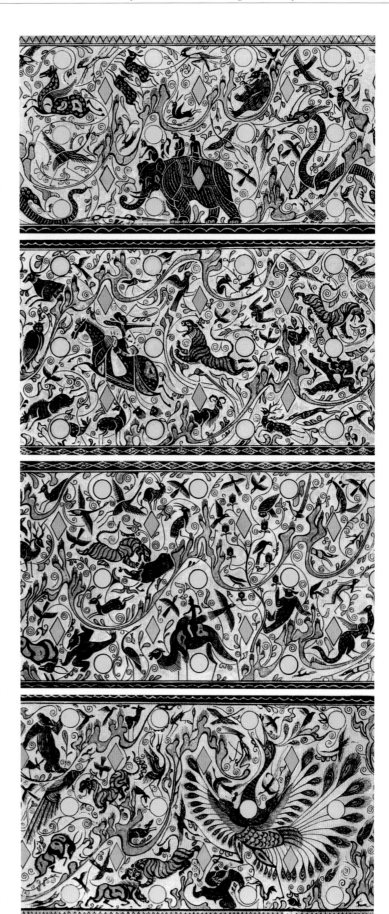

4-25 Artist's rendition of chariot canopy ornament
Former Han, late 2nd–early 1st century BCE. Bronze with inlay, height 10½″ (26.5 cm). Sanpan Shan, Ding County, Hebei. Hebei Cultural Relics Institute, Shijiazhuang

The designs on this fitting for the canopy pole of a deluxe chariot record the Han-period fascination with exotic wonders and *qi* (cosmic breath) in all its manifestations. Imperial parks like the Shanglin replicated the diversity of the natural world within their precincts with a comparable menagerie of animals and birds.

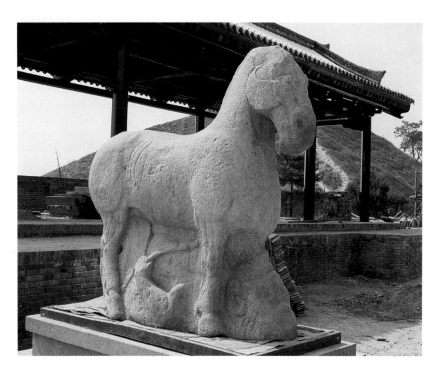

4-26 Horse and barbarian
Former Han, c. 117 BCE.
Granite, length 6′3″ (1.9 m).
Tomb of Huo Qubing,
Maoling, Xingping, Shaanxi.
Maoling Museum, Xingping

Among the generals serving Emperor Wu, Huo Qubing was a prodigy. When he died at twenty-four years of age in 117 BCE, the general of light cavalry was already renowned for his exploits in the Gansu corridor. The emperor ordered extraordinary rites and a satellite burial just east of his own Maoling. The *Han History* (*Han shu*) records particulars such as Xiongnu warriors lining the roadway from the capital to the tomb site as an honor guard. The Director of Works in the Eastern District of the Capital was charged with the construction of Huo's tomb, which for the first time incorporated stone sculpture. The intention seems to have been to memorialize the young general's exploits by an array of huge granite boulders carved as animal denizens of the mountainous area where his victories had been won. Today at least sixteen of these carved boulders can be seen at the site. They range from the most cursory shaping of natural stones to more fully realized three-dimensional works, such as a horse standing astride a bearded barbarian (FIG. 4-26). This work has been famed since in 1914 Victor Segalen acclaimed it "the oldest in the repertory of Chinese sculpture in the round." Segalen devoted a chapter to it in his pioneering volume on Chinese sculpture.

of the emissary Zhang Qian in 138 and 115 BCE, the court was better informed about the statelets on the southern and northern flanks of the Kunlun and Tianshan ranges (modern Xinjiang). The court's interest was not idle. Zhang Qian was dispatched in hopes of persuading the Yuezhi, who had been displaced westward by the Xiongnu, to join Han in fighting their common enemy. (Descendants of these Yuezhi—the Kushans—figure in chapter 5 as patrons of Buddhism in northern India and Pakistan.) Such an alliance was never formed, and for the first century of Han rule the empire was forced to buy peace with steppe neighbors through marriages and gift giving. Only in the last decade of the second century BCE did the situation change as a result of the successful campaigns of such generals as Wei Qing and Huo Qubing. During the first century BCE, the Han empire was in the position to establish an administrative apparatus to regulate its relations with the statelets of the Tarim Basin. The "Western Regions" (Xi yu) were under the military supervision of Han garrisons near Turfan and further west near Karashahr (Yanqi). The Han experience with peoples of the west encompassed heroic military exploits, the first documented contacts with far distant cultures such as Ferghana and Sogdia, as well as the material legacy of tribute from the statelets of the Silk Road.

The horse is a relative of the steppe ponies of the First Emperor's army, albeit realized more as wrap-around reliefs on the block than as freestanding sculpture. The area within the horse's four stiff legs is not cut away. Here we notice the features of a bearded figure on his back, head between the forelimbs, arms and feet visible on the other three sides. With its beard and grotesque features, the figure is assumed to be a fallen Xiongnu warrior. The bow in one hand is matched by a spear stabbing the horse's belly in the other. Even if the wound is serious, there is no response from the horse. Nor do we see any saddle or other gear to indicate this horse might have been the general's own mount. This content is conveyed with minimal carving: parallel striations evoke the warrior's hair and beard, deep grooves suggest the horse's muscles, crude lines describe the horse's cheek. Even weathered after two thousand years, it seems unlikely that the original effect was significantly more

detailed or finished. Two other kneeling horses are rather more animated, caught in postures found in real life. They too do not differ in surface detail or the use of the block. Other works of similar scale, material, and workmanship are in fact known from elsewhere in the capital region, including the Shanglin Park. Art historians have usually portrayed the Huo Qubing stones as the inception of large stone sculpture. But as the Qin underground army shows, sculpture of some scale and ambition had been produced earlier.

Han interaction with the many peoples of the south did not lead to military operations like those in the Western Regions, nor did it include tribute exchanges with a variety of statelets. The main southern states included the independent kingdom of Nanyue occupying modern-day Guangdong, subordinated in 111 BCE, which is discussed above in connection with jade working. The kingdom of Dian in Yunnan, on the other hand, gained the recognition of the Han court, as shown by a Han gold seal recovered from a Dian tomb at Shizhaishan (Jinning, Yunnan). Images of the south were widespread in Han literature and art, as an inlaid bronze tube from a chariot found in a tomb in Ding County (Hebei) illustrates most vividly (FIG. 4-25). The four registers of this cylinder, shown flattened out in this view, are a fitting summation of much Han-period art. Rows of circular and diamond-shaped inlay, which the pictorial content must work around, overlay each register. The pictorial content is organized above and below looping bands of gold inlay that spiral upward and so evoke a ridge of hills. A myriad animals and birds fill in the remaining surface, as do curling tendrils and the leaves of vines. The denizens of this tropical world include flying horses, deer, bears, tigers, boars, a dragon, and peacocks, as well as an elephant and a camel, each with riders. The riders with their pointed topknots themselves would seem to be natives of the south. The archer on horseback who confronts a leaping tiger wears the headgear of a Han

warrior. This is a complex composition, of absorbing interest and impressive energy, a visual equivalent to the rhapsodies produced by contemporary court poets. It is also a work of high craft and great imagination, worthy of careful examination in its own right. The tomb from which it comes has never been properly reported, but it probably belonged to yet another prince of Zhongshan. The tube could well have been made in an imperial workshop in Chang'an. It is thus also more evidence for the court bureaus that set the standards of the day and for the luxury lifestyle of the elite.

The imprint of the Qin and Han imperial states will be felt throughout the remainder of this volume. The imperial state and the society it engineered became "China." For the following two millennia, no other order was imaginable. The emperor on the throne was as firmly established as the sun and moon in the sky. The demands of an authoritarian state apparatus were as natural as the patriarchal order of the family. The regional diversity of natural products, industries, cuisines, and arts were nonetheless seen as components of the empire, a whole greater than its parts. The institutions of the imperial state defined civilization. Even the most distant barbarians acknowledged its manifold virtues. Han civilization impacted neighboring regions of East Asia far more than Chinese cultures of earlier times. Elements of Han culture were planted on the Korean peninsula, in Manchuria, across the Mongolian steppe, along the Gansu corridor, in the southwestern plateaus, and in the northern reaches of Vietnam. Just as Han colonists took from local peoples, the local cultures assimilated aspects of Han social organization, material culture, thought, and art. The early states that arose in these regions had a protracted history of both borrowing and resisting Han culture. The arrival of Han civilization was a significant catalytic agent in the culture histories of all East Asia.

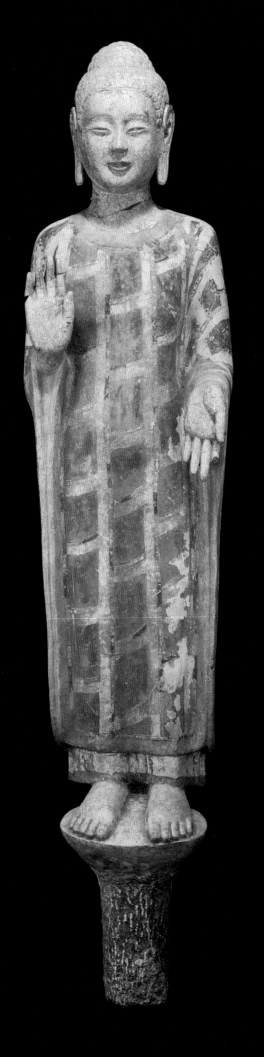

5 AGE OF THE *DHARMA*: THE PERIOD OF DIVISION

D URING THE CENTURIES following the collapse of the Han dynasty, Chinese society and culture changed in many ways. This age of political turmoil saw repeated attempts to establish a comprehensive political and social order, and later historians have used many phrases to describe such efforts. Historians designate the decades following the Han, which ended formally in 220 CE, as the "Three Kingdoms" (or "Three States") period. Separate regimes—the states of Wei, Wu, and Shu—controlled the north, the Lower Yangzi, and the Sichuan Basin, respectively. In latter-day dramas and novels this period became a romantic age of military heroes and villains such as Zhuge Liang and Cao Cao. The Jin dynasty (265–316) reestablished order and held together until the loss of their capital, Luoyang, in the second decade of the fourth century. Moving across the Yangzi River, the Jin court regrouped and made their new capital in the area of modern-day Nanjing (Jiangsu). Regimes based here became known, after the fact, as the "Six Dynasties." These states included Wu of the Three Kingdoms period, the transplanted "Eastern" Jin, and the Song, Qi, Liang, and Chen dynasties. (The latter four are also termed the "Southern Dynasties.") The loss of the north in 316 can be regarded as a pivotal event. Transplanted elite lineages established new homes in the Lower Yangzi macroregion. The spread of an ethnic Han population into new terrain along the Lower, Middle, and Upper Yangzi led to the economic development of territories that had been on the fringe during the Han period. With a favorable climate and much uncultivated land, the southeast became over time the agricultural heart of China. Southern court aristocrats and landed gentry would later play an important role in the formation of cultural institutions after the Sui reunification of 589.

In the north, after 316, a succession of short-lived regimes controlled the old Han capitals at Chang'an and Luoyang, founded by tribal people who had lived within the Han borders. Historians regarded them as "barbarian" (*hu*): they spoke non-Chinese languages and relied originally on pastoral livelihoods quite distinct from those practiced in Han society. Tribal groups descended from the Xiongnu of Han times, the Tuoba (Tabgatch), a Xianbei people (ancestral to later Mongols), and the Qiang (ancestral to later Tibetans), controlled a succession of "Five Barbarian [States] and Sixteen Kingdoms." The Tabgatch (Northern) Wei regime achieved control over the entire north by about 440 and created a long-lasting, if not stable, regime. With its capital at Pingcheng near modern Datong (Shanxi), this state mounted campaigns against its own "barbarian" neighbors to the north and established relations with powerful states in West and Central Asia. The Wei moved its capital to Luoyang around 494, but within a few decades fell apart. Two pairs of successor regimes—Eastern Wei–Northern Qi and Western Wei–Northern Zhou—emerged, both built on Northern Wei political and social foundations,

5-1 Sakyamuni Buddha
Northern Qi, c. 550–77 CE.
Polychrome limestone, height
46⅞″ (1.19 m). Longxing Si
site, Qingzhou, Shandong.
Qingzhou City Museum

and perpetuated a two-part, east–west division of the north until 581. In that year a Northern Zhou general's coup put a new ruler on the throne, and the Sui began. Within the decade Sui armies had unified both north and south, ending more than two centuries of division (see chapter 6).

If any one cultural development can be accorded primacy of some kind in this discussion, it would surely be the growth on Chinese soil of a large and prosperous Buddhist community, one with deep roots in Chinese society and intellectual respectability. The earliest traces of the *dharma* (Buddhist teachings) in China proper date to the Han period. After the Jin court's retreat to the south, Buddhist believers grew in number among the gentry, a social change so marked that Erik Zurcher has dubbed it the "Buddhist conquest." The Buddhist community matured steadily in the centuries following the court's shift to Nanjing. Important Buddhist figures such as Dao'an and Huiyuan spread doctrines and devotional practices, and imperial patronage of prelates and temples became common. Buddhist believers also flourished in the Gansu corridor (a region then called Liang). As it expanded its control over the north, the Northern Wei state also became a major patron of the *dharma*. The northern states, moreover, were tied by land routes to the sacred heartland of the Buddha (portions of the Ganges Valley in India and Nepal) and to Central Asian states that promoted these teachings. As in the south, the social elite involved itself in the life of the Buddhist community, but court-sponsored patronage also led to a greater degree of significant regulation.

STATE AND SOCIETY

Between the mid-third century and the late sixth century, the area we call China proper normally sustained two, three, or more competing polities or political organizations. Most regimes styled themselves as imperial states ruled by a "Son of Heaven." To these rulers, legitimacy loomed as an over-riding concern. Since there could not be two Sons of Heaven, one (or more) claimants must be illegitimate. Rulers had a ready pretext

for aggressive military campaigns to dislodge "false" sovereigns. For example, in 356 the Eastern Jin generalissimo Huan Wen marshalled forces and briefly retook the lost northern capital Luoyang. In 416–418, Liu Yu of Eastern Jin took advantage of internal divisions in the north and reclaimed both Luoyang and Chang'an. While these offensives had only short-term consequences, they remind us of the military aspects of state-to-state relations. The stronger regimes claimed to be the proper successors to the last Han sovereign. Cao Cao, the de facto founder of the state of Wei during the third century, made this claim with great seriousness, but his rivals in Wu and Shu did not assent. The Jin rulers, first at Luoyang and later at Nanjing, maintained a similar view, even though the north was beyond their control for good after their defeat at the Fei River in 383. Although hostility toward other states characterized debates at court, most advisors to these rulers came from a relatively homogeneous social group: gentry families established during the Han. Some families moved to the south, while others served under non-Han rulers in the north. Both groups regarded the Han model as natural and sought to re-create it under new masters. To claim the mantle of the Han, a proper imperial capital had to be created. The designers of Jiankang (Nanjing, the Southern Dynasties seat), of Pingcheng (the first Northern Wei capital), of the new Luoyang (the second Northern Wei capital, 494–534), and of Ye (Cao Cao's Wei capital and the Eastern Wei–Northern Qi capital in southern Hebei) all made claims for the legitimacy of their regimes through their city plans, imperial palace complexes, and other monuments.

Imperial Capitals: The North

Cao Cao established his capital at a site called Ye (in Linzhang County, southern Hebei) early in the third century. Although small by comparison with most later imperial cities, the new plan devised at this time established several long-lasting principles. But Cao Cao's successor promptly returned the capital to Luoyang, and Ye did not become a major center again until the Eastern Wei (534–555) and Northern Qi (555–570).

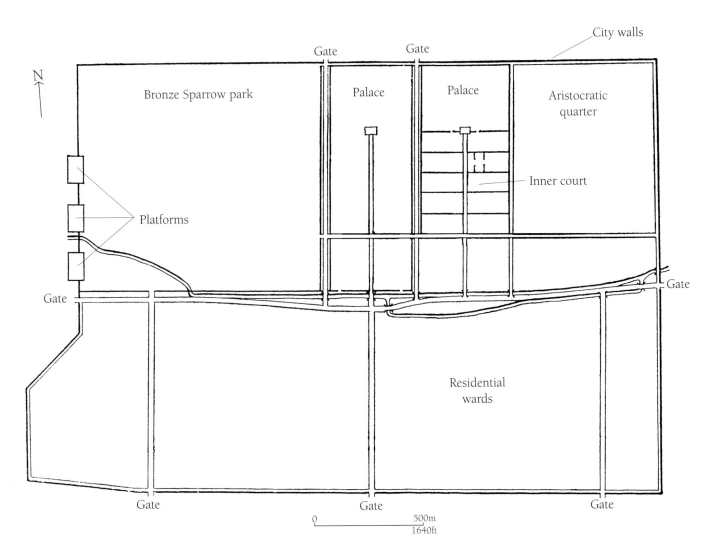

Gate
Gate
City walls

Bronze Sparrow park
Palace
Palace
Aristocratic quarter

Platforms
Inner court

Gate
Gate

Residential wards

Gate
Gate
Gate

0 500m
1640ft

During this second phase a new walled grid on the south expanded the area of the city several-fold. A rectangular wall with its long dimension running east to west defined the original (northern) city of Ye (FIG. 5-2). As might be expected, the city walls faced the cardinal directions. A major east–west thoroughfare connecting the single east and west gates bisected the city. South of this thoroughfare, residential wards (*fang*) occupied the area within the walls, while the imperial court utilized the zones to the north. The palace complex, aligned on the north–south axis, was approached from the central south gate. To the east of this imperial axis stood a second, inner court compound, similar in size and shape to the great halls of state. This precinct consisted of a series of small yards on the south and a larger rear palace. Government ministries flanked the main approach at the south of this eastern palace complex. Thus the

halls necessary for the court were situated side by side in the north-central portion of the city. The western third of the northern zone became a large imperial retreat, the Bronze Sparrow Park, which also held an arsenal and other facilities. Three elevated platforms (*tai*), integrated into the west wall, supported pavilions for the imperial clan that could serve as defensive strongholds in a military emergency. Elite residences occupied the northeast corner of the city, adjoining the inner court compound. The accommodation of the imperial establishment, its palaces, offices for court bureaucrats, and mansions for the imperial clan figures prominently in the plans of Sui- and Tang-period Daxing cheng and Chang'an (see FIG. 6-2 below).

This survey of Ye fills in an important chapter in the history of planned cities in China. The other great northern capital, Luoyang, suffered

5-2 Plan of Ye in the 3rd century CE

5-3 Guardian animal (*tianlu*)

Tomb of Emperor Wu of Southern Qi, Danyang, Jiangsu. Southern Qi, c. 493 CE. Stone, height 9′2″ (2.8 m)

Truly heroic in scale, this other-worldly animal is one of a pair crouching on the spirit path. Rarely, if ever, were larger animal sculptures installed in an imperial precinct. Yet the tomb's entire ensemble numbered simply six stones—two animals, two columns and two stele—a modest investment compared to later periods.

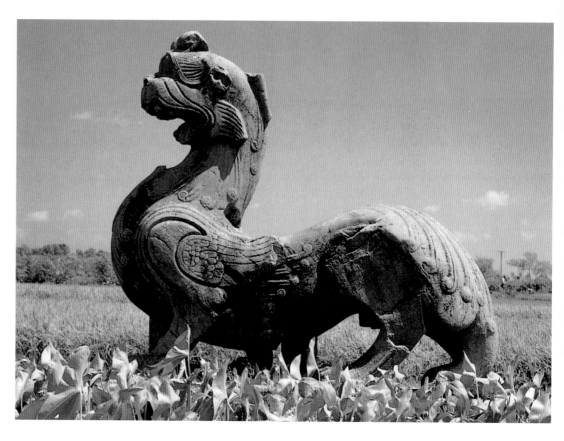

greatly at the fall of the Northern Wei in c. 534. The best preserved remains from Later (Eastern) Han and Northern Wei are those monuments sited outside the walled city, such as the Spiritual Terrace (Lingtai) of the Han or the great Yongning Temple of the Northern Wei (see FIG. 5-13 below). Similar problems of successive occupation and rebuilding confront attempts to study Jiankang. Physical remains of the ancient city underlying modern Nanjing remain virtually unknown, and all studies must rely on literary accounts; only in the suburbs of Nanjing are traces of the southern courts found (see below).

Imperial Tombs: The South

Imperial and elite tombs near Nanjing constitute evidence for an important stage in the development of burial practices. Some thirty imperial tombs have been identified (less than half of those recorded); about twenty tombs clustered northeast and southeast of the modern city can be attributed with some certainty to individual emperors and princes of the southern courts. Further east, in Danyang County south of the river,

an area favored during the Southern Qi (479–502) and Liang (502–557) dynasties has been surveyed. All these tombs are sited at high elevations and in foothills. Burial chambers were installed inside hilly terrain and protected by it, while the approach and outer precincts occupied lower, more level ground. This siting accords with "geomantic," *fengshui*, principles still important in Chinese communities around the globe. According to *fengshui*, a prime location sheltered and drained by the natural terrain insured good fortune for the deceased and, by extension, for posterity. A specialist in geomancy had the task of identifying the most auspicious natural setting for tombs, houses, even cities. Many *fengshui* principles, however, also make "common sense"; the virtues of a sunny southern exposure and sheltered northern one can easily be understood.

Large stone carvings that define the "spirit paths" (*shen dao*), the formal approach to each tomb, survive in large numbers in the landscape. The large animals that populate these sites have generally been designated by such terms as "[Bringers of] Heavenly Blessings," *tianlu*, "Unicorns," *qilin*, and "Averters of Evil," *bixie*.

The names *tianlu* and *bixie* enunciate auspicious and apotropaic (evil-averting) roles for such creatures, who are descended from the winged and horned numinous animals of Eastern Zhou and Han. Imperial tombs generally have a pair of male animals, one with a single horn (*qilin*), the other with a pair of horns (*tianlu*). A huge *tianlu* from the Southern Qi tomb of Emperor Wu (Xiao Ji, d. 493) near Danyang represents the type (FIG. 5-3). Its body is almost 10 feet (more than 3 m) in length, the rearing head reaching a similar height. Facing a single-horned creature across the spirit path, this *tianlu* pulls its head and neck back and to one side. Its mate opposite mirrors this posture. By contrast with the steed of Huo Qubing (see FIG. 4-26 above), the animal is fully undercut, its weight carried by the massive limbs and a coiled tail. Surface patterns of whiskers, wings, and feathers complement the thick-set proportions, low-slung pose, and boxy carving. When one approaches the spirit path, these two animals appear first as large silhouetted forms. As one passes between them, they seem to turn their heads at the visitor. At princely tombs, the creatures look feline with their ample manes and lolling tongues, an echo of Han prototypes. Similar leonine creatures may also have enhanced the entrances to other imperial sites, such as the palaces. At the tombs of the Tang (see FIGS. 6-5 and 6-6 below), Song, Ming, and Qing emperors, stone animals and humans continued this southern tradition of imperial burial.

The imperial and princely tombs also have pairs of stone columns flanking the path. In each instance a fluted, monolithic shaft stands on a stone plinth shaped like two curling animals face to face. In several of the best-preserved examples, a capital carved with lotus petals and a bellowing creature thought to be a lion surmounts the shaft. Mounted below the capital, a rectangular slab bears the titles of the deceased, as with one Xiao Jing, a prince of the Liang enfeoffed as Marquis of Wuping (d. 523). Fluted columns can be found as early as the Later Han period, and the use of impressive stone carvings and memorial inscriptions probably began with the Later Han imperial tombs, although no examples survive.

Elite Tombs: The North

In the Northern Dynasties, political and social elites were not a homogeneous group. Instead, a dual system reconciled political power and social prestige. Non-Han rulers drawn from the minority tribal society held sway over a much larger ethnic Han population in which some of its own social elite retained privileged status. In the Northern Wei, for example, the Tabgatch controlled the imperial state through military force. Tabgatch elders governed Tabgatch society and ultimately reported, according to their customs, to the court in Pingcheng or Luoyang. Han (Chinese) elite families, on the other hand, administered the larger, ethnic Han population. They staffed a Han-style civil bureaucracy reporting to the Tabgatch court. Northern Wei society, while multiethnic, was thus divided into parallel social and political spheres.

The adoption of Han Chinese customs by ruling minority populations has generally been characterized as "sinicization" or "sinification," the argument being that a cultural minority must inevitably be absorbed by a vastly larger majority population and their culture diluted in the process. When the Tabgatch Northern Wei court explicitly adopted Han surnames, court ritual, and dress, that has been regarded as a high degree of sinification. However, such developments affected only small numbers of Tabgatch, essentially their elite who were resident at court. It can hardly have determined much of the style of life for Tabgatch people of lesser status and away from court. One might equally think in terms of a partial "Tabgatchization," as Victor Mair has remarked. Han elites who served Tabgatch overlords in practice adopted non-Han customs and values as they served the Northern Wei court. The proto-Mongols, proto-Tibetans, and Turks of the Northern Dynasties in fact contributed in many ways to what now, rather uncritically, is considered the "Chinese" culture of the Sui and Tang.

Northern elite families came to differ from their Han-period counterparts in several respects. Men trained as horse riders and became competent in martial skills. Many tomb wall paintings and figurines of the fourth through sixth centuries

emphasize mounted figures who ride out to hunt or to do battle in large groups. Some riders even play musical instruments while on horseback. Few gentlemen of the earlier Han period or of the contemporaneous southern courts could claim such equestrian skills. The social roles of elite women in the north also differed from the norms of the Han period. The relative freedom of women outside the household provides one contrast. Women had public lives, including the ability to move about in society, rather than cloistered ones spent within the family compound. An elite woman's status in her own clan could be significantly higher and her range of activities more varied than in earlier periods. Several prominent elite families provided empresses to a succession of northern rulers during the sixth century, and the women of these surnames often wielded great authority at court after marriage. (The first Sui emperor, Yang Jian, is depicted as the paradigmatic hen-pecked husband in Chinese writings. His empress, of the powerful Xianbei Dugu family, closely monitored and often controlled the activities of her husband.) Empresses and dowager empresses became the most influential patrons of Buddhist sites and monuments in the Northern Wei. Grand Dowager Empress Ling subsidized the greatest Buddhist monument of the age, the colossal pagoda of the Yongning Si (see FIG. 5-13 below). Active roles in elite family and court life, and public roles as patrons, set the fashion for the Sui and Tang elites.

However, as with men, women in subordinate roles are more common in the paintings and figurines that survive from tombs. (Depictions of higher-status women may be found in several portable scrolls attributed to this period; see FIGS. 5-25 and 5-28.) A fourth-century tomb at Jiuquan, in the Gansu corridor, shows a small orchestra performing for the pleasure of the tomb lord (FIG. 5-5). Three of the kneeling musicians are women, as are the three dancers, including a figure at the right who wears trousers. One woman plays a string instrument, one of the earliest depictions of a lute, *pipa*, in pictorial art. The central dancer carries two fans in her hands, striking poses to the melodies of her companions. Below the other figures, two female acrobats do handstands. The depiction of the tomb lord (not shown here), with his low couch, ample robes, fly whisk, and pillbox hat, follows conventions already in place at such Later (Eastern) Han burials as Anping (see FIG. 4-22 above). Two diminutive males attend their lord, one carrying a sunshade. The life-style depicted in this mural accommodates both Han and non-Han traits. The lord could be any Han official or land owner of the gentry, while the instruments suggest that the musicians and dancers may be performing non-Han music.

Large, multichambered brick tombs of the Later Han elite served as a model for burials in both north and south. The basic model or paradigm governing elite burials rested on two propositions: (1) the scale, plan, and appurtenances of burial chambers were indexes of social status, within prescriptive limits laid down by the state; and (2) underground chambers and their decorative programs, including figurines, replicated the social world of the living. More than repositories of disposable wealth, imperial and elite tombs commemorated social identities. The Jin imperial tombs of the late third and early fourth centuries near Luoyang, for example, followed more frugal standards than those of the Han period, having only one large chamber. This reduced scale and simpler plan characterizes many burials of the Southern Dynasties. On the other hand, one Northern Wei imperial tomb, the Yonggu ling (c. 481–484) of the Grand Dowager Empress Wenming, is rather more ambitious in scale, plan (with two chambers), and materials (the use of dressed stone) than any contemporaneous imperial burial in the south. Likewise, the nearby burial of a high-ranking court figure, Sima Jinlong (d. 484), a refugee relative of the defunct Jin imperial line, had a plan and structure modeled after such Later Han burials as Holingol and Anping. Sima Jinlong's multichambered brick structure with vaulted ceilings required fifty thousand bricks made to order.

By the sixth century, tombs in the north were generally more extravagant than those in the south. They consisted of a long, sloping ramp descending from ground level to the depth of the burial chamber. Air shafts punctured the ceiling, supplying light and air. With the use of fired bricks and vaulted ceilings with corbeled

courses, a single burial chamber accommodated low platforms for a pair of coffins as well as a large range of ceramic figurines. Door panels, lintels, jambs, and pediments made from polished limestone slabs carried line engravings. In the most deluxe tombs, painting covers both this stonework and the brick walls and ceiling. Sometimes these paintings continued outside the chamber door on plastered earthen walls up the ramp to ground level. The ceiling may have celestial subjects, such as constellations, the Milky Way, and zodiacal figures and animals. An array of attendants appropriate to the social rank of the deceased occupies the walls. Ceramic figurines augmented these painted representations. Similar courtiers and servants may be found in both wall paintings and figurines. The deceased thus reposed in a simulation of his or her immediate society. With the important exception of the Mogao chapels at Dunhuang (see FIGS. 5-18, 5-19, and 5-20), murals from elite northern tombs now supply the most significant body of evidence for painting in the centuries between Han and Tang.

Lou Rui, a Northern Qi aristocrat, died in 570. His family buried him near modern Taiyuan (Shanxi), then a capital called Jinyang. Lou held the rank of "proper First Rank Noble," an honorable status that came from both his birth in the family of an empress and honors accrued during his lifetime. This station placed him at the top of a social hierarchy formalized as nine ranks. Excavators have opened only a few other tombs of such lofty personages. The figurines in Lou Rui's tomb alone exceeded six hundred items. They cover the gamut from livestock and their grooms, to household serving men and women, to the mounted and armored warriors who accompanied Lou in his official capacities. The murals around the chamber depict attendants and courtiers who accompanied the deceased. Heralds, a mounted entourage, and a camel train occupy the walls of the ramp. The two mounted warriors shown in figure 5-4 are at the rear of a procession galloping along the ramp's middle register. The horses and riders are closely bunched together so that the ones on the outside obscure the interior ones. The riders in this illustration are shown in two different views: the one at left in a three-quarter pose and the one at right in strict profile. Their horses, on the other hand, are both in profile; the one at right rears back in response to a tightening of its reins. The horses appear small in proportion to the riders but the details of each mount, its reins and saddle cloths, are all accurately accounted for. Comparatively bold and regular lines describe every form, while coloring has been applied evenly to all the bounded areas. The accomplished rendering of these riders and their companions forecasts the "great age" of horse painting in the Tang period (see FIG. 6-35). An ox inhabits the heavens of the vaulted ceiling, amid other animals of the Chinese zodiac (FIG. 5-6). This magnificent animal was first drawn on the plaster ground in a sketch using brown pigment, now visible, then the lines of the sketch were redone in ink for the finished drawing. This superimposed drawing, more controlled and also more detailed, only partially follows the sketch. Clearly the artisan wielding the brush improved on the animal as he worked. Slippery smooth lines varying somewhat in width and often ending

5-4 Mounted warriors
Detail of wall painting, Tomb of Lou Rui, Taiyuan, Shanxi. Northern Qi, c. 570 CE

5-5 Musicians playing for the pleasure of the tomb lord
Detail of wall painting, tomb at Jiuquan, Gansu. Sixteen Kingdoms, 4th century CE

in wispy tails describe this bulky animal. Lou's tomb featured extensive painting, covering a total of more than 240 square yards (200 sq. m).

Excavations of a number of imperial burial complexes have occupied archaeologists near the other Northern Qi capital, Ye. These underground chambers also are covered with murals, although none has yet been published thoroughly. Moreover, some tombs hold huge numbers of figurines, dwarfing the large quantities known from Luoyang and Taiyuan. An imperial tomb near Wanzhang (Ci County, Hebei), for example, held about 1500 figurines. The composition of this vast array is striking: 81 armored riders, 304 armed attendants, 63 armored foot soldiers, 56 archers, 83 honor-guard attendants, 83 musicians, 368 civil officials of several ranks, plus various serving and dancing figurines, livestock, and models. This large number with its strong emphasis on

military force suggests a very high-status tomb lord. We illustrate one atypical figure (FIG. 5-7). This official stands no less than 56 inches (1.4 m) tall, making it the largest tomb figure since the army of the First Emperor of Qin. The figurine was made in parts with cap, head, and torso joined. Hands within his long sleeves, the official stands at solemn attention, chest armor and long robe masking most of his body. The face has sharp features, with full lips, long nose, and pronounced, furrowed brows. One of a pair positioned outside the stone door of this tomb, a ceramic sculpture such as this compares favorably with the most sophisticated stone Buddhist images (see FIG. 5-1) from the same period. Although this tomb lacked an epitaph, its position and furnishings strongly point to an imperial attribution. Historians have suggested Gao Yang (d. 559), the founding emperor of Northern Qi.

5-6 Heavenly oxen
Detail of wall painting, Tomb of
Lou Rui, Taiyuan, Shanxi. Northern
Qi, c. 570 CE

5-7 Door guardian figurine
Northern Qi, c. 559 CE.
Earthenware, height 56¼″ (1.43 m).
Tomb at Wanzhang, Ci County,
Hebei. Institute of Archaeology,
Beijing

THE *DHARMA* COMES TO THE MIDDLE KINGDOM

The teachings of the Buddha (*dharma*) were known in the Middle Kingdom during the Later Han. Devotees from the Western Regions had been coming to the Han realm for several generations, and emigré communities were established during the first and second centuries CE. This was largely a faith and philosophy of foreigners resident in the Han territory, by all accounts marginal to the court and Han elite as a whole. The first Chinese translations of Buddhist holy texts, *sutras*, were made in Han times and still survive in the "Three Baskets" (*Tripitaka* in Sanskrit, *Dazangjing* in Chinese), the library of the Buddha's teachings, rules for monastic life, and learned commentaries. This "Chinese Canon," as it is conventionally called, came over the centuries to hold more than 2500 titles in many thousands of volumes. Rendering a text into Chinese was far more challenging than the simple term "translation" suggests. Few people knew the Indic languages of the early *sutras* (based on ancient Sanskrit) and the Central Asian languages of the monks who came to Han, as well as Chinese. Therefore the process was one of approximating meanings in steps from one language to another. More fundamentally, concepts current in Indic or Buddhist thought for which no clear counterpart existed in Chinese were expressed by coopting existing terms. Thus *fa*—"law, way, method"—became the favored Chinese equivalent for the Sanskrit term *dharma*.

The historical narrative of the *dharma* in China has usually been constructed as a cycle divisible into stages. The earliest phase is generally considered a period of introduction, preparation—embryonic. Whatever the term, the status of the *dharma* at that time, judged from a Sinocentric vantage point, is that of a newly intrusive cultural phenomenon not yet widely disseminated in Chinese culture. This may fit some of the facts, but it slights the highly evolved character and ancient history of this complex phenomenon we label "Buddhism," a nineteenth-century European coinage. Buddhism itself was not in any way "embryonic" during the centuries prior to c. 300 CE. The next several centuries, generally 300–600, are customarily regarded as a period of growth and domestication, or as formative. The total number of believers, the numbers of men and women who had taken vows, and the roles of the Buddhist community within society had grown enormously by the time of Sui unification in 589. Many characteristic features of the *dharma* in China grow over this period. As a world civilization, Buddhism was also growing and changing. Developments within China often paralleled those elsewhere and sometimes were greatly affected by them. The narrative therefore is not self-contained but rather connected to the larger, pan-Asian community.

The models by which one explains the creation of a pervasive Buddhist culture within China also require elaboration. To speak loosely of "influence" or "impact" begs specific questions. We must imagine the ways events transpired in historical time, with living human actors in real social contexts. Transmission involved several different social groups and practical mechanisms. "Elite Buddhism" was transmission by importation (the term is borrowed from Jan Nattier). If powerful patrons wished, for example, they could sponsor a learned monk from the Western Regions who could make translations or otherwise promote the *dharma*. "Evangelical Buddhism," on the other hand, was transmission by export. Buddhist believers, whether tonsured or lay persons, brought teachings with them into a new society and then actively spread the words of the Buddha to expand the community. Many monks who came to North China from oasis statelets on the routes to the west or from Kashmir (Jibin) actively proselytized. "Ethnic Buddhism," finally, designates the faith and practice of a community that moved into a new society and followed the Buddha's teachings as emigrants inside a larger society. The first Buddhist communities of the Han period were made up of such resident foreigners. Each of these mechanisms can be documented in the Six Dynasties period; each left its traces in the historical and material records.

Central Asian and Liang Buddhism

Although the overland routes that skirt the Taklamakan Desert are today part of the People's Republic, they are no less "Central Asian" sites, and this term seems preferable to phrases such as "Chinese Turkestan." (The early population of these areas was not Turkic-speaking, and its connections with China were often superficial.) This terrain is today the Xinjiang Uighur Autonomous Region, largely a desert realm with a non-Han majority population. Abundant data show that many non-Han peoples occupied these regions prior to their annexation by the Qing in the eighteenth century.

Two sites on the southern Silk Road represent the kind of presence the *dharma* had achieved during the first several centuries CE. Both locations were recorded by Sir Mark Aurel Stein during his expeditions for the British Crown in the first decades of the twentieth century. At a site called Miran, Stein uncovered ruined *stupas* (reliquary mounds) and found fragments of clay sculpture and wall painting in the ambulatory passages encircling the base level. The paintings struck his eyes as distinctly Roman or Greco-Roman and recalled the art of northwest India, Pakistan, and Afghanistan that is generally named Gandharan. Like other leading European scholars of his day, Stein was disposed to see these works this way. Trained as a classical archaeologist and linguist, he knew more than a little Greek and Latin and was well aware of Alexander the Great's forays into the Indus valley and the later Greco-Bactrian kingdoms that flourished in that region. Thus Stein interpreted the ruined wall paintings with their light and shadow and perspective effects as evidence for the eastward penetration of Greco-Roman style and culture. In the desert north of Khotan (Hetian, Xinjiang), Stein also uncovered a large monastery complex with a walled *stupa* court called Rawak ("high mansion"). Its walls were covered with large clay sculptures of Buddhas on wooden armatures or supports. Here the torsos were reminiscent of Indic sculptural styles associated with the North Indian center of Mathura, where the earliest dated Buddha images had been created. Pious monks and nuns at the beginning of the reign of the great Kushan emperor Kanishka (dates disputed, perhaps c. 75–100 CE) dedicated many of these early Mathuran images. As at Mathura, the Buddha figures from the Rawak *stupa* stand squarely on two widespread feet, their bodies cloaked by relatively lightweight robes. The swelling forms of the chest, belly, and thighs are modeled as if the thin covering garment were taut against them. The robe is augmented by fine lines or strings that represent fabric folds. Both shoulders are covered, and a cowl collar encircles the neck. By contrast with the so-called Greco-Roman style at Miran, the images from Rawak were linked stylistically to an Indian artistic center. In both instances, Stein could offer only rough dates of about fourth century CE based on coin deposits.

The Gansu corridor leading from the eastern fringe of Xinjiang southeast toward the Wei River drainage was known in this period as Liangzhou. This was the region where Huo Qubing (see page 148) enacted his military exploits against the Xiongnu in this region. During the fourth and fifth centuries the corridor was ruled by a succession of small Xiongnu and Tibetan states. By the early fifth century the Liang capital had become a center of Buddhist culture, notable for learned monks from the Western Regions. Perhaps the most influential was Kumarajiva (c. 350–410), a native of Kucha on the northern route who presided over the translation of many of the most widely read *sutras* of medieval times. Kumarajiva's rendering of the *Scripture of the Lotus Blossom of the Fine Dharma (Saddharmapundarika)* became the most influential version of that powerful text in East Asia. Kumarajiva and his cohort also translated a variety of other texts that remained at the core of Buddhist devotion and philosophy in subsequent centuries. It was the claim of several of these texts of "Greater Vehicle" (Mahayana) Buddhism that, as the words of the Buddha, they were a final and totalistic revelation of his teachings, obviating earlier *sutras* and laying before the believer an ideal of conduct (in the form of the *bodhisattva*, a being whose nature is enlightenment) and a path to salvific enlightenment.

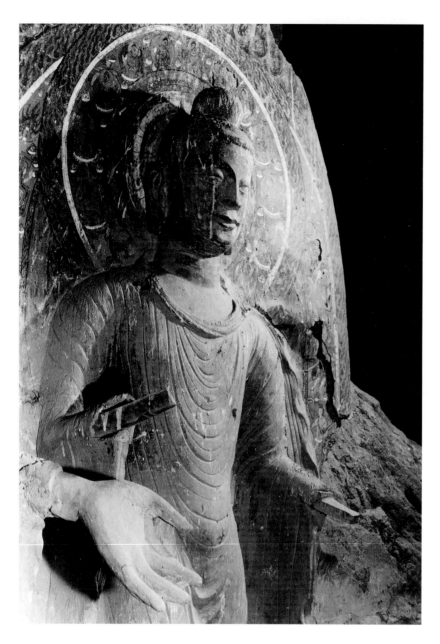

5-8 Standing Buddha
Cave 169, Bingling Si, Yongjing, Gansu. Western Qin, c. 420 CE. Clay on wooden armature, height 8′ (2.45 m)

The oldest ensemble of Buddhist images extant within China, this natural grotto high on a cliff in rugged country outside the Liang capital region features accomplished renderings of large figures derived from Central Asian and Indian models.

At some distance from the Liang capital is a cave-chapel site now known as Bingling Si (Yongjing County, Gansu). The earliest extant dated Buddhist images in China proper are clay figures and painted walls found in a natural grotto high on this cliff. Dedicated in 420 CE under the Tibetan Western Qin dynasty, these sculpted and painted images resemble those at the Rawak site near Khotan. A standing Buddha from one niche on the north wall faithfully reproduces the models created in North India (FIG. 5-8). Details such as two hems above the ankles, drapery hanging below the wrists, and the turned cowl collar reiterate conventions found at Rawak and Mathura.

At Bingling Si the head with its halo displays crisply cut nose ridge and brows, lips and eyes. This plump, idealized physical type was developed in Indian workshops to represent a "great being" (*mahasattva*) such as a Buddha. The many sculpted images and inscriptions at Bingling Si suggest that the complexities of Mahayana devotion were already in place by the early fifth century. For example, one clay image is identified as Amitayus, the Buddha of Boundless Light and Long Life, while other Buddhas and Great *Bodhisattvas* are represented in painting. Buddhas of the Three Kalpas (past, present, and future ages) and the "Five Buddhas" (Sakyamuni and his predecessors) are also present. Not least, there are donors' names, including a monk called Faxian who could be the great traveler who visited Indian holy sites around 400.

Competition among groups promoting different revelatory *sutras* led to a variety of devotional cults in this period. The *Lotus Sutra*, the several *Wisdom (Prajnaparamita) sutras*, the *Western Pure Land sutras*, the *Flower Garland Sutra*, and the *The Holy Teachings of Vimalakirti* (*Vimalakirtinirdesa*) all had a demonstrable impact on devotion, image making, and the role of the Buddhist community in society. Several *sutras* that foretold the future descent of the Buddha of the Future, Maitreya, were among the most popular in the Liang region. An impressive early example is found in Cave 275 at the Mogao chapels near Dunhuang (Gansu). Better known as the "Caves of the Thousand Buddhas," according to local tradition the grottoes were begun in the fourth century. The oldest extant chapels date only to the fifth century, c. 420–440, when the Northern Liang regime exercised control over this area. The large (nearly 11 ft; 3.3 m) seated image of Maitreya against the rear (west) wall of this cave chapel is sculpted on an armature in clay (FIG. 5-9). Much of its surface is covered with later repainting, but the robe covering both shoulders, the ridges on the skirt, and the flattened sashes on the base are likely to be original. Portions of the rear wall with a reddish-brown ground are also original in color and content. Maitreya sits on a throne with a triangular back, legs pendant and ankles crossed. His dress is that conventionally used for a

bodhisattva. He wears a long skirt (*dhoti*) but is bare chested, with a necklace and jewelry in his ears and hair. The royal attire and the *bodhisattva* attributes derive from the life story of the historical Buddha, Siddhartha Gautama, who was born a prince and existed in this world as a *bodhisattva* prior to his extinction, *nirvana*, after eighty years of life on Earth. Maitreya exists in a heavenly realm, the Tusita Pure Land. According to the major *sutras*, he will some day come down to earth, ushering in a new era.

Northern Wei Patrons

The Tabgatch (Tuoba) state supported the Buddhist community in a variety of ways. This patronage undoubtedly had complex motivations, including genuine piety, but other agendas complemented the latter. Emperors and empresses (see FIG. 5-17) and their families contributed wealth and property to the Buddhist community. The court elite too were personal patrons of Buddhist establishments, monks and nuns, and images. At the second Wei capital of Luoyang, many princely mansions were in fact turned into monasteries and nunneries on the death of the former occupant. The imperial court sponsored major projects such as the great caves at Yungang, outside the first capital of Pingcheng (near modern Datong, Shanxi). The dedications here came, in fact, after a severe proscription of the Buddhist establishment. In that light they are often seen as responses of atonement for past misdeeds. Bearing the huge expense of these large chapels may have been a kind of expiation for the bad *karma* induced by the persecution of c. 444–452. The Northern Wei state also exercised a degree of control over the community of monks and nuns. After the persecution, a monk from the Liangzhou region named Tanyao was installed as "superintendent of monks," an official post within the civil bureaucracy. Moreover, a system in which designated households contributed income and other support to Buddhist temples insured economic resources for the Buddhist community. Some writers use the term "State Buddhism" to summarize these aspects of the Buddhist community under the Wei.

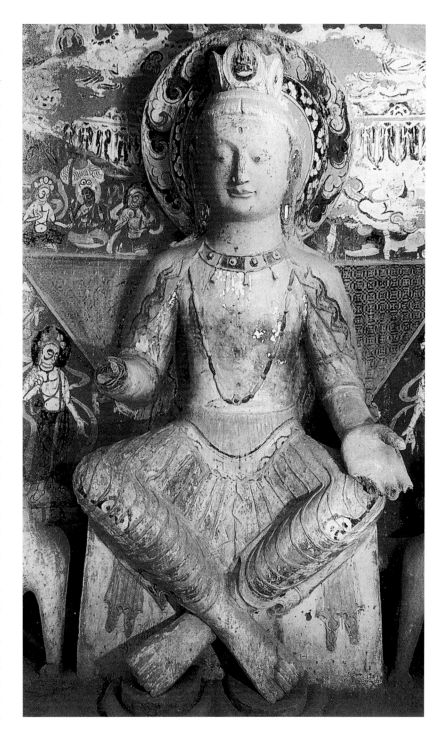

The caves cut in a sandstone cliff called Yungang (Cloudy Ridge) beginning c. 460 were the greatest projects attempted in China on behalf of the Buddhist community up to that time. The prestige and resources of the imperial state were summoned to guarantee their realization, and the results are still impressive after centuries of decay and damage. Five large caves at the west end of the cliff were probably done in two

5-9 Maitreya Buddha, Cave 275, Mogao chapels, Dunhuang, Gansu. Northern Liang, c. 420–40 CE. Clay on wooden armature, height 10′10″ (3.3 m)

phases. Numbers 18, 19, and 20 were begun first, while two eastern caves, numbers 16 and 17, seem to have been started somewhat later. This periodization, advanced by Chinese scholars responsible for the site, raises questions about the symbolical significance of this project. Many writers assume that the five large caves were dedicated to the previous five Tabgatch rulers, in line with an explicit record of five gilt-bronze images made and installed in a pagoda for this reason. More recently John Huntington has interpreted the five images as a "Buddha field" with five deities centering on the standing Buddha of Cave 18, identified as Vairocana Buddha (Pilushana), the principal Buddha of the *Flower Garland Sutra*. Given the current dating of the caves, it seems more likely that Tanyao and his helpers did not have such a scheme in mind when they began. Work on Caves 16 and 19 was not truly completed until late in the century, about the time the capital was shifted to Luoyang. Identification of two of the colossal Buddhas is secure. A cross-legged Buddha in *bodhisattva* attire in Cave 17 must be Maitreya, and a standing Buddha flanked by disciples and wearing a robe covered with a myriad small Buddhas neatly cut between the pleats (FIG. 5-10) must be Sakyamuni, the Buddha of the present age. These small emanations suggest either a miraculous event (such as that at Sravasti, where the Buddha replicated himself to an assembly) or a transcendent Buddha such as Vairocana, who represents the "body of the *dharma*" (*dharmakaya*), rather than Sakyamuni. The theory of the multiple bodies of the Buddha was an important component of Mahayana belief and philosophy at this time, and the standing figure could exemplify this understanding. When the first three images were complemented by two more, the original eastern image (Cave 18) then

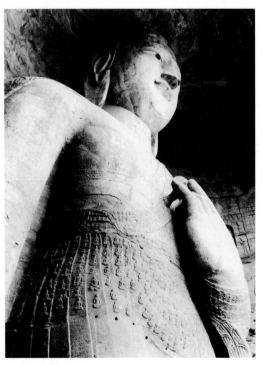

5-10 Buddha with Thousand Buddhas on robe
Cave 18, Yungang chapels, Datong, Shanxi. Northern Wei, c. 460–80 CE. Sandstone, height 51′ (15.5 m)

became the central Buddha. However, there is no evidence it was recut or otherwise emended to take into account its new, central position. Unfortunately for Huntington's argument, the traits (postures, gestures etc.) of the other Buddhas are ambiguous or uncertain and so do not support the "Buddha field" interpretation.

The exposed image of a seated Buddha designated Cave 20 has become a familiar landmark of early Buddhist art in China (FIG. 5-11). The original exterior wall has collapsed to expose this majestic figure to the elements. A standing Buddha at the west was probably destroyed by the loss of the standing wall so today only a single flanking image survives. Nonetheless it seems likely this cave represents the iconography of the Buddhas of the Three Kalpas (the past, present, and future ages). The disparity in scale between the seated Buddha (45 ft; 13.7 m) in a lotus meditation posture and the standing attendant Buddha (29 ft; 9 m) is extreme. Such a hieratic scale figured in most subsequent image ensembles. Both Buddhas are wearing so-called "western dress," attire then conventional among images in Liangzhou and along the Silk Road. Since the Wei state moved large numbers of people from the Dunhuang region to its capital at Datong, it is hardly surprising that images made there follow western models. The main Buddha is well preserved except for its hands and lower limbs, where the sandstone is much abraded. The facial features are plump and smoothly finished, with elongated eye slits, sharply cut nose and nostrils, extra large ear lobes, and wide, slightly smiling, pursed lips. The image is very broad at the shoulder and, when viewed from the sides, emerges awkwardly from the backing wall. The Buddha is in effect an extraordinarily large-scale high relief designed to overwhelm the enclosed space of its original chapel.

These five chapels created under Tanyao's direction must have produced a great sensation in the Tabgatch capital and throughout the realm. One might describe this as a "ripple effect," as when a large rock is dropped into a still pond. Images were made in explicit emulation of these grand prototypes, but to a much smaller scale. Such reproductions served as commemorative or souvenir images; brother–sister images were

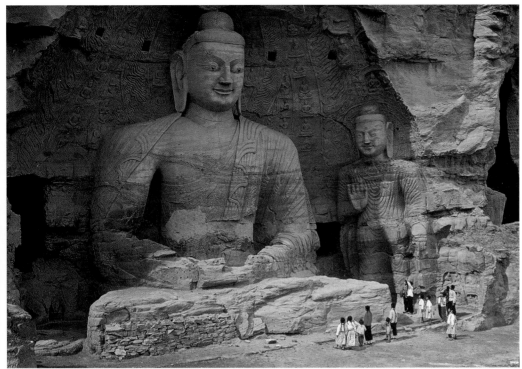

5-11 Colossal Buddha
Cave 20, Yungang chapels, Datong, Shanxi. Northern Wei, c. 460–480 CE. Sandstone, height 45′ (13.7 m)

5-12 Standing Buddha
Northern Wei, late 5th century CE. Gilt bronze, height 55″ (1.4 m). The Metropolitan Museum of Art, New York (Kennedy Fund, 1926) (26.123)

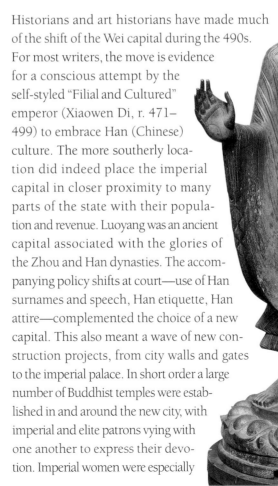

installed in other temples in the capital and elsewhere. Gift images reproducing the iconography and style were sent abroad by the court. Such processes help explain the large number of seated and standing Buddhas dated around the time of the construction of Tanyao's caves that resemble the colossal stone figures. The largest and finest is a standing Buddha, now in New York (FIG. 5-12). This graceful and pacific being falls into the lineage of Buddha images already described (FIGS. 5-8, 5-10, 5-11), descending from the North Indian type represented at Rawak and Bingling Si. It reproduces many details found on the colossal Cave 20 Buddha as well. The image is intact except for its body halo, or mandorla, and boasts a covering of gilt. Images such as this were dedicated in honor of five Tabgatch rulers, as mentioned above. Chinese Buddhist travelers including Faxian (c. 400) and the later Sungyun (c. 516–523) knew "famous" images in the Western Regions, especially in Jibin (Kashmir), Afghanistan, and North India. A gilt image like the standing Buddha could replicate an important cult image from the west, perhaps even the so-called Udyana Buddha, one of the first two images made in the earthly lifetime of Sakyamuni.

Court Patronage at Luoyang

Historians and art historians have made much of the shift of the Wei capital during the 490s. For most writers, the move is evidence for a conscious attempt by the self-styled "Filial and Cultured" emperor (Xiaowen Di, r. 471–499) to embrace Han (Chinese) culture. The more southerly location did indeed place the imperial capital in closer proximity to many parts of the state with their population and revenue. Luoyang was an ancient capital associated with the glories of the Zhou and Han dynasties. The accompanying policy shifts at court—use of Han surnames and speech, Han etiquette, Han attire—complemented the choice of a new capital. This also meant a wave of new construction projects, from city walls and gates to the imperial palace. In short order a large number of Buddhist temples were established in and around the new city, with imperial and elite patrons vying with one another to express their devotion. Imperial women were especially

active as patrons of Buddhist establishments, images, and ceremonies. The many dedicatory inscriptions from this era express ancestral piety and pious goals such as rebirth in a Pure Land or the accumulation of merit. The two pagodas discussed below and the Wei chapels opened at Longmen, south of the city, all date from the first decades of the new capital.

The greatest monument of Northern Wei Buddhism must have been the great temple and pagoda given the name "Eternal Tranquility" (Yongning Si). Located just south of the palace, this temple was constructed c. 516 under the patronage of the Grand Dowager Empress Ling. Although she was later vilified in court histories, her piety should not be questioned. She was a sponsor of other good works and of many Buddhist ceremonies on behalf of her family and the state. The empress's stereotyped, negative portrait is more likely a result of resentment engendered by her power during the reign of her juvenile son. The nine-story pagoda (*ta*) of this temple burned down in a grand conflagration in 534, but

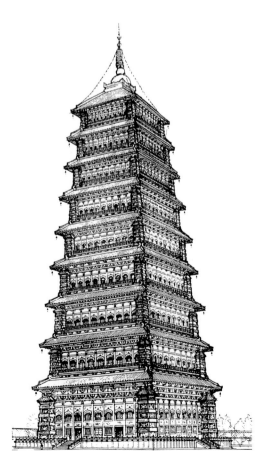

5-13 Yongning Temple pagoda

literary descriptions are reasonably detailed, and its foundations have been excavated. The literary accounts record heights of as much as 1000 feet (c. 305 m), hardly credible for a wooden-frame structure. The actual base dimensions affirm a very large structure, however, with a pounded-earth platform as much as 330 feet (100 m) square and a foundation more than 12 feet (3.6 m) thick, itself measuring 160 feet (50 m) square. Plausible interpretations, such as the recent rendering by Yang Hongxun shown here (FIG. 5-13), hypothesize an earthen core rising through several levels and a surrounding wooden frame. The total height reaches about 490 feet (150 m). This well reasoned estimate still strains credulity. The facade of Yang's drawing is derived largely from reliefs found at Yungang. Each floor has nine bays framed at the corners by miniature towers. The consistent number of bays required a regular diminution of their scale for each higher floor. The tie beams and simple brackets shown are in keeping with stone facades of the period at cave-chapel sites. The rendering of both balcony (*harmika*) and spire (*catra*) also have analogues in the period. Although the ultimate derivation of the Chinese pagoda is from the *stupa* of Indic Buddhism, the model here was more indebted to the multistoried watch towers (*lou*) of the Han era. How Buddhist pagodas evolved prior to this time remains obscure; the process was not a simple borrowing.

Quite out of keeping with this design is the oldest extant pagoda in China, the great brick monument in the foothills of Mount Song (Dengfeng, Henan). Dedicated in the 520s, the Songyue Si pagoda (FIG. 5-14) is part of a temple near a suburban Wei imperial palace. At almost 130 feet (39 m) in height, it stands perhaps one-quarter the size of the lost Yongning Si monument and only slightly taller than the oldest wooden pagoda in East Asia, the five-story example at the Hōryūji (Nara, Japan). The Mount Song pagoda rises on a thick-walled, twelve-sided base of two full stories. Then follow fifteen closely spaced eaves made of corbeled brick that trace a parabolic arc to the spire. The bottom floor is essentially plain and may have been surrounded by a now lost wooden-frame gallery. The second level has large doorways

project should be revised, and still later one that a third chapel in his honor should be added. Work on at least one of these three chapels was complete by 523 when Dowager Empress Ling visited the site. This must correspond to the so-called Central Binyang Cave (see FIGS. 5-15, 5-16, and 5-17), the largest and most lavish Wei-period chapel at Longmen. (The flanking north and south caves were completed only in the Tang era.) The work here consumed 82,366 man-days of labor, but it is not known how much of that effort was actually expended on the central cave itself. The space excavated is more than 33 feet (10 m) square and almost as high. The main image of the Buddha Sakyamuni on the rear wall is 21 feet (6.45 m) tall and is flanked by ten other large-scale images also cut from the rock as

5-14 Songyue Temple pagoda
Mount Song, Dengfeng, Henan. Northern Wei, c. 520–24 CE. Height 132′ (39 m)

5-15 Sakyamuni Buddha
Binyang Chapel, Longmen, Luoyang, Henan. Northern Wei, c. 523 CE. Limestone, height 21′ (6.45 m)

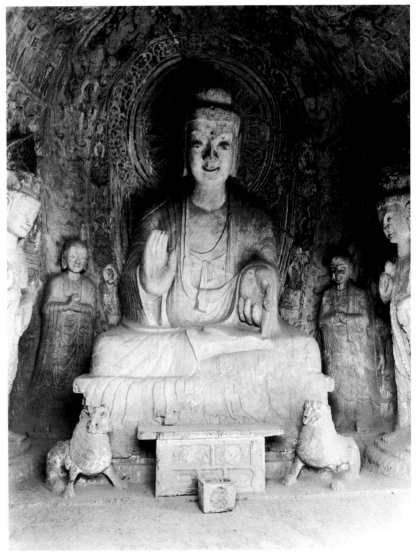

in each cardinal face and true windows in the eight intermediate walls. Those walls copy the elevation of a one-story, square *stupa*, a type associated at this time in China with the Indian king Asoka. Both the proper doors of the second level and the many miniaturized doors and windows under the fifteen eaves refer to an Indic prototype, the pointed *caitya* arch. The profile of the pagoda itself is indebted to towers (*sikhara*) over the sanctums of Indic temples. These references to non-Chinese architectural models support what texts record: Buddhist visitors from Central and Southeast Asia, including Sri Lanka and Funan (Vietnam), at the Wei courts.

The cave chapels south of Luoyang at Longmen ("Dragon Gate") on the Yi River also became a focus of imperial patronage. The "Treatise on Buddhism and Taoism" of the *Wei History* (*Wei shu*) records the effort to dedicate twin chapels to the previous emperor and empress by their son, Emperor Xuanwu, in about 500. Within a few years the emperor received a report that the

5-16 Head of Ananda
Binyang Chapel, Longmen, Luoyang, Henan

very high reliefs. The effort and detail invested were extraordinary: a ceiling with lotus designs and flying celestial beings, a floor with incised lotus motifs in imitation of carpet, and four tiers of reliefs on the front wall facing the ensemble of images.

Sakyamuni Buddha sits cross-legged on a high pedestal as the central icon of a pentad, a group of five: two standing *bodhisattvas* and two standing monks accompany him (FIG. 5-15). Each side wall has a standing triad of Buddhas with *bodhisattvas*. The entire ensemble may be interpreted as the Buddhas of the Three Ages, with Prabhutaratna or Kasyapa Buddha on one side and Maitreya Buddha on the other. The two monks or *arhats* flanking Sakyamuni contrast in appearance. The monk at the Buddha's right hand is young, perhaps intended to be Ananda, the Buddha's favorite (FIG. 5-16). The other, older figure presumably would be Mahakasyapa, the senior and most respected of the disciples. These multiple Buddhas recall the grand assemblies at the beginning of many Mahayana *sutras*, such as the *Lotus Blossom of the Fine Dharma*. Their haloes and body mandorlas, the celestials swirling above, and the other regalia of high status—from carpet to lions—truly bring the visitor into the presence of the Buddha. The makers of this cave portrayed the figures in a modified costume, perhaps another aspect of the adoption of Han customs already cited. Sakyamuni Buddha has both shoulders covered with an undergarment on the chest and a sash hanging down onto his lap. The fall of cloth over the edge of the throne platform is itself elaborated in pleasing fold patterns and ruffled edges. Similar details are visible on the standing figures, especially the hems of the Buddhas on each side. Such attire is already found at Yungang in the 480s, but became increasingly common at Longmen. It never altogether supplanted "western" garb, however, which can also be found at Longmen. Dress was a signifier of many things: attention to the rules of conduct; revered models; imperial links to the Buddhist community; and artistic styles flourishing in southern centers along the upper and lower reaches of the Yangzi River.

Images of imperial patrons actually appear, for the first time, in this cave. In spite of the major

5-17 Empress as donor
Relief removed from Binyang Chapel, Longmen, Luoyang, Henan. Limestone, height 6'4" (1.93 m). The Nelson-Atkins Museum of Art, Kansas City (40-38)

In a rare glimpse of an imperial personage, the Northern Wei empress here wears a lotus-flower head-dress and extends her arms in response to the offering of an attendant facing her at left. A matching relief illustrating an emperor as donor once flanked the chapel door but now resides in the Metropolitan Museum of Art, New York.

role of the Son of Heaven as a sponsor of artistic projects over the centuries, no credible representations of any emperor or empress survive prior to the Northern Wei period. The two reliefs that originally occupied the front wall of the Binyang Cave were hacked into pieces, but survive, reconstructed, in the Metropolitan Museum of Art (New York) and the Nelson-Atkins Museum of Art (Kansas City). The relief depicting the empress (FIG. 5-17) presents her at nearly life-size. Wearing a lotus as a crown, she is accompanied by a dozen other women of the palace in their own varied hairdos and flowing robes. Her plump features notwithstanding, it is uncertain if this is a "likeness." Yet, in its time, no visitor could mistake the reference. The composition of patron and attendants draws on conventions preserved elsewhere, as can be seen in the *Nymph of the Luo River* and Yan Liben's *Thirteen Emperors* (see FIG. 6-26).

Dunhuang: Early Narratives

Early Buddhist cave chapels were designed and decorated with careful attention to texts from the Canon and their teachings, and they respond to analysis with the textual sources at hand. Prime examples are pictorial narratives placed in the Mogao chapels (Dunhuang, Gansu): Cave 285, dated by inscription to 538/539, and Cave 428, dated to the third quarter of the sixth century.

Cave 285 is atypical in plan: a large, open chamber flanked on two sides by eight small cells, probably for meditation (FIG. 5-18). Only two other instances of this plan are preserved at the site. Such chapels would seem to have sustained both communal activities and solitary practices. The main icon is a Buddha flanked by two cross-legged monks. Indeed monks and *arhats* are at the heart of the decorative program. Meditating monks or *arhats* in a wilderness setting form a border band at the base of the ceiling. A stunning array of deities and celestial beings are pictured on the red-ground walls surrounding the three niches. More predictable painted Buddha ensembles with donors cover most of the remaining wall surfaces.

The narrative of the "five hundred robbers" is laid out in a horizontal frieze running from front to rear along the south wall (FIG. 5-19). This is an

5-18 Interior view of Cave 285

Mogao chapels, Dunhuang, Gansu. Western Wei, dated 538/39 CE

Temple worship halls and pagodas were decorated with abundant color, precious metals, and fine textiles, a far cry from the austere stone reliefs and sculptures encountered in cave chapels. This chapel evokes splendors that must equally have characterized the Binyang Cave (see FIGS. 5-16 and 5-17) and other stone-cut chapels when they were first dedicated.

episodic rendering, its discrete episodes framed more or less strictly by placement of figures, architecture, and miniaturized mountains in strong azurite and malachite pigments. At the far left, a company of warriors on foot brandishing swords and shields engages cavalry. Here the tale begins with the king's army battling five hundred robbers. To the right, below a formation of cavalry, the vanquished robbers are presented to the king, and we witness their punishment by blinding. This particular episode illustrates several steps in a sequence. Five robbers, standing for five hundred, are shown bound, stripped of their cloaks, blinded, and then suffering the agonies of their punishment in the royal courtyard. The next episode takes place in a mountainous wilderness as the blinded robbers wail in distress, contorted into grotesque poses as they realize their desperate circumstances. Another episode is portrayed just right of a pair of mountain ranges. Here the robbers have been saved and their sight restored, and

they are now seen in adoring postures before a seated Buddha. Finally, one more episode further right repeats the same composition, but with the telling detail that the one-time robbers are now in monk's dress, having taken vows. In spite of its exotic settings—the lapis mountains of the Western Regions—this pictorial rendering is what one would expect in a Chinese handscroll. A long horizontal format is well suited to episodic narration, although in scrolls the movement through time is from the viewer's right to left. The convention of a white ground on which figures and miniaturized landscape elements are placed is also in keeping with artistic practices of the two capitals, Luoyang and Nanjing. Not least, like the other icons of this chapel, the figures are drawn as elongated figures with Han-style court dress. The literary text that supplies the plot for this narrative is known from several collections in the Canon. Its message, the salvific powers of the Buddha on the one hand, and the potential for

enlightenment of all beings on the other, is firmly within the core of common Mahayana teachings.

Created on an even grander scale, Cave 428 is the largest excavation at the Mogao chapels before the Sui (589–617). The *stupa*-pillar plan here allows for a gathering of devotees in the front under a peaked ceiling and circumambulation around the pillar at rear. Painted groups on the walls complement sculpted images in niches on the four sides of the pillar. Walls flanking the doorway are in each case divided into three long registers, again calling to mind a frieze or Chinese handscroll (FIG. 5-20). The narrative on the south is the most famous of all stories of previous lives of the Buddha (*jataka*): that of Prince Mahasattva. Once upon a time in a previous incarnation Sakyamuni was a prince. One day he and his two brothers went riding in the wilderness, and there they spied a tigress and her cubs

starving for lack of food. Mahasattva, unafraid and motivated by selfless compassion (*karuna*) or charity (*dana*), offered himself to the tigress by lying on the ground. She, however, was too weak even to begin to feed. To expedite matters, Mahasattva then wounded himself with a bamboo stick and threw himself from a cliff, smashing his body on the ground within reach of the mother tiger and her offspring. Our illustration shows these two scenes in the middle register and the brothers' response thereafter below. At bottom left we see the brothers gathering Mahasattva's bones, dedicating a *stupa*, and then galloping to their father. As with the Cave 285 narrative, brightly colored mountains separate scenes, and the narrative is to be read sequentially. The virtue of charity and selflessness is one of the six perfections (*paramitas*) of the *bodhisattva* path, another cardinal teaching of Mahayana texts.

5-19 Five hundred robbers
Wall painting on south wall, Cave 285, Mogao chapels, Dunhuang, 538/39 CE

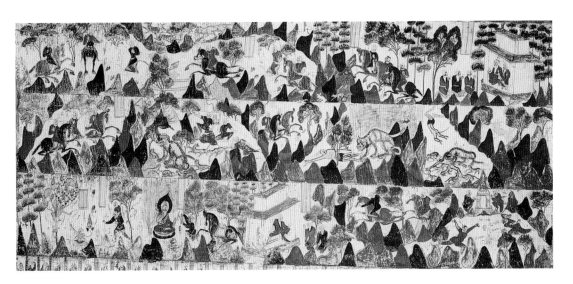

5-20 Hungry tigress (*Mahasattva jataka*)
Cave 428, Mogao chapels, Dunhuang. Northern Zhou, c. 550–575 CE

Northern Qi Patrons

We have encountered the rulers of the Northern Qi regime at their capital, Ye (see FIG. 5-2), and their tombs (FIGS. 5-4, 5-6, 5-7). The major cave chapels patronized under imperial direction have been appreciated for much longer in spite of the serious damage they suffered. The major site near Ye, Xiangtang Shan ("Echo Hall" Mountain), is actually several complexes on a pair of mountains (Fengfeng City, Hebei). Inscriptions and later records indicate imperial patronage by the first few sovereigns of the Gao lineage during the 550s–560s. The secondary capital, Jinyang (modern Taiyuan, Shanxi), was also an important cultural center, as the tomb of Lou Rui shows. Here the nearby cave-chapel site is Tianlong Shan ("Heavenly Dragon" Mountain). Both sites have the sad distinction of having been vandalized to such a degree that many heads, figures, and reliefs have been removed from the limestone and sandstone walls. Many collections outside China are replete with splendid examples.

Northern Qi patrons also commanded the energies of stone-carving workshops at Dingzhou (Ding County, Hebei), a region further north from Ye and to the east, in modern Shandong. A deposit of over 2200 marble images was found in the ruins of an ancient temple in modern Quyang in the Dingzhou region during the 1950s. The more than two hundred dated images recovered document many devotional trends, especially the rise of several key *bodhisattvas*: Maitreya, the Buddha of the Future, and Guanyin (Avalokitesvara). More recently, ancient temple sites in modern Shandong have also yielded large numbers of steles and images produced by local shops active throughout the sixth century. A standing Buddha (Sakyamuni?) represents a workshop of Qingzhou (Shandong) and has the virtue of still carrying its original polychromy or colored pigments (FIG. 5-1). The figure's torso is completely carved on all sides. The posture is erect, static, and the facial features are composed and benign. Smooth surfaces and full features characterize the head, while the robe drapes the torso so closely that little of the underlying physique can be observed. The stone is covered by umber and lapis pigment and gilt, describing an elegant monk's robe. The restrained treatment of the robe contrasts with the animated linear details of Northern Wei products, and the sculptor gives greater attention to the volume of the body—both prerequisites for images of the Sui and Tang.

LUXURY AND ELITE ARTS

Specialized craft production for the elite continued during this period at capitals and regional centers. The resources and range of products available were not uniform, however, because the map was divided between competing states. Some kinds of production, like ceramics, were widespread, and regional centers supplied a considerable variety of goods for both everyday and mortuary purposes. Green wares (celadons) were produced in the Lower, Middle, and Upper Yangzi macroregions as well as in the north, for example. The number of production centers for other craft industries such as lacquer wares and silk textiles must have been more limited, since raw materials (lac and cocoons) were not equally available in all macroregions. Such products were certainly traded across political boundaries and figured in gift exchanges between rival courts. Metal objects, including some of gold and silver, were also made in this period, but the number of metal vessels that survive is greatly reduced when compared to the early empire. There must have been a decisive shift away from the use of bronze vessels for many purposes, perhaps in favor of high-quality glazed ceramics and lacquer wares. Based on present evidence the working of hardstones seems to have been in eclipse. Sources for the minerals in the Western Regions may have been inaccessible.

Stonewares and Glazes

As early as the Shang and Western Zhou periods, potters were experimenting with clays that could be fired at high temperatures (c. 1200°C). In a reducing atmosphere, these clays burned to a gray color. Most authors designate such bodies "stoneware." High temperature fuses particles in the clay, rendering the bodies non-porous,

relatively hard, and less easily broken. These early stonewares, moreover, have a coating of glaze (see FIG. 2-12 above). This is slip with enough silica to form a glassy surface on the vessel during firing. While some glazing might have been accidental, the result of random ash deposits for example, most vessels clearly were dipped in, or painted with, a solution prior to firing. Thin glazes cover the surface but also collect in puddles or drips. These glassy spots are sometimes crackled as a result of shrinkage during cooling.

During the Southern Dynasties, major kiln centers in modern-day Zhejiang, both north and east of Hangzhou, produced stonewares with grayish-green glazes. With an eye on their glazes, European writers dubbed such ceramics either "greenwares" or "celadons," the latter term derived from the name of a theatrical character who wore a light green costume. The properties of these glazes are the result of their chemical recipes, which utilized feldspar as a fluxing agent and small amounts of iron for color. An iron content of 3 per cent can produce a dark brown glaze sometimes compared to burnt sugar (Deqing wares). Much smaller percentages yield the more typical gray-green tonalities. Starting at least by the third century, these kiln centers utilized "dragon kilns"—a type of kiln, with a large firing chamber on a pronounced slope, which can accommodate hundreds of pieces in a single firing. The forms produced, many using a fast wheel, range in size from diminutive water droppers, through basins and pitchers, to larger crocks and urns. Human and animal figurines and models for burial were made by using a variety of hand-modeling and slab techniques.

Ceramic production in the north paralleled that of the south. Many of the same utilitarian and mortuary types are found, including the ubiquitous pitchers with "chicken-head" spouts. However, several key developments are associated with northern kilns and most probably originated there during the sixth century, if not before. Unlike in the Lower Yangzi region, kiln sites of this period are not well documented, except for Shandong. Potters working in the Northern Qi realm had access to a fine-particle clay that burned white upon firing. By firing at

high temperatures and experimenting with glazes, northern potters created precursors of "true porcelains." (Here we use the term to designate a hard, brittle, non-porous white body covered by a clear glaze. By convention, a true porcelain is also translucent and resonant when struck.) With a clear glaze, these vessels are of course white wares, and white wares flourished in the subsequent Sui and Tang periods in Hebei and Henan (see pages 214–215). When the glazes incorporated minerals that change color in firing, however, polychrome effects were achieved. A jar from the tomb of Li Yun (d. 576) near Puyang (Henan) was made from white clay thrown on a wheel (FIG. 5-21). Raised lotus petals rendered with a knife define the waist, and carved square lugs have been applied at the shoulder. The petals are incised lines, as is the band just below the shoulder. Green and brown colors are played off in the glaze. The overall brown was probably achieved by dipping the pot, while the vertical green splashes must have been applied with a brush or by dribbling the mineral onto the slip. Other vessels exhibit similar experiments with freely applied touches of contrasting colors. Such wares are precursors of the "three-colored," *sancai*, mortuary vessels and figurines of the Tang.

The use of appliqué elements to create a more complex silhouette and busier surface design can be charted during the late sixth century. Several large vases from burials in Hebei, one dated 565, and related pieces in other collections illustrate this aesthetic. Made on a wheel, the vessels have segmented bodies that suggest components more commonly combined in metalwork. The example illustrated (FIG. 5-22) has both a tall ring foot and a tall neck with everted rim. Large lugs are mounted at equally spaced points on the shoulder. The body proper is divided

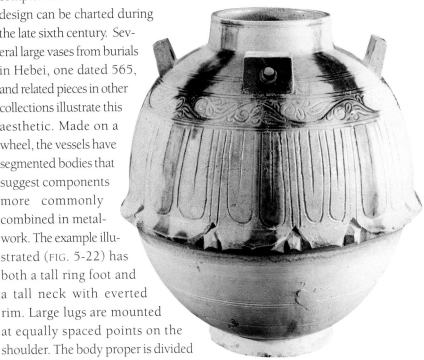

5-21 Jar with four lugs
Tomb of Li Yun, Puyang, Henan. Northern Qi, c. 576 CE. Stoneware with glaze, height 9¼" (23.5 cm). National Museum of History, Beijing

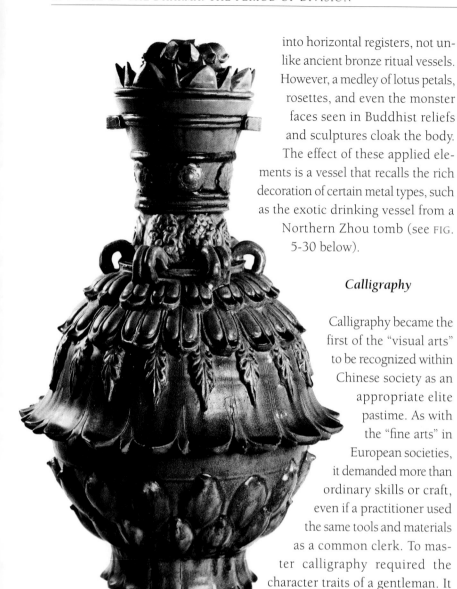

5-22 Tall jar with appliqué decor
Northern Qi, c. 565 CE. Stoneware, height 27½" (70 cm). Tomb of Feng Shihui, Jing County, Hebei. National Museum of History, Beijing

into horizontal registers, not unlike ancient bronze ritual vessels. However, a medley of lotus petals, rosettes, and even the monster faces seen in Buddhist reliefs and sculptures cloak the body. The effect of these applied elements is a vessel that recalls the rich decoration of certain metal types, such as the exotic drinking vessel from a Northern Zhou tomb (see FIG. 5-30 below).

Calligraphy

Calligraphy became the first of the "visual arts" to be recognized within Chinese society as an appropriate elite pastime. As with the "fine arts" in European societies, it demanded more than ordinary skills or craft, even if a practitioner used the same tools and materials as a common clerk. To master calligraphy required the character traits of a gentleman. It was likewise an intellectual discipline, and serious study was essential to its mastery. Calligraphy was an art form with an explicit relation to its own history and to works of the past. As calligraphic specimens were collected, critical terminology was borrowed from other fields to express ideas about and reactions to this abstract art. Terms first employed in evaluating human character for bureaucratic purposes became part of the critical parlance of calligraphy. With collecting also came catalogues and, not surprisingly, forgery and debates about authenticity. History was written about the most famous masters and their works, and this lore in turn affected the perception of and reception of brush writing.

Wang Xizhi (307–365) was born into an elite family prominent in the Eastern Jin court society of his day. Even in his lifetime, Wang's calligraphy became highly prized by his social peers and was the object of determined collectors soon after his death. His legacy was evidently perpetuated within his family and their social circle. By the Sui and early Tang periods, it came to dominate the practice of calligraphy. Lothar Ledderose has characterized the works of Wang and his son, Wang Xianzhi (344–388), as the "Classical Tradition" because they served as a reservoir of models for calligraphers working in all three modern script types, especially running and regular (see "Script Types," page 175). Brush-written specimens (*tie*) of the "Two Wangs" are exceedingly rare; it is unlikely any piece now extant is actually from their hands. However, a number of tracing copies with excellent pedigrees do exist. These copies were made in the early Tang, when the enthusiasm for such works was at its peak. We cannot second-guess the claims made in that period for these specimens. However, these works and others now known only from rubbings became the core of the classical tradition in the eyes of Tang-period and later students of calligraphy.

Among brush-written specimens, we illustrate the *Sangluan tie* (FIG. 5-23). This work does not appear in premodern Chinese literature on the Wangs by virtue of the fact that it was preserved in Japan, presumably from the eighth century onward. The text is actually a letter written by Wang Xizhi discussing the funeral of a relative. The title is taken from the fifth and sixth graphs (*sang, luan*) in the first column at the right. The ink employed is a rich, saturated black applied in generous, often wide strokes. These thick touches are, however, juxtaposed with much thinner strokes, with exceedingly thin ligatures (connections) between the strokes. Some strokes betray split brush hairs or the drying of the brush as its ink was expended. The impression of unstudied, spontaneous writing is reinforced by the internal structure of each graph. Horizontals tilt from lower left to upper right. Vertical, axial strokes are skewed, so that they also incline left. The traces of the brush create an impression of animation as if the graphs were dancing

Script Types

Three script types developed during the Han period through the collective efforts of thousands of scribes and officials wielding their brushes. In contrast to the types already introduced, these new script types were written with a soft brush on silk or paper, the latter becoming increasingly important from Later (Eastern) Han onward. Each type is therefore indebted to habits of brush writing. The new medium must, however, have given calligraphers greater freedom to experiment with different sizes of graphs, different relationships from top to bottom and side to side, and also the different effects of brush and ink on paper. Early examples of writing on paper recovered from such Central Asian sites as Dunhuang (Gansu) and Astana (Xinjiang) show a variety of handwriting, more or less controlled, more or less free, more or less in debt to the habits of Han clerical script (*li shu*; see FIG. 4-3 above).

Cursive script (*cao shu*; also commonly called "grass" or "draft" script) first appears in documents of the Han period. Its essential features are rapid execution and simplification. Individual graphs are written more economically by connecting or eliminating strokes and dots. Over time these new "spellings" became conventionalized. When individuals created their own abbreviated forms, they risked illegibility. The cursive script that became normative during the period of the Southern Dynasties was a gentleman's informal and personal medium for communication, well suited to letters and other non-

official purposes. It retained this unofficial identity until later periods. By the Tang period even works written in cursive script were engraved on stone monuments.

The running script (*xing shu*; also called "semi-cursive") is an intermediate stage between the license of the cursive script and the standardization of regular script (see below). Like cursive, running script is written at some speed and admits abbreviations or shortcuts. However, the structure or "spelling" of each graph is more closely related to the full, regular script forms, so recognition is not endangered. The great names of the Eastern Jin period, especially the "Two Wangs," put their stamp of approval on running script (see FIG. 5-23). This favored status affected the development of its formal traits and its critical reception.

Regular script (*kai shu*) descends most directly from Han clerical script. It is the most formal of the three script types discussed here and became the standard writing of the period of division. In this script type, individual strokes and dots are normally separate actions of the hand and brush, without any connections between strokes in sequence. By definition, all components of each graph are fully rendered without abbreviation, although variant spellings are known. The implied pace of execution is steady, even stately. Individual graphs are of consistent size, and ink is applied to the brush consistently. Regular script was used for public purposes, such as inscriptions and court documents.

on the paper. All of these nuances of applying ink to paper add interest. The very unsuitability of these graphs for official or formal purposes is part of their appeal. The first two graphs of the first column (*xi, zhi*) are Wang Xizhi's own name.

This kind of personal writing can be contrasted with a more studied and controlled work in regular script, the "Preface to the Gathering at the Orchid Pavilion" (*Lanting xu*; FIG. 5-24). According to the lore on the "Two Wangs," the

original version was recovered by the Tang emperor Taizong in the mid-seventh century and then interred in his tomb. Thus no one since has claimed to have access to anything but copies, and it is known only through reproductions. We illustrate the so-called "Dingwu Version," a highly regarded rubbing from a stone-cut copy originally in a place of that name in modern Hebei. The text begins by narrating the date and location where the famous gathering of poets took place. Wang's graphs

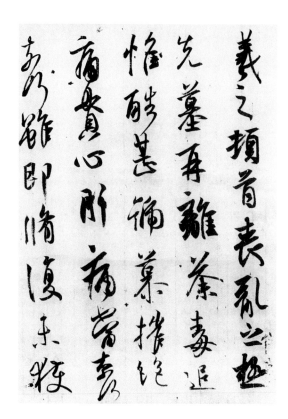

**5-23 Att. to Wang Xizhi,
*Sangluan tie***

Eastern Jin, c. 356 CE (Tang-period copy). Ink on paper. Private collection, Japan

**5-24 Att. to Wang Xizhi,
Lanting Preface, Dingwu
Version**

Eastern Jin, c. 353 CE. Rubbing. National Palace Museum, Taipei, Taiwan

are completely legible and are composed of discrete strokes and dots of relatively consistent thickness and visual weight. At the same time, this work has many qualities of a draft. The number of characters varies from column to column, some graphs are crossed out and rewritten, and omitted graphs are inserted between columns. Moreover, the resilient quality of every stroke invigorates the graphs; there are no wooden or

dead strokes. Some of the qualities found in the *Sangluan tie* are also found here, although this script is written with a more controlled rhythm. There is sufficient variation among the many versions of the "Lanting Preface" to make some of these observations debatable. For example, in certain copies some graphs exhibit more ligatures and other running-script features than the same graphs in this Dingwu version. Such variety within a single model only complicates questions surrounding Wang's own writing and its contribution to later works.

Secular Painting

Calligraphy may claim to be the first "visual art" accorded the status of a gentleman's pursuit, but painting was only a few paces behind. Some peers of the "Two Wangs" were highly regarded for their abilities at painting. By the early sixth century we have texts that rank and criticize named painters from the Han period onward. Both the record compiled by Xie He (c. 500–535) evaluating ancient painters (see "The Six Laws of Xie He," page 177) and its continuation by Yao Zui (535–602) employ critical terms borrowed from calligraphy and poetry. Their judgments assume some level of identity between the personality or character of the man and the quality of the painted work. As with calligraphy, the combination of elite social status and skill at a craft

led to problems. In the *New Account of Tales of the World (Shi shuo xin yu)*, an early fifth-century anthology, we read of a calligrapher admonishing his sons not to pursue his art. The reason: he had been humiliated at court by being forced to inscribe a plaque already in place high above the throne hall. In other words, he had been treated like a common artisan. A parallel humiliation befell the early Tang court official and painter Yan Liben (d. 673). Yan senior too advised his sons to abjure his art.

Evidence for painting in this period comprises two categories of images. The first is a growing number of authentic works: tomb murals from North China (see FIGS. 5-4, 5-5, and 5-6 above); murals at the Mogao chapels (FIGS. 5-19, 5-20); and reliefs, engraved stones, and impressed bricks with pictorial content (see FIGS. 5-26 and 5-29 below). These works were never studied by premodern scholars and for the most part were not even accessible until the twentieth century. A second category of evidence is a much smaller number of compositions preserved in portable, hand-scroll format that are traditionally attributed to this time. Until recently, art historians conceived and understood the history of Chinese painting and painters exclusively from textual sources and these attributions. From

"The Six Laws of Xie He"

Critical writings went beyond ranking painters. Aesthetic criteria for judging good painting also appear, as does prescriptive advice. The most famous of these desiderata are the so-called "Six Laws" (*liu fa*) found in Xie He's text and copied into Zhang Yanyuan's ninth-century history of painting (see pages 218–219). How to read and understand these utterances depends both on which text one reads and on how one imagines their usage. Below are three sets of translations by William Acker, Alexander Soper, and James Cahill.

(1) Spirit resonance which means vitality. (Acker)
Animation through spirit consonance. (Soper)
Engender a sense of movement through spirit consonance. (Cahill)

(2) Bone method which is a way of using the brush. (Acker)
Structural method in the use of the brush. (Soper)
Use the brush with the bone method. (Cahill)

(3) Correspondence to the object which means the depicting of forms. (Acker)
Fidelity to object in portraying forms. (Soper)
Responding to things, depict their forms. (Cahill)

(4) Suitability of type which has to do with laying on of colors. (Acker)
Conformity of kind in applying colors. (Soper)
According to kind, describe appearances. (Cahill)

(5) Division and planning, i.e. placing and arrangement. (Acker)
Proper planning and placing elements. (Soper)
Dividing and planning, positioning and arranging. (Cahill)

(6) Transmission by copying, that is to say the copying of models. (Acker)
Transmission in making copies. (Soper)
Transmitting and conveying earlier models through copying and transcribing. (Cahill)

The six "laws" are actually several kinds of statements. The first four employ a syntax in which a preliminary phrase yields a following result. (Cahill's translations of 3 and 4 preserve this order; in 1 and 2 he inverts the phrases.) On the other hand, by their syntax laws 5 and 6 pair nearly synonymous phrases, all technical aspects. Law 1 in particular is susceptible to a variety of interpretations. Most readers have seen it as an invocation to convey "vitality" or "animation" (*sheng dong*). Works of quality do so, but inferior works lack this characteristic. Law 2 is also open to various readings since "bone method" (*gu fa*) is not clearly defined, either here or in other texts on painting or calligraphy. As a set, the six laws establish a combination of qualitative standards and technical requirements. By contrast, late Tang texts on painting take much of this for granted and instead emphasize the importance of brushwork as the overriding concern of the critic.

(Acker, *Some T'ang and Pre-T'ang Texts*; Cahill, "The Six Laws and How to Read Them," pp. 372–381; Soper, "The First Two Laws of Hsieh Ho," pp. 412–423)

遷致盈必損理育固然美者自美翻以

取尤冶容求好君子所沈結恩而絕寔

此之由

**5-25 Att. to Gu Kaizhi,
*Admonitions of the Court
Instructress***
Eastern Jin, 4th century CE
(Tang-period copy).
Handscroll, ink and pigment
on silk, 9¾" × 11′4½" (25
cm × 3.45 m). The British
Museum, London

our perspective, however, literary sources and portable works must be judged against authentic extant evidence. Neither category can stand by itself for "painting" in this period. Judgments about either category must be informed by an understanding of the other.

Gu Kaizhi (c. 344/345–406), a gentleman of the Eastern Jin period, is one of the great names in the early literature of Chinese painting. Gu's biography is included in the official *Jin History* (*Jin shu*), compiled in the seventh century. Many of the anecdotes associated with Gu there were in

fact drawn from the fifth-century *New Account of Tales of the World*. In these anecdotes, Gu is praised as a maker of portraits of notables of his social circle but also as a cultivated literatus, both wise and foolish. By Tang times, a sizeable number of titles were associated with Gu's name. The catalogue of the Northern Song imperial collection recorded still more. *The Admonitions of the Court Instructress* (*Nu shi zhen*; FIG. 5-25), now in the British Museum, London, was attributed to Gu by the Song scholar, calligrapher, and connoisseur Mi Fu (eleventh century). The scroll bears a signature that may well be a later addition, as well as a purported seal from a Tang imperial academy of the eighth century. Few modern scholars would claim this silk handscroll is from Gu's hand or even his time. It is more likely a copy of an early work, preserving a pre-Tang composition.

Zhang Hua (232–300) compiled the text that inspired the scroll. It mixes simple prescriptions ("Favor must not be abused, and love must not be exclusive") with longer historical episodes in which ladies of the past acted virtuously. One passage describes an episode in which Lady Ban of Former Han times refuses an improper imperial favor:

> The Lady Ban declined, despite her desire, to accompany the Emperor in his palanquin. How could she not have been sad, but, forfending the unseemly, she acted with prudence.
> (Hsio-yen Shih, "Poetry Illustration," pp. 10–12)

The issue would seem to be an emperor allowing a consort improper privileges. Whatever the

**5-26 Seven Worthies of the Bamboo Grove
(rubbing)**
Eastern Jin, late 4th century CE. Stamped bricks,
overall length 7′10″ (2.4 m). Tomb at Xishan
Bridge, Nanjing, Jiangsu. Nanjing Museum

ruler's lack of virtue, the lady is admonished to uphold proper standards, feminine virtue in this instance compensating for the Son of Heaven's own weaknesses. Implicit is a long-held belief that female companions tempted the ruler and had to be limited to prescribed roles. In this scheme of things, the woman is virtuous for not exceeding her social role; she knows her place. The pictorial illustration is complex: a woman in profile at right faces a man within a large sedan chair carried by an awkward company of male attendants. The eye contact of the two protagonists must signify their conversation. The unseemly privilege being offered must be the honor of riding with the Son of Heaven.

· We have discussed this episode from the nine in the scroll because its main compositional device is part of a lacquered miniature screen found in a nobleman's tomb near the first Northern Wei capital (modern Datong, Shanxi). The tomb was that of one Sima Jinlong (d. 484), a southern refugee nobleman who served the Tabgatch (Tuoba) rulers. One scene on the screen (FIG. 5-27) represents the same historical episode involving Lady Ban. Here, however, the sedan chair is somewhat different and the number of bearers reduced. Perhaps the most marked contrast with the handscroll is the incongruities of scale between the four bearers, the emperor, and Lady Ban. The screen from Sima Jinlong's tomb may well have been produced in a southern workshop. Its subjects and compositions were probably conventional by this time. Even if the screen is dated only as imprecisely as some time in the fifth century, it is aligned with the end of Gu's own lifetime and the following generations. Thus a screen found in a northern tomb may testify to the pictorial art of the south.

Both the screen and the handscroll draw on a conventional composition devised for Lady Ban's story. In addition to specific props, both works share such fundamentals as a plain background and the juxtaposition of text and images in the visual field. The *Admonitions* scenes stand in a tradition of narrative illustration that shares conventional compositions for specific episodes with other, earlier works such as the screen. Comparisons might be taken yet another step. The ladies in the handscroll are slim figures standing in rigid profile (see, for example, FIG. 5-25). Their long dresses drag across an imaginary ground, while long sashes flutter behind, as if in a breeze. Much the same formal description applies to the Lady Ban on the lacquer screen. Her face and torso are turned, rather than in strict profile, but the fall of her hem and her animated sashes are similar. The manifest points in common strengthen the probability that the *Admonitions* scroll is a pre-Tang composition and that its stylistic vocabulary dates from the era of Gu Kaizhi.

The most sophisticated figural design from the time and place of Gu Kaizhi depicts the so-called "Seven Worthies of the Bamboo Grove" (*Zhu lin qi xian*), well-known eccentrics of the third century, with another more ancient legendary figure, Rong Qiqi (see FIG. 5-26). Gu is in fact recorded as a painter of this subject matter, as are a number of other well-known painters of the southern courts. The design has been transmitted to the twentieth century by the happy accident that three tombs with this theme on their walls have been excavated near Nanjing. The best known and most accomplished is a tomb of late fourth-century date at a site called Xishan Bridge outside

5-27 Lady Ban

Detail from lacquer screen. Northern Wei, 5th century CE. Tomb of Sima Jinlong, Datong, Shanxi. Datong City Museum

By contrast with the better known composition of the same theme attributed to Gu Kaizhi (see FIG. 5-25), in this detail Lady Ban faces down Emperor Cheng, shown seated alone in his sedan chair. The scroll attributed to Gu amplifies the composition but, like the lacquer screen, must depend ultimately on a common model.

the city. Two other examples in Danyang, the county east of Nanjing where the Qi and Liang imperial tombs are situated, preserve the same design. These walls are less well done and indeed mislabel some figures. The technique employed required stamping the narrow edges of bricks into a master mold so that when they were assembled in proper order a larger composition took shape. The making of the master molds presumes drawing a full-scale cartoon that was transfered to the molds. The cartoon, in turn, must derive from an original design, whether conventional or from one of the famous painters of the period. Whatever its ultimate origin, the "Seven Worthies" best epitomizes the figural art of the early Southern Dynasties.

In the Xishan Bridge tomb, the wall surface given over to this subject is about 32 inches (80 cm) high and almost 8 feet (2.4 m) long. Several hundred bricks were required for the composition. Each panel begins and ends with gingko trees of the region, and other trees—pine, locust, and willow—punctuate the design, separating the seated figures. On the south wall (FIG. 5-26), the figures are paired, two and two, by their inward gazes, and some communication may be implied. On the north wall, however (again, see FIG. 5-26), three of the figures look right, to the tomb entry, while the figure at the right end is frontal. The designer gave great attention to varying details of posture and action among these gentlemen: one plays a lute, another whistles, one raises a wine cup, another twirls a back scratcher. All are seated upon mats on the ground, either in cross-legged postures similar to a Buddha image or in more

casual attitudes with a leg raised or stretched out. Although facial details also differ, the physiognomies are more alike than different. Six of the men are shown in a three-quarters position, with the same chins, noses, brows, and ears.

The "Seven Worthies" truly represents the court art of the Southern Dynasties, the society of such painters as Gu Kaizhi. As a theme, it also epitomized social and intellectual currents of the time: the emphasis on self-cultivation and reclusion, in contrast to the normative "Confucian" injunction to serve the state and promote family values. The worthies are individuals, even if generated from a common figural and stylistic idiom, and this too accords with the social values of the day. In the two Danyang tombs, moreover, the "Worthies" are placed on walls within a matrix of other subjects including auspicious animals, celestials, and immortals. The fusion of such worldly and other-worldly types was long ago established in Han tomb decoration and here must also respond to the rise of elite interest in Daoism.

Cao Zhi (192–232), a prince of the imperial Wei house, established a reputation as a poet. One of his best known works, *Nymph of the Luo River* (*Luo shen fu*), narrates an encounter with a fairy spirit in the year 223. The preface describes the prince's departure from the capital and his vision of the nymph. Four extant handscrolls

illustrate Cao's poem: a twelfth- or thirteenth-century work on silk in the Freer Gallery of Art (Washington, D.C.), another of similar date in the Liaoning Provincial Museum (Shenyang), and two more, dates less certain, in the Palace Museum (Beijing). Two of these scrolls have the text of Cao's poem written in open areas within the composition. All are regarded today as copies at various removes from an early, pre-Tang design. Considered as a group, one can appreciate how the visual design conveys the narrative of the poem and how an early figural painting might have incorporated landscape settings. In the detail shown here (FIG. 5-28), the seated prince and his standing retinue gaze at the "nymph" from the river bank. Across the bottom margin of the silk are the rudiments of an outdoor setting with rocks, shrubs, and diminutive trees. These kinds of landscape elements characterize all four scrolls, although details vary. The tentative use of landscape elements was noted in the discussion of two Buddhist narratives above: the "five hundred robbers" (FIG. 5-19) and the "hungry tigress" (FIG. 5-20). In fact, these compositions share many traits: relatively large figures, out-of-scale landscape elements, an episodic exposition of the narrative, the use of land forms to punctuate episodes, generous open space, and sometimes the interpolation of texts. Painters of the fifth and sixth centuries had already begun the gradual integration of setting and human actors. All of our examples demonstrate the primacy of story telling at this stage.

The virtues of "filial" sons (*xiao zi*) figure prominently in early pictorial art. An impressive design, not later than the first quarter of the sixth century, was engraved on the two long sides of a sarcophagus now in the Nelson-Atkins Museum of Art, Kansas City (FIG. 5-29). Everything about this object—its stone, the decorative borders that frame the composition, the line engraving—declare it to be a product of a court workshop at Luoyang, the late Northern Wei capital. On the other hand, the pictorial design has roots in the art of the southern courts. Like the "Seven Worthies" composition, it could have been devised in the first instance by a noted painter or perhaps simply transmitted by a workshop. The scene we illustrate recounts the tale of a filial grandson. On the right, Yuan Gu helps his father carry Yuan's grandfather out to the wilds to die. The family cannot support itself, and the old man must be sacrificed if the family is to survive. In the scene at left, the boy carries the litter under his arm as his father turns back. "Why are you carrying that hateful thing," the father inquires. "I'll need it for you some day," replies the boy, thereby effecting a rapid change in his father's heart. Father and son then reclaim

5-28 Nymph of the Luo River
Eastern Jin (Northern Song copy). Handscroll, ink and pigment on silk, 10½″ × 18′9″ (27 cm × 5.72 m). The Palace Museum, Beijing

grandfather, determined somehow to make do in spite of their hardships. Thus the proper respect and love accorded a parent, filial piety, works its good influence on society.

The two scenes are cleverly enfolded in a more fully rendered landscape setting. Strange pillarlike rocks establish the near and far edges of the "stage" on which the figures move. Long-trunked trees, again reminiscent of the Nanjing "Seven Worthies," alternate at front and rear. The figures are now more appropriately smaller than the trees. A ground plane has been worked in by means of scattered rocks and a stream flowing across to the left. The narrative is presented as two groups of figures: three protagonists with a telling prop. Thus the story is divided into scenes, with a handy rock dividing the two moments. The upper register reveals agitated trees, puffing clouds, and birds with long tails whipped by the wind. Altogether six scenes of filial virtue, many of them stories in circulation since Han times, occupy the two sides of the sarcophagus, which demonstrates the persistence of Han-period subject matter, as well as the strides in pictorial art associated with the Nanjing courts and the high quality of mortuary art under the Northern Wei.

BEYOND THE MIDDLE KINGDOM

The period of division would seem at first an unlikely time for significant foreign contacts. With the north occupied by non-Han states, the refugee regimes centered on Nanjing found themselves effectively cut off from the Gansu corridor and hence the Western Regions. Similarly, the Northern Dynasties had less ability to communicate with the peoples of the southern oceans because of their enemies in the south. Yet, in spite of these obstacles, cultural relations with peoples from India, Southeast Asia, and Central Asia figure more prominently at this period than at any time before. The best known episodes and personalities are tied to the *dharma*. Consider the supposed arrival of an Indian prince, Bodhidharma (Damo), the patriarch of Meditation (Chan) Buddhism in China, whose travels took him first to the Nanjing court and then across the Yangzi to the slopes of Mount Song, outside Luoyang. The Songyue Temple pagoda of the early sixth century (see FIG. 5-14 above) provides tangible proof of Indic or Southeast Asian contacts with the Northern Wei capital, whether direct or indirect. The Northern Wei received foreign embassies from West Asian powers. Numerous visitations from Ferghana,

Sasanian Persia, and Sogdia are duly recorded in the dynastic history. The Nanjing courts likewise maintained relations with the states of peninsular Southeast Asia and the Korean peninsula.

Foreign emissaries, traders, and residents in Chinese cities left behind a residue of exotic artifacts. Glass, which played a minor role in the material culture of ancient China, had begun to appear in the Han period. Both northern and southern elites seem to have had some access to foreign glass, Byzantine and Sasanian work in particular. A clear glass bowl with a faceted surface made by grinding the exterior comes from a tomb at modern Datong (Shanxi), the Northern Wei capital until 494. A mere 4 inches (10 cm) in diameter at the mouth, this kind of bowl was widespread in the Persian lands. A similar object survives among the eighth-century donations placed in the Shōsōin (Nara, Japan). Precious metal objects also date to this period and testify to other sources of exotica. Byzantine and Sasanian silver objects appeared at about the same time that the Northern Wei consolidated their control over the north, the mid-fifth century. Several caches and tombs with such objects have been recovered from the Datong area, suggesting they had become the property of Tuoba court figures. A tall ewer of gilded silver (FIG. 5-30) adorned with repoussé classical figures may be of Sasanian or Sogdian manufacture. This beautiful example belonged to one Li Xian, an important figure at the Northern Zhou court who was ensconced on the frontier (modern-day Ningxia). His great-granddaughter, Li Jingxun, will be mentioned below in chapter 6 (see pages 221–222). Classical motifs traveled to East Asia on such precious objects, but also via architecture, such as the classical orders and moldings of Gandharan *stupas* and other Buddhist monuments.

The centuries of division contributed much to the later growth of Chinese society and culture. The forced removal of the capital and its elites from the north prompted the demographic and economic development of the south, especially the Middle and Lower Yangzi macroregions. The admixture of non-Han peoples to the population of North China and the impact of non-Han rulers over several centuries also left lasting traces in elite society. The rulers of Sui and Tang and their peers from the northwest would have grown up in a hybrid culture with martial traditions and affinities to peoples of the steppe lands that distinguished them from their southern peers. The Buddhist "conquest" of both north and south, on the other hand, constituted the greatest single force for cultural change, affecting social practices, intellectual developments, and material culture alike. The energies of the cultivated elite, especially in the southern courts, initiated cultural practices, such as calligraphy and painting, that continued with increasing vigor in the unified Sui–Tang age. The foundations of a cosmopolitan culture, so closely identified with the Tang, actually took shape in the Northern Dynasties and their frequent interactions with the cultures of Western Asia. In all of these ways, the period of division transcends any pejorative judgment as the age when the Han imperium had collapsed.

5-30 Ewer with classical figures
Sasanian or Sogdian, 6th century CE. Silver with gilding, height 14¼" (36 cm). Tomb of Li Xian, Guyuan, Ningxia. Guyuan County Museum, Ningxia

The shape of ewers like this one became relatively common in Tang ceramics, but few Chinese gold and silver examples survive. Figural friezes, however, were not much emulated. Exotic objects, like all aspects of foreign cultures, were appreciated selectively and integrated based on existing tastes and practical needs.

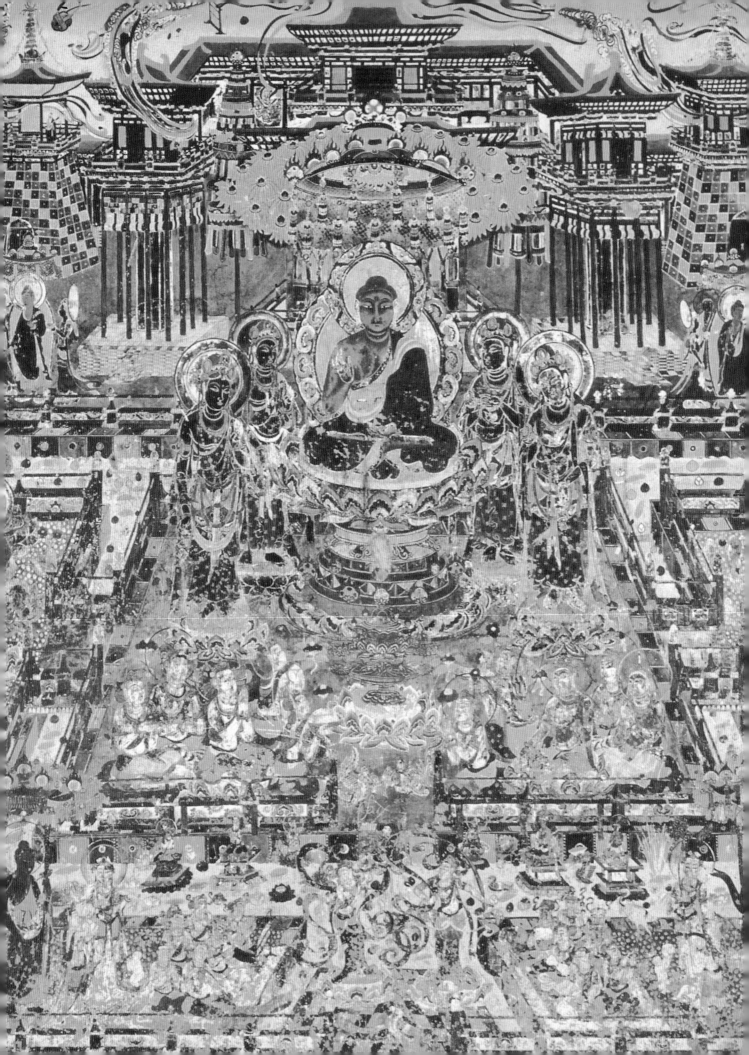

6 A NEW IMPERIAL STATE: SUI AND TANG

MOST WRITERS HAVE CELEBRATED the Sui and Tang periods as a grand culmination of earlier developments in Chinese society and culture. The sequence of a short-lived Sui regime (581–617), which accomplished the task of reunification, and a long-lasting Tang empire (618–907), which consolidated and expanded the institutions of state and society, is often compared to the Qin–Han period many centuries before. Sui and Tang constitute the middle empires, reasserting Chinese power, prestige, and cultural superiority after the dark interval of the period of division. The triumphal narrative of Sui–Tang history devotes considerable attention to the impact of Tang institutions and culture on neighboring peoples in East Asia and to the cosmopolitan culture of the great empire itself. Tang as the center of the East Asian world is a common metaphor. For many later Chinese writers the Tang epitomized exemplary government (the reign of Taizong), brilliant verse (with such famed poets as Li Bo and Du Fu), and the peak of such arts as calligraphy and figure painting.

All of the assertions sketched above are true to some degree. From a Sinocentric point of view, the Sui–Tang age is a great episode in the long history of Chinese civilization. But the Tang state was only sometimes successful in expanding its borders and projecting its power. The reign of Taizong (r. 626–649), which elicits nearly universal admiration, was followed by the very different reigns of his successors Gaozong (r. 649–683) and the

much vilified Empress Wu (r. 690–705). The terror at court under Empress Wu and the great disruptions of the mid-eighth century (including the so-called An Lushan rebellion) that concluded the reign of Xuanzong (r. 713–756) are the antithesis of a glorious age, as is the sad spectacle of the late Tang reigns when court and capital lost power to regional military rulers. Claims of high cultural achievement notwithstanding, the Tang was also an age of great turmoil and widespread suffering, of wrenching changes in social institutions, and the twilight of an aristocratic class that had dominated society during the period of division. Much celebratory writing about Sui and Tang glides over these low points, as depressing as any in Chinese history.

STATE AND SOCIETY

Reunification came over a period of years. In retrospect it can be seen as beginning with the rise of Yang Jian in the Northern Zhou (550–581) and the efforts of that state to unify the north by exterminating the rival Northern Qi (550–577). The process accelerated with the usurpation of the Zhou throne by Yang (in 581) and his subsequent campaigns against the south, leading to the eventual defeat of the Chen court in Nanjing in 589. Yang was a member of the northern aristocracy, a military and civil power elite that ruled from the Northern Wei period onward, and a group of

6-1 Western Pure Land
Wall painting, north wall, Cave 217, Mogao chapels, Dunhuang, Gansu. Tang, late 7th–early 8th century CE

families that claimed pedigrees from both Han and non-Han ethnic stock. His defeated southern peers were aristocrats too, but most often were descended from displaced Han Chinese families that had fled south with the collapse of the Jin in the early fourth century. While the two elites shared many things, after more than two centuries of division and conflict they regarded each other suspiciously as mutually inferior. Part of Yang Jian's strategy to create a strong empire was the selective coopting of southern elites and their cultural practices. The court culture that took shape in Sui and early Tang times was heavily indebted to southern traditions in such realms as court etiquette, ritual, calligraphy, and poetry. Thus while the most powerful families of the Sui and early Tang were hybrid northern lineages, their cultural models became those of the Han Chinese southern courts.

The founding of Tang was viewed, at the time, as yet another episode of usurpation among these northern militarist aristocrats. The Tang founder, later called Gaozu (Li Yuan, r. 618–626), was a general who betrayed his emperor and snatched power as still other rebels tore apart the Sui. His ability to quell the other potential claimants laid the foundations for a lengthy dynasty. But he had little opportunity to enjoy his successes. His second son, later known as Taizong (Li Shimin), in fact usurped his father's throne, murdering two brothers, including the heir, in the process. Taizong is often called the "second founder," and indeed the contributions of his era were fundamental. The era of good government over which he presided became a model in later political discourse. A wise and conscientious emperor able to take command of civil and military challenges, working in concert with and even heeding the advice of his high ministers, was a powerful ideal for later scholar–officials.

Many of the trajectories of Tang society and culture were established in the Sui and early Tang. In the mid-seventh century the centralized regime imposed order on a nation of some 50 million people through an imperial bureaucracy of 13,500 officials. These officials were educated men drawn mainly from old lineages of the northwest and northeast who traditionally enjoyed favored social status. Although civil service examinations began

during the seventh century, their main impact on governance seems to have been in unifying the ideology of the power elite and the opportunities created for provincial notables to enter capital politics. The military was drawn from the general population in a system of limited, rotating service first devised under the Northern Dynasties, and its maintenance did not create a significant burden for the state. Over the period, the population shifted rather dramatically toward the fertile and productive Middle and Lower Yangzi macroregions, leaving the Northwest and North relatively underpopulated. Land was registered and redistributed in the Tang, and the idealized system described in received texts may have been reasonably well enforced, based on the testimony of primary documents from such areas as Dunhuang and Astana. Taxes were based on both head counts and land holdings. Although coinage was made a state monopoly, payments in kind (grain and cloth) still accounted for most state revenues. Public works enhanced the economic integration of the empire, most notably the canals linking the southeast to the Yellow River basin, to points north, and to the capital district.

A New Capital: Daxing cheng and Chang'an

Once again the imperial capital was sited in the Wei River valley of the Northwest macroregion. The Sui founder declared the existing city of Chang'an, ancient capital of the Han and seat of the defunct Northern Zhou rulers, to be unsuitable for his new capital. He chose a site southeast of the old city for what was to become the largest city in the world in the seventh and eighth centuries. This area for Daxing cheng, named after the Sui founder's fief, was regarded as geomantically auspicious: Dragon Head Ridge occupied the northeast corner, the Wei River flowed beyond it to the north, and the high mountains of the Zhongnan range rose to the south. The plan was the most ambitious ever attempted: a walled city, roughly square in plan, measuring 6 miles (9.7 km) east to west and 5.3 miles (8.6 km) north to south (FIG. 6-2). The walls enclosing this vast area, considerably larger even today than the modern city of Xi'an, were as much as 39 feet

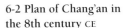

6-2 Plan of Chang'an in the 8th century CE

N

1 Mingde gate

2 Imperial city

3 Palace city

4 Taiji palace

5 West market

6 East market

7 Daming palace

8 Imperial park

9 Xingqing palace

10 Serpentine lake

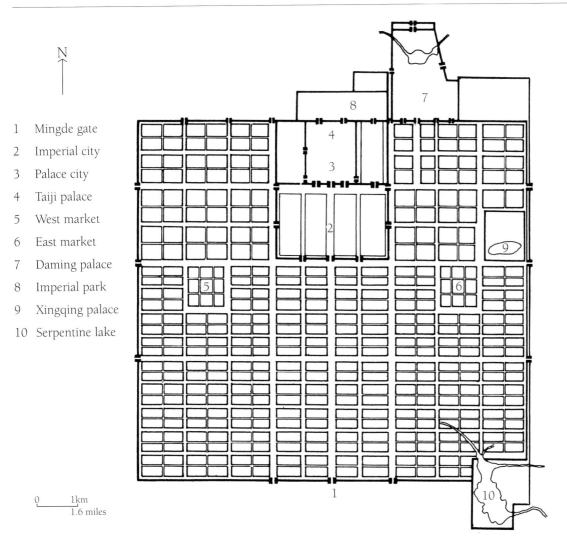

0 1km
1.6 miles

(12 m) thick, raised by the pounded-earth technique used since high antiquity. Three gates each in the east, south, and west walls, an acknowledgement of the canonical prescriptions of the "Royal City" plan (see FIG. 3-6 above), controlled access to the city. Altogether fourteen major thoroughfares ran east to west and eleven from north to south. Most streets were in the order of 130–225 feet (40–70 m) wide, although the roads beside the walls were smaller. On the other hand, two major avenues were appreciably larger. The main artery leading from the principal south gate (Mingde Men) north to the imperial city was 490 feet (150 m) wide, divided into five lanes, and was flanked by drainage ditches and rows of locust trees. Similarly, the great thoroughfare connecting the northern gates of the east and west walls also delimited the southern boundary of the palace and was as much as 720 feet (220 m) wide. These two arteries were the greatest "public" spaces

within the city the Tang renamed Chang'an, in honor of its Han ancestor.

Located in the northern third of the city were the compounds known as the Imperial City (Huang cheng) and Palace City (Gong cheng). The former was a rectangle straddling the city's axis, about 9200 feet (2800 m) wide by 5900 feet (1800 m) deep. Unlike in earlier imperial capitals, all the organs of government were concentrated here in a compact grid: the three central ministries of state and the six boards, plus the Ancestral Temple and Altar of the Soil. Tang officials appointed to the imperial service were thus at the beck and call of the court, their immediate neighbor on the north. At the same time, they were walled off from the residential quarters that dominated the city proper. The palace, in turn, was a rectangle of similar scale, with the same width but only 4900 feet (1500 m) deep north–south. It stood across the 720 feet wide thoroughfare mentioned above,

which served as a kind of palace square for vast assemblies and processions. The Son of Heaven's palace (the Taiji Gong) occupied most of this area, shifted slightly east of the axis, and was flanked by two lesser establishments, including the palace of the heir on the east. Immediately beyond the north city wall was the Imperial Park (Xi Nei Yuan) for the recreation of the imperial family. The disposition of the Imperial and Palace Cities at the north-central termination of the city axis is indebted to the plan of Ye, the Eastern Wei and Northern Qi capital (see FIG. 5-2 above).

The main arteries of the city, stretching from one gate to its opposite number, anchored a grid that subdivided the remainder of the city into 110 wards (fang). Those in the south measured about 1620 feet (500 m) square. Contained by walls and divided internally by crisscross grids ending in gates on each side, they were designed to accommodate most of the city's population. In fact, the southernmost wards were never fully built up, and many blocks remained cultivated fields or open land. The wards that flanked the Imperial and Palace City complex, however, were significantly larger and were intended, it is supposed, for aristocratic residents. The imperial court took over one of these wards and in the eighth century it became the favored residence of Xuanzong, his Xingqing Palace. Still two more areas were removed from residential use: the east and west markets (Dong shi, Xi shi) placed at the north edge of the residential wards, each about 3600 feet (1.1 km) square. The most notable aspect of the Sui–Tang city design is perhaps its attempt to regulate all aspects of urban life, especially the coexistence of imperial court and general population. This plan segregated the palace and court bureaucracy and the main features of the city served their needs. Other residents were managed as citizens of wards that shut their gates at nightfall. The markets served both the northern aristocratic and southern residential quarters of the city without disrupting the formal southern approach to the palace center. The Son of Heaven, moreover, was able to enjoy a less citified atmosphere simply by passing out of his palace to the north. With one million inhabitants in the seventh century, Chang'an was not only the largest urban center in the world, it was also the most efficiently planned and awe-inspiring metropolis of its time.

No Tang buildings stand today within Chang'an (modern Xi'an), with the exception of several masonry pagodas (see, for example, FIG. 6-14). A few segments of the Sui–Tang walls still remain visible above ground, and the city grid survives in areas of the modern city. In fact it is possible to walk along major roads, especially within the Ming-period (1368–1644) wall, that follow the paths of their Tang-period antecedents. The foundations of much of the Tang city were destroyed long ago in rebuilding, but areas that have not been occupied over the later centuries often have well-preserved Tang sites. For example, archaeologists excavated one of the Tang city gates in the 1970s and it was sufficiently well preserved to allow informed reconstructions. This is the Mingde Men (Gate of Brilliant Virtue), the principal south gate on an axis with the Imperial and Palace Cities located some 3.1 miles (5 km) further north. Built in the 580s by the Sui, we know that the gate house was renovated in 654. Its design is credited to Yan Lide, brother of the painter Yan Liben discussed below (see page 210). Unlike the other gates on the east, north, and west sides with three openings each, this structure had five portals. The center opening was apparently reserved for the emperor and used only on those occasions, such as annual sacrifices, when he left the city. The flanking interior portals were designated for pedestrians, while the two outer portals were given over to wheeled traffic.

The Imperial Park immediately north of the new capital was developed with additional palaces in the reign of Taizong. One of these, known ultimately as the Daming Gong (Great Luminous Palace), has become the best evidence available for large-scale imperial architecture. More than thirty foundations survive north of modern Xi'an as protected sites on the national register. Begun in the 630s, work was suspended until the 660s, when the Daming Gong was made the primary residence of the emperor. The palace occupied the high ground of Dragon Head Ridge and so, it is said, provided a warmer, drier, healthier environment for the Son of Heaven. It also allowed

a commanding view of the city that stretched away to the south. Unlike the Taiji Gong, the original Sui–Tang imperial residence, the Daming Gong was divided into a formal front area of halls of state aligned on an axis and a much larger informal rear palace, with several dozen buildings around a man-made lake in a landscaped park. Although its builders sacrificed the prime axial position of the Taiji Gong that symbolism dictated, they gained a superb physical setting for the life of the imperial court.

The conflation of archaeological work, textual research, and the imaginative restorations of contemporary scholars has generated new knowledge of the Daming Palace, as with the Mingde Men. In this instance, literary evidence is sufficient to supply some of the details of the front hall of state, the Hanyuan Dian (FIG. 6-3), and one of the largest halls of the rear precinct, the Linde Dian. The restorations proposed for the timber-frame halls themselves, moreover, are derived in large measure from extant structures of the Tang period, notably the East Main Hall at the Foguang Temple on Mount Wutai (Shanxi; see FIGS. 6-11 and 6-12). (For the principles and some details of this system, see "The Timber-frame System," page 196.) Although the renderings are inevitably only as good as the arguments behind them, the Hanyuan Hall in particular can now be counted as a "virtual monument" of Tang architecture that

affects how we judge the earlier and later history of imperial halls.

The Hanyuan Hall was used for the grandest ceremonial occasions such as the accession of a new sovereign or the New Year's ceremony. The yard stretching from the south palace gate to this hall was almost 2000 feet (600 m) in length. At the rear was a triple ramp comprising a broad central staircase and two narrow flanking ones. These rose more than 33 feet (10 m) to the level of the hall itself. In making this ascent, court officials were overshadowed by towers built on high pedestals at each side, their superstructures linked to the main hall by covered galleries. This scheme of flanking towers descends ultimately from Qin–Han gate towers, *que* (see FIG. 4-7 above), but has a more immediate precedent in the main south gate of sixth-century Ye. In conception this hall is a grand gate leading to the other great halls of state. Its distant echo is the Noon Gate (Wu Men) of the Ming Forbidden City in Beijing. The flanking towers, although smaller in scale, were higher than the main hall, and their roofs were almost on a level with the main hall's roof. The structures surrounding the Hanyuan Hall itself served to enhance its physical presence, its volume, and visual impact, as well as serving as a convenient stage for a great array of imperial guards and attending civil officials. The main hall stood on a double terrace surrounded by stone

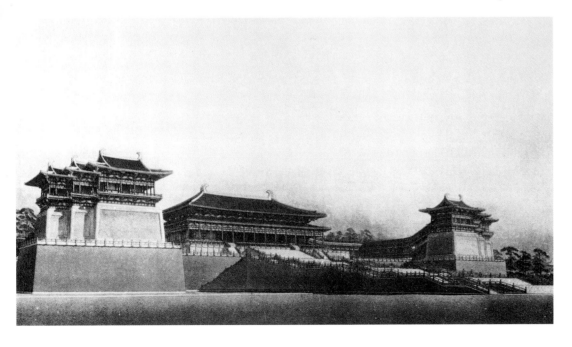

6-3 Hanyuan Hall at the Daming Palace, Chang'an
Late 7th–8th century.
Rendering by Fu Xinian

6-4 Anji Bridge
Zhao County, Hebei. Sui,
c. 595–605 CE

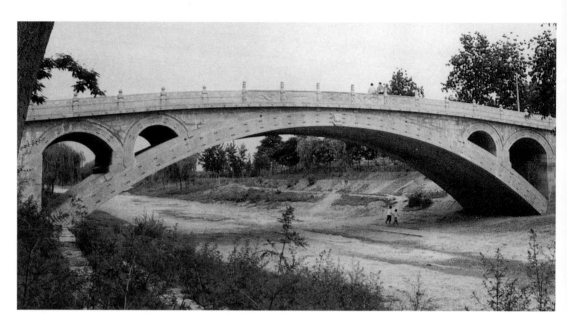

balustrades. At eleven bays wide, it presented a huge facade with its massive hipped roof and secondary eaves. The open porch across the front and a thick wall of earthen construction at both ends and across the rear defined the interior space. With central columns removed in the interior, this hall became a large rectangular space for the court's business. The columns were probably in the order of 30 feet (9 m) tall, and the spans between columns were more than 16 feet (5 m). All of the smaller features of this immense structure are lost except to the imagination. Tang-period wall paintings, stone carving, and the testimony of extant wooden halls, however, suggest a repertoire of materials, forms, and details.

Not all examples of Sui–Tang architecture were of timber-frame construction. Indeed the oldest architectural monument from the period is the "Great Stone Bridge" erected during the period 595–605 under the Sui (FIG. 6-4). An early inscription credits this bridge to a Sui official and engineer named Li Chun, otherwise unknown. For this site in modern Zhao County (Hebei), Li and his associates designed a flattened or segmental arch span of 122 feet (37.5 m). Unlike round arches known elsewhere (such as bridges and aqueducts of ancient Rome), this span rises a mere 23 feet (7.23 m) in spite of its considerable length—a ratio of 5:1. Segmental arches save building materials in the bridge, as well as in the approaches to it, while also maintaining a low

road bed. The designers also incorporated a pair of small, round arches at the two ends of the bridge, again reducing material and weight, and permitting the span to withstand the pressure of high flood waters, which pour through the arches rather than push against a solid wall. Another notable feature of this project is the use of twenty-eight adjoining arches for the span. Although some of these arches did collapse over the centuries, the bridge as a whole remained standing. The integration of sound structural logic and pleasing design manifested in this most durable span is strong testimony to the sophistication of its architects and engineers.

The Imperial Tombs

In its program to establish legitimacy the Tang court followed precedents first set by the Han. The Tang imperial tombs are one of the best examples of a modernized, hybrid tradition that nonetheless could claim to descend in orthodox fashion from the first empire. All but two of the Tang emperors were buried in the Wei River valley. Their eighteen necropolises stretch from the Qianling of Gaozong in the west for about 62 miles (100 km) eastward. The tombs are sited on the valley's high second terrace, far from the flood plain and well above the first terrace utilized by the Han emperors. Unlike the former, fourteen of the Tang tombs are

"mountain burials" in which a natural mountain serves as the mound, a practice initiated in the Han period but used only once for a Han imperial tomb. The remaining four tombs have, in traditional fashion, earthen mounds with four sides and a flat summit. The grandest of the Tang establishments dwarf all the tombs that predate them: for example, the Zhaoling of Taizong (d. 649) enclosed 23 square miles (60 sq. km), an area larger than that of Chang'an. Unlike under the Han, mausoleum tombs were not built to supply revenue and labor for the tombs.

In plan the Tang necropolises explicitly paralleled the imperial capital itself (see FIG. 6-2). At the core was a walled compound surrounding the mound or mountain, equivalent to the Palace City. Here the most important structure above ground was the Offering Hall dedicated to the deceased sovereign. As in the palace, gates controlled access from each direction, but the south gate served as the formal approach. An area comparable to the Imperial City, also walled and gated, extended southward from the gate. Here was a symbolic court assembly of over-size stone figures and animals flanking the processional path (see FIG. 6-6) in eternal attendance on the emperor. The remainder of the necropolis, equivalent to Chang'an's residential wards, lies still further south beyond another gate. Satellite burials of high officials and close relations were assigned here, again within an encircling outer wall. The most populated of the Tang sites in this respect was the Zhaoling, where two hundred satellite burials have been documented.

The program of large-scale sculpture that flanked the path (*shen dao*) of the "imperial city" compound became standardized only after the early reigns. The Tang scheme was considerably more elaborate than surviving examples from the Southern Dynasties (see FIG. 5-3 above) and such evidence as we have for Northern Dynasty practices. The best example is perhaps

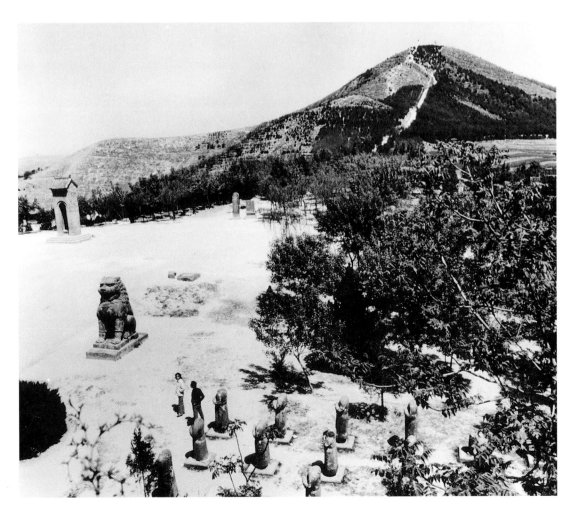

6-5 Qianling spirit path
Qian County, Shaanxi. Tang, c. 683 CE

**6-6 Spirit path official
Qianling**
Stone, height 15′ (4.6 m)

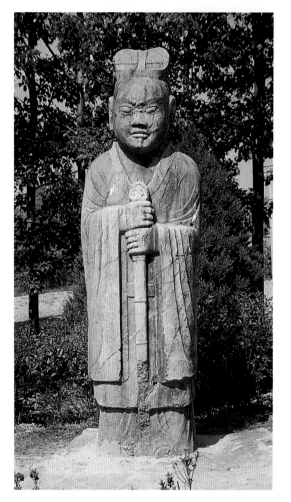

the Qianling (FIG. 6-5), dedicated to Gaozong (d. 683), where the Imperial Way extends for over 600 feet (1 km). A pair of faceted columns stands at the south, between tall gate towers built on natural hillocks some distance to each side, then come a pair of winged horses, a pair of auspicious birds (ostriches?), and five pairs of saddle horses. Leading up the slope thereafter are ten pairs of officials (FIG. 6-6). Civil bureaucrats hold their tallies of rank, while military officers grasp their swords. This frozen assembly waits on the emperor as his entourage might have done in life when he prepared to exit the palace. Pairs of stone lions crouch at the inner precinct gates, which again were fronted by towers built around earthen cores. At the Qianling there is an additional feature: sixty-one stone figures identified by inscriptions on their backs as emissaries from subordinate states of the Western Regions (see FIG. 6-5). Aligned in rows, they face onto the small plaza between the gate towers and lions.

Until an imperial tomb is opened, we must rely on the burials of imperial princes and princesses for our understanding of tombs below ground level. The epitaph found within the tomb of Prince Yide (Li Chongrun, d. 701, reburied 706) designated it a *ling* (imperial burial). At 330 feet (100 m) in length, it is the largest Tang tomb yet opened. Its plan is derived from practices established during the Northern Dynasties, such as the Northern Qi tomb of Lou Rui in Shanxi (see pages 157–158). A lengthy, steep ramp descends from ground level, its walls covered with murals. Air shafts punctuate the length of this ramp. In both walls at these points are commodious niches for burial goods, notably figurines. When the ramp ends, a corridor sealed by stone doors leads inward toward two chambers. This corridor is also the location for the epitaph slab with its cover. Each chamber is vaulted and decorated with more murals that evoke the ambience of a palace hall and populate the interior with appropriate serving staff. The rear chamber contains the sarcophagus of the deceased, a massive stone container that resembles a tile-roofed building and is covered with engraved designs. Most of the imperial tombs have been looted, but the Qianling itself may have escaped this fate. Its excavation would presumably provide a full record of the design and appurtenances of an emperor's tomb.

Scenes from Court Life

Murals in tombs built in the capital region during the seventh and eighth centuries epitomize elite life in vivid detail. We encounter the honor guard of a Tang heir assembled before the vermilion gates of his mansion (see FIG. 6-9). In another instance, the murals depict the encounter of Tang officials and foreign emissaries (see FIG. 6-36 below), a pictorial counterpoint to the stone figures of the Qianling noted above. The personal army of a prince rides across the countryside on one side of a tomb ramp (FIG. 6-7), while mounted warriors play polo opposite. As we pass from the ramp into the corridors of the tombs we encounter guards, eunuchs, and serving women. Here is a cross section of the Tang court, from dwarfs to older women who are veterans of the

palace (see FIG. 6-8). The placement of such figures within the successive portions of the tomb explicitly enforces the parallels between this underground abode and the palaces of the living. Executed over hundreds of square yards of wall surface in the largest tombs, these murals are the best surviving evidence for the work of Tang court painters. Datable and well preserved, commissioned by the highest levels of society in the capital, this evidence eclipses other bodies of Tang painting considered below.

The honor guard of Prince Yide is an army of guardsmen, cavalry, and chariots marshaled before the crenelated walls of the prince's mansion (FIG. 6-9). Soldiers with swords at their belts stand at attention before their mounts. Each horse has its own groom controlling the reins. Men with quivers at their side comprise the bowmen of this detachment. Red-cloaked civil officials fill in the rear ranks, sandwiched between the horses and large chariots of the prince, each with canopies and pennants unfurled. The painters repeated a selection of stock types in order to create this scene, yet at the same time they introduced enough minor

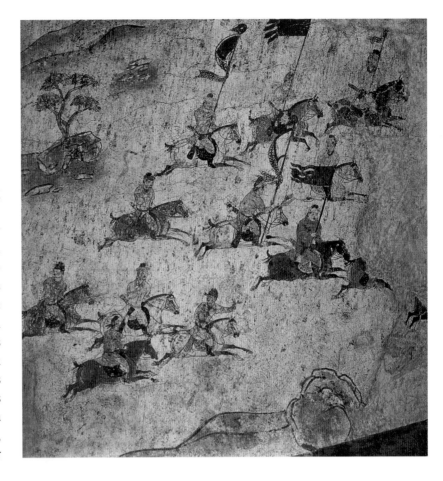

6-7 Hunting scene
Wall painting, Tomb of Prince Zhanghuai, Qianling, Qian County, Shaanxi. Tang, c. 706–711 CE

A Tang prince's personal cavalry improve their equestrian skills by playing this Tibetan pastime. Above the broad border band that separates the wall from the ramp, a few rocks and trees, larger bolders, and folds in the earth suggest the rudiments of a landscape setting.

6-8 Female attendants
Wall painting, Tomb of Prince Zhanghuai, Qianling, Qian County, Shaanxi. Tang, c. 706–711 CE

6-9 Prince's guard
Wall painting, Tomb of Prince Yide, Qianling.
Qian County, Shaanxi. Tang, c. 706 CE

variation—a sideways glance, an implied silent interaction—so that the groupings are never wooden. Figures and horses occupy a semblance of shallow space. Much attention has obviously been given to overlapping and to keeping track of obscured feet and limbs. At the same time the implied ground is tilted as if the figures are arrayed on a steep incline. More to the point, the painters depicted the rear ranks at the same scale as the front, without worrying what their composition might signify about a viewer's position. The emphasis on large figures is played off against an even larger setting: the walls and towers of the palace and the ridges and peaks of a mountainous terrain. Near and distant space is accounted for, if nothing in between.

Less crowded but even more ambitious is the hunting scene in progress (see FIG. 6-7) on the east wall of the ramp in the tomb of Prince Zhanghuai (Li Xian, d. 684). Five riders carry pennants snapping in the breeze, while below them another group of four also gallop at breakneck speed. Together the groups form a composition enclosing empty wall surface, a strong suggestion of a real space that they both occupy and define. All the horses and riders are distinct, and they are shown in various poses: profile and three-quarters, both frontal and reversed. The riders' poses depict different ways of sitting in the saddle or holding the reins. This variety creates a cinematic impression, as if we were looking at separate frames of the figures in action. Seen together they illustrate many of the stages in the movements of horse and rider. This hunting scene unfolds against white wall surface, but nearby are earthen ridges and clusters of rocks. Also scattered over the wall are more detailed renderings of the landscape, enough to show we are outside the prince's royal mansion. Landscape motifs are not scaled with attention to the riders. Setting here is a minor note within a painting focusing instead on dynamic action.

Within the front chamber of this same tomb we find a large panel devoted to moments in the life of serving women (FIG. 6-8). One woman wrapped in a shawl stands before a thin tree in a garden of the prince's palace. At center, a young woman wearing the leggings and cloak of a man seems to be pondering the cicada on the tree trunk,

her attention drawn no doubt by the insect's noisy drone. At left a third woman (not shown) strikes a more active pose, extending both arms as she cocks her head at a bird in flight and scratches her scalp with a hairpin. These women are large figures drawn from stock types, individualized to a degree by attribute or pose, and displayed within a minimal setting. Most of the corridor and chamber walls are given over to such renderings of single figures and small groups. The woman and eunuchs shown on these walls are certainly not persons of status or individuals with names. Rather they are ornaments tied to the status of others, marking the position of the deceased within the social and sumptuary hierarchy of the imperial family. We have many examples in lesser tombs of smaller numbers of such servants and attendants. It is fair to suppose the emperor's own tomb had even more.

STATE PATRONAGE OF THE *DHARMA*

The *dharma* flourished in Sui–Tang times. Although established during the preceding centuries among both northern aristocrats and southern elites, in this period Buddhism assumed a more pervasive role within Chinese society. Much of its impact can be traced to the pro-active policies of the Sui and Tang emperors. Grand gestures like the dedication of 111 relic pagodas by the second Sui sovereign in 601–604 were not exceptional. The prestige and wealth of the imperial court propelled projects such as the translations carried out by Xuanzang (c. 596–644) or the "Great Image Niche" at the Longmen chapels (see FIGS. 6-17, 6-18, and 6-19). Buddhist temples in the two Tang capitals were centers of social and intellectual life, and the focus of the greatest public festivities of the age. Leading painters of the day made their names by executing murals in these metropolitan establishments. Especially devout imperial clan members were responsible for the extraordinary richness of the reliquary deposits unearthed in recent years at the Famen Temple, west of Chang'an (see FIGS. 6-15 and 6-16). Indeed, the success of the Buddhist community was also

The Timber-frame System

The East Main Hall of the Foguang Temple (see FIG. 6-12) tells us more about timber-frame construction than any other evidence prior to the Song period (960–1279). Timber-frame halls are divisible into three tiers: the foundation block, the column grid, and the bracket tier with roof frame. Foundations changed little over time. Builders used pounded earth, stone column bases, facings of stone or brick, and tiled flooring from the early imperial era, if not earlier. The column grid, on the other hand, became more sophisticated during the centuries leading up to the time of the Nanchan and Foguang halls. Columns rested on their stone bases without any attachment; dead weight held them in place. For larger structures, the spans of columns reached 16 feet (5 m), and the height of the column and width of the span were roughly equivalent. Columns were spaced at variable intervals, so that the central bay on axis would be widest, flanking bays slightly reduced and end bays smaller still. The columns themselves were tilted inward slightly to create an impression of upright alignment. For the same reason the columns become slightly taller as they move away from the center bay. Builders tied adjacent columns together with beams at floor level and with one or more beams at their heads. The network of columns reinforced itself both laterally and in depth. It served as a stable but also flexible support for the brackets and roof frame with their considerable weight.

Extant buildings document a few basic approaches to the plan. At the Nanchan Temple, the hall is small enough to permit the builders to eliminate all interior columns. The columns form a perimeter circuit only. At the Foguang Temple hall, however, columns are arrayed in five parallel rows. The third, or middle, row is reduced to two columns at each end. The four columns subtracted create a large space for the altar and the people before it. A similar principle was in use at the Hanyuan Hall of the Tang imperial palace (see FIG. 6-3). The subtraction of interior columns and the ability to place screen walls at any row allowed designers to create a variety of spatial zones, such as an open porch, gallery, or other interior configurations. Such alternative plans were more thoroughly explored during the Song, as for example, at the Hall of the Holy Mother at the Jin Ci (Taiyuan, Shanxi).

Certainly the most complicated part of a Tang hall was its tier of bracket clusters, *dougong*, pegged atop each column, which transmitted the weight of the roof onto the stone bases in the foundation. In larger halls such as that at Foguang Temple, clusters were also placed in the middle of each bay on a tie-beam. These intercolumnar clusters supplanted the inverted V-posts and "camel humps" of earlier periods. The Chinese terminology for brackets designates their components: *dou*, "blocks," and *gong*, "arms." A large block cradles the two lowest arms crossing at right angles in slots prepared for them. These lateral arms are generally short and terminate in two smaller blocks that carry the tier above. The lowest-level transverse arms projecting at right angles from the wall plane, however, are actually extensions of interior beams that span the bays within. Likewise the second-tier lateral arm was actually a segment of a tie-beam crossing from column to column. Relief carving on this beam imitates a separate arm. Thus each successive tier of blocks and arms knits the structure together in two dimensions, laterally above the columns and transversely into beams at ceiling level. The several stacked tiers of arms typical of Tang building practice achieve two other purposes. They elevate interior beams well above the heads of the columns. They also extend in cantilever fashion transversely away from the column, both forward and backward. On the exterior this projects the eaves away from the wall, while on the interior this shortens the span between columns.

Roof frames are less complex. Trusses are created using one or more tiers of beams atop the transverse tie-beams inserted within the bracket clusters. A ceiling may or may not be dropped in at this level; at the Foguang East Main Hall, one is present. When a ceiling is in place, the beams above are generally more irregular in shape and less finished than those below. Inverted V-struts atop each truss carry the ridge pole. The use of purlins at intervals from the ridge downward allowed great flexibility in the roofs of Tang structures. Running parallel to ridge and facade, the purlins carried short rafters placed perpendicular to the ridge. Variations in the spacing and height of purlins permitted a roof line of variable slope, unlike the rigid truss used in much European timber-frame construction. The material used for the roof covering was always fired ceramic tile, sometimes glazed. However, the tiles were set in a thick bed of mud built up above the rafters and boards laid across them. The weight of the mud contributed more to the ponderous roof than the tiles themselves.

the root of its most serious setback, the proscription of the 840s under Wuzong. Court officials argued that the foreign teachings were inimical to the interests of the state and the teachings of the sages. The court turned out members of the clerical orders, closed a great percentage of the temples, and confiscated their wealth.

The Tang was an age of "international Buddhism." In addition to the famous sojourn in India of Xuanzang, the age witnessed the peregrinations of many other Chinese, Indian, and East Asian pilgrim monks. These travels invigorated Chinese Buddhist centers, establishing living links with the still flourishing Buddhist "universities" of South and Southeast Asia. Indian monks came to Chang'an and left a legacy of esoteric (*mizong*) philosophy and practice. Pilgrims from the east, the Japanese islands and Korean peninsula, also visited, studying with leading Chinese figures of the day and recording their experiences. Meanwhile, important developments in Buddhist thought and practice originated in China, notably the teachings of the Meditation School (Chan, Japanese Zen).

Temples and Pagodas

The Buddhist temples that were built in remote corners of the empire are the oldest extant architectural monuments of China (compare FIG. 5-14 above). All the great temples of the two capitals suffered repeated calamities during and after the Tang period, and only a few of their masonry pagodas survive (see below). In spite of the proscription of the 840s, at least one wooden-frame temple hall escaped destruction in the mountains of modern Shanxi, and three more structures of late Tang date are also known in this province. These halls were created as ensembles of architecture, sculptural imagery, and painting. Their requirements as the abode of potent divine images and as the settings for sacred rituals determined their plans and other features. We know enough about other sites and the larger tradition of timber-frame construction to use these Buddhist halls as good evidence for lost structures of the imperial palace and other institutions as well (compare rendering of Hanyuan Hall, FIG. 6-3).

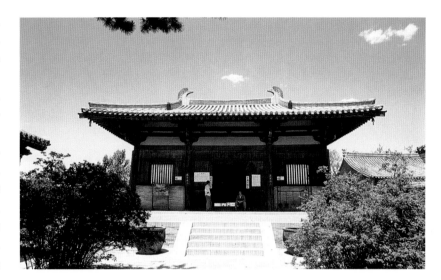

6-10 Main Hall, Nanchan Temple
Mount Wutai, Shanxi. Tang, c. 782 CE

Four timber halls have been dated to the Tang, the oldest being the Main Hall of Nanchan Temple on Mount Wutai, Shanxi (FIG. 6-10). An inscription on a roof beam dates construction to 782, and the same date is posited for the seventeen clay images on the altar platform. This is a modest hall only three bays across and three deep. As a result of the elimination of interior columns, a large open space surrounds the altar. The large outdoor "moon terrace" on the south, built at the same level as the hall, supplemented this area. Thus worship could include both assembly in front of the altar and circumambulation within the hall. The hall faces south and has high, cantilevered eaves that extend out from the wall— a design that admits maximum light and warmth in the winter months while casting deep shadows during the heat of summer. The walls are solid masonry, pierced only by the door and lattice windows of the facade, an accommodation to the northern climate and mountain setting. Inside, the roof framing is completely open so one can see the several beams crossing from front to rear that support the trusses for the ridge. The central image also takes advantage of this enhanced space. Its mandorla extends into the roof above the height of the walls. While it is likely that much of this framing is original or very early in date, the hall was remade several times over the centuries.

The most important Tang hall is considerably larger and occupies a rather more impressive setting at the tree line, high on Mount Wutai. Called

6-11 East Main Hall, Foguang Temple
Mount Wutai, Shanxi. Tang, c. 857 CE

6-12 Structural system of East Main Hall, Foguang Temple

While the complexities of the timber-frame structural system are challenging, its goals are straightforward: an efficient supporting frame of timbers, both vertical columns and horizontal tie-beams and bracket arms, must carry a roof extended as widely as possible to create optimum shelter and usable interior space.

1 - plinth
2 - eave column
3 - hypostyle column
4 - lintel, tie-beam
5 - bearing block
6 - transverse arm
7 - bracket arm
8 - tie-beam
9 - cantilever arm
10 - "nose"
11–13 - bracket arms (variable lengths)
14 - Lohan tie-beam
15 - *timu*
16 - ceiling panel tie-beam
17 - tie-beam
18 - exposed tie-beam
19 - half-camel hump support
20 - tie-beam
21 - 4-rafter exposed tie-beam
22 - camel hump
23 - lattice ceiling panel
24 - rough (hidden) tie-beam
25 - support
26 - 4-rafter rough tie-beam
27 - cross-beam
28 - strut
29 - inverted V-brace
30 - ridge purlin
31–33 - purlins
34 - rafter
35 - eave rafter
36 - flying rafter
37 - roof board

Foguang (Buddha Radiance) Temple, this establishment dates from the Northern Wei and was a well-known site for pilgrims to the holy mountain of the *bodhisattva* of wisdom, Manjusri (Wenshu in Chinese). The East Main Hall (FIGS. 6-11, 6-12) here is thought to date from 857, based on a stele inscription. It is seven bays wide and four deep, some 110 by 57 feet (34 by 17.6 m) and occupies a terrace cut from the slope behind it, so there is little room either in front or behind. The East Main Hall looms above the lower temple precinct, facing west, a single eave hall with hipped roof. Its flying eaves have probably been trimmed back and so no longer project as far as they once did. The facade is articulated as two end bays with windows and five center bays with doors. Again, thick masonry walls seal the other three sides, save for small window openings in either end. The huge

roof, giant bracket sets carrying the eaves, and broad facade make this an imposing hall, a kind more common in capital temples and palace precincts. If it is today regarded as the epitome of Tang architecture, the honor is honestly earned, not merely a fluke of preservation.

Little from the great Buddhist temple complexes of this medieval period survives. The exception is masonry pagodas, with dozens of examples extant. Two functional types can be defined: (1) burial pagodas, used to inter the ashes of eminent Buddhist monks, far and away the most numerous; and (2) relic pagodas, erected to house some trace of the revered past, whether of the Buddha himself or of another holy person, place, or thing associated with them.

Burial pagodas are generally smaller in scale, constructed of solid masonry. They are often placed away from the heart of a temple, often in plots set aside for that purpose (*ta lin*, "forest of pagodas"). Some of these pagodas are fictive architecture, reproducing the columns, bracket clusters, eaves, doors, and windows of true timber-frame structures. The burial pagoda of Master Jingzang (d. 746) at Huishan Temple (Dengfeng, Henan; FIG. 6-13) is an early example of the eight-sided plan that became common in post-Tang times. The main story features a detailed rendering of frame construction, down to simple bracket clusters atop the fictive corner columns, and inverted-V struts, a carry over from the period of division. The eaves are created from corbeled

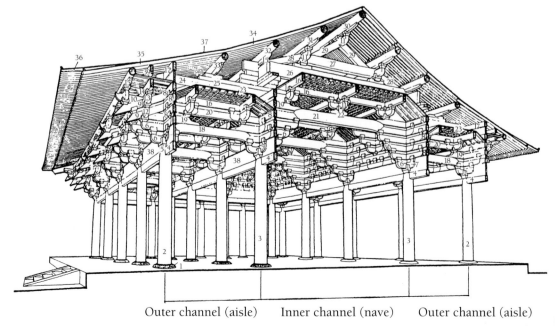

Outer channel (aisle) Inner channel (nave) Outer channel (aisle)

courses of brick, while the spire is an elabo-rately carved lotus supporting a flaming jewel. The brickwork of this structure captures some of the most advanced features of timber con-struction from the Tang.

Relic pagodas (*sheli ta*) often dominate a major courtyard of a temple. As architectural types they may be classified by their plan and prototypes. Single-story structures such as the Simen Pagoda (Licheng, Shandong), dated 611, derive from the so-called Asokan *stupas* now known only from miniature bronze examples and wall paintings at Dunhuang. This is a square stone structure topped by a pyramidal roof rising to a spire; each wall features a single doorway. Within, a cen-tral pillar permits the installation of four Buddha images facing the doors and a circumambulation path. Other one-story pagodas are more ambi-tious. The outstanding example, probably of the first half of the seventh century, is the Xiu-ding Temple pagoda near modern Anyang (Henan). This pagoda is renowned for its mantle of deeply carved and molded tiles that, like a canopy, drapes the walls. The evocation of a canopy is most direct in the upper tiers of this decoration, where a valance adorned with hanging beads encircles the eave. Below is an array of Buddhist beings, includ-ing animals and guardians, each rendered on a diamond-shaped tile.

All timber-frame, multistory pagodas built prior to the eleventh century have been lost. Sur-viving masonry examples are of square plan and differ primarily in how closely they adhere to one of two prototypes: the multistoried Han tower type (*lou*), or the close-set, multiple-eaves type first seen at the Mount Song pagoda (see FIG. 5-14). Both types may have hollow interiors in which wooden stairs and landings allowed the pious to ascend. The best-known example is the "Great Goose" Pagoda (Da Yan Ta) of Xi'an at the tem-ple dedicated to his mother by Tang Gaozong and rebuilt by Empress Wu c. 701–704. Rising from a base 82 feet (25 m) square to a height of 210 feet (64 m), this is the grandest monument to survive from Tang Chang'an. Builders gave the tapering mass of this brick tower minimal surface detail, mainly elongated pilasters that carry a simple tie-beam with only blocks above. Other examples

derived from the *lou* type in the capital region include the burial pagodas erected for Shandao and Xuanzang, in which more detailed framing is provided. The now lost Yongning Temple pagoda (see FIG. 5-13) was an early exam-ple of this same tradition. The close-set eave variety derived from Indic *sikhara* towers is best known from the so-called "Little Goose" (Xiao Yan) Pagoda (FIG. 6-14), also with-in the bounds of ancient Chang'an. The four-sided struc-ture, erected c. 707 for the Qianfu Temple, is a hollow masonry mass that actually split open in one great sixteenth-century earthquake and then closed up during a later tremor. The tower has a gently curving profile of thirteen (originally fifteen) stories; its spire

6-13 Jingzang pagoda, Huishan Temple
Mount Song, Dengfeng, Henan. Tang, c. 746 CE

6-14 Xiao Yan pagoda, Qianfu Temple
Xi'an, Shaanxi. Tang, c. 707–709 CE. Height 164' (50 m)

6-15 Reliquary in form of a pagoda

Tang, late 7th–early 8th century CE. Bronze, height 21″ (53.5 cm). Famen Si, Fufeng, Shaanxi. Famen Si Museum

6-16 Set of reliquary caskets

Tang, 871 CE. Silver and gold, height 2¾–9¼″ (7.1–23.5 cm). Famen Si, Fufeng, Shaanxi. Famen Si Museum

Originally comprising eight layers (the outermost wooden box decayed beyond restoration), these caskets preserved a "true body relic" of the historical Buddha (Sakyamuni), one of four in China during Tang times, and the only one to survive natural and human calamities down to modern times.

the holy realm of Indian Buddhism were highly esteemed in the Tang period, and at least four temples claimed to have body relics of the historical Buddha. Only one of these relic deposits has survived to our times—the finds made in the underground chambers of Famen Temple west of Chang'an (Fufeng County, Shaanxi). The collapse of a Ming pagoda on this site in 1981 presented archaeologists with an extraordinary opportunity to investigate the Tang-period foundations and crypt. The Tang pagoda, built not later than 874, had been a large square building with six bays to a side. Its appearance may well have been similar to that of a bronze reliquary (FIG. 6-15) recovered from within a stone coffer in the front chamber of the crypt. The crypt's underground chambers are among the earliest examples of their kind. In earlier periods, pagodas had simple stone coffers at the center of the pagoda base. Here, instead, is a series of connected passages and chambers over 65 feet (20 m) in length at a depth of 20 feet (6 m) below grade, accessible by stairway and passage. Stone doors similar to those in the imperial tombs discussed above facilitated removal of the Buddha relic for parading.

Archaeologists found four relics altogether in the 1987 excavations. Yizong had dedicated one of these, found in the rear chamber, in 871. The eight nested boxes used to house the relic (FIG. 6-16) are made from gold and silver, and utilized a variety of decorative techniques including chased designs and applied semiprecious stones and pearls. Lavish gifts of silver vessels and other gear, much of it made in palace workshops, accompanied this relic. Yet another relic recovered in a floor niche in the same chamber was a bone housed inside jade and rock-crystal coffins.

is also missing. Like the Mount Song pagoda, "stories" between eaves are miniaturized. Similarly, the first story is unusually tall and may once have been wrapped around by a gallery of frame construction. At 164 feet (50 m) in height, it is the second great Tang monument to survive in the capital.

The reason why these imposing structures were built should not be forgotten. Relics from

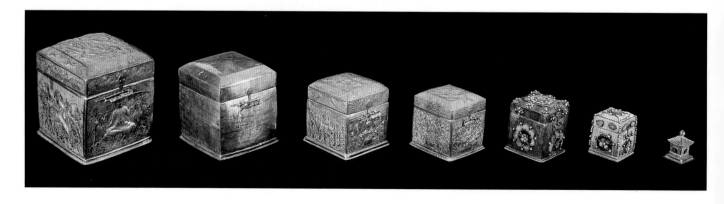

Why were these four relics gathered here? The answer may lie in the court's reaction to the proscription of Buddhism in the 840s. The largesse of the imperial dedications and donations may in fact be atonement for the damage done to the *dharma* in the decades before. Relics from other venues seem to have been consolidated at Famen Temple at this time, making it the preeminent repository of its kind in China.

The "Great Image Niche" at Longmen

The *Flower Garland (Avatamsaka) Sutra* is the longest of all the Mahayana texts and the most difficult. Its teachings are complex, a relatively late development within mature Buddhist thought. One of the text's key doctrines is the concept of the "three bodies of the Buddha" (*trikaya*). Rationalizing and synthesizing previous systems of thought, the *Flower Garland Sutra* posits: a "Body of Transformation" bound by space and time (such as Sakyamuni, who lived in a specific place and period); a "Body of Bliss" not limited in time but bound in space (such as Amitabha, the Buddha of the Western Pure Land); and a "Body of *Dharma*," a transcendental essence of the Buddha nature, not bound either by space or time. The idea that Sakyamuni was a manifestation of a transcendental Buddha nature had very ancient, Indian roots, but the power of the *Flower Garland Sutra's* teachings was their ability to order previous articulations of Buddhist belief within a totalizing framework. The greatest monument of Tang imperial patronage is a huge open niche (FIG. 6-17) devoted to the transcendental Cosmic Buddha (Vairocana; Lushena) of the *Flower Garland Sutra*.

This Great Buddha, dedicated in the 670s at Longmen, by custom has been called after a now defunct Tang temple, Fengxian Si, once located south of the cliff-face grottoes. The eighth-century inscription found on the Buddha's pedestal supplied a better name for this ensemble: "Great Image Niche" (*Da xiang kan*). The same inscription supplies two dates. In 672, Empress Wu donated 20,000 strings of cash, and in 675 the project was completed. These dates should not be taken to mean the entire project was accom-plished in a mere three years. Chinese scholars claim twenty-plus years as more plausible, and indeed this same inscription mentions the emperor Gaozong (r. 650–683) as patron. It seems most likely that the 672 donation was intended to enable completion of the work and establish the virtue of its donor, Empress Wu. In addition to details of dates and donations, the inscription also names the clerical advisors to this grand project and the court bureaucrats charged with its execution.

Of the many colossal images carved in China, the Great Vairocana Buddha at Longmen deserves a privileged place. The main images are carved in high relief from the walls of a huge artificial platform excavated from the rocky cliff. This area measures some 98 by more than 130 feet (30 by 40 m). Surely much of the time and effort expended was devoted simply to removing the

6-17 Great Buddha (Mahavairocana), Fengxian Temple
Longmen, Luoyang, Henan. Tang, completed c. 675 CE. Limestone, height 55'9" (17 m)

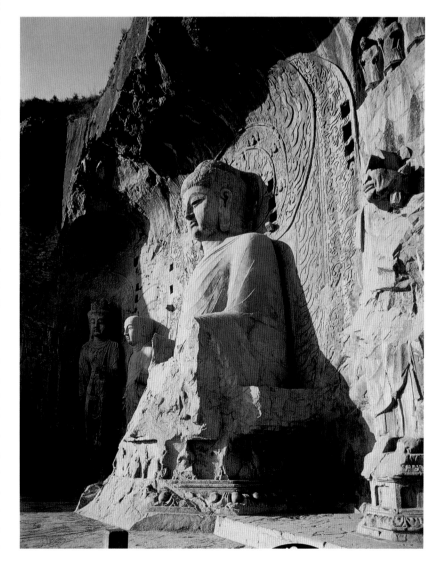

limestone, which was in any case a prime material for steles and other architectural uses. The lines of an eave are clearly visible in the walls above the figures, as are slots for beams added after the original construction. Smaller disciples and *bodhisattvas* (heights 35 and 44 feet—10.5 and 13.4 m—respectively) attend the Buddha at the center of the back wall (height 55 ft, 17 m). On each side wall are guardians, one an armored heavenly king, the other a bare-chested guardian. Coming into the area defined by these huge

6-18 A *bodhisattva* and Ananda, Fengxian Temple
Longmen, Luoyang, Henan. Tang, completed c. 675 CE. Limestone, height 35′and 43′5″ (10.65 and 13.25 m)

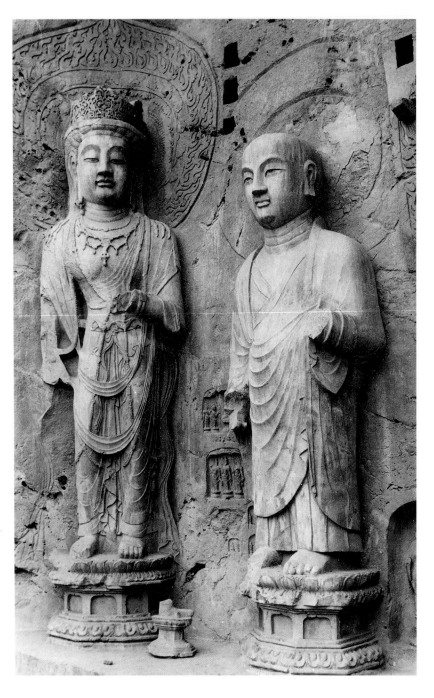

figures, a visitor is transfixed at the intersection of their downcast gazes. The Vairocana Buddha sits on an octagonal throne. The front fall of drapery is largely destroyed but may have featured patterned folds cascading over lotus petals. Upper arms, chest, and head are intact and have benefitted from a recent renovation. Vairocana's body is scarcely revealed; graceful arcs of drapery hang from each shoulder across the chest. The facial features are wide and plump. The eyes themselves are deeply carved under half-open lids. The full hair above the forehead and the extended ears with their thickened lobes frame the face. In contrast to the gravity and austerity of the image, its halo and body mandorla are full of animated detail, including airborne *apsaras* with musical instruments and fluttering scarves.

Not all of the attendant figures are well preserved. Those against the back wall stand on pedestals similar in basic structure to the Buddha's throne. The *bodhisattva* and the young disciple Ananda have stocky bodies and large heads (FIG. 6-18). The disciple's plain robe and smooth features contrast with the finery of the *bodhisattva*, who stands in a broken pose with the weight shifted slightly off one leg. This stance and the contrasting raised and lowered arms impart subtle movements to the several scarves and strands of jewelry. The patterns of the skirt are also more energized. Great attention has been given to other details such as the chest muscles, strands of hair at the shoulders, and crown. If these attendants are pacific and passive, the four guardians of the side walls are their menacing, active counterparts. Only the north wall figures are intact (FIG. 6-19). The forward guardian thrusts back one leg and swings his arms into a martial pose. Huge, broad shoulders twist above the hip-shot waist. Neck muscles and tendons strain as he rotates his head and glares down at those who approach. The heavenly king on this wall carries a miniature *stupa* in his right hand, an attribute that probably identifies him as Vaisravana, the Guardian King of the Northern Quadrant. Vaisravana is "at ease" on the left side of his body. The other leg and arm are at right angles, holding down the head of a vanquished earth spirit and lifting the *stupa*, respectively. Like the bare-chested guardian, the Guardian King

glares from a furrowed brow with beady eyes. The much-damaged guardians of the south wall had similar, complementary poses.

Court patronage of the Flower Garland school is well documented during the mid-seventh century. But other layers of association accrued to this project and its iconography. As the Cosmic Buddha, Vairocana is the source of the entire phenomenal universe. Everything in every time and place is actually a manifestation of his Buddha essence. The parallel to the role of the Son of Heaven within the Chinese world order is not exact, but the comparison favors the status of the imperial house. Moreover, the Buddhist concept of a "wheel-spinning king" (*cakravartin*) is also implicit in this imagery. A royal patron who promotes the *dharma* by "spinning the wheel of the Law," a patron who is himself a manifestation of the Buddha, made this image. Empress Wu promoted a newly discovered *Great Cloud Sutra* that prophesied the eminent appearance of a Chinese *cakravartin*, and few could doubt that she was to be that ruler. Thus the "Great Image Niche" is a forceful statement of the identity of the divine and imperial orders, and of the virtues of the ruling Son of Heaven.

Tang Chapels at Dunhuang

Of the many cave-chapel complexes patronized during the Tang period, none is better preserved and more deserving of close study than the Mogao chapels at Dunhuang. The Sui–Tang chapels at this desert site number about 360. Most are outfitted with a medley of sculptures and murals. In plan, the Tang chapels have two square chambers, the rear under a four-sloped ceiling rising like a canopy to a recessed square coffer at the center. (Many of the front chambers are partially or totally destroyed.) The entrance leading to the rear chamber usually faces a sculptural ensemble set into a raised, shelflike niche. Typical ensembles of this period are a pentad of the Buddha, two disciples, and two *bodhisattvas,* such as that on the back wall at Longmen, often with two additional sculpted guardians outside the niche. The side walls are often given over to large-scale panels with unified mural compositions. The dominant subject matter is the several devotional cults associated with Pure Land Buddhism, especially representations of the "Western Pure Land" of Amitabha (see FIG. 6-1), and various compositions with Avalokitesvara, the *bodhisattva* "who attends the sounds of the world" (see FIG. 6-23). Other Buddha Pure Lands are also represented, as are such important narratives as the encounter of Manjusri and the layman Vimalakirti.

For all of their majesty and high craft, the sculptures of the Great Image Niche at Longmen are incomplete. Tang artists finished images with a full palette to represent the tones of flesh and fabric. A fine example of these effects is the ensemble of Cave 328 at Dunhuang (FIG. 6-20), dated to the

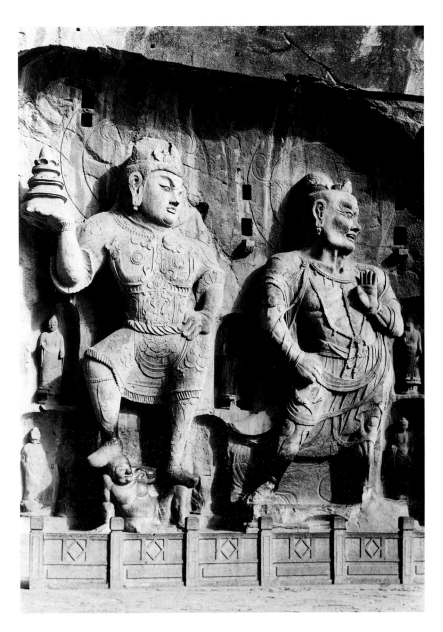

6-19 Guardians of north wall, Fengxian Temple
Longmen, Luoyang, Henan. Tang, completed c. 675 CE. Limestone, height 34'6" and 32' (10.5 and 9.75 m)

late seventh or early eighth century, within decades of the Longmen images discussed above. This is a pentad originally accompanied by four kneeling attendants clad like *bodhisattvas*. (One was removed by Harvard curator Langdon Warner, one of several scholars to disturb the Dunhuang site in modern times.) All the images are covered with white pigment over their flesh, while their robes and skirts are painted various shades of brown, red, and green. Gilt covers the borders of the drapery. The niche is painted with elaborate scenes: another Buddha ensemble is shown on the ceiling above the heads of the three-dimensional figures, and additional disciples and *bodhisattvas* appear on the three walls. The overall effect is as lifelike as any Tang critic could ask and qualitatively (both in materials and execution) as high a level as any patron could hope for.

The seated *bodhisattva* to the proper left of the Buddha (FIG. 6-21) assumes a relaxed pose,

usually compared to the "royal ease" of Indian kings. One leg hangs pendant, while the other is tucked into the body. This is a tall figure with a long waist and chest, bearing narrow shoulders. The proportions of the neck and head are also less thickset than on the Longmen *bodhisattvas*. Even seated, this figure is as tall as the standing elder disciple Kasyapa nearby. The monk clasps his hands in a reverential pose (the *anjalimudra* of adoration) so that his heavy cloak hangs evenly from the forearms, framing the arcs of the body drapery. Unlike the *bodhisattva*, Kasyapa betrays his mortality in his intense facial features. The two types are a study in contrasts: human with superhuman, worldly with otherworldly, mortal with divine, intense struggle with total confident mastery. The disciples painted behind the figures are given almost as much attention as their dimensional counterparts and are an opportunity for presenting varied facial types and different ages. These painted monks virtually step into the space of the niche and address the

6-20 Buddha ensemble
Cave 328, Mogao chapels, Dunhuang, Gansu. Tang, late 7th–early 8th century CE

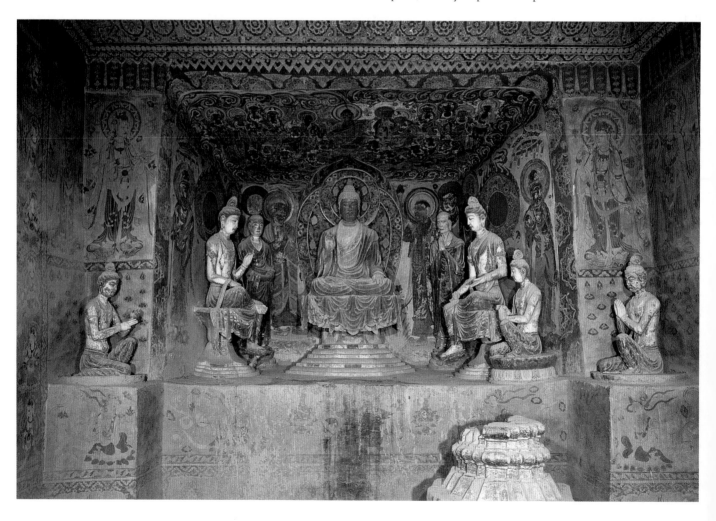

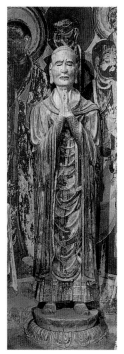

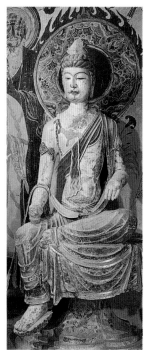

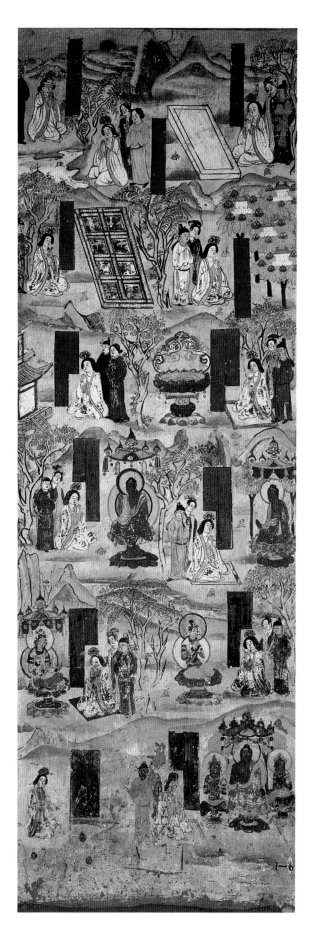

6-21 Kasyapa and a bodhisattva
Cave 328, Mogao chapels, Dunhuang, Gansu. Tang, late 7th–early 8th century CE. Height, 6′3″ and 5′11″ (1.9 and 1.8 m)

6-22 Sixteen Visualizations of Queen Vaidehi
Wall painting, north wall, Cave 45, Mogao chapels, Dunhuang, Gansu. Tang, 8th century CE

viewer from an assortment of poses. They appear to participate in the *sacra conversazione* of this ensemble.

Buddhist Themes at Dunhuang

Several first-hand accounts of the murals painted in the halls and precincts of the great temples of the Tang capital survive from the ninth century. Many famous names are represented among painters credited with these creations, and some of those "names" may have contributed important innovations in the evolving conception and elaboration of these subjects. The great proscription of the 840s, and the vicissitudes of timber-frame halls and temple precincts, doomed all of this great mural art. Already in the ninth century collectors would seek out fragments of these murals. Today other sources must stand for the great achievements of Tang Buddhist wall painting. The primary source is the murals of the Mogao chapels at Dunhuang. The range of subjects surviving here parallels themes identified in textual accounts, and datable examples span most of the Tang period.

The most "popular" trend within religious or devotional Buddhism during Tang times was the Pure Land (Sukhavati) school, whose teachings and imagery appealed to a cross section of Tang society. Many of the largest and finest

murals at the Mogao chapels from the seventh and eighth centuries derive from one of three texts associated with these teachings. The *Smaller Sukhavati* and *Larger Sukhavati sutras*, as their names suggest, seem to be simpler (and earlier) and more complex (and later) statements of a common core of ideas about the Western "Pure Land" (*jing tu*) of Sukhavati that was presided over by Amitabha Buddha. Most scholars think these texts developed in Central Asia independent of any ancient Indian, Sanskrit source. Their teachings concern the benefits of rebirth in Sukhavati, a realm bound by time and space; rebirth here is not extinction, *nirvana*. However, it is a realm purged of the lower orders of beings and a step closer to *nirvana*. Both texts stress the role of faith in achieving this rebirth, and the *Smaller Sutra* in particular emphasizes the efficacy of chanting Amitabha's name (*nien Fo*). The *Larger Sutra* portrays Sakyamuni Buddha preaching, whereby he gives a history to Amitabha as a reincarnation of a monk–*bodhisattva,* Dharmakara. This text also assigns prominent roles to Amitabha's two great *bodhisattva* attendants, Avalokitesvara (Guanshiyin or, more commonly, Guanyin in Chinese) and Mahastamaprapta (Dashizhi).

Fully elaborated compositions of these *sutras* are found in many Tang caves at the Mogao chapels. The north wall of Cave 217 is an early eighth-century example that has sustained remarkably little damage (FIG. 6-1). The central panel presents the key figures, but every part of the scene has been amplified. Amitabha sits on a large, tiered pedestal with standing and seated attendants on a tilted platform that occupies the center of the composition. Other platforms with railings and bridges linking them to the center hold the entourages of the two great *bodhisattvas*. Across the lower register is another stagelike area with musicians, dancers, and two additional standing Buddha figures. The top third of the scene presents an array of palatial halls, galleries, and towers. The strong rising orthogonal lines of the middle register platforms and the down-swept lines of the roofs and eaves above create a kind of vortex at the level of Amitabha's head. The visual emphasis is on the majesty of the three great actors

in this spectacle and on the brilliance of their Pure Land realm, points emphasized in the *Larger Sukhavati* text.

A third text of the Pure Land school was the commentary written by Shandao (613–681) to the *Visualization Sutra (Guan Wuliangshou jing)*. Shandao's text tells a narrative on the efficacy of "visualization" (*guan*), a mental discipline in which the devotee constructs the imagery of the Pure Land in the mind, step by step. This internal vision assembled in one's consciousness prior to death is a preparation, indeed a prerequisite, for rebirth in the Pure Land. Two vertical panels from the north wall of Cave 45 (mid-eighth century) lay out the narrative of the wrongly imprisoned King Bimbisara and his virtuous Queen Vaidehi (FIG. 6-22). The panel depicts the "Sixteen Visualizations" performed by the queen at Amitabha's instruction. Vaidehi is shown as a white-robed kneeling figure at both sides of each of the six registers; each episode is marked by a brown cartouche without text. The meditative stages take place outdoors in a verdant setting of sparse trees and rolling hills. The artist depicts the object of her visualizations before Vaidehi in each instance: the lotus tanks, jeweled trees, pedestal thrones, and pavilions to the great *bodhisattvas*, and eventually Amitabha himself. Missing from this panel are the final three visualizations, the three levels of rebirth with their visions of the Pure Land promised to believers. These scenes may have been displayed across the bottom of the wall, now . damaged.

One of Amitabha's two great *bodhisattva* attendants assumed great importance in Tang times. The opposite, south wall of Cave 45 (FIG. 6-23), illustrates well the independent role of Avalokitesvara. This ambitious composition actually assembles three distinct aspects of Guanyin. At the center is a large, standing, iconic rendering of the deity under a canopy. Here the great *bodhisattva* is strictly frontal, bedecked with strands of jewels and sashes, a miniature Amitabha in the headpiece confirming the identity. Across the top is an array of small scenes of the "thirty-three manifestations of Guanyin." These scenes illustrate Guanyin's ability to assume various divine and human guises as described in the well known "Pumen Pin" (Gate

to Everywhere of the Bodhisattva Who Observes the Sounds of the World), the twenty-fifth chapter of the *Lotus Sutra*. At lower registers are similar multiple scenes. Here we see illustrations of the various ways in which Guanyin can intercede on behalf of believers who call the deity's name. As with the manifestations, cartouches explicitly label each small scene. It is the charge of the painter to illustrate each peril, whether sword-wielding bandits or a dangerous storm at sea, as required.

The conception of this mural is not out of step with the painted visions of the Western Pure Land seen above. In both cases, a central pictorial unit is iconic, while the flanking units are narrative. The wall is both a focus of devotion and a "visual text" for the edification of all who come before it. The common Tang-era term for these murals is *bian xiang*, rendered by Victor Mair as "transformation tableaux." Scholars have debated the interpretation of this term and its proper application. The similar term *bian wen* (Mair's "transformation texts") is found in the titles of some scroll texts recovered at Dunhuang, but these literary works seem to encompass both Buddhist and secular subjects. These texts may sometimes have been recited for an audience, and a few were even given illustrations that could in turn be viewed during performances. The similar terminology need not mean, however, that artists also created mural compositions as the visual accompaniment to recitations before an audience. Indeed, as Wu Hung has pointed out, the cramped surroundings and darkness of the Mogao chapels make this function impractical. The term *bian xiang* seems better understood as a reference to the "miraculous" or "illusory" nature of these pictorial renderings, and indeed of the great preaching episodes in which all *sutras* were spoken by Sakyamuni himself.

The "Sutra Cave"

From a Eurocentric point of view, the wonders of the Mogao chapels were "discovered" in the early twentieth century through the efforts of such redoubtable scholars as Aurel Stein and Paul Pelliot. Both came away from their visits with large quantities of medieval documents and paintings acquired from a local monk who had stumbled upon a cache at the turn of the century. This cache was found in the "Sutra Cave" (Zang jing dong), now Cave No. 17 in the system of the Dunhuang Academy. This small chamber held an estimated forty-five thousand items gathered together from a great many sources in the Dunhuang region sometime in the eleventh century. The motivation for this project is not understood, but the result was a priceless sampling of the visual culture of the Western Regions. While some documents and *sutras* dating from the pre-Tang period were part of the cache, the bulk of the paintings and related materials date from the mid- and late Tang and subsequent Five Dynasties period. The paintings depict many devotional themes attested in records of the Tang period. In style and quality, they range from the most accomplished and up to date to the naive and old-fashioned.

A major devotional cult of the late Tang centered on the *bodhisattva* Ksitigarbha (Dizang), an intercessor deity who, like Guanyin, alleviated the sufferings of the faithful. Ksitigarbha's special charge was Buddhist purgatories and hells where the souls of the dead were held prior to rebirth. A scroll of the *Sutra of the Ten Kings of Hell (Shi wang jing)* vividly illustrates the accommodation of Indic and native Chinese concepts this subject required (FIG. 6-25). The illustrations depict the "courts" of the Ten Kings, such as Yama, the Indian god of death, and Taishan Wang, the Chinese deity of the underworld beneath Mount Tai. Heads and hands locked in stocks, hapless souls parade before each king at seven-day intervals after death. Like Chinese magistrates, the kings, seated at desks and assisted by clerks, scrutinize the records of the deeds of each soul. Most will be sentenced to rebirth in one of the "Six Realms": hell, hungry ghosts, animals, humans, titans, and gods. Only Dizang, here shown in his monk's attire, can penetrate this realm and rescue a soul from it. These illustrations are simple and direct picture storytelling, probably created earlier than the scroll itself, which is assigned to the late ninth or tenth century. Nonetheless, these scenes, along with those of Queen Vaidehi's meditations or Guanyin's manifestations,

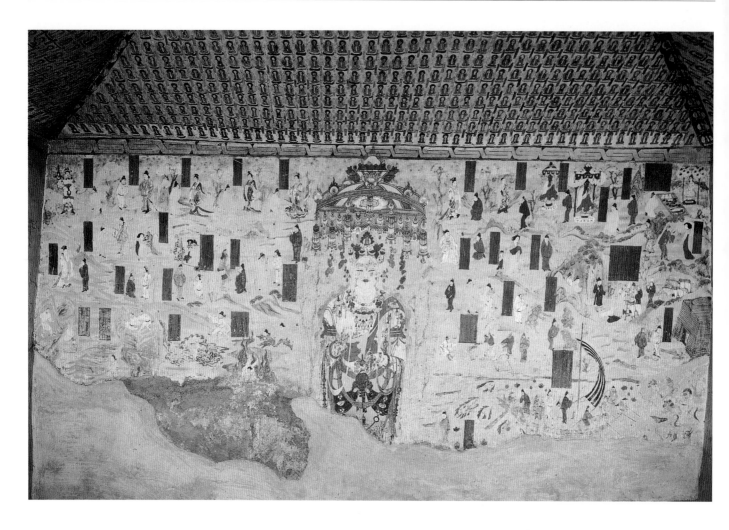

6-23 Manifestations of Guanyin
Wall painting, south wall, Cave 45, Mogao chapels, Dunhuang, Gansu. Tang, 8th century CE

6-24 Sketch of a monk
Tang, late 9th–early 10th century CE. Ink on paper, height 18" (46 cm). The British Museum, London

testify to the strong interest in narrative illustration in Tang visual culture.

While most of the painted works recovered from the Sutra Cave are silk banners in color, many other items like the "Ten Kings" scroll are on paper. Some of these are clearly sketches or practice drawings done by painters active in the region. Other works are designs that preceded a mural, or aids such as pounces for transfering motifs to the walls. An ink drawing of a seated monk (FIG. 6-24) may or may not be a finished work. Executed in ink line alone, without either ink wash or color, this subject has close parallels in several small chambers at the Mogao site used for memorial images of monks, including Cave 17, where the local monk found the great cache. It may therefore be a design for such a project. On the other hand, the drawing is without mistake or emendation, unlike preparatory sketches. There is no reason to think, save for its lack of color, that it is not finished. Tang critics writing

in the ninth century prized brushwork above all else; this monk may well have satisfied contemporary tastes.

ELITE LIFE AND ELITE ARTS

Sui and Tang society was aristocratic—a social order that was seriously affected by a variety of institutional, economic, and demographic changes. Late Tang society was markedly changed from its Sui and early Tang predecessors. Indeed, the differences were so profound that many scholars look upon this period as a great watershed in the history of Chinese society. The Tang

imperial clan was an aristocratic family with roots in Taiyuan (modern Shanxi), and the first two emperors (Gaozu and Taizong) were regarded as "first among equals" by their aristocratic peers. Their consorts and high ministers came from the same elite clans of the northwest that had dominated the societies of the Northern Dynasties and that had different ideals of manly and womanly behavior than their contemporary southern counterparts. Martial prowess and horse riding, for example, were far more important in the north than in the south. The fact that northern women assumed active roles in family life was not lost on observers from the south. Examinations to select capital and local officials probably did not affect

6-25 *The Ten Kings of Hell* (two details)
Tang, late 9th–early 10th century CE. Handscroll, ink and pigment on paper, height 11″ (28 cm). The British Museum, London

society as much as some historians have claimed, but it did widen the elite base of officials serving at court and in the capital. Great families from the "northeast" (modern Hebei, Henan, Shandong) became more prominent during the seventh and early eighth centuries. More gradually, so too did men from the clans of the "southeast" (the Lower Yangzi macroregion).

Early texts record portraits of important personages at least from the Han period; the seventh-century imperial court favoured this kind of painting. Still, we lack any credible extant works that depict specific emperors or empresses, or any other names of renown before the Song period. The handscroll known as the *Thirteen Emperors* (Museum of Fine Arts, Boston) is most likely an eleventh-century tracing copy of a Tang composition (FIG. 6-26). The attribution to Yan Liben (d. 673), although made as early as the eleventh century, is not buttressed by any Tang textual references. The first six figures with attendants are by a different hand than the final seven. The brief inscriptions that label each group may be later additions; in any case, scholars have established no clear rationale for the selection of the individual emperors. Nonetheless the scroll's designs are good evidence for an important figural type:

the imperial personage with attendants. The image of Emperor Wu of the Northern Zhou shown here is a convincing statement of his social persona. The rendering employs a hieratic scale that diminishes the stature of accompanying figures. This is an old convention that can be found in designs from the period of division, including scrolls attributed to Gu Kaizhi and the donor reliefs at the Longmen cave chapels. The emperor himself is a heavy-set man with a considerable stage presence, stern in demeanor, and august in his mortar-board hat and finery. This kind of imperial costume is repeated on other figures in the Boston scroll, but other versions of dress are illustrated as well. The heavy-set imperial type seen here is also found in the Mogao chapels at Dunhuang in murals recording the encounter of Manjusri and Vimalakirti, such as that in Cave 220 dated 642.

No authentic portrayals of any Tang empress are available, although some scrolls linked to worthy painters such as Zhang Xuan (active early eighth century) and Zhou Fang (active late eighth–early ninth century) claim to represent denizens of the imperial court, including the famous Yang Guifei. Some of these compositions accurately reproduce Tang-period conventions

6-26 Att. to Yan Liben, *Thirteen Emperors*
Tang, 7th century CE (11th-century copy). Handscroll, ink and pigment on silk, 20″ × 17′5″ (51 cm × 5.31 m). Museum of Fine Arts, Boston

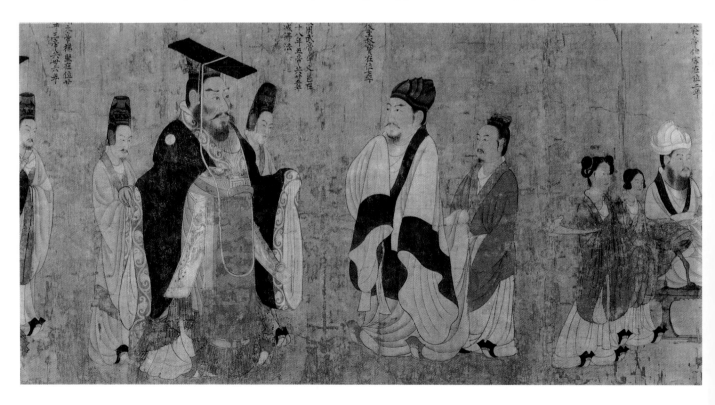

6-27 Att. to Zhou Fang,
Ladies with Flowers in their Hair
Tang, late 8th–early 9th century CE (10th-century copy). Ink and pigments on silk, 18 × 69" (45.5 × 175.5 cm). Liaoning Provincial Museum, Shenyang

for grouping figures, a repertoire of common poses and actions, and even some details of Tang fashion, such as hair, dress, and furniture. We illustrate a painting in Liaoning attributed to Zhou Fang (FIG. 6-27). Ellen Laing has demonstrated that this painting illustrates a scene on "Flower Morning," a spring holiday celebrated in Tang and later times. The actual date to be assigned to the figures is debated; some scholars regard their dress as tenth-century attire and date the painting no earlier. Moreover, the composition as it is cannot be analyzed as evidence for Tang conventions since the present handscroll is assembled from pieces of silk that may actually have been part of a different format originally. These caveats given, the figures are perhaps the best female images of early date among extant portable paintings. These ladies display many of the features of Tang taste and style admired in the poetry and other writings of the day. They are neither overly slim nor heavy. They wear high-waisted dresses without sleeves, and diaphanous wraps with large sleeves and long sashes that both mask and reveal

the dress. Gold hairpins and artificial peony blossoms in keeping with the holiday ornament high bouffant hairdos. These women epitomize Tang-style elegance and high fashion.

The considerable attention given to paintings of women distinguishes the figural art of this period. The fame of Zhang Xuan and Zhou Fang derives partly from their attention to women subjects. Even ignoring the many works attributed to them, depictions of women would still be prominent among authentic paintings from tombs and cave chapels. Several fragmentary screen paintings from the seventh- and eighth-century tombs at Astana, a cemetery site near Gaochang (in Turfan, Xinjiang), complement the evidence of murals and portable scrolls. A lady seated on a high couch placing a token on a game board (FIG. 6-28) is almost as elegant as the ladies on Flower Morning now in Liaoning. She wears a red costume with a gauze shawl or long scarf. Her makeup includes heavily rouged cheeks, a small painted forehead motif, and bright lips. On other fragments of this eighth-century screen well-dressed women

6-28 Lady playing *weiqi*
Tang, 8th century CE. Silk,
height 24¾" (63 cm). Astana
cemetery, Turfan, Xinjiang.
Xinjiang Museum, Urumqi

A game of "encirclement
chess" (better known by its
Japanese name, *go*) occupies
a refined Tang lady, a theme
also known from tomb
murals and portable scrolls.
The painter's interest in elab-
orate coiffure, heavy
makeup, diaphanous
scarves, and colorful textile
patterns is similar to such
works as the better known
*Ladies with Flowers in their
Hair* (see FIG. 6-27).

stand and watch idly, while two little boys in trousers
play in the long grass to one side. The activities
shown in such designs reflect the ornamental
life of many women in Tang elite society. Privileged
and pampered, they were nonetheless all too
subservient to stereotyped roles and the whims
of their menfolk. A brilliant entourage of house-
hold or palace women was as much a status symbol
for a gentleman as his fine horses.

Cosmopolitan Life

Most features of the cosmopolitan life we asso-
ciate with the Tang capital had roots in the Northern
Dynasties. Luxury goods crafted in regions far
west of China are not infrequently recovered from
elite burials of the sixth century. The Sui–Tang

period differed in several respects, however. First,
Chang'an was a magnetic center for the wealth
and industry of a unified state whose ambitions
and resources far surpassed those of regimes of
the period of division. Early Tang society may have
been relatively frugal, but by the eighth
century a luxury life-style was well developed,
and many historians regard the late Tang as a
decadent age. Second, during the seventh cen-
tury Taizong and Gaozong achieved control
over the oasis states of the Tarim Basin. Tang
intrigues helped splinter the Turkish empires, and
a sizable Turkish population settled in the capi-
tal, as did a refugee Sasanian prince and his
followers. The seventh century also saw the arrival
of many other foreign visitors and resident mer-
chants in the markets of the capital. All of these

Precious Metals

Silver vessels from the Byzantine and Sasanian empires and from Sogdia became increasingly common in the north by the sixth century. They must have continued to arrive in the capital during the seventh century as Taizong and Gaozong secured the Silk Road statelets that served as way stations between these West Asian cultures and Tang. Imported goods circulated from foreign royalty to their Chinese counterparts; they were probably not common trade goods. The actual transmission of such luxury items may have taken place in several ways: through direct embassies from foreign rulers to the Tang court; as gifts presented to emissaries sent from Tang; or as gifts offered by resident foreigners such as the refugee Sasanian prince who escaped to Chang'an in the seventh century.

Working silver and gold required hammering sheets of the metal out of ingots. This method was antithetical to Chinese traditions that relied on casting. The process of raising up a bowl or other shape around a form using a mallet and finishing the object through additional cold work is quite distinct from Shang and Zhou metalworking. Decoration on silver or gold vessels could be chased onto the surface by engraving lines and patterns into the soft metal. Major motifs were often raised by hammering from the back (repoussé), a technique which normally left only one face of the object presentable. Metal workers overcame this drawback by soldering pieces with repoussé designs onto vessels, thus hiding the worked underside. Gilding was common as a decoration technique, usually gold patches applied to silver. This technique had Chinese precedents in the flash gilding of Han times.

It is not until the late seventh and first half of the eighth century that Tang metalworking begins to depart from the vessel forms and decorative motifs of imported prototypes. There is a gradual increase in the number of types, and more types imitate forms already in use in other media. In addition to large quantities of serving dishes, saucers, and bowls, we begin to find other food serving types, tea and wine vessels in particular, as well as more unusual creations, such as spherical censers. The decoration of eighth- and ninth-century vessels elaborated both foreign and native prototypes, as can be seen in an eighth-century plate (FIG. 6-29) from a cache in Kuancheng (Hebei). This plate is nearly 20 inches (50 cm) in diameter, cut and hammered to form the six pointed lobes of its raised rim. The border of each lobe is filled with a floral and fruit spray. The center of the plate is taken up by a standing deer. Like the border motifs, it is in repoussé and gilded. The plate stands on three cast silver legs. This plate is remarkably similar to a well-known example in the Shōsōin, a storehouse in Nara, Japan, dedicated in the mid-eighth century in honor of the deceased emperor by his empress. The Shōsōin example differs in the pose of the deer, which looks back over its shoulder, and in the specific floral motifs that fill the border. Nonetheless one could claim that both plates emanated from the same workshop.

The latter half of the Tang was the high point of gold and, especially, silver vessel production. Tribute sent to the capital by officials and regional comman-

6-29 Plate with deer
Tang. Silver, diameter 19¾″ (50 cm). Hebei Provincial Museum

ders accounts for many objects. It is likely that the Hebei plate discussed above was actually made in the Lower Yangzi macroregion. By the late eighth and ninth centuries, the south was the major source of gold and silver tribute. Five "circuits" were famous for their wares: Jiangnan, Huainan, Jiannan, Lingnan, and Qiannan. The profusion of floral and bird motifs that characterizes late Tang silver can be traced to southern workshops active in this period. However, some tribute was in the form of ingots that were then worked by imperial artisans. Much of the silver found in the relic crypt of the Famen Temple bears inscriptions detailing its creation in the Wensi Yuan, the main workshop of the Tang palace. Imperial donors to the Famen Temple made offerings of censers, bowls, salt cellars, tea grinders, and a variety of other objects from their own pantries and serving sets.

developments enhanced the foreign presence inside Tang society, at least in the capital and other urban areas. Tang society therefore had both the means and the opportunity to enjoy exotic fashions and customs as never before, and to develop adaptations and spin-offs from the imported goods available to them. An infusion of non-native motifs and styles generally marked hairstyles, jewelry, costume, dance, music, food, drink, and the decorative arts. Traditional products such as glazed stonewares and silk textiles profited from a new vocabulary of forms and motifs. Craft traditions with relatively shallow roots, such as the working of gold and silver, also reached a new maturity.

One legacy of the Sui and early Tang consolidation of the economy was the growth in all kinds of ceramic production. The far greater number of kiln centers active by middle and late Tang times overshadowed the relatively small number of such centers presently known from the Sui. Production in the south continued to expand, with a strong emphasis on greenwares (celadons), especially in Zhejiang, where the Yue kilns were active. Production of white wares was centered in the north, in modern Hebei and Henan. While these macroregions were famous for distinct ceramic traditions, in fact individual production centers more often than not sold a range of wares with several different glazes. An example of such a multifaceted production complex was the Huangpu kilns in Tongchuan County (Shaanxi), the foundation for the Yaozhou wares of Song and later periods. The Huangpu site has revealed thick deposits with hundreds of thousands of sherds and wasters stretching along the bank of a river. Workshops were cut into the bank for forming and glazing the different wares, and many nearby kilns were used to fire the wares. The production included architectural pottery, three-color wares for mortuary use, and a range of celadons and painted wares for everyday use.

Although East Asian and Euro-American ceramics specialists have much debated the definition of "porcelain," it may now be safe to claim that true porcelains first appeared in the Tang period. The clay required, kaolin, had been known and utilized in North China since prehistory.

With sufficient refining and washing prior to potting, the particles were rendered exceptionally fine. Ceramicists added feldspar and flint to the clear silica glaze. The effect of high firing, in excess of 1250°C, was the virtual integration of the glassy surface coating with the body. The body itself became vitrified—like glass—and the bond between surface coating and fabric indestructible. The result is a body that is white, impervious to water, and resonant when struck. The remaining characteristic of European definitions of "true porcelain"—translucence—is not, however, common in Tang wares. Tang white wares are best known from kiln centers in the north, including Quyang (Hebei) and Gong County and Mi County (Henan).

Another Tang ceramic tradition that predicts the high achievements of Song and later times is that of Yue celadons. This ancient tradition, with its roots in Zhou times, flourished under the Southern Dynasties. Tang-period production was centered around such cities as Shangyu, Yuyao, and Ningbo (Zhejiang). The Yue kilns sent large quantities of their production to the Tang court as tribute. They also shipped their output overseas to Japan, Korea, and Southeast Asia from the port of Ningbo. Yue wares were used in food, tea, and wine service. The growth of tea drinking may have affected the popularity of celadons in particular; Yue tea bowls were already the highest ranked wares in the view of the *Tea Classic* (*Cha jing*, an eighth-century text). The local regimes that followed the demise of the Tang dynasty continued to patronize these centers and have been associated with a deluxe production called "secret color" (*mi se*) ware. Several pieces of this high-quality Yue ware were found in the crypt of the Famen Temple (see pages 200–201 above). A bottle must date from before the 874 investment of imperial gifts there and thus shows that the highest quality Yue wares predate the tenth century. Unlike Tang porcelains, this bottle has a grayish body and a hazy green glaze. Faint crackling appears in the glassy surface, the result of the different rates of cooling of body and glaze. Chinese connoisseurs highly prized both the depth of the celadon glaze and its crackle.

Calligraphy

In early Tang times the integration of cultural practices from north and south strengthened the state. Calligraphy was the preeminent art of the age. The emergence of the first "great masters" of this art in the Later Han (25–220) and Eastern Jin (317–420) periods accompanied the development of major script types. By the late sixth century, the tradition of the "Two Wangs" (see pages 174–176 above) was the outstanding source of models for serious calligraphers. High officials gathered around Gaozu and Taizong—Yu Shinan, Ouyang Xun, and Chu Suiliang in particular—presided over the institutionalization of this tradition in the new capital. In fact, Yu Shinan (558–638), a southerner and a student of Zhiyong, a descendant of Wang Xizhi, taught Taizong himself. Yu and Ouyang together instructed the sons of the capital elite in the academy. These ministers also acted as artistic advisors, authenticating works in the "Two Wang" tradition and supervising the production of meticulous tracing copies of autograph brush-written specimens (*tie*). Taizong's enthusiasm for Wang Xizhi is legendary. It is generally believed that he went to his grave in 649 with the *Lanting Preface*, the most famous work of Wang Xizhi (see FIG. 5-24 above).

Works by the early Tang masters show their debts to the tradition of the "Two Wangs" but also register conventions of the well-developed inscribed stele (*bei*) tradition of the north. Yu Shinan's regular script, as seen here in a detail from his *Stele for the Confucian Temple* (dated c. 627), perpetuates many formal traits of the Wangs' writing (FIG. 6-30). Even in a rubbing taken from an engraved stone, the qualities of the brush strokes and the freedom of writing are easily seen. The individual characters are buoyant, placed onto the surface with a sure sense of balance, confidently aligned on a common vertical axis, the horizontal strokes and segments tilted slightly toward top right. The thickness of strokes and the spacing required to construct each graph suggest a controlled, rhythmic process of writing. Individual elements, however, are varied from one writing to another. For example, the top "grass" radical is given a slightly different form in each of

6-30 Yu Shinan, *Stele for the Confucian Temple*
Detail of rubbing, Beilin, Xi'an. Tang, c. 627 CE

6-31 Yan Zhenqing, *Stele for the Guo Family Temple*
Detail of rubbing, Beilin, Xi'an. Tang, dated 764 CE

6-32 Emperor Xuanzong, *Stone Terrace "Classic of Filial Piety"*
Detail of rubbing. Beilin, Xi'an. Tang, dated 745 CE

three successive graphs at the left-hand column of this detail. This kind of regular script was the model for Taizong's own inscriptions.

By the eighth century, a revival of interest in the regular script of the northern tradition blossomed with such figures as Yan Zhenqing (709–785). Yan's graphs, however, are some steps removed from the reserved, graceful forms found in most sixth-century inscriptions. This detail from his *Stele for the Guo Family Temple* (dated 764) is representative (FIG. 6-31). Large individual graphs occupy most of the area of the imaginary boxes in which they are written. As a result the vertical columns and adjacent registers appear crowded. This is a brush style derived from chiseled epigraphic prototypes in which individual strokes are powerful and firm. The virility of these graphs sacrifices the suavity of works in the Wangs' tradition. Rhythm and a pliant brush tip are less evident. The virtues of boldness and contrasting thick and thin strokes have superceded the attractions of a graceful and mannered execution.

Both the emperors Taizong and Xuanzong were noted calligraphers. The latter produced one of the greatest monuments of his age in the so-called *Stone Terrace "Classic of Filial Piety"* (dated 745; FIG. 6-32). These stones stand today before the "Forest of Steles" (Beilin) in the former Confucian temple of Xi'an, China's oldest museum. The stele itself is unusual in being composed of four massive slabs 20 feet (6 m) in height that create a square pillar placed atop an elaborate base and topped with a cloud-bedecked cap. The *Classic of Filial Piety (Xiao jing)* was one of the most

widely read Confucian classics. Here it is written in the imperial hand with a commentary, also composed by the Son of Heaven, interspersed at intervals. To realize this project, Xuanzong chose clerical script, *li shu*, the preferred script type when the first "Stone Classics" were created in the Later Han (compare FIG. 4-3 above). The text thus is consciously presented in an archaic script that must have called to mind both the earlier Han project and the remote age of the sages credited with the teachings. In contrast to the modern

6-33 Monk Huaisu, *Autobiographical Essay*
Tang, 777 CE. Handscroll, ink on paper, 11″ x 24′9″ (28 cm x 7.55 m). National Palace Museum, Taipei, Taiwan

6-34 Att. to Zhan Ziqian, *Spring Outing*
Sui, early 7th century CE (later copy?). Handscroll, ink and pigments on silk, 17 x 31¾″ (43 x 80.5 cm). Palace Museum, Beijing

running and regular scripts of his day, the graphs here are compact and plump with ample space all around. Some graphs have decidedly old-fashioned elements, such as the left-hand element in the graph *ming* ("bright") in column 2. The writing preserves such notable traits as the flaring terminals of strokes that angle downward to the left. It seems likely that Xuanzong and his tutors had access to the Han stones or rubbings taken from them. Thus they were engaged in the study of ancient models as an integral aspect of their own aesthetic practice. Other Tang calligraphers such as Li Yangbing investigated the potential of the even more archaic seal script, spurred on by such sources as the "Stone Drums" (see FIG. 3-2 above) and inscriptions carved for the First Emperor of Qin (see FIG. 4-2).

While it is highly unlikely that we have many autograph works from pre-Tang and Tang masters, excellent tracing copies were produced, often under imperial direction (compare FIG. 5-23). Some scholars believe that the most famous specimen of the "wild cursive" (*kuang cao*) script from the Tang, the *Autobiographical Essay* by the monk Huaisu (725–785), is a tracing copy (FIG. 6-33). Other authorities are convinced that it is a brush-written specimen from the monk's hand. Whatever the case, the writing on this paper handscroll is full of the quirks of brush compositions. Traces of the brush reveal when it was charged with ink and when the hairs became sufficiently dry to spread apart, leaving white streaks within a stroke. The execution is full of energy and broken cadences. Graphs vary in size and shape; nothing of an imaginary underlying grid is left. Being a fully cursive (or "grass") script, the graphs are linked to one another in series, several written out without lifting the brush tip. This entails considerable simplification and abbreviation, so much so that legibility is in doubt in many passages. To a modern-day viewer similarities to action painting may seem appropriate, but to critics of the day the work invoked metaphors to the way a swordsman brandishes his weapon or a dancer swirls her scarves.

Although writings about calligraphy began prior to the Tang period, this age produced many new critical and theoretical works. Several Tang critics established a ranking system for evaluating calligraphers, the most enduring being that of the *Judgments on Calligraphy (Shu duan)* by Zhang Huaiguan (eighth century). Zhang classified calligraphers into three grades: *shen* ("divine, inspired"), *miao* ("marvelous, excellent"), and *neng* ("able, competent"). Within these grades, further distinctions were possible, such as "upper," "middle," and "lower." Ranking schemes were not the only aspect of calligraphy criticism and theory that was applied to painting. The qualities of fine brush writing were the very qualities most admired by Tang painting critics.

Secular Themes in Painting

Our two best textual sources for Tang painters and paintings were produced in the mid-ninth century: Zhang Yanyuan's *Record of Famous Painters through the Ages (Lidai ming hua ji)* and Zhu Jingxuan's *Record of Famous Painters of the Tang (Tang chao ming hua lu)*. They devote attention to the personalities and achievements of painters who made their careers at court and in the capital temples. Zhu's text is the more informative in this regard. Some of the most familiar anecdotes of Chinese painting are first recorded here. Zhu also adopted Zhang Huaiguan's three-level ranking scheme. In this implicit competition Wu Daozi, the dynamic Buddhist mural painter of the eighth century, ranked well above all others as "divine class, upper rank." Zhu also appended another category at the end of his ranking: *yi pin* ("untrammeled class") to designate those painters whose works or methods were not susceptible to the usual norms of criticism. Wang Mo, "Ink Wang," for example, was known to paint while inebriated (a common condition of poets, calligraphers, and painters alike). More importantly, Wang would fling his long hair into the ink and then onto the painting. Zhang's *Record of Famous Painters through the Ages*, on the other hand, is an encyclopedia of ancient lore and recent historical material, arranged on the model of a dynastic history. It is virtually impossible to get beyond the accounts in these two texts—both what they say and what they omit—in any investigation of Tang painting.

The late Tang writers show a considerable interest in new subjects in painting, including landscapes. The father of Sui–Tang paintings of this subject was Zhan Ziqian (active c. 550–604?), a ranking court figure of the Northern Qi, Northern Zhou, and Sui. Early Tang critics regard him highly, but late Tang writers consider his work old-fashioned. A handscroll in the Palace Museum, Beijing (FIG. 6-34), gives visual evidence for Zhan Ziqian's efforts as a painter of "vistas with horses and figures." Entitled *Spring Outing* in a label written by the Northern Song emperor Huizong in the early twelfth century, this composition compresses a deep recession into the relatively confined handscroll format. The scene opens with a spit of land that moves up the painted surface toward a valley before a large peak wreathed in low-hanging white clouds. Horses and riders prance along the lower shore and also move into the middle distance toward a rustic compound nestled in the foot hills of the peak. A large river or lake opens up from the center of the scroll and recedes out of sight toward a highly placed horizon at top left.

On the near shore, an irregular triangle of land on the lower left, figures await a ferry.

The composition has both old-fashioned and reasonably sophisticated elements. Several techniques for invoking the illusion of spatial recession are emphasized: the diagonal expanse of water, the foreshortened landforms of the opening passage, the changing scale of land and trees in that same area, and the use of overlapping forms to suggest diminution. On the other hand, the meticulously drawn waves, the conventional forms for trees at several distances, and the fungus-like clouds all have an archaic, even decorative quality. However scholars choose to date the painting now in Beijing, it seems to be a good candidate for an early design, one linked in the twelfth century to the time of Zhan Ziqian. The techniques of brittle line and warm color for the land, especially the blue and green boulders that erupt from the brown earth, can be compared to the scenes from the *Lotus Sutra* found in Cave 103 at Dunhuang or to details visible above the crenelated wall of Prince Yide's tomb ramp (see FIG. 6-9).

6-35 Att. to Han Gan, *Night-shining White*

Tang, 8th century CE. Handscroll, ink on paper, 13⅞ × 12⅛″ (34 × 30.8 cm). The Metropolitan Museum of Art, New York (77.78)

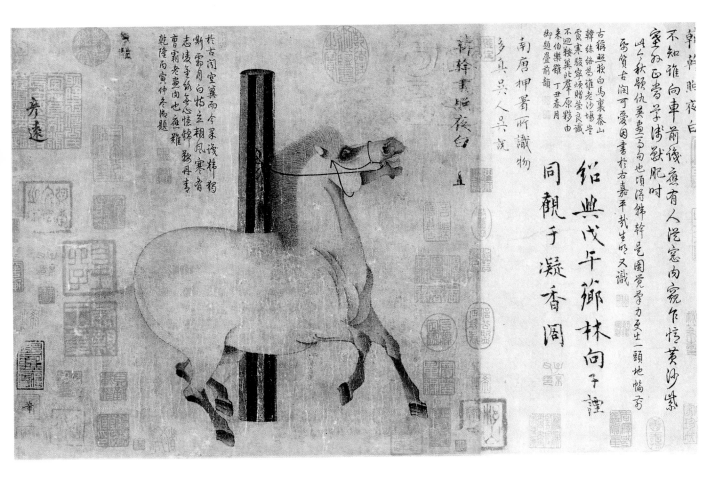

Another subject of considerable interest to Tang patrons, critics, and painters was that of fine horses. Emperor Taizong had his best war horses memorialized in a design by Yan Liben for reliefs installed at his tomb, the Zhaoling. (Two of these are now in the University of Pennsylvania Museum, Philadelphia, while the other four may be seen in Xi'an at the former Confucian temple.) The most famous of all portable paintings attributed to a Tang artist depicts the *Night-shining White* (FIG. 6-35). The scroll shows only the emperor's famous horse, tethered somewhat unconvincingly to a post against a void. Important documentation for this work leads back to a tenth-century attribution to Han Gan, active in the early eighth century. The painting's title is recorded as one of Han Gan's own projects on behalf of Emperor Xuanzong. The painter has concentrated on the horse's powerful silhouette, the muscled chest, and the animation of the horse's eyes, nostrils, and mouth. Like the depiction of noble women, the painting of horses was a genre that flourished intermittently after the Tang period, a subject linked inextricably to the ethos of the imperial house.

BEYOND THE MIDDLE KINGDOM

The Sui and Tang capitals attracted visitors from throughout East, South, and Central Asia. Literary testimony to such visitors includes the travel journals of Arab, Japanese, and Chinese travelers, and such inscriptions as the famous Nestorian Stele of Xi'an, which records a small Christian community during the eighth century. The residents of Chang'an were not surprised that their city drew such diverse peoples. After all, Tang armies projected the power of the Son of Heaven into the Tarim Basin, the Korean peninsula, and the northern reaches of modern Vietnam. Chinese pilgrim monks and official travelers made the arduous journey to India and even further afield in the southern ocean. Xuanzang, whose *Record of the Western Regions* (*Xi yu ji*) supplies rich documentation about the peoples of the Silk Road

and India, was well received at court. Taizong subsidized his translation of *sutras*, but the emperor's true motivation may have been as much to gain strategic knowledge about geography.

Official or state-sponsored contact was conducted through embassies. From the Tang perspective, such embassies conveyed the desire of their rulers to submit to the Tang court. Received as loyal dependents of the Son of Heaven, the ambassadors were rewarded with munificent gifts and allowed trading privileges. Several representations of delegations are found in imperial edifices: the stone statues at the Qianling have already been mentioned. A number of pictures portraying foreign emissaries are credited to Tang painters in literary sources. The most authentic is the pair of murals from the ramp of the tomb of Prince Zhanghuai (FIG. 6-36), dated to the early eighth century. Three Tang officials in court attire huddle in deep conversation. Three differently clad foreign visitors wait nearby, although two have crept forward as if to eavesdrop (only one foreigner is shown here). The three foreign figures are distinguished by their facial features, prominent noses, and bald pate, and by their costume, such as a fur or feathered cap. A similar array of facial and costume types is seen among the dignitaries who attend Vimalakirti in the murals at Dunhuang. Tang representations such as the mural shown here were not derived from literary accounts. Foreign visitors plied the streets and lanes of Chang'an, and foreign residents traded from stalls in the capital's markets.

Many fine objects of foreign origin have been retrieved from tombs and caches of the Sui and Tang capital. The burial of one Li Jingxun (d. 608) in a nunnery west of the Imperial City documents intimate relations among the Sui–Tang aristocratic elite. The young lady was the daughter of a high court official of the Sui; her mother was a member of the imperial house of the defunct Northern Zhou; she was also therefore related to the Sui emperor. After her death at age eight (nine by Chinese reckoning), her grieving family provided a lavish burial that included a stone sarcophagus in the form of a miniature timber-frame hall. Her grave goods included fine glazed stonewares as well as unusual vessels of gold and even glass. The

6-36 Tang officials and foreign emissary
Wall painting, Tomb of Prince Zhanghuai, Qianling, Qian County, Shaanxi. Tang, c. 706–711 CE

Eavesdropping on three Tang officials' conversations, a foreign emissary awaits the results of his host's deliberations. To painters of the capital, foreigners were not uncommon, and models for this one and his two companions (not shown here) must have strolled the streets and markets of Chang'an.

6-37 Rhyton
Sasanian or Sogdian, 6th–7th century CE. Onyx, length 6″ (15.6 cm). Hejiacun, Xi'an, Shaanxi. Shaanxi History Museum, Xi'an

most unusual of her funerary gifts, however, was a necklace of gold and precious stones. The polyhedron (multifaced) beads that make up the necklace are crafted from gold granules with ten miniature pearls each, an ancient craft practiced in South Asia. The precious stones are themselves mounted and carved in ways that suggest exotic origins. Assembly of the various components could have taken place in the capital. The necklace may well be an heirloom treasured in the family and then consigned to the grave of a beloved daughter.

The richest find of precious, exotic objects in the Sui–Tang capital was made in the fall of 1970. At a modern-day village called Hejiacun in the south-central part of Chang'an, two large ceramic crocks were found, stuffed to capacity with nearly a thousand objects of silver, gold, glass, and semiprecious stones. The cache initially was attributed to an imperial prince, a relation of Emperor Xuanzong, who may have fled the capital in great haste in the disruptions of the 750s. More recent analyses of the objects, however, suggest the date of the cache is actually later in the eighth or early ninth century. Moreover, a reexamination of the ward in question suggests the location of the cache need not be connected to the prince's mansion. The gold and silver objects offer a selection of types and styles available in the capital,

probably below the imperial level, from the sixth through the eighth centuries. A unique object from this hoard is a rhyton carved from variegated brown and white onyx in the shape of an antelope with a golden nose (FIG. 6-37). Several ancient cultures made this kind of drinking cup, which originated in Western Asia. The Hejiacun piece must be an import, perhaps a work of the sixth or seventh century from a Sasanian or Sogdian workshop. Like the necklace of Li Jingxun, the onyx rhyton from Hejiacun is an index of the cosmopolitan world of the capital consumer in the Sui and Tang periods.

The impact of Tang culture on the peoples whose embassies visited Chang'an is an important topic in its own right. The best known examples are the capital plans, Buddhist temples, sculpture, and pictorial arts of the medieval Korean and Japanese states. Wholesale borrowing is certainly a part of that story, but the result was not a uniform culture embracing all of East Asia in the seventh and eighth centuries. Korean and Japanese builders and artisans who worked for the Silla and Heijō courts imparted new ideas to their works. While the Heijō and Heian capitals in Japan were demonstrably indebted to Daxing cheng and Chang'an in their overall plan, by the same token the Japanese cities did not replicate the Chinese model; Buddhist halls and pagodas in Korea

and Japan exhibit features for which we lack any Sui–Tang (or earlier Chinese) source. Given these differences, works in Korea and Japan cannot be used as interchangeable surrogates for now lost Sui–Tang structures. By its very nature, borrowing is selective, driven by the needs and goals of the borrowers.

The Sui–Tang periods bear out some of the observations in the introduction to this volume about the dangers of using political chronology to discuss cultural history. The short-lived Sui was simply one of many northern dynasties ruled by hybrid aristocratic–military elites, and the Tang began as yet another instance. The consolidation and elaboration of institutions in the mid-seventh century created a new kind of imperial state, one truly continental in scope and active internationally. That new state lasted barely a few decades before it was wracked by court intrigues. By the mid-eighth century, barely a century after the initial Tang consolidation, this same state was falling apart, and the restoration that eventually ensued was largely cosmetic. A new society emerged in the last century of the Tang period, one dramatically different from Sui and early Tang. The fiction of imperial and institutional continuity masks these and other profound changes that differentiate the first and second halves of this dynasty.

7 TECHNOLOGIES AND CULTURES OF THE SONG

THE PERIOD FROM THE TENTH to the late thirteenth century CE was one of the most dynamic in all of Chinese history in terms of technological innovation, economic development, and social change. For convenience we will refer to the period as the Song era, after the two Chinese dynasties that spanned most of this age, but competitive regimes ruled substantial territories at various times, including the non-Chinese Liao and Jin dynasties. In the social arena, the shift from Tang-era politics and culture dominated by a hereditary aristocracy to the Song state, in which power and prestige were at least shared by educated scholar–officials, had long-term implications. The democratic openness of the examination system as an avenue to bureaucratic position, power, and wealth is often exaggerated, since elite families had many advantages and provided a disproportionate number of successful candidates. Nonetheless, the ideal of education rather than birth as the avenue to success that took hold in this period operated for the rest of the imperial era as a motor for the growth of schools, publishing, and the pursuit of the kinds of literary and historical scholarship that were most relevant to examination success.

Economic developments also contributed to social change. This was a dynamic era of growth in population—which reached about 100 million by the late Song— and of commerce, and urban centers. The dynamics of commercial urbanization in particular led to occupational specialization and a new complexity of social relationships.

Wealth and economic status opened new venues for cultural participation, as paintings and calligraphies were displayed in restaurants and teahouses, and song–poems from popular dramas circulated in the cities.

Technological innovation was as important— and even more distinctive of Song China—as social and economic change. The great inventions of the Song—the magnetic maritime compass, printing with woodblocks and movable clay type, gunpowder and firearms, and large-scale porcelain production—had worldwide importance when they spread eventually to the rest of the world and profound consequences for China in the economic, military, and social realms. Song China was the most technologically advanced state of its time, and the accompanying changes in social and economic organization were almost as significant, including large-scale manufacturing, interregional and international trade, and market-based economies. In the closely related cultural realm, Song China became a center of education and of information distribution, especially through the medium of printed books.

Each of these areas of development had important consequences for the arts. In ceramics, for example, we see technical innovations in manufacture, the economics of large-scale production and distribution, and in the social realm the association of certain wares with particular groups and tastes as markers of distinction. The rise of landscape painting as an independent genre may have

7-1 Long-necked vase, Guan ware
Southern Song, 13th century. Stoneware with soft blue crackled glaze, height 7⅛″ (18 cm). Percival David Foundation, London

been linked with urbanization and changing land economies. Even art theories and symbolic forms became linked to the competition between interest groups and political factions. Some arenas of cultural change that were relatively suppressed in the accounts of contemporary critics and commentators are as revealing as those aspects that were prominently celebrated. In the Song era, these included the cultures of foreign, border peoples, the status of women as active participants and subjects in artistic culture, and the diversity of Buddhist religious arts.

These long-term cultural, social, and technological changes were embedded within a dynamic landscape of political history. The long period of fragmentation of the late Tang period in the ninth century, which saw the rise of regional military commanders and a major suppression of Buddhist monastic institutions in 845, gave way to an acknowledged era of local centers of power known as the Five (Northern) Dynasties and Ten (Southern) Kingdoms. All of these regimes rose and fell within the period of little more than half a century, but this was nonetheless a culturally dynamic era, with especially important developments in painting at the regional courts of the Southern Tang, centered in Nanjing in southeast China, and Shu, in the southwestern Sichuan region.

Northern Song and Liao Empires (left)

Southern Song and Jin Empires (right)

With the reunification of China under the regime of the Northern (Early) Song, starting in 960 CE and completed within twenty years, came a return of the political center to north-

central China at modern Kaifeng, a site linked to the emerging prosperous southeast by canal systems. The Northern Song was a period of flourishing technology and commerce, with considerable military capability. Northern Song China, however, had formidable rivals along the northern and northwestern frontiers. The Liao dynasty of the Qidan peoples and the Western Xia dynasty of the Tanguts were regimes of nomadic origin that by this time were partly sedentarized cultures, whose incursions led to an institutionalized system of purchased peace through more or less extorted trade goods. Around the decades from 1060 to 1080, the Northern Song government was deeply split by factional rivalries, occasioned by the sweeping fiscal and land reforms proposed by the minister Wang Anshi (1021–1086). His opponents, representing for the most part the conservative interests of families of landholders and officials, included some of the most prominent poets, painters, and calligraphers of the entire age.

The profound political debates of the late eleventh century gave way in the early twelfth century to a more central position for artistic pursuits and cultural standards. The emperor Huizong who ruled during this era (1101–1125) is closely linked, through personal production, sponsorship, or taste, with the appearance of elegant calligraphy, meticulously observed bird and flower paintings, monochrome imperial ware ceramics, and the elaborate garden complex and artificial mountain at his palace. Of equal importance for cultural history were Huizong's artistic institutional reforms, including the training of artists at the National University and the establishment of competitive examinations for painters, as well as the publication of catalogues of imperial collections of ancient bronzes and paintings. Huizong has been accused of neglecting affairs of state in favor

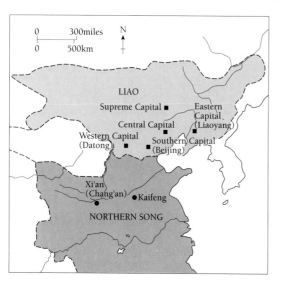

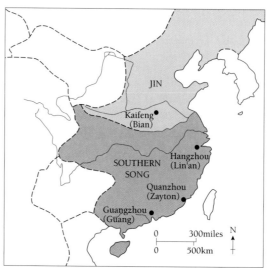

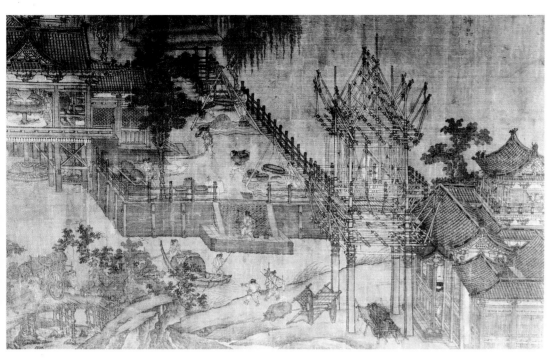

7-2 Anon., *Water Mill*
Five Dynasties–Northern
Song, 10th–11th centuries.
Detail of handscroll, ink and
colors on silk; 20½ x 47″
(52.2 x 119.3 cm). Shanghai
Museum

of artistic pursuits. His regime fell to the invading forces of the Jurchen, a sinicized people from Manchuria, whose rise was abetted by Song diplomatic efforts to establish them as a counterforce to the Qidan Liao.

The Jurchen captured Huizong and his eldest son, who had succeeded to the imperial throne just before the invasion, along with several thousand members of his family and court, and established their own Jin (Golden) dynasty over northern China, centered at Beijing. After some years of wandering, the refugee Song court, led by a junior son and heir of Huizong posthumously known as Gaozong (r. 1127–1162), established a southern court and regime centered at modern Hangzhou, which was continually troubled by issues of dynastic legitimation. Meanwhile, the Jin regime claimed both political and cultural leadership over northern China, including patronage and preservation of the culture of highly educated gentlemen that had emerged during the late eleventh century, through the encouragement of scholars and poets. The Southern (Late) Song regime was under continuing diplomatic and military pressure from the north, first from the Jurchen and later from the Mongol conquerors of the Jin. The Mongols largely completed their conquest of China in 1276 when they took Hangzhou and the beleaguered last Song emperor threw himself into the sea. The precarious situation of the Southern Song court at Hangzhou, in terms both of military security and political legitimacy, encouraged a certain escapism and awareness of transience as a cultural style. Nonetheless, in society at large, the growth of a commercial economy, handicraft industries, and a diverse urban life continued unabated, continuing the shift of centers of economic and cultural life to southeastern China.

MEASURING EVERYDAY LIFE

Pictorial images of city life, commerce, crafts, and industry from the Five Dynasties and Song periods were sometimes categorized in a specialist genre of "ruled-line paintings" (*jiehua*), meaning pictures of carpentered objects such as buildings, ships, and carts produced with the aid of rulers and other drawing instruments. Such paintings reflect the importance of precise, repeatable measurement in commercial culture. Other paintings of this kind were designed to spread knowledge of useful techniques and belonged to governmental or gentry programs of public improvement.

A short handscroll painting dating from the tenth or eleventh century depicts a water mill (FIG. 7-2) as the center of a busy network of transportation and activity. All of the buildings, including

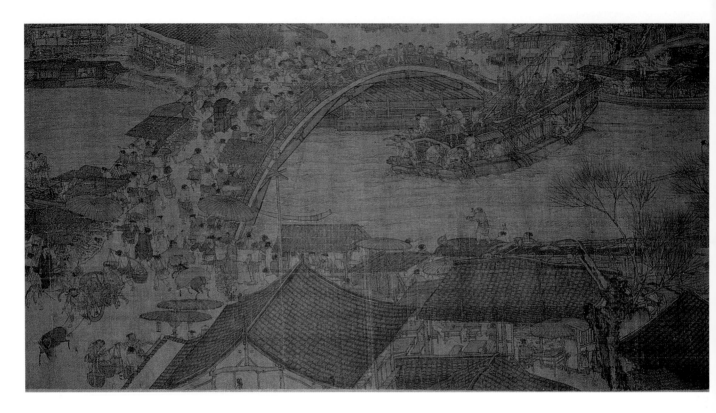

7-3 Zhang Zeduan (active early 12th century), *Spring Festival on the River*

Northern Song. Detail of handscroll, ink and colors on silk; 9¾ × 17'4" (24.8 cm × 5.28 m). The Palace Museum, Beijing

This panoramic handscroll painting shows a full range of urban life and activities, most likely in twelfth-century Kaifeng, the Northern Song capital. Using the technique of "ruled-line" painting, the scroll displays the measurable structures of buildings, boats, and bridges, and the social spaces of shops, restaurants, and street life in extraordinary detail. Beyond its documentary function, this kind of painting may have served to praise the government for encouraging this busy prosperity.

a tower still under construction, are depicted in meticulous detail, down to each beam, bracket, tile, and brick. Each of the buildings is slightly angled toward the viewer's upper left as a way of revealing not only their facades, or elevations, but also to clarify their extension into depth. The scroll also offes glimpses into interiors, with views that penetrate forms and spaces nested one within another. The result is a consistent perspectival rendering, with most receding lines and planes parallel to one another, that serves many of the same purposes as the mathematically based perspective systems developed centuries later in European pictorial art of the early Renaissance period. Clarity, legibility, and accuracy of measurement are very compatible with the subject, in which a manager sits in a pavilion (not shown) keeping track of accounts, with assistants and clients gathered around, watching the whole system with interest. The grain is transported to and from the mill by boat, with piles of grain on the platform, ready for sifting and weighing. The great grinding wheel is the center of all this activity, driven by water in the sluice, with piles of ground flour heaped up at mill-floor level. Porters move the grain on the platform or tote the sacked flour.

A much more elaborate and famous painting of this kind is the long handscroll known as *Spring Festival on the River* (FIG. 7-3) by the early-twelfth-century painter Zhang Zeduan. Less than a foot in height but over 17 feet long (24.8 cm x 5.28 m), this silk scroll presents a panoramic overview of the suburbs, riverside, and street life of a crowded Song city, purportedly the Northern Song capital of Kaifeng (then known as Bianliang). As in the depiction of the water mill, the artist established a high viewpoint, emphasized architecture, boats, and vehicles, and even repeated the motif of a tower under construction. *Spring Festival* is a set-piece of the ruled-line genre. Instead of a corner of commerce, it presents a full spectrum of urban lives and activities, penetrating more deeply in both social and visual terms, as the river and street scenes turn perpendicular to the picture plane into deep illusionistic space, and boats and buildings are shown sharply foreshortened to heighten the tension of volumetric rendering. Among its other interesting features, the painting provides almost an illustrated encyclopedia of Song material culture, with the rigging and carpentry of boats, the underside construction of bridges, the techniques of wheelwrights, and all the paraphernalia of a multitude of shops

and occupations, depicted with a clarity of detail that allowed the viewer to understand their construction and organization. The emphasis on boats and river traffic is a reminder of the importance of both domestic waterways and maritime trade to the Song economy. The capital at Kaifeng was connected by canals to the immense navigable system of the southern Yangzi River and its tributaries, a network more than 31,070 miles (50,000 km) long, and linked in turn to the big southeastern coastal ports for maritime trade. Paddle-boats up to 65 feet (20 m) in length plied the rivers, and the big high-seas junks, with water-tight partitioned hulls, stern-post rudders, multiple decks and masts, which were navigated with the aid of the mariner's compass, carried up to a thousand men. The composition of *Spring Festival on the River* builds up to and away from an arched, or "rainbow," bridge midway along the length of the scroll, where a boat crew is busily collapsing a mast and rigging to allow the vessel to pass safely beneath the bridge. Onlookers on the bridge above are diverted from the rows of foodstalls and vendors that line its length to watch the operation on the water with the same interest and participation as "sidewalk supervisors" in urban settings of any place or time. The streets in the last half of the scroll are full of shops and stalls, many with signs for fortune-tellers, apothecaries, and restaurants. The panorama, moving right to left in the customary unrolling direction of a horizontal scroll, ends by meeting a stream of merchants and visitors, including a camel caravan, monks, and well-to-do ladies, entering the city under a tower gate. Beyond the interest of the urban spectacle and the *tour-de-force* renderings of people and objects, the scroll may have functioned to commemorate the prosperity and, by implication, the good government of the Northern Song capital. Later versions of this composition, including one produced at the Qing-dynasty court of the eighteenth century, where the architecture, entertainments, and pastimes were updated to reflect a more contemporary prosperity, served similar ideological purposes.

The careful documentation of the appearance, structure, and organization of things seen in *Spring Festival* is a widespread concern in Song-era

painting and sculpture. It is visible elsewhere in the meticulous rendering of flower petals and animal fur, illusions of atmosphere and rock textures in landscapes, and convincing effects of fleshiness and fabric in figural painting and sculpture. More than in any other era in China, Song art was broadly engaged with effects of illusionism, transcription of appearances, and the organization of complex phenomena. While this surely should be described as a kind of realism, it would be misleading to treat this only as a technical conquest of representational problems. Realism is a deceptively straightforward phenomenon, bound up with complex values, attitudes, motivations, and even ideologies. *Spring Festival*, for example, is concerned on the most basic level with the way things look and how they are made. This suggests an orientation to the "here and now" of worldly values and the interests of a technological culture. Notable too is a specific way of representing the world, emphasizing the spatial and structural legibility achieved through illusionistic pictorial devices such as foreshortening, consistent viewpoints, and perspectival architectural drawing. Here, as later in Renaissance Europe, such devices convey an ambition to master and control the world through representation, a valuing of clear measurability, and a psychological distancing of the viewer from scene or subject. The objective values of a calculating, commercial society are at work. Realism could also serve the expression of political ideology, as in the claims of prosperity, flourishing commerce, and good administration embodied in the social and economic relations depicted in *Spring Festival*. Still other varieties and functions of realism were operative elsewhere in Song art. Meticulous transcription of appearances could aim at recording and preserving auspicious phenomena, perhaps even "realizing" their supernatural efficacy. Other Song realisms are related to a scientific outlook that valued close observation and classification.

The political and ideological purposes of paintings, even those of commercial and technological subjects, could thus be as important as their representations of material fact. Identifying the sponsors and audiences for such paintings helps

7-4 Anon., *Sericulture*
Southern Song, c. 1178.
Detail of handscroll, ink and
light colors on silk; 10¾″ ×
16′9″ (27.5 cm × 5.13 m).
Heilongjiang Provincial
Museum, Harbin

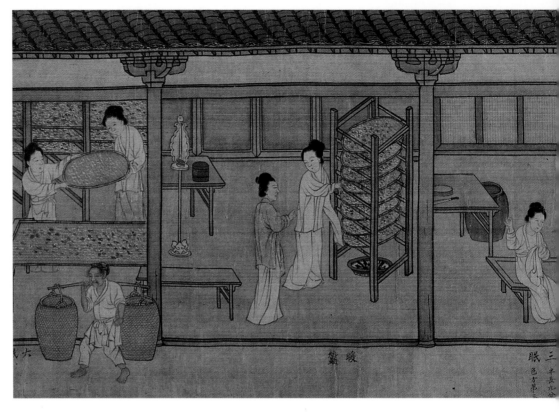

in assessing their functions. Court-sponsored painting in the early decades of the Southern Song was often explicitly concerned with issues of authority and legitimacy because of the refugee status of the regime and continuing military pressures from the north. An interesting case of private patronage lay behind the handscroll illustrating processes of sericulture (FIG. 7-4), or silk production, sponsored by a well-to-do official from southeastern China around 1178. Sericulture and crop farming for centuries had been seen as the twin pillars of China's traditional agricultural economy. Beyond their illustrative value, images of farming and weaving were associated with a Chinese cultural identity centered on a settled agrarian economy, and by implication promoted values of industriousness and discipline. Silk production and weaving were craft skills particularly associated with women, so these scenes were also emblematic of feminine domestic virtues.

Beyond its associations with household virtues, silk production was a major craft industry, playing an important part in domestic trade, taxation, and even international diplomacy, since tribute to the northern nomadic regimes was paid in part in rolls of silk. Images such as these also had a

practical, educational function. In later times sets of images of agriculture and sericulture were reproduced many times in painting and print versions. These, along with textual manuals of advice for farmers, could be distributed as step-by-step guides to cultivation and production. The early *Sericulture* scroll is of particular interest for the legibility of its renderings of loom machinery and the weaving process, using some of the same devices of measured drawing as earlier ruled-line paintings. The painting seems to convey enough information to allow viewers to understand the construction of the machinery on which weaving operations are carried out by women with a quiet discipline. The presentation of this scroll to the court by a member of the gentry promoted traditional virtues but also suggested support of commerce and crafts, with a further benefit of conveying practical information.

Commerce and domestic life at the village level is the subject of several images of knick-knack peddlers offering their wares. A number of such images are associated with the court painter Li Song (active c. 1200), who himself came from the relatively humble craftsperson's background of a family of carpenters. His paintings of knick-

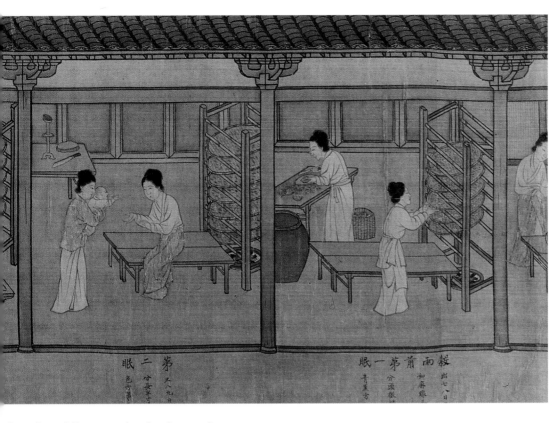

眠二第 眠一第莆雨穀
色今璧十 分頭髮如再與出七八日
二分璧草土 青嵐方

knack peddlers are closely observed vignettes, as in the small, fan-shaped album leaf (FIG. 7-5). A village nursemaid or mother literally has her hands full, warding off the peddler's salesmanship, the pleas of a toddler tugging at her skirt, and a suckling babe-in-arms who turns from her breast to grasp at the trinkets dangling within reach. The figures convey a certain earthiness; they are rendered vividly and with a secure knowledge of anatomy, unusual in a pictorial tradition in which even partial nudity was rarely portrayed. The clambering children and fleshy, animated features of the adults suggest the lively disorder of village life, far from the restrained decorum of elite ideals of behavior. The same profusion appears in the vendor's wares, an explosion of trinkets, toys, amulets, and utensils which displays a full range of Song manufacture and material goods. Since Li Song was a court painter, the image may have been intended as a genre painting for the amusement of an aristocratic audience, containing themes of abundance both economic and familial, with glimpses of acquisitiveness on the part of both vendor and children. The artist's inscription, which claims the ability to render five hundred separate objects within the diameter of the album leaf,

7-5 Li Song (active c. 1190–c. 1230), *Knick-knack Peddler*
Southern Song, dated 1210. Fan mounted as album leaf, ink and light colors on silk; 10⅛ × 10⅞" (25.8 × 27.6 cm). National Palace Museum, Taipei

suggests still other messages: the craftsman's pride in his skill at rendering, and perhaps an advertisement aimed at potential patrons or customers, since Li Song and his imitators painted at times for a wider urban market. The image is of the Song commercial economy at street level, with merchandising and consumption emphasized over production.

ART TECHNOLOGIES AND ECONOMIES

Apart from pictorial representations of technologies and economic activity, many kinds of art in this period were tangible products of developing technology or belonged to large-scale manufacturing and marketing systems. No technology had a larger impact on Song and later culture than that of printing, using engraved woodblocks, and including some experiments with clay movable type. The spread of education in the Song was founded on printed books, which offered opportunities for a standardization of culture. Printed pictures also played an important role in conveying information about archaeology and art in books such as an illustrated catalogue of the Song imperial collection of bronze antiquities. The late-Song-period *Meihua xishen pu*, compiled by Song Boren and published in 1261, was an illustrated

catalogue of prunus (apricot or flowering plum) plants, the first in what was to be a long and distinguished series of manuals that could serve as pattern books for painters and decorators.

Song Architecture and Urbanism

Printed books could also record and disseminate information about architectural construction and design, as in the *Yingzao fashi (Building Standards)* in thirty-four chapters, compiled by the superintendent of construction at the late Northern Song court of Emperor Huizong, one Li Jie, and published in 1103. As a government manual, the text reflects a Song tendency toward standardization and classification in the arts. The chapter topics include structural and decorative carpentry, brick and tile masonry, and painted decoration; definitions of terms and illustrations were included. An emphasis on repeatable, modular elements is notable in the treatise. While early Song and Liao buildings continue many Tang architectural practices, surviving middle and late Song buildings such as the Moni (Pearl) Hall at Longxing (Dragon Flourishing) Temple in Zhending, Hebei (FIG. 7-6), datable to 1052, show a greater emphasis on lightness in the double roof and gable-hip construction. In this building, foyer structures, each with gable-end roofs, protrude in all four directions, so that the entire roof

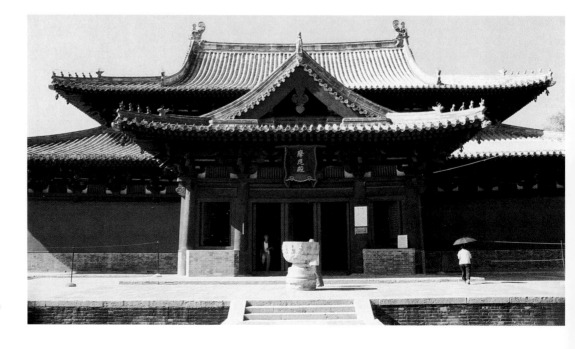

7-6 Moni (Pearl) Hall, Longxing (Dragon Flourishing) Temple
Zhending, Hebei. Northern Song, datable to 1052

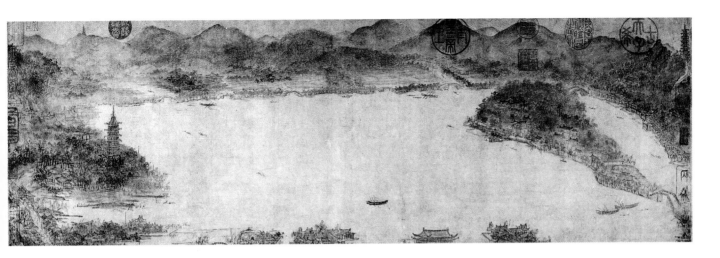

complex includes sixteen corners and thirty-three ridges. Here and elsewhere Song design shows a greater complexity of detailing, in the under-eave bracketing systems among other elements.

Only a few dozen Song-period buildings survive, mostly Buddhist temple halls and pagodas. Because most of these are in compounds or isolated sites, they offer only a hint of the appearance of Song cities. Otherwise, paintings such as *Spring Festival* offer views of urban architecture, or the palaces and mansions of the aristocracy, and they document the organization of urban life in the Northern Song. The importance of river transport and the commercialization of streets and bridges into corridors lined with shops and stalls is clear. Unlike in Tang capital cities, which were aristocratic and administrative centers with commerce, crafts, and entertainment confined to controlled districts and markets, all over Kaifeng stores and workshops sprang up, and the amusement quarters remained open all night. The Southern Song capital of Hangzhou, also advantageously situated for communication and transport, had more than a million inhabitants and developed a sophisticated urban culture. Descriptions of the capital could serve as guides to visitors, with both the attractions—gardens, clubs, entertainment centers, and specialty shops—and the perils of the city, in the form of hustlers and high prices for drinks and female companionship, recounted in detail (see "Urban Life and Culture in Hangzhou," page 234). The city was also a thing to be seen and enjoyed visually. A painting attributed to Li Song, *View Over West Lake at Hangzhou* (FIG. 7-7), combines a blurred ink-wash evocation of the misty hills surrounding the lake with a panoramic overview of notable features as if seen from a high hill: pagodas and temples, bridges, islands, and buildings. The painting is at once a dreamy spectacle and a maplike guide filled with unobtrusive information.

Ceramic Production

For scope and length of economic importance, no other art form matched Chinese ceramics. In the period from the late Tang to the end of the Song there was an especially broad distribution of kiln sites and ware types, which supported local economies. International trade in export ceramics, mostly for household use, extended from Southeast Asia, India, and Africa to the Near East and to Japan, where Chinese tea bowls for monastic use were highly prized.

The high point of the international porcelain trade did not occur until after the Song, but the technology of porcelain production was substantially advanced during this period. Wares made from the southern porcelain stone that is characteristic of later porcelains date only from the tenth century, though many of the same qualities are found in high-fired white wares produced in the Xing kilns of North China as early as the seventh century (see page 214). The establishment of the Jingdezhen kilns in southeastern Jiangxi Province, the center of the highest-quality deposits of primary kaolin clays, also dates from the early Song.

7-7 Att. to Li Song (active c. 1190–c. 1230), *View Over West Lake at Hangzhou*
Southern Song. Handscroll, ink on paper; 10⅝ × 31¾″ (27 × 80.7 cm). Shanghai Museum

Urban Life and Culture in Hangzhou

The growth of cities in Song China was accompanied by literature about urban life in the capitals of Kaifeng and Hangzhou. These writings could take the form of reminiscences about the days before the fall of the capitals to invaders or serve as guides for visitors. The following excerpts from a description of Hangzhou written in 1235 focus on aspects of urban life related to the production and consumption of arts, crafts, and luxury goods (excerpted from Ebrey, ed., *Chinese Civilization and Society: A Sourcebook*, pp. 178–185, translated by Clara Yu). They reflect a city culture dominated by commerce, knowledgeable about matters of quality and taste, with diverse audiences for artistic and craft products. In this period Hangzhou encompassed 7 to 8 square miles (c. 18 to 21 sq. km) and had a population of more than 1 million.

Scenes of Hangzhou markets:

"Here we find pearl, jade, talismans, exotic plants and fruits, seasonal catches from the sea, wild game—all the rarities of the world seem to be gathered here… In the evening, with the exception of the square in front of the palace, the markets are as busy as during the day. The most attractive one is at Central Square, where all sorts of exquisite artifacts, instruments, containers, and hundreds of varieties of goods are for sale. In other marketplaces, sales, auctions, and exchanges go on constantly. In the wine shops and inns business also thrives… This cycle goes on all year round without respite."

Specialty stores:

"[In] the commercial area of the capital… there are more than one hundred gold, silver, and money exchanges… Around these exchanges there are also numerous gold and silversmiths… A score of pawnshops are scattered in between, all owned by very wealthy people and dealing only in the most valuable objects… Some famous fabric stores sell exquisite brocade and fine silk which are unsurpassed elsewhere in the country. Along the river, close to the Peaceful Ford Bridge, there are numerous fabric stores, fan shops, and lacquerware and porcelain shops."

Teahouses:

"In large teahouses there are usually paintings and calligraphies by famous artists on display. In the old capital, only restaurants had them, to enable their patrons to while away the time as the food was being prepared, but now it is customary for teahouses as well to display paintings and the like."

The Four Departments and Six Offices:

"For the households of the noble and the wealthy, there are the Four Departments and Six Offices in charge of entertainment… The Setup Department is responsible for preparing the place for the occasion: setting up tents and awnings, banquet tables and seats; providing screens, embroidered hangings, paintings, calligraphy and so on."

Clubs:

"For men of letters, there is a unique West Lake Poetry Society. Its members include both scholars residing in the capital and visiting poets from other parts of the country; over the years, many famous poets have been associated with this society."

The Three Teachings:

"Buddhist temples are numerous. There are around one hundred Zen monasteries… There are also convents, religious societies, and various places of worship."

Two representative Song porcellaneous wares are the white Ding wares from northern China and the *qingbai* or bluish-white wares made at Jingdezhen from the late Song period. Ding wares are notable for their thin white clay bodies and refined shapes, very distinct from the full rounded shapes of Tang white wares. Designs on Ding wares are often as subtle as the shapes and include carved or molded plant or water-bird motifs. The Ding pillow in the shape of a recumbent child (FIG. 7-8) is a full-bodied sculpture rather than a delicate vessel, but the fine patterns on the textiles and simulations of folded and tied cloth are very much in keeping with the subtleties of other

forms and designs in this type of ware. Mold production of both shape and decor was an important technical innovation of the eleventh and twelfth centuries, which, along with another innovation, the upside-down firing of stacked bowls and dishes, permitted more rapid and uniform production of what had become a very popular ware. The appeal of Ding ware may have been due in part to its service as a less expensive substitute for similarly articulated, thin, and very light shapes and elegant designs in silverware. The unglazed rims of dishes fired inverted were themselves often fitted with gold, silver, or copper strips.

Some Ding wares were offered as tribute to the imperial court, but others of lesser quality and refinement were popular among other social groups, including officials and merchants. Mobility of taste is broadly characteristic of the Song, where an increasingly complex society, improved communication, and urbanization allowed tastes and fashions to move relatively freely from one medium or social arena to another. Technologies of production were surely driven by markets and tastes. The southern *qingbai* bluish-white wares may themselves have emulated the northern Ding wares. They are thinly potted, with subtly carved floral decor when not left undecorated, and rely mostly on elegance of shape for their impact. Composite shapes are common, such as the spouted ewer-and-basin types which served the practical function of allowing wine or tea to be warmed at table. A pair of just such vessels is depicted on the near end of a table in the *Night Revels of Han Xizai* handscroll (see FIG. 7-23 below).

The northern green wares produced at the Yaozhou kilns in the northwestern city of Tongchuan (Shaanxi) also made extensive use of mold technology for efficiency and standardization of production. Surviving molds show how patterns such as peony flowers could be pressed into the leather-hard ceramic form. Olive-green glaze of this type, often called northern celadon, pools in and around the molded or carved patterns to lend an effect of shading and higher relief to the decor. Handcarved vessels have a more attractive irregularity in the design, allowing deeper

shading effects, and may have been more highly valued for their aura of handcrafting. A water pot (FIG. 7-9) of this type is unusually elaborate, both in its combination of carved palmette designs and modeled animal decoration and in the technical ingenuity of its function. This vessel is designed to be inverted when used, filled through the base, and with a funnel-shaped tube on the inside which

7-8 Pillow in the shape of a recumbent child
Ding ware. Northern Song (960–1127). Porcellaneous stoneware with white glaze over carved and incised decoration, height 7⅜″ (18.8 cm). National Palace Museum, Taipei

7-9 Water pot, Yaozhou ware
Song (960–1279). Stoneware with olive-green glaze over incised, carved, and applied decoration, height 7½″ (19 cm). Historical Museum of Shaanxi, Xi'an

Wares of this type were frequently produced with the use of molds, which aided large-scale production and consistency of decoration. This vessel is cleverly designed to be used when inverted, filled through a hole in the base and with a tube on the inside that serves as a stopper when the vessel is upright.

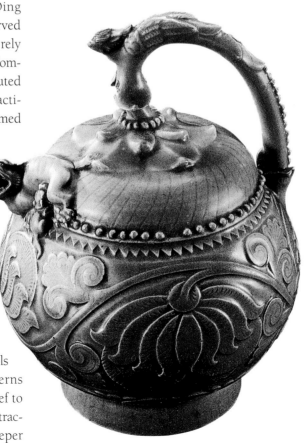

serves as a stopper when the vessel is upright. Clever conceits extend to the spout in the form of an open-mouthed mother lion suckling her cub and the handle in the form of a lotus stalk and petal. Taste and market forces were at work as much as design innovations. The Yaozhou wares were probably made as widely available emulations of the more prestigious Yue wares of the late Tang and Five Dynasties periods (see page 214); a thirteenth-century writer noted the imitative relationship but characterized the Yaozhou wares of his time as suitable only for restaurant use because of their coarseness and durability.

SOCIAL COORDINATES OF STYLE AND TASTE

As Song society became more urbanized, commercial, and bureaucratic, the complexity of social roles and structures also increased. Along with technical innovations, another useful way of thinking about Song art is in terms of its social environment: the interests, tastes, and economic capacities of both the producers and consumers of art. These could include artists and craftspersons, as well as patrons, customers, audiences, and markets, depending on the scale of production and distribution of various media. Not every social group is represented in the audience for every medium, of course, since luxury goods such as gold and silver, and elite arts such as certain kinds of calligraphy and painting catered to the tastes of select groups defined by wealth, status, or cultural initiation. In general, the most important groups in terms of patronage and taste included: the imperial family and aristocrats (including the courts of the semi-nomadic regimes to the north); scholar–officials; a less well defined group of prosperous merchants and land owners, ranging down to a kind of middle class of well-to-do shopkeepers and craftsmen; and Buddhist and Daoist religious institutions. Laborers, servants, small farmers, and peasants comprised the vast majority of the population in this as in other periods, but they left little documentation of their tastes and patterns of consumption, which were probably limited

largely to textiles, low-grade ceramics, and manufactured utensils. We should not underestimate, however, the level of mutual awareness of taste and quality between different social groups, particularly in urban settings, or the possibilities for emulation of elite objects in more popular contexts.

Style and taste in art objects could serve as a marker of status and wealth, but also of intellectual interests and even of claims to moral qualities. The imperial family and their aristocratic relatives continued many patterns of earlier courtly taste, including command of the most precious materials, favoring the highest levels of technique, craftsmanship, and refined design, and promotion of ideologies of authority and traditional culture. Compared to earlier periods, however, Song courtly taste was less oriented to luxury goods and opulence, and more involved with displays of refinement and high culture, features that suggest the infiltration of scholarly values into court arenas.

Educated scholar–officials seem consciously to have sought to differentiate themselves from both courtly modes above and popular urban taste below. As a relatively newly important power and interest group in the Song, scholar–officials were highly conscious of defining their prerogatives and status in symbolic and cultural arenas as much as in political and economic terms. As with other elite cultural movements of the highly educated at other times and in other places, the scholar–officials took pride in reactive or counter values, rejecting decorative qualities, technical skill, obvious impact or appeal to sentiment or emotion. The values that they promoted, "natural spontaneity" (*ziran*) and "pure blandness" (*pingdan*), conveyed ethical positions or character traits as much as purely aesthetic values: avoidance of artifice, calculation, or meretricious display.

The taste of the well-to-do and middle classes is more difficult to characterize. They seem to have favored decorative and functional objects that emulated some of the qualities of high-status court art, but in forms that manifested strong design, direct impact, and accessible subject matter and meaning. Religious art for Buddhist and Daoist institutions and audiences included dynamic and

decorative iconic or narrative images. Another, very different facet of Buddhist art appears in the context of Chan Buddhist sects, whose calligraphy and painting styles reveal the impact of scholar–official values of spontaneity and naturalness.

All of these groups interacted with and sometimes emulated one another, particularly in environments such as the capital cities, where aristocrats, scholar–officials, monks, and tradesmen inhabited the same urban settings. The range of distinctions observable in Song art and society is still very considerable, in terms of motives, premises, and functions.

Perhaps the widest spectrum of surviving types is found in craft goods of daily use such as ceramics and textiles. Ceramics can be classified according to many different features. Technical criteria, including firing temperature and body types; style features, including glaze, decor, and favored shapes; geography or kiln sites; and the issues of taste, use, and markets discussed here are all important. Ceramic wares range from middle-class types to refined luxury wares commissioned by the imperial household and limited to that environment. The Song produced a greater variety of wares compared to earlier periods, reflecting more niche tastes. Multiple kinds of wares were made at single kiln sites, suggesting a readiness to respond to complex markets. Large- scale production and distribution, including a substantial export industry, technical innovations, the imitation of popular wares by other kilns, and the emulation of other media such as precious metals and jade are all symptoms of response to a competitive and discerning market.

Wares produced specially for the imperial court offer a consistent pattern of taste. We have seen that the finest examples of some types, such as the Yue green wares and the white Ding wares, were sometimes offered as tribute items to the court. The fondness for lightly decorated or undecorated monochrome wares represented by those types continues in the most famous of the imperial wares, the Ru type, produced briefly and in small quantities under the regime of the emperor Huizong in the first quarter of the twelfth century. Ru vessels are stonewares in

elegant and very restrained shapes, with a lightly incised underglaze decor or a slight crackle pattern within the characteristic bluish-gray or bluish-green glaze as the only embellishment. This ware seems to have been responsive to a particular emperor's taste, replacing Ding wares as court favorites and recalling the jadelike colors and cracked-ice patterns that appear in contemporary court painting and poetry images. Its rarity, its restriction to imperial use, and the long-standing mystery of its origins enhanced the cachet of Ru ware for later collectors, including the Qianlong emperor of the eighteenth century, who had appreciative inscriptions incised into the glaze of many of the Ru pieces in his hands. An oval narcissus pot of Ru type is depicted among other precious collected antiques in an early-eighteenth-century court painting (see FIG. 9-1 below, upper left). Twentieth- century archaeologists and ceramic specialists had searched unsuccessfully for the Ru kiln site for fifty years when, in 1986, a technician from a local ceramic factory discovered a shard of what he believed was Ru ware in a wheat field at the village of Qingliangsi in Baofeng County (Henan). The site has since yielded several complete pieces of Ru ware, adding to the very limited number of extant examples worldwide, as well as numerous shards, saggars (clay boxes in which pottery is packed for firing), and other kiln furniture.

Monochrome glazes and sophisticated shapes are characteristic of the Southern Song official, or Guan, ware, produced at various kilns in the vicinity of the capital of Hangzhou for palace use under the supervision of the Department of Palace Supply. In many cases the shapes are ceramic imitations of archaic bronze vessels, reflecting the taste for antiquities that had emerged already in the late Northern Song as well as

7-10 Vase, Cizhou ware
Northern Song, 12th century. Stoneware covered with white and black slip under transparent glaze with *sgraffito* decoration of dragon and foliage, height 22⅜″ (56.9 cm). The Nelson-Atkins Museum of Art, Kansas City

an ideological program of claiming affinity with prestigious forms of traditional culture. The long-necked vase (FIG. 7-1) is a simpler shape and conveys an effortlessly organic quality, abetted by a softly lustrous glaze. This effect of simplicity is dependent on a high achievement of the potter's art, since the vessel is more thinly potted than the layer of glaze that covers it. The crackle patterns on thick-glazed Guan wares are sometimes densely spaced and spread over the entire surface of the vessel, suggesting that what may have originated as the accidental product of uneven shrinkage of glaze and vessel body had become a deliberately produced effect. Longquan wares (see FIG. 8-21 below for an example of later date) produced near the late Song capital in southern Zhejiang also often imitate ancient bronze shapes in pieces made as altar vessels, but the thick blue-green glaze, in this period only lightly decorated, seems to be a deliberate evocation of the lustrous color and texture of jade.

The monochromatic glazes and restrained shapes and decor of these court-centered wares are very far removed from the bold pictorial decor and strongly profiled shapes of the utilitarian Cizhou stonewares produced widely across North China. Cizhou wares include loaf-shape pillows and broad-shouldered jars with pictorial designs painted in brown and white slip under transparent glazes, along with a wide range of carving and incising techniques. Subjects include auspicious plants and narrative figure painting, with the same kind of energetic rendering found in the predecessor underglaze-painted wares from the Tongguan kilns near Changsha from the late eighth or ninth centuries. Underglaze painting was to become a staple of the blue-and-white porcelains of Yuan (1279–1368) and later times. In the Cizhou wares it seems to be associated with a broadly middle-class market that favored lively and dynamic effects, sketched with rapidity and vigor by decorators and accompanied at times by inscriptions or poems and often by the family name of the potters' studios which produced the wares. Cizhou potters were technically innovative, seeking both efficiencies of production and the market value of novelty. Although one of the most notable Cizhou innovations is overglaze enameling of pictorial designs in iron red, a whole host of carving techniques, including the incision through one layer of slip to reveal a contrasting slip color, known as *sgraffito*, are more representative. An extraordinarily dynamic black-and-white dragon design on a high-shouldered vase (FIG. 7-10) from the twelfth century is a powerful example of this technique, with high-contrast combed, stippled, scaled, and scrolled designs adding to the visual impact.

The dark-bodied tea bowls (FIG. 7-11) made in the southeastern coastal province of Fujian, and hence called Jian wares, illustrate some of the paradoxes of Song style and taste. These are coarse-bodied wares, with thick iron-brown or iron-black glaze patterned into textures known as "hare's fur" or the iridescent blue-black "oil spot," and often pooling into thick drips around the foot. Although Jian wares had a seemingly everyday, utilitarian quality and were

7-11 Tea bowl, Jian ware
Southern Song, 12th–13th centuries. Stoneware covered with "oil-spot" glaze, black with iridescent spots, height 2⅝" (6.7 cm), diameter 4¾" (12 cm). Seikado Foundation, Tokyo

technically undemanding, since they did not require painter's or carver's skills or any particular refinement of glazing, conoisseurs early on recognized their special suitability for tea drinking and even emperors prized them. The froth of whipped tea was thought to appear to best advantage against the dark color of Jian bowls, while the thick body retained the heat of brewed tea well, and the rims and rolls of glaze appealed to the sense of touch of lip and hand. The qualities of Jian wares were paralleled in the dark-glazed wares of Henan in north-central China and in the Jizhou wares of Jiangxi in the southeast. The Jizhou tea bowls included designs produced by applying cut-paper patterns underneath the glaze before firing, with floral motifs or auspicious phrases reflecting popular crafts and sentiments. Japanese Zen monks, shogunal collectors, and tea-ceremony practitioners valued Jian and similar wares as the prized *temmoku* types, named after the Buddhist monastic center of Mount Tianmu in Fujian Province.

Painting and calligraphy in the Song display a similarly broad range of style and appeal. Three paintings that all treat parallel themes of filial duty and morality seem to belong not only to different realms of taste, interest, and audience but almost to distinctly different conceptions of painting. *Welcoming the Emperor at Wangxian Village* (FIG. 7-12) is an anonymous painting of the Southern Song period in the style of court artists active around 1200. The subject is the deposed Tang emperor Xuanzong's return from exile after the suppression of the An Lushan rebellion. He is accompanied by his son, also distinguished by a ceremonial parasol held by attendants, and greeted by throngs of villagers in a complexly staged figural narrative of loyalty. In this case, contemporary concerns are played out in a historical setting. The parallelism is with the Northern Song emperor's capture by Jurchen forces, and it is a pathetic one because Huizong's restoration to the Southern Song occurred posthumously, with the return of his corpse following treaty negotiations with the Jin. The emphasis is on convincing description of a full array of figural types, from the babes-in-arms, villagers, and prostrating elders below to the more

7-12 Anon., *Welcoming the Emperor at Wangxian Village*
Southern Song, second half of 12th century. Hanging scroll, ink and colors on silk; 6′4″ × 43⅛″ (1.95 m × 109.5 cm). Shanghai Museum

7-13 Li Gonglin (c. 1049–1106), *Illustrated Classic of Filial Piety* Northern Song, c. 1085. Detail of handscroll, ink on silk; 8⅝″ × 15′6″ (21.9 cm × 4.75 m). The Metropolitan Museum of Art, New York

dignified ranks of the emperors, officials, and guardsmen above. Each figure and garment is rendered carefully in outline and color, and even the great pine tree that arches over the emperors like a protective canopy is shaped by the same taste for precision and elegance. The village is turned into the equivalent of a palatial platform for court ceremony, with elaborate staging and carefully observed distinctions of high and low position.

The *Illustrated Classic of Filial Piety* was painted about a century earlier, around 1085, by the late Northern Song scholar–official Li Gonglin. The text was a Confucian classic, often promulgated by emperors because of the values of social harmony and order it promoted. While the ethos of the painting is not far from that of *Welcoming the Emperor*, the presentation of the scenes in a reserved plain-outline style with a minimum of embellishment speaks to very different tastes. The scene shown here (FIG. 7-13) accompanies a text passage about ritual propriety in familial and

political relationships, exemplified by a younger sibling bowing to his elder brother. The figures are modest and simple, drawn with an archaistic and slightly amateurish quality. These are surely deliberate effects, since others of Li's surviving works show that he was an accomplished draftsman. His intention seems to have been to evoke the qualities of an earlier and presumably more filial age, and some of the moral qualities that might be associated with the old-fashioned and honestly unskillful, such as sincerity and rectitude. While the text has an ethical rather than a poetic content, the focus on isolated, evocative episodes and resonant abbreviation instead of detailed illustration and elaborately staged narrative creates defamiliarization effects akin to those of poetry. The weathered garden rock and bamboo suggest a minimal setting, but they are also common scholar–official themes symbolic of strength in adversity, with a close, sheltering relationship here that parallels that of the brothers.

Sets of scroll paintings produced at the southeastern port city of Ningbo in the late twelfth century depicting the *Kings of Hell* are very far from the elegant refinements of court painting or the poetic sensibilities of scholar–official artists. These were commercial pictures, produced in sets with the aid of stencils for use at monasteries or for pious pilgrims. The artist who signed the pictures, Jin Chushi, was the master of a workshop known for this kind of product. Each picture in the set of ten follows the basic pattern of a single king of hell seated in a garden, in front of a painted screen and behind a desk (see FIG. 6-25 for an earlier version). Assistants present the cases of the damned, who are shown below receiving horrific tortures as their punishment. The hell kings are thus counterparts of earthly judges, presiding over a grisly bureaucracy. The graphic images of torture, the grotesque faces of the demonic minions, and the bright primary colors that dominate the pictures are part of a taste for intense, dynamic effects and bodily violence that is rarely seen outside the realms of popular religious art. In this scene (FIG. 7-14) the condemned sinner is made to witness his own crime, the murder of a man on a boat, in a magical karmic mirror that reflects the past, before being flayed by swords below.

Courtly and scholar–official styles of calligraphy similarly could embody powerful contrasts of approach and implication. Huizong's imperial calligraphy style from the early twelfth century, accompanying a picture of an auspicious omen called *Cranes Above Kaifeng* (FIG. 7-15) shows hyper-refinement into meticulously slender, tensile strokes, with each character disciplined into a uniform rectangular space. The calligraphy (FIG. 7-16) of the poet–official Huang Tingjian (1045–1105) from a generation earlier is continuously varied, irregular, and bluntly simple in its broad lines and hidden finishing strokes, where the brush often retraces the final lines before it is lifted from the paper, in a legible act of restraint. Calligraphy, like painting, could embody moral and political sentiments in both formal and referential terms. Huang Tingjian's large-scale, thickly brushed characters are consciously indebted to the precedent of the eighth-century scholar and statesman Yan Zhenqing (709–785, see FIG. 6-31 above). Yan's robust characters are more regularly shaped, balanced, and sharply articulated than Huang's, but the qualities of monumentality achieved with rounded, simple strokes are shared by both writers. Yan was a model not only of the calligrapher's art but also of political loyalty and integrity, as a defender to the death of the Tang regime against rebel generals. Indeed, because so many of Yan's writings were political memorials, political and calligraphic virtues were closely linked, and imitation of his writing style was a means of claiming affinity with his moral

7-14 Jin Chushi (late 12th century), *Kings of Hell*
Southern Song. Hanging scroll from set of five (originally ten), ink and colors on silk; 44 × 18¾″ (111.8 × 47.6 cm). The Metropolitan Museum of Art, New York

7-15 Att. to Emperor Huizong (1082–1135, r. 1101–25), *Cranes Above Kaifeng*
Northern Song. Handscroll, ink and colors on silk; 20⅛ × 54⅜″ (51 × 138.2 cm) (with inscription). Liaoning Provincial Museum, Shenyang

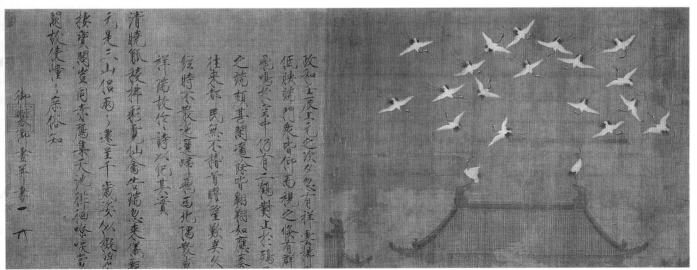

Calligraphy was a means of elite communication, with messages conveyed by both the content and form of written texts. Personal writings could take advantage of the supple modulations possible with the animal-hair brush to form characters with inventive brushstroke shapes and character compositions.

rectitude. Huang Tingjian, however, took Yan's style only as a point of departure for experiments in formal and personal development. A rising left-to-right rhythm of horizontals is often counterpoised and anchored by blunt, oval dots, so that each character performs an act of dynamic balance. Characters are freely expanded and contracted in ways that seem to answer to an oval or circular surround instead of a rectilinear grid. Adjacent characters in a column interpenetrate one another's space, so that an entire vertical line is energized by rhythms of movement and response. Rather than an already achieved, technically demanding standard, scholarly calligraphy suggests personal exploration, experiment, and openness to improvisation.

CONSTRUCTING LANDSCAPES

A discussion of landscape painting, one of the art forms that developed most dramatically in the Song era, may seem out of place in the context of urbanism, commerce, and technology. We should recall, however, that the burgeoning of landscape art in seventeenth-century Holland was connected to urban environments and to the values of commercial culture and that related factors may have been operative in Song China. Land and land-

scape representations could evoke many kinds of significance: sacredness, leisure, political and social structures, and theories of natural order and functioning. The foundation of both the economy and the culture of the Song was ultimately the productivity of the land and waterways, through agriculture, mining, and commercial transportation. The land supported a growing population, approximately double that of the Tang period, through more intensive agriculture, especially in the lower Yangzi River region. Iron production, using coke-fired blast furnaces in large-scale enterprises, reached some 125,000 tons per year in the late eleventh century (more than twice the amount produced in England at the dawn of the Industrial Revolution in the late eighteenth century), supporting a substantial armaments industry as well as the manufacture of agricultural tools and coinage. Song writers warned against the environmental despoliation that accompanied over-exploitation of timber and mining resources. Landscape images or gardens could serve as sites of escape from the physical and psychological pressures of urban environments or as symbolic compensations for experiences and modes of life that were increasingly hard to realize. There is no doubt that Song landscape paintings embodied experiences of physical sites and that painters of this period, more than any other, were

adept at representational illusions of texture, mass, and atmosphere. It is equally true that most landscape artists were not mountain-dwelling rustics but urban court painters, professionals, and scholar–officials, and that their audiences belonged mostly to the same urban milieu, or to those groups who alternated between periods of urban residence and suburban or rural retreat.

To speak of landscape as a construct implies several things. First, representations of landscape in painting (and in writing) are not simply discovered and transcribed, but instead involve histories and purposes. Ideas, values, and meanings associated with landscape are built up in the cultural sphere, rather than being intrinsically attached to natural forms. Moreover, some renderings reflect a more tangible kind of construction of landscape, in terms of the structural and ecological transformations of the physical landscape wrought by habitation, agriculture, forestry, mining, and hydro-engineering. Representations of landscape are built upon structures of form, significance, and social function.

Using the term "landscape" in a Chinese context is a convenience that requires some clarification. In Europe, where landscape art only achieved an independent status around the seventeenth century, landscape referred originally to land shapes in the physical or administrative sense, and later to prospects or vistas over the land, whether real or represented in pictures. The Chinese terms for landscape have different associations. The most commonly used term in China was *shanshui*, "mountain-and-water (pictures)," and other designations also involved subsets of landscape elements, such as "forests and streams" (*lin chuan*). Initially, then, the Chinese terminology seems to place more emphasis on geophysical features and less on landed property than in the European tradition. In the Song, most landscapes did indeed emphasize mountains, rivers, or lakes rather than farmsteads and countryside, but the scenic and thematic range was already very broad. Chinese landscapes evoked everything from remote mountain wildernesses to suburban scenic spots, activities of travel and appreciation, and relationships of ownership and investigation.

References to nature in the context of Chinese landscape art also require some explanation. Chinese philosophical and art writing includes a good deal about "naturalness" (*ziran*, literally "self-so"), in the senses both of spontaneous generation of geophysical and biological phenomena and of the uncalculated behavior of human beings. The Chinese term does not imply the long-standing Western associations of Nature as a divine creation, an Edenic realm of innocence, a maternal fecundity, or a place of pastoral ease. There were, however, early Chinese associations of landscape with Buddhist and Daoist religious experiences and with alternative values from those prevailing at court or in society.

A widespread Chinese mode of understanding landscape forms and forces in China, the body of lore and practice called *fengshui* or *dili* (literally "wind-and-water" and "earth's principles," both usually rendered as geomancy), probably has some bearing on customary responses to landscape painting. Geomancy includes principles of understanding energy flows and structural formations of topography that have implications for the propitious siting of residences and tombs. Along with a magical–divinatory aspect, geomancy embodies much practical wisdom of land management. The common admonition to site a residence with a mountain behind and water below, for example, can be seen as magical protection from baleful influences but also as a useful formula to insure shelter from winds, ready sources of water and wood, protection from floods, and other benefits for the householder or estate manager. Geomantic lore usually did not provide specific structures for landscape paintings but rather a general frame of expectations for landscape compositions and relationships.

As we have seen in previous chapters, there were long-standing traditions of landscape painting and theory and of landscape or so-called nature poetry before the Song. Early writing about landscape as a distinctive subject of painting emphasizes its spirituality, either as an object of Buddhist meditation—as in Zong Bing's text *Hua shanshui xu*—or in terms of a Daoist affinity between the physical and the spiritual (see FIG. 5-28 above). Tang landscape served mostly as a background

for Buddhist narrative subjects or as a decorative setting for aristocratic pleasures and pursuits (see FIGS. 6-7, 6-22, and 6-34 above). Early landscape poetry might evoke rhapsodic spirit travel, a retreat from social and political entanglements, or quietistic contemplation with Buddhist overtones. Song landscape arts built on such earlier associations and meanings or reacted against them.

There is a rich literature on the theory of landscape painting and on the lives of landscape artists in the Five Dynasties and Song periods, testimony to an awareness of the cultural importance of the subject. The art historian Guo Ruoxu, writing in the late eleventh century, was clear about the historical trajectory of landscape in relation to other genres: figure painting, he wrote, reached its apogee in the Tang and earlier periods, but nothing in early landscape painting could compete with the achievements of what was for Guo the recent past. He compared three tenth- and early-eleventh-century landscapists, one of whom was Fan Kuan (see FIG. 7-19 below), to the three legs of a tripod, using a metaphor that evokes the monumental quality of their imagery.

There were several regional centers of this developing genre of landscape painting, including the Southern Tang state centered in Nanjing in the mid-tenth century. In later times the painter Dong Yuan (d. 962), who was active there, was raised to the status of a patriarch of landscape art and often linked with a follower named Juran (active 960–980) as the founders of an influential Dong-Ju school of landscape painting. Dong's office, interestingly, was in the royal parks administration for the regime, suggesting an early connection between landscape painting and land use. While no work of certain authenticity by Dong has survived, the stylistic profile that emerges from attributed works in his manner is consistent with a reliably documented work from the period, Zhao Gan's handscroll *Early Snow Along the River* (FIG. 7-17). From a high vantage point, the scroll offers a panoramic view of the activities of fishermen along a marshy river. Huddled in thatch shelters against the cold, or tending nets raised and lowered by long pivoting poles, the fishermen are unsentimentalized, thin and sinewy as a result of their hard life. Their situation is counterpointed by an upper-class couple and their servants traveling by donkey, passers-by discomforted by the chill wind. The season is evoked by the opaque white dots of the early snow. Low, earthy banks shaded into volume are layered over by fields of reeds, and a rickety arched wooden bridge rendered with strongly shaded posts shows its upper and undersides from a consistent vantage point. All these features are associated with Dong Yuan as well, whose paintings are described as including a perceptual effect of looking blurry and vague when seen close up, but resolving into

7-17 Zhao Gan (active c. 961–75), *Early Snow Along the River*
Southern Tang. Detail of handscroll, ink and color on silk; 10¼ × 12′5¼″ (25.9 cm × 3.77 m). National Palace Museum, Taipei

legibility from a distance. In related paintings like *Early Snow Along the River* there is a kind of realism which is both visual and social.

Archaeological evidence for early Song-era landscape is most abundant in the far northeast, in areas ruled by the Qidan regime of the Liao dynasty. An important discovery of two scroll paintings interred in a late-tenth-century tomb in present-day Liaoning included the small *Landscape with Secluded Chess Players* in vertical scroll format (FIG. 7-18). This scene is more highly structured than the earthy landscapes of the southeastern school. A vertical cliff provides a dominant axis, while bluffs with jutting outcroppings and concave sides reveal contemporary concern with dynamic volumes. Deeply hollowed grottos play with illusions of penetrated space, and interior vertical contours suggest surface textures. The funerary context of a portable scroll such as this is ambiguous. The painting might have been a personal treasure of the occupant of the tomb, either of local Liao or imported Chinese origin. This might also have been a functional funerary painting, with an image of chess playing and wine drinking in a grotto retreat understood either as a depiction of enjoyment of the after-life or as a specific reference to a realm of immortal beings.

Around the beginning of the eleventh century Fan Kuan painted one of the best known of all

7-18 Anon., *Landscape with Secluded Chess Players*
Liao, late 10th century. Hanging scroll, ink and colors on silk; 60 × 21½″ (154.2 × 54.5 cm). Excavated from a tomb at Yemaotai, Liaoning. Liaoning Provincial Museum, Shenyang

7-19 Fan Kuan (c. 960–1030), *Travelers Among Mountains and Streams*
Northern Song. Hanging scroll, ink and color on silk; 6′7¼″ × 40¼″ (2.06 m × 103.3 cm).
National Palace Museum, Taipei

Chinese landscapes, known as *Travelers Among Mountains and Streams* (FIG. 7-19), a descriptive rather than an inscribed original title. Fan Kuan's painting goes much further than the excavated scroll from the Liaoning region in developing structures of what is generally known as monumental landscape: a dominant cliff or peak of impressive scale, and an articulated structure of subordinate flanking lower cliffs, bluffs, streams, and pathways in the foreground. Organization extends to the smallest elements of the scene. Patiently accumulated foliage and texture patterns render trees and rocky surfaces as if to account for the structure and appearance of all objects. The pervasive sense of order and an ambition to provide a systematic account of everything in a linked, hierarchical fashion may be related to trends in contemporary speculative philosophy, among thinkers who sought common underlying principles in the moral and physical realms, with a special interest in patterns and a parallel ambition toward comprehensiveness. There are elements of a protoscientific attitude of observation and explanation in Song thought, represented by such writers as the polymath Shen Gua (1031–1095), as well as a stronger strain of what in the West would be called natural philosophy, mixing ethics, epistemology (the theory of knowledge), and metaphysics. A comment attributed to Fan Kuan suggests an awareness of the issues of knowledge of the world:

> In the beginning Fan Kuan studied the method of Li Cheng. After realizing the futility of this, he said, "My predecessors always found their methods in natural phenomena. So for me to take people as my teachers cannot compare with learning from natural phenomena. Better still would it be to learn from my heart-mind." Thereupon he discarded his old habits. Dwelling in geomantically suitable places in the midst of cliff crannies and forested foothills of Mt. Chongnan and Mt. Hua, he observed the changing effects of atmosphere and light so difficult to represent in painting and silently encountered [the spirit of those places].
>
> (*Xuanhe huapu*, in Liscomb, *Learning from Mt. Hua*, pp. 68–69)

Fan Kuan already shows an awareness of historical models, observation of phenomena, and some kind of guidance from principled introspection as contributing procedures for landscape painting. The visual complexity of *Travelers Among Mountains and Streams* matches this variety of approach. Representing or viewing this scene implies multiple standpoints: on a level with the huge boulder that blocks off what lies behind it in the low foreground; then rising to a point above the building rooftops on the bluff in the middle distance; and finally a commanding position surveying the shrubby growth atop the highest cliff. Multiple viewpoints suggest an accumulation of experiences underlying the painted representation. At the same time, this method allows a more comprehensive understanding than would have been available from a single vantage point and avoids compromising the monumentality of the depiction.

Fan Kuan's career lies about midway between the dates of two important texts on landscape painting written by artists: *Record of Brush Methods* by Jing Hao (c. 900) and *The Lofty Message of Forests and Streams* by the Song court painter Guo Xi (c. 1000–c. 1090) and his son, the official Guo Si (d. after 1123). There are no surviving works by Jing Hao, who is listed among the early masters of landscape painting by Song writers. His text emphasizes the analogies with human character and symbolic implications of pine trees more than a comprehensive view of landscape, although it includes a classificatory list of mountain formations that foreshadows the systematic interests of Fan Kuan. Elsewhere, Jing Hao emphasizes distinctions between outer surface appearance and inner truth in a conservative reflection of a strain of spiritualism in early landscape theory. Writing almost two centuries later, Guo Xi and his son Guo Si present in *The Lofty Message of Forests and Streams* a view of landscape painting that is fully involved with a social and institutional network. By contrast, Jing Hao describes the landscape painter as being initiated into a hidden inner truth by a mountain hermit, and Fan Kuan is described in the biographical passage above as a resident of mountains, following the authority of phenomena and the principles of

his inner mind. Guo Xi represents landscape art aimed at busy officials who cannot get away from their offices to visit real scenery, and he draws a specific parallel between mountains and pine trees and the social hierarchies of court:

> A great mountain is dominating as chief over the assembled hills, thereby ranking in an ordered arrangement the ridges and peaks, forests and valleys as suzerains of varying degrees and distances. The general appearance is of a great lord glorious on his throne and a hundred princes hastening to pay him court… A tall pine stands erect as the mark of all other trees, thereby ranking in an ordered arrangement the subsidiary trees and plants as numerous admiring assistants. The general effect is of a nobleman dazzling in his prime with all lesser mortals in his service…
>
> (Bush and Shih, *Early Chinese Texts on Painting*, p. 153)

Guo Xi painted for imperial halls, government offices, and temples, in well-defined institutional contexts and with clear symbolic or programmatic functions (see "A Song Court Painter at Work," page 249). This categorization of meaning and purpose is clear in the text, with its full classification of seasonal themes, corresponding moods, and aspects.

Guo Xi's major surviving work is *Early Spring* (FIG. 7-20), titled, signed, and dated by the artist in 1072 CE. Like some earlier monumental landscapes, this is fitted around an armature of a frontal, centralized peak, with subordinate lower cliffs on either side, waterfalls and streams flowing to the foreground, and buildings and travelers in the foreground areas. The dominant central peaks and pine trees recall the analogies of landscape with social hierarchies in the artist's *Lofty Message* text. Even with these strong elements of structure, *Early Spring* is anything but static. The title suggests a transitional period in the seasonal cycle, and the painting is full of dynamic change, process, and transformation. Modeling of earthy bluffs by contrasts of light areas and dark ink creates a visual play of pattern that is increased by coiling, deeply eroded mountain forms and by the energetic arcs of tree branches. Human travel, the circulation of

7-20 Guo Xi (c. 1000–c. 1090), *Early Spring*
Northern Song, dated 1072. Hanging scroll, ink and color on silk; 62¼ × 42⅝″ (158.3 × 108.1 cm). National Palace Museum, Taipei

Guo Xi was a court painter whose landscapes were most often commissioned for palace halls and government offices. In such settings landscapes could become icons of hierarchical authority. In the artist's own writings, the great mountains and tall pines were seen as symbolic counterparts of great lords and noblemen.

water and mist, and the growth of vegetation are prominent themes. The knitting together of diverse vignettes into a larger unity suggests both the organismic analogies of landscape—rocks as bones, water as blood, foliage as hair— mentioned in the *Lofty Message* text and a corporate effect. If the painting were intended, as many of Guo Xi's works were, for a government office, the high mountains and unified scenery might have conveyed a sense of authority and good administration, while providing an imaginative respite from bureaucratic life.

Northern Song landscape paintings are sometimes associated with qualities of the eternal, but they were equally affected by contemporary concerns of politics, land use, and taste. Guo Xi was a favorite painter of the emperor Shenzong (r. 1068–1086), and his plentiful commissions came from the highest levels of patronage. By the early twelfth century the emperor Huizong guided a pronounced shift in taste that led to the removal of Guo's cycles of painting from the palace walls. His work had become so devalued that his unmounted silk paintings were used to wipe the tables in the imperial mounting studios.

Landscape painting could embody a wide range of meanings and values, often linked to the social contexts for which they were produced and received. Landscape modes associated with literary men and scholar–officials for the most part were images of particular places with historical, literary, personal, and often political associations resonant for the artist and his audience, such as the illustration of the *Second Prose-Poem*

A Song Court Painter at Work

The following excerpt is from a text on landscape painting authored by the painter Guo Xi and supplemented and edited by his son Guo Si (the narrator of the passage below), a court official and minor painter under Emperor Huizong. The passage offers glimpses of Guo Xi's working methods, with an additional emphasis on the value of painting for moral edification and self-cultivation that reflects the ideology of court officials.

In the past I saw my father working on several paintings. Sometimes he would put one aside and ignore it. For perhaps ten or twenty days he would not give it a glance, then after thirty days he might add to it. It was a case of losing interest in the work, and is this not the listless energy he mentioned?

When working at a peak of interest he would completely forget about everything else. When his concentration was disturbed by even a single external interruption, he would put his work aside and ignore it. Is this not exactly the dulled energy he mentioned?

Each time he put his brush to work, he would sit by a bright window at a clean table. To left and right were lighted incense. He would lay out fine brush and ink, wash his hands, and clean the inkslab as though he were receiving a major guest. His spirit at ease and his interest settled, only then did he proceed. Is this not exactly what he said about not daring to trifle heedlessly? Once the composition was laid out, he would work through it in

detail. Once the painting was built up, he would add the enriching shades of ink. Though the first time seemed enough, he would work over it again, and perhaps yet again. Every painting would be reworked several times from start to finish, and he would be alert as though on guard against some insidious enemy until it was done. Is this not exactly what he said about not daring to abruptly disregard the subject? Whatever task you care to mention, no matter large or small, it can only thus be properly concluded. If my father so often repeated this advice in different fashions, was it not to teach me to honor it to the end of my life, taking it as a path to progressive self-cultivation?

(Bush and Shih, *Early Chinese Texts on Painting*, pp.156–57)

on the Red Cliff discussed below (see FIG. 7-36). Stylized or metaphoric treatment of scenic elements is favored over illusionistic techniques. By contrast, aristocratic tastes for decorative and dynamic scenery are manifested in the early Southern Song court painting *Autumn Colors Along Rivers and Mountains* (FIG. 7-21) by Zhao Boju (c. 1120–1162), a relative of the imperial

family. Against a backdrop of winding chains of cliffs, travelers enjoy the seasonal display, rendered in bright mineral green, ochre, and opaque white colors. Within that stage is displayed a diverse array of human activities and settings, including travel, appreciating the view of a waterfall, shepherding, and fishing. There is a balance between imposing cliffs, with travelers negotiating

7-21 Zhao Boju (active 1120s), *Autumn Colors Along Rivers and Mountains*
Southern Song. Handscroll, ink and colors on silk; 22" × 10'6" (55.7 cm × 3.23 m). The Palace Museum, Beijing

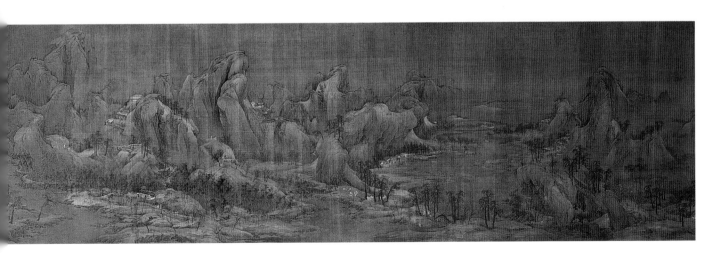

蒲湘煙雨為三
楚佳境每讀蘇
軾題宋復古瀟
湘晚景圖詩輒
為神生惜不為
一見也今見龍
眠是圖正未知
執為甲乙一再
展玩雲山整水
真不啻卧遊矣
董敢謂顏氏名
卷育四今乃敢
而復合乎異豐
城之遇也乾隆
御識

7-22 Master Li (12th century), *Dream Journey on the Xiao and Xiang Rivers*
Southern Song, colophon dated 1170. Detail of handscroll, ink on paper; 11⅞″ × 13′2⅞″ (30.3 cm × 40.4 m). Tokyo National Museum

difficult passes, and a more domesticated vision of landscape as a site for habitation, productivity, and enjoyment. The dwellings, rocky cliffs, and figures have a vivid particularity of structure, texture, color, and spatial position. In the section illustrated, sightseers linger at the base of an impressive waterfall, cascading in transparent ribbons into a broad pool below. Another passage of the scroll nicely examplifies the geomantic advice to situate an estate with mountains behind and water below, with a fisherman exploiting the nearby river.

Another style of late Song landscape dispenses almost entirely with linear drawing in favor of graded washes and atmospheric effects. Unlike earlier Song landscapes that emphasize the distance of the viewer from monumental formations, late Song landscapes often draw the viewer into the scene, where an internal distance of vaguely defined vistas encourages a perceptual or contemplative absorption. A superb example is the handscroll *Dream Journey on the Xiao and Xiang Rivers* (FIG. 7-22), by the otherwise unidentified Master Li, from around 1170. The subject of the Xiao and Xiang rivers was a specifically southern one, referring to a region in Hunan Province famous for misty scenery and linked with old mythologies of river spirits and sylphs, and to more recent poetic themes evocative of fragile,

transient moments. In the late Song, the theme of "Eight Views" of the rivers became popular in Chan Buddhist painting and poetry circles, for related associations of the evocative moment and the apparitional. This scroll was painted for a retired Chan priest, who regretted never having visited the Xiao and Xiang region during his decades of travel and used this painting to complete an imaginary journey. In the *Dream Journey* scroll any effect of deliberate drawing or representational mediation virtually disappears, along with nearly all sense of solid matter in the painting. The subtlety of illusion is impossible to convey in reproduction, but the image combines a secure placement of major masses with a nearly phantasmagoric quality of misty atmosphere. The evocation of an intense psychological absorption on the part of the viewer, whose attention, intuition, and even active participation is required to make sense of the image, is a widespread feature of late Song landscapes. This quality is remarked in a colophon on the scroll written by a contemporary of the artist and recipient: "People of the past could see painting in a collapsed wall. It is not that a collapsed wall can paint; it is how the viewer's mind meets with it, and a painting emerges" (Fong, *Images of the Mind*, p. 58).

Because landscape, unlike such genres as historical or religious figure painting, came

with so few preestablished meanings, it could be a vehicle for significance as diverse as the multiple social environments of the Song era at large. Landscapes could be broadly religious in the sense of an involvement with sacred sites, funerary functions, ritual symbols, or a general geomantic aura; political in terms of representation of general structures of authority or personal situations of protest; intellectual in relation to broad world views or the specifics of geology and weather; economic in regard to land use, travel, and habitation; and elsewhere literary or psychological in their implications. No single avenue of interpretation can do justice to that diversity or fit every case. Instead, local circumstances of production and reception are the most useful guides to understanding.

CULTURES OF ART

Technology, economics, and tastes associated with social position could all be considered part of Song culture, broadly conceived, but other kinds of more specifically cultural environments were equally important. Culture in this context can mean either anthropologically distinct cultures, high literary culture, or subcultures such as those based on social position, gender, or religious practice. All three senses of the term operated powerfully during the Song era. The ethnically and linguistically distinct cultures of the Qidan Liao and the Jurchen Jin regimes were in direct competition with the Chinese courts and society of the Song. Literary men guided Song taste and critical writing, making calligraphy and problems of the poetry–painting relationship prominent in the agendas of the arts. Local cultures and subcultures at the ruling courts, or among women, or within the Buddhist community guided distinctive modes of production.

Court Cultures

The ruling courts of various Song-era regimes continued, as in earlier times, to be the major centers of artistic patronage. They employed court artists and craftsmen, in various versions of bureaucratic or academic offices and workshops, and set the agendas of production and style through direct commissions, political programs, and prevailing climates of courtly taste. Historical circumstances, cultural traditions, rulers' personalities, and deliberate artistic policies all played a part in shaping court art.

The Southern Tang regime, with its capital at Nanjing, ruled southeast China after the fall of the Tang at the beginning of the tenth century and absorbed many refugees from the Tang capital until it was conquered by the Song in 975. Its rulers were cultivated men, including the lyric poet Li Yu (r. 961–975), who placed a high value on recruiting talented artists as painters in attendance. Zhao Gan, the painter of *Early Snow Along the River* (see FIG. 7-17 above), was one such artist, and his combination of representational sophistication with acute observation of social types reveals one aspect of court interests. An active role in the shaping of painting projects by the Southern Tang rulers is indicated by the lore surrounding the most famous, and notorious, work of the era, the *Night Revels of Han Xizai* (FIG. 7-23) handscroll attributed to the court artist Gu Hongzhong (active 943–960). Several narratives treat the motivation for the painting. In the best known version, the Southern Tang ruler is said to have commissioned the work from the artist as a kind of visual reporting on the licentious parties hosted by the minister Han (907–970), in order to determine Han's suitability to hold high office. The best surviving version of the painting is several times removed from such an original sketch. It is a finished studio work which may be an early-twelfth-century, very high-quality copy of a tenth-century original. The host, Han Xizai, appears in each of the sections, portrayed in a variety of costumes and activities, including seated cross-legged and bare to the waist on a chair and playing an upright drum, but always identifiable by his fezlike tall cap and heavy-lidded, fleshy face. Sensual and sexual indulgence is the pervasive theme of the painting, though presented with considerable subtlety. The tables are piled with wine and delicacies in ceramic and lacquer containers, evoking tastes, smells, and textures. A female lutanist is the object of rapt and interested gazes from Han and other guests. The diminutive figure in blue

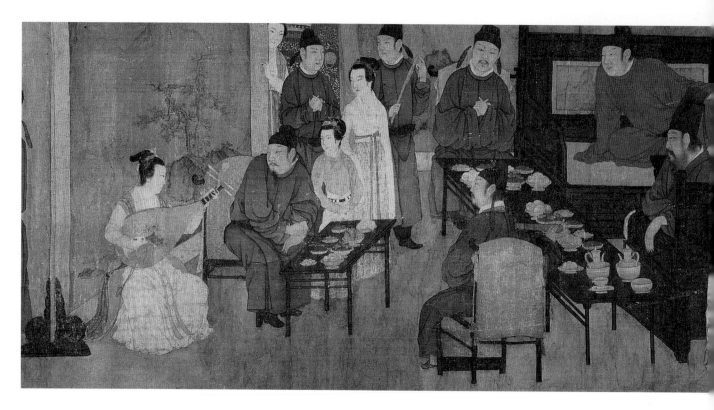

7-23 Att. to Gu Hongzhong (active 943–60), *Night Revels of Han Xizai*
Song (c. 12th century) copy of Southern Tang composition. Detail of handscroll, ink and colors on silk; 11¼″ × 11′1″ (28.6 cm × 3.40 m). The Palace Museum, Beijing

is a youthful dancer named Wu, who performs for the assembled company in a later section of the scroll. Elsewhere a troupe of female musicians play vertical flutes, an appeal to the sense of hearing and at the same time a sexual enticement. A couple of vignettes show canopied bedsteads with rumpled coverlets and musical instruments tossed casually aside, in discreet but unmistakable glimpses of the after-effects of musical and other kinds of arousal. Everywhere there is a delight in visual description of strong colors and clear forms, intricate furniture structures, complex spaces and groupings of figures, and above all of intense, charged looking, with the women often returning gazes as frank as those of the men. The visual complexity of the painting is deepened by its reputedly documentary purpose, with the implied gazes of the artist and the intended imperial viewer layered over those visible within the painting.

The Liao dynasty (916–1127, in the northeast) was a sedentarized, or settled, regime of the originally nomadic Qidan people, who conquered large parts of Manchuria and Mongolia from the tenth century on and at the time of their greatest power ruled all of the steppe area of northern China. The Northern Song regime settled a peace treaty in 1004 that required annual pay-

ment to the Qidan of large quantities of silver and silk—wealth that supported international commercial activities. Contact with the Chinese also resulted in cultural and technology transfers in agriculture, iron production, and weaving, a sinicization of political institutions, and the creation of a Qidan writing script. Even so, the Liao maintained distinctive forms that reflected their pastoral origins, as much to assert cultural identity as for practical reasons. Liao ceramics in the shape of leather flasks and short-spouted ewers reflect a history of equestrian use, and versions of Tang three-color glazes claim an inheritance of Tang cultural traditions that was a part of Liao ideology.

Liao art includes many references to culturally identifying practices in depictions of dwellings, culinary habits, costume, and coiffure. The scenes of nomadic encampment in the *Eighteen Songs of a Nomad Flute* series (discussed below, see FIG. 7-31 and pages 258–259) are probably based on Liao customs, with circular yurts or tents, outdoor cooking, and equestrian culture featured in the setting of open steppelands. Seasonal hunts of deer in autumn and swans in spring were ceremonial court events that claimed links to an ancestral hunting culture. The mural

7-24 Anon., *Deer in an Autumn Forest*
Liao, 10th–early 11th century. Hanging scroll, ink and colors on silk; 46⅝ × 25⅛" (118.4 × 63.8 cm). National Palace Museum, Taipei

painting cycle of seasonal landscapes from the Liao imperial tombs at Qingling, Manchuria, datable to around 1000, with autumnal colored trees and deer in one scene and swans in another, have a ritual purpose enhanced by the yurtlike configuration of the mausoleum. One of the finest of all animal paintings preserved in China, *Deer in an Autumn Forest* (FIG. 7-24), may have been part of a similar program. The supple-bodied deer, heads held high and turned as if alert to the presence of an unseen hunter, are set within an autumnal forest reminiscent of a tapestry scene. Both the rich colorism of the scene and the sympathetic and knowing rendering of the animals suggest the influence of the distinctive Liao cultural tradition.

Our understanding of Liao culture has been dramatically enriched by recent archaeological finds. An intact tomb excavated at Qinglongshan in Inner Mongolia had a yurt-shaped circular rear chamber containing the coffin and bodies of a prince and princess of the Chen kingdom (FIG. 7-25), the latter of whom who died in 1018. The burial equipment of the bodies includes many distinctive elements of Liao material and funerary culture, such as openwork gilded silver crowns, gold funerary masks, amber necklaces with Buddhist associations, and silver boots with gold floral

7-25 Prince and princess of the Chen kingdom
Tomb of prince and princess of the Chen kingdom, Qinglongshan, Inner Mongolia. Liao, epitaph dated 1018

The formerly nomadic Qidan people became more sedentarized as rulers of the Liao dynasty but retained distinctive burial customs. This tomb of a princely couple preserves gold funerary masks, silver riding boots, and hunting belts that were markers of cultural identity.

designs. Elaborate belts called *diexie*, which carried knives and tools needed in nomadic hunting life, were part of tradition-al Qidan costume that here were used ceremonially. Later Liao period tombs of Chinese subjects suggest an ongoing process of cultural synthesis. Recently excavated mural paintings of *Attendants Preparing for a Sutra Reading* (FIG. 7-26) from the tomb of Zhang Shiqing reveal a broad-out-line, volumetric figure style derived from Tang mural painting traditions. The objects and furnishings depicted belong to religious and material culture in a variety of styles, including a *sutra* case and labeled Buddhist *sutra* texts, a round lacquer box, an incense burner tripod, a cup with stand, and a large dish-mouthed bottle.

The artistic culture of the court of Emperor Huizong (r. 1101–1125) at the end of the Northern Song period is one of the best known in Chinese history because of the direct participation of the emperor as tastemaker, collector, painter, and calligrapher. Equally important were Huizong's institutional reforms and sponsorship of catalogues, the latter including the imperial painting and calligraphy collection and an illustrated catalogue of ancient bronzes which manifested an interest in archaeology. Huizong sought to raise the status and codify the training of painters, calligraphers, and musicians by making them part of court bureaus or at other times students in the National University, with regular procedures for recruitment, education, and examinations before promotion. The system emphasized a literary education for artists, along with clear standards for technique and pictorial conception. Huizong's artistic policies had something in common with those of the political reform movement of Wang Anshi in the previous generation, which

7-26 Anon., *Attendants Preparing for a Sutra Reading*
Tomb of Zhang Shiqing, Xuanhua, Hebei. Liao, 1115. Detail of wall painting, 49 × 35½″ (125 × 90 cm). Excavated in 1974

7-27 Wang Tingyun (1151–1202), *Old Tree and Bamboo*
Jin. Handscroll, ink on paper; height 15″ (38 cm). Fujii Yurinkan, Kyoto

were revived in his reign, in their emphasis on technocratic and methodical solutions. Even the process of turning poetic images into pictures, a key subject for court painters' examinations, was judged according to stated, ranked criteria (see "Training and Examination of Court Artists," page 266). Huizong's own calligraphy (see FIG. 7-15 above) epitomizes a formulaic approach in its uniform shapes and calculated stylizations of meticulous, sharp strokes. His paintings have a related thinness and exactitude, largely restricted to the foreground and to the observable surfaces of things. Ru-ware ceramics reflect another facet of his specific tastes in their refined shapes and subtle modulations of monochromatic, jade-like glazes.

Cranes Above Kaifeng (again, see FIG. 7-15 above) is one of many paintings attributed to Huizong that may have employed the talents of his court artists. It was one of a large series of pictures commemorating auspicious phenomena that were thought to manifest Heaven's approval of his reign. The few paintings of the series which survive embody a realism which is oriented toward documenting and preserving the magical efficacy of the events. The image of cranes wheeling in the sky above the main gate of the palace chronicles a particular occasion in the winter of the year 1112 when the birds, associated with wisdom and long life, appeared along with auspicious cloud effects, probably to accompany the performance of palace music and the celebrations of the Lantern Festival. The cut-off composition, which hints at but does not overtly depict the scale and splendor of the palace ceremony below, is consistent with the aesthetic criteria of Huizong's court, favor-

ing clever subtlety over monumentality. The entire series of auspicious images reflected another side of Huizong's temperament, his interest in the occult. The construction near the capital of a vast cosmic garden called the Genyue, in order to improve the geomantic fortunes of the dynasty, was another product of these interests.

Huizong and his eldest son, already briefly enthroned as emperor, along with several thousand other members of the imperial court were captured by the Jurchen invaders after the fall of Kaifeng. Huizong's twelfth son led the refugee court southward and established what was at first considered a temporary capital at Hangzhou in the southeast, ruling the Southern Song as its first emperor, Gaozong (r. 1127–1162). Gaozong had a living rival claimant to the Song throne, his captive elder brother, and military and cultural rivals in the northern Jin regime of the Manchurian Jurchen steppe tribe. The Southern Song was under more or less constant military pressure from the Jin (and, after 1235, from their Mongol conquerors), who received annual tribute payments from the southern regime in exchange for peace.

The Jin (1115–1234) courts were also patrons of traditional Chinese culture, including substantial achievements in belles-lettres, painting, and calligraphy that followed late Northern Song scholar–official approaches. In many respects the Jin were conquerors, heirs, and preservers of the heartland traditions of northern conservative culture, including art traditions of monumental landscape and literati practice as well as, more tangibly, major imperial collections of painting and calligraphy. The Jin maintained versions of the imperial academy institutions for painting and

calligraphy that had been established during the Northern Song. Wang Tingyun (1151–1202), chief supervisor of the Bureaus of Painting and Calligraphy and also an academician, was both artist and official. His short handscroll of *Old Tree and Bamboo* (FIG. 7-27) conveys as well as any surviving work the scholar–official's ideal of naturalness and spontaneity in ink play. The rough textures of the tree branch, wet moss, and blunt bamboo seem unmediated by any pattern of form or aesthetic standard. There was not a strong separation of scholarly and professional artists at the Jin court, however, and equally characteristic were temple mural paintings of scenes from Buddhist history in contemporary settings and illustrations of romantic scenes from literature, such as *Sima Yu's Dream of the Courtesan Su Xiao-xiao* (FIG. 7-28). The painter, Liu Yuan, was a court artist attached to the Commission of Palace Services in the early thirteenth century. The story concerns the supernatural romance of the eleventh-century scholar Sima Yu, who while in Luoyang had an erotically charged dream encounter with the spirit of Su Xiaoxiao, a famous courtesan of centuries before, who sang to him. The tale was the basis for song compositions and later a popular musical suite, and the setting of the painting suggests the environment of a stage, with the dreaming official asleep in a chair on a veranda, and the mist-wrapped courtesan accompanying her melancholy song with wooden clappers. A woodblock print image of

famous beauties, also produced under the Jin (see FIG. 7-30 below), similarly suggests the emergence of popular-culture imagery.

The cultural competition between the Southern Song and the Jin was fertile ground for the invention of traditions and encouraged themes of retrospection, legitimation, and restoration at the Southern Song court. Gaozong participated, as sponsor and calligrapher, in some large-scale projects to illustrate the classic poems of the *Confucian Odes* as a way of claiming a legitimating linkage with the great traditions of classical culture. Gaozong (or his consorts and assistants writing in imitation of his style) wrote the text inscriptions that are interspersed with illustrations by the court painter Ma Hezhi (active c. 1130–1170), executed in a deliberately naive, evocative style that has some affinities with literary men's painting (see

7-28 Liu Yuan (active early 13th century), *Sima Yu's Dream of the Courtesan Su Xiaoxiao* Jin, early 13th century. Handscroll, ink and colors on silk; 11½ × 29″ (29.2 × 73.6 cm). Cincinnati Art Museum

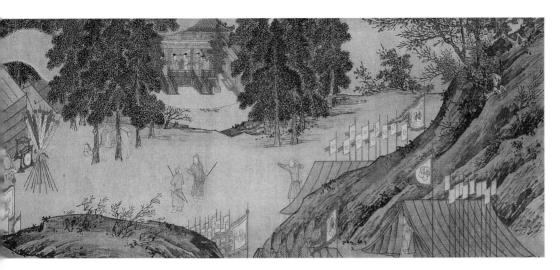

7-29 Xiao Zhao (active 1130–60), *Auspicious Omens for Dynastic Revival*
Southern Song, Gaozong reign (1127–62). Detail of handscroll, ink and colors on silk; 10½ × 50¼˝ (26.7 × 127.7 cm). Tianjin Municipal Museum

FIG. 7-36) and conveys nostalgia for an idealized past. Court-sponsored ceramics of the Southern Song, such as the Guan and Longquan wares discussed above (see FIG. 7-1), similarly often invoked talismanic ritual bronze vessel forms from the distant past, implying connections with classical authority.

Political, rather than cultural, legimitation is the explicit theme of the images of *Auspicious Omens for Dynastic Revival* (FIG. 7-29) produced by the court painter Xiao Zhao (active 1130–1160) as illustrations to a pseudo-documentary text by a Song official. These are after-the-fact accounts of a dozen auspicious or miraculous events that predicted or confirmed the mandate of Gaozong to rule the Song, in a combination of myth, history, and propaganda. In one scene Gaozong, while encamped in the field at the head of a military expedition to rescue his elder brother from the Jurchen, dreams that his brother visits him and hands over his imperial robe as a sign of legitimate succession. *Welcoming the Emperor at Wangxian Village* (see FIG. 7-12 above) is another Southern Song court painting that focuses on themes of restoration and return.

Women's Culture

Unlike such well established genres as landscape, religious figures, and symbolic plants and animals, there was little specific recognition given to images of women in Song writing about art. This seems in some ways a deliberate act of exclusion, because images of women are widespread in this era and more diverse in subject matter, though perhaps less abundant, than Tang-era paintings and tomb figurines of female palace beauties, servants, and musicians. We have already encountered, in tenth-century painting from the Southern Tang tradition, images of women as the focus of men's gazes (*Night Revels of Han Xizai*, see FIG. 7-23 above). Later Song images display women's virtuous and active roles in silk production (*Sericulture*, see FIG. 7-4 above) and aspects of everyday domestic life (*Knick-knack Peddler*, see FIG. 7-5). There is, of course, a vast difference between images of women's normative social and cultural roles, enforced within a system of values and power that might fairly be called patriarchal, and a true women's culture of active participation and performance. The latter is harder to locate in a system that remained heavily dominated by male patronage and production, but some aspects of women's values and interests emerge in art from a variety of contexts.

Some indication of a popular understanding of women's roles appears in one of the earliest surviving New Year's prints, the image of *Four Beauties* (FIG. 7-30) produced in the late Jin era by the Ji family of printers. The elaborate framing of the image imitates a scroll painting mount, but such prints were meant for wide distribution and should reflect tastes and interests beyond the court and scholarly elites. The four beauties in the garden, each identified by a written cartouche, were talented women from the period around the Han dynasty (206 BCE–220 CE) who met tragic fates at their own or others' hands. The image

7-30 Ji Family Publishers, Shanxi, *Four Beauties*
Jin, 12th century. Woodblock print, ink on paper; 27½ × 11¾" (70 × 30 cm). Excavated in 1909 at Lishuicheng, Gansu. Far Eastern Museum, St. Petersburg

combines a taste for overt appeal, in the women's graceful figures and their elaborately patterned costumes, with an interest in the tragic consequences of customary limitations on the freedom of women of high status. One of the four, Wang Zhaojun, is shown writing a text. She was married off to a nomadic chieftain during the Han period for diplomatic reasons, and her tragic exile probably resonated with audiences in a period when many Chinese in the north lived under Jurchen rule.

Images of women only rarely embody women's viewpoints, but one important theme in Song painting illustrates a woman's narrative of exile and conflicting emotions of cultural loyalty and maternal devotion. *Eighteen Songs of a Nomad Flute* was originally a poem cycle by Lady Cai Wenji of the Han dynasty, who was married off to a chieftain of the nomadic Xiongnu or Huns and bore him two sons. When ransomed back to her Chinese home she left her nomadic life and family behind. Her poetic complaints of the loneliness and rigors of a frontier life in an alien culture and of the pain of parting from her children were imitated by a male writer, Liu Shang of the early Tang period. He adopted Lady Wenji's female voice and persona, and his versions were the source for later pictorial cycles of illustration. (This is an example of women's cultural performances continually being absorbed into the dominant male system):

> I sleep by water and sit on grass; The wind that blows from China tears my clothing to pieces. I clean my hair with mutton fat, but it is seldom combed. The collar of my lambskin robe is buttoned on the left; The fox lapels and badger sleeves are rank-smelling, By day I wear these clothes, by night I sleep in them. The felt screens are constantly being moved, since there is no fixed abode; How long my days and nights are—they never seem to pass.
>
> (Rorex and Fong, *Eighteen Song of a Nomad Flute*, section 13)

The distant historical and literary theme resonated with circumstances in the Song, when cultures with nomadic roots established competitive regimes along the northern frontiers and eventually within the northern territories of the Song. As we have seen, when the Jin overran North China, they took members of the imperial family hostage and ruled a large subject population of ethnic Chinese. Issues of divided loyalty were thus very close at hand, accompanied by a curiosity about nomadic life, including women's roles. The story of Lady Wenji involves a woman's quandary of attachment to children and family as opposed to the duty of loyalty to her Chinese home. Illustrative paintings include an image of parting from the nomadic encampment, in which the distinctiveness of nomadic cultural practices is displayed in tent architecture, hairstyles, cooking, and costumes, and in the seemingly unorganized scattering of

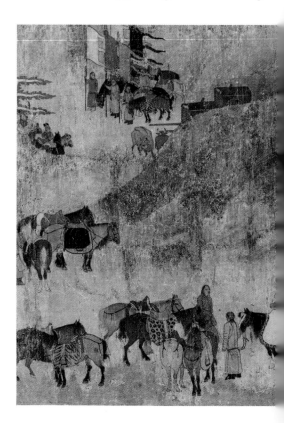

elements around the scene. The pivotal emotional scene of Lady Wenji parting from her sons is signaled only by a restrained raising of sleeves to tear-filled eyes (FIG. 7-31).

The cultures of the Liao and Jin, which constituted competition, threat, and attraction all at once for the Chinese under the Song, may have stimulated a protective concern with moral and behavioral norms for Song women. Promotion of traditional Confucian values at court included illustrations of didactic texts such as a women's version of the *Classic of Filial Piety*, addressed to aristocratic women in particular. Scenes from a Song-period tomb of the Zhao family at Baisha in Henan, dated to 1099, belong to a more widespread realm of values, where domestic harmony extends into the after-life. The matron of the house is shown receiving gifts from visitors, dressing in the company of handmaids, and at a banquet with her husband, attended by servants. The latter scene (FIG. 7-32), with its hybrid media, reveals a fascination with complex illusionistic effects at all social levels. The tableau appears beneath simulated rolled-up bamboo blinds in low relief. The table and chairs, wine ewer, cups, and the seated couple themselves are likewise low-

7-31 Anon., *Eighteen Songs of a Nomad Flute*
Southern Song, mid-12th century. One of four album leaves, sections cut from a handscroll, ink, gold, and colors on silk; 9⅞ × 22″ (25 × 55.8 cm). Museum of Fine Arts, Boston

The conflict between cultural allegiance and maternal affection is exemplified in the poetic narrative of Lady Cai Wenji, who must leave her sons, born to a nomadic chieftain, behind when she is reunited with her Chinese home:

> My children pull at my clothes, one on either side; I cannot take them with me, but in leaving them behind, how I shall miss them! To return home and to depart in sorrow—my emotions are mixed. Now I must abandon my children in order to return home. Across ten thousand miles of mountains and rivers, I shall arrive at our border stations. Once having turned away, forever there shall be no news from my children. With tear-stained face I turn toward the setting sun; All day long I have stood there, looking to the south and then to the north.

> (Rorex and Fong, *Eighteen Songs of a Nomad Flute*)

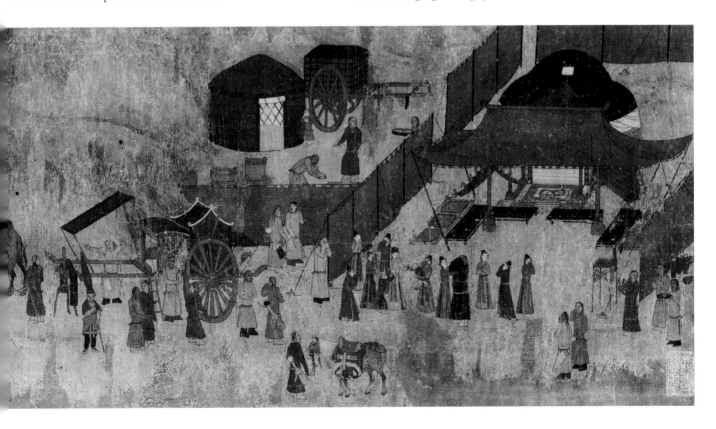

7-32 Song tomb of the Zhao family at Baisha
Baisha, Henan. Northern Song, datable to 1099. Low-relief sculpture, brick, clay, and pigments; 35½ × 53″ (90 × 135 cm)

relief sculptures formed out of bricks, with the faces further modeled in clay and painted. Illusionistic screens frame the main couple, and the servants are set behind the screen of waves but in front of a large simulated calligraphy screen.

Even with all the emphasis on female duty and domesticity in late Song art, images of court women's pleasures and entertainments remained prominent. One of the most complex of such scenes, though managed within the confines of a fan-shaped album leaf, depicts a long procession of aristocratic women and attendants wending their way from in front of a palace building, decorated with fabric-draped chairs and potted coral branches, through a monumental garden rockery up to a high pavilion for viewing the evening sky. The palace women's figures are nearly ethereal in their slenderness. The empress and her maids, marked by tall fans, are preceded by musicians and a leashed sheep, as if in preparation for a ritual. They are probably observing the romantic *Women's Festival of the Double Seventh* (FIG. 7-35), marking the once-a-year meeting of the Herd-boy and Weaver-girl constellations, otherwise separated by the starry river of the Milky Way.

The late Southern Song reigns of the emperors Ningzong (r. 1194–1224) and Lizong (r. 1224–1264) were linked in part by the influence of Empress Yang (1162–1232), consort of Ningzong and a key figure in bringing Lizong to power. Court paintings from this era are often accompanied by poetic inscriptions by

7-33 Ma Yuan (c. 1190–1225), *On a Mountain Path in Spring*
Inscribed couplet by Emperor Ningzong (1164–1224, r. 1194–1224). Southern Song, Ningzong reign. Album leaf, ink and color on silk; 10¾ × 17″ (27.4 × 43.1 cm). National Palace Museum, Taipei

members of the imperial family, indicating the direct guidance of aristocratic taste. The subtlety of pictorial effects, whether exquisitely nuanced descriptions of blossoms, birds, and animals or the indeterminacy of distant misty reaches are a powerful lure for the viewer. The seductive power of painting had previously resided primarily in its imagistic content, especially in pictures of court beauties. In the late Song, this effect resides more in the manipulation of visual experience and attention. The status of painting as lure is evident in the court painter Ma Yuan's *On a Mountain Path in Spring* (FIG. 7-33), where the blossoming branches lure the birds, the birds attract the stroller's gaze, and the entire scene entices the viewer with its calculated diagonals and framing willow branches. The couplet at upper right was inscribed by Emperor Ningzong, but the tone and content are reminiscent of poems inscribed by Empress Yang (known as Yang Meizi) on many court paintings. The poetic text uses birds and flowers symbolically to hint at palace women stirred by the emperor's presence:

> Brushed by his sleeves, wild flowers dance in the wind;
> Fleeing from him, hidden birds cut short their songs.

Empress Yang's own poetic inscriptions appear on other works by Ma Yuan or his son, such as *Apricot Blossoms* (FIG. 7-34), where associations of the subject with delicate feminine beauty seem paramount, and the poetry and accompanying painting serve as a vehicle for courtly communication. Ma Yuan's characteristic diagonal composition here takes the form of wide-spreading branches that suggest erotic promise and invitation, confirmed by the language and tone of Empress Yang's poem:

> Meeting the wind, they offer their artful charm;
> Wet from the dew, they boast their pink beauty.

Literary Culture and the Arts

Elite literary culture was engaged with the arts during the Song period in two major areas.

First, there was an unprecedentedly large and diverse body of writing about the arts of painting, calligraphy, architecture, and antiquities. This took the form of catalogues, biographies, histories of art, criticism, and treatises on theory, connoisseurship, archaeology, and technique. It also included more traditionally literary writing, in the forms of poetic or essayistic comments and appreciations of painting and calligraphy in particular. Second, the problem of the relationship between poetry and painting was a central concern in Song artistic culture among critics, theorists, and both scholar–official and court artists.

Art Literature and Discourses

The literature of art, the categories and contents of writing about art, can be distinguished from art discourses, the underlying issues, concepts, and metaphors or figures of comparison that structure the history and criticism of art. Song art literature includes many categories of writing that existed in the Northern and Southern Dynasties and the Tang, such as histories and catalogues of painting, biographies and critical evaluations of artists, theoretical treatises on

7-34 Ma Yuan (c. 1160–1225), *Apricot Blossoms* Southern Song. Inscribed couplet by Empress Yang (Yang Meizi, 1162–1232). Fan mounted as an album leaf, ink and color on silk, 10 × 10¾" (25.8 × 27.3 cm). National Palace Museum, Tapei

7-35 Anon., formerly att. to Zhao Boju, *The Han Palace/Women's Festival of the Double Seventh*
Southern Song, late 12th–early 13th century. Fan-shaped album leaf mounted as a hanging scroll, ink and colors on silk; diameter 9⅝″ (24.5 cm). National Palace Museum, Taipei

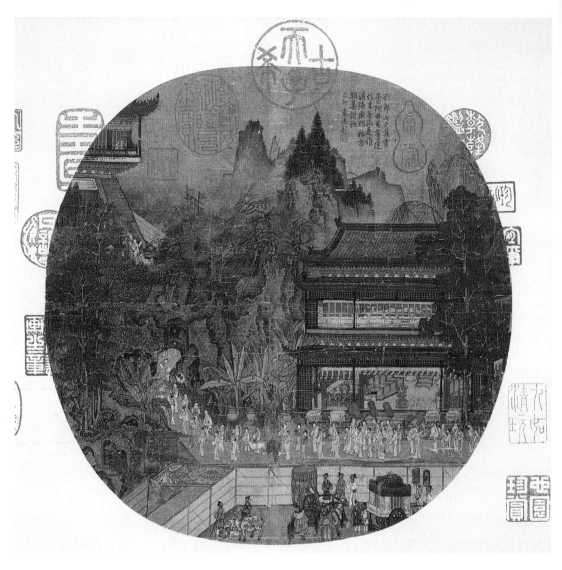

landscape, and literary appreciations of artists and their works. What is unprecedented is the range, systematic approach, and diversity of Song writing on the arts, which treats not only painting and calligraphy but also architecture, antiquities, and the connoisseurship of art objects. Writing about art became more widespread compared to earlier times. Literary men wrote occasionally about it, reflecting their social and aesthetic outlook. Technical treatises and genre-based classifications were newly prominent categories of writing in keeping with broader Song interests. However, the underlying concerns and shaping discourses that run through Song writing on the arts are more distinctive of the period than the categories of texts.

Consciousness of historical relativism. Historical writing about art was not new in the Song, but the sense of a break with the past and a certain detachment from it are marks of a historical self-consciousness. Illustrated catalogues of ancient bronzes as objects of distant archaeological and epigraphic interest, rather than talismans of ritual power, are part of this outlook. A passage by the late-eleventh-century painting historian Guo Ruoxu conveys an awareness of historical trajectories and relativism:

> If one is speaking of Buddhist and Taoist subjects, secular figures, gentlewomen, or cattle and horses, then the modern does not come up to the ancient. If one is speaking of landscapes, woods and rocks, flowers and bamboo, or birds and fishes, then the ancient does not come up to the modern.
>
> (Bush and Shih, *Early Chinese Texts on Painting,* p. 94)

Painting Formats and Materials

Almost all the major formats of Chinese painting were in use by the Song era. These display the diversity of paintings as physical objects, as well as the variable status and functions of paintings as cultural objects.

Wall paintings, whether in tombs or in above-ground settings such as Buddhist or Daoist temples or government offices, already had a long history as public monuments, reaching back at least to the Han period (206 BCE–220 CE). These were typically large-scale works, painted on prepared surfaces of clay, whitewashed and sized with glue or alum, rather than a wet fresco technique. Favored subjects included religious narratives, commemorative scenes for funerary contexts, or exemplars of political and moral virtues (see FIGS. 4-11 and 6-36 above). Palace and temple murals engaged the talents of some of the most celebrated artists through the Tang period and into the Song, but after the Song period wall paintings became almost exclusively the province of lesser-known specialists.

Screen paintings were large works used for relatively long-term interior decoration. Chinese painted screens were most often single-panel works framed in self-supporting wooden stands, but the multipanel hinged screen was also used. The painting surface could be either silk or paper panels. Screens functioned architecturally to divide interior spaces and to demarcate areas of special importance, as in screens placed behind thrones, or were used as wind protection and status markers (see FIG. 7-23 above; see also FIG. 8-11 below). Very few Chinese screen paintings survive in their original frames, but representations of screens in wall and scroll paintings show

that this was an important and widely used format (see FIGS. 8-29, 9-4, and 9-29 below).

Handscroll, or horizontal scroll, paintings conveyed high prestige based on their long history and the generally high status enjoyed by calligraphic texts, for which the format was first used. Early handscroll paintings often illustrated poetic and narrative texts, which could be interspersed with the pictorial illustrations (see FIG. 5-25 above and FIG. 7-36 below). The textual underpinnings of horizontal scroll paintings can be seen in the common practice of providing calligraphic frontispieces, inscriptions following or interspersed with the painted sections, and appreciative or commentarial colophons on mounted papers at the end of the painting. Physically, handscrolls consisted of joined silk or paper sections, backed with paper layers and framed with silk brocade, with a thick core serving as a roller. The height of the scroll could vary from a few inches to a couple of feet (5–60 cm), and the length from an arm's width to potentially a hundred feet (30 m) or more. Handscrolls were viewed in arm-length sections, usually by only one or a few persons at a time, and were not normally displayed fully unrolled. This sectionality introduced a dimension of time into the viewing process and was conducive to narrative subjects, panoramic overviews of landscape, or episodic figural themes.

The hanging scroll (or vertical scroll) format seems to have achieved widespread use only in the Song era. Many attributions to this period survive in the vertical format, and others are mentioned in catalogues of the time. In some cases, images that survive today as single vertical

scrolls may have been mounted as sections of multipanel screens or may have belonged to multiscroll sets of paintings. Hanging scrolls, like handscrolls, were relatively easy to store, transport, and display. They were mounted with paper backing and framing brocade like horizontal scrolls, with the addition of a protruding roller at the bottom to serve as a hanging weight. Hanging scrolls could vary in size, depending on the architectural context. They could serve as long-term elements of interior decor but often were hung and viewed only temporarily, on specific occasions such as birthdays or at appropriate seasonal or festival times (see FIG. 8-5 below).

Paintings on functional round fans are represented in Tang-era wall paintings, and these continued in use in later times, along with fan-shaped album leaves (see FIG. 7-35 above) mounted in booklike formats. Square or rectangular album leaves were also used, mostly on silk in early times and later on paper. Album leaves are generally small in size and intimate in effect, meant for close-up viewing (see FIGS. 8-32 and 8-34 below). Fan-shaped leaves in particular may have retained something of their aura as former objects of women's personal adornment. The arc-shaped folding-fan format was an import from Japan that became fashionable in China only in the Ming period (1368–1644). The multileaf album devoted to a single theme was also largely a post-Song innovation. Other formats included small paintings inset into couches, chairbacks, and other furniture, a practice documented in the *Night Revels of Han Xizai* scroll (see FIG. 7-23 above) that continued through the end of the imperial era.

In the context of the persistent Chinese cultural practices of venerating the past, this even-handed treatment may be seen as a bold claim for the value and distinctiveness of contemporary art. The modern genres identified were not only areas of technical accomplishment, but subjects of increased cultural importance. Landscapes, woods, and rocks were topics of political debate and objects of escapist yearning among Song literary men. Flowers and plants such as bamboo were subjects of symbolic interest to poets and literati, while birds and fishes were prominent themes in court painting. The passage thus implies other important concerns of Song art discourses: categorization by genre and the social contexts of painting subjects.

Genre classification. The early-twelfth-century imperial painting catalogue *Xuanhe huapu* was the first to be organized by genre categories, but other texts from the period refer to subject specialties and categories. Genre groups are one way of organizing experiences of the world, and the list of genres in the *Xuanhe* catalogue is accompanied by explanations of the larger cultural values and associations of each subject.

Social contexts of art and the promotion of scholar– official values. Song writers on art are aware of the social status of artists and the social contexts of specific genres. The promotion of the values of educated artists in several texts may have been in part a by-product of the authorship of most art texts by educated gentlemen and scholar–officials. However it also reflects the importance of educated artists and critics in the art world in general and the infiltration of their interests and values into court circles. Art thus became, even more strongly than in the past, an arena of social competition.

The debate over form-likeness. The most famous formulation of an attitude denigrating mere form-likeness or illusionism in painting is attributed to the poet–official Su Shi (1037–1101), who noted that "if anyone discusses painting in terms of formal likeness, his understanding is close to that of a child" (Bush and Shih, *Early*

Chinese Texts on Painting, p. 224). This position suggests a sophistication in taste and standards not unlike that of modernist movements in the West, when skillfully illusionistic rendering was deemed uninteresting and in some ways aesthetically naive. The debate also implies a contest of values between social groups. Su Shi belonged to a conservative faction of scholar–officials; his opponents were the court aristocrats and technocrat officials who patronized a more technically skilled, decorative, and illusionistic kind of painting. The alternative offered by the scholar–officials emphasized inner qualities of naturalness, lack of artifice, and something akin to the natural purity of water ("blandness"). This debate echoes the opposition in Jing Hao's text on painting (see page 246 above) between inner substance and outer appearance and ornamentation. Underlying all of these discussions were still earlier literary debates about the relative values of ornamentation and rhetorical artifice as against the plain substance of meaning.

Debates about form-likeness were thus ultimately as much about politics and ethics as they were about aesthetics. The most ready-at-hand alternative to the values of illusionistic painting lay in the realm of literature, and specifically poetry. Poetry was a non-representational art, and only a

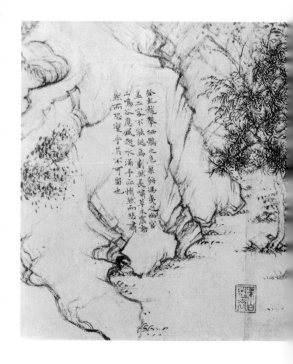

naive reader would criticize a poem for a lack of verisimilitude. Moreover, literary and poetic skill was the province of the scholar–official class, unlike skillful painting. Thus in these cultural debates the more that painting approached the condition of poetry, the greater the advantage to scholar–officials.

Varieties of Poetic Painting

The assertion that painting and poetry are in some ways equivalent is expressed in versions of the maxim "Poetry is painting without form; painting is unspoken poetry" (see Bush and Shih, *Early Chinese Texts on Painting*, p. 203). This became a prominent topic in Song-era critical writing, but it had an earlier parallel in the West in statements attributed to the ancient Greek philosopher Simonides of Ceos. On the most basic level the doctrine could point primarily at the descriptive and narrative qualities shared by both art forms. In Song China there were also social and political dimensions to the claim. Asserting an equivalence with poetry, the most prestigious of the literary arts, meant a rise in cultural status for painting and painters. The establishment of a painting academy at court under Emperor Huizong in the early twelfth century, with a literary curriculum analogous to those of other bureaucratic trainees, was another important component of

that effort to raise the status of painting as an art. The physical inscription of poetic or other literary texts on the surfaces of paintings, most often seen in court paintings in the Song, but in later times adopted as a distinctive practice of scholarly or amateur painters, is another aspect of this trend.

An equivalence of painting and poetry may also suggest that painting can perform some of the same functions of political complaint and critique as poetry sometimes does but accomplish it soundlessly, and hence in a less dangerously public manner. The equivalence of the two arts became a cliché in later times but should not be assumed for all periods. In the Northern and Southern Dynasties, we might say painting aspired to the status of music, in seeking qualities of resonance and wordless, responsive communion. In the Tang, some kinds of painting aspired to the status of sculpture, in its vividness, tangibility, and expressive power.

The theme of poetic painting (and painterly poetry) is very widespread in Song art writing. Its appearance in texts by someone like Su Shi, primarily a literary man and poet, is understandable, but the topic emerges in many other settings. Illustration of lines of poetry was a testing device for prospective painting academy entrants at the late Northern Song court

7-36 Qiao Zhongchang (active first half 12th century), *Illustration of Second Prose-Poem on the Red Cliff*
Northern Song, colophon dated 1123. Detail of handscroll, ink on paper; 11½" × 18′4″ (29.5 cm × 5.6 m). The Nelson-Atkins Museum of Art, Kansas City

Among many efforts to link painting with poetry in the Song era, artists of the scholar–official school tried to create pictorial counterparts of the imagery and metaphors of poetic texts:

> I lifted the hem of my coat and stepped ashore. Treading on the steep rocks, parting the dense thickets, I squatted on stones shaped like tigers and leopards, climbed twisted pines like undulating dragons, drew myself up to the perilous nests of perching falcons, looked down into the underwater palace of the River God. Neither of the guests was able to keep up with me.
>
> (Birch, *Anthology of Chinese Literature*, pp. 383–84)

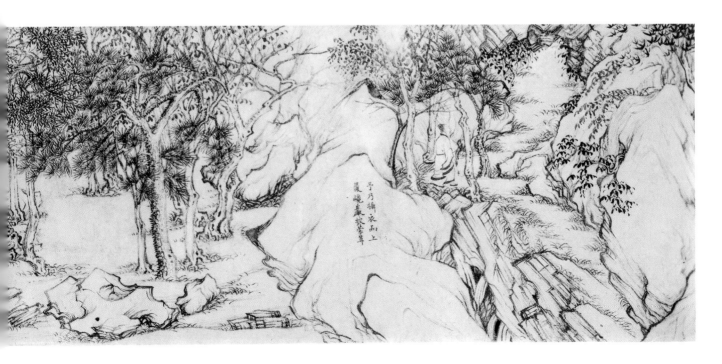

Training and Examination of Court Artists

The following excerpts are from a history of painting by Deng Chun, a former Northern Song official who completed his text in 1167. It includes accounts of recruitment, examination, and training of court artists during the Huizong era, including anecdotes about the emperor's personal input.

In the instruction of the various craftsmen, as in that of the *jinshi* (accomplished scholar) degree graduates, [Huizong] had topics set to select candidates… One of the topics set for the examination was: "Deserted waters, without men crossing;/ An empty boat, horizontal the whole day." From the second best man on down, most attached an empty boat to the side of a bank, with perhaps a perching heron on the edge of the deck, or settling crows on the top of the mat-roof. But the best candidate did nothing of this sort. He painted a boatman lying at the stern of the boat with a single flute placed horizontally. His interpretation was that it did not mean "without a boatman," just "without travelers." Therefore he showed the boatman in a state of total relaxation.

(Bush and Shih, *Early Chinese Texts on Painting*, pp. 134–36)

of Huizong (see "Training and Examination of Court Artists," above), and in the previous generation Guo Xi (see pages 247–249) identified several couplets as most appropriate poetic themes for landscape painting. Southern Song court paintings often bore poetic couplets inscribed by members of the imperial family (see FIG. 7-33 above). Some poetic subjects such as the "Eight Views" of the Xiao and Xiang rivers (see FIG. 7-22 above) were also popular among painters affiliated with Chan Buddhism.

One of the most straightforward ways of integrating poetry and painting was the illustration of poetic texts. An important example is the handscroll illustration of the scholar–official Su Shi's *Second Prose-Poem on the Red Cliff* (FIG. 7-36). It was painted in the early twelfth century by one Qiao Zhongchang, a follower of the major literati painter Li Gonglin, who was in turn an associate of Su Shi, and it thus embodies the taste of that group of literary men. The painting is explicitly literary, with passages of Su Shi's text (see FIG. 7-36, caption) inscribed at irregular intervals amid the illustrative scenes. The ink monochrome painting on paper uses old-fashioned devices such as hieratically scaled figures, maplike architectural compounds, and geometrically stylized cliffs to distinguish itself from more technically sophisticated court styles. The emphasis on rhythmic brushwork, rather than on effects of representational illusionism, is another feature which foreshadows later literati

painting. Modifications of scale and the idiosyncratic shaping of tree and cliff forms are aimed at conveying the emotional tone of the poem. Most of all, however, it is the effort at rendering literary figures through pictorial equivalents which contributes to the project of poetic painting. In a passage such as "stones shaped like tigers and leopards… twisted pines like undulating dragons" (see caption) in the scene reproduced, the hunched, muscular rocks and pulsating tangle of tree branches seem aimed at a direct translation of poetic language into a kind of visual metaphor. Set against works such as *Spring Festival on the River* (see FIG. 7-3 above) or *Autumn Colors Along Rivers and Mountains* (see FIG. 7-21), these features must be read as deliberate claims of distinction that involved not only pictorial but also social and even moral qualities. The repudiation of devices of decorative illusionism is not just a stylistic choice but a sign of other values such as naturalness, self-restraint, and deep literary understanding.

Another dimension of literary approaches, seen in the paintings and writings of Mi Fu (1052–1107) and his son Mi Youren (1075– 1151), emphasized qualities of naturalness that have counterparts in both the moral and literary spheres, in promoting ideals of the unadorned and of uncalculated spontaneity. Their simple landscape images, with a minimum of detail and almost no variety in brushwork, suggest cloudy bands among rolling hills with broad sweeps of ink

wash and repetitive horizontal ink dabs. The aesthetic of the incomplete functions in their work and in many other kinds of Song poetic painting (see FIGS. 7-22 and 7-33), allowing the viewer/reader to participate in completing the image, and thus drawing on reservoirs of association and emotion that can lend it qualities of resonant depth and implication. The effect is analogous to the appeal of poetry suggested by the late Song critic Yan Yu (1180–1225): "[A good poem should be like] a sound in mid-air, colors in an apparition, moonlight in water, or images in a mirror. While words are exhaustible, ideas barely suggested are limitless" (Bush, *The Chinese Literati on Painting*, p. 44).

Another in this array of Song devices linking poetry and painting is symbolism. Well-established motifs could convey specific references to literature, history, or ethics and an accompanying range of meanings. The "Three Friends of Winter"—pine, apricot (plum), and bamboo—are of this sort, with associations ranging from the scholarly to the sexual, but with a core significance in analogies to human character: flourishing in adversity, strength, and persistence. In Wang Tingyun's *Old Tree and Bamboo* (see FIG. 7-27 above) the closely related symbolic associations are couched in a pictorial rendering that seems to preserve a direct link between the idea, the process, and the image. This belongs to the aesthetic of painting as a spontaneous "mind-print," a theory of painting and calligraphy as direct self-expression in the manner of personal signatures.

Calligraphy from the same circle of literary men could embody qualities of spontaneity and the metaphorical as much as in painting. Huang Tingjian's writing (see FIG. 7-16), for example, suggests not only an improvisatory process of continuous adjustment, but a possible reading in terms of somatic, or bodily, effects. His large, blunt characters isolate the kinesthetic movements of individual stroke formations. Moreover, the construction of characters primarily in terms of qualities of dynamic balance, extension, and enclosure suggest aspects of the body metaphorically. The collector and art historian Mi Fu more fully engages the interplay of calligraphic text and pictorial

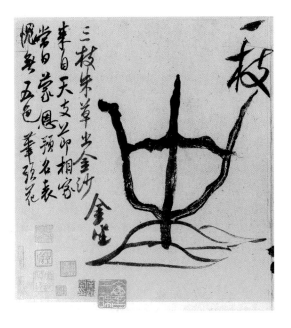

7-37 Mi Fu (1052–1107),
Letter About a Coral Tree
Northern Song, c. 1101.
Album leaf, ink on paper;
10½ × 18″ (26.6 × 47.1 cm).
The Palace Museum, Beijing

image. His *Letter About a Coral Tree* (FIG. 7-37) includes a sketch of a three-pronged coral branch set on a metal stand that seems consciously to reenact the rhythms of his framing calligraphy. The easy flow of his calligraphic text, while disregarding consistent structure in characters that bulge and hollow, swell and thin by turns, conveys an air of effortless naturalness.

The most explicit statements about poetic painting in the Song appear not among the scholar–officials but instead in the milieu of the late Northern Song court, when under Emperor Huizong specific problems of poetry illustration were used as test problems for prospective entrants into one of several short-lived court institutions for training court artists. As recorded by later Song writers (see "Training and Examination of Court Artists," page 266), these topics—a line or couplet of poetry that the painters competed to illustrate—were aimed first at encouraging a literary sensibility and cultivation among artists. Painters had to understand the nuances of the poetry first, and conceptual ingenuity seems to have weighed more in the competition than painting skill. The case examples that are given suggest that the qualities prized included indirect or partial suggestion of a theme rather than full illustration. The "poetic" quality of such paintings lay in their capacity to suggest something in the way of situation or mood beyond the depicted forms. In this sense poetic painting at court was

similar to some strategies of literati painters. However, surviving works of court painting from this period indicate a taste for decorative and technically accomplished illusionistic detail, however indirect the thematic rendering (see FIG. 7-15 above).

Later in the Southern Song, court paintings were often accompanied by poetic couplets or quatrains, often written in the hands of members of the imperial family (see FIG. 7-33 above). In these cases, the function of poetic painting seems to have been as a kind of embellishment for personal communication between members of the court. The subtlety or indirection of the poetic illustration involves something like veiled allusion in poetry, using the conventional or symbolic associations of birds and flowers to convey romantic longing, melancholy, neglect, or desire, for example, when the fragile, delicate blossoms of the apricot stand in for the brief erotic flowering of a court lady (see FIG. 7-34 above).

Buddhist Artistic Culture

Despite the large-scale suppression of Buddhism in the late Tang dynasty, when thousands of monasteries were closed and hundreds of thousands of monks and nuns returned to secular life, Buddhism flourished in a variety of forms throughout the Song era. What Buddhism lost in terms of official sponsorship and patronage from the court, it made up for in trends toward popularization and humanization. In artistic terms the ninth and tenth centuries of the late Tang through early Song were periods of great vitality and innovation in Buddhist arts. Many of the iconographical themes that developed in this period involved beings who were intercessor figures or relatively approachable, in comparison to the majestic and idealized Buddha pantheons and paradises of earlier times. The *bodhisattva* Guanyin, for example, embodies the virtue of compassion and is often depicted as a feminine figure and in informal settings and poses. *Luohan*, or disciples of the Buddha, might be shown as outlandish eccentrics, but they were also shown in very familiar settings, performing actions as mudane as washing laundry. Even the kings of hell (see FIG. 7-14 above), despite the ferocity of their demeanor and grotesque nature of their punishments, reflect the familiarity of the real-world bureaucracy. Similarly, the most prominent Buddhist sects in the Song era included the Pure Land, with its popular appeal of a promised rebirth in luxurious paradises, and the Chan sect, with strong ties to secular literary culture. Realism, emotionalism, and dynamic energy were important components of this trend in Buddhist arts.

Architecture

A number of important Song-era Buddhist temple buildings survive, mostly from the regions of north-central and northeastern China under the early Song and Liao regimes. The Great Pagoda of the Fogong (Buddha's Palace) Temple at Yingxian, Shanxi, datable to 1056, was built under the Liao and, at c. 221 feet (67.3 m), is the tallest wooden building in the world (see FIG. 0-1 above). Despite the massive scale, with five external stories and four more windowless interior stories making a total of nine, some structural innovations made the interior space of the pagoda more accessible for worship (FIG. 7-38). In place of the central column of earlier pagoda designs, the columns here are arrayed in two concentric rings in an octagonal plan, leaving a central space for Buddha images on all five levels, with the space between the column rings available for worshippers. A slight tilting of the columns from floor to floor, adding both to the impression of height and to the structural stability of the pagoda, relieves the heaviness of the structure, some 98 feet (30 m) in diameter at the base. The mid-eleventh-century Moni Hall at the Longxing Temple (see FIG. 7-6 above) represents another trend in Song Buddhist architecture, with its light profile and complex rooflines.

7-38 Cross-section diagram of the Great Pagoda of the Fogong (Buddha's Palace) Temple
Yingxian, Shanxi. Liao, dated 1056

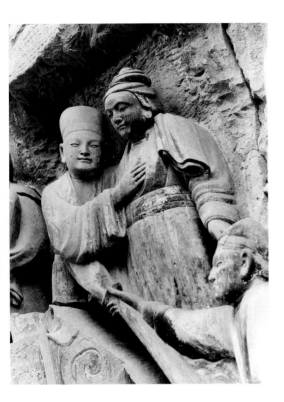

7-39 Dazu Grottos
Baodingshan, Sichuan. Southern Song, 1179–1249. Stone carving

7-40 *Guanyin*
Southern Song. 12th–13th century. Wood and pigment, height 7′9″ (2.41 m). The Nelson-Atkins Museum of Art, Kansas City

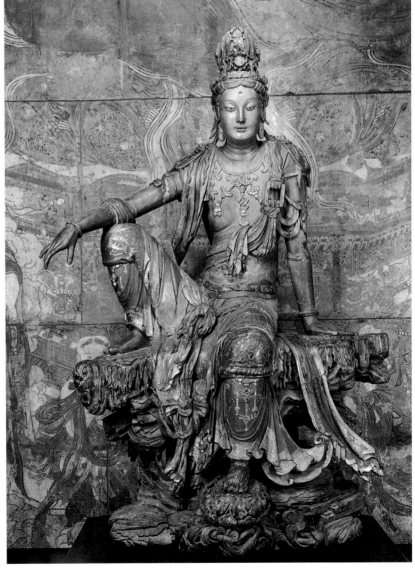

Sculpture

The Dazu Grottos of Sichuan include Southern Song-period sections at Baodingshan, carved under the supervision of the Esoteric sect monk Zhao Zhifeng from 1179 to 1249. The painted stone images and vignettes include a number of subjects that seem aimed at popular taste through scenes of strong emotion and violence. Scenes of hell include demonic, grotesque torturers and their mournful victims, while images of non-Buddhist ascetics taunting the Buddha Sakyamuni for his lack of filial piety convey a sense of the ethical and social tensions within which Buddhism operated in China. Most remarkable are sculptures illustrating a carved text warning of the effects of drunkenness. In one vignette, where a drunkard is shown murdering his father and raping his mother, the placid faces of the sculpted actors, masklike both in their frozen intensity and quality of individuation, belie the extremity of the social transgression and Oedipal fantasy they act out (FIG. 7-39).

A much more overtly appealing mode of Buddhist sculpture popular in the Song appears in monumental images of the *bodhisattva* of compassion, Guanyin (FIG. 7-40), fashioned from carved and polychromed wood. The figure, if not

7-41 Zhang Shengwen (active late 12th century), *The Long Roll of Buddhist Images*
Southern Song, inscribed 1180. Detail of handscroll, ink, colors, and gold on paper; 12″ × 52′9″ (30.4 cm × 16.12 m). National Palace Museum, Taipei

This elaborate handscroll presents an encyclopedic depiction of Buddhist iconography during the Southern Song era, along with a view of the local religious culture of the Dali kingdom of Yunnan in the far southwest. Narrative vignettes such as Buddha's temptation by the demon Mara are interspersed with vivid images of ferocious guardian kings.

explicitly feminine, is characteristically graceful, long-limbed, and soft-featured. The casual pose, with one leg raised to the side and the weight resting on one supporting arm, suggests momentary rest rather than iconic stability, and the deeply carved, folded, and swirling drapery adds to the impression of a being who inhabits the same realm as the human viewer. The rocky platform is a reference to Guanyin's abode on Mount Potalaka in the southern sea, a sacred site, but also located within this world.

Song Buddhist Iconographies
The richest surviving record of Song Buddhist iconography is the *Long Roll of Buddhist Images* (FIG. 7-41), painted by Zhang Shengwen between 1173 and 1176. It documents the Buddhist beliefs of the far southwestern Dali kingdom of Yunnan, which were focused on a talismanic palladium, a locally protective or tutelary deity, in the form

of a golden Nepalese-style image of the *bodhisattva* Avalokitesvara (Guanyin). This region was open to influences from many directions, however, including Nepal, Tibet, and China, and the full scroll, some 53 feet (16.1 m) in length and with 136 sections in its present form, offers a nearly encyclopedic illustration of contemporary Buddhist themes. There are enthroned Buddhas in the midst of worshipful assemblies, along with esoteric deities from Tantric Buddhism, fierce protective beings with multiple visages and arms holding weapons. The patriarchs of Chan Buddhism are portrayed, as well as the Sixteen Great *Luohan*, disciples of the historical Buddha. Most scenes are rendered in a precise but energetic outline and color style, with great attention to iconographic detail and completeness. Esoteric deities are given greater intensity of presence through brighter colors and stronger patterns. Imaginative anecdotal details enliven narrative scenes such as

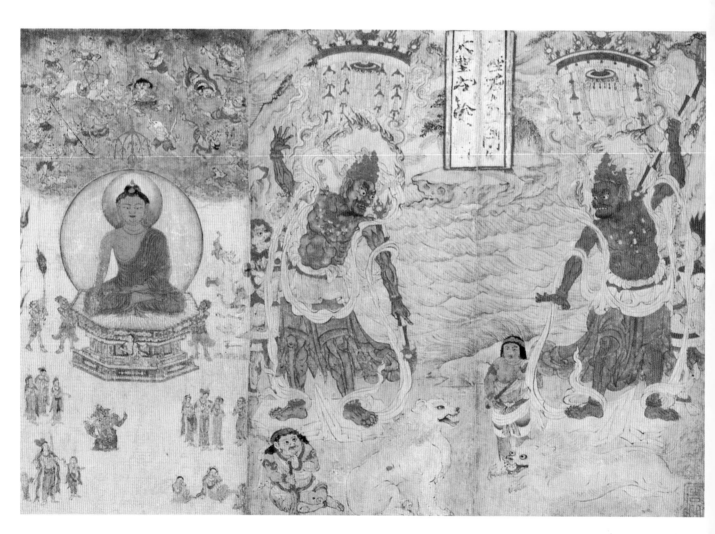

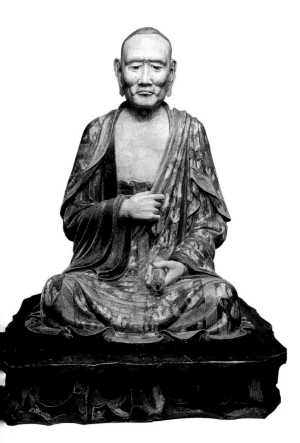

7-42 *Luohan*
Liao, 10th century. Earthenware with three-color glaze, height 30″ (76.2 cm). The Metropolitan Museum of Art, New York

7-43 Zhou Jichang and Lin Tinggui (active c. 1160–80), *Five Hundred Luohan*
Southern Song, dated 1178–88. One from a set of one hundred hanging scrolls, ink and colors on silk; 43⅞ × 20⅞″ (111.5 × 53.1 cm). Museum of Fine Arts, Boston

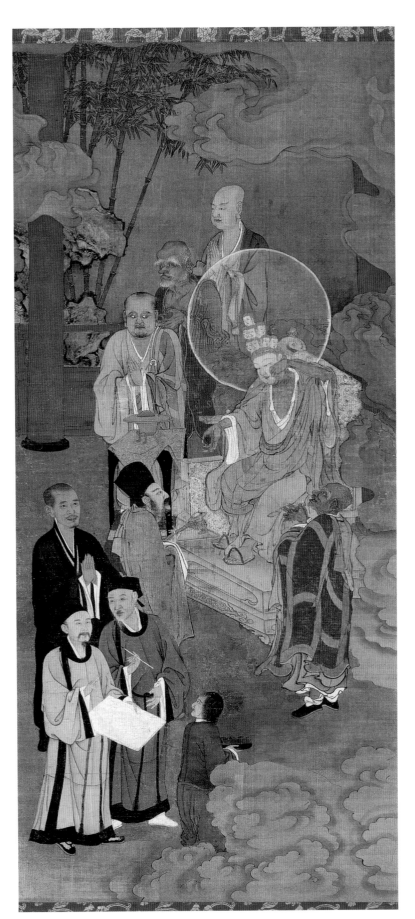

the Buddha's temptation, just before his final enlightenment, by the the demon Mara. Mara's demonic minions boil out of the dark clouds that shadow the serene and unmoved presence of the Buddha.

The *arhat* or *luohan* image was especially prominent in Song-era Buddhist art, in part because these beings were open to representation as vivid, sometimes fantastic or grotesque figures and to a wide range of worldly, rather than heavenly or cosmic, settings. The Sixteen Great *Luohan* were, according to a Sanskrit text translated into Chinese in the seventh century, disciples of the historical Buddha charged by him with the protection of the Buddhist law until the arrival of the Buddha of the future era. They were endowed with transcendent powers of long life and knowledge. While *luohan* could be represented as ordinary monks, their special powers were frequently emphasized, along with their status as outlandish foreign types, and they were often shown as denizens of remote mountain caverns or nested in craggy tree trunks. Ceramic sculpture images of seated *luohan* in three-color ware produced under Liao rule, from a region close to the Northern Song border, combine both aspects (FIG. 7-42). These life-size images have an almost uncanny presence, with a rough intensity in their faces that suggests a portraitlike intent, related to a tradition of funerary effigies for Buddhist monks. The simulated ledge of eroded rock on which the *luohan* sits recalls the remote haunts for many such images, in which the gnarled figures seem almost to fuse with their natural settings. The influential formulations of painted *luohan* by the ninth–tenth-century monk–painter Guanxiu (832–912) are mostly of the latter type, based, according to the artist, on visions that appeared to him in dreams.

Whatever the origins of *luohan* imagery in realms of the exotic and the visionary, by the late Song period they had become thoroughly domesticated and popularized. A series of *Five Hundred Luohan*, depicted in a set of one hundred hanging scrolls produced in the coastal city of Ningbo over a span of ten years, starting in 1178, documents the process. The project was generated by the abbot of a nearby temple, with individual donors supplying funds for the production of as little as one scroll at a time, often as offerings for the benefit of the soul of a deceased relative. The full set of images was displayed at the temple on important feast days and at funeral ceremonies. These were products of religious painting workshops that also supplied a market of Japanese Buddhist pilgrims and travelers with images such as the *Kings of Hell* (see FIG. 7-14 above). Because these were functional religious paintings in popular styles, not much prized by later collectors and connoisseurs, such paintings were well preserved only in Japan. This series of *Five Hundred Luohan*, painted jointly by the professional Ningbo artists Zhou Jichang and Lin Tinggui, was preserved intact at the Daitokuji Temple in Kyoto until early in the twentieth century, when twelve of the one hundred scrolls went to the United States. Each scroll depicts a group of five *luohan* engaged in some event or narrative: witnessing or performing miracles, feeding beggarlike hungry ghosts or washing clothes in a stream. Even the miracle scenes are so embedded in vividly described material settings as to take on the tangibility of everyday life. The taut, muscular bodies, colorful textiles, and energetic forms of trees and cliffs create an effect of extraordinary events played out on the stage of a familiar world. One of the most interesting of the scrolls suggests an explicit kind of theatricality (FIG. 7-43). One of the *luohan* poses as the Eleven-Headed *Bodhisattva* Guanyin by wearing a mask. In the lower corner is a further image of the process of representation, in the form of an artist, very likely a self-portrait of the painter of the scroll, holding a paper on which is traced the likeness of one of the monks. The painting is thus multileveled, conveying both the possibility of a miraculous manifestation and a sophisticated awareness of the artifice of representation in theater and painting, fully in keeping with the urban mentality of late Song China.

Chan Art

The best known Buddhist sect in the West is that of Chan (Japanese Zen). The Sanskrit term from which these names derive denotes meditation, and the search for direct, personal enlightenment through meditative practices

remained an important part of Chan. Stories about the founder of Chan in China, the sixth-century Indian monk Bodhidharma, who is supposed to have meditated for years in front of a wall and to have torn off his own eyelids to prevent himself from falling asleep, suggest the intensity of self-discipline encouraged by Chan.

The sect's early history in Tang-period China was dominated by rivalry between proponents of gradual versus sudden paths to enlightenment. By the late eighth century the sudden enlightenment camp, which emphasized spontaneous, intuitive insight and direct transmission from master to disciple instead of scriptural study and ritual practice, was predominant. The lore of Chan focuses on its radical, iconoclastic side and the careers of patriarchs and Chan eccentrics who might be illiterate laborers or kitchen helpers but possessed full enlightenment. The dialogic *gong'an* (Jap. *kōan* or "cases," religious problems to be worked through) literature, records of conversations between teachers and disciples emphasizing paradox and the unconventional, suggests the contribution of philosophical Daoism to the formulation of Chan styles.

Despite its unworldly and unconventional ideologies, Tang Chan masters received invitations to court, where doctrinal disputes were resolved. In the Song era, Chan had a complex institutional structure and its own substantial literature of monks' biographies, aphoristic teachings, and recorded anecdotes. Chan commingled with other Buddhist modes, as is clear from works such as the *Long Roll of Buddhist Images* (see FIG. 7-41 above), and with secular courtly and literary culture. While Chan art had a radical side, marked by extreme abbreviation and dynamic performance in painting and calligraphy, many of its features were foreshadowed in the aesthetic approaches of scholar–officials and literary men. Other modes of Chan art, central to its religious practice, are solidly within styles familiar from different religious and even secular contexts. Included were the formal portrait images of Chan abbots, known as *chinzō* in Japan, where Chan flourished after its decline in China and where most surviving Chan art was preserved. In sculptural or painted form, these served as vivid effigies

and commemorations of the presence of a revered teacher for his disciples. The painted portraits, when inscribed, may have served as a kind of identifying certificate of transmission of authority from master to pupil, and they recall the importance of direct master–disciple contact in Chan. In form, these belong to the tradition of ancestral, imperial, and other monastic portraiture, with great attention to the faithful rendering of details of costume, furniture, and religious accouterments that signal the status and authority of the subject. The 1238 portrait of Abbot Wuzhun (FIG. 7-44), a lecturer to Emperor Lizong who appointed him head of a monastery near the Southern Song capital, pays special attention to details of facial expression and finely nuanced, volumetric modeling of the facial features, in an effort to convey the presence and something of the intelligent, good-humored temperament of the teacher.

Better-known Chan images are those depicting a distinctive subject repertory in relatively unconventional, abbreviated, or expressive styles. The subjects include: Chan eccentrics, holy men of uncouth aspect who convey the idea of spiritual insight accessible in humble or unlikely contexts; Chan encounters, embodying lessons conveyed through conversation, often between Chan and Confucian figures; historical Chan patriarch figures who received and transmitted the doctrines; and particular aspects of the historical Buddha and *bodhisattvas*. While the subjects are mostly distinctive, there appears to have been considerable stylistic crossover between Chan and other modes of Song painting, including court and literati artists. In turn, Chan monks and abbots associated with and wrote for contemporary poets, while Chan monk–painters painted secular subjects such as landscapes, flowers, and fruit in monochrome styles that are abbreviated and suggestive, but not dramatically more so than works of scholar–official painters (see FIG. 7-27 above).

The career of Liang Kai exemplifies some of the complexity of Chan-affililated art and artists in the Song period. He was appointed a court painter at the beginning of the thirteenth century but soon retired to a Chan monastery near the capital. His secular paintings include a broad range of figure-in-landscape compositions executed

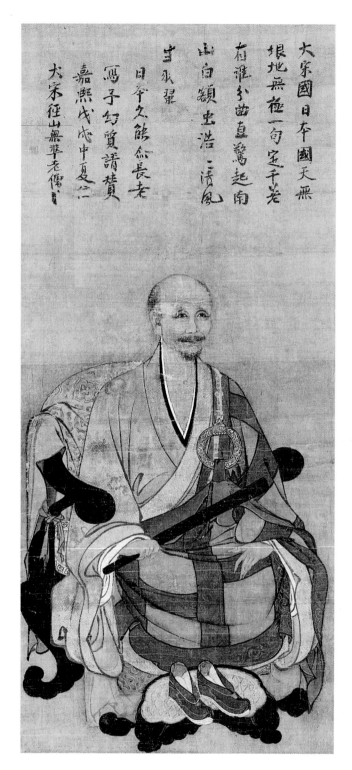

大宋國日本國天無
根地無極一旬定千㺩
雨淮分曲直鷲起南
山白額虫浩一清風
宇承㺩
日㐀久饒㝵長老
寫子幻質請贊
嘉熙戊戌中夏二
大宋徑山無準老僧䇿

7-44 Anon., *Portrait of the Chan Abbot Wuzhun*
Southern Song, dated 1238. Hanging scroll, ink and colors on silk; 48¾ ×
21⅞″ (123.8 × 55.2 cm). Tōfukuji, Kyoto

**7-45 Liang Kai (active early 13th century), *Sakyamuni Emerging from
the Mountains***
Southern Song, dated 1204. Hanging scroll, ink and colors on silk; 47 × 20″
(119 × 52 cm). Tokyo National Museum

in a suave, courtly style. Liang's 1204 painting of *Sakyamuni Emerging from the Mountains* (FIG. 7-45) is signed as a member of the imperial painting academy and uses an accomplished representational technique to render the wintry atmosphere, barren trees and cliffs, and wind-blown robe of Sakyamuni. The tone of the painting is uniformly bleak, however, and very far from the elegance of most contemporary court painting. This subject involves a period of ascetic privation the historical Buddha Sakyamuni spent in the mountains seeking enlightenment, before his announcement of the less strenuous Middle Way. Accounts of the episode are ambiguous about the spiritual success of this period of ascetic retreat, but Liang Kai depicts a disconsolate Sakyamuni, vulnerable to suffering from seasonal cold. This emphasis on the humanity of Sakyamuni is in keeping with the Chan understanding of him as an individual seeker of enlightenment, like any contemporary practitioner. He is certainly unidealized in Liang Kai's rendering, clearly Indian in his strong features, swarthy and hairy down to his feet, and withdrawn in his expression. This approach to representing the historical Buddha, direct and probably a bit shocking to contemporary viewers, is in keeping with Chan religious style, but the pictorial style is close to that of other late Song figure-in-landscape paintings from the environment of the court.

Another representative Chan subject by Liang Kai depicts the *Sixth Chan Patriarch Chopping Bamboo* (FIG. 7-46), presumably a reference to the biography of Huineng, who supposedly achieved enlightenment while gathering firewood. The crude features and ambiguous expression of the patriarch are consistent with Chan attitudes, finding the sacred in common things and activities, and asserting a paradoxical non-differentiation between the pre- and post-enlightenment view of the world. Blunt, energetic brush strokes for the figure's drapery and the dynamic sweep of the brush that renders an angled tree trunk reflect a taste for effects of spontaneity and rough simplicity in Chan circles, but in the hands of an accomplished academy-trained painter such as Liang Kai these were surely calculated devices.

7-46 Liang Kai (active early 13th century), *Sixth Chan Patriarch Chopping Bamboo*
Southern Song, 13th century. Hanging scroll, ink on paper; 28¾ × 12½″ (73 × 31.8 cm). Tokyo National Museum

7-47 Muqi (13th century), *Guanyin, Crane, and Mother Gibbon and Baby*
Southern Song, 13th century. Set of three hanging scrolls, ink and colors on silk; each approx. 5'7" × 38⅞" (1.74 m × 98.8 cm). Daitoku-ji, Kyoto

Chan significance could be manifested in a wide range of styles, from the formal and finished to the spontaneously abbreviated. More reliable guides to Chan content include subject matter, religious function, and a monastic context of production, but even these allow ambiguities of understanding. The Chan monk–painter Muqi, for example, active around Hangzhou in the mid-thirteenth century, painted many images of ostensibly secular subjects such as landscapes, fruit and flowers, and animals. Muqi's participation may have endowed such subjects with a

special Chan spirituality, but it seems equally plausible that the interaction of monk–painters with a broader cultural community stimulated the production of such works, and that they lacked specific religious significance. Meaning is always shaped by context and reception, however, and after-the-fact interpretations can be as historically important as original intentions. Muqi's famous triptych of *Guanyin, Crane, and Mother Gibbon and Baby* (FIG. 7-47) preserved at the Daitokuji Temple in Kyoto is a case in point. The central panel is the only explicitly religious subject, an

informal portrayal of the white-robed *bodhisattva* Guanyin in a rocky grotto that represents that being's abode of Mount Potalaka in the southern sea. The side panels—a crane in a misty bamboo grove and a mother gibbon with its offspring— may not have belonged with the Guanyin image originally but possibly were only arranged in this grouping after their removal to Japan. Nonetheless, the triptych is a historical fact of long duration, and our understanding of the crane and gibbon pictures is inevitably affected by their Buddhist context. The mother and baby gibbon picture in particular, which combines a maternal embrace evocative of human feeling with a blank, confronting stare of the mother gibbon that confounds any interpretation, in this context suggests the unsettling ambiguities of the Chan encounter.

8 OFFICIAL, PERSONAL, AND URBAN ARTS OF THE YUAN TO MIDDLE MING

THE CONQUEST OF CHINA by the Mongols, who first displaced the Jurchen regime of the North Chinese Jin dynasty in the period from 1215 to 1234 and completed their capture of the Southern Song territory in 1279, brought China into an international Mongol confederation. The Mongol regime in China, known dynastically as the Yuan, was the easternmost of four such empires that ruled most of the Asian land mass in the thirteenth and fourteenth centuries. As a group, these formed the largest land empire in the history of the world. They acheived their conquests with a ferocious, cavalry-based martial culture and military technology, developed in part from Chinese inventions, that included innovations in siege warfare and the use of cannon and firearms. They followed campaigns under Chinghis Khan (1167–1227) that had pushed well into eastern Europe before withdrawing. These allied regimes provided unusual opportunities for travel and trade across Asia, including missions from the Roman Pope in search of alliances against the Islamic occupiers of the Holy Lands, and merchant travelers such as the Venetian chronicler Marco Polo (1254–1324). Polo's accounts of Chinese cities include elements of fable and exaggeration, but his sense of the superiority of Chinese over contemporary Italian cities in matters of hygiene, comfort, and public administration is clear. The collapse of the system of Mongol confederated regimes in the fifteenth century, with its infrastructure for long-distance trade and communication, including a mounted postal relay system, may have indirectly encouraged the great age of maritime exploration that followed, as sea routes were sought to replace the newly perilous overland trade connections. In China, the Mongol Yuan regime fell to the native Chinese Ming in 1368. The Ming eunuch admiral Zheng He led several expeditions to Malaysia, the Indian coast, and as far as the horn of eastern Africa in the period from 1405 to 1433, some decades before the Portuguese and Spanish sought routes to the East Indies. The Chinese maritime explorations ended as a result of domestic military and political pressures, in keeping with a general policy of economic self-sufficiency, leaving the great age of mercantile exploration to the Europeans.

Combining the Yuan and early to middle Ming periods—the years from 1279 to about 1550—in this chapter emphasizes broad economic and social processes over the importance of restoration of native Chinese rule under the Ming and the political unity of the Ming dynasty. The linking features of this period include a slowdown in urbanization and commerce in comparison to the Song. This was in part due to the depopulation and displacement that accompanied the Mongol conquest and decades of disorder at the end of the Yuan period, but it was also a result of deliberate policy. The Mongol regime was more interested in exploiting the wealth of Chinese cities for taxation than in nurturing the commercial

system, and even the opportunities for international trade opened by the pan-Asian Mongol regimes resulted only in extractions from China and an impoverishment of Chinese wealth. The first Ming emperor, himself of peasant background, established enduring policies that favored farming over merchant activity. While the early Ming saw a brief flowering of international maritime exploration and trade, the Yuan and Ming regimes withdrew from the maritime expansionism of the Song in favor of a much more limited coastal routes of grain tax shipments. This contraction was due in part to continuing internal challenges and also to problems with coastal naval piracy. Agricultural sectors flourished in the early Ming, with large-scale reforestation and land reclamation projects put in place. Ideals of rural retreat and the land-holding gentleman, which were so strongly a part of Yuan and Ming painting as themes and models for painters' lives, thus had some basis in larger political and economic trends. A revival of commerce and the renewed growth of urban centers emerged gradually in the early sixteenth century. Another factor at work in the Yuan through middle Ming period was a growth of absolutist tendencies of rule and centralization of authority at court. The relaxation of that centralized authority in the mid-sixteenth century was both a marker of a changed political reality and a spur to an economic and cultural dynamism that shaped a new era, despite the continuation of Ming rule for nearly another century.

Distinctions between official and personal spheres of art are thus related to larger political and social trends, where the very concentration of power in the court sphere may have stimulated a reactive strengthening of personalized artistic approaches. The official sphere included art and architecture produced at the imperial court or made by and for officials for political purposes, along with regional projects such as temple building patronized by court-affiliated sponsors such as emperors, officials, and eunuchs. The personal sphere of art and life-styles was centered on those who were withdrawn from official life either because of loyalist (i.e. anti-Mongol) sentiments, discrimination, lack of success in the official examination or recruitment process, or retirement.

The spaces of personal arts included gardens, studios, and mountain retreats and circulated variously around themes of hermitic withdrawal, social gathering, and travel. Distinctions between official and personal spheres overlap with ideas of the public and private, or with work and leisure spaces. Although the audience for official art was mainly the imperial establishment rather than the populace at large, it did have a public dimension, as it spread to regional shrines and temples and drew stylistically on traditions of mural painting and monumental architecture and sculpture that over time had become broadly known and accessible. The artistic products of the personal sphere were concerned with relatively private life, but almost always with a social or group connection. Though often conveying an aura of escapism or of leisure, cultural work was accomplished there, in constructing a space of shared group values of the educated elite, outside of official life. The educated elite formed the class from which high officials were drawn, of course, but during periods such as the Yuan, when native Chinese were discriminated against for office holding, they could comprise an interest group marked by resentment or by sentiments of loyalty to the fallen Song dynastic regime. During the native Ming dynasty, members of the elite who were retired, withdrawn, or at leisure from office used the realm of art and architecture to mark a personal space of cultural performance.

A broad contrast between official art and personal leisure arts appears in a comparison between the imperial ceremonial complexes of Beijing and the garden spaces of Suzhou. The region of Beijing had already been one of five capital cities of the Qidan Liao dynasty. It continued as the primary capital of the Jurchen Jin regime and became for the first time the capital of all of China when it was established as Dadu, the capital of the Mongol Yuan dynasty (see "The Establishment of the Yuan Capital of Dadu at Beijing," page 281).

Little of the physical fabric of Yuan-dynasty Beijing survives, but the basic axial plan of the imperial city and its ritual satellites, along with a series of enclosing walls, was preserved in later rebuilding. Although most of the surviving buildings and walls of the imperial palace

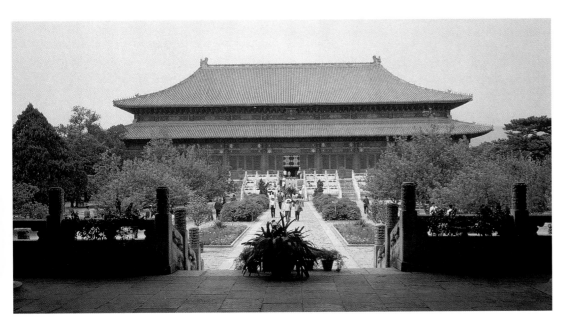

8-2 Sacrificial (Leng'en) Hall at the tomb of the Yongle emperor
Changping, Hebei. Ming, Yongle era (1403–24). 219 × 96′ (66.75 × 29.31 m)

in Beijing date from the eighteenth century, some mid-fifteenth-century (early Ming) buildings survive. These follow a bay system of facade organization around pillar divisions, with heavy, horizontally oriented hipped tile roofs and stone foundations and floors. The palace included domestic spaces and gardens in the rear, north compounds, but all were set within a system of axial and geometric walled enclosures. The main focus of the palace was on ceremonial official spaces and buildings uniformly facing south along the central axis, with raised terrace platforms serving to mark hierarchical relationships between ruler, officials, and subjects. One of the best preserved of the early Ming official-style buildings is the Sacrificial (Leng'en) Hall at the tomb of the Yongle emperor, part of the Ming imperial tomb complex at Changping (Hebei) in the Beijing region (FIG. 8-2). Built during the emperor's reign, between 1403 and 1424, it stands on a three-tiered marble

The Establishment of the Yuan Capital of Dadu at Beijing

The capital city, called Dadu, established by Khubilai Khan in 1267 on the site of modern Beijing, was to remain the capital of China until the end of the imperial era in the early twentieth century, except for a half-century period at the beginning of the Ming. Dadu replaced Shangdu, some 168 miles (270 km) north of Beijing, as the main administrative center for the Mongol regime; Shangdu (Coleridge's Xanadu) remained a summer capital and imperial hunting park.

Dadu occupied more or less the same site as earlier Liao and Jin capital cities, but it was newly built on Chinese principles under the supervision of Liu Bingzhong, a classically educated former Chan Buddhist monk. Liu was an important advisor to the early Mongol regime, advocating Chinese modes of policy and administration. Dadu was a triple-walled city of almost perfect geometric regularity, a feature which impressed Marco Polo. Within the outer walls, built first, the second walls enclosed the administrative buildings and a separately walled palace city. Unlike later Beijing, the palace complex occupied the southernmost portion of the capital, but its south-facing position on the central axis of the city was fully in accord with classical Chinese capital planning principles. The city was subdivided by major north–south and east–west avenues and a network of subsidiary streets into about fifty wards. The only major departure from this regular plan involved the artificial Taiye Pond and the Wanshou Shan island within it, both to the west of the main palace city, that were left over from the Jin capital and assured the palace's water supply as well as serving as a place of recreation. Overall, the city plan and architecture of Dadu played an important symbolic role in legitimating Mongol rule over China.

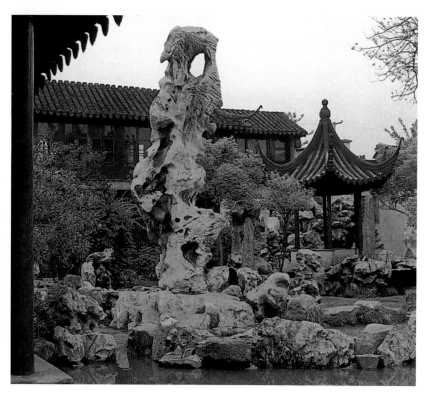

8-3 Liu Garden Pond and Rockery

Suzhou, Jiangsu. Ming, Jiajing era (1522–66) and after

Urban and suburban gardens of scholars, officials, and merchants served variously as sites of retreat, cultural performance, and for displays of wealth. Although individually famous gardens were often remodeled by successive owners, elements of pavilions for viewing, ponds, ornamental framing windows, and rocky grottos or sculpturally eroded monumental limestones from Lake Tai were long-term features of garden aesthetics.

terrace like those of the ceremonial buildings of the imperial palace complex. Massive in scale, the building is almost 220 feet (67 m) in width and some 98 feet (30 m) deep, divided into nine bays on the facade, with a wide-spreading, double-tiered roof covered in imperial yellow tile. The emphasis on the central axis and on regularity of design is characteristic of the official style and of the imperial city as a whole.

The city of Suzhou in the southeast emerged as an important commercial site in the Yuan–Ming period, in part because of its location at the meeting of the Grand Canal and the Yangzi River. It was an important internal shipping point for grain sent north from the rice-growing regions of the southeast and for other goods such as textiles and handicrafts, for which it became an important production center. Suzhou was thus tied to Beijing and the rest of China by economic and transportation networks. Culturally and symbolically, it became in the Yuan–Ming period a complement to the stern life of the official northern capital, a region of pleasure, leisure, and a desirable retirement spot for officials. Suzhou's gardens were the primary marker of this culture, and the city acquired a reputation as a garden and tourist center that persists to this day.

Garden taste was not stable and seems to have shifted from an early Ming ideal of the productive self-sufficiency of a country estate to a characteristic later Ming extravagance and artifice in urban gardens. Surviving garden complexes that originated in the Yuan or Ming periods have been much modified over time and embody the tastes of later periods, while still including many of the elements seen in early Ming representations. Most extant gardens are in urban settings, walled off from the busy street life outside, and cultivate a contrasting atmosphere of isolation and refinement. In practice, gardens were often well-populated family or social enclosures. They were sites of considerable investment of wealth and craft, where good taste, if not outright luxury, was on display and where the natural and the artificial were intermingled in very calculated ways. The Liu Garden Pond and Rockery (FIG. 8-3) is part of a generously scaled Suzhou complex, originally built as a private garden in the first half of the sixteenth century. While the garden is no more accurately preserved than most, the basic elements of pavilions, walkways, groves, rock arrangements, and water are comparable to features documented in fifteenth-century paintings of Suzhou gardens (see FIG. 8-6 below). The metamorphic garden rock known as the Crown Cloud Peak is the centerpiece of the garden, set in a pool and surrounded by verandas, outdoor pavilions, and windowed halls that make it the focus of multiple views. Such rocks were often individually famous and could be among the most stable design elements of old gardens. The rock combines the action of water on limestone from nearby Lake Tai with a mason's construction and composition, embodying a taste for artificially achieved effects of naturalness. Monumental single rock compositions, or more extensive rocky mountain compositions or labyrinths, were a popular mode of sculptural expression in this period, and more innovative than most figural sculpture of the time. A late Ming writer discusses artificial mountains in terms of standards of taste, aesthetic effects, and practical considerations:

[For] a skillful maker [of artificial mountains]…
the natural (*zi ran*) is not lost in the midst of human

8-4 Shang Xi (active c. second quarter of 15th century), *Guan Yu Captures the General Pang De*
Ming, c. 1430–41. Hanging scroll, ink and colors on silk; 6'5" x 7'7" (2 x 2.37 m). The Palace Museum, Beijing

craft (*ren gong*), and a marginal piece of land preserves the flavor of the wilderness. Eschew a fractured fussiness, which is distasteful. Eschew a formal order, which approaches vulgarity. Do not have an excess that strives after splendor. Do not have too much cleverness, which buries the real. Thus people will wander among them for a whole year without wearying. As for obtaining these things, in general rocks are easy to get, water is harder to get, and large and ancient trees are even harder to get.

(Excerpt is from *Wu za zu* (Five Collected Offerings) by Xie Zhaozhe (1567–1624), cited in Clunas, *Fruitful Sites*, p. 74)

Rockeries can evoke the transcendent realms of grotto worlds or, as here, suggestions of bodily forms, muscular protrusions, and hollow orifices, along with a dynamic of transformation. Elsewhere the combination of halls, outdoor kiosks, ponds, walkways, and verandas offers multiple perspectives and the effect of a varied

and irregular world unto itself, very different from the axiality and hierarchy of official ceremonial compounds. However much values of naturalness and even rusticity might be evoked, such gardens are full of artifice, skill, and subtlety,

8-5 Att. to Xie Huan (active 1426–52), *Literary Gathering in the Apricot Garden*
Ming, 1437. Detail of handscroll, ink and colors on silk; 14½" x 7'8" (36.6 cm x 2.4 m). The Metropolitan Museum of Art, New York

**8-6 Du Qiong
(1397–1474),
*Befriending the Pines***
Ming. Handscroll, ink and
colors on paper; 11½ ×
36⅜" (29.1 × 92.3 cm). The
Palace Museum, Beijing

in which the intricate geometry of window lattices alone is worth a separate treatise. Gardens were also historically dynamic sites, subject to changes in ownership, taste, and even their basic personal orientation. By the late Ming period, one famously opulent Suzhou garden was subject to public commercial exploitation:

> Xu Shaopu's… family dwelling was in a garden within the Feng Gate, and reached one to two hundred *mu* [15 to 30 acres] of rare rocks and sinuous ponds, splendid halls and high towers, all extremely majestic and grand. In springtime the visitors were like ants, and the gardeners admitted them for coins. Many of his neighbors set up wine shops to serve the visitors. A few of those who entered the garden did not behave themselves, but picked the flowers and shouted; they were all prosecuted, and for this reason people did not care to enter lightly.
>
> (Excerpt from *Shi yuan bu ke ji*
> (A Record of Avoiding Guests in the Apt
> Garden), Lu Shusheng (1509–1606),
> cited in Clunas, *Fruitful Sites*, p. 96)

Since gardens passed through many owners' hands over time, with ongoing modifications in scope, design, planting, and architecture, it is difficult to identify characteristic features of Yuan–Ming gardens from their current forms. Paintings and literary descriptions can help us to reconstruct their appearance, but these often include embellishments and distortions aimed at conveying ideals of cultivation or rusticity. Still, paintings and surviving garden sites can

convey something of the tastes and values of Yuan and Ming garden culture. A handscroll called *Befriending the Pines* (FIG. 8-6) depicting a fifteenth-century garden was painted by Du Qiong (1397–1474), an artist who was well-connected to the Suzhou cultural elite. Many such paintings were personalized by teacher–student or other social relationships between the artist and the owner of the garden, and by individual names given to features within the gardens. In this case the garden owner was the artist's brother-in-law, and the title of the scroll and name of the main pavilion were drawn from the self-chosen studio name of the owner. Studio names were one of several forms of alternative names chosen by the elite, including literary names, to claim or reflect some aspect of their character or interests, and they are often used in signing compositions or inscriptions on paintings. The handscroll painting offers an overview of a rail-fenced garden compound and a further mat-fenced cottage enclosure within, reminding us that gardens were personal property, reflecting pride of ownership and often considerable wealth in real estate, plantings, and other embellishments. The purpose of the painting and of the garden it represents was to function in social networks and occasions. Here, the host and a guest sit in conversation within the main building, while other guests stroll the paths of the grounds, where chess tables and refreshments await. In comparison to the official-style palace or ceremonial compounds, the garden is irregular in layout, with small-scale, relatively rustic buildings and elements that evoke naturalness. Stone tables

hold dwarf trees in trays and planters, and an eroded garden stone from nearby Lake Tai sits within groves of banana palms and bamboo. A further enclosure harbors a small waterfall, pond, and bridge, ringed by small hills and accessible through double doors set within an overhanging grotto. The rough textures and muted tones of the painting style, along with the seemingly natural surroundings, are calculated to convey values of simplicity and integrity.

At their most extreme, the contrasts between personal and official arts are readily apparent in every aspect of style, theme, and function. In comparison to *Befriending the Pines*, a contemporary work such as Shang Xi's court painting *Guan Yu Captures the General Pang De* (FIG. 8-4) seems almost to belong to an entirely different art form. Massive in size, executed in bright colors and with strong designs probably transmitted in pattern books or mural-painting sketches or stencils, Shang Xi's work is at the furthest remove from the personalized, understated brushwork of Du Qiong's handscroll. The public realm of heroic martial virtues embodied in dynamic, muscular figures seems likewise a world apart from the focus on rough-textured natural objects in the garden picture. To some extent, these distinctions parallel the stylistic differences between the Suzhou or Wu school of Du Qiong and the Zhe school of painters from the Zhejiang region such as Shang Xi. The Southern Song capital of Hangzhou was in Zhejiang, and many Zhe school artists of the Ming drew on Southern Song court painting devices, such as the dramatic graded ink washes, faceted cliffs, and dynamic tree shapes seen in Shang Xi's painting. More fundamentally important than the regional and stylistic distinctions, however, were functional contrasts between official and relatively public narrative art by court or professional painters and the more personal works by independent artists.

However, official and personal spheres of art were not always so dramatically separate, because they circulated around the values and tastes of the same groups of elite patrons and audiences, whether they were in or out of official roles. Moreover, communication and emulation of styles of living and art became increasingly a part of the cultural sphere, assisted by opportunities for interaction in the emerging urban centers of the middle Ming period. However much gardens, estates, and rustic retreats may have served as places (or images) of personal escape and cultivation, they were primarily sites of socially recognized values and as such were open to the aspirations of members of the official realm as well. Evidence for this is found in Du Qiong's handscroll (see FIG. 8-6), where the host is shown dressed in red official robes, and in a portrait handscroll of 1437 depicting three of the highest officials of the early Ming period participating in a scene entitled *Literary Gathering in the Apricot Garden* (FIG. 8-5). The officials and their guests (among whom the painter, a court artist named Xie Huan, is portrayed in one version of the scroll) are dressed formally, with the ministers wearing brocaded emblems and belts emblematic of rank on their colorful robes. The garden furnishings and plants are rendered in a richly detailed ornamental style that is also associated with the court. The officials are, however, engaged in cultivated activities such as viewing paintings and writing calligraphy within the leisure space of a garden, as if they had engaged the artist to certify their fitness to participate in the more personal side of elite culture.

ART AND OFFICIAL IDEOLOGY

The use of art for ideological purposes, to illustrate or propagate the values and interests of the dominant ruling group, was an important feature of court painting in the early Ming period. The political and ideological functions of art of the Yuan period are harder to trace, in part because the Mongol rulers were more sporadic patrons of art than either the preceding Song or following Ming courts. Mongol rule brought a disruption of Southern Song court traditions of artistic training and stylistic and thematic practice. Court-affiliated artists under the Yuan included such artisan craftsmen as sculptors and carvers, a small number of proper court painters who carried out official commissions, and educated Chinese officials who served as painting and calligraphy connoisseurs and advisors. Scholar–officials

8-7 Att. to Liu Guandao (active c. 1275–1300), *Khubilai Khan Hunting*
Yuan, 1280. Hanging scroll, ink and colors on silk; 6′ x 41″ (1.82 m x 104 cm). National Palace Museum, Taipei

Tibetan–Nepalese style had a lasting impact on Buddhist art production. In some ways, this was an artistic counterpart of the Mongol political and cultural policy of promotion of the Mongols and their non-Chinese allies and discrimination against ethnic Chinese, especially those from the south. Another, symbolic venue for promoting Mongol interests and values appears in paintings of horses. The prominence of mounted cavalry warfare and equestrian skills of the hunt in Mongol culture may account for the importance of horse imagery in Yuan-period painting. A scroll attributed to the court painter Liu Guandao portraying the first Yuan emperor, Khubilai Khan, hunting (FIG. 8-7) is a straightforward representation of those interests. It serves in part as an imperial portrait, with the emperor, accompanied by the empress Chabi, as a central, supervisory figure of more active hunters. His attendants and guards are arranged in circles around the imperial couple, in an echo of Mongol cavalry formations, and have a distinctly exotic, multicultural flavor, with dark-skinned figures and coarse features prominent. All are arrayed on the kind of featureless plane that was a conventional landscape setting for the northern frontiers.

Horses were also a traditional symbol of government officials, by analogy with the loyal and hardworking inhabitants of the imperial stables. Skill in judging horseflesh was indirectly equated with wise selection of competent officials. A depiction of handsome steeds could convey a message of wise administration, and other, more specifically political messages were possible. Ren Renfa's *Lean and Fat Horses* (FIG. 8-8) carries an inscription that makes an explicit comparison between the fates of horses and officials. The sleek and prosperous steed (or official) under imperial favor is set against the rickety nag who exhausts himself in unrecognized and under-rewarded service. In the hands of loyalist artists—those whose allegiances remained with the fallen Song regime—the starving horse could be still further extended into an anti-Mongol symbol of the plight of the disenfranchised Chinese scholar.

The Ming dynasty reinstituted a more regular system of court-appointed artists and a

who painted primarily in non-official contexts will be discussed in a later section.

The promotion of Mongol tastes and values in art could be accomplished by importation, as when the Nepalese sculptor Anige (see FIG. 8-12 below) was brought to court, where the

large-scale obligation of service by artisans and craftsmen to the court. Furniture such as the large, carved red-lacquer table (FIG. 8-9) produced by the Peach Orchard manufactory at the Xuande-period imperial court manifests the lavishness of Ming crafts. Deeply and intricately carved dragons, phoenixes, and plants testify to the patient skill of the imperial lacquer craftsmen. Artists were given official appointments to specific palaces or to the Embroidered Uniform Guard (which also served as a kind of secret service), with rank and salary included in the bureaucratic scale, but without the literary educational program that had characterized the late Northern Song painting academies. The ideological and political purposes

of court painting appeared in works of straight-forward symbolism and narrative content. Liu Jun's *First Song Emperor Visiting his Prime Minister in Winter Snow* (FIG. 8-10) offers a historical model of the ruler so intent on obtaining the best advice that he disregarded status and protocol, as well as personal comfort, to consult with the minister at his snowbound home. This kind of large, anecdotal, and vividly descriptive painting comes very close to the Western category of history painting. It is of a size probably meant for display in a palace, government bureau, or official's residence, where it could have served either as a model for emulation or as praise of the accomplishments of minister or ruler. The choice of a

8-8 Ren Renfa (1255–1328), *Lean and Fat Horses*
Yuan. Handscroll, ink and colors on silk; 11⅜ × 56⅝" (28.8 × 143 cm). The Palace Museum, Beijing

8-9 Table
Ming, Xuande era (1426–35). Carved red lacquer, height 29½" (79.2 cm). Victoria and Albert Museum, London

8-10 Liu Jun (active c. 1475–c. 1505). *First Song Emperor Visiting his Prime Minister in Winter Snow*
Ming. Hanging scroll, ink and colors on silk; 56 × 29½″ (143.2 × 75.1 cm).
The Palace Museum, Beijing

historical episode in the Song is typical of Ming court art, which emulated Song styles and sought a symbolic legitimation through claimed affinities with the previous native dynasty. The painting has a certain theatrical quality, with ample figures disposed in a spatially legible architectural stage. The grooms left shivering in the wintry cold while the emperor and his minister converse earnestly inside are there for a certain reality effect—ordinary folk who confirm the rigors of the season.

Liu Jun's painting of the emperor's visitation is structurally quite similar to images of hermits and retirees who held themselves aloof from ambition to official service, which were common, politically charged images in the early Ming. Many of these are large-scale paintings by artists of high reputation, probably intended for the offices or residences of officials. The rustic subjects embodied a kind of paradoxical personnel policy, in which one's fitness for high office was best demonstrated by a reclusive disdain of bureaucratic ambition. That this could be a calculated strategy to invite attention from those in power had been recognized as early as the Han dynasty, and certainly by the Ming these had become highly conventional images of virtue.

We should be cautious in accepting any work of art as a direct transcription of lived reality, since elements of convention and idealization are important in almost every genre. Portraits of contemporary persons certainly accommodate documentary content better than imagined scenes from history and literature, however, and a work such as Xie Huan's *Literary Gathering in the Apricot Garden* (see FIG. 8-5 above) no doubt offers a useful image of how prominent Ming officials lived. The painting emphasizes the ample and somewhat self-satisfied dignity of powerful men, shown not as active administrators but as men of refinement and taste. The activities shown of appreciating paintings, bronzes, and other collected antiques in part represent an idealization of officials as men of culture, but this almost certainly illustrates the actualities of wealth and power that allowed such men to accumulate expensive art collections.

Another strongly promoted aspect of official ideology had to do with ideals of loyalty and martial valor. The early and middle Ming were

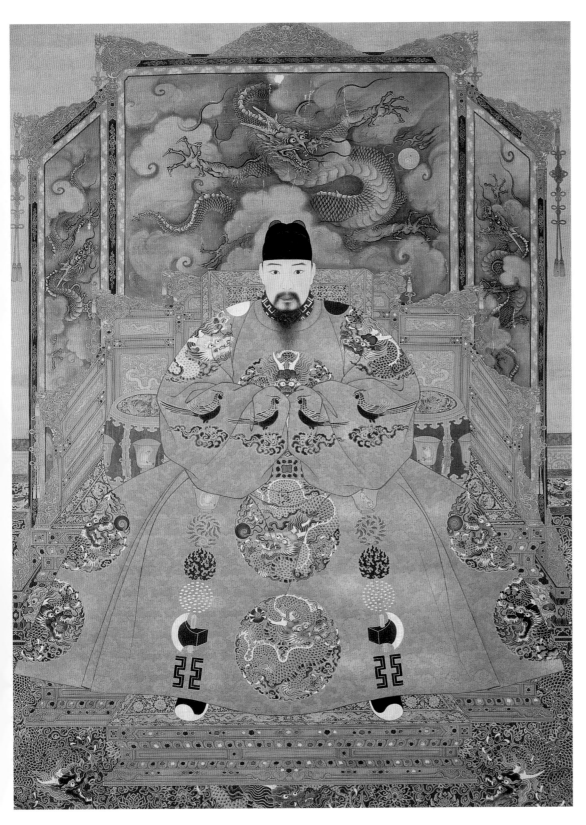

8-11 Anon., *Portrait of the Ming Hongzhi Emperor*
Ming, 15th century. Hanging scroll, ink and colors on silk; 6´8″ × 60¾″ (2.08 m × 154 cm). National Palace Museum, Taipei

Portraits of emperors could be objects of ceremonial veneration and served very different functions than informal portraits of artists and scholars. This frontal, hieratic image encases the emperor's person with the paired, embroidered symbols of imperial rank on his robe and framing imperial dragons on the robe and screen. Imperial portraits nonetheless served to construct distinctive, recognizable identities.

periods of pressing military concerns, in which many of the emperors actively served as leaders of campaigns. The founder of the Ming had been a successful rebel general, emerging from a peasant background. His brother, later known by his reign name as the Yongle emperor, usurped the throne from his nephew, the designated heir, by leading a military rebellion, and another mid-fifteenth-century emperor was captured by the Mongols after leading an ill-advised punitive expedition. Paintings such as *Guan Yu Captures the General Pang De* by the court artist Shang Xi (see FIG. 8-4 above) should be understood in that context. It depicts a famous general of the Three Kingdoms period (220–265 CE), following the breakup of the Han dynasty, an era overshadowed by issues of regional rivalry, strategy, and conflicting loyalties. Guan Yu was renowned for his loyalty to the ruler Cao Cao of Wei and later became one of the fictional heroes in the novel, *Romance of the Three Kingdoms*, which popularized his exploits. A further level of cultural absorption involved Guan Yu's deification in later times as a popular god of war, with temples dedicated to his worship, and sculptural and popular print images as the focus of veneration. The career of Guan Yu is an interesting example of cultural transformation at work, where different aspects of Guan Yu appealed to audiences distinguished by class and social function. For a large elaborate court painting such as this, it should be primarily the historical Guan Yu who is invoked, as a model of valor and loyalty suitable for emulation by contemporary viewers. Because this is a visual image, however, it seems likely that the literary and cultic versions of Guan Yu had a part to play as well. There is something undeniably theatrical about the array of figures on a shallow stage, who strike poses of magnified muscularity and communicate with a heightened play of intense gazes. Some of the same qualities, including the bright colors and gilding, were to be found in altar sculptures in the Guan Yu temples. Whatever the mixture of sources and significance, this image belongs to a pictorial tradition of great narrative power and visual impact, found in religious mural and official history painting. The muscular nudity of the captured general is rarely seen, in part owing to a culturally conditioned sense of decorum. In this context of contrast with the brilliant armor of Guan Yu, the exposed body of the captive is a sign more of humiliation than of heroism.

Imperial portraits were another vehicle for asserting dynastic authority. They were not, however, public monuments. Part icon and part life-portrait, their very making constituted a link in a dynastic chain of rulership that conveyed power, however infrequently they might have been displayed. Imperial portraits in this period are always formal, with an emphasis on details of costume and throne. Most surviving examples from the Song and early Ming are also individuated in facial features, rendered with considerable attention to modeled tonalities and precise forms, and with the figures in a three-quarters presentation that emphasizes both volume and the possibility of action. A *Portrait of the Ming Hongzhi Emperor* (FIG. 8-11), who ruled at the end of the fifteenth century, inaugurates a trend toward static frontality in imperial portraiture that would persist as one mode of presentation until the end of the imperial era. Emblems of rank and authority, including imperial symbols placed symmetrically on the emperor's robe and the dragons on the backing screen, robe, and carpet, drown the figure in a hypnotic sea of pattern while also highlighting a new lavishness of imperial furnishing and display. The face of the emperor is a nearly masklike, flat cipher, as frontal as all the rest, and lacking much sense of presence or personality. This seems a fitting image of the absolutist tendencies of the Ming imperial system, where the emperor is almost swallowed up in the trappings of power, and which would lead late in the Ming to a kind of paralysis and emptiness at the imperial center.

OFFICIAL PATRONAGE OF RELIGIOUS ART AND ARCHITECTURE

The emperors and officials of the Yuan and early Ming periods were major sponsors of Buddhist and Daoist religious art projects, the surviving

fragments of which offer a glimpse of a tradition of free-standing (as opposed to excavated cave temples) monumental-scale architecture, mural painting, and sculpture in courtly styles that left even fewer traces from earlier times. This patronage arose from a blend of religious and political motives. The Mongol rulers of the Yuan practiced a mixture of shamanism and Tibetan-style Lamaist Buddhism and consulted Daoist advisors as well. Patronage of Tibetan Buddhism helped to forge an alliance with the strategically important border kingdom of Tibet. Tibetan spiritual leaders, or lamas, who were brought to Beijing endowed the Mongol regime with an aura of sanctity and served as hostages who ensured a peaceful border. The esoteric pantheon of Tibetan Tantric Buddhism also included fierce protective deities who were invoked to aid the survival of the Mongol dynasty. Even after the resumption of native Chinese rule under the Ming, esoteric Buddhism continued to be a significant factor, particularly in North China. Other kinds of religious patronage under the Ming from emperors and high officials, including powerful eunuchs, served to enhance the donors' reputation for sanctity and good works, cast an aura of spiritual protection over the regime, and projected the influence of the court out into the empire at large through the visual media of courtly forms and styles.

One striking remnant of Mongol patronage of Lamaist forms of Buddhism is the Tibetan-style White Stupa (FIG. 8-12) of the Miaoying Temple in Beijing. The temple was built in 1279, designed by the imported Nepalese architect, sculptor, and painter Anige, who had a profound effect in promulgating distinctly Tibetan–Nepalese styles at the capital, then called Dadu. The bulbous *stupa* and thirteen-ringed conical spire, rising to some 164 feet (50 m) high and stuccoed with white lime, was so different from the rectilinear articulated forms of traditional Chinese architecture as to serve as a continuing reminder of the multiculturalism of Mongol rule.

Part of the rich Buddhist pantheon and range of styles of the Mongol period is preserved in the marble relief sculptures of 1345 at the Juyong Gate, a free-standing ceremonial gateway

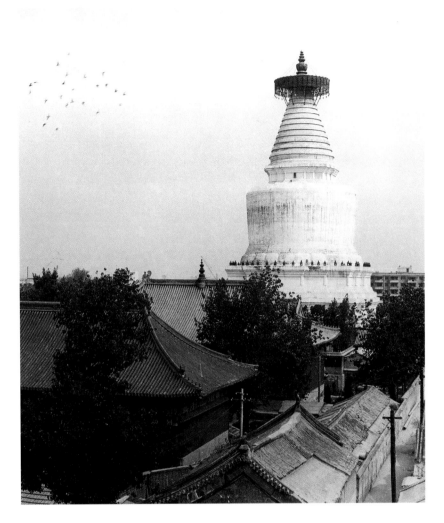

8-12 Anige, White Stupa
Miaoying Temple, Beijing.
Yuan, 1279. Height c. 164′
(50 m)

north of Beijing, where dynamic martial guardian kings stand symbolic watch over the boundary between China and the Inner Mongolian frontier. Designed by Tibetan lamas, the monument's decor includes cosmic diagrams, or *mandalas*, as well as seated Buddhas and was originally surmounted by three Buddhist memorial *stupas*. Equally important are the inscriptions translated into six languages that reflect the multicultural nature of the Yuan empire and claims for the Yuan emperors' special status as patrons of Buddhism and world rulers. The style of these relief carvings—ornate, muscular, and with an emphasis on breadth over depth—suggests a mixture of Chinese and Tibetan elements. Accompanied by armored attendants and trampling demons underfoot with characteristic ferocity, the Guardian King of the East, Dhrtarastra (FIG. 8-13) holds a Chinese lute, or *pipa*, in his hands instead of a weapon. The richly detailed and dynamic style is paralleled in some

8-13 Guardian King of the East, Dhrtarastra

Juyong Gateway, Changping Xian, Hebei. Yuan, 1345. White marble, height c. 9'2" (2.8 m)

The monumental stone relief sculptures at the Juyong Gateway north of Beijing include symbolic guardians of the empire at this important border point. The wide range of figural types suggests artistic influences from across Asia, and inscriptions in several languages reflect the culturally synthetic nature of the Mongol-dominated Yuan regime.

Buddhist handscroll paintings by the court artist Wang Zhenpeng (c. 1270s–after 1330). His image of the Buddha's aunt, Mahāprajāpatī, nursing the infant Buddha (FIG. 8-14) emerges from the same climate of lavish and courtly Buddhist iconography, but with the additional interest of a subject illustrating maternal affection and populated largely by female figures. One of the major art collectors and patrons of artists such as Wang Zhenpeng at the Mongol court was the Princess Sengge Ragi, who accumulated an important collection of famous early Chinese paintings and gathered Chinese literary men to inscribe them with their appreciations.

We find another great Chinese tradition of religious iconography in the monuments of religious Daoism, which had its own institutions—often called *guan*, lookout towers, or *gong*, palaces—and its own pantheon of nature deities and immortals to parallel, and rival, those of Buddhism. Religious Daoism, as distinguished from the broad tradition of philosophical Daoist writing and world view associated with the pre-imperial writers Laozi and Zhuangzi, emphasized a mixture of immortality cults, star worship, and other magico-divinatory practices. This form of Daoism had developed an artistic iconography as early

as the period of division after the Han, with sculptural icons very comparable to those of contemporary Buddhism, and in later times images of land and water deities, star gods, and processions of Daoist immortals appeared in mural and scroll paintings. An important surviving Daoist shrine site from the Yuan period is the Yongle Gong (Everlasting Happiness Palace) in the north-central province of Shanxi, one of the richest regions for both Buddhist and Daoist remains. The shrine was originally located at Yongji, the legendary home of the Daoist immortal Lu Dongbin, to whom one of the halls is dedicated. Dates for the Yuan-period buildings range from 1247 to 1294. The gates and main shrine buildings are lined up on a north–south axis like a palace compound. The main hall, Sanqing Hall (FIG. 8-15), dedicated to the Daoist deities known as the Three Pure Ones, comprises seven bays; it is some 92 feet (28 m) across, raised on a high base and with a ceremonial platform in front. A heavy hipped roof gives the building a monumental appearance, while five door bays with lattice windows admit light to make interior wall paintings visible. Two of the halls contain monumental wall paintings, with some figures nearly 10 feet (3 m) high,

8-14 Wang Zhenpeng (active c. 1280–1329). *Mahāprajāpatī Nursing the Infant Buddha*
Yuan. Handscroll, ink on silk; 12½" × 37⅛" (31.9 × 94.4 cm). Museum of Fine Arts, Boston

8-15 Sanqing Hall, Yongle Gong
Ruicheng, Shanxi. Yuan, 13th century. Width 91¾' (28 m)

This "Hall of the Three Purities," built in North China in the thirteenth century, is an early surviving example of Daoist religious architecture. Dynamic mural paintings of rulers of the Daoist pantheon surround the altar.

including vast hosts of heavenly spirits assembled like a court audience around the larger enthroned rulers of the Daoist pantheon. The mural paintings were done between 1325 and 1358 by groups of collaborating muralists. The main figure paintings, with broad outlines, three-dimensional bodies and bright decorative colors, suggest the spread to central China of a courtly, heroic figural style. Others of the wall paintings depict more popular members of the Daoist pantheon such as the Eight Immortals, who include Lu Dongbin and Li Tieguai, the latter shown in the form of a beggar whose body Li was forced to inhabit after his own was prematurely cremated while his soul was off wandering in a religious trance.

This more popular aspect of Daoist art appears also in the broodingly powerful paintings of the late Song–early Yuan painter Yan Hui. Yan's image of *Li Tieguai* watching his soul, in the form of a tiny homunculus figure, depart (FIG. 8-16) is literally one of a soul trapped in a prison of flesh, in which the very coarseness of the body and heavy, relentless gaze hypnotically evokes something beyond itself. Another facet of Daoist art appears in the work of the late Yuan landscape painter Fang Congyi, a self-professed Daoist

adherent who painted sacred mountain sites such as Mount Wuyi in southeastern Fujian. Commentators often speak, in ways that are too general to be very illuminating, of a Daoist spirit in

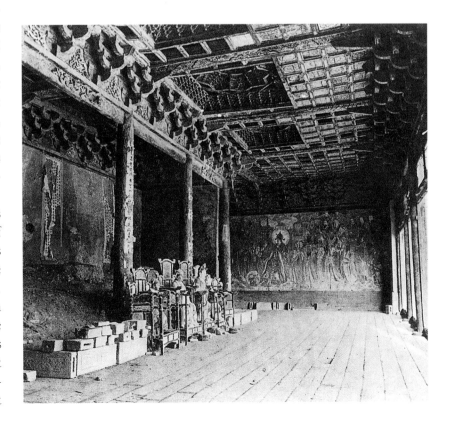

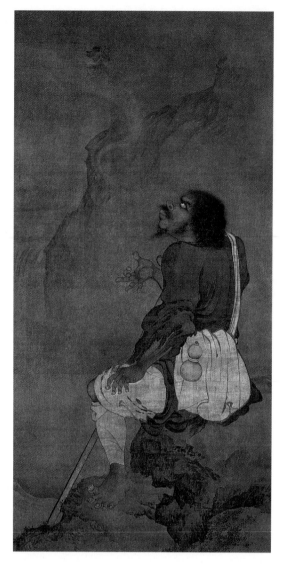

8-16 Yan Hui (active late 13th–early 14th century), *Li Tieguai*
Yuan. Hanging scroll, one of a pair, ink and colors on silk; 6′3″ × 31⅜″ (1.91 m × 79.6 cm). Chion-in, Kyoto

Chinese landscape painting at large, but without identifying any specific linkages to Daoist belief, practices, or iconography. For self-identified Daoist artists or images of particular sacred sites, however, we might legitimately point to an iconic Daoist mountainscape.

Shrines such as the Yongle Gong were not direct products of official patronage, but their architecture and wall paintings belong to a tradition derived from conservative court styles that the temples brought to more provincial regions, where they intermingled with popular elements. Popular subjects drawn from the theater or mythology were also widespread in the Yuan period, where they are sometimes found at religious sites or in the ritual context of tombs. Near the Yongle Gong in southern Shanxi is a mixed Buddhist–Daoist temple site called Guangsheng

Si (Extensive Triumph Monastery), rebuilt following an earthquake in the years from 1305 to 1324. The Daoist building at the site was dedicated to the Dragon King and used for ceremonies performed before large audiences on festival occasions. One of the murals there is an image of a theatrical troupe and musicians (FIG. 8-17), who stand on a stage decorated with painted banners on which a sword-wielding warrior confronts a dragon. The mural offers a glimpse of popular theatrical culture associated with a religious ceremonial site. Yuan-period dramas sometimes dealt with religious or supernatural themes, but temples and their stages were also centers of village or urban life and culture, and secular subjects were also performed there. The Yuan was a classic age for the development of early drama, taking its plots from stories of love, intrigue, and heroism. The banner at the top of the stage identifies the traveling troupe of Zhong Duxiu. The actors represent traditional roles marked by costumes and make-up, including false beards and masks, and include the young male lead role, the female lead, the clown, and the butt or comic villain. Ceramic sculptural figures of performers and musicians (FIG. 8-18) were also part of the furnishing of tombs of the Jin and Yuan periods. The earthenware figures, each a little over a foot (0.3 m) in height, inset in the walls of a square Yuan-period tomb chamber from north-central China, were chiseled from already-baked clay bricks. They include lively and expressive musicians and performers from the variety shows that developed into more formal dramas, such as the whistling clown or comic actor who holds a clapper in one hand and the dancing figure caught in mid-step, with his long coat swirling around his twisted legs, arms raised and lowered in a vigorous gesture. Other Jin and Yuan-period images drawn from fiction and drama are illustrated in paintings and ceramics.

Encounters between official and popular religious cultures usually took the form of efforts to suppress popular cults and replace them with state ceremonies, often Confucian in nature, that promoted ideals of loyalty and filiality. Popular religion was seen as competitive and potentially subversive if it became the focus of

local devotion. Nonetheless, elements of popular religion often became important art subjects (see FIGS. 8-4 and 8-16 above). *Erlangshen Exorcizing the Mountain Demons* (FIG. 8-19) is another case in point, a narrative handscroll subject whose central theme is the conquest of local spirits by a government official. The deity Erlangshen was originally a seventh-century human named Zhao Yu who served in the southwestern province of Sichuan. He killed a dragon that was causing floods in the region and subdued a bull with magical powers. The subject was illustrated in painting as early as the Song period, but the earliest extant version, probably Yuan or early Ming in date, is filled with the dynamic action and imaginative grotesqueries that seem to be hallmarks of popular religious subjects such as the kings of hell (see FIG. 7-14 above). This work displays powerfully outlined design and a choreographed flow of action from beginning to end. Erlangshen's celestial warriors are themselves portrayed as demonic figures, with wild orange hair and animalistic, fanged faces. They and their hound, eagle, and tiger minions harry the troublesome local creatures, which include serpents and monkey spirits in female human form. Some of the seemingly female victims of the arrows and claws are shown with monkey's paws as signs of their

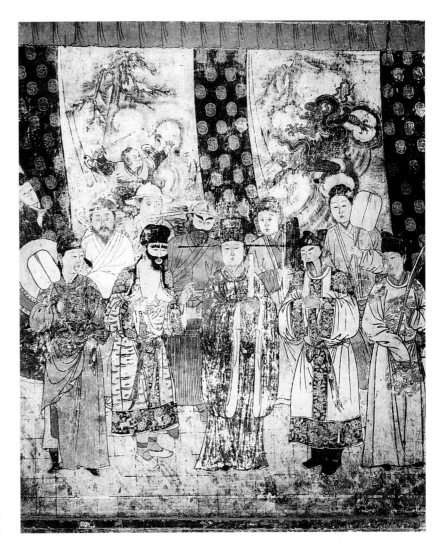

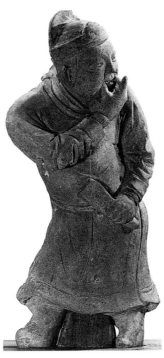

8-17 Theatrical Troupe and Musicians
Mural, Mingying Wang Hall, Shuishen shrine, Guangsheng Temple, Lower Monastery, Hongdong, Shanxi. Yuan, c. 1324. Pigments on clay, 12'7" × 10'2" (3.9 × 3.12 m)

The temple setting for this mural depiction of a theater troupe onstage suggests a close connection between popular religion and music-and-drama performances, which flourished in the Yuan period. Assembled before painted backdrops, the troupe includes musicians and actors costumed in conventional roles such as young male lead and comic villain.

8-18 Performers and Musicians
Yuan (1279–1368). Gray earthenware, height 14½" (c. 37 cm). Excavated from a tomb in the village of Xifengfeng, Jiaozuo, Henan. Henan Provincial Museum, Zhengzhou

8-19 Anon., *Erlangshen Exorcizing the Mountain Demons*

Yuan, 14th century. Detail of handscroll, ink and colors on silk; 21″ × 17′5″ (53.4 cm × 5.33 m). The Palace Museum, Beijing

This dynamic tableau of violence and transformation is one of many painted illustrations of the legend of a deified official who conquered local spirits. The victims of the celestial army of demonic warriors, hounds, and eagles are shown as half-simian, half-women, whose human guises afford no protection from the pitiless attack.

true nature, but the graphic images of violence directed at women are no less disturbing for that. Here as elsewhere, popular religious imagery seems to have been an outlet for themes of violence and sexuality otherwise suppressed by standards of elite decorum. The stylistic qualities of flatly staged, densely overlapped designs of strongly outlined figures in stylized tableaux seem to foreshadow qualities of the urban *ukiyo-e*, or "floating world," pictorial tradition in later Japan, which depicted similar themes from popular culture.

Official patronage of Buddhist institutions and art continued vigorously under the native Ming dynasty, often in the form of sponsorship by powerful and wealthy eunuchs. Eunuchs were castrated male attendants to the imperial household who traditionally served in the women's quarters of the palace. Abuses of their privileged access to the imperial family were particularly widespread in the Ming, in part because of a trend toward despotic concentration of power in the hands of the emperors and their confidants, as against the official bureaucratic class. Eunuchs were at any rate prominent in the official and cultural life of the Ming, including the admiral–explorer Zheng He. The sponsor of the Fa hai si (Sea of the Law Temple) built in the western suburbs of Beijing between 1439 and 1443 was another eunuch named Li Tong, who served in military expeditions under two emperors and was later appointed Director of Imperial Accouterments at the palace, in which capacity he would have employed artists and artisans. The

partially surviving mural painting cycles of the temple, originally accompanied by large wooden sculptures of Buddhas and *luohan*, were painted by fifteen painters supervised by the palace artists Wan Fuqing and Wang Shu—an example of the close ties between official and religious painting traditions.

The Sea of the Law Temple murals include images of Indian Hindu deities, and other early-fifteenth-century monuments also reveal international and exotic influences. The third Ming emperor, known by his reign title as Yongle (r. 1403–1424), maintained a particularly strong interest in Indian and Tibetan Buddhism, alongside his sponsorship of Admiral Zheng He's overseas maritime expeditions. He ordered the building of a temple in Beijing based directly on a model of the Bodhgaya Temple in India, site of the Buddha's first sermon. An embroidered silk *thangka*, or icon, centered on the bull-headed wrathful deity Yamantaka (FIG. 8-1) is also thought to be a product of the Yongle era, probably dedicated to a Tibetan lama who visited the emperor in China and whose portrait is included in another section of the embroidered icon. Yamantaka is a wrathful manifestation of the *bodhisattva* of wisdom, Manjusri, whose cult was already prominent at the Mongol court of the Yuan and was central to the Gelugs-pa order of Tibetan Buddhism. The ferocious deity, wreathed in serpents and garlands of skulls, tramples gods, humans, animals, and birds underfoot, triumphing over all existence. His multiple heads, legs, arms, and attributes are distinguished by color, shading, and textural effects achieved by varying

the direction, length, and technique of stitches to create a design as rich and intricate as any painting. The Sino-Tibetan style reflects the long-term importance of Tibetan Buddhist imagery and religious diplomacy in the Yuan–Ming period, which would reemerge under the Manchu rulers of the Qing (see FIGS. 9-36, 9-38, and 9-39 below).

Another large-scale project of official patronage of Buddhist art appears in the form of a cycle of scroll paintings commissioned to accompany the ecumenical Water and Land salvation ritual (FIG. 8-20) for the benefit of all beings in heaven and on earth. The scroll paintings produced to accompany the ritual performance comprise not only a full Ming religious pantheon but also a substantial social register, with representatives from most important social groups portrayed in affiliated arrangements, as if partaking in a religious procession. One partially

surviving set was commissioned by the imperial court in 1454; another, more complete set of scrolls preserved at the Baoning Temple in northwestern China was probably produced around the same time as an imperial gift to the temple. The latter set includes paintings with unusual scenes of violence, retribution, and childbirth. Part of the Buddhist world view of karmic effect, such scenes also offer an unusual glimpse of common lives and unedifying emotions.

THE PORCELAIN INDUSTRY AT JINGDEZHEN

Ceramic production continued to be a major craft industry in the Yuan and Ming periods, both for domestic consumption and for export. Regional kilns and ware types from the Song that continued production into the Yuan period included the northern Yaozhou (see FIG. 7-9 above) and southeastern Longquan celadon or green wares, along with the slip-painted and carved northern Cizhou wares (see FIG. 7-10 above) and splashed-glaze Jun types. The large scale of production even for export is indicated by the shipwrecked transport vessel bound for Japan that was found off the Korean coast in 1976, loaded with some seventeen thousand pieces of export wares (see "Ceramics from a Yuan-dynasty Shipwreck," page 298), including many Longquan celadons and white or bluish-white porcelains from Jingdezhen. In general, the Song kilns that continued production in the Yuan show a coarsening of shape and design, with many mold-produced patterns and less taut vessel shapes. Innovations included the use of contrasting colors in the Longquan

8-20 Anon., *Childbirth and Sunstroke, Water and Land Salvation Ritual Painting*
Ming, c. 1460. Hanging scroll, one of 139; ink, colors, and gold on silk; approx. 46½ × 24¼″ (118 × 61.5 cm). Baoning Temple, Shanxi

8-21 Large plate with dragon designs
Longquan ware. Yuan, 14th century. Stoneware with celadon green glaze and appliqué designs; diameter 17″ (43.1 cm). Percival David Foundation, London

Ceramics from a Yuan-dynasty Shipwreck

In 1976, fishermen working off the southwestern coast of Korea near Sinan recovered Chinese ceramic objects in their nets, leading to a full-scale salvage of the contents of a shipwrecked Chinese wooden vessel. Ultimately nearly seventeen thousand ceramic articles were recovered, along with some 18 tons of Chinese coins, and some metal and lacquer objects. Subsequent research indicated that the ship was bound for Japan and had sailed from the southeastern port city of Ningbo, an important center for production of Buddhist export art as well. Documentation found on the contents of the ship indicates a date of 1323 for the voyage.

More than half of the recovered ceramics were greenware celadons from the Longquan kiln complexes of southern Zhejiang Province, not far from the port of origin. The second largest group comprised porcelains from the Jingdezhen kilns in Jiangxi. Some of the ceramics were found packed in surviving wooden carriage boxes, ten or twenty to a box,

inscribed in ink with marks and numbers that identified their destinations and owners (FIG. 8-22). Along with individual Japanese surnames, some fifteen of the shipping tags carried the name of the Tōfuku-ji Zen (i.e. Chan) Buddhist temple in Kyoto as their destination. Zen temples used Chinese objects as part of an effort to base their monastic practices as closely as possible on Chinese models, including ceramics used as tea bowls by the monks or as quasi-ritual objects such as incense burners and flower vases.

Many of the Longquan celadons were Yuan-period versions of Southern Song forms, suggesting a continued marketability that encouraged a conservatism of production. Also included were more

8-22 Pinewood box loaded with ceramics
From the Yuan-period shipwreck at Sinan, off southwest Korea

up-to-date types, such as celadons with unglazed relief appliqués that created a brown against-green color effect (see FIG. 8-21).

green celadon types, achieved by the use of iron to form decorative brown spots or with relief appliqués of fired but unglazed clay, as in the rust brown rosettes and dragon patterns applied to a large plate with dragon designs (FIG. 8-21).

An important new direction was the development of the porcelain industry centered at the Jingdezhen kilns in northeastern Jiangxi. The Yuan period was pivotal in the history of porcelain for several reasons. There was a definitive concentration of production at the Jingdezhen kilns in the landlocked southeastern province of Jiangxi. This region was favored by abundant concentrations of the necessary special clays, as well as forests for wood to fire the kilns, and a relatively central location well connected for

water transport and distribution. The Yuan rulers established an official agency to supervise ceramic production at Jingdezhen in the thirteenth century, and it continued as the official governmental porcelain center under the succeeding Ming and Qing dynasties. In addition to official kilns that supplied wares for palace use and for diplomatic gifts or awards to officials, the Jingdezhen region had many private kilns that produced wares for broad domestic consumption and for export.

The concentration of resources, artisanal expertise, and imperial prestige at Jingdezhen led to the development of a virtual porcelain industry of national and international scale. Specialization of labor and rationalization of manufacture, in pursuit of efficiencies of mass production,

characterized procelain production like later industries (and some earlier Chinese precedents, such as lacquerware production in the Han period). By the mid-sixteenth century, ceramic production involved more than ten thousand craftsmen in the region, and a single piece might undergo seventy-two processes before completion. The result was a centralized craft industry of vast scale that supplied markets ranging from the imperial households to export markets in Southeast Asia and, eventually, Europe and America. Jingdezhen was a major factor in the Chinese and world economies for centuries and continues as a porcelain production center today.

In terms of technique and style, the Yuan period was important for the appearance of underglaze-painted decoration using copper red and, most famously, cobalt blue pigments for the lastingly popular blue-and-white types. Although Song taste had favored monochrome wares with pictorial designs limited to carved or molded patterns, earlier precedents existed for lively pictorial designs brushed on ceramics with inklike iron oxide or colored overglaze enamel pigments in the northern Chinese Cizhou types and the still earlier underglaze painted designs in the southern Changsha wares of the Tang period. These were less refined stonewares, fired at lower temperatures, however, and Yuan-period Jingdezhen saw the first large-scale combination of porcelain technique with underglaze painting, following some experimental developments of the Northern Song period. The taste for underglaze blue porcelains may have been both stimulated and enabled by the international connections of the Yuan regime. The best sources for the cobalt used for the blue ornamentation came from Western Asia and so were more easily supplied during the period of Mongol domination of Asia, with its open trade routes. Much early blue-and-white production seems also to have been aimed at export markets in the Middle and Near East and Southeast Asia. Some of the design of these wares may have aimed at replacing cruder painted Near Eastern wares with more durable and refined porcelains decorated in similar style, and much of the demand that stimulated production of blue-and-white wares may have originated from Arab clients in West Asia.

One of the great advantages of underglaze-painted decoration—besides its durability, since the painting was done on the fired porcelain body and then covered over with a transparent protective glaze—was its adaptability to a wide range of tastes and markets. Skilled painting specialists produced lively designs of decorative flowers and plants, dragons, ducks, fish, or figural scenes drawn from popular drama as the occasion demanded. Designs in Islamic script or incorporating Tibetan Buddhist motifs were produced in large numbers for those markets and recipients. In general, blue-and-white vessel shapes—mostly large jars, vases, bowls, and dishes—were less refined and crisp than those of Song monochrome wares because the shapes were less crucial to the main impact of the vessels, now conveyed primarily by the painted decor. As always, distinctions in taste, period, and audience had important effects, and some fifteenth-century Ming imperial porcelains included monochrome wares with very elegant shapes.

An early-fourteenth-century jar (FIG. 8-23) excavated at Baoding in the northern Chinese province of Hebei shows the early development of underglaze-painted decor in the Yuan period. The decor combines cobalt blue and copper red underglaze painting, with red used for the flower heads in an openwork panel attached to the main body in a semisculptural fashion, surrounded by a cusped, beaded frame. The busy, diverse painted designs, with cloud-collar shapes on the shoulders of the vessels, floral patterns, meander designs and others all competing for attention, are common in the Yuan period and contrast with the tendency of Song-period ceramics to offer unified designs in harmony with vessel shapes. Some Yuan blue-and-white wares exported to the Near East and preserved at the Topkapi Saray in Istanbul, Turkey, are still denser and busier in design and suggest the influence of Islamic taste and textiles. Later on, early-sixteenth-century blue-and-white wares with Arabic script designs were produced both for export and for the use of Islamic eunuchs at the Ming court. Underglaze blue painted ceramics also became a popular medium for fully pictorial designs throughout the Yuan and Ming periods. Cizhou ware iron-brown

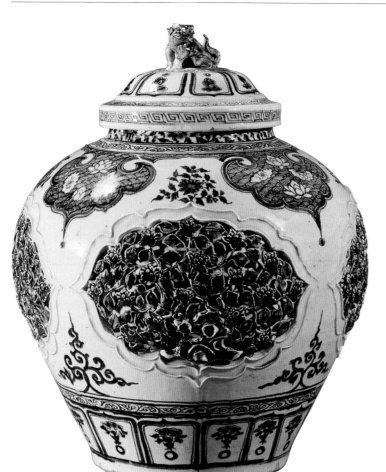

dimension of the Yongle emperor's interest in things Tibetan. An eighteenth-century Qing-dynasty court painting (see FIG. 9-1, upper right) depicts a red ewer of this type among the treasures of the palace collection arrayed on shelves. The refinement and simplicity of the shape and monochrome decor recall Song taste, but the successful firing of the exceedingly difficult-to-control copper red glazes was an achievement of the early-fifteenth-century Ming. Underglaze blue-and-white wares of the same period include dramatic dragon vases (FIG. 8-24), with incised dragon figures in reserve against a dynamic ground of blue waves. The five-clawed dragon symbol was reserved for imperial use, but those with three or four claws were common as well.

8-24 Dragon vase
Ming, Xuande era (1426–35). Porcelain with designs in underglaze blue, height 18″ (45.8 cm). The Palace Museum, Beijing

8-23 Jar
Yuan, 14th century. Porcelain with relief decoration and painting in underglaze blue and copper red. Excavated at Baoding, Hebei. Height 16⅝″ (42.3 cm). Hebei Provincial Museum, Baoding

Porcelains from the Jingdezhen kilns of Jiangxi decorated with underglaze cobalt blue (here combined with the less common copper red) pictorial designs became enormously popular in the Yuan period and for centuries thereafter. They were produced variously for the imperial court, for broad domestic consumption, and for export to the Near East and elsewhere.

painted pillows of the Song offer a precedent for such pictorial scenes. Blue-and-white jars illustrating scenes from Yuan plays are of interest for documenting the importance of the literary and performance genre of drama in the Yuan period and for the energy of their rendering.

Jingdezhen porcelains for the Ming imperial court in the early to mid-fifteenth century commanded the finest and most elaborate techniques and decor, with greater unity of design and shape than in the Yuan. The lustrous white and red porcelain "monk's cap" ewers of the Yongle period take their name from the profile of the lid and spout section, which resembles the caps worn by Tibetan Buddhist monks, and embody another

PERSONAL ARTS OF THE EDUCATED ELITE

We have already encountered the emergence in the eleventh century, that is, the Northern Song period, of a movement in painting, calligraphy, and art theory associated with scholar–officials. This movement defined a social group and a stance in culture and politics that was in some ways conservative in its awareness of past history and tradition, and often in its political attitudes. It also had a specific literary quality that had to do with the rendering of poetic devices of image and metaphor in painting. In terms of the overall history of Song art, this was a fairly minor movement, but important because of the cultural stature and literary activities of its adherents.

In the Yuan and early to middle Ming periods, a related mode of painting among the educated elite became relatively much more prominent and historically important. For convenience this can be called the art of the literati, or those with a classical literary education, although the term did not become standard until the later sixteenth century. Because social and cultural circumstances were changed by this time, however, we should clarify the distinctions from Song scholar–official art. Neither of the two main defining characteristics of Song scholar–official painting—the artist's status as a government official and the rendering of poetic effects in painting—was as important in the Yuan to middle Ming periods. Many of the Yuan–Ming literati artists held minor and brief official positions or none at all. This was in part due to historical circumstance. Educated southern Chinese were discriminated against in the competition for official appointment by the Mongol rulers of the Yuan. At the beginning of the Ming a large number of scholars who were suspected of seditious leanings were persecuted and the rise of eunuch power in a climate of generally increased governmental despotism made official careers relatively unattractive to many who could afford to ignore this traditional route to wealth and status. Furthermore, most

Multicolored wares reached a high degree of subtlety during the Chenghua era (1465–1487), when artists filled in underglaze blue outlines with overglaze enamel greens, yellows, purples, or reds in the technique known as *doucai* or "joined colors," often on small cups and jars, in part because of the expense of producing wares with such a complex technique. The Chenghua emperor's favorite consort, Wan Guifei, in another instance of the impact of elite women on art production, may have guided the taste for these delicate and luxurious objects. The large polychrome jars with carp and waterplants (FIG. 8-25), produced in the Jiajing era (1522–1566), offer a strong contrast in taste. These also make use of underglaze blue and overglaze enamel decoration, but with a much bolder palette of bright reds, blues, greens, yellows, and golds and without the delicacy of the "joined colors" blue-outline technique. The jars are also thickly potted, and the subject matter of carp or goldfish suggests a popular appeal, both in its reference to the hobby of ornamental fish breeding and in its symbolic import of wishes for an abundance of wealth.

8-25 Jar with cover, *wucai* (five-color) ware Ming, Jiajing era (1522–66). Porcelain with underglaze blue and overglaze enamel decorations, height 17¾" (44.3 cm). Asian Art Museum, San Francisco

Yuan–Ming literati painting was poetic in a more limited sense than in the Song. Most of the artists in this group were educated men of some literary attainment, in poetic or essayistic forms, which often found its way into the inscriptions on painting. There was, however, comparatively less concern in this period with finding pictorial counterparts for poetic devices of metaphor and imagery.

Because this type of personalized painting was so significant in the Yuan–Ming period, we should review some other characteristic features. Literati painters are often called amateurs, but this was true only in a limited sense. Amateurism can involve aspects of training and practice as well as compensation arrangements. Most literati artists of any period were not trained painting specialists, and they often had other ostensible "professions," even if only potential ones as examination candidates and officials. They often cultivated an air of amateurishness in technique, and most were in fact limited in comparison to the technical capabilities of highly trained professionals, but their own styles demanded special skills in the manipulation of brush and ink. They were not usually bound to institutional contexts such as court appointments or monastic affiliations. Many did, however, spend much of their time as artists, and they almost always were involved in some system of exchange of value for their art. This could take very indirect forms, such as introductions or access to men of status or power, or various kinds of barter arrangements, for such things as medical care, hospitality, banquets, gifts of food and wine, or presents of valuable art materials such as paper, silk, or ink. Direct cash payments were less often recorded but probably not uncommon. In any case, most paintings were done for some kind of social purpose and involved compensation, however indirect.

In more positive terms, we can say that literati art always had a strong component of social group identity. In the Yuan–Ming period we are considering, this group was primarily composed of educated gentlemen of some literary attainment. They might come from prominent families or the local land-holding gentry. Painting and calligraphy were social tokens in this milieu, exchanged to certify relationships or obligations,

and frequently involved with social occasions. Such paintings might commemorate actual gatherings or ceremonies of parting, or they might be circulated as talismans of a claimed social bond.

Literati painting is often said to be an art-historical art, but in the Yuan–early Ming period there was relatively little specific mention of ancient masters as models. Instead, there was a broad valorization of an "air of antiquity" in painting, a turning to the past as a source of value. The early Yuan painter Zhao Mengfu said:

> The spirit of antiquity is what is of value in painting. If there is no spirit of antiquity, then, though there may be skill, it is to no avail… My own paintings seem to be quite simply and carelessly done, but connoisseurs will realize that they are close to the past and thus may be considered superior. This is said for the cognoscenti, not for the ignorant.
> (Bush and Shih, *Early Chinese Texts on Painting*, p. 254)

Such statements first and foremost locate the standards for judging art with the artist and others of like taste and knowledge, in another act of shared group values. The widespread valorization of the past does mark an important cultural turning point, in which pursuit of innovative styles and representational techniques is counterbalanced by a nostalgia for the past and a strong awareness of its separateness from the present era.

Literati paintings are sometimes identified as self-expressive, or direct traces of the artist's feelings. This is often overstated, since many such paintings are thoroughly conventional works, deriving more from conditions of status, genre, and situation than direct self-expression. Some artist's statements, such as Ni Zan's comments on his bamboo painting, allude to self-expression and freedom from representational constraints:

> I do bamboo simply to express the untrammeled spirit in my breast. Then how can I judge whether it is like something or not; whether its leaves are luxuriant or sparse, its branches slanting or straight? Often when I have daubed and rubbed awhile, others seeing this take it to be hemp or

rushes. Since I cannot bring myself to argue that
it is truly bamboo, then what of the onlookers?
(Bush and Shih, *Early Chinese Texts on Painting*,
p. 280)

As with Zhao Mengfu's statement about the "air
of antiquity," the primary import has to do with
the artist's autonomy from any concerns other
than his own satisfaction, including even representational legibility. This is both a very
sophisticated withdrawal from representational
aims and standards in painting, and an extreme
claim of elite status. Literati paintings tended
to be more distinctively personalized than other
modes in terms of brush technique, style, and the
addition of prominent autograph texts and signatures that mark the painting unmistakably
as the work of a specific person. This was partly
because the value of such paintings and calligraphy could derive from the social position or
literary renown of the artist as much as from
the quality of the work. The paintings partook of
the value system of the autograph, trading on distinction in both its senses of being distinguishable
and being by distinguished persons.

Another characteristic of Yuan–Ming literati
painting is an interest in locality. Many such paintings are landscapes, and very often they are
representations of particular places that held
personal associations for the artist: rivers and mountain dwellings, retreats and studios, locally famous
scenic spots or historical sites. This is another way
in which such paintings could be personalized,
through linkage to the biography or situation of
the artist, recipient, or both.

When we combine the emphasis in Yuan–Ming
literati painting on personalization through style,
writing, and local association with claims of
aesthetic and critical autonomy, it seems clear that
this kind of painting was primarily about defining a sphere of cultural independence for the class
of educated but often disenfranchised or independent gentlemen. The valorization of the past
also suggests a conservative orientation among
those elite and often well-to-do land holders whose
aspirations to official status and power were threatened by Mongol discrimination or by the
inhospitable Ming political climate.

The Mind Landscape of Xie Yuyu (FIG. 8-26)
is a horizontal scroll painting by Zhao Mengfu
(1254–1322), a descendant of the Song imperial family who took a high official position under
the Mongol Yuan regime. The style and theme of
the painting embody several aspects of the values and interests outlined above. The fine-line
drawing of animated rock and tree forms is a
visual reference to an archaic style that was already
nearly a millennium in the past by Zhao's time
(see FIGS. 5-26, 5-28 above). The subject of the
painting refers to an anecdote about the fourth-
century painter Gu Kaizhi, who explained his
unusual portrait of the courtier Xie Yuyu amidst
mountains and valleys as an emblem of character, since Xie had himself claimed superiority
not in court protocol but in the temperament
of a high-minded recluse—an imaginary inhabitant, in other words, of mountains and valleys.
Zhao's rendering of the subject in turn identifies him as someone involved with an air of
antiquity and ambivalent about political service in his own time.

The archaic and decorative blue-and-green
style was one available mode of conveying literati
interests, but a much more typical manner in the
Yuan–Ming period was a monochromatic ink-on-
paper mode that left a legible record of its
production. This allowed the viewer to reexperience the making of the painting to a considerable
extent and personalized the painting both as
an individual product and as one which encouraged a bond between painting and viewer. Since
we have emphasized the importance of themes
of women's culture in Song-period art and some
related subjects in the Yuan–Ming period (see
FIGS. 7-34, 7-35, and 8-14 above), we should note
the appearance of a notable woman artist in
the early Yuan period, Guan Daosheng, Zhao
Mengfu's wife. She was a woman of education
and culture, a poet and painter whose surviving works are monochrome images of scholarly
themes such as bamboo and rocks. *Bamboo Groves
in Mist and Rain* (FIG. 8-27) is an evocative work
in this manner, with a certain delicacy of treatment of the slender, vibrant plants. The scroll
is also dedicated to a woman, evidence of another
mode of women's cultural participation.

8-26 Zhao Mengfu (1254–1322), *The Mind Landscape of Xie Yuyu* Yuan, c. 1287. Detail of handscroll, ink and colors on silk; 10¾ × 46″ (27.4 × 117 cm). Princeton University Art Museum

The most renowned single example of this mode of literati ink-painting is the *Dwelling in the Fuchun Mountains* handscroll inscribed by the artist Huang Gongwang in 1350, after some three years of working on it (FIG. 8-28). Its fame and influence is due in part to its later history of ownership by major Ming painters such as Shen Zhou and Dong Qichang (see FIGS. 8-34 and 9-6 below), among others, before it entered the imperial collection in the eighteenth century. It also embodies, to an unusual degree, qualities of personalization and painting-as-process that are central to the literati aesthetic. The Fuchun Mountains near Hangzhou were both a site of the artist's activity and associated with

a history of politically motivated reclusion. In his dedication to a friend, Huang records that he worked on the painting for some three years after first laying out the composition in a burst of inspiration. The painting is thus in some ways an autobiographical document, which displays the record of its making in the largely transparent overlays of ropy brush strokes and ink-wash accents. The interplay of complementary compositional and formal elements, such as close-up crowded passages with distant open sections, or dark ink passages over light drawing, is recommended in Huang Gongwang's brief treatise on "Secrets of Landscape Painting":

8-27 Guan Daosheng (1262–1319), *Bamboo Groves in Mist and Rain* Yuan, 1308. Handscroll, ink on paper; 9⅛ × 44⅞″ (23.1 × 113.7 cm). National Palace Museum, Taipei

Dense areas alternate with sparse areas, and one must achieve a balance… The method of painting rocks is to start with diluted ink, so that there can be changes and corrections, and gradually add richer ink over this… It is the use of ink that is hardest in painting. But one should simply first use diluted ink to build up [a painting] until it can be looked at; then use scorched, dry ink and heavy inks to distinguish the paths in fields or the near and the distant.

(Bush and Shih, *Early Chinese Texts on Painting*, pp. 262–65)

It was this combination of personalization—through the artist's inscription, the associations of the site, and the style—with a formal system of production that made the work so lastingly influential for later literati painters.

Strategies of personalization could turn paintings of landscapes or symbolic plants such as bamboo into self-representations of the artist, and it is in this sense that frequent contemporary

comments about seeing the man in his work are meaningful. More straightforward portrait representations include an anonymous *Portrait of Ni Zan* (FIG. 8-29), who was a notable poet and calligrapher as well as a landscape and bamboo painter. The young artist had himself portrayed as a man of means and culture, attended by servants and surrounded by part of his collection of antiquities, books, and paintings. A long laudatory inscription by an older friend praises Ni Zan (1306–1374) for his refinement and a fastidiousness that was manifested both in his legendary obsession with personal cleanliness (one of the servants is bringing water and towels for washing) and in the careful deliberation he brought to his painting. The spare river landscape on the screen behind Ni Zan is in his typical style and may be his own work, an emblem of his taste for minimal, subtly positioned scenery. The fine-line, fluent drawing of the figures, though not Ni Zan's own, is similarly evocative of a chaste, refined temperament. The portrait celebrates Ni Zan as an exceptional person, but his temperament is conveyed mostly by conventional symbols and elements. This was a continuing paradox of literati painting, which appears also in Ni Zan's late landscapes. Ni's river or lake scenes, with empty pavilions overlooking a stretch of water and low, distant hills, could serve as poignant evocations of displacement from his home estate under pressure from Yuan officials, when so identified by inscriptions. Later in his life, that symbolic formulation of locality and personal circumstance could be adapted to other social situations, as in his *Rongxi Studio* (FIG. 8-30) of 1372. This work

8-28 Huang Gongwang (1269–1354), *Dwelling in the Fuchun Mountains*
Yuan, c. 1348–50. Detail of handscroll, ink on paper; 12⅞″ × 20′9″ (33 cm × 6.36 m). National Palace Museum, Taipei

Autobiographical in its artist's inscription, subject, and form, this long handscroll depiction of Huang's home region displays traces of its three-year-long process of production in its layering of brushstrokes and of dry over dilute ink. Despite its restraint and personal reference, this became one of the single most influential paintings in Chinese history, owned and imitated by major artists and eventually entering the imperial collection.

was painted in advance of its later dedication to the physician owner of that studio, a purpose recorded in Ni Zan's precise, energetic calligraphic text at the top of the scroll. This type of landscape was thus by this time primarily a token of Ni Zan's identity, which could be exchanged for future favors from the physician recipient. None of this diminishes the subtlety of the work, which achieves a sense of volume and vibrant tension within the most economical use of pale ink and angled touches of the brush.

The achievement of literati painting in the Yuan lay in opening up an arena for personal performance, analogous to what had emerged earlier on in calligraphy and painting, but not fully realized in Song-period scholar–official painting. The work of Ni Zan's contemporary Wang Meng (c. 1309–1385) indicates the range of possibilities available through this conception of painting. His *Dwelling in Reclusion in the Qing Bian Mountains* of 1366 (FIG. 8-31) is nearly antithetical to Ni's style. It is densely textured, monumental, and dynamic, with a broad range of light and dark tonalities. The situation of the artist exemplifies the degree to which literati painting in this period was a matter of local social or familial networks. Wang Meng was the maternal grandson of Zhao Mengfu (see FIG. 8-26) and probably made the painting for a cousin to commemorate a family retreat threatened by the military disorders at the end of the Yuan period. The tall mountainscape combines references to a couple of tenth- or eleventh-century monumental landscape styles,

but in a manner which emphasizes the complexity and ambiguity appropriate to the contemporary situation of social dislocation and upheaval.

The widespread emphasis on locality in Yuan painting may in part have represented a response to foreign conquest, particularly among literati painters who came from relatively well-to-do landholding families. Another case involves the physician–painter Wang Lu, who devoted himself to the study of the western sacred mountain range known as Mount Hua. He traveled there and became steeped in the lore of the place, producing a large-scale album of forty leaves accompanied by extensive inscriptions in 1382. Wang Lu was an educated artist and writer who might be considered one of the literati, adding his representationally ambitious style to the range of what they produced. However, his "Essay on Painting Mount Hua" deliberately opposes the aims of contemporary educated artists and their emphasis on the expression of ideas over formlikeness. Most of all he defends representational accuracy and form-likeness as the paramount value in painting:

> Although painting is representational, the emphasis is on the expression of ideas [yi]. If the meaning is insufficient, one may say that a painting is not even representational. Nevertheless, ideas exist in visual forms; if one discards these forms, where can one find the ideas? Thus, one who realizes the actual forms has a painting in which the forms are filled with ideas. What kind of representation is

8-30 Ni Zan (1306–74), *Rongxi Studio*
Yuan–Ming, dated 1372. Hanging scroll, ink on paper; 29¾ × 14″ (74.7 × 35.5 cm). National Palace Museum, Taipei

8–31 Wang Meng (c. 1309–85), *Dwelling in Reclusion in the Qing Bian Mountains*
Yuan, 1366. Hanging scroll, ink on paper; 55½ × 16⅝″ (141 × 42.2 cm). Shanghai Museum

possible if one loses the forms of things? In painting it is desirable that the painted images resemble the actual things. How can one paint things without actually knowing them? After all, was the fame of the ancients achieved by groping in the dark? Many who devote themselves to copying paintings are content to know things through paintings and do not venture outside, so their own paintings become increasingly false and removed from reality. The loss of representational likeness is bad enough, but the loss of ideas is even worse. If I did not know the visual forms of Mt. Hua, how could I paint them?

(Liscomb, *Learning from Mt. Hua*, pp. 28–29)

Where literati painters were interested in particular places primarily for their personal associations, Wang Lu is interested in conveying the specific look and historical lore surrounding the many famous sites of Mount Hua. His album leaf depicting *The Top of Blue Dragon Ridge* (FIG. 8-32) is one of three devoted to a formation that is the subject of a long narrative account of his climb:

Looking at the topographical force of the mountains undulating into the clouds, I could not imagine how I had ever reached this place… In every direction there were low-lying ridges. I stole a glance and looked back over my shoulder down the side of the ridge; however, it was so deep I could not see the bottom! How, then, could I know its depth? Yet, I could watch the tops of the pines as they emerged and disappeared harmoniously in the azure mist. Innumerable peaks were arrayed in arching layers. The fronts and backs of the peaks with their high and low points, their slanting and upright positions, and their rising and falling movements were like a torrent of green waves competing to be first… I looked up from the lower part of the ridge to what would be called the summit. Nothing could surpass it in height. Reaching the upper extremity of the ridge, I saw the head of the peak stuck up into the clouds, and I still did not know how many miles to the top. From then on my muscles and bones felt weak and emaciated. I was panting so hard I could not say a word…

(Liscomb, *Learning from Mt. Hua*, pp. 61–62)

8-32 Wang Lu (c. 1332–c. 1391), *The Top of Blue Dragon Ridge*
Ming, 1383 or later. Album leaf, one of forty; ink and light colors on paper; 13⅝ × 19⅞" (34.7 × 50.6 cm). Shanghai Museum

The physician–painter Wang Lu's travel to and study of the sacred Mount Hua evolved into a painting theory advocating the primacy of accurate representation of visual forms, and many vivid essays and pictorial renderings of specific sites: "…Yet, I could watch the tops of the pines as they emerged and disappeared harmoniously in the azure mist. Innumerable peaks were arrayed in arching layers…"

Rather than using an entirely neutral approach for this purpose, Wang adopted a version of the Southern Song academic landscape style, with angular, precise texture strokes and tree contours, and attention to atmospheric effects of clouds and mist. Wang Lu's composition is much less formulaic than those of the Southern Song court painters, however, and adapts to the distinctive topography and formations of each of his notable sites. The three-tiered summit of Blue Dragon Ridge, shrouded in thick clouds, is centralized and looms over the diminutive climber. In the end, in a formulation that invites comparison with the words of the Northern Song landscapist Fan Kuan (see page 246 above), it was Mount Hua that was his teacher and model: "[When asked] 'Who is your master?' I replied, 'I take my heart-mind to be my teacher. It takes as its master my eyes, which in turn revere Mt. Hua as their teacher'."

The urban and suburban landscape of Suzhou and its environs, rather than remote sacred mountains, became the most important locality for educated painters of the early to middle Ming. Suzhou's commercial prosperity and emergence as a handicraft and textile production center, along with its emerging renown as a garden site, combined to form a congenial environment for art patronage and art production. Although Suzhou had an increasingly dynamic economic environment throughout this period, much literati art emphasized leisure culture, either as a reflection of the opportunities of prosperity or in a deliberate avoidance of the values of urban commerce.

Shen Zhou (1427–1509) was the very type of the educated Suzhou amateur artist, a role which he was free to cultivate because inherited wealth in land relieved him from the necessity of earning a living. He never undertook an official career, devoting himself instead to literary and artistic pursuits at his estate and in the society of the Suzhou region. His subjects were mostly familiar sites, famous nearby scenic and historical places, and social gathering spots, in contrast to the remote hermitages and unpopulated scenery of so much of Yuan literati painting. He often worked in the format of a multileaf album devoted to a single theme, an innovation of the late Yuan–early

8-33 Wen Zhengming (1470–1559), *Pine Trees and Waterfall* Ming, dated 1527–31. Hanging scroll, ink and colors on paper; 42½ × 14⅞" (108.1 × 37.8 cm). National Palace Museum, Taipei

白雲如帶東山腰石
磴龍空細路遙獨倚
枕藜舒眺望百鳴
澗落吹簫沈周
題

**8-34 Shen Zhou
(1427–1509), *Poet on a
Mountain Top***
From *Landscape Album: Five
Leaves by Shen Zhou, One
Leaf by Wen Zhengming.*
Ming. Album leaf, one of six,
ink on paper; 15¼ × 23¾"
(38.7 × 60.2 cm). The
Nelson-Atkins Museum of
Art, Kansas City

Ming period that allowed for development and variations of subjects. One such album is mostly devoted to themes of departure and return, reflecting the importance of travel, sociability, and long separations to elite lifestyles. It is instructive to compare Shen Zhou's leaf *Poet on a Mountain Top* (FIG. 8-34) with the Southern Song court painter Ma Yuan's *On a Mountain Path in Spring* (see FIG. 7-33, above) in terms of treatment of poetry/painting problems. Shen Zhou's painting is much more personalized in the sense that he illustrates his own poem, written in his own hand, full of evocations of missing a departed friend:

> White clouds like a belt, encircle the mountain's
> waist.
> A stone ledge flying into space and the far thin
> road.
> I lean alone on my bramble staff and gazing
> contented into space
> Wish the sounding torrent would answer to
> your flute...
> (Ho et al., eds., *Eight Dynasties of Chinese
> Painting*, p. 185)

Ma Yuan, by contrast, illustrates a court poem written in the hand of a member of the imperial family. On the other hand, Shen Zhou's figures are merely conventional types, incapable of conveying

emotion through posture and expression as Ma Yuan's figures do. Instead Shen Zhou's blunt brushwork and rhythmic, graphic patterns of ink must convey personal qualities of character and feeling. Shen Zhou's work was already widely forged in his own, admittedly very long, lifetime, an indication that even amateurism was acquiring a market value.

Shen's younger associate Wen Zhengming (1470–1559) became the leading figure of the Suzhou, or Wu, school as it was known, owing to the many relatives and followers who emulated his approach. Wen made a couple of brief and unsatisfactory forays into official life but like Shen Zhou spent most of his life as a participant in Suzhou society and artistic culture. His hanging scroll painting *Pine Trees and Waterfall* (FIG. 8-33) began in Beijing as a pictorial reminiscence of his Suzhou life. Though more distinctly set in the countryside than Shen's work, the painting offers a sociable setting for strollers in the form of a parklike grove of pine trees in the lower portion of the scroll. The upper half of the picture is given over to a solitary figure gazing at a waterfall, which is rendered strikingly against a field of smooth gray wash in contrast to the surrounding heavy textures of the boulder-strewn peaks. The landscape combines personal reminiscence and sociability, with points of refined clarity in the branches and waterfall that reflect the heightening effects of memory.

Wen Zhengming was also a superb calligrapher. His most powerful works are large-character emulations of the thick, stable compositions of Yan Zhenqing of the Tang, combined with a blunt power derived from Huang Tingjian of the Northern Song (see FIGS. 6-31, 7-16 above). More independent are the cursive-script performances of his Suzhou contemporary, the literary man Zhu Yunming (1461–1527). Zhu's writing, as in his wild cursive rendering of *Poems by Cao Zhi* (FIG. 8-35) from the year before his death, conveys speed and intensity above all, with curvilinear characters twisting and slashing in dynamic freedom.

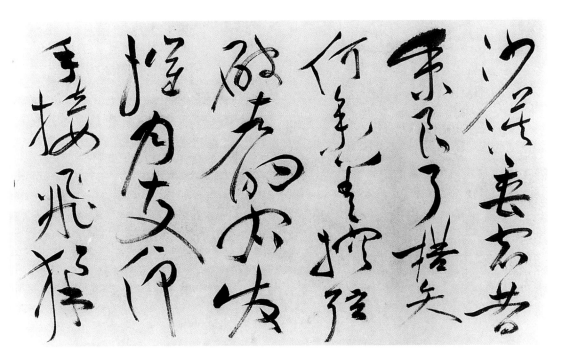

8-35 Zhu Yunming
(1461–1527), *Poems by
Cao Zhi*
Ming, c. 1526. Detail of
handscroll, ink on paper;
14¼" × 37'9⅝" (36.2 cm ×
11.54 m). National Palace
Museum, Taipei

8-36 Zhou Chen (c.
1450–after 1535),
*Beggars and Street
Characters*
Ming, 1516. Detail of
handscroll, ink and colors on
paper; 12½" × 8' (31.9 cm ×
2.44 m). The Cleveland
Museum of Art

Zhou Chen explained his own work as the impromptu picturing of images of street and market characters that crowded his mind but also as a "warning and admonition to the world." A half-century later, other writers saw in his work a critical commentary on the dire consequences of misrule.

URBAN ARTS

The official and personal spheres of art of the Yuan to middle Ming periods paid little explicit attention to the commercial culture of urban centers. Official art focused on historical, religious, or ideological themes, while personal art evoked suburban or rustic realms of leisure, self-cultivation, or escape. In the late fifteenth and early sixteenth centuries, however, professional painters whose practices and painting subjects acknowledged their urban environment emerged in cities such as Suzhou and Nanjing.

Zhou Chen (c. 1450–after 1535) was an urban professional painter in Suzhou whose specialty was polished figure-in-landscape compositions emulating the technically fluent styles of Ming court painters and their Southern Song academic models. Such paintings, which often showed a gentleman awaiting guests in his villa or studio, would have appealed to well-to-do customers on several levels. They evoked the life-styles of gentlemen of leisure and held the visual appeal and prestige of elegant academic styles. Zhou Chen's best known work, *Beggars and Street Characters* (FIG. 8-36), is anomalous both within his own career and for Chinese painting in general. The urban underclass was seldom represented, though a limited genre of depictions

of blind musicians and beggars existed from the Song period on. Zhou Chen presents a full spectrum of urban street denizens, from itinerant storyteller and monkey trainer entertainers, to marginal types such as brushwood gatherers and beggars and vagrants, the latter suffering from various extremes of hunger and disease. The most affecting among the more than two dozen figures are a blind mother, suffering from goiter and edema of the leg and holding a malnourished infant in her arms, and a nearly skeletal firewood gatherer with a ghostly stare betraying near starvation, who clutches a broken, and in any case empty, rice bowl. Zhou Chen's renderings are sketchy and direct, neither sentimentalized nor cruel, but all the more disturbing for their matter-of-fact documentation. His inscription, dated to 1516, states that these images of urban characters crowded into his consciousness in a moment of reverie, indicating a kind

一宿姻緣逆旅中　姻詞聊以

識泥鴻當時我作陶穀意

何必尊前面發紅　唐寅

8-37 Tang Yin (1470–1524), *Tao Gu Presents a Poem*
Ming, c. 1515. Hanging scroll, ink and color on silk; 5′5½″ × 40¼″ (1.68 m × 102 cm). National Palace Museum, Taipei

On the threshold of his triumph he became embroiled in a cheating scandal at the national examinations in Beijing and returned home to Suzhou, forced to live on his wits and his connections. He sold the products of his literary and artistic talents in the form of paintings, calligraphies, and literary compositions such as epitaphs and tributes. In turn, during later Ming times Tang Yin became a character in fiction (though presumably one based on his real-life activities and reputation), exemplifying the type of the romantic and somewhat dissolute urban artist, overindulging in the pleasures of wine and female entertainers.

Tao Gu Presents a Poem (FIG. 8-37) seems to embody references both to historical anecdote and to the contemporary circumstances of Tang Yin's life, in a mirroring of the way that Tang was turned into a fictional character. The story involves a confusion of identities, in which the tenth-century scholar–official Tao Gu mistook the courtesan Qin Luolan for the daughter of a local official while on a diplomatic mission to the Southern Tang state. After presenting her with a poem and spending the night with her, Tao Gu encountered her again in her true role as an official entertainer at a banquet given by the king, to his great embarrassment. The painting illustrates the evening tryst by candlelight, as Tao keeps time to the lute playing of his lover, in a garden lushly appointed with painted screen landscapes and sculpted garden rocks. Both the setting and the situation suggest contemporary Suzhou garden culture and Tang Yin's pleasure seeking as much as they do a historical setting. Tang Yin's poem at upper right makes the projected identification explicit:

> After his night in the traveler's lodge,
> He sent [to his lover] a short poem.
> If I had been the emissary Tao that day,
> I would not have blushed when again we met!
> (Translation from *Possessing the Past*, p. 383)

of vivid experience that could not be repressed. Later commentators on the work understood it as a political criticism of corrupt administrators in the region.

One of Zhou Chen's pupils in Suzhou was Tang Yin (1470–1524), whose life exemplifies the complexities of an urban career. Tang was a prodigy in scholarship and the arts, with seemingly effortless talents that promised a brilliant official career.

Tang Yin responded to the urban marketplace for art in several ways. Like his teacher Zhou Chen, he produced many large landscape and figure paintings in a fluent version of the Ming and

8-38 Att. to Du Jin (active c. 1465–c. 1509), *Enjoying Antiquities*

Ming. Hanging scroll, ink and colors on silk; 49⅝" × 6'1⅓" (126 cm × 1.87 m). National Palace Museum, Taipei

Southern Song academy styles. This output suggests that such paintings held broad appeal for their representational skill and graceful execution and that Tang's technical command gave him a competitive advantage in the marketplace. His reputation as a scholarly and literary talent and his personal relationships with members of the Suzhou elite such as Wen Zhengming also stood him in good stead. One of his major modes of production drew on both his skill and his connections. In collaboration with other writers, Tang painted many works of a type that have been called commemorative portraits. These are figures in studios or garden settings, engaged in the kinds of activities that constituted their social identities, or sometimes exemplifying their studio or literary names in a direct translation of name into image. The portrait figures themselves are mostly small and relatively unindividualized, because identity was constituted less by appearance than by cultural performance and social relationships. Instead, the identity of the subject was constructed

8-39 Qiu Ying (c. 1495–1552), *Spring Morning in the Han Palace*

Ming, c. 1540. Detail of handscroll, ink and colors on silk; 12" × 18'10⅜" (30.6 cm × 5.74 m). National Palace Museum, Taipei

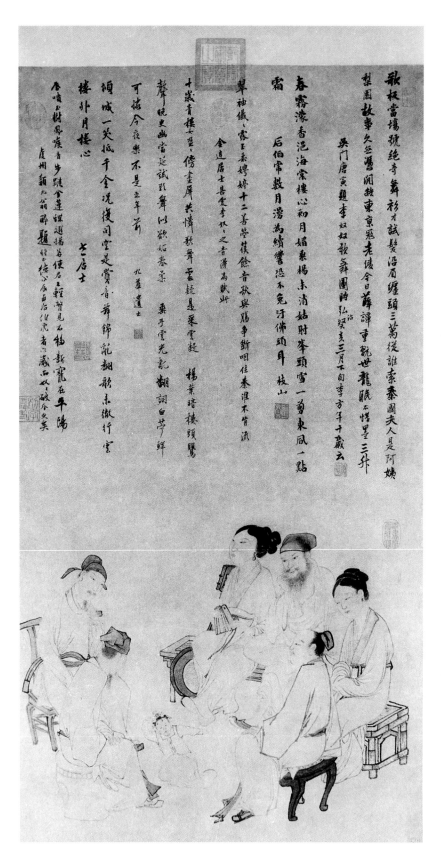

8-40 Wu Wei (1459–1508), *Little Slave Li*
Ming, 1503. Hanging scroll, ink on paper; 46⅞ × 25½″
(118.9 × 64.9 cm). The Palace Museum, Beijing

by textual prefaces and colophons for the painted scrolls, written by a recurring group of collaborators in what became a kind of cottage industry of commemoration. The subject of the scrolls need not have had a close relationship with Tang Yin or his collaborators, but in such cases the paintings allowed the recipient to claim connections with a prefabricated network of renowned and talented associates.

Culture and artistic talent were clearly commodities in this kind of urban environment, and some images make the commerce in culture a central concern. Du Jin (active c. 1465– c. 1509) was, like Tang Yin, an educated professional artist who failed his examinations for official position and thereafter had a professional career in Beijing, Nanjing, and Suzhou. His large painting on the theme of enjoying antiquities (FIG. 8-38) places collecting and perhaps even trade in antiques on prominent display. The host is a confident and somewhat aloof figure who offers his antiques for inspection to a guest, who examines them with a close attention that could belong as much to the customer as to the connoisseur. Ironically, some recent studies have suggested this painting is a close copy after an original now preserved only fragmentarily; if so, the painting exemplifies the ways that problems of authenticity and pressures of the market affected paintings as much as the antique objects on display. The garden setting suggests a sociable leisure, but the busy attentions of attractive female and male servants suggest another kind of lure for a potential customer. Du Jin's rendering is another kind of display and one might say an advertisement of his capabilities, offering a large-scale tableau, a decorative and vivid description of figures, furnishings, and art objects, and a veneer of elite culture, since the objects depicted also evoke the polite accomplishments of music and chess, in addition to the artist's calligraphy and painting.

Another work from this urban milieu offers the more direct pleasures of erotic entertainment for at least vicarious inspection. The hanging scroll of male patrons avidly enjoying the charms of a young girl dancer, known as *Little Slave Li* (FIG. 8-40), as part of a brothel entertainment, dispenses with the usual genteel fictions of presenting

contemporary women of pleasure as famous beauties from the past or as anonymous attendants. This is a historical figure, only nine years old at the time of the painting and depicted as a diminutive, doll-like waif, but already the object of wealthy admirers' attentions, according to the inscriptions. Although an extreme and somewhat grotesque case, this scene reflects the reality that many prostitutes were young adolescents whose prime careers might be over by the time they reached their early twenties. This side of male entertainment and pleasure seeking was as much a part of urban culture as literary gatherings and generated its own literature in the later Ming and Qing periods, but it was seldom documented as forthrightly as it is here. The artist, Wu Wei (1459–1508), was another educated professional like Tang Yin, and both Tang and the calligrapher Zhu Yunming were among those who inscribed the painting. Fond of drink and known for his disregard of decorum, Wu split his career between life as a professional painter in Nanjing and service as a court painter in Beijing. Like Tang Yin he exemplifies the rise of a somewhat bohemian ideal of artistic life, in which talent was the supreme value, excusing even extremes of self-indulgent or eccentric behavior. Wu Wei, for example, supposedly appeared drunk and disheveled for an imperial audience, where he quickly won not only forgiveness but admiration with a bravura painting performance of scribbled and smeared ink.

The life of another Suzhou professional painter, Qiu Ying (c. 1495–1552), exemplifies the ways that urban careers overlapped categories of patronage and performance. Qiu was a pure painter, with no evidence of education or aspirations as a literary man or calligrapher. Nonetheless, he was admired by and associated with eminent men of letters such as Wen Zhengming on the basis of his extraordinary talents in representationally skillful painting. Much of his painting was devoted to subjects found also in the art of the literati, such as figures in landscapes, or scholars in gardens listening to music or engaging in artistic and literary pursuits. Qiu's renderings were, however, much more polished and technically ambitious than those of the literati. He also made many paintings that copied or followed classic works, and he had the capabilities to emulate Song pictorial qualities of light, atmosphere, and illusionistic surfaces. One of Qiu's major patrons was the Suzhou pawnbroker Xiang Yuanbian (1525–1590), who amassed a huge art collection as an outgrowth of his business activities. Xiang had Qiu Ying make copies of many famous old works in his collection, and his most lavish commission to Qiu conveys something of the commercial atmosphere of this side of the Suzhou art world. He paid Qiu the fabulous sum of two hundred taels of silver—more than a court minister's yearly salary—to paint the *Spring Morning in the Han Palace* handscroll (FIG. 8-39), which drew for its vignettes on many old paintings in Xiang's collection. The work thus combines art-historical references, though of a much more directly imitative kind than the sort often associated with literati painting, with a subject centered on palace life and having many episodes quoting old court painting, but in a spirit very different from both official and personal painting. Qiu offers instead an urban fantasy of palace life, decorated in marble and silk, exotic plants and peacocks, in which palace women move about in a dreamy world of entertainment and self-adornment. The palace halls open up to the viewer in alternating projecting and receding bays, like so many shopfronts on an urban street. Quotations from surviving old works such as *The Night Revels of Han Xizai* (see FIG. 7-23 above) abound. In one scene, a court portraitist works at a table with his dishes of pigments beside him, painting a portrait of an empress or imperial consort, and allowing the viewer to compare his likeness with the figure of his subject. The painter seems a surrogate for Qiu Ying, offering his privileged viewers or patrons behind-the-scenes glimpses of the secrets of palace life and artists' practices, while subordinating himself to the task of skillful replication and to the judgments of his patrons.

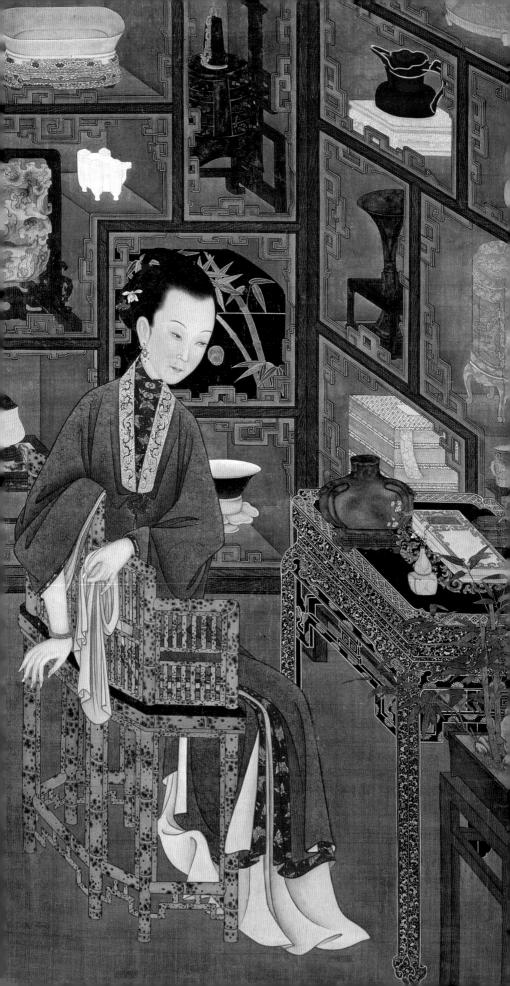

9 ART SYSTEMS AND CIRCULATIONS: LATE MING TO MIDDLE QING

Aperiod comprising the late Ming and the early to middle Qing dynasties, from about 1550 to 1800. In 1644 the Ming regime in Beijing, long in a decline marked by inattentive emperors, powerful eunuchs, and vicious factional struggles among bureaucrats, fell first to forces led by a rebel Ming general and soon after to the ethnically distinct regime of the Manchus. The Manchus (descendants of the Jurchen rulers of the North Chinese Jin dynasty of the Song era) consolidated their rule in the face of a refugee Southern Ming regime and substantial continuing resistance and rebellions based in southern China that lasted in various forms until 1681. Some of that consolidation took the form of bloody campaigns against Ming loyalist cities such as Nanjing and nearby Yangzhou, in which tens of thousands of soldiers and civilians were slaughtered, culminating in the death of the last Ming pretender to the throne in Yunnan, in the far-off southwest, in 1662.

This dramatic era of resistance, suppression, and continued resentment against the Manchus by their Chinese subjects has colored our understanding of the mid-seventeenth-century Ming/Qing transition as an epochal moment of rupture. In addition, the style of Qing culture, with its emphasis on central control, orthodoxy, and system in both the political and the artistic arenas, was notably different from the fragmentation, individualism, and experimental flavor of the late Ming. If

we take long-term economic and social trends as our primary basis for organization, however, there were important linkages across this era. It was, first and foremost, a period of great prosperity and population growth, during which China again became a major world economic and political power. Even with the interruptions caused by increased death rates during the decades of the Manchu conquest, China experienced a steady population growth to around 300 million by the late eighteenth century. Trade and commerce flourished, with the emergence of interregional market centers and new urban and regional centers of prosperity. Southern Anhui Province and the city of Yangzhou, both in southeastern China, are notable examples where important activity in illustrated book publishing, painting, calligraphy, domestic architecture, and garden construction accompanied local concentrations of wealth.

Growth of a Prosperous Age (FIG. 9-2), an overview of Suzhou painted by the Qing court artist Xu Yang in 1759, incorporates many prominent features of late Ming and early Qing art. The bird's-eye viewpoint and panoramic sweep of the handscroll more than forty feet long are reminiscent of the *Spring Festival on the River* scroll from the Song era (see FIG. 7-3 above), which itself was copied with updated architectural details several times during the Qing. Both works emphasize busy urban prosperity, with views of streets, shops, boat traffic, and the local populace. Such

paintings make implicit ideological claims for the benefits of the current administration, in this case that of the Manchus. The artist Xu Yang himself was a kind of local product of Suzhou, a talented painter who submitted an album to the later eighteenth-century Qianlong emperor during an imperial tour of the south and was then appointed court painter. The section of his scroll reproduced here focuses on commercial abundance, with boats crowding the waters and strollers gazing into the open shopfronts that line even the city walls. Diminutive boats and the receding lines of the walls in the upper right distance belong to a complex of European pictorial devices prominent in Qing court painting, part of a broad internationalism in Qing art. The overview of the city suggests an interest in centralized control, or even surveillance, over the centers of economic activity, with detailed renderings of complex systems of transport, circulation of goods, and commerce. Close supervision was characteristic of Qing

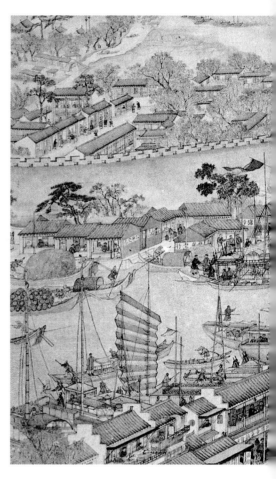

governmental and cultural policy, from the regulation of officials to the censorship of literary expression.

Much of the growth in trade during the late Ming and early Qing periods was international, as China became integrated in a global economic system. With the establishment of trading entrepots by Europeans in such places as Goa in India, Malacca in Malaysia, and Nagasaki in Japan, following the intense maritime exploration of shipping routes known (from the European point of view) as the Age of Discovery, China had access via intermediaries to global markets and imports. China shipped vast quantities of porcelains and textiles to Europe and other regions and imported mostly raw materials and foodstuffs as well as silver from Spain's South American colonial sources, via the Philippines. Trade also introduced New World food crops such as corn, potatoes, and peanuts into China. The free flow of silver from the New World, with periodic interruptions caused by geopolitical events contributing to

Southeast China

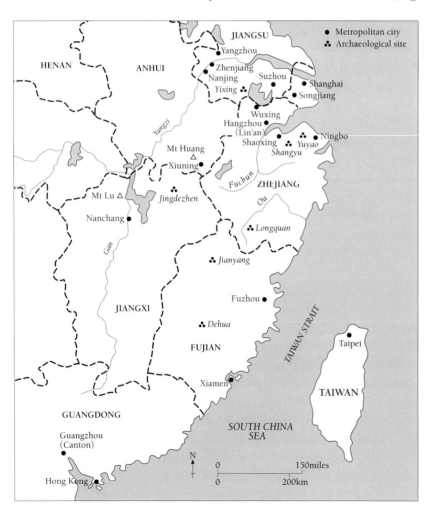

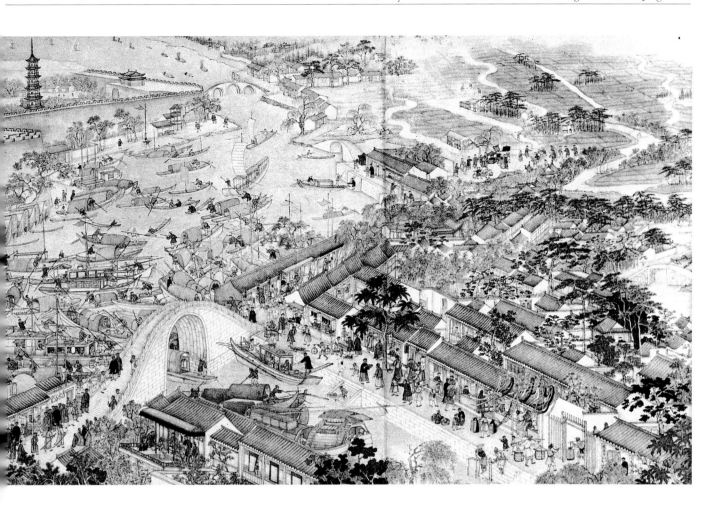

episodic depressions in the Chinese economy, enabled and, occasionally, disturbed the growth of a money economy, accumulation of wealth and luxury goods, and the expansion of broad trade and commercial networks.

Internationalization of trade had important consequences in China and Europe, not only for the economies and quality of daily life and material culture but also in the artistic and ideological realms. Jesuit missionaries first became active in China and Japan in the late sixteenth century, bringing with them religious images in the form of sculptures, paintings, and prints (see FIG. 9-17 below), as well as secular works such as atlases illustrated with engraved landscapes, cityscapes, and maps. The impact of this material, which carried along with it European conventions of representation, was episodic, but by the mid-eighteenth century the court ateliers of the Qing rulers included European painters and architectural designers, cloisonné decorators, and a well-established genre

of perspectival painting (see FIGS. 9-33 and 9-43 below). In Europe, Chinese decorated porcelains and silks carried pictorial designs and color schemes that influenced taste and contributed to the European arts known as *chinoiserie* and to the mostly fanciful decoration of gardens with kiosks and pavilions in a loosely Chinese mode (see FIG. 9-37 below). This era saw the formation of an influential idea of China in the imagination of the West, in the work of writers and political philosophers such as Leibniz and Voltaire. China's stature as a world commercial power, along with its military presence through the eighteenth century as a great Asian land power, added luster to missionaries' reports of a philosopher's state, uncontaminated by religious strife and ruled by sage emperors and their scholar–official bureaucracy. However much affected by fantasy and wishful projection, this image of China helped to form the intellectual context for the European Age of Enlightenment and the establishment of meritocratic systems of civil service in the West.

9-2 Xu Yang (active c. 1750–after 1776), *Growth of a Prosperous Age*

Qing. Detail of handscroll, ink and color on paper; 14⅛″ × 40′6″ (35.8 cm × 12.39 m). Museum of Chinese History, Beijing

Published abundantly in this era were the systematic historical and theoretical treatises on art and manuals for codifying and transmitting art techniques. Systems of production included the institutional structures of Qing court patronage and elaborate organizations of craft and ceramic manufacture. Qing culture was systematic in a broader, intellectual, sense, with vast projects of compilation and classification—bibliographies, dictionaries, and art encyclopedias among others—sponsored by the imperial court. Art circulation had a tangible basis in the movement of art and craft goods at local, regional, and international levels. "Circulation" also implies migration of styles and themes between different art forms and media, and transfers of knowledge about art and standards of taste between social groups.

WOODBLOCK ILLUSTRATION

9-3 *Bridal Du Painting a Self-portrait*
From *The Peony Pavilion*. Ming, Wanli era (1573–1619). Woodblock print; 8¼ × 5″ (20.8 × 12.5 cm). Beijing Library

The medium of books illustrated with woodblock prints flourished in this era. Print images already had a long history in China, beginning in the ninth century with illustrated Buddhist *sutras* (texts) and including illustrated treatises on antiquarian and artistic themes in the Song and Yuan periods. Many illustrated editions of dramas, Buddhist *sutras*, and morality books were published in the Yuan and early/middle Ming periods. The last century of the Ming era saw both an increased volume of illustrated editions and a greater variety and sophistication of pictorial devices and techniques, including multi-colored prints. Publishing was a business before anything else, and late Ming print illustrations reflect a wider commercialization of culture, as well as a broadening literate public for works of fiction and drama, encyclopedias, catalogues, guides, and manuals, including guides to participation in elite cultural activities. The broadening

market and success of illustrated books attracted the participation of major painters as print designers. These were only one facet of a diverse image industry, ranging from single-sheet popular New Year's prints and crudely illustrated cheap editions of plays to sophisticated editions illustrated by family studios of specialist block carvers and designers, working in distinctive styles that show great ingenuity and skill.

Woodblock prints thus exemplify many of the leading features of late Ming and early Qing artistic culture. They were products of commercial ventures whose centers in the southeast at Anhui, Fujian, Nanjing, and Suzhou belonged to a wider circuit of commerce and travel. Prints intersected with many media and art forms, including drama, fiction, and painting, increasingly available to a more widely educated and appreciative public, whose cultural skills were aided by published guides and manuals of taste. Such publications were part of a trend to systematize cultural knowledge that extended from independent publishers in the late Ming to the great encyclopedic projects of the Qing court. Publishing and print illustrations actively contributed to interchanges between different arenas of society and culture and made the late Ming and early Qing eras when the court, urban, and scholarly spheres were all impacted by such trends as commercialization and internationalization. Other popular themes for print illustration included love stories and tales of heroism, which reflect an emerging concern with themes of human feeling and psychological conflict.

Among the most popular dramas of the period was *The Peony Pavilion*, written around 1600 by the playwright Tang Xianzu, a contemporary of Shakespeare. The story illustrates the power of love; in it the young heroine, Bridal Du, pines away, dies and is resurrected by the imagination of her lover, inflamed in his desire by the image in a self-portrait she had left behind. The print illustration of the portrait scene, in which the triple images of Bridal Du, her image in a mirror, and her portrait image all have much the same reality status (FIG. 9-3), conveys the confusion of reality and illusion which lies at the heart of the drama. This intermingling of the real and

imaginary, or fictive, sphere operated broadly in late Ming cultural life. However much the play turns on inner life, the print and the play it illustrated were both in the public realm of performance and circulation. Beyond the art world of pictures and drama, the play inspired a cult of interest and emulation among late Ming women, who wrote commentaries about the play and in one famous case reputedly even imitated the circumstances of the heroine's death. The name of the carver of *The Peony Pavilion* scene, Huang Mingqi, is included on the print, indicating that specialist craftsmen were achieving a certain independent reputation for their skills.

In other cases, drama illustrations attracted elite artists, as in the print designs for *Story of the Western Wing*, a Yuan-period romance in the common narrative pattern of love between talented male scholar and beautiful maiden. The popularity of the play drew the talents of major artists such as Chen Hongshou (1598–1652, see FIG. 9-10 below), who had to compete with other editions to find innovative approaches to problems of text illustration. Perhaps the most elaborate of these editions, from 1640, is known only by the name of its publisher, one Min Qiji, a reminder of the commercial motivation and sponsorship of such series. Multiple colors are used, along with "blind printing" or *gauffrage* to give depth and texture to the scenes. One of these images shows the heroine Yingying secretly reading a letter from her lover, while being spied upon by her maid Oriole (FIG. 9-4). The choice of a painted screen as the setting for the event accomplishes several purposes at once. It marks an arena of privacy and allows us to see the intrusion of the maid, so that the viewer has greater knowledge than the heroine. This situation is like that of the stage, with the screen serving the same purpose as a stage prop or "scenery" (though painted scenery as such was not a convention of Yuan and Ming drama). Having the heroine revealed only by her image in the mirror, and by glimpses of her robe and sashes, recalls staging in another way by setting up alternative levels of reality comparable to real actors performing fictional roles in the liminal space of a stage. In the print, the painted screen and mirror image have a greater

visual presence than the "real" figures in the scene. This deliberate confusion of illusion, reality, and fiction is characteristic of many other kinds of late Ming artistry.

Illustrated editions helped to make important literary texts more widely known and accessible to a broader audience. Another infuential group of illustrated books in the seventeenth century included painting manuals, which emphasized cultural memory rather than themes of desire and fantasy. Manuals combined an interest in systematic analysis and organization of painting genres and motifs with fairly broad circulation. Among the best known manuals was the *Ten Bamboo Studio Manual of Calligraphy and Painting* (completed in 1627), produced by the Nanjing publisher Hu Zhengyan (1584–1674). The preface announces its purpose as making knowledge of art more widely accessible, although this was in some ways a luxury edition, with elaborate, multicolored printing techniques and subtle effects of graded ink and color evoking brush techniques. Motifs are grouped into labeled categories such as flowers, birds, and rocks, with the general effect of an elaborate multileaf album.

Some decades later, a group of Nanjing artists under the leadership of the painter Wang Gai (1645–c. 1710) collaborated in the production of the more widely influential *Mustard Seed Garden Manual of Calligraphy and Painting*. The publisher of this compendium was the playwright and bookseller Li Yu (1611–1680), owner of the Mustard Seed Garden and Bookshop, who used an album of landscape sketches by the late Ming painter Li Liufang (1575–1629) belonging to his son-in-law as the basis for a volume on landscape painting styles. The genesis of the project illustrates the inter-mingling of fine art and commerce,

9-4 Min Qiji (1580–after 1661), *Yingying Reading a Letter from Student Zhang*
From *Story of the Western Wing*. Ming, 1640. Polychrome woodblock print; 10⅞ × 12¾″ (27.5 × 32.3 cm). Museum für Ostasiatische Kunst, Cologne

9-5 Wang Gai (1645–c. 1710), *Landscape in the Tang Yin Manner*
From *Mustard Seed Garden Manual of Calligraphy and Painting.* Qing, 1679. Polychrome woodblock print; 8⅞ × 5¾″ (22.5 × 14.5 cm)

Woodblock illustrated painting and calligraphy manuals were an important means of disseminating pictorial knowledge to a broadening audience. The *Mustard Seed Garden Manual* was reprinted and revised many times in China and Japan. It included sections on landscapes, birds and flowers, symbolic plants, and human figures among other subjects, often analyzed down to the level of codified brush strokes or individual motifs that could be selected or combined for the user's own purposes.

and the transition from private studio sketchbooks to publicly accessible manuals. Beginning with a first edition in 1679, this manual was reissued and supplemented many times in China and Japan over later decades and centuries, adding sections on symbolic plants, flowers and birds, portraits, and figures among other subjects, and it became one of the most widely used introductions to painting techniques. Consistent with trends in Qing culture, there is much emphasis on systematic classification of motifs, types, and techniques, down to the level of codified foliage patterns, tree and branch structures, and texture strokes for mountains and earth surfaces, using the metaphorical terminology (such as "ax-cut" and "raindrop" texture strokes) of Chinese painting criticsm. An array of component elements could be reconstituted into versions of famous artists' styles and full compositions (FIG. 9-5). There are parallels to this in the "practical learning" movement in the same period, which resulted in many published compilations that could be used for instruction. The *Mustard Seed Garden Manual* focuses on art-historical and technical lore but served a similar purpose as an encyclopedia of types and techniques. This approach, and the woodblock-print medium, in turn had an impact on the production of painting, as artists composed works from ready-made, often graphic components.

LITERATI PAINTING AND CALLIGRAPHY

Another arena in which issues of memory and systematic approach merged in late Ming art was in the painting and calligraphy of the literati. We have used "literati" as an all-purpose designation for educated artists, but the specific term, translating the Chinese *wenren*, only came into wide currency in the later Ming period. Artists and critics used the term to emphasize the literary accomplishment of a self-described group and as a point of distinction from those with different values. The late Ming literati claimed the scholar–official artists of the Song and the educated, amateur, or outsider artists of the Yuan and early Ming as ancestors, but distinctions between the eras are still meaningful. As we have seen, Song scholar–official artists explored the poetic potential of painting, while Yuan–Ming amateurs emphasized locality and personalization of painting. The late Ming literati promoted an art-historical program of approved models for painting and a method of acknowledged imitation as a basis for innovation.

The literati approach could result in very formulaic painting, saved from the pure conventionality of the painting manuals only by the idiosyncrasies of the artist's calligraphic brushwork. There was certainly an element of defensiveness about the literati movement, staking out an arena of "in group" correctness in a period when education, including education about art, was becoming more widely accessible to non-elite groups. The literati attacks on professional and court painters, and even on contemporary Suzhou school artists who had popularized and commercialized earlier scholar–amateur styles, should be seen in that light.

Dong Qichang (1555–1636) chiefly formulated the art-historical theory of literati painting. Dong had a career as a high governmental official in the late Ming, interspersed with long periods of retirement that protected him from the dangerous, and sometimes fatal, factional struggles at court. Coming from a modest family background, he amassed a large fortune and art collection. Much of his art was dispersed after

a popular uprising against his family for abuses of wealth and status that led to a looting of his estate in 1617. The pattern of his life, played out against a background of dramatic changes in economic status, factional struggle, and class conflict, indicates the dynamic environment in which he formulated his approach to art.

The Northern and Southern School theory, developed in the critical writings of Dong Qichang and his associates as a basis for the practices of the literati painters, seems clearly factional in its division into approved and disapproved camps and seeks a clarity that was often elusive in their political and personal lives. The admired Southern School included poets and official painters of the Tang and Song and educated amateur artists of the Yuan and early Ming such as Ni Zan and Shen Zhou (see FIGS. 8-30 and 8-34 above). The denigrated Northern School included academy and professional painters (see FIG. 8-4 above). Thus the chief determinants of the system seem to have been education and class. In fact the theory was less clear-cut than at first appears. Certain types of painters such as imperial relatives (see FIG. 7-21 above) and educated urban painters such as Tang Yin (see FIG. 8-37 above) did not fit comfortably into either camp. The Northern and Southern categories were not primarily geographical but were borrowed from Chan Buddhist divisions between Northern (gradualist) and Southern (sudden enlightenment) sects. This kind of intermingling of Buddhism, art, and literary discourse is also typical of the late Ming. The theory in some respects served as a memory device, ordering Dong Qichang's vast experience with old painting into a coherent pattern.

Dong Qichang's paintings suggest a parallel ongoing effort to resolve incompatible factors, including memory and current experience, structure and experimentation. His version of the *Qing Bian Mountains* (FIG. 9-6) is loosely comparable to the structure of the Yuan painter Wang Meng's rendering of the subject (see FIG. 8-31 above), which Dong Qichang owned for a time. The departures from the original are just as notable, as we might expect from someone who disdained direct copying and sought instead a transformation of an original stimulus. Dong Qichang

9-6 Dong Qichang (1555–1636), *Qing Bian Mountains*

Ming, 1617. Hanging scroll, ink on paper; 7'3½" × 26½" (2.25 m × 67.2 cm). The Cleveland Museum of Art

carries the spatial and structural ambiguities of Wang Meng's painting much further, with rocks that bulge forward in heavy masses blended with seemingly incompatible flat strips that plunge

precipitously downward. Dong Qichang's landscape forms are more harshly contrasted, with shaded forms surrounded by stark, vacant bands. Most of Dong Qichang's paintings are characterized by a play of dynamic tension, with angled or torsioned forms pulling against stable horizontal or vertical axes. His working procedure incorporated bits of remembered experience in an ongoing process of imitation, experimentation, and theorizing that was well suited to the dense cultural interplay of the late Ming.

Orthodoxy and the Fate of Literati Painting

The engagements with the past seen in Dong Qichang's paintings are almost always filled with productive tension. In the work of many of his associates and followers, however, the citation of approved old masters in inscriptions on paintings "in the manner of" was often only a perfunctory exercise that aligned the artist and recipient in a community of literati taste. A further danger was that the working guidelines of artistic relatedness that formed the Northern and Southern School theory could harden into formulaic rules. This was one direction in what became known as the Orthodox School in the Qing period, comprised of followers of Dong Qichang's theories who emphasized imitations of approved, so-called Southern School masters from the past. The tendency toward systematization of culture in the Qing played a part in this, as did the association of important followers of Dong

Qichang with the regimentation of the imperial court. In any event, we should avoid projecting the characteristics of the later Orthodox School back onto the more open-ended experiments of Dong Qichang.

The most influential of the Orthodox School painters was Wang Yuanqi (1642–1715), who served the Kangxi emperor as an art expert. Wang held a high bureaucratic position, and in this he belonged to a distinguished lineage of scholar–official artists and critics that runs from Su Shi and Mi Fu (see FIG. 7-37 above) in the Northern Song period through Zhao Mengfu (see FIG. 8-26 above) in the Yuan. Unlike those earlier artist–officials, whose work was mostly distinct from the styles of patronized court artists, Wang Yuanqi made many paintings in standard orthodox landscape styles directly for the court. In the later Qing, orthodox painting became substantially coopted by the court, as one of several coexisting palace styles.

Wang Yuanqi's status as a bureaucrat and arbiter of taste is conveyed well in a portrait made of him by Yu Zhiding (1647–1716), who functioned as a kind of high-society portraitist. Wang is shown as prosperous, well-fed, and cultivated, admiring potted chrysanthemum flowers brought to him by servants, as he sits on a *kang*, or couch, surrounded by books emblematic of his learning (FIG. 9-7). The chrysanthemums are a reference to the favorite blossoms of the early recluse–poet Tao Yuanming (365–427), but their very profusion here creates an aura of

9-7 Yu Zhiding (1647–1716), *Portrait of Wang Yuanqi Appreciating Chrysanthemums*
Qing. Detail of handscroll, ink and colors on silk; 12¾ × 53¾" (32.4 × 136.4 cm). The Palace Museum, Beijing

9-8 Wang Yuanqi
(1642–1715),
Wangchuan Villa
Qing, 1711. Detail of
handscroll, ink and colors
on paper; 14⅛″ × 17′6″
(35.7 cm x 5.37 m). The
Metropolitan Museum of
Art, New York

luxury somewhat at odds with that claimed affinity. Wang Yuanqi's portrait conveys some of the same qualities of wealth and refined taste found in the image of the independent poet–painter Ni Zan from the fourteenth century (see FIG. 8-29 above), but with a clearer sense of worldliness conveyed through the addition of strong color for the fabrics and faces.

One of Wang Yuanqi's contributions to the Qing systematic approach to culture was his editorship of the *Peiwen Studio Encyclopedia of Calligraphy and Painting* sponsored by the Kangxi court. This is a massive compendium of biographies, inscriptions, art theories, and catalogue records, more a cut-and-paste effort than original scholarship, but useful as a source book for quotation, like the painting manuals of the period. Wang's more original painting theory is systematic in another way. Instead of Dong Qichang's concern with artistic lineages, it emphasizes an abstract analysis of landscape painting into complementary elements and rhythms: rising and falling, opening and closing. This theory holds something in common with geomantic analyses of the underlying forces of physical landscape, but it also recalls the Yuan painter Huang Gongwang's understanding of landscape painting as

primarily a construction of brush and ink (see page 305 above).

Wang Yuanqi's paintings can build extremely powerful structures out of those elements. A long handscroll painting after the Tang poet–painter Wang Wei's famous *Wangchuan Villa* composition exemplifies his most successful efforts. Wang Yuanqi uses complementary warm and cool pigments, ochres and blues, to shape forms that harbor a powerful tension between surface and three-dimensional readings (FIG. 9-8). The uptilted ground planes further that tension, while also conveying a reference to early pictorial devices of Wang Wei's era in the eighth century. Large reserve areas of clouds and water are shaped by surrounding land forms as flat shapes, but ambiguous in recession and solidity.

If absorption into the environment of court painting was one direction of literati painting, the other was commercialization. By the later seventeenth century literati painting was one kind of cultural product for sale among many others, a fate openly, if ironically, announced in the career of the eighteenth-century Yangzhou artist Zheng Xie (see page 346 below). Thus by the Qing period two of the hallmarks of the literati tradition as a whole—its independence from court styles and

ideologies, and its claims or pretense of amateurism—were broadly inoperative. What remains of the original impulse is largely the association with educated artists and the embellishment of paintings with texts. This was enough to sustain a significant mode of painting that maintained energy through the nineteenth century and indeed down to our own day.

ARTS OF DESIRE AND MEMORY

The late Ming was a period of notable freedom from constraint and of experimentation, in culture and mores as in the economic sphere. Themes of romance, desire, and sexuality figured prominently in drama and fiction, including the often-illustrated classic erotic novel *Jin Ping Mei*, translated variously as *The Golden Lotus* or *The Plum in the Golden Vase*. The Qing regime officially promulgated much more straitlaced cultural standards, including censorship of morally dubious texts, but the composition of erotic and fantasy tales continued unabated by such masters of uncanny and supernatural fiction as Pu Songling (1640–1715) and Yuan Mei (1716–1798), and the Qing court sponsored its own genre of alluring images of female beauties (see FIG. 9-1 above). Themes of memory took many forms in this period, such as the intermingling of personal and art-historical memory in Dong Qichang's late Ming approach to literati painting. Another arena for the interplay of personal experience and historical outlook was the painting and calligraphy of the loyalist subjects of the Ming who lived through the Qing conquest. Elements of belatedness, regret, nostalgia, and grief were blended in their work.

All of this suggests a strong psychological content in late Ming to mid-Qing pictorial and calligraphic arts. Such themes were by no means unprecedented in Chinese painting, as we have seen with erotically charged imagery in the Song era (see FIG. 7-23 above) and the prominence of memories and personal association in the literati painting of the Yuan and early Ming. What does seem new in the later Ming period and beyond is the complexity of emotions that are conveyed.

Guilt, ambivalence, and irony are implicated in the situations of the artists and their images and writings, in ways that seem comparable to a modern sense of inner conflicts and the divided self. The sheer complexity of life in this period, in which artists, among others, were forced to play many roles and confront the discrepancies between traditional ideals and contemporary realities, surely contributed to this phenomenon.

Although the inner world of memory and desire may seem a long way from the relatively impersonal realms of the systematic production and circulation of goods and art objects, there are some important linkages. The fate of the profligate hero of *The Golden Lotus*, the merchant Ximen Qing, reveals how immoderation and excess in the economic sphere of circulating silver currency and goods carries over into destructive self-indulgence in domestic and erotic life. Similarly, many of the memories that haunt the works of loyalist painters and writers were of relatively public, historical events.

Chen Hongshou (1598–1652) had a varied career in southeastern China as a professional painter and designer of woodblock-print illustrations of drama and fiction, and a brief and disappointing period of service to the Ming court. Chen had aspirations both for the status of a literatus and for meaningful official service, but the realities of life as an urban professional painter were less exalted. He lived through the Manchu conquest of the Ming and took pen names such as "Old and Too Late" and "Regretful Monk" to express his loyalties to the Ming and his sense of failure for not playing an effective role in preventing this catastrophe. However, he seems never seriously to have considered the kinds of active military resistance or loyalist suicide chosen by many of his contemporaries.

Chen's *Lady Xuanwen jun Giving Instructions on the Classics* (FIG. 9-10) was a picture made for his aunt on her sixtieth birthday. Staged as an elaborate historical tableau, it implies a comparison between an ancient hereditary woman scholar, teaching a company of male students from a raised platform, and a learned senior female relative. The confusion of human identities, contemporary and historical, is echoed in the brilliantly

rendered setting, where the painted landscape screen and bird-and-cloud textile table drape seem more vivid than the "real" figures and landscape around them. This play of reality, illusion, and fiction is similar to that seen in the *Story of the Western Wing* prints (see FIG. 9-4 above), a subject that Chen also illustrated.

The prominence of portraiture in this period, including many images and self-portraits of artists, testifies to a rising self-consciousness surrounding social presentation and cultural performance. In the late Ming this combined with a cult of *qing*, or authentic feelings, including romantic love, to foreground the importance of emotions. The woodblock portrait in *The Peony Pavilion* (see FIG. 9-3) discussed above links self-portrayal to powerful romantic desires, conveyed in visual form. Late Ming philosophers, such as Li Zhi (1529–1602), and literary theorists also championed unconstrained expressions of authentic feeling.

These factors could lead to extreme and even pathological manifestations. We have already seen how an emphasis on the personal in the Yuan period could lead to a display of idiosyncratic character, as in Ni Zan's fastidious behavior (see pages 302–306). The middle Ming urban environment created space for a romantic artistic type, seen as prodigiously talented, unconventional, wine- and pleasure-loving, exemplified by Tang Yin and Wu Wei (see pages 312–315). Late Ming culture accommodated even the tormented and radical behavior of Xu Wei (1521–1593), a dramatist and painter–calligrapher who, like Chen Hongshou, was from the wine-producing commercial town

of Shaoxing in the southeast. Xu became irrationally jealous of one of his wives and murdered her. He was committed to prison for twelve years and was only released through the intercession of influential admirers. During his darkest guilt-ridden periods Xu inflicted cruel punishments on himself, driving a nail into his ear and crushing his own testicles. His ink paintings and calligraphy are less morbid than this account might suggest, but they do strongly convey qualities of impulsiveness and unrestraint. His typical subjects are loose images of flowers and fruit, some, like grapes, associated with a culture of intoxication, and others suggesting sensual indulgence and pleasure in beauty. Xu combines an ink-wash technique that permits chance effects of flow and absorption to show with energetic, nearly violent strokes and spatters, as in the image of seeded plants illustrated here (FIG. 9-9). He risks the loss of coherence and control that is partly representational and, given what we know of his life, seemingly psychological as well.

The slippage we observe in late Ming pictures between the real and the artificial or dreamed, or between coherence and chance, seems symptomatic of a period when free-floating desire disrupts the stability of boundaries. The Buddhist figure paintings and mountainscapes of the late Ming professional and court painter Wu Bin (active c. 1583–1626) are full of images of metamorphosis and transformation. His depiction of the *Lantern Festival* (FIG. 9-11), one of a series recording annual observances, is more straightforward but conveys an atmosphere of urban spectacle, with crowds

9-9 Xu Wei (1521–1593), *Flowers and Other Plants* Ming. Detail of handscroll, ink on paper; 12" x 34'3" (30.5 cm x 10.45 m). Nanjing Museum

9-10 Chen Hongshou (1598–1652), *Lady Xuanwen jun Giving Instructions on the Classics*
Ming, 1638. Detail of hanging scroll, ink and color on silk; 5′7″ × 21⅞″ (1.74 m × 55.6 cm). The Cleveland Museum of Art

of onlookers gathering to view a miniature mountain decorated with elaborate lanterns. Intricate illusions, shifts in scale from the miniature to the monumental, and the intermingled social spaces of looking and being seen are all suggested here and in the observations of late Ming writers. Writing of Suzhou's Tiger Hill during the Mid-Autumn Festival, Yuan Hongdao (1568–1610) notes:

> It is especially crowded on the Mid-Autumn Festival. Whenever this day arrives, so does every family in the city, shoulder to shoulder. From fine ladies and elegant gentlemen down to shanty dwellers, all put on their finery, and the women don makeup. They spread out layers of mats and drink wine by the roadside…
>
> (Strassberg, *Inscribed Landscapes*, p. 306)

Zhang Dai (1599–1684?) likewise focuses his report on Hangzhou's West Lake at the Midsummer Festival on the audience, rather than the site:

> …at the Midsummer Festival, there is nothing worth watching except those who come to watch the midsummer moon. One type: those on spacious pleasure boats where music is played, wearing formal dress, enjoying magnificent banquets under lantern lights, entertained by actors as sounds and sights dissolve into one another. They call this "watching the moon," though they never really see it. They themselves are worth watching…
>
> (Strassberg, *Inscribed Landscapes*, p. 342)

The richest evocation of late Ming desire is found in the novel *The Golden Lotus*, which was illustrated with woodblock prints during the late Ming and later with a set of one hundred album-leaf paintings. The latter are unsigned but are probably the work of an early Qing court painter such as Gu Jianlong, whose sketchbooks are discussed below (see FIG. 9-27 below). Each leaf illustrates one chapter episode from the novel, with particular attention to the material life and surroundings of the characters. Painted and carved

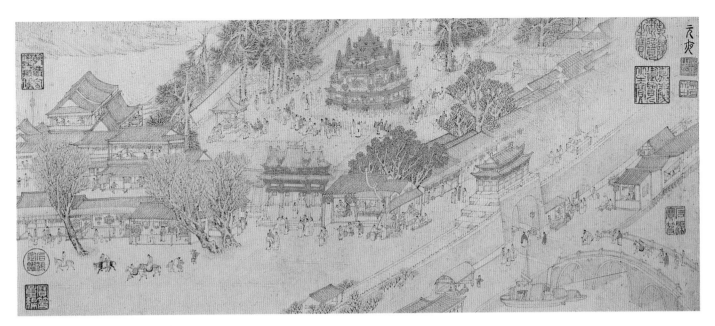

railings and lattice windows, luxury objects of jade, gold, and porcelain and all the elegant fabrics worn by members of the *nouveau riche* household of the merchant Ximen Qing are depicted in meticulous detail and color, as if the extravagance and unbridled desire of the protagonist could be materialized in objects. The licentiousness of the narrative seems not to have bothered the imperial patrons of the album, though the Qing rulers otherwise promulgated a stern moral code. This album was a kind of luxury edition, utilizing the finest skills and materials, for the delectation of the imperial reader. The scene illustrated is an outspoken image of sadistic sexuality. The kneeling figure of the concubine Pan Jinlian (the "Golden Lotus" of the novel's title) is shown stripped naked and kneeling in a garden (FIG. 9-12). She is being interrogated and tortured by her angry lover Ximen Qing, who suspects her of having had a love affair while he was out of town. The seated woman is a maidservant who is supporting her mistress's (false) claims of innocence, but whose mere presence only deepens Golden Lotus's humiliation. The sudden turn of emotion, from affection to angry disdain, seems symptomatic as well of the instability of late Ming cultural life, ruled by desire and its inconstant attentions.

The association of erotic desire and luxury objects is continued in later Qing court images of beautiful women in lavishly furnished interiors.

One notable example, *Beauty Before a Curio Case*, includes a full cabinet of rarities, with fitted shelves and display alcoves filled with porcelains (including famous imperial wares of earlier dynasties), jades, corals, and cloisonné (FIG. 9-1). The slender beauty whose direct glance and provocative gestures convey an invitation to the presumably male viewer is scarcely more alluring than the rarities behind her. Like them, she is one of many such images, part of a collection, and depicted as a beautiful object for display.

9-11 Wu Bin (active c. 1583–1626), *Lantern Festival*
From *A Record of Yearly Observances*. Ming. c. 1600. Twelve-leaf album, ink and color on silk; each leaf 11⅝ × 27½" (29.4 × 69.8 cm). National Palace Museum, Taipei

9-12 Style of Gu Jianlong (1606–1687 or later), *The Golden Lotus*
Qing. Hundred-leaf album, ink and colors on silk. Collection of Andrew Franklin, CVO, CBE

9-13 Dong Qichang (1555–1636), *Calligraphy in Running and Cursive Scripts* Ming, 1603. Detail of handscroll, ink on silk; 12¼″ × 20′7″ (31.1 cm x 6.31 m). Tokyo National Museum

Loyalist Arts of Memory

The late Ming world of luxury and unrestrained desire produced anxieties about eroding traditional values among contemporary observers, but for those looking back from the more stable Qing, the late Ming was the subject of nostalgic remembrance and a sense of loss. More somber regrets attended the status of loyalists, or "remnant subjects," who had been born under and owed allegiance to the fallen Ming regime but lived on under the Qing. Their political guilt was compounded by the counter-example of those loyalists who had chosen suicide rather than surrender to the Manchus, and by the terrible slaughters that occurred when loyalist cities in the southeast, such as Nanjing and Yangzhou, finally fell to the invaders. Many faced difficult practical choices between service, accommodation, or outright resistance to the Manchu regime. After a transitional period that lasted almost a generation there was widespread accommodation to the Manchu rulers, who were able administrators and energetic patrons of traditional Chinese culture. But many writers and artists continued associations with networks of loyalist friends and disguised expressions of loyalist sentiments within their work. For those with close connections to the fallen regime, life could be dangerous, because the Manchus were rightly fearful of resistance and Ming restoration movements, which continued for several decades after the conquest in 1644, and were

severe in their suppression of potentially seditious expression.

The act of writing in China was so deeply charged with cultural implications that calligraphy could be an important vehicle for political statements in ways that did not necessarily depend on the content of the calligraphic text. Certain modes of writing were associated with official proclamations and edicts and thus conveyed the authority of the ruling regime. Skillful writing was the most common cultural talent of the educated elite, those trained for official careers, whether realized or not, and the texts they copied during their studies inculcated norms and ideologies through both content and writing styles. Because the historical reservoir of texts and styles was so deep, the significance of a calligraphic text could be conveyed in a variety of ways. Text content was of course important, but overt political statements could be very dangerous during a period like the Qing, when writing of all kinds was censored and the production of such genres as private histories of the Ming was a seditious offense punishable by death. Sentiments disguised in historical or poetic allusions, or networks of personal association displayed in the dedications of a calligraphic scroll, were less direct ways of conveying messages. Calligraphic styles could allude to the political positions and historical reputations of earlier writers. Less directly, style could be modulated almost endlessly in relation to other texts to position the calligrapher

in regard to current aesthetic, cultural, and political issues.

Dong Qichang was the most influential calligrapher of the late Ming period. His handscroll of *Calligraphy in Running and Cursive Scripts* (FIG. 9-13) belongs to the tradition of copy-book imitations of the elegant scripts of famous writers, but in the direction of graceful improvisation. The handscroll ends with a series of very large, free-flowing characters that suggest some of the qualities of spontaneity and natural impulsiveness found elsewhere in late Ming aesthetics and literary theory. The writing of the early Qing loyalist calligrapher Fu Shan (1607–1684/85), by comparison, often embodies deliberately contrary values: "I would rather [my calligraphy] be awkward, not skillful; ugly, not charming; deformed, not slippery; spontaneous, not premeditated" (Q. Bai, "Fu Shan and the Transformation of Chinese Calligraphy in the Seventeenth Century," p. 112). These are aesthetic, or anti-aesthetic, terms, but they could also evoke moral qualities of rugged independence and rejection of easy accommodation that were consistent with loyalist political stances. The rough ungainliness of Fu Shan's calligraphy in *Poem in Cursive Script* (FIG. 9-14) is very far from the fluency of Dong Qichang's writing, and the angularity of many of his forms recalls Fu's interest in ancient stone-engraved scripts. Many early Qing loyalist intellectuals favored a style of plain scholarship and historical investigation as an antidote to the self-indulgent introspection of late Ming thought. In calligraphy, this could encompass study of stone stele inscriptions in ancient script types. Such stone monuments belonged to a realm of public culture rather than the private world of letters found in copy-book models. Visits to old stone stelae also provided a tangible point of contact with the distant past that could offer consolation for recent traumas or serve as an act of mourning for lost historical eras.

Two of the most notable loyalist painters of the early Qing were relatives of the Ming imperial family. Their position was doubly precarious in that, beyond any loyalist sentiments, they might potentially be suspected of involvement in Ming restoration movements. Like many others of their

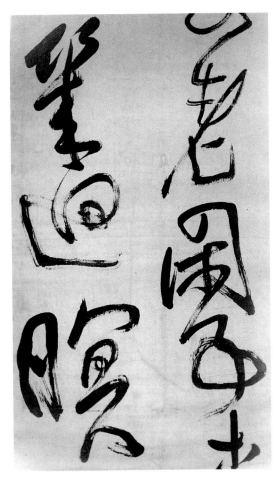

9-14 Fu Shan (1607–1684/5), *Poem in Cursive Script*
Ming–Qing. Detail of a hanging scroll, ink on silk; 5'7" x 19¼" (1.74 m x 49.6 cm). Shanghai Museum

time, they sought refuge and disguise in the Buddhist monastic community. Buddhist monks took new religious names, and their monks' robes and tonsured heads afforded both a changed physical appearance and a means of avoiding the enforced Manchu hairstyle (shaved forehead and hair tied in a queue) that stopped short of outright defiance. The older of these artists was named Zhu Da (1626–1705) but is better known by his Buddhist literary name of Bada Shanren. He was only a youth at the time of the Manchu conquest and took up a Buddhist identity for some time thereafter. Like many other prominent cultural figures in the late Ming to early Qing eras, he was beset with severe psychological and emotional problems. He seems to have had difficulty communicating and for a time announced himself in writing as "dumb," in the sense of lacking capacity for speech. Some accounts indicate an outright psychological breakdown in mid-life, though feigned madness to avoid political entanglements or service is another possible explanation for

9-15 Zhu Da, also known as Bada Shanren (1626–1705), *Fish and Rocks*

Qing, c. 1691. Detail of handscroll, ink on paper; 11½" × 5′1½" (29.2 cm × 1.57 m). The Cleveland Museum of Art

Zhu Da's typically cryptic pictorial and poetic imagery may in part have been intended to disguise or protect the expression of someone born a relative of the fallen Ming imperial family. Occasionally his imagery can be deciphered, as here, where the paired fish in a spatially incoherent setting may represent the artist and another imperial relative—whose hopes for position would be thwarted by the collapse of the Ming dynasty—and a world thrown into disorder.

his sometimes disturbed behavior. There is an edge of incoherence as well to many of his paintings, mostly of plants, birds, and landscapes, which are often fragmentary in imagery and setting. His poems and motifs seem deliberately cryptic, in some instances certainly a way of masking loyalist statements. In a few cases his work can be decoded. A handscroll of *Fish and Rocks* (FIG. 9-15) includes some odd dislocations: a view of fish either as seen underwater or floating in some indeterminate space; and a bulging metamorphic rock suggestive of a human head, likewise free of any ground or context. The accompanying poems link the fish to aristocratic youths—the artist and a relative perhaps—unable to develop into princely dragons and recall memories of the holdout Southern Ming court and the last claimants, who were Zhu Da's relatives, to the Ming imperial throne. The odd dislocations within the scene then suggest both the distortions of memory and the fragments of an old, unrecapturable order.

The younger painter who was a Ming imperial relative was Shitao (1642–1707). His call for a "method that is no-method" and painting based on the "unitary brush stroke" or "primordial line" was both a theoretical position set against the art-historical methods of the Orthodox School painters and a wishful, longing reversion to the simplicity and unity of the early world of his childhood. Shitao imbued his monumental painting *Viewing the Waterfall on Mount Lu* (FIG. 9-16) with many layers of personal and cultural memory. As a very young child, Shitao was spirited away by a servant to escape the dangers of factional struggle and invasion that attended the Manchu conquest of China. He began a wandering life

as a Buddhist monk and artist that took him eventually through most of the important urban and commercial centers of the time: Anhui, Nanjing, Beijing, and Yangzhou. As a youth, he lived at the ancient Buddhist center of Mount Lu, studying religion with a politically astute Buddhist abbot. Shitao's landscape painting of Mount Lu, painted late in his life, is in part a nostalgic evocation of his early life. The figure in the painting who gazes into the rolling clouds at the base of the waterfall is no doubt a surrogate for Shitao, engaged in acts of reminiscence, as in many of his paintings. The artist's style and inscription focus instead on the cultural memory of the Northern Song monumental landscape painter Guo Xi. The grand scale, towering cliffs, and effects of dynamic transformation of the Mount Lu painting do evoke qualities of Guo Xi's art (see FIG. 7-20 above). Shitao takes the occasion to question the authenticity of attributed Guo Xi paintings that he had seen and to claim that his own work comes closer than those to being a genuine Guo Xi. This kind of challenge to tradition, and the desire to return to early origins and begin everything anew, is central to Shitao's life, art, and painting theory. The energy of his painting comes from its fresh colorism and unstructured ink effects, and from its nonconventional composition and brushwork. In political terms, starting over and a return to origins implied something more than artistic originality, perhaps even a hope for restoration of the Ming regime. Shitao's focus on landscapes charged with Buddhist and loyalist associations suggests such an agenda. His advocacy of "no-method" likewise conveys a resistance against *fa*—which can be translated variously

as methods, regulations, and laws—and could be read in both artistic and political terms. Shitao's position was in some ways reactionary, set against the systematization of culture promulgated by the Manchus and found in orthodox movements or the published painting manuals. In the end, resistance to both Manchu rule and art-world systems was ineffective. Shitao accommodated himself to the Qing regime and sought audiences with the Kangxi emperor in mid-life, and he ended his career as a professional artist, subject in some degree to the discipline of commercialization, though never of outright orthodoxy.

COMMERCIAL AND DOMESTIC ARTS

The career of an artist such as Shitao, who despite aristocratic roots and a complex personal agenda in art and theory was caught up in the professionalization of art in the major urban centers of southeast China, illustrates the strength of commercial culture in the late Ming to middle Qing periods. This impetus was centered in the cities and commercial regions of the southeast, around the Yangzi River. Suzhou's importance as a center of silk weaving and handicraft production, Nanjing's urban prosperity, and Jingdezhen's status as the center of porcelain production were already long established by the late Ming. Other centers of art production and patronage did not emerge until the later Ming period and after. The regions of southern Anhui and Songjiang, near modern Shanghai, became important in the late Ming, and Yangzhou's reemergence as a cultural center came as late as the late seventeenth and eighteenth centuries. The growth of an art market, patronage, and art production characteristically accompanied rising prosperity in a city or region, but the sources of that prosperity also often fell into the category of functional arts and craft industries. Porcelain production and textile design and weaving were large-scale industries of great economic importance, regionally, nationally, and internationally; publishing, furniture manufacture, metalworking, and production of other luxury craft objects, as well as art materials such as paper

9-16 Shitao (1642–1707), *Viewing the Waterfall on Mount Lu*
Qing. Hanging scroll, ink and color on silk; 8'9" x 24⅞" (2.12 m x 63 cm). Sumitomo Collection, Kyoto

9-17 Cheng Dayue, ed. (1541–c. 1616), *Christ and St. Peter*

In *Mr Cheng's Catalogue of Pictorial Designs for Molded Ink Cakes.* Ming, 1594. Monochrome woodblock print, frame 9¾ × 5⅝" (24.7 × 14.2 cm). American Museum of Natural History, New York. Laufer Collection

and ink were substantial regional enterprises. While particular places became renowned for special local products and skills, the prosperity of the era in general was based on the free circulation of goods, of information, and of people such as traveling merchants.

The commercialization of art in this period had several aspects. The first was the importance of large-scale art and craft industries with broad economic impact that were based on the cultivation of technical and design skills. Another involved the emergence of a wealthy merchant group and the dissemination of their standards and tastes through art patronage. A third phenomenon was the spread of wealth more generally, giving rise to broader markets for arts and crafts and a need for published guides to taste and consumption, which were themselves available for purchase. Finally, elite arts such as literati painting and calligraphy became increasingly engaged in the marketplace and commodified.

The region of southern Anhuì was one of the newly emergent centers of commerce and culture in the Ming period. Many merchants operated from this region and later moved to cities such as Yangzhou, including salt merchants who were able to accumulate huge fortunes. Local forest products, tea, and salt were the foundation of the economy. A subset of these notable local products were the implements of high culture: fine paper; ink cakes made from compressed pine soot; inkstones for grinding ink; ornamental rocks for the scholar's table; and brushes. Thus even in its commercial products southern Anhui had links with high culture. This was complemented by a flourishing publishing industry and a notable school of wood-engraving illustrators, the emergence of the nearby Yellow Mountains as a famous

scenic and travel destination, and the growth of a local school of painting.

An example of the intermingling of commerce and art in Anhui and the wide circulation of cultural elements was *Mr. Cheng's Catalogue of Pictorial Designs for Molded Ink Cakes*, edited by an Anhui ink merchant at the beginning of the seventeenth century. It served some of the functions of an advertisement or sales catalogue and at the same time was a manual of popular designs across a wide range of subject matter. In addition to the editor, the catalogue drew on the local talents of the painter Ding Yunpeng (1547–c. 1621) as picture designer and Huang Lin as block carver. Ding was a notable painter of Buddhist subjects and landscapes, while Huang was part of a family studio famous for wood engraving from the late sixteenth century and for two centuries thereafter (see FIG. 9-3 above). There were thus at least three recognizable "brand names" involved with the catalogue that lent their stature both to the catalogue as a work of fine printing and to the ink cakes as luxury objects. The ink-cake designs were often filled in with colors, sometimes conveyed in single-block color prints in the catalogue. Most of the designs were of auspicious themes such as plants, children, or rebuses of good wishes, but they included Christian themes imitating the copperplate prints brought to China by the Italian Jesuit missionary Matteo Ricci in 1581. The print of *Christ and St. Peter* (FIG. 9-17), following an engraving by the Flemish printmaker Anton Wierix after a design by the painter Martin de Vos, combines the crisp outlines characteristic of Anhui engravers with the European elements of torsion of poses, strong gestures, and deep recessions that were appropriated elsewhere in Chinese religious and landscape paintings. The circulation of products and images in late Ming China thus extended even to material from abroad.

Another important kind of circulation in Ming–Qing China involved the movement of people. Wood engravers originally from the Anhui school were also active in other urban centers of printing such as Nanjing, Suzhou, Hangzhou, and Yangzhou. Merchants from Anhui and elsewhere also traveled widely to pursue business opportunities. Itinerant merchants, officials

taking up posts in new regions, and prosperous leisure travelers all played a part in the development of tourist centers and related hospitality and entertainment enterprises. Descriptive travel literature such as the essays of the notable sojourner Xu Hongzi (known as Xiake, 1586–1641), and a large body of topographical paintings of specific and identifiable sites accompanied a strongly developed appreciation of travel for leisure and pleasure in this period. The albums of scenes of Mount Hua by Wang Lu are early Ming examples related to this genre (see FIG. 8-32 above). The Yellow Mountains (Huangshan) of southern Anhui only became accessible to travelers after the establishment of Buddhist temples in the late Ming led to the opening of trails, hostels, and hot springs. By the late seventeenth century the site had developed not only a tourism infrastructure, including porters to carry the visitors and their baggage up the steep mountainsides, but also a lore of associations and named scenic spots and vistas that constituted a cultural landscape, parallel to the physical one. A notable school of painting in the early Qing years of the late seventeenth century that took the Yellow Mountains as its primary subject was part of that cultural landscape. Some of those artists, such as Shitao during the years he lived in Anhui and in paintings of reminiscence thereafter, imbued the site with loyalist associations as a refuge from Manchu rule. Others, such as the literary leader Mei Qing (1623–1697) and his younger relatives, seemed more concerned with local pride and identity. Dai Benxiao (1621–1693), the son of a loyalist who fought against the Qing and starved himself to death, combines both aspects in his work. A painting of the Manjusri Monastery (FIG. 9-18) set amidst the twisted peaks and isolated pines of Yellow Mountain summits is a recognizable icon of the site and one of its primary destinations. Such paintings could serve as souvenirs for travelers to the mountains, or as surrogate experiences for those unable to undertake the arduous climb. The loyalist writer Qian Qianyi (1582–1664) wrote an essay on a trip to "The Yellow Emperor Mountain (Huangshan)" that recounts the famously distinctive sights of the itinerary and culminated at the same monastery:

9-18 Dai Benxiao (1621–1693), *The Manjusri Monastery on Mount Huang* Qing. Hanging scroll, ink on silk; 6'2" × 21½" (1.88 m × 54.5 cm). Ssu-hua Collection, Birmingham

I passed by the Old Man Peak, where the rock looks like the hunched back of an old man. There are many unusual pines extending out beyond the cliffs. They break through the rocks to grow forth and form a cover with their intertwining branches. The luxuriant white clouds rushed up on the pines. A monk said, "The clouds are about to spread out and form a sea; why not wait awhile and see it?"

I therefore rested at a pavilion that faced the peaks. From the heights of this mountain I had a complete view of the vast landscape of mountains and rivers; it all became a sea. When it is about to rain, clouds collect in a bunch around the mountain. When it is about to clear, the clouds disperse and return into the mountain. This collection and dispersal throughout the vast landscape of mountains and rivers is what is called the "Sea of Clouds." …Openings are pierced by light, then the clouds rush forward and brush against each other, looking like hundreds of towers and pavilions, like galloping horses, like sailboats—racing, leaping, retreating, merging… Proceeding along the foot of Celestial Capital Peak and turning westward, I arrived at Manjusri's Temple and spent the night there.

(Strassberg, *Inscribed Landscapes*, pp. 315–16)

Residential Architecture

Within the broader physical and cultural landscapes of Anhui lay the material surroundings of daily life. Relatively little of early domestic architecture survives, and hence our emphasis has so far been on religious and palace buildings. Significant numbers of Ming-period houses do remain in the Anhui and nearby Jiangxi regions, however. Some of these were merchants' houses, which had to balance aspirations for luxury and display against the restrictions imposed by official sumptuary laws that regulated consumption, building, and dress according to social rank. By the late Ming, such regulations were often transgressed or ignored, but they did have some effect in limiting the size of residences for even wealthy merchants.

Surviving houses in the Shexian region of Anhui or nearby Jiangxi are typically urban courtyard houses, with whitewashed masonry or brick walls facing the street (FIG. 9-19). For security and privacy, openings in the outer walls are usually limited to the doorway and a single window, with light and fresh air provided by one or more inner courtyards open to the sky. Doorways became focal points of decoration and status display. Sometimes doors were fashioned in the form of embedded ceremonial gateways, or *paifang*, which

9-19 Residences, Yi County, Anhui
Ming–Qing (1368–1911)

as free-standing ceremonial structures of pillars and transverse beams were awarded as honorific commemorations for official service and other meritorious public actions. Otherwise, door frames were often decorated with richly carved brick or stone low-relief sculptures of auspicious plants and figures. In more modest houses door paintings often took the place of sculpture. Combined with the rectilinear stepped profile of end walls characteristic of houses in this region, the door-framing elements lend a strongly articulated quality to the architecture.

Along with entry decorations, the other main method to compensate for size restrictions was in the lavish carving of interior wooden elements such as roof beams, window sashes, and cantilevered balconies (FIG. 9-20). The second-floor rooms surrounding the courtyard made efficient use of restricted townhouse space, allowed more sunlight to enter the upper rooms, and provided privacy for female members of the household while permitting them to overlook the courtyard. Inhabitants also used upper-floor rooms for storage of food and other items. The multilayered and compartmented wooden balconies were often richly carved with floral designs, and window sashes were filled with intricate

geometric patterns. Large curved roof beams and the brackets of supporting members could be similarly carved with cloud volutes or floral designs. Roof beams in official buildings were sometimes decorated with bright colors reminiscent of textile designs, but those in merchant houses were mostly painted black. The extensive use of carved wood in the interiors of Anhui residences gives them a particular warmth. Material comfort extended to the use of devices for winter heating and summer cooling (see "The Arts of Living: Leisure, Pleasure, and Material Culture," page 340).

Hardwood Furniture

Along with residential architecture, furniture and craft objects shaped the material environment and culture of late Ming and Qing living. Such objects embodied aesthetic tastes but also participated in the organization of social life and the expression of values. Best known among later Chinese furniture are the plain hardwood types, especially those known as *huanghuali* and *zitan*, often referred to in English as rosewoods. These dense and fine-grained woods presented several kinds of choices even before they were shaped into furnishings.

9-21 Models of study furniture

Ming, Wanli era (1573–1620). Tomb of Pan Yunzheng (16th–early 17th century). *Ju* wood and brass, height c. 1¾–10⅝" (4–27 cm). Shanghai Museum

This miniature-scale suite of model hardwood furniture from the tomb of a late-Ming-dynasty official suggests the grouping of interior furnishings that might be found in the homes of the well to do. Included are an armchair and writing table, a daybed, clothing chests, and other items that reflect an interest in practical comforts, cultural performance, and status display.

9-22 Folding roundback chair

Ming–Qing (1368–1911). *Huanghuali* wood with brass mounts, 31 × 15 × 15" (78.7 × 38 × 38 cm). The Nelson-Atkins Museum of Art, Kansas City

They were expensive woods imported from far southern China or Indochina that showed to best advantage when the grain patterns were unpainted. The hardwoods therefore represented an alternative to colorful, deeply carved lacquered or inlaid furniture (see FIG. 8-9 above). Hardwood furniture also became linked to scholarly tastes and thus associated the owner with qualities of simplicity and refinement, whatever his or her actual status or personality. These furnishings depended for their effect on the color and grain of the wood, the artfulness of joinery without nails, clean lines and careful balancing of proportions, and subtle carved decoration.

While modern collecting practices tend to focus on pieces as individual works of art, furnishings were objects of daily use as well as appreciation and were displayed in groups as part of architectural interior arrangements. Many illustrated books of the period indicate how furniture was used, and some recent archaeological discoveries of scale-model wood furniture from the late Ming period offer a glimpse of furniture ensembles. The tomb of Pan Yunzheng, a late Ming official, contained model sets of bedroom and study furniture. The actual size of the model study furniture illustrated here (FIG. 9-21) is from about 2 to 10 inches (5–26 cm) in height, but the

forms and even the joinery techniques of contemporary Ming furniture are shown in exact detail. The study ensemble includes an armchair and table that could be used for writing or painting, a rattan-covered daybed that could be used for sitting or leisure activities, standing cabinets for clothing or object storage, as well as clothing racks and stands for chests, washbasins, and charcoal braziers. Furniture thus addressed requirements for the practical necessities of domestic life, cultural activities, and displays of social status all at once.

Suzhou had a reputation as a center of fine furniture manufacture, but workshops probably operated in most major cities. The functional ingenuity and architectonic elegance of the best Ming-period furniture is visible in examples such as the folding roundback chair (FIG. 9-22), with fine relief carving of scrolling vines and flowers on the back support. Such chairs were easily transported and could be used out of doors, but even large cabinets and alcove beds could be relatively easily disassembled for the frequent moves that officials had to undertake. In this chair, the dynamic equilibrium between straight and curved elements is particularly striking.

9-23 Canopy bed with full-moon opening
Ming (1368–1644). *Huanghuali wood*, 7′4½″ × 8′1″ × 6′1″ (2.27 × 2.47 × 1.87 m). The Palace Museum, Beijing

Gender relationships could be embodied in furniture along with social and cultural roles. Large canopied beds, the central elements in sleeping rooms, could function almost as self-contained rooms when equipped with curtains, cushions, and portable armrest and tables. Such beds were often prime components of women's dowries and remained at the center of the woman's domestic life (and legally her possession) throughout a marriage. While beds are structurally similar to low tables with the addition of a superstructure of railings, posts, and canopy, they are often elaborately decorated with carving on the base and openwork in the frame above. A canopy bed with full-moon opening (FIG. 9-23) conveys the character of a room with windowlike elements, and the intricate lattice pattern of linked cloud motifs in the frame is also close to the patterns found in architectural windows.

Craft Objects from the Suzhou Region

Domestic interiors also held ornamental and luxury objects of considerable variety, including functional and decorative objects for the scholar's desk—bamboo brush holders, inkstones, ceramic or jade water droppers, softstone seals—and an array of antiques and curios for the study as well as for living and sleeping rooms. These objects were not unique to the period, but this era saw a considerable investment in increasing the variety and ingenuity of craftsmanship in these and other media. A related phenomenon was the widespread awareness of individually famous craftspeople. Although some individual pieces bear craftsmen's signatures, their names often served as studio, factory, or even brand names belonging to collective and long-lasting enterprises, while bearing witness to the increasing

The Arts of Living: Leisure, Pleasure, and Material Culture

The arts and pleasures of living became important themes in seventeenth- and eighteenth-century writing. Matters of taste and consumption were the subjects of connoisseurs' guides and handbooks, and the material comforts of life occupied many essayists. The intellectual and spiritual pleasures of leisure and retirement were not new subjects, but in this period there was increased attention to tangible inventions and devices that made daily life more convenient, efficient, or comfortable. A parallel situation can be found in eighteenth-century Europe and North America, when designs aimed at domestic comfort and efficiency occupied the energies of men such as Thomas Jefferson. The prosperity of late Ming and early to middle Qing China created opportunities for extravagance but also for thoughtful efforts at improving the quality of everyday life.

The authors quoted below were urbane, educated gentlemen but not immune to the perils of rapid economic change. Li Yu (1611–1680) was a playwright and bookseller, the publisher of the *Mustard Seed Garden Manual of Calligraphy and Painting* (see FIG. 9-5 above). His essays in *A Temporary Lodge for My Leisure Thoughts* are full of domestic details concerning interior design, clothing, food, adornment of women, and inventions aimed at increasing the comforts and pleasures of daily life. The latter included a heated armchair for winter and a porcelain cooling bench for summer. He also developed the "landscape window," a framed view of scenery that changed with the days and seasons like a living painting, and the "fan-shaped window" that provided pleasure-boat travelers with a changing panorama within the format of a fan painting. Shen Fu

(1762–after 1803) was the author of the autobiographical *Six Records from a Floating Life*, which includes chapters on the pleasures of leisure and travel. The autobiography is notable for the prominent role Shen Fu's wife, Chen Yun, who is given credit for many of the inventions and domestic improvements Shen Fu records.

Li Yu on domestic architecture:

A man cannot live without a house as his body cannot go without clothing. And as it is true of clothing that it should be cool in summer and warm in winter, the same thing is true of a house. It is all very imposing to live in a hall twenty or thirty feet high with beams several feet across, but such a house is suitable for summer and not for winter. The reason why one shivers when he enters an official's mansion is because of its space...

(Mao and Liu, *Li Yu*, pp. 24–25)

Shen Fu on flower arranging and appreciation:

Every year chrysanthemums would grow east of the fence, blooming in the autumn. I preferred to pick them and put them in vases, rather than raise them in pots [see FIG. 9-7 above]... when putting chrysanthemums in a vase one should select an odd number of flowers, not an even number. Each vase should contain flowers of only a single color. The mouths of the vases should be wide so that the flowers can spread out naturally... Some of the flowers should stand up gracefully, while others spread out at angles. Some should be high and some low, with a few buds in between, to keep the arrangement from looking stiff and unnatural... No more than seven vases should be set on one

table, or... the arrangement will look just like the cheap chrysanthemum screens sold in the markets.

(Pratt and Chiang, "The Pleasures of Leisure," *Six Records of a Floating Life*, pp. 56–57)

Shen Fu on garden design:

In laying out gardens, pavilions, wandering paths, small mountains of stone, and flower plantings, try to give the feeling of the small in the large and the large in the small, of the real in the illusion and of the illusion in the reality. Some things should be hidden and some should be obvious, some prominent and some vague... Here is a way to show the real amidst an illusion: arrange the garden so that when a guest feels he has seen everything he can suddenly take a turn in the path and have a broad new vista open up before him, or open a simple door in a pavilion only to find it leads to an entirely new garden [see FIGS. 8-3 and 8-6 above].

While Yun [his wife] and I were staying with the Huas at Xishan, Madame Hua had her two daughters learn characters from Yun. As they studied, the summer sun beat down with a fierce glare in the courtyard of their country home, so Yun showed them how to make moveable screens out of live flowers... The screens were about six or seven feet tall, but two people could easily move one of them. They can be put anywhere you like, filling the windows with green shade and blocking the sun while letting a breeze through. If you make several, they can be set out in winding patterns that can be rearranged as you like; thus they are called "moveable flower screens."

(*Six Records of a Floating Life*, p. 63)

market value of fame and public recognition in the arts. Most craft objects, however, were anonymously or cooperatively produced.

The background for the development of Ming–Qing individualized craft traditions is seen as early as the Yuan dynasty in the work of a silversmith named Zhu Bishan, who was active in the prosperous commercial city of Jiaxing, between Suzhou and Hangzhou. His silver goblet (FIG. 9-24) is elaborate in both technique and conception. It is a small-scale sculpture of cast and carved silver about 7 inches (18 cm) high, in the form of the Tang poet Li Bo reading on a raft fashioned as a gnarled old tree trunk. The flowing curves of the tree and its textured bark, along with the posture of the figure, convey a mood of floating relaxation, appropriate to the image of the poet as a river-borne drinker and to the function of the goblet as a luxurious drinking vessel. The goblet bears an unusual amount of inscribed text, including Zhu Bishan's signature, the title "Dragon Raft," and a poem by Du Fu alluding to Li Bo's drinking.

Other sculptural media focused on implements for the scholar's desk included carved bamboo objects such as brush holders, which gave rise to local schools in Jiading, near Suzhou, and in Nanjing, and carved inkstones, used for grinding and diluting compressed ink sticks and cakes. Inkstones were prized for their associations with famous literary men as well as for their shapes, textures, and carved decorations, and they were collected and independently appreciated as far back as the Tang period. An inkstone of yellowish green limestone decorated with the shallow carving of a phoenix enfolding both sides of the stone is signed by an eighteenth-century carver named Gu Erniang, notable not only in her status as an individual artisan but as a named woman artisan (FIG. 9-25). Gu married into a Suzhou family with a long reputation for inkstone carving, suggesting one of the avenues by which continuity of family and workshop traditions was achieved. Scholars' implements conventionally were male cultural objects, but increasingly in the Ming and Qing periods women from elite families as well as courtesans participated actively in literary and artistic culture.

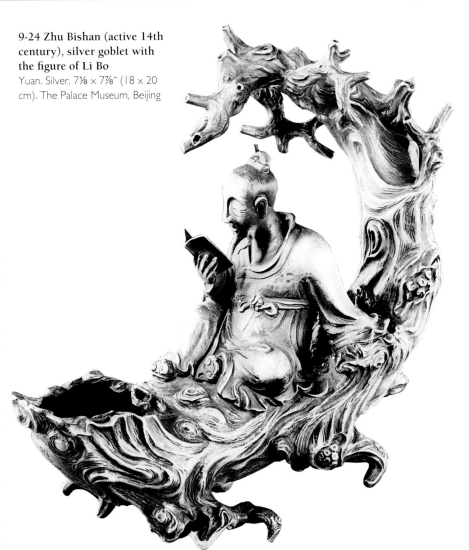

9-24 Zhu Bishan (active 14th century), silver goblet with the figure of Li Bo
Yuan. Silver, 7⅛ × 7⅞″ (18 × 20 cm). The Palace Museum, Beijing

9-25 Gu Erniang (active early 18th century), inkstone with carving of phoenix
Qing. Yellowish green limestone, length 5⅛″ (13 cm). The Metropolitan Museum of Art, New York

An unusual surviving signed object made by a female craftsperson, this carved inkstone shows the participation of eighteenth-century women in elite tastes as both producers and consumers. Educated women wrote and painted using the same implements of the scholar's desk as men, although here the phoenix design conveys feminine associations.

The phoenix is often symbolically associated with the wife or female member of a couple, and the quality of the carving here, at once delicate and ornate, with the wings embracing the top of the inkstone and the tail feathers sweeping down the underside, might suggest a conventionally feminine style also.

Suzhou was famous for many other crafts as well, including jade carving, woodblock carving for pictorial prints (with some fifty shops in the city in the eighteenth century), furniture manufacture, and most of all for fine silk production. The period's accomplishment in these and other craft media can only be suggested here by surviving objects from the palace collection, which drew on talented artisans from throughout the empire (see FIGS. 9-32 and 9-40 below).

Ceramics for Domestic Markets

The circulation of styles and information in Ming and Qing culture took many forms. Urban artists and craftsmen aspired to something of the prestige and technical sophistication of court-sponsored arts while responding also to popular and merchant tastes, and foreign modes impacted on both court and urban arts. A case in point is another arena with multiple orientations, the porcelain-production industry centered at Jingdezhen in north-eastern Jiangxi Province. Large-scale production for domestic, foreign, and court markets coexisted at the same site, making use of a broadly shared technology and artisanal talents. However, differences in taste, materials,

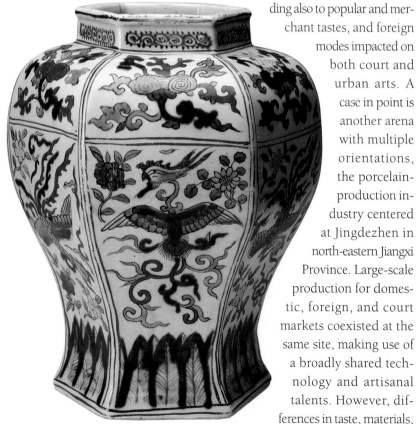

9-26 Hexagonal baluster vase
Ming. Longqing mark and period (1567–72). *Wucai*, porcelain with underglaze blue designs and overglaze enamels; height 10″ (25.4 cm), diameter 8¼″ (21 cm). Asian Art Museum, San Francisco

financial support, and organization of production could result in very different wares. One of the most popular domestic wares in the late Ming period was the polychrome type known as "five-color ware," *wucai*, porcelains with underglaze blue designs combined with from three to eight or more overglaze enamel colors. The decor on a hexagonal baluster vase (FIG. 9-26) with phoenixes among flowers and auspicious symbols is quite close in subject and color scheme to some silk tapestries, with bright primary colors of blue, red, green, and yellow forming boldly outlined patterns.

Porcelains produced at Jingdezhen for the court and for export will be discussed below (see pages 354, 357–358), but some of the economics of production are worth noting in this context. In the mid-sixteenth century more than ten thousand people were actively involved in ceramic production at Jingdezhen in what was an industrial scale of operation, with each piece, according to a seventeenth-century writer, undergoing seventy-two processing stages before completion (see FIG. 0-2 above). Private family kilns coexisted with those that were imperially sponsored, sometimes contributing to production goals for imperial tribute wares when the demand was especially heavy. The economic importance of porcelain from Jingdezhen, not to speak of other active kiln sites, was national and international as well as local, with hundreds of thousands of pieces produced for various markets. The technology of porcelain production was thus a major industrial secret, with implications for international trade balances, national prosperity, and ultimately for international power that was not lost on Europeans. Letters by the Jesuit missionary Père d'Entrecolles, who visited Jingdezhen in 1722, provided the most detailed early Western reports on the porcelain industry there. His letters were dated only a few years after the first successful manufacture of a hard-paste porcelain in Europe in 1709, achieved at Meissen by the chemist Johann Friedrich Böttger (though made from different raw materials than Chinese porcelain), working under the patronage of Augustus the Strong of Saxony. Père d'Entrecolles offered detailed accounts of the local

Chinese administration and of the technical basis and organization of production at the porcelain kilns:

> The material of porcelain is composed of two kinds of earth, one called *pe-tun-tse*, the other named *kao-lin*. The latter is disseminated with corpuscles which are somewhat glittering, the former is simply white and very fine to the touch... It is to *kao-lin* that fine porcelain owes its strength, and it is only a combination with the soft earth that fortifies the *pe-tun-tse*, which is derived from the hardest of rocks. A rich merchant told me that some years ago the English or Dutch had had purchased for them some *pe-tun-tse*, that they took to their country to make porcelain with, but that, having taken no *kao-lin*, their enterprise failed, as they confessed afterward... In the less frequented parts of Jingdezhen are vast sheds, surrounded by walls, in which one sees ranged, story above story, a great quantity of jars of earth. Inside these walls live and work an infinite number of workmen, each of whom has his allotted task. A piece of porcelain, before it leaves them to be carried to the furnace, passes through the hands of more than twenty persons... A cup, when it comes off the wheel, is very imperfectly shaped, like the top of a hat before it has been put on the shaping mold... The cup, as it comes from the wheel, is first handed to a second workman, who is seated beneath. It is passed by him to a third, who presses it on a mold, and gives it its shape; this mold is fixed upon a kind of wheel. A fourth workman polishes the cup with a knife, especially round the rims, and makes it thin enough to be transparent; each time he scrapes it, it must be moistened carefully, or it will break. It is surprising to see the rapidity with which the vases pass through so many different hands, and I am told that a vase that has been fired has gone through the hands of seventy workmen...
>
> (From the letters of Père d'Entrecolles, Bushell, *Oriental Ceramic Art*, pp. 332–58)

Père d'Entrecolles also documents contemporary Chinese interest in antiquities and methods of forgery, as well as European prejudices against Chinese painting methods. His investigations paralleled the slightly later research of Tang Ying, appointed Supervisor of the Imperial Kiln Factory in 1726. Tang Ying spent three years in detailed study of clay, pigments, mining, and firing, living and working among the potters and even decorating porcelain himself. Tang edited the *Illustrations of Ceramics Manufacture*, which included pictures documenting the twenty major processes involved in porcelain production.

Urban Professional Painters

The cities of Suzhou and Nanjing already had active groups of professional painters in the middle Ming period around 1500. These continued as centers of professional painting in the late Ming and early Qing and were joined by the nearby city of Yangzhou in the late seventeenth and eighteenth centuries. As in earlier periods, a number of late Ming and Qing professional painters had some literary education, though many were more narrowly trained artisans. While in the middle Ming, professional painters worked largely in technically accomplished styles related to the court academies, late Ming and Qing professional painting accommodated a wide range of styles, from decorative high technique to casual literati efforts. This suggests that an aura of scholarly taste had become a saleable commodity and that educated gentlemen were pushed by economic circumstances, or their own ambitions, into the art marketplace.

A glimpse into the working methods of a Suzhou-based professional painter is offered by the career of Gu Jianlong (1606–1684). Known particularly for his portraits and figure paintings, Gu also worked as a court painter in Beijing during the late seventeenth century. Such links between the imperial palace ateliers and urban studios were not uncommon, as artists recruited to the court retired or returned to hometowns and urban centers in the south. Gu may have been the artist responsible for the unsigned album, discussed above (pages 328–329), of illustrative scenes from *The Golden Lotus* painted for the Qing court, which combines refined eroticism with meticulous description of material objects and settings (see FIG. 9-12). His *Album of Assorted Copy*

9-27 Gu Jianlong (1606–1684), *Assorted Copy Sketches after Old Masters*

Qing. One of forty-six album leaves, ink and colors on paper; 11⅞ × 7½" (30.2 × 18.8 cm). The Nelson-Atkins Museum of Art, Kansas City

Along with published painting manuals, artists used personal collections of sketches to record source materials for future compositions. The professional and court painter Gu Jianlong's sketches mostly record the work of earlier court artists. His notations to this collection of figure types identify the Tang painters Yan Liben and Zhou Fang, among other sources.

Sketches after Old Masters is a rare surviving example of a *fenben*, or artist's copy-book, a ready source for motifs and styles that most probably was standard equipment for professional artists and perhaps for literati painters as well. The forty-six surviving leaves are a notebook of landscape and figure elements, including building types and costume details, probably drawn directly from originals, and often including notations identifying the stylistic source. Gu's favored models in this compendium were Southern Song court artists, and in this he continues the orientation of middle Ming professionals. The page with bust-length and seated female and male figures includes abundant notations identifying the source styles as court and professional paintings of palace beauties and shows how a finished painting might be composed directly from preexisting elements (FIG. 9-27).

This copy-book or catalogue approach to composition is thoroughly embodied in the *Mustard Seed Garden Manual of Calligraphy and Painting* (see above, FIG. 9-5) and other similar woodblock-printed compendia, which made some versions of artists' jealously guarded sketch books broadly available to interested buyers. Similar sketch books have been attributed to the painter Gong Xian (c. 1617–1689), a contemporary of the *Mustard Seed Garden Manual* editor Wang Gai in the Nanjing–Yangzhou region, though Gong's comments on the sketches still belong to the genre of studio secrets. Gong Xian held strong loyalist sentiments for the fallen Ming dynasty, expressed in poetic inscriptions on his landscapes and in the somber isolation of his scenery, with empty cottages and darkly textured blocky cliffs and trees conveying a mood of desolation and mourning. Gong Xian may seem an unlikely professional painter, because there is not much range and variety in his work and very little display of technical skill. To some degree Gong's harsh evocations of loyalism may have been his professional stock in trade, aimed at audiences with similar sentiments whose resistance to the established Manchu regime was limited to the indirect, symbolic spheres of culture. Other artists active in the late seventeenth century, such as Bada Shanren and Shitao (see FIGS. 9-15, 9-16), likewise operated at times as professional loyalists, producing nostalgic or symbolic themes in substantial numbers. Gong Xian's work shows that even a deliberately limited, systematic approach can yield results of great expressive power and complexity. His *Thousand Peaks and Myriad Ravines* (FIG. 9-28) is both oppressive and monumental in its crowded density. Some features, such as the strong dark–light contrasts, sweeping diagonal recessions, and sculpted buttes and cloud forms suggest the impact of European landscape engravings in the mannerist style, brought to Nanjing by Jesuit missionaries but here thoroughly transposed into a Chinese idiom.

At the other end of the stylistic and thematic spectrum were professional painters such as Yuan Jiang, active in Yangzhou around the time of Gong Xian's late life and on into the mid-eighteenth century. Yuan Jiang was a dynamic and masterful draftsman who specialized in elaborate architectural and landscape fantasies in the manner of Song monumental landscapes, with deep pictorial spaces and illusionistic textures. His paintings seem to have been aimed at wealthy merchants or those with pretensions to wealth,

whose ambitions he flattered with images of elaborate mansions and gardens, equipped with marble terraces and imposing rockeries.

A group portrait handscroll commemorating *The Literary Gathering at a Yangzhou Garden* (FIG. 9-29) represents the cultural life that flourished in those gardens, and the elite audiences and patrons for Yangzhou painting. The event included poetry rhyming contests, listening to zither music, flower viewing, and appreciating antiquities, painting, and calligraphy by a group comprised of retired officials, wealthy merchants, and scholarly writers and collectors. The Ma brothers, wealthy Yangzhou bibliophiles and owners of the Temporary Retreat where the gathering took place on the Double Ninth festival day of 1743, hosted the event. Their private library was one of the greatest in China, and they patronized writers and scholars by hosting them as long-term guests. The guests portrayed here included authors of works of historical scholarship, literary anthologies, and histories of court painting among others. One of the two artists who collaborated on the scroll, the landscape painter Fang Shishu, is included

9-30 Zheng Xie (1693–1765), *Ink Bamboo and Rocks* Qing, 1753. Four-fold screen, ink on paper, 47" x 7'7" (119.3 cm x 2.35 m). Tokyo National Museum

among the guests by the portraitist Ye Fanglin. Fang, who was himself a well-regarded poet, is shown reading a scroll of text in front of the table laden with antiques and wine cups. There is a deliberate serenity to the image, which glosses over some underlying tensions in Yangzhou cultural life. Collecting and patronage of high culture allowed men from wealthy merchant backgrounds to participate freely in the elite society of officials and scholars. The antiquarian interests and scholarship that occupied so many of the guests were relatively safe, uncontroversial activities in a political climate where many of those same writers had been subject to arbitrary punishments and intellectual censorship by the Manchu regime. In that light, the elegant garden precincts might be seen not so much as a privileged refuge as an agreeable prison.

The complement to merchant patronage of literati culture was what might be called the professional literatus, exemplified in the career of Zheng Xie (1693–1765), active in and around Yangzhou late in life after an official career as a magistrate. Zheng, a writer of note who throughout his life relied on selling his painting and calligraphy for financial support, eventually became quite prosperous. His subjects were almost exclusively ink bamboo, orchid, and rocks, traditionally

symbolically associated with the virtues of the scholar–gentleman, but by this time more general emblems of the educated class, and often inscribed in Zheng's boldly swelling calligraphy (FIG. 9-30). He painted these themes often in large, showy hanging-scroll or screen formats and in what must have been very large numbers. There is thus an air of formulaic mass production to his work. Zheng Xie's status as an educated official may have been as important as his skills with brush and ink in conferring value on his paintings as tokens of status, and he was not shy about calculating their value explicitly, as in his famous price list:

Six taels [a measurement of silver] for a large painting, four taels for a middle-sized one; and two taels for a small painting. Calligraphy in couplets: one tael. Fan or [album] leaf: five qian [a smaller unit of money]. Better give me silver [money] rather than any gifts or foodstuffs, for the latter may not dovetail to my needs. However, if you should bring cash, my heart will rejoice and [consequently] my painting and calligraphy will be of better quality. Gifts are troublesome, and purchases on credit even less welcome…

**9-31 Luo Ping
(1733–1799),** *Ghost
Amusement*
Qing, 1797. Detail of
handscroll, ink and color on
paper; 10½" × 8'4" (26.7 cm
× 2.57m). Xubaizhai
Collection, Hong Kong

Painted bamboo costs more than the real
 bamboo.
When the paper reaches a height of six feet
 [I charge] 3,000 cash.
Let others wrangle or argue over the price,
 It is but autumn wind passing by my ears.
 (Chou and Brown, *The Elegant Brush*, p. 169)

The prevailing commercialization of art is made
explicit here. Although Zheng may in part have
been satirizing the cruder pricing practices of
his contemporaries, some equivalent rule of thumb
relating size and subject matter to cost for paint-
ings and calligraphy was probably widespread
among artists of his day.

In keeping with contemporary practices,
Jin Nong (1687–1763), another calligrapher–
painter active in the Hangzhou–Yangzhou region
in the mid-eighteenth century, also earned money
as an art dealer and decorator of painted lanterns
and used "ghost painter" assistants to increase the
output of paintings bearing his signature. The
range of subject matter in Jin Nong's art sug-
gests the importance of variety and novelty to his
viewers, and many artists pushed their styles in
the direction of bold, eye-catching techniques.
Bird-and-flower paintings in bright colors or large-
scale paintings with rough, dynamic brushwork
and rich ink effects were popular and sympto-
matic of these trends. The taste for extreme and
extravagant cultural statements was nurtured gen-
erally by the new and competitive wealth of
salt-merchant families and in the art world gave
rise to the reputation of eighteenth-century
Yangzhou-area artists such as Zheng Xie, Jin Nong,

and Luo Ping as members of the "Eight Eccentrics
of Yangzhou." Like most such categorical labels,
this after the fact designation is too sweeping
to be very helpful and may have served as a
convenience or even a marketing device in a com-
plex market and information-oriented culture.
The stylistic and technical adventurousness of
Yangzhou artists generally made an effective strat-
egy, given the diversity of prevailing tastes. At first
glance, the *Ghost Amusement* (FIG. 9-31) scrolls
painted by Jin Nong's student and assistant Luo
Ping (1733–1799) seem to fit those charac-
terizations. The scenes are extreme in subject and
style, showing green-skinned apparitional figures
with swollen heads or rubbery limbs emerging
from vaporous obscurity. In one handscroll ver-
sion of the subject, the borders around and between
the pictures are packed with inscriptions by promi-
nent contemporary writers, proof that the ghostly
subjects held wide contemporary interest in both
literary and pictorial forms. Rather than a per-
sonal quirk or eccentricity, Luo Ping's ghost pictures
should be seen as part of a broad fad for ghost and
fantasy literature in the mid- to late eighteenth
century. Apart from answering a taste for bizarre
escapism among urban audiences, the genre per-
mitted exploration of erotic and transgressive
themes otherwise largely suppressed under Qing
literary censorship.

Luo Ping's ghost paintings
were part of an eighteenth-
century fad for stories of
ghosts and the supernatural
that engaged the talents of
many notable writers. Such
stories and pictures
answered a contemporary
taste for the novel and
strange and allowed explo-
ration of transgressive
themes of sexuality and
crime.

COURT ARTS

Although the late Ming period saw a notable weak-
ening of central authority, marked by uninterested

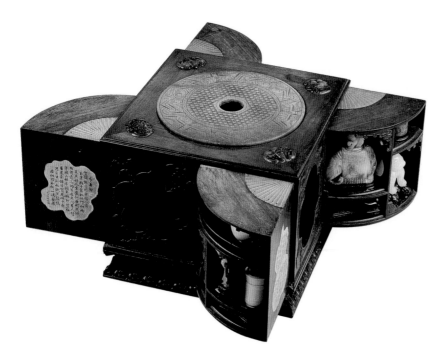

9-32 Square treasure box (*duobaoge*) containing thirty items

Qing, Qianlong reign (1736–95). Carved *zitan* wood, height 8⅛″ (21 cm), closed width 9⅞ × 9⅞″ (25 × 25 cm). National Museum, Tapei

or ineffectual emperors, factional struggles, and usurpation of power by eunuchs, the Qing regime established by the Manchus in 1644 was characterized by strong, energetic emperors and a centralization of power at court from the time of its founding until the end of the eighteenth century. Patronage and production of art by the imperial court revived spectacularly, reaching a peak during the long reign of the Qianlong emperor (1736–1795) that covered most of the last two-thirds of the eighteenth century. Centralization of authority at court had a tangible counterpart in the tide of art collecting and cataloguing sponsored by the Qianlong emperor, when the palace collections as they survive today were largely formed.

Court art in the Qing dynasty served many of the same purposes as in earlier times, gratifying the tastes of the imperial family and fulfilling the decorative, ceremonial, and recreational needs of an entire palace community. Beyond the extensive requirements of the emperor and a very large imperial family, court art production involved officials and functionaries as well as gift items for diplomatic and reward presentation. Along with palace architecture, furnishings, textiles, and painting and calligraphy for palace decoration or personal enjoyment, there was large-scale production of porcelain wares at the imperial kilns at Jingdezhen,

of enamelware and cloisonné at palace workshops, as well as Lamaist Buddhist bronze and wood sculpture, jade and ivory carving, luxury glass, and jewelry. The members of the Qing imperial family were voracious accumulators and consumers of art and luxury objects, and some emperors were energetic producers of art as well. During the Qianlong emperor's sixty-year reign he personally executed more than 2,500 works of painting and calligraphy and inscribed appreciative inscriptions on thousands more. The range of imperial acquisitiveness is represented in microcosm in the treasure boxes (*duobaoge*) filled with miniature objects in diverse media. The example illustrated here (FIG. 9-32) houses thirty objects in custom-fitted, sometimes hidden, compartments within a hardwood case. The objects are a tiny fraction of the million or more in the imperial collection of the Qianlong era. This and other treasure boxes include miniature paintings and calligraphies, ancient and contemporary jades and ivory carvings, bronzes, and other decorative and exotic objects. The large-scale, sometimes illustrated cataloguing and documentation projects for objects in the imperial collections also manifested the desire to possess and control material tokens of history and empire embodied in the treasure boxes.

Ideological functions were thus embedded in collecting activities at court, and they are prominent in much of the art produced there as well. The Qing was a Manchu conquest dynasty ruling over vast territories and multiethnic populations, including the majority so-called Han Chinese,

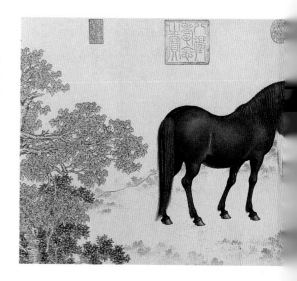

each with significant differences in language and customs. As a land empire the Qing was constantly concerned with potential troubles from border populations of Mongols, Central Asians, and Tibetans. The Manchu regime emphasized the doctrine of "The Great Unity," which implied not only geopolitical unification but also a union of complex, multiethnic, and multicultural populations. Some forms of court art directly promulgate this ideology of Manchu authority and unification. The "Southern Tour" pictures, a series of monumental handscrolls collaboratively produced by groups of court painters, commemorated the multiple inspection tours carried out by the Kangxi emperor between 1684 and 1707 and by the Qianlong emperor between 1751 and 1784. The tours were designed to assert the pacification of the southern regions, especially in the southeastern Yangzi River valley, that had been centers of resistance by the Ming regime and their loyalist subjects, and to examine conditions in the regions that were the economic engines of Qing prosperity. Tours included ceremonial display of the large imperial retinue, sometimes lavish expenditure and construction on the part of local hosts to provide the requisite hospitality, and inspection of historical sites and public-works projects such as flood-control dams. Thus the tours were great visual spectacles and material projections of imperial power in circulation.

Another kind of overt, though less grandiose, pictorial embodiment of Qing authority is the handscroll depicting the *Qianlong Emperor Receiving Tribute Horses from the Kazaks* (FIG. 9-33). The emperor and his officials are raised above the Central Asian emissaries on a marble platform, with the Qianlong emperor given pride of place by his central, seated position and a framing screen. The emissaries are shown in deferential attitudes or performing prostrations. Central Asian horses were prized tribute items and emblems of power in the imperial stables from as far back as the Han dynasty and were frequently represented in painting and sculpture. What is new here is the architectural perspective and full modeling of portrait faces and figures with light and shadow, the contribution of the Italian Jesuit painter at the Qianlong court, Giuseppe Castiglione (1688–1768), given the Chinese name Lang Shining. The talents and techniques of the European artist are another kind of offering in the service of the Qing court.

Many other forms of court art had political and ideological implications, even when not directly illustrative of diplomatic or military events. The large-scale production of Tibetan Buddhist *thangka* paintings, sculptures, and ritual objects is a case in point. Cultivation of Tibetan religious leaders and Lamaist Buddhist practices was in part designed to insure peaceful relations with neighboring Tibet and Mongolia. Visiting Dalai and Panchen Lamas brought religious objects as tribute gifts and were rewarded with religious presentation items from the court.

Even the few examples cited here make it clear that despite the emphasis on a "great

9-33 Giuseppe Castiglione (Lang Shining, 1688–1768), *Qianlong Emperor Receiving Tribute Horses from the Kazaks* Qing, 1757. Handscroll, ink and colors on paper; 17¾" × 8'7½" (45 cm × 2.67 m). Musée Guimet, Paris

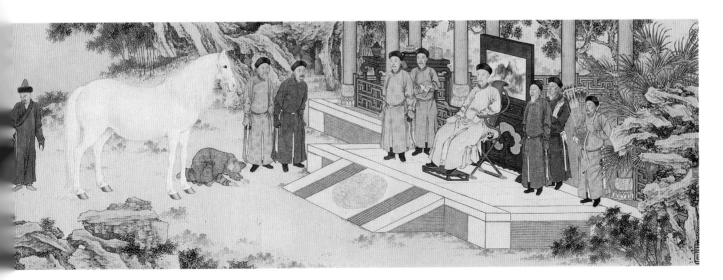

unification" and the centralization of authority under the Qing rulers, court art encompassed much more than the imperial palace in the Forbidden City. Architecturally, the court included summer palaces near Beijing and at Shenyang, Manchuria, in what is now Liaoning, far to the northeast, as well as a summer resort and Tibetan-style religious building complexes at Chengde, also known as Jehol (northern Hebei). Ceremonial buildings and altars around Beijing and imperial tomb complexes were part of the imperial ritual world. The southern inspection tours physically projected the court into the southeastern regions of the country, and patronage of Lamaist Buddhism engaged Tibet and Mongolia. Court art patronage extended massively to the imperial kilns at Jingdezhen in the southeastern province of Jiangxi, and imperial collecting extended throughout China and encompassed objects from Japan and Europe, among other foreign places. Tribute and presentation items to and from the court circulated throughout China and to neighboring regimes. Court art thus involved national and ultimately international networks of production, acquisition, and consumption.

Palace Architecture

The unquestioned center of the Qing imperial networks was the Purple Forbidden City, so designated because of the identification of the emperor with the numinous purple radiance of the Pole Star. While we have emphasized the political, military, and economic roles of the emperor, his ritual and priestly functions were equally important to the orientation and layout of the palace precincts. As the Son of Heaven, the emperor maintained cosmic order by performing annual rituals such as those at the Altars of Heaven and Earth, the Temple of Imperial Ancestors, and the Altar of Society. The Forbidden City was oriented along a dominant north–south axis that encompassed the main altar complexes, with the palace buildings facing south in a plan of great antiquity reaching back to texts associated with the Zhou dynasty. A primary dynamic of the imperial palace complex was the interplay between gateways and directional axes, which governed flow through the palace and out from it to the world beyond, and the walls and enclosures that separated and compartmentalized the Forbidden City from the empire at large and organized functions within the palace.

The city plan of Qing-dynasty Beijing was a series of nested, walled enclosures, with the central Forbidden City surrounded by a walled Imperial City of government buildings and temples, a residential Inner City, and to the south the walled commercial Outer City. The series of enclosures visible in Xu Yang's *Bird's-Eye View of the Capital* (see FIG. 0-5 above) seem in some ways a magnification of the compartmentalized treasure boxes

9-34 Hall of Supreme Harmony
Forbidden City, Beijing. Qing, 1697 and later

within which the Qing emperors symbolically controlled the culture of China (see FIG. 9-32 above). Within the palace, grand ceremonial spaces and buildings along the central axis in the front part of the complex were further separated from domestic spaces, garden precincts, offices, and workshops in the northern, rear and side precincts. The high, vermilion- painted walls within and around the palace served both practical defensive and symbolic purposes. This was very evident at the major interface between the palace and the city beyond, the 125 feet (38 m) high Meridian Gate, topped by five pavilions, which was the main entrance and also the site where edicts were issued, audiences held, and rebels publicly executed.

Most of the extant buildings in the Forbidden City date from the eighteenth-century Qianlong era, though the complex was founded in 1407 after the third Ming emperor moved the capital there from Nanjing in the southeast, and a few Ming-era buildings survive. The Qing palace buildings are more impressive for their scale and for their position within a majestically orchestrated spatial ensemble that encompasses terraces, courtyards, and vistas than for any specific architectural innovation.

The largest audience and throne hall in the palace, and one of the largest single buildings in premodern China, was the Hall of Supreme Harmony (FIG. 9-34), occupying the most prominent position along the central ceremonial axis that extends nearly two miles (3.2 km) from north to south. It was rebuilt after 1697, replacing a hall destroyed by fire in 1679. It stands with two other ceremonial halls on a three-tiered marble platform 23 feet (7 m) high. The hall and its large courtyard were used to celebrate the emperor's birthday, the New Year, and for other important proclamations and ceremonies. Twelve imposing columns across the facade form eleven bays, the widest more than 26 feet (8 m) across, and support a heavy, double-eave hipped roof decorated in the yellow tiles symbolic of imperial status, with sculptured mythological creatures set along the ridge lines.

Off the main ceremonial axis, some buildings in the rear and side precincts of the Forbidden City that were used as offices, studies, or living quarters are less grandiose in scale and are integrated with tree and rockery garden settings. The interior decoration of even domestic and studio spaces tends toward richness of materials. Of particular interest is the Sanxi Tang, or Hall of Three Treasures (FIG. 9-35), a private study for the Qianlong emperor named for three especially prized ancient calligraphies in his collection. It is a modest space by any measure, but especially within the context of the Qing palace, allowing the emperor to savor favorite objects free from the distractions of grander surroundings. The centrality of acquisition and possession in Qing palace culture is conveyed also in paintings of beauties surrounded by collected treasures produced by court artists in the eighteenth century (see above, FIG. 9-1).

The Summer Mountain Resort (*Bi shu shan zhuang*) built for the Kangxi emperor between 1703 and 1708 at Chengde, outside of Beijing, manifests another facet of palace architecture. The site was used for summer hunting parties and recreation away from the capital, in a thickly wooded, hilly region reminiscent of the Manchu homelands. The buildings are mostly modestly scaled, one- or two-story pavilions set among lakes, gardens, and rockeries, sometimes composed of simple cedar columns and rafters. The large-scale landscape gardens with designated

9-35 Hall of Three Treasures
Forbidden City, Beijing. Qing, 1723

The personal study of the Qianlong emperor is a much more intimate space than the ceremonial halls of the palace. Named for three treasured masterpieces of early calligraphy in the imperial collection, this study was where the emperor examined and inscribed thousands of his acquired objects.

literary titles built there for the Kangxi emperor were the subject of illustrative copperplate engravings, made by the Italian priest Matteo Ripa following Chinese court paintings of the site, that circulated in Europe by 1724 (FIG. 9-37). The irregularity, asymmetry, and winding pathways of Chinese garden design documented in such prints significantly impacted the so-called Anglo-Chinese style of garden design in mid-eighteenth-century England.

Buddhist Arts at Court

The Qing courts were active patrons of Tibetan Lamaist Buddhism. There is no reason to doubt the personal devotion of the emperors, but every imperial action carried political and symbolic significance as well. The diplomatic benefits of sponsorship of Lamaist Buddhism lay in maintaining peaceful relations with the Tibetan and Mongolian regions where lamas held political as well as spiritual authority.

Present-day controversies over Chinese efforts to control Tibet thus have their roots in the early Qing period, and military conflicts with Tibetan peoples date back to the Tang era (618–907). To include a full account of Tibetan Buddhist art within a history of Chinese art would itself be a politically charged choice; instead we will focus on hybrid Sino-Tibetan modes located in traditionally Chinese regions. The most important complex of Lamaist temple buildings in China is adjacent to the imperial Summer Resort at Chengde. Many of these were replicas of Tibetan temples, built to commemorate visits of important Mongolian or Tibetan lamas, and suggest a literal incorporation of Tibetan religion into Chinese imperial culture. The most extraordinary was a replica of the Potala Palace in Lhasa, Tibet, the center of Lamaist Buddhism since the Tang period, built at Chengde between 1767 and 1771. Here too was a mixture of religious and diplomatic motives, as the complex was built to celebrate an assembly of borderland leaders and

9-36 Anon., *Shadakshari Lokeshvara*
Qing, Qianlong era (1736–95), Hanging scroll, embroidery and couching on silk; 6′8″ × 34⅛″ (2.09 m × 86.7 cm). Asian Art Museum, San Francisco

the unification of the country after a rebellion. The Putuozhongcheng (FIG. 9-38), as it was called, covers some 2.3 million square feet (220,000 sq. m), running up a valley from the entrance gateways to the fortresslike Big Red Platform at the top. Chinese and Tibetan architectural modes are blended, with bulbous Tibetan-style *stupas* coexisting with yellow tile roofs in the Chinese manner. Many monuments in and around the Forbidden City in Beijing also manifest close links between the Qing imperial family and Lamaist Buddhism. The Yonghe Palace in eastern Beijing was originally built in 1694 as a princely palace but was converted to a Lamaist temple in the Qianlong reign.

The multicultural nature of Qing court culture is demonstrated even more fully in the iconographic explanatory labels attached to the backs of *thangkas*, painted or embroidered religious icons produced at court in emulation of Tibetan models. The multilingual labels include Manchu, Chinese, Tibetan, and Mongolian versions of the texts. *Thangka* subjects include diagrammatic *mandalas*, manifesting the structure of Buddhist realms, images of fearsome esoteric deities, and portraits of lamas and other religious leaders. Court *thangkas* utilized a hybrid Sino-Tibetan style, where the hieratic scale and pure symbolic colors of Tibetan icons are blended with naturalistic drawing of trees, spatial recessions, and landscapes rendered with mineral colors in the Chinese manner.

Presentation gifts to religious representatives took many forms, including elaborate silk textiles. A series of these produced in the Qianlong era includes brilliantly colored images of enthroned *bodhisattvas*, surrounded by patterns of flowers and auspicious inscriptions in Sanskrit and Tibetan scripts. The *bodhisattva* of compassion, Guanyin, is represented in the form of *Shadakshari Lokeshvara*, or *Lokeshvara of the Six Syllables* (FIG. 9-36),

9-37 Matteo Ripa (1682–1765), *One of Thirty-Six Views of the Summer Mountain Resort at Jehol*
Qing, 1712–14. Copperplate etching on paper, 10¾ × 11¾″ (27.3 cm × 29.8 cm). Philadelphia Museum of Art

9-38 Putuozhongcheng (replica of the Potala Palace, Lhasa), Chengde
Qing. 1767–71

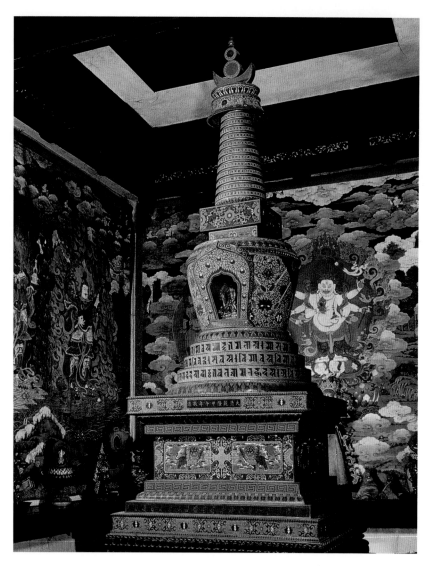

9-39 *Stupa* shrine
Qing, 1782. Cloisonné, height
7′5″ (2.31 m). The Palace
Museum, Beijing

perhaps originating among Islamic craftsmen in southwestern China, in which colored glass paste was used to fill in and decorate cells (known as *cloisons*, French for "partitions") that were outlined by copper or bronze wires on the surface of metal vessels or objects. Intense hues, often with gilding, dominated color schemes. Cloisonné objects, most often vessel shapes, were devoted primarily to palace or temple use because of their expensive and lavish technique.

Court-sponsored Crafts

The high technical achievement in court crafts during the early to mid-Qing era was due in large part to systematic organization of, and commitment of resources to, official workshops. Success in art production thus was related to administrative effectiveness and prosperity in governance at large. From the 1680s on, after the country was pacified and revenue increased, workshops were reestablished at court or supported at traditional regional centers such as the Jingdezhen porcelain kilns. An office of the imperial household administration called the Office of Manufacture and Procurement (*Caobanqu*) managed official workshops. Some were located within the Forbidden City near the emperor's residence, and emperors occasionally visited the workshops to offer personal critiques or supervision. Painting studios, workshops for hardstone and ivory carving, and a glass factory were located at the nearby Yuanmingyuan summer palace northwest of the capital. Court-sponsored kilns at Jingdezhen were supervised by appointed professional directors such as Tang Ying (not Tang Yin the painter), who worked there for more than twenty years after 1728 and was deeply knowledgeable about production processes.

a personification of his own sacred chant, or *mantra*, written in cobalt-blue Sanskrit script above. Since this form of Guanyin was thought to be incarnate in Dalai Lamas, the image was an appropriate gift from the court to the Tibetan lamas. The embroidered opalescent lotus-flower base for the throne is one of many indications of the very high level of technical achievement in Qianlong-era crafts.

An especially lavish court religious object was the gilded cloisonné *stupa* shrine (FIG. 9-39) produced for a Buddhist hall in the Forbidden City by a palace cloisonné workshop in 1782, during the Qianlong era. More than 7 feet (2 m) high, with gold, red, blue, and green colors over a copper body, the *stupa* bears winding Sanskrit *sutra* text inscriptions around a three-tiered plinth and thirteen-level tower. Cloisonné was a technique popular since the Yuan and early Ming dynasties,

The century-long period from the late Kangxi era through the reigns of the Yongzheng and Qianlong emperors was one of the most innovative in Chinese ceramic history in terms of development of glaze types and of the enamel colors painted on over the glaze and refired at lower temperatures. Refinement in technique and production gave Qing imperial wares qualities of exquisite finish. They have been prized collector's items

around the world down to the present day, although such wares often tended toward a cold, precise conservatism. The taste for revivals of Song and early Ming vessel shapes and glazes that were already perceived as "classical" by the Qing era, a mode consistent with contemporary intellectual interests in historical scholarship, also contributed to this conservative trend.

In the Kangxi era ceramicists explored several families of glaze and enamel colors. Among the difficult-to-control monochrome copper-red glazes, those that came to be known as "sacrificial red," "oxblood," and "peach bloom," from evocative variations in the glaze color and uniformity, were used primarily to decorate tall vases. More broadly important were the new combinations of soft enamel colors that used opaque white enamel to create a pastel-like effect. Known also as "foreign enamel," these soft enamels were derived from European materials. Popular both for export and imperial wares, the *famille rose* pinkish enamels and other color groups were combined with fine draftsmanship to create bird-and-flower compositions of subtle precision. Many enamel-painted court porcelain and copper vessels carried European pictorial themes. Especially notable are the shading and graded-color effects in flower petal motifs, visible also in enamel painting on copper vessels (see FIG. 9-43 below). Some of the most exquisitely refined of Chinese porcelains were produced during the brief Yongzheng era (1723–1735) using new enamel colors, including a rouge red and pale apple green.

Many different kinds of carved art objects were produced in the Qing palace workshops, with especially high output and technical quality achieved during the stable, prosperous years of the Yongzheng and Qianlong eras. Small-scale objects for decorating the emperor's study and desk included bamboo brush holders and wrist rests, carved inkstones and soapstone seals, small carved lacquer screens and boxes, jade and other hardstone brush rests and miniature sculptures, as well as decorative miniature ivory carvings of landscapes and narrative scenes. The Office of Manufacture and Procurement supervised official carving workshops with talented artisans often recruited by imperial command from traditional,

usually southeastern, local centers of craft production: Jiading in Jiangsu Province for bamboo carving, Guangzhou in the far south for ivory carving, and several centers of jade working, including Yangzhou and Tianjin. As with porcelains, eighteenth-century court taste tended toward technical virtuosity in miniaturized, complexly packed, or illusionistic carving. The many varieties of object and media contained in the treasure boxes (see FIG. 9-32 above) must here serve to represent this profusion of craft accomplishment.

At the other end of the spectrum from the exquisitely wrought miniature was the taste for the grandiose at the Qing court. The massive physical scale of the imperial palaces and the wealth

9-40 *Great Yu Regulating the Waters*
Qing, c. 1788. Jade, height 7′3″ (2.24 m). The Palace Museum, Beijing

9-41 Celestial sphere
Qing (1644–1911). Gold leaf, pearls, and cloisonné; height 32¼″ (82 cm). The Palace Museum, Beijing

(FIG. 9-40). Yu was the legendary founder of the ancient Xia dynasty, a sage–emperor credited with being the original controller of flood waters. The sculpture shows squads of laborers on diagonal pathways and ledges of the mountains, using sledgehammers and pickaxes to excavate stones and simple levered machines to drive piles. Given the importance of flood control and hydraulic engineering projects to the reputation of any Chinese regime, and the jade sculpture's theme of organization of complex human activity, it is an appropriate emblem of the achievements of the Qing rulers.

Beyond even the mythical scale of regulating the waters, a model celestial sphere (FIG. 9-41), just over 32 inches (82 cm) in height, decorated with gold leaf and inlaid with pearls, speaks for the intense interest in astronomical calculation at court. One of the chief avenues by which Jesuit missionaries gained access to the court was through their advanced knowledge of astronomical phenomena, and Jesuits were among those who staffed the imperial observatory in Beijing. Observation of heavenly events and the accuracy of the calendar were crucial to the proper regulation of the state and to the emperor's performance of vital rituals. The sphere is encircled by bands representing the celestial equator and the celestial meridian, with inlaid pearls configured as three hundred constellations and over three thousand separate stars with engraved name labels. The celestial model thus incorporates a large volume of astronomical knowledge, while at the same time functioning as a decorative object enlivened by nine supporting intertwined dragons arching up from a cloisonné enamel base.

INTERNATIONAL ARTS

Many Qing court paintings contain clear evidence of European pictorial devices, and by the Qianlong era in the late eighteenth century European elements in court architecture, enamelware, and painting were so common that it would be difficult to give an adequate account of court art without addressing the topic. European artistic impact in the late Ming and Qing eras constitutes only one

available to imperial patrons encouraged an atmosphere of lavish expenditure and excess. Often this took the form of a sheer proliferation in numbers of objects, but it could be combined with extraordinary physical size as well. Among the rarities of the Qianlong court was a huge boulder of jade, the largest single piece in the world, over 7 feet (2.24 m) high and weighing nearly 11,000 pounds (5000 kg), from Xinjiang in the far northwest. It was transported at great expense and carved over some ten years at a workshop at Yangzhou in the southeast that was under the supervision of the Office of Manufacture and Procurement, with a complex narrative scene of *Great Yu Regulating the Waters* set in a mountainous landscape

chapter in a long history of importations and exoticisms in Chinese culture. Almost as far back in time as we can recognize a Chinese polity we can find imported elements of great economic and cultural consequence: jades and horses from Central Asia; Sasanian and Islamic vessel types and designs from the Near East; Central Asian, Near Eastern, and Tibetan music, dance, and costume; jewels, ivory, timber, and exotic animals from Southeast Asia. These elements were mostly the result of border or intra-Asian trade, and although there were periods of relatively little foreign contact, in general this was of such volume and historical duration that to single out East–West trade after 1500 for special notice may seem an act of Eurocentric bias.

Nonetheless, there are historically interesting reasons for focusing on Sino-European trade during this era. Direct, large-volume, and long-distance East–West trade was a significant new factor in the world economy starting around 1550. Previously, goods from China reached Europe only sporadically through intermediary merchants. The very existence of a meaningful world economy was also new, an outgrowth of the exploration and colonization of the New World and the opening of maritime routes to Asia that had been motivated by European desires for direct access to Asian spices, tea, porcelains, and silks. By the mid-sixteenth century Asia, Europe, and the Americas were participants in interlinked economies that involved movements of goods and money around the globe. Furthermore, the structure of trade changed with the formation of public stock companies such as the British and Dutch East India Companies, which accepted investment, sold shares, and paid out dividends. The establishment of corporate enterprises that operated globally marked a new system of economic activity that is still with us today. Finally, the impact of large-scale East–West trade extended to the intellectual and political sphere. The prestige of Chinese goods and the prosperity of China lent authority to Chinese modes of political and social organization, which held great interest for European political thinkers. The seventeenth century also saw the first efforts at translation between Chinese and European languages and the beginnings of systematic sinological studies.

In discussing art in an international context, we should be wary of imposing overly rigid categories of "Chinese" and "European" identities on art forms, styles, and subject matter. The game of totaling up credits for this or that innovation or influence in some sense only perpetuates the simplistic nationalisms of earlier eras and also ignores the dynamic processes of adaptation and transformation by which cultures function. Even exotic elements are quickly naturalized and domesticated by powerful cultural systems. Thus, for example, European artists active at Chinese courts, and following the dictates of Chinese patrons, can be considered primarily as Chinese artists, fundamentally no different than Tibetan or Central Asian specialists who might be recruited for particular talents and tasks. And while we cannot ignore the European origins of certain artistic technologies such as perspective and chiaroscuro, we should recognize that their appearance in Chinese products was a matter of deliberate choice and active acquisition rather than a passive reception of influence. Similarly, Chinese ceramics, textiles, or furniture made to order for European markets could be considered primarily European arts, even though signs of exoticism in design or manufacture were part of their appeal. In many cases, it will be useful to think of international arts as hybrids. For example, a porcelain jar made in China might respond to changing European taste by imitating a colorful Japanese ware. After arriving in Europe, the jar could be dramatically transformed with the addition of French gilt-bronze mounts, changing not only the framing and effect of the jar but functionally turning it into an urn. Labeling such a complex object as either "Chinese" or "European" is probably more misleading than helpful.

Export Ceramics

Ceramics constituted one of the largest-volume exports from China to Europe. They had an especially major impact on the visual culture of Europe because they were domestic items in regular use, most often decorated with pictorial designs that could be imitated in local ceramics or transferred to other media. The European fascination

9-42 Dish, Kraak ware
Ming–Qing, c. 1635–55.
Porcelain with underglaze
blue designs, diameter 18¾″
(47.5 cm). Victoria and
Albert Museum, London

with porcelain in particular, and the quest to unlock the secrets of its production, forms an important chapter in the cultural and economic history of Europe. The export trade was dominated by the Portuguese in the sixteenth century and later, in much larger volumes, by the Dutch East India Company after 1600 and by the British East India Company after 1730. Already by 1638 the Dutch had shipped some three million pieces of Chinese porcelain to Europe, and the British conveyed several hundred thousand pieces a year in the mid-eighteenth century. The majority of these were mass-produced items, decorated, just like those exported to other regions of Asia, with standard patterns. As early as 1615 the directors of the Dutch East India Company were ordering specific items and quantities, including shapes of European origin such as beer mugs and butter dishes that were suited to the local market and customs. Drawings and models were sent from Europe to guide production, and European designs of coats of arms, Christian scenes, and the like were also made to order in China.

The letters of Père d'Entrecolles introduced above (see pages 342–343) discuss the economic risks of industrial-scale enterprise and production for foreign markets:

It is not surprising that porcelain is so dear in Europe, for, apart from the large gains of the European merchants, and of their Chinese agents, it is rare for a furnace to succeed completely; often everything is lost, and on opening it the porcelain and the cases will be found converted into a solid mass as hard as a rock. Moreover, the porcelain that is exported to Europe is fashioned almost always after new models, often of bizarre character, and difficult to reproduce; for the least fault they are refused, and remain in the hands of the potters, because they are not in the taste of the Chinese and cannot be sold to them. Some of the elaborate designs sent are quite impracticable, although they produce for themselves some things which astonish strangers, who will not believe in their possibility… The mandarins, who know the genius of the Europeans for inventions, often ask me to have brought from Europe novel and curious designs, in order that they may present to the emperor something unique.

(Bushell, *Oriental Ceramic Art*, pp. 352, 355)

The most popular export wares in the early period of European trade, from about 1575 to 1650, were those known as "Kraak" ware, a Dutch term probably derived from the Portuguese carracks, or cargo ships, that first transported the wares. A common type was an underglaze blue dish (FIG. 9-42) with a central round pictorial scene surrounded by radiating panels with floral designs and figures. Sometimes Chinese scenes are combined with European elements, such as the panels with tulips illustrated here.

After the fall of the Ming in 1644 there was some interruption in foreign trade and in the administration of the kilns at Jingdezhen. There was no slackening of European demand, which was met in part by built-up stockpiles in China and Taiwan, and by shifting production to Japanese kilns. So-called "Transitional Wares," produced in the period from about 1620 until 1683 when official kilns were reestablished at Jingdezhen, continued to be exported.

Along with export ceramics carrying Chinese, European, or mixed designs, there was a large production of enamelware vessels with porcelain or metal bodies decorated with European motifs

made directly for the Chinese court. A characteristically complex example is the vase with European figures (FIG. 9-43), painted with enamels on copper. This eighteenth-century vessel displays a large cusped panel of a bucolic couple in a landscape with a European-style building. On the neck of the vessel above, a smaller panel shows birds amid blossoming branches and bamboo in a thoroughly Chinese mode representative of a vast body of courtly bird-and-flower painting, but one also practiced adeptly by the Italian Jesuit Castiglione. Meanwhile, the gilt handles are in the form of Chinese dragons found on ancient bronze vessels. The sources for European designs on enamel wares included actual examples of Limoges enamel, engravings in imported books, and model designs produced by European artists at the Qing court.

Other Export Crafts

Apart from ceramics, export crafts included enamelware, silk textiles, furniture, lacquer wares, carved ivory, metalwork vessels, and paintings in large numbers, though frequently in forms specially adapted to European tastes. Among these, only the painted paper panels used as wallpaper by Europeans were without a functional equivalent in Chinese interior decoration and were probably adaptations of Chinese scroll or screen painting panels.

Furniture provides especially prominent cases of international and hybrid arts, because it was so readily subject to imitation and adaptive reuse. Furniture was imported from a variety of Asian sources, including ebony pieces inlaid with mother-of-pearl and ivory from India, and lacquered cabinets and chests from Japan. The latter technique was known generically as "japanning" in Europe. Local imitations became one of the chief fashions in European and North American furniture produced from the 1660s until the mid-eighteenth century, practiced by amateurs as well as factories, and following illustrated

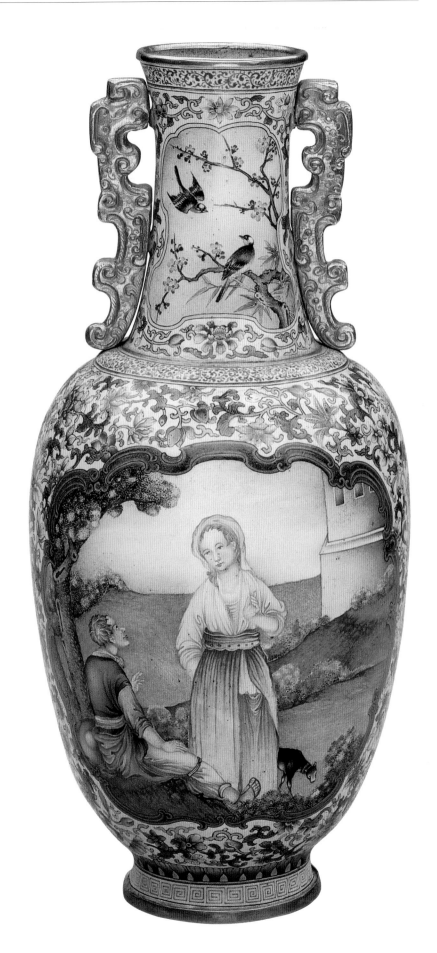

9-43 Vase with European figures
Qing, Qianlong mark and period (1736–95). Painted enamel on copper, height 8⅛″ (20.4 cm). National Palace Museum, Taipei

treatises such as that published by Stalker and Parker in 1688. Various forms of Chinese lacquer were imported as well, including inlaid lacquer screens that were sometimes cut up and used as inlaid decorative panels on European cabinets. Furnishings were among the chief vehicles for *chinoiserie*, that is, a complex of objects and art forms produced in Europe that together constructed an imaginary China.

European Arts and Artists at the Qing Court

We have already encountered some Qing court paintings and enamelware vessels that used European decorative or representational techniques, or were executed in whole or in part by European artists working at the Chinese court (see FIGS. 9-2, 9-33, and 9-43). These latter were mostly Jesuit missionaries, whose artistic talents gave them an entrée into the court and opportunities for interactions with high officials and even the emperor. That access, it was hoped, would provide a short-cut to the goal of winning Catholic converts among the Chinese elite, and ultimately the populace at large. In practice, missionary artists were often put to work at mundane labors such as in the enamelers' workshops. They had relatively little overt impact on their elite Chinese audiences, who found straightforwardly European pictorial styles powerfully affecting but lacking in artistry as the Chinese defined it. European artists were also encouraged to use Chinese media and to modify their styles into a hybrid manner that provided a smoother integration with work done by their Chinese collaborators. In the artistic sense, then, the European missionary artists were to some degree converted by their Chinese patrons.

Missionaries brought a variety of useful talents and skills to their service at court. Aside from painters, there were sculptors, architects and fountain designers, enamelers, printmakers, glass carvers, and clock makers. Most of their specialties involved particular kinds of knowledge or technical expertise, valued by their imperial patrons and applicable outside the arena of art. Mathematics, astronomy, and time-measurement skills were highly valued. The Qing emperors, as enthusiastic collectors of clocks, prized the mechanical talents of clockwork makers and fountain designers. The perspectival rendering techniques so prominent in court paintings were just a concrete application of broader mathematical knowledge. Father Ferdinand Verbiest (1623–1688), a Flemish mathematician and astronomer who served at the imperial observatory in Beijing during his years in China from 1659 to 1688, probably taught mathematical perspective techniques to a younger Chinese colleague at the observatory named Jiao Bingzhen (fl. c. 1689–1726), who later became a prominent court artist.

Among the European artists active at the Kangxi emperor's court was the Italian lay priest Matteo Ripa (1682–1765), who served at court from 1710 to 1723. He introduced the technique of copperplate engraving into China, but his most important impact may have been in Europe. His engravings illustrating the gardens at the imperial summer retreat at Chengde (Jehol) were circulating in Europe by 1724 (see FIG. 9-37 above) and provided visual information about a kind of garden design based on effects of natural landscape and asymmetry of layout, instead of the geometrical designs and careful tending of lawns and plants of the contemporary European garden. The seeming naturalness and rusticity of the Chinese imperial gardens were in fact highly deliberate, even artificial effects, achieved with great expense and labor, but their visual formulation was distinctive enough to be influential on European thinking about gardens. Chinese-style gardens came to stand in Europe for values of naturalness and freedom from constraint, which took on political significance in local debates between English and pre-Revolutionary French thinkers, and within English political discourse. The history of the so-called "Anglo-Chinese" garden (a name bestowed by French writers who did not want the English to get sole credit for the development) thus belongs to the history of European culture and had very little basis in direct knowledge of Chinese gardens. Nonetheless, Ripa's engravings, along with written accounts of Chinese gardens and other prints illustrating Chinese architecture, provided some guidance for English estate gardens that disguised boundaries, eliminated

9-44 Yuanmingyuan,
Beijing
Qing, 1747–59

fences, and made use of asymmetrical masses of trees, ponds, and broad vistas over lawns or meadows to create effects of natural unconstraint. Vaguely Chinese or other Asian-style pavilions were often built in the gardens, along with Classical structures, to lend them an air of historical depth or exoticism. Such gardens chiefly invoked political discourses of naturalness and liberty. The uses to which imperfectly known Chinese gardens were put in Europe parallels the ways in which partial reports of an idealized and largely imagined Chinese system of government functioned in the debates among Enlightenment political philosophers such as Voltaire and Quesnay, as a rhetorical foil for local concerns.

We have already encountered the Italian Jesuit Giuseppe Castiglione (1688–1768), who served at the courts of all three major Qing imperial patrons, the Kangxi, Yongzheng, and Qianlong emperors, over the long period from 1715 to 1766. Like most European artists at court he was given a Chinese name (Lang Shining) to signal his absorption into the Chinese cultural system. He was the most broadly talented of the missionary artists

and painted many images that celebrated the glory or promoted the ideological motives of his patrons: imperial portraits, court audiences, treasured horses from the imperial stables, other pets and exotic animals, and battle scenes among others (see FIG. 9-33 above). He was also asked to collaborate with other missionary artists in designing European-style buildings and fountains for one section of the Yuanmingyuan grounds, part of the summer palace and garden complex in the northwest suburbs of Beijing. The marble buildings, which were damaged by European expeditionary forces in 1860 and suffered from neglect, fire, and vandalism in the years before and since that attack, exist now only as ruinous fragments (FIG. 9-44), but a series of copperplate engravings document their original appearance. Palaces, gateways, fountains, and gardens re-created an entire European palatial environment in somewhat reduced scale, in some ways like an architectural collection or a much magnified version of a treasure cabinet. The site was in many respects the counterpart of the Chinese-style pavilions decorating European gardens of the time, though

9-45 Athanasius Kircher (1602–1680), *Portraits of Fr. Matteo Ricci and Paulus Hsu*
In *China Illustrata*, 1677. Stanford Book Collection. Stanford University, California

P. Matthæus Riccius Macerat. è Soc. Jesu
prim.̃ Chriãnæ Fidei in Regno Sinarum
propagator.

Lij Paulus Magnus Sinarum Colaus
Legis Christianæ propagator.

C c

more architecturally accurate because of the participation of European designers. The larger Yuanmingyuan complex was founded by the Kangxi emperor and successively modified in the Yongzheng and Qianlong reigns. It functioned as an outlet for the fantasies and recreational needs of the emperors, realized on a grand scale.

European Images of China

Europeans had a potentially wide range of sources of information about China. Material artifacts of Chinese culture such as porcelains, furniture, textiles, and other craft objects circulated widely. Textual and pictorial reports from missionaries and travelers with direct experience of China were available, though many pictorial images were mediated and filtered in transmission. For example, one important seventeenth- century source of information about China was the 1667 publication *China Illustrata*, edited by the German Jesuit scholar Athanasius Kircher (1602–1680). He based his account on the reports of Jesuit missionaries such as Matteo Ricci and on the books and pictures the Jesuits sent back to Rome, rather than on personal experience. His accounts are thus second-hand compilations, and his illustrations are altered by the process of translation from the original medium to engravings and by the representational habits of the local

9-46 Pyramidal ceiling in the "Porcelain Salon"
1661–87. Santos Palace, Lisbon

The craze for Chinese blue-and-white porcelains led to the construction of "porcelain rooms" all across Europe from the late seventeenth century on. Divorced from their original functions, blue-and-white wares were used as architectural decorations and as emblems of fascination with things Chinese.

illustrators. A pair of religious images rendered in line drawings preserve much of the iconograpy of the originals, and some architectural renderings offer useful information about Chinese buildings. However, most of the illustrations have a distinctly European quality in costume and interior details, and many are imaginative fabrications based on textual or oral accounts. Kircher's engraved *Portraits of Fr. Matteo Ricci and Paulus Hsu*, the latter Ricci's Chinese convert and associate, conveys some of the complex mutualities of European–Chinese relations (FIG. 9-45). The two figures are alike in dignified demeanor and even broadly similar in dress. Part of the success of the Jesuits in China was due to their learning and seriousness of purpose, which put them on the same plane as Chinese scholar–officials. In turn, the high esteem in which things Chinese were held in Europe was due in part to the projection of wisdom and gravity by Chinese statesmen. The wall plaques include a framed painting of the Virgin and Child, a Chinese text in ancient script, and two transliteration sets of Chinese characters and Latin Romanizations. Translation of Christian and scientific texts into Chinese and of Chinese historical and moral texts into Latin was one of the chief projects of the missionaries. The Virgin and Child image on the wall recalls Chinese accounts of religious paintings brought by Ricci to China, which impressed Chinese viewers with their lifelike solidity and modeling of facial features with highlights and shadows.

Other influential early textual sources on China included the Dutch writer Johan Nieuhoff's 1673 *An Embassy to the Emperor of China*, which included engravings of Chinese cities and pagodas based on Nieuhoff's visits around 1635. For eighteenth-century Europeans, the most important source was Father J.B. du Halde's encyclopedic *Description of the Empire of China*, of 1735, based on his compilation of letters and reports from Jesuit missionaries there. The compendium treated geography, history, politics, and physical description and included translated excerpts from classical philosophical texts and some poetry, fiction, and drama. Literary excerpts offered Europeans another source of views of China, and writers as important as Voltaire and Goethe rendered their own conceptions in versions of a play included in du Halde's encyclopedia, a Yuan-period drama called "The Orphan of the House of Chao." Finally, writers and philosophers such as Gottfried Wilhelm Leibniz (1646–1716), Montesquieu (1689–1755), Voltaire (1694–1778), and Freiherr Christian von Wolff (1679–1754) offered their own understandings and constructions of China in discussions of political philosophy and statecraft. For most of the period from the late seventeenth to the late eighteenth century, European Enlightenment thinkers held China in very high regard. It was seen as a model for Europe in this period in the arenas of civil life, ethics, and politics. China was portrayed by many as a philosopher's state, run by scholars chosen on the basis of merit rather than birth, which practiced religious tolerance, maintained public order and an agriculturally based prosperity, all under the aegis of an enlightened despotism that seemed to follow laws of natural order.

There was much idealization and projection of European concerns in such images of China, which were sometimes criticized for their inaccuracies by contemporary European writers with different agendas. There was also some basis in fact for such accounts. Indeed, a mixture of fact, fantasy, and fable is characteristic of most European images of China, from philosophical writing, fiction, and travel literature to pictorial illustrations. Even the direct material traces of Chinese culture found in imported craft objects were intermingled with hybrid imports made in China to suit European tastes, or with European imitations, or with fantasy *chinoiserie* products. Images of China that are amalgams of concrete data, mediated reports, wishful thinking, nostalgia, and projected fantasies are, of course, still very much with us today.

Chinoiserie, as the European styles that mixed exotic, vaguely East and South Asian themes and media came to be known, is often dismissed as derivative or trivial and, most of all, inauthentic. Still there was a large investment of resources and interest in such styles. For more than a century *chinoiserie* constituted a significant movement within ceramic and textile production, lacquerware, furniture, interior and garden design,

metalwork, tapestries, and pictorial art. Because *chinoiserie* belongs firmly within the history of European art, it lies beyond the focus of this book. We should, however, note the participation of major artists such as François Boucher and Giovanni Battista Tiepelo in *chinoiserie* projects, as well as the potential for *chinoiserie* to generate entirely new artistic configurations, unprecedented in either Europe or China. Such is the case with porcelain rooms, best known from the German term *Porzellanzimmer*. These had a vogue all over Europe from the late seventeenth to later eighteenth century and were in part manifestations of the European mania for porcelain and the fascination that the secrets of its production held for the European imagination. Porcelain interior decoration of European palaces could rely on imitation Chinese blue-and-white tiles or other objects produced at the Dutch kilns at Delft or elsewhere. In a number of cases, artists incorporated copious numbers of Chinese porcelain vessels into the designs, in part as a reminder of the wealth and collecting acumen of the patron. A notable example is the bedroom in the Santos Palace Collection

in Lisbon, where the pyramidal ceiling is decorated with some 260 pieces, primarily Ming blue-and-white porcelain (FIG. 9-46). The decoration of the room was carried out under the ownership of a nobleman of the Lancaster family between 1664 and 1687. Many of the pieces date back to the sixteenth century, including four large dishes in the center of each side of the ceiling from around 1500. They represent several generations of collecting activity on the part of both the Lancasters and the previous owner of the palace, Don Manuel I, king of Portugal from 1495 to 1521, who sponsored maritime expeditions attempting to reach China and was intensely curious about all things Chinese. Such porcelains were ordinarily considered luxury items for use in banquet service. Their display as architectural decorations creates an almost dizzying effect of massed pattern and testifies both to pride of possession and to the status of Chinese porcelain in seventeenth-century Europe. The architectural scale and pyramidal arrangement turn the room into something like a shrine dedicated to the veneration of porcelain and other things Chinese.

10 IDENTITY AND COMMUNITY IN NINETEENTH- AND TWENTIETH-CENTURY CHINESE ART

THE PAST TWO CENTURIES have been among the most turbulent in China's long and often troubled history. The most epochal changes came in the political arena with the collapse of the imperial system and the founding of a Republic in 1912, and the establishment in 1949 of the People's Republic of China by the victorious Communist Party following civil war at the end of World War II. Those transforming events were embedded within a painful landscape of warfare, rebellion, and social dislocation reaching well back into the nineteenth century. Repeated encroachments, annexations, and invasions by foreign powers, of which the Opium War (1839–1842) and two Sino-Japanese Wars (1894–1895, 1931–1945) were only the most flagrant, alternated with equally devastating internal conflicts, among them the Taiping Rebellion (1850–1864), the Chinese Civil War (1945–1949) and the Cultural Revolution (1966–1976). Tens of millions of people died in these conflicts, and the further cost in destruction, dislocation, and human suffering was enormous.

Amidst all this turmoil, the cultural sphere was, if anything, even more complex, driven by multiple pressures and conflicting forces. Art was politicized and at times was turned into an instrument of warfare and class struggle. Traditional local modes competed with foreign styles and media. Art movements and theories clashed with the same intensity as the political debates of which they formed a part, while the art

world was subject to the same economic disruptions and threats of physical destruction as society at large. Linking the discussion of nineteenth- and twentieth-century artistic developments does not deny the profound cultural consequences of the end of the imperial system and the establishment of a nation state in 1912. Reformist calls for repudiation of Confucian and traditional culture and its replacement by modern, Western, scientific thought and institutions, including a vernacular modern literature based on common speech and influenced by Western literary forms, as well as Western-style painting and other arts accompanied the new republic. Policies of the People's Republic of China (PRC) were at times still more radical in seeking the destruction of traditional culture and elite authority, and in demanding an activist political agenda from the arts. While explicitly political art and avant-garde movements are twentieth-century phenomena, this chapter emphasizes cultural structures and concerns that link the last two centuries.

One of the most important of these ongoing themes involved changing power relationships between China and the West. As we have seen, relations between China and Europe in the seventeenth and eighteenth centuries were by and large cordial and mutually respectful. This was in part because the two regions maintained a benign distance and ignorance of one another, and also because of a general balance of power and prestige. During this era China was prosperous and

10-1 Liu Dahong (b. 1962), *Spring*
1991. One of set of four paintings, oil on canvas; 27½ × 15¾" (70 × 40 cm)

The contemporary painter Liu Dahong grew up during the Cultural Revolution years surrounded by an ever-present iconography of Chairman Mao as hero and savior. Here he appropriates a key icon of that era, the young Mao as labor organizer, and parodies the excesses of the era by showing the outright deification of Mao and the dubious quality of his followers.

a great military land force, with both its government and craft industries held in very high repute. At the same time Western European countries collectively were rising maritime and mercantile powers with increasingly impressive achievements in science and technology and were catching up with China, even in craft technologies such as porcelain manufacture. The German philosopher Leibniz (1646–1716) expressed a prevailing understanding of this cultural balance of power in his treatise "Latest News from China" of 1699. In his summary, Europe excelled in astronomy, military science, geometry, logic, and metaphysics, while China excelled in principles of civil life: ethics and politics, the tranquillity of public life, and in the understanding of natural religion.

That equilibrium of political and cultural power altered drastically, and to China's detriment, in the nineteenth century. A pivotal event, in both historical and symbolic terms, was the failed mission headed by Lord George Macartney in 1793 from the British East India Company to the court of the aging Qianlong emperor, seeking greater trade opportunities and diplomatic recognition. The mission arrived on an armed warship and brought examples of current British manufacture as unmistakable signs of developing European military and industrial capabilities. The goods, however, were taken as simply more tribute from abroad, and the diplomatic and trade initiatives that might have integrated China into an emerging modern world order were rejected. China, which had been the world leader during the Song–Yuan periods (tenth–fourteenth centuries) in science and technology, including metallurgy, armaments, and other military technology, and which had a considerable international maritime presence through the early fifteenth century, rapidly fell behind Europe in just those areas crucial to the projection of power: maritime technology, armaments, and the applied mathematics and technologies of mechanics and industrial arts. Most importantly, China lost ground in the economic infrastructures of prosperity and competitive advantage: industrial organization, machinery, and transportation. While it had pioneered the industrial scale of production and division of labor

as far back as the lacquer industries of the Han period (206 BCE–220 CE), it participated only lightly in the industrial revolution of the nineteenth century, primarily as a source of materials and cheap labor. As China's political and economic stature fell, so too did the reputation of its artistic and craft products, replaced by surrogates from the Wedgwood kilns in England or the French looms of Lyons.

The history of internationalism in China's nineteenth and twentieth centuries then became one dominated by exploitation and tragedy. The Opium Wars fomented by the British from 1840 to 1842 followed a quarter century of imports of opium into China by the British East India Company, which caused a long-term deficit in the balance of trade and consequent recession in China. The Treaty of Nanking of 1842, in which China ceded Hong Kong and was forced to open several port cities to opium imports, was just the first chapter in an ongoing saga of colonial appropriations. French and British expeditionary forces sacked Beijing in 1860, when the Yuanmingyuan imperial resort was looted and burned (see FIG. 9-44 above). The last half of the nineteenth century was filled with colonialist banqueting on the Chinese body politic and with concessions of extraterritorial rights and financial indemnities from China to the European powers, Russia, and Japan. Impoverished and diminished, the Qing imperial dynasty yielded to the Republic in 1912, but foreign intrusions continued unabated. Russia and Japan carved out spheres of influence in northeastern China and Outer Mongolia in the last years of the Qing empire, and Japan's invasion of Manchuria in 1931 began a period of domination there that lasted until the end of World War II in 1945.

The troubles that beset China were of course not entirely or even primarily due to foreign interference. Corruption and incompetence in the ruling elites, overpopulation, poor financial policies, extravagant expenditure, and over-extension of China's own empire contributed to widespread impoverishment and discontent. The Taiping Rebellions that began in 1850 inaugurated an era of uprisings that lasted almost a quarter of a century, bringing enormous destruction and social

dislocation. Likewise, the political and social tensions that led to the fall of the imperial system, the Civil War between Nationalists and Communists, and the Cultural Revolution that pitted devotees of Chairman Mao against the older generation and traditional culture were internal events (however much influenced by Western political discourses) that exacted an immense toll in economic stagnation, as well as in human lives and suffering.

Thus it would clearly be inadequate to portray China's recent political and cultural landscape primarily in terms of "China's response to the West." It would be equally misleading to deny the profound consequences of the weakening of the Chinese political, social, and economic fabric over the past two centuries, in which Western intrusions were both a cause and a symptom. In the cultural sphere, this took the tangible forms of imported Western styles, artistic educational systems, and art theories. More broadly, ongoing concerns with issues of identity and community might be seen as compensations for, or reactions to, a pervasive environment of political and cultural disintegration.

Issues of identity are everywhere in Chinese art of the last two centuries. Already in the nineteenth century the presence of foreign settlements in treaty ports such as Shanghai complicated the question of what Chinese cultural identity meant in a context of new media, audiences, and institutions. Meanwhile, the problematic nature of artists' and patrons' identities, caught between commercial motives and lingering literati values, emerged prominently in the genre of portraiture. Especially in the twentieth century, artists have been confronted with an international range of styles, schools, media, and thematic orientations, including traditional Chinese modes, in situations where choices carried political as well as aesthetic implications. Many artists had split or transnational careers, and others operated in overseas communities where the tension between Chinese cultural identity and local affiliations could be acute. For a twentieth-century China operating in an international arena structured around competing modern nationalisms, the problem of identity

reached out from the personal into the political arena, as the visual arts became an important vehicle for group identification and competition.

The importance of community in Chinese art of the last two centuries is an outgrowth of the fundamental reorganizations of social structures that occurred repeatedly over that time. The end of empire in 1912 involved a wholesale displacement of aristocrats, their retainers, and court-appointed officials. Well before that, the explosive growth of Shanghai reshuffled relationships in ways that had significant social repercussions, particularly in the commercial cities of the southeast. The influx of population from many regions, the rising importance of banking and other kinds of financial systems, and the availability of modern communications and transportation modes altered the quality of human interactions. New institutions formed and old ones evolved in response to changed conditions. In the artistic sphere, artists' associations emerged that were less like literary clubs and more like trade associations, forthrightly promoting the careers and welfare of their members.

The restructuring of work, domestic life, social relations, politics, and culture under the Communist system after 1949 could hardly have been more complete. From the rearrangement of the agricultural economy into collective forms to the destruction of old economic and governing elites, traditional society was thoroughly transformed. The arts played a role in the formation of new communities through the bonds of shared cultural forms, from peasant prints to propaganda paintings. Already in the Republican era earlier in the century, artistic movements had forged communities of shared interest among groups of modernists or woodcut artists. Some of those communities reached across national boundaries to compatible artists in the West or to diaspora populations of Overseas Chinese around the world.

IMAGES OF THE SELF

The artistic genre most directly linked to issues of identity is portraiture, which became increasingly prominent in the last two centuries as it

10-2 Fei Danxu (1801–1850), *Feelings about Former Times in the Orchard Garden*
Qing, 1849. Detail of handscroll, ink and light color on paper; 11⅜ × 41½" (29 × 105.4 cm). Zhejiang Provincial Museum, Hangzhou

engaged questions of familial continuity, personal status, and gender or cultural roles. While many Chinese portraits depicted living individuals, an equally prominent function was the commemoration of deceased ancestors and the documentation of lineage continuity in group portraits. Elements of all these purposes are intermingled in the handscroll *Feelings about Former Times in the Orchard Garden* (FIG. 10-2) painted

in 1849, just a year before the death of the painter, the southeastern professional artist Fei Danxu (1801–1850). It depicts an acquaintance named Mr. Zhang, seated in a chair in the position of seniority, along with two standing youths. The orchard setting evoked in the title, depicted in an earlier section of the handscroll, points to themes of familial continuity, of youthful fruit from the family tree. In fact, however, this is an elegiac scroll, commemorating the deaths of the two boys, Mr. Zhang's nephew and young son. Ordinarily memorial images portrayed a deceased senior member of a lineage, affirming a respectful continuity of familial roles. Portraits of dead children, made especially poignant by the empty length of handscroll separating the son from his father, seem a cruel reversal of natural order and a reminder of the bitter circumstances of much mid-nineteenth-century Chinese life. The entire painting, executed in a fine-line style, conveys both an air of refinement and, in the still unformed features of the departed youths, something of their fleeting presence and fading memory.

10-3 Zhang Xiaogang, *Bloodline: The Big Family No. 2*
1995. Oil on canvas, 5'9" × 7'5½" (1.8 × 2.3 m). Private collection

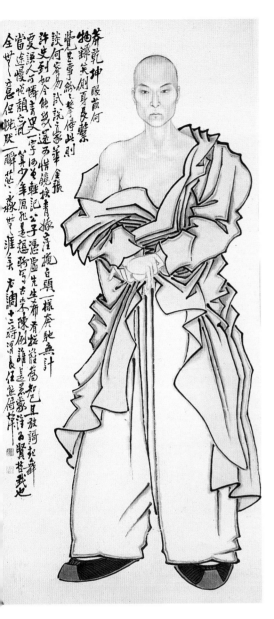

The fate of the family line under the very different circumstances of post-Mao China is suggested by Zhang Xiaogang's oil painting of 1995, *Bloodline: The Big Family No. 2* (FIG. 10-3). The lugubrious young couple, nearly stripped of personal and gender identity in what seems almost an anti-portrait, are literally draining their lifeblood via threadlike red conduits into their young son, who grows fat and ruddy even as the parents fade into a thin pallor. The hopes and focus of family identity and continuity in a generation of the politically mandated one-child family policy (where the ironic "big family" of the title should number no more than three) rest not so much on the shoulders as the sex organs of

the infant, who seems prematurely aware of the solemnity of his role.

Many nineteenth-century portraits of individuals manage both to be intensely personal and to project an awareness of public roles. A *Self-portrait* (FIG. 10-4) by Ren Xiong (1823–1857) must be only a few years later than Fei Danxu's family group, but it is a world apart in presence and demeanor. The nearly life-size figure, rendered with thick, jagged clothing outlines and heavily stippled shading that models the facial features, confronts the viewer directly. Rather than the genial or formal expression of most Chinese portraits, Ren Xiong portrayed himself as both melancholy and aggressive. Like Chen Hongshou in the late Ming (see FIG. 9-10 above), Ren Xiong was a literate professional artist. Most of his prolific output as a painter and print designer was occasional or functional, done for specific patrons or markets, without strong projection of personal concerns. Ren's long inscription on his *Self-portrait* speaks of a world in turmoil and his sense of failing to have accomplished anything significant. He may be referring to the contemporary Taiping Rebellion and to political or military ineffectualness, or to a sense of artistic inadequacy, though either concern seems surprising in someone no older than his early thirties. This self-portrait makes powerful claims in both visual and social terms and may embody a new sense of public responsibility and stature among nineteenth-century professional artists.

The discontent manifested in Ren Xiong's self-portrait is more explicitly directed at the political sphere in a portrait of the artist Wu Changshi (1844–1927) as *The Distressed Official* (FIG. 10-5). The portrait was made by the Shanghai-based

10-4 Ren Xiong (1823–1857), *Self-portrait*
Qing. Hanging scroll, ink and color on paper; 5′8″ × 30⅞″ (1.77 m × 78.5 cm). The Palace Museum, Beijing

10-5 Ren Yi (1840–1896), *The Distressed Official*
Qing, 1888. Hanging scroll, ink and color on paper; 5′3″ × 29⅜″ (1.64 m × 74.6 cm). Zhejiang Provincial Museum, Hangzhou

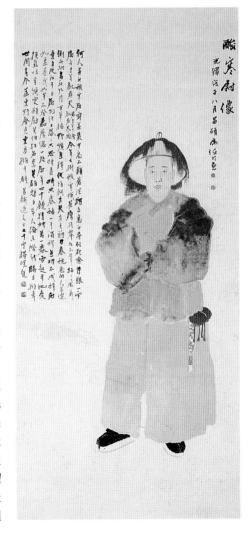

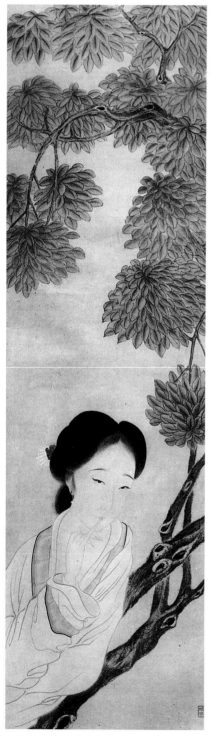

**10-6 Jiang Xun
(1764–1835), *Beauty***
Qing. One of a pair of
hanging scrolls, ink and color
on paper; 44 × 12⅞″ (111.7
× 32.7 cm). The Nelson-
Atkins Museum of Art,
Kansas City

professional painter Ren Yi (Ren Bonian, 1840–1896), who was Wu's painting teacher but was also an admirer of the better-educated Wu's performance of other aspects of elite culture, such as calligraphy in ancient styles (see FIG. 0-4 above) and seal carving. Wu had a very brief and unsatisfying career as an official, and this portrait, one of several that Ren Yi painted of him, may be a satire on his aspirations to a scholar–official's identity. The portrait originally carried a long inscription by Wu which detailed the discomforts and humiliations of a minor functionary's life, forced to endure long sessions at the government offices, rising in the morning cold and sweating in the midday heat while wearing the heavy official outfit depicted. Ren Yi's image diminishes Wu Changshi's stature by isolating him in an undefined middle-distance space, where the costume seems an awkward burden. In this and other portraits of Wu, Ren Yi seems to be negotiating his own identity in relation to his younger but more prestigious student.

The tone of passivity and complaint in Wu Changshi's poetic account of official life is one aspect of a broader pattern of feminization of Chinese male culture under the Manchus. The theme of the official as the spurned or neglected lover of the ruler had a history as far back as the pre-imperial period, in the rhapsodic poems of Qu Yuan in the third century BCE, who drowned himself in despair after falling out of royal favor. Feelings of emasculation were particularly acute in the Qing period, when foreign military conquest was reinforced by cultural restrictions, such as the compulsory shaving of the forehead and dressing of the hair in the Manchu-style queue, or "pigtail." In the nineteenth century a series of humiliating European annexations and forced concessions were superimposed on Manchu mechanisms of control.

In such circumstances, images of women painted by male artists can be complicated puzzles of identity, involving gender roles, ethnic identifications, and projections of male anxieties. Images of palace beauties from the eighteenth century (see FIG. 9-1 above) already harbored complexities, as the women, Chinese in appearance and costume, are presented in Manchu palace environments as objects of desire and emblems of cultural possession. In the early nineteenth century, the southeastern artists Fei Danxu, Gai Qi (1774–1829), and Jiang Xun (1764–1835) produced large numbers of images of a distinctive type of willowy beauty. The popularity of the type might be explained as a fashion for slender figures and delicate features, but it also suggests a response to contemporary masculine needs. At the very least, the type implies a compensation for concerns about male ineffectualness in the form of images of compliant, passive women, shown always available in the quiet precincts of the garden or inner, private quarters. The women are sometimes depicted in dutiful performance of domestic tasks such as spinning or sewing, but more often, as in Jiang Xun's *Beauty* (FIG. 10-6), they are portrayed as dreamy, acquiescent creatures, sometimes delicately seductive as is this maiden who touches her pinkie suggestively to her lips. Languorous poses and drapery lines combine with the glossy ink of piled hair and bust-length views to convey qualities of sensuality, promised intimacy, and invitation. The identity of such women is ambiguous. They might be portraits but more likely were idealized types of beautiful maidens or courtesans, where the production in multiples suggests something like the status of pin-ups. One of Jiang Xun's scrolls quotes a poem by the middle Ming painter Tang Yin, invoking a tradition of earlier images of beauties and courtesans and parallel ambiguities of identity and social status (see FIG. 8-37 above).

Early-twentieth-century images of women embodied still more complex issues of identity. The female artist Guan Zilan (1903–1986) in 1929 painted a *Portrait of Miss L* (FIG. 10-8) that evokes the approach of the French modernist painter Henri

10-7 Zhang Hai'er (b. 1964), *1989*
1989. Photograph

Matisse (1869–1954). The flat colors and strongly outlined design executed in oils make a formal experiment in visual presence and vivid colorism. Because Matisse was known for primitivist effects and for images of exotic, "Oriental" (in his context North African) women, however, this could not be an innocent stylistic choice. In part, Guan Zilan's painting is self-exoticizing. It presents a Chinese woman in the form of a Western vision of the exotic racial Other, while in Chinese terms the style is exotically Western and modern. For a Shanghai-based woman artist in the 1920s, the painting also made a claim on a local, Republican-era modernity of artistic and personal status. Conflicts between Chinese and Western identifications, while surely in play, could not be sharply drawn in the strongly international context of the 1920s and 1930s Shanghai art scene. Guan Zilan, for example, was the pupil of an artist who had studied in Japan with a Paris-trained teacher, and most modernist experiments were strongly shaped by the audiences and contacts provided by the presence of foreign communities in Shanghai.

**10-8 Guan Zilan
(1903–1986),** *Portrait of
Miss L*
1929. Oil on canvas, 35½ ×
29½" (90 × 75 cm). Chinese
National Art Gallery, Beijing

The confusion of aspirations and identities that have been so much a part of the far more recent era of liberalization is captured in Zhang Hai'er's photograph *1989* (FIG. 10-7). Fashionability, sex appeal, consumerism, and even an updated, personal version of a century-old national self-strengthening movement are entangled in an image of the art and social worlds as self-conscious spectacle.

SITES OF COMMUNITY AND PUBLIC SPACES

The social bonding functions of art have been highly valued in many arenas and periods of Chinese culture. This is true not only of folk and popular arts but also in such modes as the painting and calligraphy of educated elites, where the making, inscription, and appreciation of art takes on the quality of a social ritual affirming

group identity. A wide range of art forms in the nineteenth and twentieth centuries have been concerned with ideas of community, or were deliberately communal in the case of the post-1949 PRC. These have a special significance in an environment where so many long-standing forms of community were threatened. Mass displacements engendered by wars and rebellions, rapid urbanization of populations in cities such as Shanghai, the breakdown of the imperial system of governance, and transformation to a socialist economy and Maoist political system all had profound impacts on economic structures, living arrangements, and population distributions.

Shanghai, which grew explosively in the later nineteenth century, relied on institutions such as native-place associations and merchant or trade guilds to manage that growth. Both types of institution formed communities based on professional ties or place of origin rather than on long residence in the new urban environment. Because such organizations had economic as well as social functions, they generated substantial building programs, and most of the urban and suburban growth of Shanghai in the nineteenth century was instigated by the associations and guilds. A typical compound might include office halls, temple buildings, theaters, gardens, dormitories, and cemeteries. Merchants also contributed to the reconstruction of civic buildings and spaces, such as the Yu Gardens (FIG. 10-9) in Shanghai, which was located in the midst of many common-trade organization headquarters. While gardens of earlier times constructed by private wealth certainly served social functions as elite gathering places, the Yu Gardens became more of a public or civic institution, even though independent of governmental support. The relative profusion and density of the Yu Gardens in comparison to the Suzhou and Yangzhou gardens of Ming and earlier Qing times (see FIGS. 8-3 and 9-29 above) in part embodies a widespread nineteenth-century taste for intricacy of design but may also have been a by-product of its communal sponsorship.

The Yu Gardens had a corporate, quasi-public status but retained the traditional garden architecture of enclosure and interiority. The Beijing-based contemporary artist Zhan Wang (b. 1962) inverts that culture of interiority by casting stainless-steel ornamental rocks (FIG. 10-10), which turn all of the labyrinthine hollows and dark recesses of traditional garden rocks into

10-9 Yu Gardens, Shanghai
Qing

10-10 Zhan Wang (b. 1962), *Ornamental Rock*
1996. Stainless steel, 6′8″ × 47″ × 47″ (2.07 × 1.2 × 1.2 m). Collection of the artist

10-11 Zhencheng Lou, Yongding County, Fujian
1911

Circular or oval multistory communal living compounds are characteristic of the minority Hakka communities of southern Fujian and northern Guangdong provinces. The high-walled enclosures provide security, while the concentration of cooking, storage, and living spaces on separate levels encourages communal interaction.

mirrors of their surroundings. Typically situated amid an architecture of glass, steel, and concrete, his rocks acknowledge the materials of modernity and the high-rise isolation of urban communities instead of disguising contemporary environments with a false traditionalism. At the same time, the distorting curves of his reflecting surfaces offer an implicit critique of the dislocations brought by modern urban life.

A type of circular apartment building specific to southwestern Fujian and northeastern Guangdong provinces in southeast China is an architectural embodiment of communal social arrangements. Made mostly from clay with timber framing, the buildings are deliberately self-contained. This was due in part to their defensive purposes as stockades, with provisions around their outer perimeters for under-roof runways, designed for gun placements and easy circulation of defenders. The largest of these buildings were as much as four stories tall with diameters of some 260 feet (80 m), accommodating as many as four hundred households and a total population of up to 1,800 people (FIG. 10-11); they were further clustered to form communities. Most often associated with the Hakka people, a quasi-ethnic group supposed to have been descended from immigrants from the central plains centuries before, such round stockades embody local building techniques and a fondness for remote, hidden residences. Circular compounds were divided into residential bays, but the functional division into vertical levels, with kitchens on the ground floor, storage rooms above that, and living areas on top, ensured a communal experience. The centers of the compounds might be occupied by ancestral temples and other rooms in a double- or multiple-ring arrangement. The earliest such compounds were founded in the late Ming period around 1600, but most date from the eighteenth century up to the early twentieth-century Republican era. The example illustrated here dates from the early Republican era and is notable for its excellent preservation and for the impressive geometric simplicity of its design (FIG. 10-12).

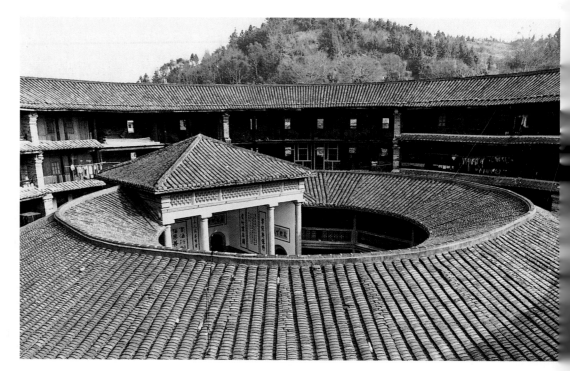

10-12 Interior view of Zhencheng Lou, Yongding County, Fujian
1911

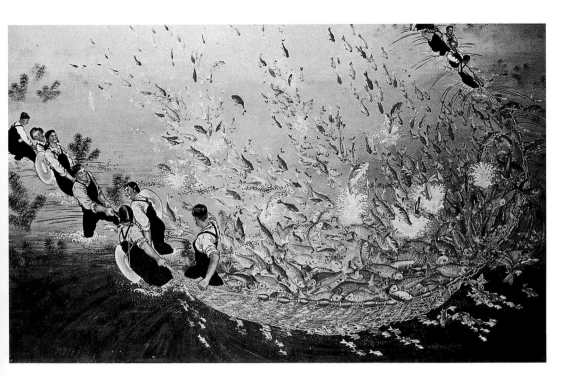

10-13 Dong Zhengyi (active 1960s), *Our Commune's Fishpond* Gouache

The rural commune art movement in the PRC illustrates both the potential and the contradictions of an officially led popular art movement. Beginning with the period of the "Great Leap Forward" (a disastrously unsuccessful attempt to boost industrial and agricultural output through mass action) in 1958–1960 and continuing through the Cultural Revolution era (1966–1976), peasant painting was encouraged at rural communes as part of a policy to erase distinctions between city and countryside. Early in this period genuinely self-taught peasant artists produced large numbers of drawings, paintings, and mural images on themes of agricultural abundance in places like Pixian (Jiangsu), as part of a mass art movement. Art classes on the communes were often sponsored by Communist Party officials, however, who sometimes engaged teachers from provincial or national art institutes, so that even rural or folk styles became a standardized art-world product. The best known of the art-producing communities was Huxian near Xi'an in the northwest, selected as a model art commune by Chairman Mao's wife Jiang Qing in 1972. This meant that local origins were completely superseded by national goals, with professionals training commune artists who became involved in publicity and cultural programs directed from the highest levels. Many of the products of this system share markers of an evolved peasant style: strong outlines, bright colors, and designs with prominent repeated patterns, all elements that suggest linkages with New Year's print traditions (see FIG. 10-24 below). Themes focus on productive labor or political education, almost always with a straightforward ideological message of praise for the Communist Party or support for the Cultural Revolution. Dong Zhengyi's gouache *Our Commune's Fishpond* (FIG. 10-13) stays within this program, but the exuberant richness of the design, with sweeping rhythmic arcs of net-tenders and jumping fish that fill the nets and the sky above, moves beyond the conventional practices of the genre.

Communes in the PRC were ideologically based but involved real social arrangements. The notion of a transnational Chinese cultural community is more abstract but may be helpful for understanding art produced in Taiwan and Hong Kong or by Chinese émigré artists around the world, if used with a clear sense of its limitations. Taiwan had a long history of engagement with the mainland polity since the early Qing period in the late seventeenth century and became a bastion of Nationalist Party (Kuomintang) refugees, and of a particular concept of traditional high Chinese

10-14 John Thomson (1837–1921), *Hong Kong Painter at Work*
c. 1870. Photograph. Stanford Rare Book Collection, Stanford University, California

10-15 Chen Shun-chu (b. 1963), *Family Parade*
1995–96. Installation with framed photo-graphs, dimensions variable, each photo 11⅜ × 9½″ (29 × 24 cm). Collection of the artist

culture, after the Communist victory in the Chinese Civil War in 1949. Hong Kong, ceded to British administration in 1842 after the Opium Wars, remains a multicultural society and international commercial center even after its recent restoration to PRC governance. Overseas Chi-

nese communities elsewhere around the world vary widely in their size, cohesiveness, and visibility but often maintain a high level of concern for ideas of Chinese cultural heritage and identity. Any Overseas Chinese or émigré art that engages questions of Chinese history and identity or that makes use of traditional Chinese media, genres, or languages fits easily within this account. At the same time, we should not be captive to a museological or preservationist concept of Chinese culture, artificially divorced from multicultural environments or from contemporary media.

The ambiguities of Hong Kong identity and community are already conveyed in the photographic image of a Hong Kong painter at work made by the English photographer John Thomson around 1870 (FIG. 10-14). Thomson was an early ethnographic photographer whose images, collected in a volume called *China and Its People*, participated in the objectifying and exoticizing program of colonial photography aimed at a Western audience. The Hong Kong artist's audience is an international community, conveyed in the mixture of portraits and harbor scenes he is set to copying, translating photographs into paintings both for local customers and as part of a much larger industry of China trade pictures and souvenirs produced in quantity for the European market. Already in the mid-nineteenth century Thomson's image and the Hong Kong artist's products are locked into a complex series of mirrorings and translations, between photographic and painted media and Chinese and Western audiences.

Expressions of alienation and loss often accompany diffusions of communities, as in the photographic installations of the contemporary Taiwanese artist Chen Shun-chu (b. 1963). His *Family Parade* (FIG 10-15) projects involve black-and-white serial photographs of relatives, arrayed in ordered, framed rows or inset into the walls of ruined buildings on his native Penghu Islands, offshore from Taiwan. The photographer's relatives are presented staidly in frontal, standing poses or, more enigmatically, directly from behind, suggesting both formal identification photos and memorial images of the dead. An effect of premature mourning is only increased by the insertion of photographs into the wall

of ruined buildings, whose forms evoke the above-ground tombs in some Chinese family burials.

The outright destruction of community brought about by the economics of urban modernization has been the subject of a number of politically conscious contemporary artists. The 1995 performance by Lin Yilin (b. 1964) in the streets of the southern city of Guangzhou literally stopped traffic as he transported a cinderblock wall, brick by brick, across a major thoroughfare, from one construction site to another, in a parody of the seemingly endless cycle of demolition and construction caused by economic development, and a reminder that globalization has profound local effects. Installations by the contemporary artist Yin Xiuzhen (b. 1963) create an archaeology of absence from the detritus of Beijing's ongoing urban renewal, with arrays of salvaged roof tiles standing in for destroyed communities of traditional houses, conveying her sense of a pervasive process of social decay.

POST-LITERATI ARTS AND NATIONAL-STYLE PAINTING (*Guohua*)

Another kind of cultural community over the past two centuries that merits separate discussion because of its artistic importance involves practitioners of painting and calligraphy in traditional media—ink or ink and colors on paper using an animal-hair brush—focusing on painting styles and subjects associated with literati artists in earlier times: landscapes, birds and flowers, symbolic plants, or scholarly gatherings. These choices took on added significance when the alternatives were not just academic or professional styles but international media such as lithography and oil painting, and a vastly expanded range of possible themes. The term "post-literati" art is useful to reflect the dramatically changed social and cultural circumstances in which artists operated, in comparison to the literati of late Ming and earlier times.

In the twentieth century a further subcategory of post-literati art appeared in so-called *guohua*, "national-style painting." *Guohua* began as a programmatic movement in the early years

10-16 Qian Du (1763–1844), *Strolling in Moonlight by the Thatched Hall on Mount Yu*
Qing, 1813. Hanging scroll, ink and color on paper; 54⅜ × 20⅞″ (138.2 × 53.1 cm). Osaka Municipal Museum of Art

of the Republic, in the term *xin guohua*—"new national painting" or "painting for the new nation." Originally a reformist counterpart to the "national language" vernacular-literature movement, it combined traditional brush and ink media and formats with contemporary and popular themes and some realistic representational techniques derived from the West. The movement had important political implications, as the painting of an emerging Chinese nation, and later at times became linked with nativist overtones as the painting proper to a Chinese ethnocultural complex, serving as an academic alternative to Western-style painting. Where post-literati painting conveyed an act of identification with imagined communities of past artists, *guohua* suggested a kind of cultural citizenship.

The political implications of the *guohua* movement were not unprecedented. The adoption and sponsorship of literati styles by the early-Qing-dynasty court (see FIG. 9-8 above) to constitute the Orthodox School was in some ways a parallel effort to borrow a culturally prestigious art form to promote the ideology of the state. Although *guohua* (along with the art of the communes) might also belong in a discussion of art and politics, the political content of many products of this movement was not especially prominent.

Among early-nineteenth-century artists, Qian Du (1763–1844) had definite connections with the literati painters of the past. He had inherited wealth from his prominent Hangzhou family, and his father was a friend of the mid-eighteenth-century painter–calligrapher Jin Nong (see page 347 above). Qian Du's *Strolling in Moonlight by the Thatched Hall on Mount Yu* of 1813 (FIG. 10-16) is evocative of the world of mid-Ming-period Suzhou scholar gentry such as Shen Zhou and Wen Zhengming (see FIG. 8-33 above). Figures converse in a moonlit clearing in front of a garden compound with high walls and sheltered cottages that suggests a privileged, exclusive community. The dedication of the painting mentions the host making tea and inviting twenty-three guests to join him. Such personal dedications continued to be a means of establishing networks of association and, as in earlier times, certain styles, subjects, and literary or historical references

also implied bonds of shared culture. Also as in earlier times, many such dedications were probably only formalities, and the literati-style works they accompanied were signs of status more or less openly for sale. In any case, the very existence of a market for such works of art testifies to the ongoing prestige of literati modes. The profuse textures, colorism, and densely patterned surfaces of the garden rocks are distinctive of Qian Du's own era, with something of the same taste for overwrought detail found in the Yu Gardens of Shanghai (see FIG. 10-9 above).

The careers of two painter–calligraphers active in the late nineteenth century demonstrate how ostensibly conservative modes could be vehicles for significant innovations. Zhao Zhiqian (1829–1884) and Wu Changshi (1844–1927—see his portrait, FIG. 10-5 above) were from the southeastern coastal province of Zhejiang, and both were devotees of antiquarian script of the sort engraved on ancient bronzes and stone stelae (see FIGS. 0-4, 3-2 above). In addition to their literary and scholarly interests, both men had at least brief official careers. Their life-patterns thus fit the types of literati or scholar–artists in many respects, but with many marks of an emerging modern social environment. Although most of Zhao Zhiqian's works bear personal dedications, the evidence of contemporary letters makes it clear that he usually painted for money. Wu Changshi participated in broad networks of personal association and fellowship, but some of the artistic societies he participated in had publicity and marketing functions extending into the international arena, with students and collectors in Japan who organized exhibitions of his work in the 1920s. Active mostly in Suzhou, Shanghai, and Hangzhou, Wu, a founding member of the Yu Garden Charitable Association of Calligraphers and Painters and other societies of painters and seal carvers in Shanghai, became a director of the Xiling Seal Society headquartered at the West Lake in Hangzhou after 1913. The discomfort we perceive in the portrait of Wu as a discontented Qing minor official (see FIG. 10-5) may have arisen in part out of a related awareness of the disconnection between traditional roles and contemporary realities.

Zhao's and Wu's lengthiest artistic involvement was with calligraphy and seal-carving scripts, but both were influential and productive painters as well. Flowers, fruit, and symbolic plants were their most common subjects, along with occasional landscapes. The eighteenth-century Yangzhou School raised related genres of bird-and-flower or plant paintings to a central position, answering contemporary tastes for bold, showy execution and popular subject matter. Zhao Zhiqian and Wu Changshi added new qualities of saturated colorism and dense, surface-oriented compositions filled with overlapped patterns of unoutlined, blended colors and ink. Color and pattern are an undeniable part of the appeal of their paintings and suggest a response to contemporary popular art produced for urban markets and tastes. In the case of Wu Changshi, whose first painting teacher was the Shanghai professional Ren Yi (again, see FIG. 10-5), these links are easily discernible.

More subtle, but equally important, are the connections between script and image in both artists' works. This is partly a formal relationship, as the thick, slow-bending modulations of branches, vines, and leaves pick up rhythms of the blunt, wandering inscriptional texts. On a deeper level, pictorial motifs are often treated like characters in a Chinese text, combined on the basis of potential for meaning rather than the logic of real-world relationships. In Zhao Zhiqian's *Cactus and Oleander* (FIG. 10-17), one of a set of four hanging scrolls painted after a visit to a garden in the southeastern city of Wenzhou in 1861 to view exotic plants, Zhao's inscriptions point both to the novelty of the subject of cactus and the arbitrariness of the juxtaposition of oleander:

> [The subject of] cactus has never been painted. In a village at Rui'an, the largest grows to the height of twenty feet. In shape, it calls to mind strange goblins. In Wenzhou, oleander [grows] well, a tree with a hundred branches. In a spirit of playfulness, I've brought the two together…

Further on, he records the theoretical justification for such arbitrary combinations: "Since we are all acquainted, I need not tarry but can easily pick any

subjects, the plants being metaphors of our friendship…." (Brown and Chou, *Transcending Turmoil*, pp. 262–63)

The metaphorical use of pictorial motifs had a long history that extended to rebuslike combinations of subjects for their phonetic readings, but such paintings usually had a naturalistic pretext. Plant paintings by Zhao and Wu often pack disconnected elements into a surface without background or context. In their work the use of the independent sign character of motifs to produce meaning, in what can be called a semiotic operation, is very prominent, though much disguised by the sensuous richness of surface. This foregrounding of the independent sign element is paralleled in other nineteenth-century collagelike image combinations and may have been based on a widespread archaeological awareness of conventional ancient script types and design motifs.

Throughout the last two centuries many post-literati and *guohua* artists grappled with the mixed blessings of traditional sources, balancing opportunities for allusion against the originality-stifling weight of the past. The continued vitality of a post-literati art depended on accommodation to changing social and cultural realities, rather than fossilized repetition of old modes. Important mid-twentieth-century painters such as Huang Binhong (1864–1955) from Anhui and Fu Baoshi (1904–1965) from Nanjing operated in modern modes of scholarship, teaching, and publishing while consciously exploring aspects of historical styles. Huang was an editor of the *Meishu congshu*, the major compendium of Chinese fine arts-related texts from all eras. Fu Baoshi was educated partly in Japan and wrote many instructional books about ink painting as well as scholarly studies of earlier artists such as Shitao (see FIG. 9-16 above). His attitude of ironic nostalgia for the past was shared by other post-literati artists, such as the internationally active painter, collector, and forger Zhang Daqian (1899–1983), perhaps the best-known twentieth-century Chinese artist in the international arena. Both Fu Baoshi and Zhang Daqian were immensely skilled technicians whose popularity led to risks of repetition and even self-parody. In many respects they represented not so much the

**10-17 Zhao Zhiqian
(1829–1884), *Cactus and
Oleander***
Qing, 1861. One of set of
four hanging scrolls, ink and
color on paper; 52⅜ × 12⅜″
(133 × 31.5 cm). Tokyo
National Museum

**10-18 Shi Lu
(1919–1982), *The Banks
of the Yellow River***
1959. Hanging scroll, ink and
color on paper; 38⅝ × 26″
(98 × 66 cm). China
International Exhibition
Agency, Beijing

particular subject matter of their paintings but rather a personally constructed, theatrical vision of the whole history of traditional Chinese painting.

While many post-literati and *guohua* artists settled for a skilled facility of technique, meeting well-defined genre expectations, the potential of *guohua* painting modes to achieve qualities unprecedented in the past and unmatched in non-Chinese media is amply demonstrated in the careers of other artists. Shi Lu (1919–1982), from the northwestern province of Shaanxi, had a remarkably diverse career as a political print maker and painter of epic propaganda pictures, as well as a calligrapher and landscape and flower painter

10-19 Jia Youfu (b. 1942), *The Taihang Mountains*
1984. Hanging scroll, ink and color on paper; 39⅜″ × 5′5″ (1 × 1.7 m), Chinese National Art Gallery, Beijing

in *guohua* modes. His ink and light color hanging scroll *The Banks of the Yellow River* (FIG. 10-18) from 1959 is a deceptively simple bird's-eye view of steeply foreshortened boats on curling waves, a dramatic but not unprecedented composition. An adjacent turbulent mass of undulating dark ink lines, dots, and washes is much harder to comprehend. The title of the painting written just above suggests that this should be the river bank, but the very placement of the calligraphy encourages a reading as a great vertical cliff viewed straight on and radically disjunct from the adjacent river scene. The form of the dark mass recalls images of rocks from the seventeenth century that conveyed a physical intensity (see FIG. 9-15 above), and it is hard to avoid reading this inchoate but enlivened form in terms of embodiment, or perhaps even of psychic turmoil. The date of this painting in the midst of the catastrophic Great Leap Forward production policies (1958–1960) suggests other metaphoric possibilities or even political readings. Shi Lu's very identity as an artist was fashioned from internal contradictions. He constructed his artistic pen name out of the names of the seventeenth-century princely loyalist painter Shitao and the modern literary reformer and political activist Lu Xun (see pages 390–391). Shi Lu later became a victim of the Cultural Revolution, imprisoned and abused to the point of physical and mental illness.

Jia Youfu (b. 1942) devoted some fifteen years of his career to the subject of the *Taihang Mountains* (FIG. 10-19), which he visited on many painting study trips to Shanxi Province. This seems a curiously old-fashioned regimen, reminiscent of Wang Lu's obsession with Mount Hua in the late fourteenth century (see pages 306–309). Jia's composition in a huge 1984 version of the subject is also reminiscent in some ways of Northern Song monumental landscape, with overlapping planes of slablike cliffs and faceted rock faces (see FIG. 7-19 above). There are also many contemporary dimensions to this work. Since the Taihang Mountains were the site of military campaigns during the Sino-Japanese War, the painting embodies recent historical and patriotic associations. At the same time, the somber masses and stark simplicity of forms put notions of abstraction into

play, with even more particular overtones of Mark Rothkoesque reduction of form and inner luminosity of color. The potential of such *guohua* paintings for multiple interpretations and rich, unpredictable responses on the part of the beholder is at the farthest remove from the reduced potential of played-out traditions.

FUNCTIONAL ARTS

Functional modes of art are those in which the content and treatment are directly shaped by an external purpose or agenda, and often also by commercial contexts. Examples include: illustrational arts, where imagery is secondary to some story or narrative (though we will leave the large category of political art, propaganda, and wartime illustration for separate discussion); graphic design for book and periodical covers; commercial art for advertising; and some kind of documentary or illustrational photography. Social functions likewise strongly determined the iconography and treatment of many kinds of portraiture and occasioned pictures such as birthday paintings. Often these modes of art making were the province of highly specialized professionals in earlier times, but, as we have seen, the distinctions between professionals, on the one hand, and amateur or scholarly artists, on the other, become much less clear and useful at the end of the imperial era. Many artists working in literati-derived modes straightforwardly engaged in art commerce in the Ming and Qing periods, even publicizing their prices in the eighteenth century. Moreover, with the establishment of formal art-education institutions in the early twentieth century, the concept of art as a profession took on a new significance, implying passage through an academic curriculum and elite status. A very large percentage of notable artists in the twentieth century have been professionally trained in art schools, and in the PRC for long periods most prominent artists were affiliated with art academies or artists' associations, receiving a set salary for their labor, whatever the orientation of their work.

Illustrational and Design Arts

The design of prints and paintings illustrating literary scenes from dramas, stories of heroes, and life episodes of cultural paragons was a stock-in-trade of so-called Shanghai School artists such as Ren Xiong (see FIG. 10-4) and Ren Yi (see FIG. 10-5). Ren Xiong's younger brother Ren Xun (1835–1893) had a long career as a professional painter in Suzhou, producing mostly bird-and-flower paintings but some narrative illustrations as well. His scenes from *The Romance of the Western Chamber* exhibit the slightly brittle, dynamic drawing style that was his signature, along with original twists on what had become long-established illustrative themes in paintings and prints (see FIG. 9-4 above). His album leaf depicting the episode of *The Interrupted Dream* (FIG. 10-20), in which the drama's scholar–hero dreams of his lover, the maiden Yingying, pursued by bandits, makes use of the old pictorial convention of the dream balloon to convey the dreamer's mental state. Ren Xun reinforces the contrast between real world and dream world by burying the faces of the scholar and his servant invisibly deep in the folds of their sleeves, a concrete image of the waking state submerged as subconscious desires arise.

Though much illustrative imagery dealt with knights-errant, martial exploits, and other masculine themes, the importance of themes of romance, desire, and the interiority of feminine spaces is notable, partly due to their centrality in the literary works that were so often the subjects for illustration. Toward the end of the nineteenth century an emerging journalistic arena of public representation was in part defined by the attention paid to the private, often secret and illicit, sides of contemporary life, carried out in brothels or boudoirs and

manifested in crimes of passion. The *Dianshizhai huabao* (Dianshi Studio Pictorial), a lithographically illustrated pictorial published by the Englishman Frederick Major in Shanghai from 1884 to 1898, was one of the chief vehicles for such sensibilities and was soon joined by Chinese-published competitors such as the *Feiyingge huabao* (Fleeting Shadow Pavilion Pictorial). Wu Jiayou (who often signed his work as Wu

10-20 Ren Xun (1835–1893), *The Interrupted Dream*, from *The Romance of the Western Chamber*
Qing. Album leaf, ink and color on paper; 13⅜ × 14″ (34 × 35.5 cm). The Palace Museum, Beijing

10-21 Wu Jiayou (d. 1893), *Thief in the Flower Garden*
Qing, 1891. Lithograph, 10 × 5″ (25.5. × 12.8 cm). Courtesy of Kuiyi Shen

The introduction of lithography in the late nineteenth century allowed large-scale distribution of images in illustrated periodicals in Shanghai, some of which were copublished by Europeans. Wu Jiayou was a prolific illustrator of contemporary urban life, including themes of romance and scandal such as the spurned lover who cuts and steals a courtesan's long hair.

10-22 Qian Juntao (b. 1906), cover design for *Great Love*
1930. Collection of the artist

Youru, d. 1893) was one of the chief illustrators for both pictorials. Wu's lithographic illustration for the *Feiyingge huabao* of a scene of a spurned paramour exacting revenge on a courtesan by stealing into her bedroom and chopping off her hair (FIG. 10-21) is accompanied by a long descriptive text that places it firmly in the arena of contemporary life. The picture unfolds as a series of partial revelations of visibility. The female subject is turned away from the viewer, and her mirror stand is draped, but the spectator is offered several surrogates of visibility on the rear wall. The traditional hanging scroll of a beauty under trees above the dressing table stands in for an idealized view of the courtesan, and the adjacent framed photographs are at once explicit reminders of contemporary media and blatant advertisements for the courtesan's services. The large Western-style looking-glass to the right serves a different function, a stand-in not for the figures in the scene but for the spectatorial gaze of the pictorial-reading public, capturing the intruder in the act, even as he steals away with his fetishistic prize.

Along with lithographic illustrations for pictorials, book and journal cover design and typography were among the most publicly accessible modes of functional art. Graphic designers carried out some of the most interesting and successful modernist experiments in China. Here the intrinsic formalism of Chinese characters made for an easy transition to abstraction and new formats offered abundant opportunities for design innovation. The circle of the literary reformer Lu Xun (1881–1936) was the point of origin for many book designers. Lu (who is discussed in greater detail below, see pages 390–391) was an amateur woodblock print maker and cover designer himself, and he also supported or commissioned work from other designers. Among them was Qian Juntao (b. 1906), who met Lu Xun in 1927 and viewed some of his collection of ancient

10-23 Cheng Shifa (b. 1921), Illustration to chapter 98 of *The True Story of Ah Q*
5⅜ × 3⅜" (13.9 × 8.8 cm)

calligraphic rubbings. Qian was also supported by his teacher Feng Zikai, who acknowledged the commercial aspect and public appeal of work in book design. Qian's 1930 cover for *Great Love* (FIG. 10-22) integrates text and pictorial design in a quasi-Cubist mode. The lettering takes on an Art Deco look, with hints of forms from Roman alphabets, mathematical symbols of equivalence, and even abstract bodily figures. Less conspicuous English letters form parts of the word "love," bridging the gap between the simply outlined male and female figures behind the title text. Even the figures overlap and blend, in acknowledgment of Cubist practice and the theme of the story.

Among the most widely experienced of all functional arts are the serial illustrations known as *lianhuanhua*, ranging from comic-strip style to elaborate line drawings or even oil paintings, that accompanied stories and novels or were published as independent picture books, including Communist Party propaganda tracts illustrating the lives of exemplary heroes. Precedents for such linked illustrations appear in narrative paintings or prints and stone-carvings throughout most

f the imperial era, but the narrower use of the erm *lianhuanhua* refers to publications using nodern printing techniques. As a group these sold n hundreds of millions in the PRC and engaged ne talents of important artists and illustrators. he Shanghai artist Cheng Shifa (b. 1921) illusrated a number of literary classics, including a 962 reissue of Lu Xun's modern vernacular novella *he True Story of Ah Q*. In Lu Xun's story, Ah Q s a passive and uncomprehending victim of ne social turmoil at the end of the imperial period, vho proclaims himself a revolutionary out of ignoance and ends up being executed for crimes e did not commit. In the chapter illustrated here, ne illiterate Ah Q faces a revolutionary tribunal nat looms over him replete with images of authory that are at once military and political, traditional nd modern, and where he is coerced into making the false confession that will lead to his eath (FIG. 10-23). Lu Xun's story is set in an arlier generation, but the conditions of social turulence and state-sanctioned violence it recounts vould be repeated within a few years of Cheng hifa's illustrations in the excesses of the Culural Revolution. The fate of the medium of

serial picture books, which lost most of their audience in the 1980s, suggests that the contemporary arena for functional narrative imagery lies within film and television media.

Popular Arts

The genre of serially illustrated picture-books can be considered a popular mode of representation in terms of its mass audience and the vernacular cartoon or comic-strip styles often employed. While cinema and television are the contemporary inheritors of this tradition of narrative art, there are antecedents in popular prints and book illustrations reaching back many centuries. New Year's prints (*nianhua*) of gate guardians, calendrical themes, and auspicious imagery date back at least to the Southern Song era (twelfth–thirteenth centuries), and by the late Ming period, toward the end of the sixteenth century, there were established publishing centers for such prints at Tianjin in the north and Suzhou in the southeast, along with a dozen or so other cities in various regions. Most surviving New Year's prints date from the nineteenth century and after, when

10-24 Anon., *The Lotus Bears Precious Seeds (Mother and Three Sons)* Qing. Woodblock print, 23⅜ × 41¾″ (60 × 106 cm). The State Hermitage, St. Petersburg

Publishers produced richly colored popular New Year's prints of auspicious themes, protective deities, theater scenes, and the like in large numbers in the nineteenth century. Imagery and text captions combine to convey overlapping auspicious sentiments of prosperity, abundance, and familial success.

10-25 Su Renshan (1814–1850). *Leading the Phoenixes by Playing the Flute*
Qing, 1848. One of pair of hanging scrolls, ink on paper; 9′¼″ × 47¼″ (2.78 m × 120 cm).
The Chinese University of Hong Kong

subjects and settings often became quite elaborate and complex. The simplest New Year's prints depicted frontal images of auspicious or protective deities, often with calendrical texts, but subjects ranged from symbols of good fortune and genre scenes to literary and theatrical themes. The latter types illustrated episodes from stories, but many such prints conveyed messages by nonnarrative means. Texts were often part of the prints, usually in the form of formulaic sayings or maxims that might have been part of the aural culture of semiliterate viewers. Another non-textual way of conveying those messages was through rebuslike visual imagery, which when described in words and sounded out might form a homophonic phrase for an auspicious message or text. A basic form of such a pictorial rebus appears in the image of a mother with three sons, clearly associated with domestic prosperity (FIG. 10-24). The words for the prominent motifs of lotus, panpipes, cinnamon branch, and pomegranate seeds can be sounded out to form the printed sentence "The lotus bears precious seeds," which is a homonym for the underlying message "May eminent sons be born continuously." This surplus of significance, with doubles or multiples of image, pronunciation, text, and homonymic message, is characteristic of the genre and conveys in its very semiotic structure a message of abundance. The undulating chain of flowering or fruiting plants and figures is another visual marker of continuous fecundity.

New Year's prints often depicted immortals and deities drawn from the realm of popular religion, mythology, and legend. Similar subjects were a staple of nineteenth-century urban professional painters such as Ren Yi in Shanghai and Su Renshan (1814–1850) in Guangzhou. While in the New Year's prints such figures tend to be stereotyped, in the hands of urban painters deities are treated with clever idiosyncrasies, as if elements of folklore were being appropriated for the appreciation of a sophisticated audience. Su Renshan worked in several towns and cities in the Guangdong and Guangxi regions of far southern China. He was educated for the civil service examinations but, after failing to advance, made a living as a teacher and painter. Guangdong

10-26 Chen Shizeng (Hengke, 1876–1924), *Beggar Woman*
1914–15. From *Beijing Customs*. Album leaf, ink and color on paper; 11¼ x 13½" (28.6 x 34.6 cm). China National Art Gallery, Beijing

was outside the mainstream of the art world, and although Su may have had access to some local collections of old paintings, his chief sources were probably woodblock-printed painting manuals that illustrated a wide range of motifs and compositions, which may account for the strongly graphic quality of his painting style. The manuals popularized elite artistic culture, and Su's additional involvement with subjects from popular religion gave much of his work a dynamic directness. His *Leading the Phoenixes by Playing the Flute* from 1848 (FIG. 10-25) is one of a pair of large hanging scrolls with figures of female and male immortals riding phoenixes, their presence dramatically enlivened by surrounding large-character texts written in a range of forms from loose running script to archaic seal script. In contrast to the New Year's prints, where images could be read out like words, the calligraphy here challenges the pictorial forms. Large written characters pick up the dark, blunt rhythms and graphic energy of the painted figures and compete evenly with them for visual prominence and position, taking on a talismanic power. The crowded, somewhat chaotic placement of the inscriptions conveys a raw urgency and has something of the effect of a collection of graffiti. Su Renshan's painting also embodies

some of the same archaeological interest in old script styles, and a related integration of picture and texts, as the painting-and-writing scrolls of antiquarian artists such as Zhao Zhiqian (see FIG. 10-17 above).

Another side of popular art involves genre scenes or subject matter drawn from commonplace and street life. Images such as Zhou Chen's mid-Ming *Beggars and Street Characters* (see FIG. 8-36 above) or the vivid street life from *Spring Festival on the River* (see FIG. 7-3) are precedents for such subjects, but in later Qing and Republican periods these are treated with a sharper sense of social class divisions. One of the most interesting examples, the album of *Beijing Customs* (FIG. 10-26) from 1915 by Chen Shizeng (known as Hengke, 1876–1924), suggests an ethnographic project of documenting local folkways before they disappeared in the face of social and technological changes. Chen Shizeng depicts many itinerant musicians, performers, street vendors, and a few performers of unique social roles among the thirty-four images, with brief ethnographic accounts included among some of the inscriptions. Most of the figures would not seem out of place in a Ming- or Qing-period picture, but the image of an old beggar woman supplicating a rickshaw passenger stages the encounter of the traditional and the modern in stark terms. The rickshaw itself was a modern conveyance, dependent on ball-bearing wheels as much as on muscle power. The passenger in Western dress casts only a fleeting glance back at the beggar woman as he speeds away and out of the frame, as if he were watching a disappearing culture. Ironically it is the modern man who is drab and almost effaced by the frame, while the beggar woman retains a bit of local color, even in her patched rags.

The world of street vendors, itinerants, and entertainers constitutes a community of its own, but one that could embody a threat to the broader social order. Many popular uprisings and full-scale rebellions throughout Chinese history fed on the discontents of physically and economically displaced groups. The social and systemic changes that have accompanied economic liberalization in the PRC in very recent years have been as wrenching in some respects as those of earlier times. Large

10-27 Fang Lijun (b. 1963), *Series II, No. 6* 1991–92. Oil on canvas, 6'5½" × 6'5½" (2 × 2 m). Private collection

numbers of workers pushed into unemployment by privatization of state industries, along with rural agricultural laborers in search of a better life, have flooded the coastal cities, giving rise to a substantial rootless population. Among these are the so-called *liumang*, vagrants or petty hoodlums, who seem to be a primary point of reference for the contemporary painter Fang Lijun (b. 1963). His group figure paintings are by no means documentary, and the precise identity or social class of his subjects remains elusive. Fang often represents males in groups, wearing clothing that takes on the character of a uniform, even if a stylish one in some cases, with their identically shaved heads and oppressively close-up presentation conveying the vaguely ominous effect of an approaching crowd (FIG. 10-27). The figures are idle, and their heavy-featured expressions, whether bored, taciturn, or smiling, are always veiled and carry an edge of threat. Fang's pictorial type has a counterpart in other contemporary media, such as the popular novels of Wang Shuo that focus on the language and culture of cynical urban operators, and related television soap operas which bring that social type before a mass audience.

POLITICAL ARTS

Since the beginning of the twentieth century, Chinese political thinkers have considered the visual arts to be a key component of social and cultural reform programs. In the PRC, politicization of visual arts extended to every facet of art education, production, and dissemination, to a degree difficult to comprehend by participants in societies where artistic autonomy is more highly valued. However, any adequate understanding of the careers of PRC artists or the visual products of that system must take that political control into account. Early in the century, the visual arts became instruments of propaganda and resistence in wartime, and vehicles of satire, protest, or critique during periods of social crisis and fragmentation. Public spaces, media, and art institutions also played important roles in an era of cultural conflict.

Images of War, Resistance, and Propaganda

In some images of urban life social discord is present only as a threatening atmosphere, but China in the past two centuries has been more strongly marked by outright armed conflicts, rebellions, and wars in exhausting succession. The functional arts that emerged in times of war were occasionally documentary and almost always propagandistic in nature, distinguished from other kinds of political art primarily by explicitly violent subject matter. The leaders of the Taiping rebels of the mid-nineteenth century, who hoped to establish their Kingdom of Heavenly Peace on a mixture of principles from Old Testament Protestantism and ancient Chinese ritual, decorated the walls of their palaces with conventional paintings of flowering plants and buildings in landscapes. More pointed were the battle paintings commissioned by the Qing leaders who suppressed the rebellion. A maplike overview of *A Battle Between Qing Forces and Taiping Rebels* (FIG. 10-28) clearly shows the disposition of forces and a bloody calculus of the battlefield, as the besieged Taiping rebels in the center are systematically annihilated by inescapable lines of cannon fire from the surrounding Qing forces on the battlements.

The appearance of mechanical and mass media such as photography and film projected war imagery into more public arenas, with broadened potential for direct political effects. Film could represent invasion as an event but could also embody it in its means of production, as in the staged battle scene of US cavalry assaulting the South Gate of Beijing during the Boxer Rebellion, where a tangible icon of Chinese authority was reduced to a cinematic backdrop for a battlefield adventure. One of the founders of Chinese literary modernism, who wrote under the pen name Lu Xun (1881–1936), was stimulated to turn from his medical studies in Tokyo toward a career in politically conscious literature in 1906 when he witnessed a newsreel documenting Japanese troops beheading a suspected Chinese spy for the Russians during the Russo-Japanese War. This event was made even more horrific by the presence of Chinese spectators, who were forced to witness the beheading, in a grim synopsis of the long-term dismemberment of the Chinese body politic through imperialist incursions.

Lu Xun channeled his energies chiefly into literature, cultural education, and the promotion of woodblock-print production as instruments of modernization and political activism. He was appointed to a pivotal position in the Ministry of Education just after the founding of the Republic of China in 1912, taking as his mandate the development of public cultural institutions such as museums, libraries, theaters, and cultural monuments. After 1926 Lu had a falling-out with the Nationalist government and became increasingly sympathetic to left-wing and Communist causes. Lu amassed a significant collection of European woodcut prints, admiring especially those with social and political content. He published and exhibited his collection, and in 1931 he organized a printmaking workshop taught by the brother of a Japanese bookstore-owner friend in Shanghai named Uchiyama Kanzo, which was the nexus of the later Chinese woodcut movement. Although the movement was based on mixed European and Japanese sources, with a further background in traditional Chinese woodblock-print illustrations,

10-28 Anon., *A Battle between Qing Forces and Taiping Rebels*
Qing, 1860s. Ink and color on paper. Collection of Chaoying Fang

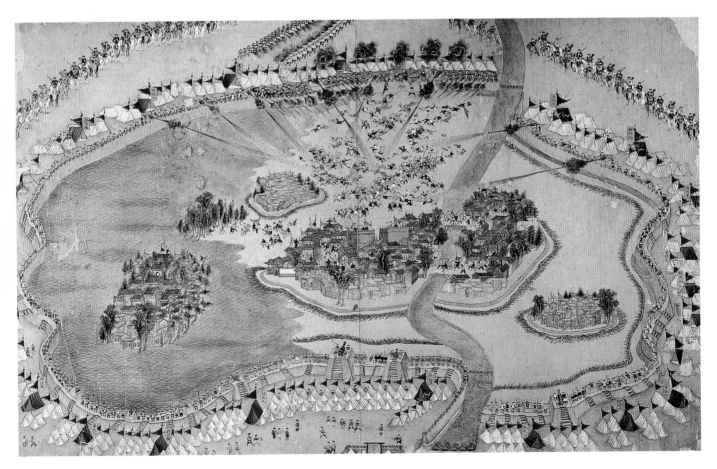

most of its practitioners saw the movement as entirely modern and European in origin. The personal carving and printing of wood blocks and the use of oil-based printing inks distinguished the products of the modern woodcut artists from traditional prints, with their water-based inks and division of labor between artist–designers, wood engravers, and publishers (see FIGS. 9-3). While the early woodcut movement mixed modernist and political themes and aims, the Japanese invasion of Manchuria and bombing of Shanghai in 1931 turned much of the woodcut movement toward a leftist political and militant agenda. Hu Yichuan (b. 1910), the designer of *To the Front!* (FIG. 10-29), was only twenty-two when it was made in 1932, by then already an associate of Lu Xun and a member of the Communist Youth League and League of Left-Wing Artists, which was leading to his expulsion from the Hangzhou West Lake National Arts Academy. The print was exhibited at the Shanghai YMCA in 1932, as part of a group whose manifesto called for "Modern art… to become a powerful tool for educating the masses, informing the masses,

organizing the masses" (*A Century in Crisis*, p. 216). The urgency of the shouting main figure, crushed against the picture plane in broad slashes of white and black, both impelled on and followed by the masklike phalanx of figures behind, conveys the uncontrollable dynamics of a mass movement. The print aimed at fomenting resistance against the Japanese invaders while denouncing the inaction of the Nationalist government.

One of the most enduring figures in the modern woodcut movement was Li Hua (1907–1994), a native of Guangzhou in touch with the international communities of Hong Kong and Macao, and a youthful enthusiast for Parisian modernism. In 1934 while a teacher at the Guangzhou Municipal Arts College he organized the Society for Research on Modern Creative Woodcuts, which published the journal *Modern Woodcut* between 1934 and 1936 as a central vehicle for the movement, acknowledging the seminal inspirational role of Lu Xun by sending him copies of each issue for his response.

The militant art of the modern woodcut movement gave way in large measure under the art

10-29 Hu Yichuan (b. 1910), *To the Front!* 1932. Woodcut, 9⅛ × 12″ (23.2 × 30.5 cm). Lu Xun Memorial, Shanghai

10-30 Ye Yushan and
team of sculptors from
the Sichuan Academy of
Fine Arts, Chongqing,
*The Rent Collection
Courtyard*, detail
1965. Dayi, Sichuan. Clay,
life-size

system of the PRC to another international mode of military and propaganda art based on Western realist styles of oil painting and sculpture. The art produced under the PRC system of political control was far from monolithic, but it was subject to close direction and certain prohibitions (see "Ideological Control of the Arts," page 394). As we have seen, peasant and folk art styles, woodcuts with mixed European Expressionist and journalistic sources, *guohua* modes of traditional media and subjects, and Western realist styles were all practiced and countenanced in the PRC. Abstraction and most modernist styles were out of favor, either because of a lack of readily visible social content or because of being tainted with associations of bourgeois decadence and self-indulgence. By and large, artists saw versions of Western realist styles as the most suitable vehicles for socialist messages. Their narrative or representational content was accessible and easily understood, and realist styles were congenial to vivid representations of heroic figures with a powerful sense of drama and presence. Realist styles were suitable for many media. One of the most notable sculptural examples was a life-scale tableau of more than a hundred figures, made by a team of sculptors from the Sichuan Academy of Fine Arts in 1965 and called *The Rent Collection Courtyard* (FIG. 10-30). Set up in a mansion formerly belonging to a Sichuan warlord and landlord, it vividly depicts the exploitation and oppression that had gone on there. Because of the real-world setting, this is

more like a theater frozen in clay than ordinary representation, and the poses of the figures are appropriately high-pitched and dramatic. This is unapologetic propaganda, unmodulated in its blunt naturalism and appeal to sentiment, but with at least the virtues of its emotions and sense of outrage. The artistic products of the Cultural Revolution years, especially after the ascendancy of Mao's wife Jiang Qing from 1970 to 1976, are more ominously formulaic. Smiling Socialist automatons play out their roles as workers, peasants, and soldiers in a sea of obligatory red color, their vacuously frozen expressions suggesting an enormous effort of repression.

While Socialist Realism generated many histrionic and almost palpably formulaic images of leaders, heroes, and exemplary figures, there were many hybrid variations of style and presentation, sometimes blending oil painting with the aesthetics of woodblock prints or traditional *guohua* painting. Shi Lu, whom we have encountered as an ink landscapist and printmaker (see FIG. 10-18 above), in 1959 undertook a huge picture in traditional media of ink and color on paper, as monumental as large oil paintings, but conveying an additional nationalist message through the choice of materials. *Fighting in Northern Shaanxi* (FIG. 10-31) reduces Mao Zedong to modest scale, seen from behind in a relatively unassertive, though unmistakable, profile. Mao overlooks a vast terrain of fissured bluffs stretching to the horizon, conveying both the difficulty of his military

Ideological Control of the Arts

The system of official control of the arts was a construction of the Communist Party, outlined by Mao Zedong himself in his famous Yan'an Talks on Literature and Art in 1942 as part of a forum held at the Communist stronghold in Shaanxi Province. The basic tenet of that doctrine is that art must serve the masses: the workers, peasants, and soldiers. While both Chinese traditional forms and modes borrowed from elsewhere are permissible, bourgeois individualism and self-expression are to be avoided. The goal of art is to "awaken the masses, fire them with enthusiasm, and impel them to unite and struggle to transform their environment." Mao's remarks are non-prescriptive in terms of style, making room for both native traditions and foreign modes, specialist skills and high standards, but all should be subordinated to reflecting the life of the masses. He placed special emphasis on acknowledging folk art and popular art forms and using these to guide fine art production. Above all, art should be in the service of politics: "subordinated to the revolutionary tasks set by the Party in a given revolutionary period... [demanding] the unity of politics and art, the unity of content and form, the unity of revolutionary political content and the highest possible perfection of artistic form." The mechanisms for enforcing the political disciplining of the arts are signaled in a further passage:

If everyone agrees on the fundamental policy [of serving the workers, peasants, and soldiers and of how to serve them], it should be adhered to by all our workers, all our schools, publications, and organizations in the field of literature and art and in all our literary and artistic activities. It is wrong to depart from this policy and anything at variance with it must be duly corrected.

(Laing, *The Winking Owl*, pp. 3–4)

In practice, the Chinese Communist Party controlled artistic standards and policy in the PRC through such organs as the Department of Propaganda, the Ministry of Culture, and the Chinese Artists Association, which variously had charge of art education, publications, and exhibitions.

task during the Civil War years, with his own horse just struggling to join him at the top of the cliff, and an analog for the vast nation which Mao seems already to command. In a terrible illustration of the ways in which art and artists were prey to shifting political winds, Shi Lu was sent to a labor camp during the Cultural Revolution years because this painting was thought to show Mao "separated from the masses and hoping he would fall off the cliff" (Sullivan, *Art and Artists of Twentieth-century China*, p. 250). Shi Lu accomplishes the transformation of the landscape from a natural to a national political emblem in part by the reddening of the cliffs where Mao stands. Large-scale paintings such as these were mostly commissioned for public buildings. The most notable example was the monumental *This Land So Rich in Beauty*, a collaborative *guohua* work

10-31 Shi Lu (1919–1982), *Fighting in Northern Shaanxi*
1959. Ink and color on paper, 7′8″ × 7′ (2.38 × 2.16 m). Musuem of the Chinese Revolution, Beijing

29.5 feet (9 m) long and 18 feet (5.5 m) tall, commissioned for the new Great Hall of the People legislative building on Beijing's Tiananmen Square in 1959. In this explicitly political space, the panoramic landscape of mountains, rivers, and cloudy plains becomes an icon of the nation, in part because of its location as a backdrop for ceremonial events and also through its synopsis of China's geography, the title reference to a Mao Zedong poem, and straightforwardly symbolic devices such as a red rising sun.

Political Spaces and Art Institutions

Monumental paintings on public themes can activate imaginary and symbolic spaces inside the tangible political space of a government building. The most potent of such real political spaces is the Tiananmen area, now a great plaza south of the imperial palace in Beijing, originally a gated forecourt leading to the Gate of Heavenly Peace at the south entrance to the palace (FIG. 10-32). After the fall of the Qing and founding of the Republic, this area was the site of major political demonstrations. The date of the 1919 student protest against the international peace treaty that ceded former German possessions in China to Japan gave its name to a widespread May Fourth Movement for radical political and literary modernizations on Western models, which included such figures as Lu Xun. Further demonstrations in 1925 protested the massacre by police in Shanghai's International Settlement of a crowd protesting against the shooting of a worker. In 1949, the founding of the People's Republic was proclaimed from Tiananmen Gate, and National

Day celebrations were held there thereafter. The old gates and walls of the forecourt were demolished to form a great public plaza, and during the 1950s a marble Monument to the People's Heroes, with sculpted scenes of revolutionary struggle, was erected in its center, with the congress building called the Great Hall of the People and the National Museum of Chinese History defining the west and east sides of the square. The History Museum constructed a socialist narrative of oppression and liberation from the artifacts of the past. Tiananmen was thus saturated with political symbolism, memory, and event, where the old imperial order embodied in the palace complex met the new Communist regime. The monumental image of Chairman Mao hung at the center of the gate to the palace and the placement of the Chairman Mao Memorial Hall directly on the main axis of the palace complex a year after his death in 1976 only sharpened that confrontation. A spontaneous demonstration at the Monument to the People's Heroes in Tiananmen Square, honoring Premier Zhou Enlai after his death in 1976, was brutally suppressed, and the mass pro-democracy demonstrations in Tiananmen in the late spring of 1989, ending in the massacres of June 4, moved the great political stage of twentieth-century China briefly and tragically into the arena of global media theater.

Ideas of political space can be manifested in imagery or in institutions as much as in physical gathering spaces such as Tiananmen. The shift toward an emerging public arena is marked by the juxtaposition of Ren Yi's portrait of Wu Changshi as a distressed official (see FIG. 10-5 above), which shows him in an official but not

10-32 Tiananmen Square
Beijing

The area south of the Gate of Heavenly Peace (Tiananmen) of the Forbidden City was cleared following the founding of the People's Republic of China to create a great public plaza and site for public buildings and monuments. The proximity of Tiananmen to the palace had already caused the area to be used as a site for political protests in the early years of the Republic, a tradition that continued down to the pro-democracy protests of 1989. Today the Monument to the People's Heroes and the Mausoleum of Chairman Mao are aligned with the main axis of the Forbidden City, while the politically and culturally potent buildings of the Great Hall of the People and the Museum of History flank the western and eastern sides of the square.

10-33 Chen Shizeng (Hengke, 1876–1924), *Viewing Paintings at an Exhibition*
1917. Hanging scroll, ink and color on paper; 34½ × 18¼" (87.7 × 46.6 cm). The Palace Museum, Beijing

a public role, with Chen Shizeng's *Viewing Paintings at an Exhibition* of 1917 (FIG. 10-33), which both illustrates a public space and participated actively in constituting it. The very notion of the public presupposes a changed configuration of the political landscape, with an accompanying sphere of civic activity and institutions independent of narrow interests. *Viewing Paintings* represents a public art exhibition organized in Beijing's Central Park to benefit the victims of major floods, an unquestionably civic purpose. At the same time, the painting embodies the idea of broad civic representation in its documentation of inclusive participation, with Chinese and Westerners, men and women, those in traditional and in Western dress, intermingled equitably in a public space. While many native place and trade associations and some artists' associations performed charitable activities for their members, filling the gap between family (or lineage) and governmental involvement with organizational activity, *Viewing Paintings* suggests a national role for the arts beyond local and personal interests.

Another dimension of that role lay in building public arts institutions such as art schools and museums. The transformation of the Qing palace complex into a public museum and the placement of the National Museum of History across from the Great Hall of the People are reminders of the centrality of art history and archaeology to the formation of national identity and political life.

Parts of the Qing palace collection were reorganized and exhibited to the public as early as 1914, soon after the founding of the Republic in 1912. Full transfer of the imperial collection from the ambiguous ownership of the last, abdicated Qing emperor and his household to a public National Museum, still housed in the precincts of the palace, did not occur until 1925. Chinese museums have always been instruments of politics and diplomacy, along with their curatorial and educational purposes. The removal of important portions of the palace collections to Taiwan during the Chinese Civil War and the establishment there of a National Palace Museum that is competitive with the Palace Museum in Beijing is the clearest modern example of an art heritage being used as an instrument of political legitimation. International loan exhibitions from various incarnations of the Palace Museum have been used to gain respect and support for Chinese regimes since the time of the Sino-Japanese War in the 1930s, and more recently archaeological loan exhibitions have used terra-cotta soldiers from the First Emperor of Qin's burial complex to accomplish some of the same goals as living diplomats.

From the outset in 1912 the Republic sought to build a nation to replace the fallen dynastic regime of the Qing, with the arts conceived as much more than an embellishment to politics. The reformers and intellectuals who shaped the new order, such as Cai Yuanpei (1867–1940) and Chen Duxiu (1880–1942), saw the arts as nothing less than a substitute for religion in the creation of an ideal society, fully as important as military, technological, moral, and international education. The arts also had a practical role to play in modernization and national self-strengthening movements, since Western modes of rendering were recognized as the most useful for the mechanical drawing and illustration needed for industrial design and production.

The reformist orientation and overseas educational background of many of the founders of the Republican government, combined with the push for modernization, gave Western art forms a clear advantage in the competition for political sponsorship. Returning artists who had studied in Europe or Japan imported some

modernist modes, but the staple curriculum of the emerging art schools was some version of Western academic and realist styles. These were non-traditional in the Chinese context, and thus congenial to the goals of the reformist New Culture Movement, but mostly separate from the non-traditional modernisms of Europe and the United States. It is useful to keep this distinction in mind, because while anti-traditional *modernisms* were mostly unofficial movements in the West, the untraditionally Chinese, but *non-modernist*, modes of Western representation had a continuous history of official support and institutional sponsorship from the early days of the Republican era through the cultural policies of the PRC. There were thus at a minimum three major modes of politically and ideologically charged art after the imperial age ended in 1911: Western academic or realist styles; imported modernisms; and versions of traditional styles promoted by those associated with a National Essence School seeking the revitalization of native cultures.

Each of these distinctive modes of art had some foothold in the curricula of official art-education institutions and in exhibition venues, so that debates concerning the political functions and importance of art also played out in the politics of the art world. Most Chinese art schools and academies down to the present have maintained parallel departments of oil painting—usually in realist styles—and *guohua*, or "national style painting," utilizing traditional media of brush and ink or colors on paper, along with departments of sculpture, print making, and the like. Modernist modes had a more localized base at the National Hangzhou Arts Academy and in various Shanghai-based art schools and societies. The more limited success of modernist modes relative to the others was in part due to its localized status, which made modernist monuments particularly vulnerable to destruction during such episodes as the Japanese bombing of Shanghai in the 1930s and the campaigns of the Red Guards in the Cultural Revolution years of the late 1960s. Modernism's "failure" in China, if it can even be considered such, also lay in its lack of penetration into the intrinsically public arenas of architecture and industrial product design.

Combined with the major destruction of modernist paintings, this meant that modernism's most visible legacy in China lay in graphic design of journals and advertising, and in some Expressionist modes of the woodcut movement of the 1930s.

Politically motivated art and art-world politics in twentieth-century China were part of a constantly shifting landscape of positions and events that makes the history of this era both difficult and fascinating. No schematic account of movements or personalities can do justice to that complexity, but the careers of a few key figures may outline some important issues. Cai Yuanpei (1868–1940), who had studied in Germany and France, was ideally positioned as Minister of Education in the early years of the Republic and Chancellor of Beijing University after 1917 to set official policies for the arts. He felt that aesthetic education should have a central role in shaping the citizens of a new society, and that the cultivation of aesthetic detachment would lead to a deeper perception of reality and to a release from feelings of greed and prejudice that were obstacles to the formation of a new Chinese social order. Cai was an energetic promoter of Western art forms, which he saw as possessing an aesthetic and social relevance that traditional Chinese painting could not fulfill. His emphasis on cultural regeneration saw a special role for education of the younger generation, which found expression in the pages of the journal New Youth (Xin Qingnian), first published in 1915 and edited by Chen Duxiu, whom Cai later appointed as dean of the college of letters at Beijing University and who became one of the founders of the Chinese Communist Party in 1921.

Cai Yuanpei's governmental activities for the Republic included the establishment of an Office of Social Education in 1912, charged with promoting cultural education. One of his appointees was the writer Lu Xun, put in charge of the section overseeing museums, libraries, drama, and music. Lu was one of the first to give public lectures on art, in which he emphasized its social and ethical functions. Lu Xun's central role in fostering the woodcut movement as an instrument of modernization, social consciousness,

and revolutionary propaganda has been discussed above (see pages 390–391). Lu also promoted exhibitions and museums as venues for a broad social awareness of the arts.

Art academies were the main theaters where political programs and art-world politics were played out, following the founding of the Republic in 1912. Governmental intrusion into the affairs of the academies could be through the appointment of directors, the supervision of cultural ministries, or the promotion of specific styles and subjects as occurred under the PRC. Since art academies were the main training grounds for art teachers, politically motivated art was directly or indirectly disseminated to a very broad public. The major officially sponsored academies were only part of a wide spectrum of art associations, societies, and organizations that emerged all over China, many quite transient but nonetheless energetic. Because of their longevity, official status, and prominent locations, the major academies in Beijing, Shanghai, and Hangzhou had more enduring roles in the politics of art, but these were living institutions, shaped and changed by historical events and internal personalities. The cultural reforms of the early years of the Republic, political repression in the late 1920s, Sino-Japanese conflict in the 1930s and early 1940s, the Civil War and Communist victory in 1949, anti-Rightist campaigns of the 1950s, and the Cultural Revolution of the late 1960s and early 1970s, to list only the most prominent landmarks of the political landscape, all profoundly shaped art institutions and the careers of those who worked within them.

Xu Beihong, Lin Fengmian, and Liu Haisu all played foundational roles in the major urban academies and had careers that extended into the regime of the PRC. These key figures all had substantial European experience and were sympathetic to Western art modes and movements, exemplifying the central role played by students returned from Japan or Europe in the formation of art institutions in twentieth-century China. And all three men significantly altered their early artistic strategies in the context of a changing cultural landscape after their return to China.

Xu Beihong (1895–1953) was a central figure in the art world and in art education for most of the years of the Republic and the early years of the People's Republic as well. He studied in Shanghai and Tokyo as a young man and in 1918 came into the orbit of Cai Yuanpei, who appointed him a teacher at Beijing University. Along with other reform-minded associates of the New Culture Movement, he saw traditional Chinese painting as in full decline and urged a synthesis of Western painting modes with whatever of value could be salvaged from native approaches. As for many artists and writers of his generation, Japan provided important formative experiences and a model for Asian cultural modernization that softened full-scale Westernization with emerging identifications of national traditions. In 1919 Xu was sent as a sponsored student to Paris, where he studied the academic style and participated in official Salon exhibitions. He returned to China in 1925 for another university appointment by Cai Yuanpei.

Xu Beihong was an accomplished draftsman and oil painter in a conservative realist style. After his return to China he attempted many variations of synthetic styles, usually blending traditional Chinese media of ink and colors on paper with European academic drawing techniques of modeling and foreshortening. His later subjects were often Chinese, or hybrid. Xu's stature as an internationally known artist and frequent representative of China at cultural events and congresses abroad meant that his work had a historical importance quite independent of its quality and sometimes of the artist's intent. His *Yu Gong (Foolish Old Man) Removes the Mountain* (FIG. 10-34) is a mural-scale adaptation of European history-painting modes to a Chinese subject and medium of ink and colors on paper. The fate of the painting exemplifies the ways in which art can be captured by political discourses that take on a life of their own. Xu's painting illustrates the story of an old man who resolved to remove a mountain blocking his view by hewing it away bit by bit with the help of his descendants over the years. The work was executed in India in 1940 while Xu was engaged in patriotic missions in support of the resistance against Japanese invasion. Many of the

10-34 Xu Beihong (1895–1953), *Yu Gong (Foolish Old Man) Removes the Mountain* 1940. Ink and color on paper. Xu Beihong Memorial Museum, Beijing

figures are versions of heroically muscular academic nudes, and some are clearly Indian, suggesting a program of pan-Asian cooperative effort against the Japanese. In any case, this work attracted the notice of Mao Zedong, whose interpretation of it as a parable of the power of communal effort to accomplish any goal ensured that the painting could only be read as a socialist icon, and no doubt assured Xu Beihong's position in the art hierarchy of the PRC as well. After liberation he was made head of the Central Academy of Fine Arts in Beijing and also Chairman of the China Artists Association, where he was well positioned to promote a realist, stridently anti-modernist aesthetic that left a very problematic legacy for official art in the PRC.

Lin Fengmian (1900–1991) went from Shanghai to Paris in 1918, where he studied at the Ecole des Beaux Arts and at the museums. Lin found contemporary trends in European painting much more congenial than Xu Beihong and had a special affinity for Matisse. After his return to China in 1925, Lin again encountered Cai Yuanpei, who in 1927 offered him the chance to start a new national art academy in Hangzhou. Lin gathered a teaching staff that included many fellow students returned from France and promoted a program: "To introduce Western art; to reform traditional art; to reconcile Chinese and Western art; to create contemporary art" (Sullivan, *Art and Artists of Twentieth-century China*, p. 49). Lin Fengmian was a pivotal figure as an institution builder and teacher, and several of his students are among the best known painters of the late century, informed

by the same openness to colorism and formal design that is seen in Lin's own works.

The third member of this generation of leaders in art education was Liu Haisu (1896–1994), who was associated with Shanghai-area institutions for most of his career. He opened his own art school in Shanghai at the age of sixteen and was one of the first to introduce life drawing into the curriculum. An exhibition he organized that included nude-figure painting studies was considered scandalous by some critics. His first visit to Europe, again with the help of Cai Yuanpei, did not come until 1929, but he returned there in 1933 and met Picasso and Matisse. After 1923 his main center of activity was his Shanghai Academy of Art, successor to his earlier forays into art education. In his early decades Liu followed the seeming paradox of championing Western art when in China, while promoting and exhibiting *guohua* art when in Europe. Aside from securing his role as an artistic rebel, which Liu cherished, this pattern reveals the fundamental linkage of artistic affiliations to emerging nationalist formations of culture. Western art styles, whether conservative or modernist, were significant in China first and foremost for their "otherness" from traditional Chinese painting and served as a visual manifestation of the new culture of the Republic. In Europe, on the other hand, the practice and exhibition of *guohua*-style works not only responded to audience expectations but also constituted an identity of Chineseness. Despite their shared promotion of Western art in China, Xu Beihong and Liu Haisu were bitter rivals in the

10-35 Ding Cong (b. 1916), *Xianxiang tu,* *Images of Present Times* 1944. Handscroll, gouache on paper; 11¼ × 58⅜" (28.6 × 149.3 cm). Spencer Museum of Art, University of Kansas, Lawrence, gift of William P. Fenn

This wartime pictorial satire was directed primarily at the social corruption and political repression of the Nationalist regime. Combining a political cartoon style influenced by leftist Mexican artists with the traditional handscroll format, the painting targets impotent artists, war profiteers, the uncaring rich, and incompetent officials.

politics of the Chinese art world. Dating back to the 1920s, they struggled over the directorship of the Beijing Academy, their status and reputations in Europe, and above all over the proper direction for art in China. While Liu championed versions of early modernist styles and artistic freedom of choice, Xu Beihong's promotion of an academic realism won out as the official mode of the PRC.

Satire and Protest

While political art is often associated with heavy-handed doctrinal propaganda, there was also a rich tradition of humorous or satirical drawings and paintings related to cartoon styles. There are loose antecedents to these modes in popular imagery from Ming and Qing times, such as the woodblock-printed cards used in drinking games of chance that were decorated with figures from popular literature and legend. Explicit political commentary was more directly derived from Western traditions of caricature and cartooning that entered Chinese visual culture with European-sponsored publications of the late nineteenth and early twentieth centuries, chiefly in Shanghai, such as the *Dianshizhai Pictorial* and *Shanghai Puck*. Another important source was the Japanese *manga* or cartoon tradition, which became familiar to the many Chinese artists who studied in Japan. The turbulent years of the late 1920s

and 1930s provided a strong impetus to political dissent against internal political repression, Western imperialism, and Japanese invasion. A Cartoon Society and many journals devoted to cartoon art were founded in the decade between 1926 and 1936, more or less in tandem with the Woodcut Movement, which had similar international sources and political motivations. Some of the journals were devoted to popular and mass culture in broad terms, including not only satirical drawings but movie-star and news photos as well as art and literary reviews.

Among the more complex products of this movement were the satirical paintings of Ding Cong, such as his *Images of Present Times* from 1944 (FIG. 10-35). Like many wartime satires, it is directed more at the corruption and repression of the Nationalist regime led by Chiang Kai-shek than at anti-Japanese sentiment. The exaggerations and grotesqueries of this episodic handscroll owe as much to leftist Mexican artists, such as the cartoonist Miguel Covarrubias, who visited Shanghai in 1930, as to any other sources. Ding Cong, the son of another Shanghai cartoonist, studied with Liu Haisu and spent the early war years in Hong Kong, returning to Sichuan in southwest China for the remainder of the war. His handscroll is as critical of artists and intellectuals as more blatant kinds of social parasites. At the beginning of the composition a student pores over useless old classics, neglecting

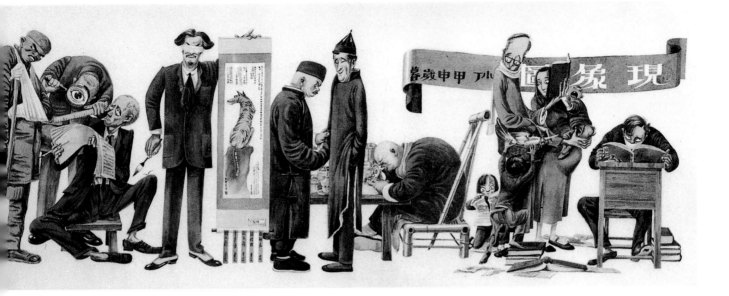

modern textbooks; an impoverished professor is unable to provide for his ragged family. The foppish artist in Western dress is blindfolded, and the seated writer next to him submits his words to the cyclopean magnified eye of a censor. Other figures expose corruption and inequality: the seated war profiteer calculating his take; the rich couple who shrink from the stench of a crippled soldier's war wounds and refuse aid to a refugee; and officials who let relief supplies of food and clothing rot while they argue. The final figure is a journalist who is silenced by the official notice stuffed in his mouth. The last image found a striking echo more than three decades later in another era of political interference and official censorship. Wang Keping's wood sculpture *Silence* (FIG. 10-36) of 1978 manages to combine primitivist references to the powerful body imagery of tribal arts with a blunt display of forcibly sealed expression. Wang Keping was an organizer of the Stars, a group of outsider artists who were among the first to challenge official control of exhibition spaces after the Cultural Revolution. In 1979 they hung their work on the railings outside the China Art Gallery in Beijing, the most prestigious venue of the official China Artists Association, and after a further series of protests they won access to exhibition spaces.

Shadowing what might be called the active political spaces of propaganda production and official cultural policy are spaces of resistance and reception. The very potency of a space such as Tiananmen Square as a site of indoctrination made it a magnet for the display of protest. In other contexts, satire was a more effective strategy of resistance, insinuating itself in the cracks of the official cultural facade. An example of the complexities of cultural politics is the scandal surrounding a modest composition, well described by the title *The Winking Owl*, painted for a friend in 1974 by Huang Yongyu (b. 1924). The painting was confiscated by followers of Chairman Mao's wife Jiang Qing and exhibited among other supposedly counter-revolutionary works in a so-called Black Paintings exhibition. The very ambiguity of the painting made it a target of suspicion in the paranoid atmosphere of the Cultural Revolution, as an image of ridicule, possibly aimed at Jiang Qing herself and her cultural activities, or at socialism. Any suggestion of humor or irony was perhaps enough to condemn a work of art amidst the single-minded zealotry of the Cultural Revolution, and Huang had already gotten into trouble for his illustrated poem-fables that could be read as satires on political figures. The larger

10-36 Wang Keping (b. 1949), *Silence*
1978. Wood, height 15⅜″ (40 cm)

context for the anti-Black Paintings campaign was the rivalry between Jiang Qing and the ailing Premier Zhou Enlai, who was seen as a champion of traditional culture.

For artists active during Chairman Mao's lifetime and especially during the Cultural Revolution years, even hints of irony and ambivalence in the intensely politicized sphere of public imagery could have drastic personal consequences. Artists of the younger generation who were children or youths during the Cultural Revolution may look at images of Chairman Mao as inescapable icons in their visual culture, to be freely manipulated or reworked with a mixture of nostalgia and cynicism in an era of greater openness. The oil painter Liu Dahong (b. 1962) borrows iconic images of Chairman Mao and surrounds them with environments that are by turns disturbing, comic, and ominous in his *Four Seasons* series of 1991. In each of four oil paintings Mao is the hieratic center of a ring of figures, ranging from admiring throngs waving his little red book to the funereal victims of his power. The first in the series, *Spring* (FIG. 10-1), appropriates a key icon of the Cultural Revolution, a 1967 oil painting, *Chairman Mao Going to Anyuan*, showing him as a young Communist organizer of striking workers in the 1920s. In that oil painting, reproduced by the millions and displayed everywhere during those years, the young Mao is shown as a heroic figure, overshadowing the mountains and nearly saintly in his determination. Liu Dahong's image moves this instantly recognizable icon toward full deification, with a radiant halo and golden rays emanating from his upraised palm, beneath a sky alive with auspicious dragons. Though an oil painting, Liu's image brilliantly appropriates the imagery of the traditional Chinese medium, with convoluted cypress trees and contorted dragons dominating a landscape of rolling hills and the rising sun. Mao's acolytes are a motley assortment of peasants and adventurers, and the skeleton grasping the tree trunk suggests the darker side of Mao's ascension.

Following the economic liberalizations promoted in the 1980s by Premier Deng Xiaoping, and with the recognition that PRC politics are centrally about economic life, many artists turned to consumerism as a target for satire. The social changes that accompanied the move from a public ethic of self-sacrifice, drab uniformity of dress, and restraint of consumer desire under Mao to an official encouragement of growth through advertising, status symbols, and consumption were disorienting in their speed and redirection. Wang Guangyi (b. 1956) shrewdly juxtaposes the advertising logos of global consumer-products corporations with the equally ubiquitous worker/peasant/soldier iconography of the Cultural Revolution years in his *Great Castigation Series: Coca-Cola* of 1993 (FIG. 10-37). Political propaganda is shown to have been the advertising of the Mao years, equally amenable to being transformed into the accessible visual language of Pop art, with the stern purpose of the figures turned toward planting the red flag of revolution on the financially firmer footing of a brand-name banner. An installation by Wang Jin (b. 1962) called *Ice Wall: Central China* of January 28, 1997, was a public art project commemorating the opening of the first shopping mall in the central Chinese city of Zhengzhou (Henan). Wang built a wall of ice within which he embedded popular consumer objects such as cell phones and jewelry, temptingly visible in the manner of department store display windows, yet frustratingly beyond reach. The project offered a materialization of the Marxist idea of the commodity fetish, while alluding to the "great walls" of ideology and economic development that had kept China frozen out of the flow of the global consumer economy. A wintertime work that was fated to seasonal obsolescence in any case, the *Ice Wall* incited its own premature destruction as visitors hacked it apart to liberate the goods within.

The free-market conception of art is carried to a further stage in the work of the Shanghai conceptual artist Zhou Tiehai (b. 1966), who offered himself as traded shares on the Shanghai Stock Exchange. The visual content of his work included stock charts tracking his rising value in the market, along with mock covers of international news and financial magazines touting his success. His slogan "The relations in the art world are the same as the relations between states in the post-

Cold War era" aims equally at the overshadowing of diplomacy by global corporate politics and the commodification of transnational art careers. The much less glamorous domestic and feminine spaces of the new consumer economy are the subjects of the installation artist Lin Tianmiao (b. 1961). *Bound and Unbound* (FIG. 10-38) was the product of a couple of years of her patient labor, in which she wrapped dozens of household objects with white thread and scattered them around the variable spaces of gallery installations as spectral presences, useless but recognizable trophies suggesting both the freedom and the burdens of purchasing power. An accompanying video projection of a disembodied hand endlessly cutting thread alludes to the deep history of feminine domestic tasks (perhaps also distantly to the legend of the Confucian sage Mencius's mother, who cut the threads of her sewing as a maternal admonition to her son not to cut short his studies) and to the central role of women in the labor force of China's export industries.

10-37 Wang Guangyi (b. 1956), *Great Castigation Series: Coca-Cola*
1993. Oil on canvas; 6′5″ × 6′5″ (2 × 2 m). Collection of the artist

10-38 Lin Tianmiao (b. 1961), *Bound and Unbound*
1995–97. Installation with video projection and household objects wrapped in thread, dimensions variable. Collection of the artist

TRANSNATIONAL ARTS AND AVANT-GARDE MOVEMENTS

One of the many paradoxes of twentieth-century Chinese art is that, even as it has been intensely preoccupied with national identity, it has all the while been deeply engaged with larger international art communities. As we have seen, it has been impossible to discuss Chinese political arts without frequent reference to artists trained in Japan or Europe, the emulation of European Expressionist prints and graphic design, and in the PRC the promotion of international styles of Socialist Realism. Although specific modernist or leftist allegiances sometimes aligned these and other emulations with truly international movements, in almost every case local Chinese circumstances and agendas were equally important. Thus European or Japanese styles always had a dual significance: for their intrinsic visual qualities and for their status as alternatives to traditional Chinese modes.

Previous chapters traced a substantial history of international arts in Qing-period (1644–1911)

China and earlier in the form of export arts and of European artists active at the Manchu court. In some cases these were complexly multicultural and hybrid products. The distinction between earlier international and twentieth-century transnational arts is by no means hard and fast but hinges mostly on the relative stability of locations of production and consumption. Earlier international arts were largely produced at specific points of origin and aimed at particular audiences or markets in China or the West. Twentieth-century transnational arts and art movements may involve amalgams of Western, Japanese, and Chinese sources and motivations or be the products of hybrid environments, such as the mixture of Chinese and foreign communities in Shanghai, with audiences found among multicultural and multinational circuits around the world.

The transnational character of much art in the twentieth century was foreshadowed at the end of the nineteenth century in the *Dianshizhai huabao*, published in Shanghai from 1884 to 1898 by the Englishman Frederick Major, mentioned above, in emulation of periodicals such as *The Illustrated London News*. Wu Youru and many collaborators produced the lithographic illustrations, with extensive Chinese explanatory texts, but they drew their subjects from domestic and foreign sources in a mixture of news and fantasy, emphasizing crimes, disasters, and curiosities, in the same manner as the *Feiyingge huabao* illustrations by the same artist reproduced above (see FIG. 10-21 and page 385). Executed in a detailed, reportorial style, the line drawings made abundant use of perspectival techniques, while the subjects blended the here-and-now of specific places, names, and dates with the transnational media space of journalistic sensationalism.

One of the earliest efforts at a conscious synthesis of Western realism and Chinese traditions appeared among a group centered in Guangzhou in far southern China and known, following another name for the region, as the Lingnan school. Guangzhou (Canton) had a long history as the major port for international trade and site for European cultural incursions in the mid-Qing period, and many leading reformers in

the years leading up to the fall of the imperial system and founding of the Republic came from there as well, including the founder of the Republic, Sun Yat-sen (1866–1921). Gao Jianfu (1879–1951), the leading figure in the Lingnan school, and a follower of Sun Yat-sen, joined Sun's radical Alliance Society, dedicated to the overthrow of the Qing dynasty, while studying art in Tokyo in 1906. Gao's revolutionary involvement after he returned to Guangzhou in 1908 extended to the organization of a China Assassination Group aimed at senior Manchu officials and overseeing bomb production for the revolutionaries. The integration of art theories with violent revolutionary politics may seem incongruous, if not bizarre, but for Gao Jianfu and his associates art and politics were equally necessary elements of a program of national reform. As we have seen above, Japan offered an appealing model of modernization and Westernization without sacrificing cultural identity. The *Nihonga* (modern Japanese-style painting) artists with whom Gao and his associates studied in Japan followed a related strategy of blending Japanese themes and media with Western techniques of realistic representation. The Chinese counterpart of that strategy promoted by the Lingnan painters was the goal of a New National Painting (*Xin Guohua*) that would blend Chinese traditional media with an accessible realism of style. This was in many ways a pictorial parallel to the vernacular-literature May Fourth movement that aimed at freeing literature from elitism and class-boundedness. A strong sense of social mission animated both movements. In 1912 Gao Jianfu opened the Aesthetics Bookshop in Shanghai and briefly published *The True Record Illustrated Magazine* as a vehicle for his theories. His paintings, such as *Flying in the Rain* (FIG. 10-39), acknowledge modern technologies while insisting on a recognizable Chinese cultural matrix, with the biplanes that hover over a misty ink landscape perhaps deliberately inviting misidentification as dragonflies.

A much more thoroughgoing involvement with European modernisms emerged briefly in 1930s Shanghai and Guangzhou, spearheaded by artists who had experienced Japan or Europe. The

1935 NOVA exhibition of the China Independent Art Association included artists such as Zhao Shou (b. 1912). Originally from Guangzhou, Zhao went to Japan in 1933 to study and was exposed to the recently arrived art and theory of Dadaist, Constructivist, and Surrealist movements, as well as to Post-Impressionist and Fauvist styles that had circulated in Japan since the early 1920s. After returning to China in 1935 as a self-proclaimed Surrealist, Zhao exhibited in Guangzhou and Shanghai works such as *Color* (FIG. 10-40), which in its coloristic intensity and reference to tribal masks seems most indebted to Fauvist and early Cubist approaches. Contemporary journals of criticism such as *Yifeng* (Art Winds) that reviewed and published such exhibitions also included translations of modern art theory, such as André Breton's *Surrealist Manifesto* of 1924, and reproductions of works by an array of European modernists.

The theoretical and polemical aspects of modernist practice were most clearly exemplified in the Storm Society, founded in Shanghai in 1931 by a group of artists who had trained in Japan or France. Their manifesto struck a tone of combative urgency common to many avant-garde movements:

> The air that surrounds us is too desolate. The commonplace and the vulgar enclose us on all sides, numberless feeble wriggling worms, endless hollow clamor… We can no longer be at ease in this atmosphere of compromise… Release the disturbing power of Realism! Let us arise! Summon up the passion of wild beasts, the will of steel, to create an integrated world with line, color and form! We recognize that art is certainly not the imitation of nature, nor is it the inflexible repetition of objective form. We must devote our whole lives to the undisguised expression of our fierce emotion! We do not take art to be the slave of religion, nor is it the explanation of a culture… We want to use the new art to express the spirit of a new era…
>
> (Sullivan, *Art and Artists of Twentieth-century China*, p. 62).

The intermingling of multiple and sometimes contradictory aims fairly reflects the situation of Chinese modernists, who were faced with rapidly

assimilating a wide range of experiences and theories, while being pulled about by the competing claims of nationalism, political factions, and aesthetics. The leading figure in the Storm Society, Pang Xunqin (1906–1985), had studied modernist styles in Paris in the late 1920s. After his return to China in 1930, he continued to paint images of the fragmentation of modern urban life in Paris and Shanghai, with some indebtedness to Cubist collage techniques. An anonymous photomontage from the 1934 issue of the Shanghai periodical *Young Companion* further manifested the linkage of modernism to transnational urban experience. Titled *Intoxicated Shanghai* in English and *Stimulation in the Metropolis* in Chinese, the disjunct images associate the modern with fragmented urban experience, with leisure consumption

10-39 Gao Jianfu (1879–1951), *Flying in the Rain*
1932. Hanging scroll, ink and color on paper; 18 × 14″ (46 × 35.5 cm). The Art Gallery, Chinese University of Hong Kong

10-40 Zhao Shou (b. 1912), *Color*
1934. Oil on canvas, 36¼ × 30¾″ (92 × 78 cm). Guangzhou Art Museum

in the form of movies, horse racing, and jazz, with the mechanical media of photography and film, the high technology of skyscrapers, and most of all with a voyeuristic male sexuality (FIG. 10-41). Pang Xunqin himself destroyed most of his paintings related to this kind of idiom in 1966 at the outset of the Cultural Revolution, rightly fearing that they might be used to incriminate him on ideological grounds.

In truth, modernist art faced an inhospitable climate in China almost from the beginning. There was almost no market or regular gallery venues for such art, and contact with international modernism depended on study abroad, occasional visiting artists, and irregular publications. The Storm Society manifesto suggests that Chinese modernism was pushed toward an apolitical stance of formalism and self-expression in order to distinguish itself from the competing claims of the New Culture Movement's nationalistic reformers and leftist revolutionaries. If there was a viable space for such a stance, it disappeared

with the Japanese invasions of the late 1930s and the widespread calls for art to serve the aims of nationalism and resistance. This was one manifestation of what might be called the structural disadvantage of avant-garde movements in China. Whereas in the West (outside of Soviet Russia) avant-garde movements were always outsider movements that could take up attractively radical reformist positions without fear of being asked to realize them, in China much of the space of the avant-garde was occupied by officially adopted reformist programs in the arts, from the time of Cai Yuanpei after the founding of the Republic through the cultural policies of the Communist Party in the PRC. Since Western realism was, in the context of traditional China, a radical break with the cultural past, carrying the additional advantages of accessibility and instructional potential, it was always the first choice of reformers, consigning modernism to the role of a self-indulgent and difficult private art. We might note a further historical paradox: China may have had a greater impact on the formation of international modernist theories than modernism ever had on early-twentieth-century China. The imagist poetics of Ezra Pound and the film theory of Sergei Eisenstein assigned a central role to Sino-Japanese concepts of the ideogram as the model for techniques of imagistic juxtaposition or montage that produced intense and novel insights.

Modernist modes had a more hospitable reception outside the PRC when practiced in Taiwan, Hong Kong, or among expatriate Chinese artists. The Fifth Moon Group, formed in Taipei in 1956 and active until 1970, pursued a technically adventurous abstraction in a variety of painting media under the clear stimulus of American Abstract Expressionism. The best known member of the group, Liu Kuo-sung (b. 1932), turned to Chinese media in the early 1960s with energetic ink abstractions on textured paper grounds (FIG. 10-42) that recall some of the dynamic forms in black-and-white abstractions by Franz Kline and Robert Motherwell, at the same time perhaps pointing to the earlier indebtedness of Abstract Expressionists to East Asian calligraphy and ink painting.

10-41 Anon., *Intoxicated Shanghai (Stimulation in the Metropolis)*
In 1934 issue of *Young Companion.* Photomontage

Accompanying a story of male urban adventure published in the periodical *Young Companion*, the modernist device of photomontage and mixed fragments of Chinese and English text are used to convey the dislocations and fragmentations of experience in the international metropolis of Shanghai. Speed, sensation, and voyeuristic sexual stimulation are conveyed as the central attributes of the modern city.

The situation of Chinese artists in the 1920s and 1930s, forced to come to terms with a bewildering array of art theories, movements, and styles in a very short time while contending with the internal pressures of cultural nationalism and art politics, strikingly paralleled the experience of post-Cultural Revolution PRC artists of the late 1970s and 1980s. Deconstructionism, Conceptual art, and post-Modernism were only a few among many new terms of discourse promoted by a flood of translations from, and occasional visits by, Western artists and critics. New opportunities for travel and exhibition abroad opened up, but whereas artists who had studied in Japan or Europe earlier in the century mostly returned to careers in China, the episodic repression of experimental art by the cultural authorities and limited economic opportunities in post-Mao China encouraged a substantial expatriation of transnational

10-42 Liu Kuo-sung (b. 1932), *Landscape*
1966. Ink and color on paper, 20⅛ × 35⅞″ (51 × 91 cm). Private collection

artists, self-identified as Chinese but living, working, and exhibiting in international arenas. The question of what Chinese cultural identity can mean in such circumstances continues to be a significant concern for many such artists. It is an issue admittedly entangled with the self-serving marketing advantages of fitting into an established art-world category, and one made still more attractive by the common assumption by Western audiences that such art must have a politically dissident purpose.

Though the issue of Chinese identity becomes increasingly less relevant for artists who successfully operate within global art-marketing and exhibition systems, transnational positions have sometimes been placed in the foreground thematically in the work of artists such as Wenda Gu (b. 1955). Gu trained as an ink painter and in the mid-1980s experimented with monumental pseudo-characters as a way of divorcing the visual impact and semantic potential of Chinese writing from the authority of established meanings. By so doing, Gu deprivileged insider cultural knowledge and opened up his work to international audiences on a more or less equal footing with Chinese viewers. After moving to North America in the late 1980s, Gu began a project called

the *United Nations Series* that explicitly thematizes multicultural engagements. Gu created a series of monumental installations of invented scripts fashioned from human hair gathered from the country where the projects are realized. Woven into screens sometimes more than 20 feet (6 m) high and surrounding visitors in architectural configurations are pseudo-scripts of ancient Chinese, Arabic, and Roman characters that simultaneously invoke and deny the political authority of writing.

THE ARTS OF HISTORY

It seems appropriate for a written history of art to conclude with a discussion of the arts of history and language. The last two centuries have been a period of profound disruption of traditional forms of social and cultural life, but they also saw a compensating deep engagement with the study of the past. We should recall that archaeology, while focused on early history and the prehistoric, is also primarily a modern-era intellectual pursuit, one of many efforts to reconstruct the past through theoretical and historical constructions. A widespread response to the fragmentations of modern life has been the invention

of traditions to provide a reassuring sense of continuity as well as to serve contemporary political needs. The painful transition from imperial dynasty to nation state in the years around 1900 required not only the invention of a new apparatus of government and new concepts of personal identity but also new narratives of history that could accommodate changed conditions and values. The archaeological discovery of concrete remains of a Shang-dynasty culture and the rediscovery of the Dunhuang Buddhist cave temples around just this time were unpredictable but fortuitous, and every regime in the years since has made use of such discoveries for ideological purposes. The presentation and interpretation of archaeological discoveries offer a particularly potent arena for ideological construction, because deep history and prehistory are imbued with an aura of uncontaminated origins. It is little wonder that archaeological sites linked with central culture narratives, such as the tomb of the First Emperor of Qin, have become overlaid with theme-park mythologies to the point that it is possible to experience multiple representations of the site without ever seeing the actual excavations and their recovered contents. Museum displays and the historical representations and narratives they construct are another primary vehicle for the art of history.

Starting in eighteenth-century China, the critical study of historical and textual tradition through the application of epigraphic and other evidential techniques of analysis, in which tradition was not simply accepted as an inherited environment but was subjected to a distancing critique, may mark the beginnings of an intellectual modernity. Turn-of-the-century archaeology and engagement with Western historiographic perspectives are further components of this process. In the visual arts, an awareness of the fragmentation and corruption of the inherited past, an engagement with the deep history of language forms, and primitivist impulses were all related phenomena.

A very plainspoken manifestation of this complex of interests is found in some of the clay pottery wares produced in the Yixing district on the western side of Lake Tai across from Suzhou in Jiangsu Province in southeastern China. A center of teapot production since the late sixteenth century, Yixing was nearly unique in the ceramic industry in developing an awareness of individual potters, who marked their works with seals or carved inscriptions and formed distinctive styles and specialties. Individuation also implied a pursuit of originality and inventiveness, and many of the sixteenth- to eighteenth-century wares involve elaborate representational conceits, in which the clay teapots, cups, and water droppers are fashioned in the form of tree trunks and branches, fruits and vegetables, or other plants and creatures. The pliable clays of the region, most commonly a purplish brown known as "purple-sand" but including many other colors, are ideal for molding and shaping. Mostly left unglazed, the surfaces are sometimes decorated with carved pictorial designs and calligraphy, turning pottery from an artisan's medium into a full-fledged form of post-literati art. Many other vessels, especially in the nineteenth century, reflect the archaeological turn in culture with imitations of the shapes of ancient bronze vessels and other antiquities. The brick-shaped teapot illustrated here (FIG. 10-43) is modeled after the humble form of a late-fourth-century brick, down to a facsimile of its dated inscription. Along with its antiquarian and epigraphic interests, the pot bears seals of its maker, one Yang Pengnian, and its patron, Qiao Zhongxi, a calligrapher and connoisseur; both were active in the early nineteenth century. The total geometric simplicity of the vessel shape is appealing to modern minimalist or functionalist tastes, but in its own time it aimed more at conveying the rugged integrity of ancient forms and scripts.

The movement known as "stelae studies" was an important manifestation of an archaeological turn in culture from the late eighteenth through the early twentieth century. Scholars viewed stone slabs or stelae engraved with ancient calligraphic texts, along with other inscribed archaeological artifacts such as ritual bronze vessels or stone tombs, as more reliable and direct conduits to the past than the copy-books which allowed distortions to be transmitted over time. In addition, stelae and other archaeological texts dating from the distant Zhou through Six Dynasties

10-43 Brick-shaped teapot, Yixing ware Qing, early 19th century. Clay, height 1¾″ (4.4 cm), length 6 3/16″ (15.6 cm). Bei Shan T'ang, Taipei

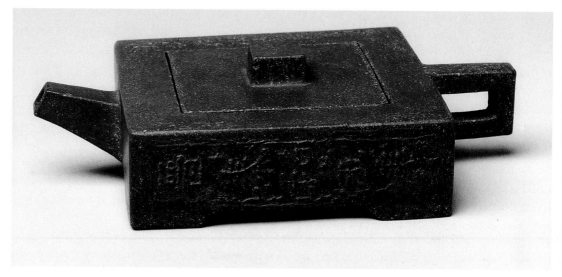

era were often relatively anonymous and public or religious in character, in contrast to the private and individualized scripts of famous masters of the more recent past transmitted in copy-books. Stelae styles, which were often relatively simple in form because of the character of the carved stone medium, were thus associated with values of authenticity and direct power that made them attractive to proponents of cultural reform and self-strengthening.

We have already seen how artists such as Zhao Zhiqian (1829–1884) and Wu Changshi (1844–1927) sought to infuse their painting with some of the blunt directness of form and language-like combinatorial potential of ancient scripts (see FIG. 10-17 above; see also page 381). Wu Changshi's 1915 set of four calligraphy scrolls in the manner of the Stone Drum script, following a model from the later Zhou dynasty (see FIG. 3-2 above), completes a circuit between text and image by exploring the pictographic character of this early form of writing (see FIG. 0-4 above). At the same time, the blunt simplicity of this archaic style seems to liberate a raw, rhythmic energy that might be seen as a kind of primitivism, seeking sanction in the temporally remote (rather than the geographical and cultural distance of European primitivism) for liberation from cultural constraints.

A more explicit kind of primitivism emerges powerfully in the *Zoon* paintings (FIG. 10-44) of the contemporary Taiwan artist Huang Chih-yang (b. 1965). A tribe of overpoweringly massive

ink figures, painted separately on overlapping hanging scrolls each more than 17 feet (5 m) high, crowd the surface of the paintings and the perceptual space of the viewer with vibrant, heavily textured forms. The figures seem not only prehistoric but at times prehuman, with heads diminished to a blur of ink, while breasts, muscles, entrails, and sexual organs are magnified in images that can be read as internal anatomy, corporeal form, or as a kind of primordial body landscape. Up close, the forms are full of dynamic ink gestures, but the harsh tonal contrasts and obsessive cell-like patterning give the figures both the archaeological quality of fossilized imprints and the ghostly anatomical aura of contemporary medical imaging. The *Zoon* images are forceful reminders of the primitive residue that survives even in a postindustrial world.

One side of the archaeological turn in nineteenth- and twentieth-century Chinese art involved the recovery of deep cultural structures and the liberating energy of primitivism. The other face of this movement includes an awareness of the fragmentation and loss that accompanies the rupture of the present from the past. The damaging effects of time are thematized in a genre of painting popular in the late years of the nineteenth century known as the "Eight Brokens." These are collagelike images of overlapping artifacts such as pages of books, paintings, rubbings of calligraphy, as well as occasional coins and ancient vessels. In many cases artists showed the assembled artifacts as torn, folded, burned, worm-eaten,

or otherwise damaged and fragmentary—appropriate emblems for an era that saw as much destruction as it did recovery. Even the tattered remnants of the past, however, are revealed in the end to be illusionistic tricks of painting rather than tangible survivals, suggesting the many barriers and filters blocking an authentic experience of history. Overlapping tangles of depicted antiquarian objects show inherited culture to be not so much a treasured legacy as a burden, requiring complex acts of decipherment and reconstruction. After the end of the dynastic era, moreover, the whole assemblage of imperial culture and collecting required much vaster acts of reconstitution within the displays and narratives of public museum spaces.

The burden not only of historical art but of art history is confronted in an installation by the contemporary artist Huang Yong Ping (b. 1954). Huang was a founding member of the group "Xiamen Dada" that organized art and anti-art events centered in the southeastern coastal city of Xiamen (Amoy) in Fujian, which had a long history as an international trading port. Two stan-dard art-history texts, the Chinese *History of Chinese Painting* and the English *A Concise History of Modern Painting,* were washed in a washing machine for two minutes, and the resulting intermingled pulp of texts was exhibited in 1987. This gesture of destructive refusal of the limiting categories of art-historical discourse is somewhat cynical and even self-canceling, in that it references the history of Dada events from the early years of the century. Aspirations toward Sino-Western synthesis, which had been central to cultural programs since the beginning of the century and were very much in play during the cultural liberalization periods of the 1980s, along with the unsystematic encounter with critical theories, doctrines, and art movements from all over that characterized the Chinese art scene in those years, are materialized as undigested mush. Other Xiamen Dada events included the public burning of works from their inaugural exhibition, in a painful preemptive strike against cooptation by the art market or domestication by critical language. This act was also inevitably reminiscent of the

10-44 Huang Chih-yang (b. 1965), *Zoon*
1996. Hanging scrolls, ink on paper; each 17′1″ × 59″ (5. 2 m × 150 cm). Collection of the artist

10-45 Song Dong (b. 1966), *Printing on Water* 1996. Performance in the Lhasa River, Tibet

burning of traditional artifacts during the Cultural Revolution years and, still further back, of the destruction of dangerously competitive texts by the Legalist authorities of the Qin, the first empire of China.

Every act of refusal of history and language thus seems fated to be recaptured by those very cultural systems. The strenuousness with which many contemporary artists confront the weight of tradition reveals the centrality of this issue to the full history of twentieth-century Chinese art. Because so much of Chinese cultural tradition takes the form of inculcated performance—memorization, recitation, repetition of writing—some of the most powerful resistance against tradition takes the form of performance art. The installation *Writing the "Orchid Pavilion Preface" One Thousand Times* by Qiu Zhijie (b. 1969) documents in video and calligraphic samples acts of reiterated cultural inscription carried out over the period from 1986 to 1997. The *Orchid Pavilion Preface* text is a canonical touchstone for calligraphic practice by the fourth-century patriarch of calligraphy Wang Xizhi, endlessly

reproduced over the centuries even though the original was long since lost (see FIG. 5-24 and pages 174–176 above). Both the satisfaction and futility of such imitation are embodied in Qiu's thousand-fold practice of the text on a single sheet of paper. That repetition results in a gradual illegibility and final cancellation of the text into a velvety chaos of black ink, suggesting the void of undifferentiation from which language emerges and to which it seemingly must return. A related enactment of the negation of cultural formations is the performance *Printing on Water* by Song Dong (b. 1966) of 1996 (FIG. 10-45). Seated in the shallow waters of the Lhasa River in Tibet, Song struck the flowing surface repeatedly with a large seal carved with the character for "water," conveying the absurdity of efforts to contain the world with language. Carved seals may be the most coercive form of writing, because they imply direct impression and physical contact with the receiving surface. In this case, the location of the performance in a Tibetan river suggests the added dimension of efforts to stamp Tibet with the overlaid forms of Chinese culture.

The Great Wall of China and China's reputation as the site of invention of gunpowder and fireworks are among the deep historical structures in play in *Project for Extraterrestrials No. 10: Project to Extend the Great Wall of China by 10,000 Meters* (FIG. 10-46) by Cai Guo Qiang (b. 1957). In this pyrotechnic event, the Great Wall was both visually extended and dematerialized in an explosive blaze. The work also transcended the Great Wall's status as a land barrier and marker of cultural boundaries, with an invoked audience that moves beyond the transnational and global into the extraterrestrial realm. Song Dong's water printing and Cai Guo Qiang's fire building suggest a contemporary engagement not only with deep structures of history and language but also with the most elemental, though never entirely precultural, forces.

Installations by Xu Bing (b. 1955) known as *A Book from the Sky* are all about language, or a kind of anti-language, but they also have a fundamental and talismanic power that is better conveyed in alternative renderings of the title as *A Mirror to Analyze the World* or as *Heavenly Scriptures*. These take the refusal of legibility all the way through an invented lexicon of a thousand or more characters, each painstakingly carved in wooden blocks and hand-printed to form a sea of text that both invites and frustrates reading (FIG. 10-47). The installation comprises a wavelike array of traditionally bound books on the floor, panels of dense wall text, and arcing banners of suspended printing above to create an all-encompassing surround of meaning that remains just beyond reach. Xu Bing evokes many historical vehicles for the authority of writing, such as books, handscrolls, collections of engraved stone stelae, and even wall displays of newspapers and official pronouncements. The authority of every format is undermined by its resolute illegibility. The appearance of the first version of *A Book from the Sky* in the late 1980s in Beijing, at a time of frequently alternating permissiveness and repression of unofficial art, has encouraged a reading of the installation as a protest against the corruption and abuse of language in the political arena. Many other possible implications are in play, including a liberation

10-46 Cai Guo Qiang (b. 1957), *Project for Extraterrestrials No. 10: Project to Extend the Great Wall of China by 10,000 Meters*
1993. Pyrotechnic event

10-47 Xu Bing (b. 1955), *A Book from the Sky*
1988. Installation of carved woodblocks, bound hand-printed books, and ink on paper, dimensions variable. Exhibited November 1991–January 1992, Elvehjem Museum of Art, University of Wisconsin-Madison

from the regime of determined meanings and a demonstration of the emptiness of laborious cultural production. Three of the primary markers of Chinese artistic culture noted in our introduction—highly developed craftsmanship, involvement with the past, and the centrality of the written text—are fully engaged in this project, only to be subverted. *A Book from the Sky* holds in suspended equilibrium an excess of cultural forms and a total vacancy of determined meaning. Somewhere in that space lie a future Chinese art and a history of that art yet to be written.

GLOSSARY

Amitabha (Emituo Fo) Buddha who presides over the Western Pure Land; Buddha of Infinite Life.

antiquarianism The study of objects from the past, which in pre-modern China was an activity that supplemented and corrected the received historical record by the investigation of inscribed objects, especially ritual bronze vessels and texts cut into stone.

archaeological culture A concept created by archaeologists to identify a collection of data derived from a site or group of sites with a human group.

arhat *See luohan.*

assemblage An archaeological term for a group of objects found in association with one another and in a context from which one may infer function and mutual relationships.

Avalokitesvara *See Guanyin.*

Bai Di A non-Han northern people who founded the state of Zhongshan in the Spring and Autumn period.

bei A stone monument with either an incised text and/or images.

bi A flat disk usually made from a nephritic hardstone with a central perforation. It is traditionally interpreted as the symbol of Heaven.

bian xiang ("transformation tableaux") Illusory conjurations, many of which survive in Buddhist murals.

bixie ("averter of evil") A name applied to a guardian creature, including those placed along the spirit path.

Bodhidharma (d. 532 CE) The First Patriarch of Chan Buddhism, an Indian or Sogdian monk who is traditionally believed to have transmitted Chan from India to China.

bodhisattva A being whose nature is enlightenment (*bodhi*) as in the Historical Buddha prior to his final enlightenment.

bracket cluster (*dou gong*) A combination of blocks (*dou*) and arms (*gong*), usually atop a column, that serves to transmit the roof weight to the column grid and foundation.

bronze In ancient China, an alloy of copper, tin, and lead that was in use by the early second millennium BCE.

cakravartin A Buddhist king who "spins the Wheel of the Law."

camel hump A scalloped wooden block that carries an arm, beam, or purlin.

Cao Cao (155–220 CE) A general of the late Han dynasty who took part in the coup of 189 CE and later established his own kingdom, the Wei, in northern China.

celadon European term for any high-fired green-glaze ware; applied especially to Yue, Yaozhou, and Longquan wares.

chiefdom A regional polity, with a leader (chief) who is usually hereditary; characterized by status differentiation, specialized production, and elite control of wealth.

Chan A Buddhist sect that emphasizes meditation and personal transmission of doctrine. Traditionally believed to have been transmitted from India by Bodhidharma, but possibly of Chinese origin. In Japanese, Zen.

chinzō A Chan term for official portraits of priests, which may have served to document the transmission of doctrine from master to pupil.

chinoiserie European styles of the

seventeenth to nineteenth centuries that mixed exotic, vaguely East and South Asian themes and media.

chiwei ("owl's tail") A tile architectural ornament that anchors the ends of the roof ridge.

Cizhou ware Stonewares produced at many kilns across northern China from the Song to the Ming periods. Decorative techniques include slip painting beneath transparent glaze, incising sgraffito, carving of layers of slip in contrasting colors, and cut glaze in white, black, brown, and sometimes green and red colors.

clerical script (*li shu*) A script type that emerged during the early empire derived from the brush writing in everyday use. It was named after the clerks who produced such writings.

cloisonné A technique in which colored glass paste was used to fill in and decorate cells (known as *cloisons*, French for "partitions") outlined by copper or bronze wires on the surface of metal vessels or objects.

cong A squared hollow tube, usually made from a nephritic hardstone and traditionally interpreted as the symbol of Earth. Most common in the Liangzhu Culture of the lower Yangzi.

Cultural Revolution A movement which lasted from 1966 to 1976, launched by Mao Zedong to remove party rivals through the mobilization of millions of young people known as Red Guards.

cursive script (*cao shu*) An informal writing characterized by its rapid execution, many simplifications in orthography, and ligatures connecting graphs in sequence; also called "grass" or "draft" script.

Dazu A center of Tantric Buddhism and the site of Buddhist cave temples and carvings dating from the Tang to Qing dynasties, located northwest of the city of Chongqing, Sichuan Province.

dharma (Chinese, *fa*) The Sanskrit term for the teachings or "law" of the Buddha and by extension the Buddhist faith and community in general.

Di High God of the Late Shang oracle-bone inscriptions.

Dian Kingdom and people in the region of Lake Dian, Yunnan province, during the Warring States and Han periods.

di gong ("underground palace") A pagoda's crypt, especially one with proper chambers.

doucai ("joined colors" or "contending colors") A type of porcelain decoration that combines underglaze blue outlines with filled-in overglaze enamel colors.

du Zhou-period concept of a settlement with ancestral temples of the ruling lineage.

Eight Buddhist Emblems Eight objects associated in various ways with Buddhism that are frequently used as designs on ceramics and other objects—jar, conch shell, parasol, canopy, lotus, wheel, fish, and knot.

fang A walled residential ward within a city grid.

fang guo A general term for the statelets or chiefdoms bordering the Shang domains recorded in the oracle-bone inscriptions.

fengshui ("wind and water"; *dili*, "earth principles") Geomancy, the lore and methods of siting buildings, graves etc. with regard to the propitious or harmful influences of landscape formations.

flash gilding A technique for bonding gold to the surface of metal objects. In Han times mercury was used.

Fu Xi and Nu Wa Mythological beings often represented in Han art and believed to be the male and female progenitors of the human race.

ge Bronze blade mounted at right angles to a shaft and used for stabbing and hacking. It was one of the main weapons of the Shang and Zhou arsenals.

Gong cheng ("palace city") The area of the imperial palaces in Tang Chang'an, located on axis at the north of the city.

Great Leap Forward A movement launched by Mao Zedong in May 1958 to collectivize agriculture and increase industrial production.

guan ("visualization") A meditative practice in which the devotee creates mental images, sometimes using visual aids.

Guan ware ("official" ware) with special reference to a Southern Song crackled celadon ware made at kilns in Hangzhou.

Guanyin (Sanskrit: Avalokitesvara) The *bodhisattva* of compassion, one of the attendants of Amitabha Buddha and a popular object of devotion throughout East Asia.

guohua ("National-style painting") A modern term of reference for painting using traditional media, formats, and themes as an alternative to Western-style painting.

Guo Ruoxu A minor official of the Song dynasty and author of *Tuhua jianwen zhi* (*An Account of My Experiences in Paintings*), an account of painters active beween 841 and 1074 completed sometime around 1080.

hangtu Hard pounded earth, an ubiquitous building material for foundations and the like in Bronze Age China.

Hariti A female Indian deity who devoured human children but was converted by the Buddha and renounced her former ways. An example of a folk deity absorbed into the Buddhist pantheon.

"Heart/mind print" A term used by scholar theorists and artists to refer to paintings that were thought to reveal the mind or personality of the painter.

Hou Ji ("Lord Millet") Legendary ancestor of the royal Zhou lineage.

Hua–Xia A term coined in Zhou times to refer to the people and culture of the central states.

Huang cheng ("imperial city") The area south of the palace in Tang Chang'an devoted to ministries and other organs of state.

Huineng (638–713) One of two contenders for the title of Sixth Patriarch of Chan Buddhism, traditionally known as the "founder" of the southern school of Chan.

ithyphallic An image that presents the phallus.

jadeite A sodium pyroxene, with a different microstructure, greater toughness, and a different range of colors than nephrite; glassy in appearance. It was not used in ancient China.

jiagu wen See oracle-bone inscriptions

Jian ware A type of sturdy stoneware favored for tea drinking in China and Japan, glazed in blacks, browns, and yellows, first produced in Fujian in the Song period. Glaze types include "hare's fur" and "oil spot," each produced when excess iron in the slip precipitates out during reduction.

jiehua ("ruled-line painting") A style of painting in which rulers and other tools were used to produce precise and detailed images of man-made constructions such as architecture and boats.

jin wen ("writings on metal") A term for inscriptions on bronze ritual vessels and also used to refer to a major branch of traditional Chinese antiquarianism.

Jurchen A semi-nomadic people who founded the Jin dynasty (1115–1234) in the north of modern-day China and forced the Song-dynasty court south of the Huai River in 1127.

kalpa A Buddhist term for "great age."

kaolin (China clay) A white clay, mostly silicon oxide and aluminum oxide, with few impurities, which is an essential ingredient in porcelain.

kōan (Japanese, from the Chinese *gongan*) A nonsensical or paradoxical question or story used in Chan Buddhism as a method to force the listener to abandon logical thought and attain a suprarational understanding.

Ksitigarbha (Dizang) An intercessor *bodhisattva* attired as a monk who rescues souls from purgatory and hell.

Kuomintang See Nationalist Party

kuang cao A type of cursive script, known as "crazy cursive" script.

li The "ritual," "ceremony," and "etiquette" as formulated in canonical texts that govern all social interaction.

ling ("mound") From Han times, a term for an imperial burial.

logographic script A writing system that uses conventionalized signs to represent words, often referred to as "Chinese characters."

Longquan ware A porcellaneous stoneware with a grayish body and thick, green glaze first produced in Zhejiang Province in the Song period. Decorated with incised, carved, molded, and fully sculptural designs.

lost-wax casting A process of bronze casting that uses a wax positive model. After being surrounded by clay, the wax is melted out, leaving an empty mold for the molten metal to fill.

Lotus Sutra The teaching on universal salvation expounded by the Buddha on Vulture Peak, the source of many works of Chinese Buddhist art.

luohan (Sanskrit: *arhat*) The major followers of the Buddha who vowed to remain alive to preserve his teachings.

Mahastamaprapta (Dashizhi) A great *bodhisattva*, usually an attendant to Amitabha Buddha.

mandorla A halo around the body of a Buddhist deity.

Manjusri (Wenshu) The great *bodhisattva* of wisdom (*prajna*), whose holy mountain is Mt. Wutai (Shanxi).

material culture The whole range of things made by humans, from the largest, most durable modifications of the earth to the smallest, most perishable objects. It represents the principal category of evidence for studying prehistoric cultures using archaeological techniques.

matrilineal A matrilineal (or matriarchal) social organization is one in which women occupy a privileged place in society and descent is reckoned through mothers. Chinese Marxist archaeologists and prehistorians assume "primitive" cultures changed over time from matrilineal to patrilineal social organization.

Meditation School A school of Chinese Buddhism devoted to intense mental regimens (*dhyana*, *chan*, *zen*) as a means of attaining enlightenment.

Meissen City in Germany, home to a ceramic kiln founded in 1710 that first produced a European version of porcelain.

mi se ("secret color") A fine grade of Yue ware produced during late Tang and Five Dynasties.

moon terrace A large, open, elevated platform in front of a hall.

Nationalist Party The political party which governed China from 1911 to 1949. It dominated politics in Taiwan for several decades after the defeat of Nationalist forces by the Communist army in 1949 forced the removal of the Republic of China government to that island.

nephrite A tough fibrous mineral that was the favored material for prehistoric Chinese hardstones.

Northern and Southern School theory A theory of the history of painting, associated with Dong Qichang, which divided painters into two lineages, the Northern and Southern—categories which were borrowed from Chan Buddhist divisions between Northern (gradualist) and Southern (sudden) enlightenment sects.

oracle-bone inscriptions (*jiagu wen*) Inscriptions incised into turtle shells and ox scapulae as part of Late Shang divination.

pagoda A tower-like structure housing a reliquary deposit, derived from the Indian *stupa*.

Parinirvana (Sanskrit) The "final nirvana" or death of the historical Buddha.

patrilineal A patrilineal (or patriarchal) social organization is one in which men are socially dominant and descent is reckoned through fathers. Chinese Marxist archaeologists and prehistorians assume "primitive" cultures changed over time from matrilineal to patrilineal social organization.

patrimonialism A state in which kinship bonds are the key qualification for positions, but administration is proto-bureaucratic.

petuntse (China stone) *Bai Dunze* (white briquettes), a white feldspathic stone used in making porcelain, which aids in the process of vitrification.

pingdan ("blandness" or "simplicity") Scholars considered this to be a desirable quality in one's personality, writing, painting etc.

porcelain A high-fired ceramic made from white clay (kaolin) with clear glazes producing a vitreous, resonant, and translucent body.

Potalaka The island home of Guanyin, believed to be located off the southern coast of India, but in China identified with Mount Putuo, off the coast of Zhejiang Province.

pre-casting (casting on) The casting of an element of a bronze object, such as a handle, before casting the object itself. The pre-cast piece is then inserted into the mold assembly for the object and is "cast on" when the alloy for that object is poured.

purlin A small beam in the roof frame that runs parallel to the ridge pole and supports the rafters.

qilin Mythical animal with a single horn, usually placed on the spirit path.

Qidan (Khitan) A semi-nomadic people who founded a kingdom on the northern border of Song-period China, which was given the dynastic name of Liao (947–1125).

qingbai ("bluish-white") A porcelain ware with blue-tinged glaze first produced in Jiangxi Province in the tenth century. It is thinly potted and may have incised or molded designs.

que Gate tower common to major buildings in Qin and Han times. Surviving examples in stone are the most common extant architectural monuments of this period.

Queen Mother of the West (Xiwangmu) Mythical being linked to cult of Mount Kunlun in western regions and especially popular in the Later Han period.

rebus A punning reference to one thing or concept using an image or word with a similar form or sound.

regular script (*kai shu*) The most formal of the three mature types of script, the others being cursive and running scripts.

repoussé A technique of hammering metal from the rear to raise the front surface.

Ru ware An extremely rare stoneware with thick, gray-blue glaze first produced for the Northern Song court at an official kiln in Henan Province.

running script (*xing shu*) Also called "semi-cursive," this script type has some abbreviations but retains its legibility and was a major script type from the time of the Two Wangs onward.

Sakyamuni ("Sage of the Sakyas") An honorific name for the historical Buddha, Siddhartha Gautama, who was a member of the Sakya clan.

Sasanian Dynasty Imperial dynasty that ruled Persia (modern Iran and neighboring areas) from 224 to 651.

secondary burial A term for multiple skeletons re-interred together after their initial burial.

sectional (piece) mold casting A technique of bronze casting using several outer mold segments with an inner core, typical of Shang and Zhou bronze production.

seriations Ordered sequences constructed by scholars from unordered data, reflecting change over time and/or space. Seriations are useful in pottery analysis for establishing relative chronologies.

shaman A person endowed with special gifts that permit communication with spirits or out-of-body travel to the other world. Found in the cults of Siberian and native American peoples, shamans are widely assumed to have been part of much ancient Chinese religious experience.

shanshui ("mountains and water") A generic term for landscape.

shi Originally a warrior, the lowest status within the elite of the Eastern Zhou period.

Silk Road A term coined by European scholars to describe the land routes crossing modern-day Xinjiang along the margins of the Tarim Basin. It was also used to designate the manifold trade and cultural relations between China Proper and Central and Western Asia during the Han–Tang period.

"Six Laws" (*liu fa*) Six critical and technical prescriptions for painting first found in Xie He's *Gu hua pin lu* (c. 500–535).

"slender gold" A style of calligraphy associated with Emperor Huizong (r. 1101–1125) of the Song dynasty, characterized by attenuated lines and sharp hooks.

small seal script (*xiao zhuan*) A type of script developed during the Qin period as a standard for the new empire and ascribed to Li Si.

Sogdia A region and state north of the Oxus River, in the modern-day Uzbek Republic.

soul jar (*hun ping*) Greenware cinerary

urns with covers shaped like towers which were popular during the Southern Dynasties.

spirit objects Objects made for burial, most typically of clay, including vessels and figurines; *ming qi, xiong qi*.

spirit path (*shen dao*) The processional approach to a tomb site, flanked by stone carvings.

Stars A group of dissident artists who in 1979 displayed their works outside the Chinese National Art Gallery, Beijing.

stoneware A high-fired (above 1000 degrees centigrade) ceramic that is partially virtrified, hence non-porous and hard and often covered with a feldspathic gray-green or brown glaze.

stupa (*ta*) An Indian sacred mound erected by Buddhists to enshrine a relic; a precursor of the Chinese pagoda.

Sukhavati The Western Pure Land of Amitabha Buddha.

sutra (*jing*) The holy texts, words, and teachings of the Buddha.

Tabgatch (*Tuoba*) A Xianbei people who founded the Northern Wei dynasty.

"The Three Friends of Winter" A traditional grouping of pine, bamboo, and flowering plum, which represent perseverance through adversity.

Tian ("Heaven") The all-powerful sky deity of the Zhou.

Tiananmen The Gate of Heavenly Peace, which stands at the southern entrance to the Forbidden City and just north of Tiananmen Square, the location of many major government and cultural buildings and the site of frequent demonstrations in support of or in opposition to the government.

tianlu Mythical animal with two horns, typically placed along the spirit path.

tie Brush-written specimens of calligraphy, but also used to refer to rubbings of calligraphy from steles and woodblock prints of calligraphy.

trikaya ("three bodies of the Buddha") A doctrine of the Flower Garland (Avatamska) School.

type site An archaeological term that usually refers to the first locality where a certain type of archaeological data is found or the most representative instance of it.

ukiyo-e ("pictures of the floating world") Paintings or prints depicting urban scenes, often in the entertainment and pleasure quarters, produced during the Edo and subsequent periods in Japan.

Vairocana (Lushena) The Cosmic Buddha of the *Avatamsaka Sutra*.

Vaisravana (Bishamen Tian) The Guardian King of the Northern Quadrant.

wattle and daub A form of wall and roof construction consisting of interwoven branches (wattle) that were then plastered with mud (daub).

Xing ware A stoneware with white glaze made in North China from the Sui period onward, which derives its name from Xingzhou, Hebei Province.

Xiongnu Steppe people who are first mentioned in Chinese records of the fourth century BCE in the area of Inner Mongolia and northern Shaanxi, Shanxi, and Hebei.

Yan'an Talks Remarks on cultural policies of the Communist party given by Mao Zedong on May 2 and 23, 1942, in Yan'an (Shaanxi).

Yaozhou ware A stoneware with grayish body and usually decorated with an olive-green glaze, first produced in Shaanxi Province in the Tang period. Carved and molded decorations are most commonly used.

yi A term from oracle-bone inscriptions designating a settlement.

yi pin ("untrammeled class") A special classification outside the normal three-part ranking scheme which was given to painters due to their unusual practice.

Yue ware A green-glazed stoneware produced in Zhejiang Province from the second or third centuries CE.

ziran ("self-so") A desirable quality of natural spontaneity—lack of artifice and resonance with nature—in one's personality or creative work.

zong ("school") A term used to designate major trends in Tang Buddhism, each focusing on key *sutras* and their commentaries.

Zong Bing (375–443) A painter, Buddhist recluse, and author of an early text on painting, *Hua shanshui xu* (*Introduction to Painting Landscape*).

zoomorphic Of animal form or feature; such motifs are often found on Shang objects.

ANNOTATED BIBLIOGRAPHY

The readings recommended below are a sampling of the current literature in English; most have proven useful in teaching and/or as sources for student research projects. A significantly larger literature grows ever more rapidly in Chinese.

CHAPTER 1

Source references
The definition of "nephrite" comes from G. Wen and Z. Jing, "Chinese Neolithic Jades: A Preliminary Geoarchaeological Survey," *Geoarchaeology: An International Journal* 7/3 (June 1992): 251–75; see p. 254.

The plan of Jiangzhai village is after Banpo Museum et al., *Jiangzhai: Xin shiqi shidai yizhi fajue baoga* (Jiangzhai: Excavation report of a neolithic site) 2 vols. (Beijing, 1988), fig. 6. The wattle-and-daub house is after Yang Hongxun, *Jianzhu kaoguxue lunwenji* (Collected essays on architectural archaeology) (Beijing, 1987), p. 8. The plan of Grave 10, Dawenkou cemetery, is after Shandong Cultural Relics Administration and Jinan Museum, *Dawenkou: Xin shiqi shidai muzang fajue baogao* (Dawenkou: Excavation report of a neolithic cemetery) (Beijing, 1974), pp. 24–5.

General studies
The best overview of prehistoric topics remains K.C. Chang's *The Archaeology of Ancient China*, 4th ed. (New Haven, 1986), especially its conceptual framework of interaction spheres. The essays in D.N. Keightley, ed., *The Origins of Chinese Civilization* (Berkeley, 1983) address a variety of major topics, but like Chang's 4th edition, by now account for only a fraction of current data. G. Barnes, *China, Korea and Japan: The Rise of Civilization in East Asia* (London, 1993) is a regional approach by a specialist in Japanese archaeology. Up-to-date

treatments of many topics considered in this chapter will be found in the essays and entries in X. Yang, ed., *The Golden Age of Chinese Archaeology: Celebrated Discoveries from the People's Republic of China* (Washington, D.C., and New Haven, 1999). This volume is also useful for many of the other chapters below; its notes will direct readers to many important sources in the Chinese archaeological literature.

The first-hand narratives of two pioneers in the field are still of interest: J. Andersson, *Children of the Yellow Earth: Studies in Prehistoric China* (Cambridge, Mass., 1973, reprint of the 1934 ed.) and G.D. Wu, *Prehistoric Pottery in China* (London, 1938).

Specialized studies
The author's understanding of social complexity is derived from A. Johnson and T. Earle, *The Evolution of Human Societies* (Stanford, 1987). A. Underhill has begun the task of applying anthropological models to ancient China; see her "Pottery Production in Chiefdoms: The Longshan Period in Northern China," *World Archaeology* 23 (1991): 12–27, and "Variation in Settlements During the Longshan Period of Northern China," *Asian Perspectives* 33/2 (1994): 197–228. Useful treatment of the Hongshan and Liangzhu cultures include: D. Guo, "Hongshan and Related Cultures" in *The Archaeology of Northeast China: Beyond the Great Wall*, ed. S. Nelson (London, 1995): 21–64; E. Childs-Johnson, "Jades of the Hongshan Culture: The Dragon and Fertility Cult Worship," *Arts Asiatique* 46 (1991): 82–95; Z. Sun, "The Liangzhu Culture: Its Discovery and Its Jades," *Early China* 18 (1993): 1–40.

W. Boltz has written clearly about the question of the origins of Chinese writing in "Early Chinese Writing," *World Archaeology* 17 (1986): 420–36 and *The*

Origin and Early Development of the Chinese Writing System, American Oriental Series, vol. 78 (New Haven, 1994). A thought-provoking discussion of prehistory is D.N. Keightley, "Archaeology and Mentality: The Making of China," *Representations* 18 (Spring 1987): 91–128.

CHAPTER 2

Source references

The translation of the oracle-bone inscription (*Bingbian* 247) is from D.N. Keightley, *Sources of Shang History: The Oracle-Bone Inscriptions of Bronze Age China* (Berkeley, 1978): fig. 12. The text translation of the Li *gui* is from E. Shaughnessy, *Sources of Western Zhou History: Inscribed Bronze Vessels* (Berkeley, 1991): 89, 105. Both books are valuable models of scholarly rigor.

General studies

Recent scholarly overviews of Shang and Western Zhou will be found in M. Loewe and E. Shaughnessy, eds., *The Cambridge History of Ancient China: From the Origins of Civilization to 221 BC* (Cambridge, 1999). K.C. Chang, *Shang Civilization* (New Haven, 1980), however, remains indispensable. Li Chi's personal narrative also retains its value, even though the material discussed is predominantly from the 1928–37 excavations; see his *Anyang* (Seattle, 1977). For Western Zhou, see also C. Hsu and K. Linduff, *Western Chou Civilization* (New Haven and London, 1988). The best overview of Xia remains R.L. Thorp, "Erlitou and the Search for the Xia," *Early China* 16 (1991): 1–38.

Specialized studies

D.N. Keightley, "The Religious Commitment: Shang Theology and the Genesis of Chinese Political Culture," *History of Religions* 18 (1978): 211–25, considers the long-term debt of Chinese civilization to Shang cult. R. Eno, "Was There a High God *Ti* in Shang Religion?" *Early China* 15 (1990): 1–26, offers a fresh perspective. The spaces of cult are examined in R.L. Thorp, "Origins of Chinese Architectural Style: The Earliest Plans and Building Types," *Archives of Asian Art* 36 (1983): 22–39.

W. Fong, ed., *The Great Bronze Age of China: A Symposium* (New York, 1980) presents lush photography and careful commentary on many of the most attractive bronze vessels recovered through recent archaeology. W.T. Chase, "Bronze Casting in China: A Short Technical History," in *The Great Bronze Age of China: A Symposium*, ed. G. Kuwayama (Los Angeles, 1983): 100–23, is a strong technical introduction. U. Franklin's "The Beginnings of Metallurgy in China: A Comparative Approach" in the same volume (pp. 94–9) is also valuable. R.W. Bagley, *Shang Ritual Bronzes*, in *Ancient Chinese Bronzes in the Arthur M. Sackler Collections*, vol. 1 (Washington, D.C., and Cambridge, Mass., 1987) and J. Rawson, *Western Zhou Ritual Bronzes*, in *Ancient Chinese Bronzes in the Arthur M. Sackler Collections*, vol. 2 (Washington, D.C., and Cambridge, Mass., 1990) offer a huge volume of data and illustrations for their respective topics. R.L. Thorp presents a different approach to understanding bronze vessels in "The Growth of Early Shang Civilization: New Data from Ritual Vessels," *Harvard Journal of Asiatic Studies* 45 (1985): 5–75, and "The Archaeology of Style at Anyang: Tomb 5 in Context," *Archives of Asian Art* 41 (1988): 47–69. S. Allan, *The Shape of the Turtle: Myth, Art, and Cosmos in Early China* (Albany, 1991) and L. Kesner, "The *Taotie* Reconsidered: Meanings and Functions of Shang Theriomorphic Imagery," *Artibus Asiae* 51 (1991): 29–53, lead the reader down fascinating interpretive byways too often neglected.

L. Ledderose, *Ten Thousand Things: Module and Mass Production in Chinese Art* (Princeton, 2000) offers an innovative approach to understanding many kinds of art production, from bronze casting and ceramics to architecture and printing, and so is relevant for most chapters below.

CHAPTER 3

Source references

The plan of the lower capital of Yan is after Hebei Cultural Relics Institute, *Yan Xiadu*, 2 vols. (Beijing, 1996), fig. 2. The drawing of the "Royal City" is after Nie Chongyi, *San li tu* (Illustrated Three Ritual Canons) (1676). The reconstructed casting assembly for bell is after Shanxi Institute of Archaeology, *Houma zhutong yizhi* (The casting site at Henan), 2 vols. (Beijing, 1993):304.

General studies

The best general introduction is Li Xueqin, *Eastern Zhou and Qin Civilizations*, trans. K.C. Chang (New Haven, 1985). The essays in M. Loewe and E. Shaughnessy, eds., *The Cambridge History of Ancient China: From the Origins of Civilization to 221 BC* (Cambridge, 1999) are also recommended. C. Hsu, *Ancient China in Transition: An Analysis of Social Mobility, 722–222 BC* (Stanford, 1965) and M. Lewis, *Sanctioned Violence in Early China* (Albany, 1990) offer fascinating, extended discussions of the material summarized in the Loewe and Shaughnessy volume. J. Crump, Jr., trans., *Chan-kuo ts'e* (Oxford, 1970) introduces the texture of the times through fascinating anecdotes and speeches of court figures of the Warring States period.

Specialized studies

J. So, *Eastern Zhou Ritual Bronzes*, in *Ancient Chinese Bronzes in the Arthur M. Sackler Collections*, vol. 3 (Washington, D.C., and Cambridge, Mass., 1995) completes the grand enterprise launched by Bagley and Rawson (cited above). Institute of Archaeology of Shanxi Province, *Art of the Houma Foundry* (Princeton, 1996) introduces this major casting center. More informative are R. Bagley "Replication Techniques in Eastern Zhou Bronze Casting," in *History from Things: Essays on Material Culture*, ed. S. Lubar and W.D. Kingery (Washington, D.C., 1993): 231–41, and "What the Bronzes from Hunyuan Tell Us about the Foundry at Houma," *Orientations* 26/1 (Jan. 1995): 46–54. R.L. Thorp, "The Sui Xian Tomb: Re-Thinking the Fifth Century," *Artibus Asiae* 43/1–2 (1981–2): 67–92, considers this major discovery from several perspectives. L. van Falkenhausen, *Suspended Music: Chime-Bells in the Culture of Bronze Age China* (Berkeley, 1993) is a daunting but very thorough survey of all matters

pertaining to chime-bells and musical culture.

T. Lawton, ed., *New Perspectives on Chu Culture During the Eastern Zhou Period* (Washington, D.C., 1991) and C. Cook and J. Major, eds., *Defining Chu: Image and Reality in Ancient China* (Honolulu, 1999) both elaborate on the most distinctive of the regional cultures bordering the central states through a selection of specialist essays. E.G. Pulleyblank, "The Chinese and Their Neighbors in Prehistoric and Early Historic Times," in *The Origins of Chinese Civilization*, ed. D.N. Keightley (Berkeley, 1983): 411–66, and E. Jacobsen, "Beyond the Frontier: A Reconsideration of Cultural Interchange Between China and the Early Nomads," *Early China* 13 (1988): 201–40, open up discussion of the non-Hua–Xia peoples.

CHAPTER 4

Source references

For the translation of Sima Qian's report, see W.H. Nienhauser, Jr., ed., *The Grand Scribe's Records*, vol. 1, *The Basic Annals of Pre-Han China* (Bloomington and Indianapolis, 1994), p. 138. The translated quotation from *Historical Records* on the First Emperor's efforts to connect the long walls is from A. Waldron, *The Great Wall of China: From History to Myth* (Cambridge, 1990): 17. For the translation of the inscription on the lacquer cup see Z. Wang, *Han Civilization* (New Haven, 1982): 86. The translated quotation from *Huai nan zi* is from J.S. Major, *Heaven and Earth in Early Han Thought: Chapters Three, Four and Five of the Huai na zi* (Albany, 1993), p. 62.

The plan of Han Chang'an is after Intitute of Archaeoogy, *Han Chang'an cheng Weiyang gong: 1980–1989* (The eternal palace of Han Chang'an: Report of archaeological excavations, 1980–1989), 2 vols., Archaeological Monographs, Series D, No. 50 (Beijing, 1996).

General studies

D. Twitchett and M. Loewe, eds., *The Ch'in and Han Empires, 221 BC–AD 220*, in *The Cambridge History of China*,

vol. 1. (Cambridge, 1986) supercedes all other general references for the period, but lacks any treatment of archaeology and art. B. Watson, trans., *Records of the Grand Historian: Qin* (New York, 1993) and *Records of the Grand Historian: Han* (New York, 1993) offer readable translations of some of Sima Qian's annals and biographies for Qin and Former Han times. W.T. de Bary and I. Bloom, eds., *Sources of Chinese Tradition*, vol. 1, 2nd ed. (New York, 1999) is the most compendious and valuable of collections of primary sources; see especially Part Two, "The Making of a Classical Culture," pp. 225–374. For the interface of such ideas and art, see M. Powers, *Art and Political Expression in Early China* (New Haven, 1991) and H. Wu, *The Wu Liang Shrine: The Ideology of Early Chinese Pictorial Art* (Stanford, 1989).

Specialized studies

The architectural legacy of early imperial times is analyzed in R.L. Thorp, "Architectural Principles in Early Imperial China: Structural Problems and Their Solution," *The Art Bulletin* 68 (Sept. 1986): 360–78. The chapter on "The Monumental City Chang'an" in H. Wu, *Monumentality in Early Chinese Art and Architecture* (Stanford, 1995) is also recommended. The lectures of Xia Nai, *Jade and Silk of Han China*, trans. and ed. C.T. Li (Lawrence, Kans., 1983) are useful introductions to these topics.

L. Kesner, "Likeness of No One: (Re)presenting the First Emperor's Army," *The Art Bulletin* 67 (1995): 115–132, offers a post-modern interpretation of the so-called underground army. R.L. Thorp, "An Archaeological Reconstruction of the Lishan Necropolis," in *The Great Bronze Age of China: A Symposium*, ed. G. Kuwayama (Los Angeles, 1983): 72–83, is more down to earth but in need of revision in light of recent work at the site. M. Poo, "Ideas Concerning Death and Burial in Pre-Han and Han China," *Asia Major* 3 (1990): 25–62 is a fine introduction to its topic; see also the same author's *In Search of Personal Welfare: A View of Ancient Chinese Religion* (Albany, 1998). A. Birrell, *Chinese Mythology: An Introduction* (Baltimore and

London, 1993) and S. Cahill, *Transcendence and Divine Passion: The Queen Mother of the West in Medieval China* (Stanford, 1993) are exemplary, readable studies. R.L. Thorp, "Mountain Tombs and Jade Burial Suits: Preparations for Eternity in the Western Han," in *Ancient Mortuary Traditions of China*, ed. G. Kuwayama (Los Angeles, 1991): 26–39, and H. Wu, "Art in a Ritual Context: Rethinking Mawangdui," *Early China* 17 (1992): 111–44, offer guided tours of major monuments of Former Han.

A.F. P. Hulsewe with M.A.N. Loewe, *China in Central Asia: The Early Stage: 125 BC–AD 23* (Leiden, 1979), and Y. Yu, *Trade and Expansion in Han China: A Study in the Structure of Sino-Barbarian Economic Relations* (Berkeley, 1967) survey Han experience with the "Western regions."

CHAPTER 5

Source references

V. Mair's "Tabgatchization" is from his "Review of James O. Caswell, *Written and Unwritten*," *Harvard Journal of Asiatic Studies* 52 (1992): 345–61. J. Nattier's model for the transmission of the *dharma* was published in "Visible and Invisible," *Tricycle* (Fall 1995): 42–9. The translated quotations of the "Six Laws of Xie He" are from W.R.B. Acker, *Some T'ang and Pre-T'ang Texts on Chinese Painting*, 2 vols. (Leiden, 1954 and 1974); J.F. Cahill, "The Six Laws and How to Read Them," *Ars Orientalis* 4 (1961): 372–81; A.C. Soper, "The First Two Laws of Hsieh Ho," *The Far Eastern Quarterly* 8 (1949): 412–3. The account of Lady Ban is taken from H. Shih, "Poetry Illustration and the Works of Ku K'ai-chih," *Renditions* 6 (1976): 6–29.

The plan of Ye is after Xu Gangji, "Cao Wei Yecheng de pingmian fuyuan yanjiu" (Research on the restoration of the plan of the Cao-Wei city of Ye), in *Zhongguo Kaoguxue luncong: Zhongguo shehui kexueyuan Kaogu yanjiuso 40 nian jinian* (Collected essays on Chinese archaeology: Commemorating the 40th anniversary of the Institute of Archaeology of the Chinese Academy of Social Sciences) (Beijing, 1993), pp. 422–37.

General studies

For cities, architecture, and tomb sites, see respectively: N. Steinhardt, *Chinese Imperial City Planning* (Honolulu, 1990); S.C. Liang, *A Pictorial History of Chinese Architecture* (Cambridge, Mass., 1984); A. Paludan, *The Chinese Spirit Road: The Classical Tradition of Stone Tomb Statuary* (New Haven, 1991).

E. Zurcher, *The Buddhist Conquest of China: The Spread and Adaptation of Buddhism in Early Medieval China*, 2 vols. (Leiden, 1959) is fundamental to modern scholarship, but equally valuable is J. Gernet, *Buddhism in Chinese Society: An Economic History from the Fifth to the Tenth Centuries*, trans. F. Verellen (New York, 1995). Recommended translations of primary sources include: A.C. Soper, *Literary Evidence for Early Buddhist Art in China* (Ascona, 1959); L. Hurvitz, *Wei Shou: Treatise on Buddhism and Taoism*, in *Yun-kang: The Buddhist Cave-Temples of the Fifth Century AD in North China*, vol. 16, Supplement (Kyoto, 1956) and *Scripture of the Lotus Blossom of the Fine Dharma* (New York, 1976); I. Wang, *A Record of the Buddhist Monasteries in Lo-yang, by Yang Hsuan-chih* (Princeton, 1984); R. Mather, *Shih-shuo Hsin-yu: A New Account of Tales of the World, by Liu I-ch'ing, with Commentary by Liu Chun* (Minneapolis, 1976).

Specialized studies

H. Wu, "Buddhist Elements in Early Chinese Art (2nd and 3rd Centuries AD)," *Artibus Asiae* 47 (1985): 263–352, surveys the earliest traces of the *dharma* in China. A.C. Soper's studies focus on patronage and style, most notably: "Northern Liang and Northern Wei in Kansu," *Artibus Asiae* 21 (1958): 131–64; "South Chinese Influence on the Buddhist Art of the Six Dynasties Period," *Bulletin of the Museum of Far Eastern Antiquities* 32 (1960): 1–112; "Imperial Cave-Chapels of the Northern Dynasties: Donors, Beneficiaries, Dates," *Artibus Asiae* 28 (1967): 241–69.

. Huntington offers a new interpretation of a familiar monument in "The Iconography and Iconology of the Tan Yao Caves at Yungang," *Oriental Art* 32 (1986): 142–60, while S. Abe, "Art and

Practice in a Fifth-century Chinese Buddhist Cave Temple," *Ars Orientalis* 20 (1990): 1–31, provides an excellent discussion of a Buddhist chapel in its multiple contexts.

On the "fine arts" see: L. Ledderose, *Mi Fu and the Classical Tradition of Chinese Calligraphy* (Princeton, 1979); S. Bush and H.-y. Shih, comps. and eds., *Early Chinese Texts on Painting* (Cambridge, Mass., and London, 1985). The best study of an early theme in painting is A. Spiro, *Contemplating the Ancients: Aesthetic and Social Issues in Early Chinese Portraiture* (Berkeley, 1990).

CHAPTER 6

Source references

The plan of Chang'an is after Fu Xinian, "Survey: Chinese Traditional Architecture," in *Chinese Traditional Architecture*, ed. N. Steinhardt (New York, 1984), pp. 10–33. The drawing of Hanyuan Hall is after Fu Xinian, *Fu Xinian jianzhu shi lunwenji* (Collected essays on architectural history by Fu Xinian) (Beijing, 1998), col. pl. 3.

General studies

D. Twitchett, ed., *Sui and T'ang China, 589–906*, Part I, in *The Cambridge History of China*, vol. 3 (Cambridge, 1979) narrates the political history of the period; Part II (forthcoming) promises complementary essays on a wider range of topics. H. Wechsler, *Offerings of Jade and Silk: Ritual and Symbol in the Legitimation of the T'ang Dynasty* (New Haven, 1985) explains many aspects of imperial art production, while S. Weinstein, *Buddhism under the T'ang* (Cambridge, 1987) offers a useful, chronological account of the *dharma* during the period.

Specialized studies

On Chang'an, see N. Shatzman Steinhardt, *Chinese Imperial City Planning* (Honolulu, 1990) and S.P. Chung, "A Study of the Daming Palace: Documentary Sources and Recent Excavations," *Artibus Asiae* 50 (1990): 23–41. A.C. Soper, "A Vacation Glimpse of the T'ang Temples of Ch'ang-an: The

Ssu-t'a Chu by Tuan Ch'eng-shih," *Artibus Asiae* 23 (1960): 15–40, is useful, as is N. Steinhardt, "The Mizong Hall of Qinglong Si: Space, Ritual, and Classicism in Tang Architecture," *Archives of Asian Art* 44 (1991): 27–50.

A rare patronage study of a major site is A. McNair, "Early Tang Imperial Patronage at Longmen," *Ars Orientalis* 24 (1994): 65–81. R. Whitfield and A. Farrer introduce the Mogao chapels in *The Caves of the Thousand Buddhas* (London, 1990). The treasures brought back by Sir Mark Aurel Stein are published in R. Whitfield, ed., *The Art of Central Asia: The Stein Collection in the British Museum*, 3 vols. (Tokyo, 1981–84). Paul Pelliot's finds are presented in similar luxurious fashion in J. Gies, ed., *The Arts of Central Asia: The Pelliot Collection in the Musée Guimet* (London, 1996).

V. Mair, *Tun-huang Popular Narratives* (Cambridge, 1983) offers translations of four "Transformation" texts, including the illustrated "Sariputra." S. Teiser, *The Scripture on the Ten Kings and the Making of Purgatory in Medieval Chinese Buddhism* (Honolulu, 1994) artfully merges discussions of popular devotion and illustrated texts.

M. Medley, *T'ang Pottery and Porcelain* (London, 1981) is a useful overview of the subject, if now incomplete. J. Rawson, *Chinese Ornament: The Lotus and the Dragon* (London, 1984) suggests some of the richness and complexity of the life of motifs that spanned Eurasia.

C.-h. Chang and H. Frankel, trans., *Two Chinese Treatises on Calligraphy* (New Haven, 1995), includes a translation of Sun Guoting's *Shu pu*. S. Bush and H.-y. Shih survey and translate important works in "T'ang Criticism and Art History," in *Early Chinese Texts on Painting*, comp. and ed. S. Bush and H.-y. Shih (Cambridge, Mass., and London, 1985): 45–88. E.J. Laing, "Notes on *Ladies Wearing Flowers in Their Hair*," *Orientations* 21/1 (May/1990): 32–9, introduces this important painting. M. Sullivan, *Chinese Landscape Painting of the Sui and T'ang Dynasties* (Berkeley, 1980) remains useful but inevitably somewhat out of date.

E.O. Reischauer, *Ennin's Diary: The Record of a Pilgrimage to China in Search of the Law* (New York, 1955) and E. Schafer, *The Golden Peaches of Samarkand: A Study of T'ang Exotics* (Berkeley, 1963) suggest the wealth of source materials available for the study of intercultural relations in this period.

CHAPTER 7

Source references

The translated excerpts from a description of Hangzhou are by C. Yu in P.-B. Ebrey, ed., *Chinese Civilization and Society: A Sourcebook*, 2nd ed. (New York, 1993): 178–85. The comment attributed to Fan Kuan in a biography of him in *Xuanhe huapu* (dated to 1120), is taken from K.M. Liscomb, *Learning from Mt. Hua: A Chinese Physician's Illustrated Travel Record and Painting Theory* (Cambridge, Mass., 1993): 68–9. The translated passages by Guo Xi on landscape and at work are from S. Bush and H.-y. Shih, comps. and eds., *Early Chinese Texts on Painting* (Cambridge, Mass., and London, 1985): 153, 156–57. The scroll inscription about images on a wall is from W. Fong, *Images of the Mind* (Princeton, 1984): 58. Liu Shang's poem on Lady Cai Wenji and the caption for FIG. 7-31 are from R.A. Rorex and W. Fong, trans., *Eighteen Songs of a Nomad Flute: The Story of Lady Wen-chi* (New York, 1974): section 13. For imperial family couplets on Ma Yuan's paintings, see *Chinese Art Treasures: A Selected Group of Objects from the Chinese National Palace Museum and the Chinese National Central Museum, Taichung, Taiwan* (Geneva, 1961): 118, 120. For Guo Ruoxu on historical relativism; Su Shi on form-likeness; and poetic painting see respectively Bush and Shih, *Early Chinese Texts on Painting*: 94, 224, 203. The translation of Su Shi's ode on the Red Cliff is by A.C. Graham in C. Birch, ed., *Anthology of Chinese Literature: From Early Times to the Fourteenth Century* (New York, 1965): 383–84. Yan Yu's quote is from S. Bush, *The Chinese Literati on Painting: Su Shih (1037–1101) to Tung Ch'i-ch'ang (1555–1636)* (Cambridge, Mass., 1971): 44. Deng Chun on training of court

artists is from Bush and Shih, *Early Chinese Texts on Painting*: 134–36.

General studies

For essays on Song politics and society, see J.W. Haeger, ed., *Crisis and Prosperity in Sung China* (Tucson, 1975); also R.P. Hymes and C. Shirokauer, eds., *Ordering the World: Approaches to State and Society in Sung Dynasty China* (Berkeley, 1993). W.H. McNeill, *The Pursuit of Power: Technology, Armed Force, and Society since AD 1000* (Chicago, 1982) discusses Song technology in a comparative, global context. J. Gernet, *A History of Chinese Civilization* (Cambridge, 1982) is a comprehensive narrative focusing on economic, social, and institutional change; his *Daily Life in China on the Eve of the Mongol Invasion, 1250–1276* (Stanford, 1962) is an account of late Song social and material culture. P.B. Ebrey, *The Cambridge Illustrated History of China* (Cambridge, 1996) pays particular attention to visual and material culture. See also Ebrey's study of women's social roles under the Song in *The Inner Quarters: Marriage and the Lives of Women in the Sung Period* (Berkeley, 1993).

S.-c. Liang, *A Pictorial History of Chinese Architecture* (Cambridge, Mass., 1984) is an account of architectural history and the development of Chinese architectural studies. Like L.G. Liu's topical, superbly illustrated *Chinese Architecture* (New York, 1989), Liang's survey devotes considerable attention to Song and Liao building. N. Shatzman Steinhardt, *Chinese Traditional Architecture* (New York, 1984) provides a lucid introduction to building technologies, forms, and styles, and her *Liao Architecture* (Honolulu, 1997) is a focused study of that innovative era.

The archaeologically informed account in H. Li, *Chinese Ceramics: The New Standard Guide* (London, 1996) provides much up-to-date discussion of problems in the ceramic history of the Song and other eras. M. Medley, *The Chinese Potter* (New York, 1976) is especially helpful on technical developments for the Song as well as later eras. M. Tregear, *Song Ceramics* (London, 1982) surveys this period.

Socially and culturally based arenas of taste and production are explored in: S. Kotz, ed., *Imperial Taste: Chinese Ceramics from the Percival David Foundation* (San Francisco and London, 1989); Y. Mino, *Freedom of Clay and Brush through Seven Centuries in Northern China: Tz'u-chou Type Wares, 960–1600* (Indianapolis, 1980) and *Ceramics in the Liao Dynasty: North and South of the Great Wall* (New York, 1973).

R.M. Barnhart et al., ed., *Three Thousand Years of Chinese Painting* (New Haven, 1997) is a recent collaborative survey with a broad range of illustrative material. J. Cahill, *Chinese Painting* (New York, 1985) remains an exceptionally readable and insightful account. R.H. van Gulik, *Chinese Pictorial Art, as Viewed by the Connoisseur* (Rome, 1958) is still an informative guide to painting materials, formats, and collecting practices. H. Wu, *The Double Screen* (Chicago, 1996) explores the representational and narrative aspects of an important early painting format. W. Fong, ed., *Images of the Mind* (Princeton, 1984), and *Beyond Representation: Chinese Painting and Calligraphy, 8th–14th Century* (New York and New Haven, 1992) provide detailed accounts of the development of early landscape painting. J. Cahill, *Three Alternative Histories of Chinese Painting* (Lawrence, Kans., 1988) includes an essay exploring the multiple significances of Chinese landscape. Y.-f. Tuan, *China* (Chicago, 1969) discusses both physical and cultural geographies.

Aspects of text-and-image relationships as well as art theory for the Song and later eras, are explored in: A. Murck and W. C. Fong, eds., *Words and Images: Chinese Poetry, Calligraphy, and Painting* (New York and Princeton, 1991); see also S. Bush and C. Murck, eds., *Theories of the Arts in China* (Princeton, 1983). J. Cahill, *The Lyric Journey* (Cambridge, Mass., 1996) includes an essay on Southern Song poetry–painting relationships. *The Translation of Art* (New Territories, Hong Kong, 1976) includes studies of poetry–painting relationships. S. Bush, *The Chinese Literati on Painting, Su Shih*

(1037–1101) to Tung Ch'i-ch'ang (1555–1636) (Cambridge, Mass., 1971) provides source materials for literati painting and theory for the Song and later. R.M. Barnhart, *Li Kung-lin's Classic of Filial Piety* (New York, 1993) and R.E. Harrist, Jr., *Painting and Private Life in Eleventh-century China: Mountain Villa by Li Gonglin* (Princeton, 1998) are exemplary studies of pivotal figures in the development of literary painting. M. Bickford, *Bones of Jade, Soul of Ice: The Flowering Plum in Chinese Art* (New Haven, 1985) documents the pictorial and literary implications of a major theme.

S. Fu, *Traces of the Brush* (New Haven, 1977) and R.E. Harrist, ed., *The Embodied Image: Chinese Calligraphy from the John B. Elliott Collection* (Princeton, 1999) provide informative surveys of the history of Chinese calligraphy and its cultural status. A. McNair, *The Upright Brush* (Honolulu, 1998) explores the political implications of calligraphic practices. L. Ledderose, *Mi Fu and the Classical Tradition of Chinese Calligraphy* (Princeton, 1979) and P.C. Sturman, *Mi Fu: Style and the Art of Calligraphy in Northern Song China* (New Haven, 1997) explore the calligraphic art of a key figure in literati aesthetics.

J. Cahill, *The Art of Southern Sung China* (New York, 1962) offers a concise, integrated account of Southern Song arts. The essays in M.K. Hearn and J.K. Smith, eds., *Arts of the Sung and Yuan* (New York, 1996) include focused studies on Southern Song painting.

Z. Bai, *Dazu Grottoes* (Beijing, 1984) provides a guide to the design and iconography of the site. J. Fontein and M. Hickman, *Zen Painting and Calligraphy* (Boston, 1970) surveys Chan pictorial and calligraphic art, while H. Brinker and H. Kanazawa, *ZEN Masters of Meditation in Images and Writing* (Zurich, 1996) emphasizes Chan monastic life, portraiture, and interpretation.

Specialized studies

On ceramics see: Sir J. Addis, *Chinese Ceramics from Datable Tombs and Some Other Dated Material* (London, 1978). On painting see: R. J. Maeda, "Chieh-hua: Ruled-line Painting in China," *Ars Orientalis* 10 (1975): 123–41. On landscape painting see: S. Jang, "Realm of the Immortals: Paintings Decorating the Jade Hall of the Northern Song," *Ars Orientalis* 22 (1992): 81–96. On the arts of the Liao and Jin dynasties see: S. Bush, "Literati Culture Under the Chin (1112–1234)," *Oriental Art* n.s. 15 (1969): 103–12, and "Five Paintings of Animal Subjects or Narrative Themes and Their Relevance to Chin Culture," in *China Under Jurchen Rule: Essays on Chin Intellectual and Cultural History*, ed. H.C. Tillman and S.H. West (Albany, 1995): 183–215; H. Tsao, *Differences Preserved: Reconstructed Tombs from the Liao and Song Dynasties* (Portland, 2000); Q. Zhu, "The Liao Dynasty Tomb of a Prince and Princess of the Chen Kingdom," *Orientations* 22/10 (October 1991): 53–61. On Song court painting see: P.C. Sturman, "Cranes Above Kaifeng: The Auspicious Image at the Court of Huizong," *Ars Orientalis* 20 (1990): 33–68; J.K. Murray, "Ts'ao Hsun and Southern Sung History Scrolls: Auspicious Omens for Dynastic Revival and Welcoming the Carriages," *Ars Orientalis* 15 (1985): 1–29. On women's artistic culture see: C.-s. Chiang, "The Identity of Yang Mei-tzu and the Paintings of Ma Yüan," *National Palace Museum Bulletin* 2/2 (May 1967): 1–14; 2/3 (July 1967): 9–14; J.K. Murray, "The Ladies' Classic of Filial Piety and Sung Textual Illustration: Problems of Reconstruction and Artistic Context," *Ars Orientalis* 18 (1988): 95–129; B. Su, *Baisha Song mu* (The Song Tomb at Baisha) (Beijing, 1957). On calligraphy see: C.-h. Chang and H.H. Frankel, trans., *Two Chinese Treatises on Calligraphy* (New Haven, 1995). On poetry and painting see: R.C. Egan, "Poems on Paintings: Su Shih and Huang T'ing-chien," *Harvard Journal of Asiatic Studies* 43/2 (Dec. 1983): 413–51. On Chan Buddhist art see: Y. Shimizu, "Six Narrative Paintings by Yin T'o-lo: Their Symbolic Content," *Archives of Asian Art* 33 (1980): 6–37, and "Zen Art?" in *Zen in China, Japan, East Asian Art*, ed. H. Brinker (Berne, 1985): 73–98; H. Brinker, "Shussan Shaka in Sung and Yüan Painting," *Ars Orientalis* 9 (1973): 21–40.

CHAPTER 8

Source references

The translated excerpts about artificial mountains and Suzhou gardens are from C. Clunas, *Fruitful Sites: Garden Culture in Ming Dynasty China* (Durham, N. C., 1996): 74, 96. For Zhao Mengfu, Ni Zan, and Huang Gongwang on painting see S. Bush and H.-y. Shih, comp. and ed., *Early Chinese Texts on Painting* (Cambridge, Mass., and London, 1985): 254, 280, 262–65. For the translation of Wang Lu on painting Mt. Hua and the quotation in FIG. 8-32 caption see K.M. Liscomb, *Learning from Mt. Hua: A Chinese Physician's Illustrated Travel Record and Painting Theory* (Cambridge, Mass., 1993): 28–9, 61–2. For Shen Zhou's painting inscription see translation by R. Edwards (with changes) in W.k. Ho et al., eds., *Eight Dynasties of Chinese Painting: The Collections of the Nelson Gallery-Atkins Museum, Kansas City, and the Cleveland Museum of Art* (Cleveland, 1980): 185. The translation of Tang Yin's poem is from W.C. Fong, J.C.Y. Watt et al., eds., *Possessing the Past: Treasures from the National Palace Museum, Taipei* (New York, 1996): 383.

General studies

T.J. Barfield, *The Perilous Frontier: Nomadic Empires and China, 221 BC to AD 1757* (Cambridge, Mass., 1989) provides an overview of inner Asian geopolitics, including the Mongol empires. S.E. Lee and W.-k. Ho, *Chinese Art Under the Mongols: The Yuan Dynasty, 1279–1368* (Cleveland, 1968) is a comprehensive account of all the Yuan arts in social and cultural contexts. N. Shatzman Steinhardt, *Chinese Imperial City Planning* (Honolulu, 1990) discusses the history of Beijing as a capital city.

J. Cahill surveys the full range of Yuan and early-to-middle Ming painting in *Hills Beyond a River: Chinese Painting of the Yuan Dynasty, 1279–1368* (New York, 1976) and *Parting at the Shore: Chinese Painting of the Early and Middle Ming Dynasty, 1368–1580* (New York, 1978). Two catalogues from the National Palace Museum, *The Four Great Masters of the Yuan* and *Ninety Years of Wu School*

Painting (Taipei, 1975) provide abundant biographical and visual documentation of those periods of painting.
R.M. Barnhart's catalogue *Painters of the Great Ming* (Dallas, 1993) sheds new light on Ming court painting. C.-t. Li, *The Autumn Colors on the Ch'iao and Hua Mountains: A Landscape by Chao Meng-fu* (Ascona, Switzerland, 1965) is a seminal study of scholar–amateur painting theory and approaches. K.M. Liscomb, *Learning from Mt. Hua: A Chinese Physician's Illustrated Travel Record and Painting Theory* (Cambridge, Mass., 1993) illuminates a lesser-known side of Yuan–Ming era painting theory.
R. Edwards, ed., *The Art of Wen Cheng-ming (1470–1559)* (Ann Arbor, 1976) documents the career of a major painter–calligrapher and his followers. A. de C. Clapp, *The Painting of T'ang Yin* (Chicago, 1991) includes discussion of a collaborative system of commemorative portrait production. C. Clunas, *Fruitful Sites: Garden Culture in Ming Dynasty China* (Durham, N. C., 1996) offers a revised view of Ming garden culture.

M. Weidner, ed., *Latter Days of the Law: Images of Chinese Buddhism, 850–1850* (Lawrence, Kans., and Honolulu, 1994) includes topics on official patronage and iconography of Yuan and Ming Buddhist art. J.C.Y. Watt and A.E. Wardwell, *When Silk Was Gold: Central Asian and Chinese Textiles* (New York, 1997) includes substantial accounts of Yuan–Ming period textiles. Daoist arts of the Yuan–Ming eras are included in S. Little, *Realm of the Immortals* (Cleveland, 1987) and K. Munakata, *Sacred Mountains in Chinese Art* (Urbana, Ill., and Chicago, 1991).

Specialized studies

On religious arts see: J. Murata, ed., *Chü-yung-kuan: The Buddhist Arch of the Fourteenth Century AD at the Pass of the Great Wall Northwest of Peking* (Kyoto, 1958); N. Shatzman Steinhardt, "Zhu Haogu Reconsidered: A New Date for the ROM Painting and the Southern Shanxi Buddhist–Daoist Style," *Artibus Asiae* 48/1–2 (1987): 5–38; Los Angeles County Museum of Art and Overseas Archaeological Exhibition Corporation,

organizers, *The Quest for Eternity: Chinese Ceramic Sculptures from the People's Republic of China* (San Francisco, 1987); *Baoning si Ming dai Shui lu hua* (Ming Dynasty Paintings of the Waterland Ritual from the Baoning Temple) (Beijing, 1985). On ceramics see: M.A. Rogers, "Cultural Relics Found Off the Sinan Coast," *Orientations* 14/2 (December 1983): 32–40. On official arts see: Z. Hong with Y. Cao, "Pictorial Representation and Mongol Institutions in *Khubilai Khan Hunting*," in *Arts of the Sung and Yüan: Ritual, Ethnicity, and Style in Painting*, ed. C.Y. Liu and D.C.Y. Ching (Princeton, 1999): 181–201; M. Weidner, ed., *Flowering in the Shadows: Women in the History of Chinese and Japanese Painting* (Honolulu, 1990); J. Silbergeld, "In Praise of Government: Chao Yung's Painting, Noble Steeds, and Late Yuan Politics," *Artibus Asiae* 46/3 (1985): 159–98. On landscape and personal arts of elites see: J.W. Dardess, "A Ming Landscape: Settlement, Land Use, Labor, and Estheticism in T'ai-ho County, Kiangsi," *Harvard Journal of Asiatic Studies* 49/2 (December 1989): 295–364; R. Vinograd, "Family Properties: Personal Context and Cultural Pattern in Wang Meng's *Pien Mountains* of AD 1366," *Ars Orientalis* 13 (1982): 1–30; S.E. Nelson, "Intimations of immortality in Chinese landscape painting of the fourteenth century," *Oriental Art* n.s. 33 (Autumn 1987): 275–92; M. Loehr, *Chinese Painting After Sung* (New Haven, 1967) and "Chinese Landscape Painting and Its Real Content," in *Four Views of China, Rice University Studies*, ed. R. Kapp, vol. 59/4 (Fall 1973): 67–96. On urban arts see: E.J. Laing, "Ch'iu Ying's Three Patrons," *Ming Studies* 8 (Spring 1979): 49–56; S. Lee, "Literati and Professionals: Four Ming Painters," *Bulletin of the Cleveland Museum of Art* 53 (Jan. 1966): 2–25, and "Early Ming Painting at the Imperial Court," *Bulletin of the Cleveland Museum of Art* 63 (Oct. 1975): 243–59; S.-c. Shih, "Langdang zhi feng—Mingdai zhongqi Nanjing di baimiao renwu hua" (The Air of Decadence: Mid-Ming *baimiao* Style Figure Painting from Nanjing), *Meishu yanjiu jikan* (Journal of Art Historical Studies) 1 (1994): 39–62.

CHAPTER 9

Source references

The translations of Yuan Hongdao and Zhang Dai on festivals are from R.E. Strassberg, *Inscribed Landscapes: Travel Writing from Imperial China* (Berkeley, 1994): 306, 342. The quotation from Fu Shan on his calligraphy is from Q. Bai, "Fu Shan (1607–1684/85) and the Transformation of Chinese Calligraphy in the Seventeenth Century" (New Haven: Ph.D. Dissertation, Yale University, 1996): 112. The quotation from Qian Qianyi on the Yellow Emperor Mountains is from R. Strassberg, *Inscribed Landscapes*: 315–16. For Li Yu on domestic architecture see N. Mao and T.-y. Liu, *Li Yü* (Boston, 1977): 24–5. For Shen Fu on flower arranging and garden design see L. Pratt and S.-h. Chiang, trans., *Six Records of a Floating Life* (London, 1983): 56–7, 63. For the translated letters on ceramics by Père D'Entrecolles see S.W. Bushell, *Oriental Ceramic Art: Collection of W.T. Walters* (New York, 1899): 332–58. For Zheng Xie on his painting and calligraphy price lists see J.-h. Chou and C. Brown, *The Elegant Brush: Chinese Painting under the Qianlong Emperor, 1735–1795* (Phoenix, 1985): 169.

General studies

M. Elvin, *The Pattern of the Chinese Past* (Stanford, 1973) offers a broad-scale theory of economic development. R. Huang, *1587, A Year of No Significance: The Ming Dynasty in Decline* (New Haven and London, 1981) includes case studies of political and intellectual crises. T. Brook, *The Confusions of Pleasure: Commerce and Culture in Ming China* (Berkeley and Los Angeles, 1998) emphasizes commercial culture and lifestyles in the late Ming. For the larger context of commerce and material culture see S.A.M. Adshead, *Material Culture in Europe and China, 1400–1800: The Rise of Consumerism* (New York, 1997). S. Naquin and E.S. Rawski, *Chinese Society in the Eighteenth Century* (New Haven, 1987) summarizes topics in social and cultural history in that era. F. Mote, "The Intellectual Climate in

Eighteenth-century China," in *Chinese Painting under the Qianlong Emperor: The Symposium Papers in Two Volumes*, in *Phoebus Occasional Papers in Art History* 6/1 (1988): 17–55, and B.A. Elman, *From Philosophy to Philology: Intellectual and Social Aspects of Change in Late Imperial China* (Cambridge, Mass., 1990) focus on intellectual developments in the eighteenth century. D. Ko, *Teachers of the Inner Chambers: Women and Culture in Seventeenth-century China* (Stanford, 1994) provides richly detailed studies of women as active cultural participants.

C. Clunas, *Pictures and Visuality in Early Modern China* (Princeton, 1997) offers an account of the production and consumption of many kinds of pictures, while his *Superfluous Things* (Urbana, Ill., 1991) analyzes the discourses of connoisseurship and collecting in the late Ming. C.-t. Li, J. Cahill, and W.-k. Ho, eds., *Artists and Patrons: Some Social and Economic Aspects of Chinese Paintings* (Lawrence, Kans., 1989) provides many specific case studies. H. Kim, *The Life of a Patron: Zhou Lianggong (1612–1672) and the Painters of Seventeenth-century China* (New York, 1996) is a richly documented study of an important artistic circle. J. Cahill, *The Painter's Practice* (New York, 1994) offers insights into the practical and economic situations of artists.

W.k. Ho et al., eds., *Eight Dynasties of Chinese Painting: The Collections of the Nelson Gallery-Atkins Museum, Kansas City, and the Cleveland Museum of Art* (Cleveland, 1980) includes detailed accounts of a number of important Ming–Qing paintings. C.-t. Li and J.C.Y. Watt, eds., *The Chinese Scholar's Studio: Artistic Life in the Late Ming Period* (New York, 1987) documents scholar–amateur taste, style, and discourses in the late Ming. National Palace Museum, *Style Transformed: A Special Exhibition of Works by Five Ming Artists* (Taipei, 1977) documents the careers of late Ming masters. J. Cahill, *The Distant Mountains: Chinese Painting of the Late Ming Dynasty, 1570–1644* (New York, 1982) offers a full account of late Ming painting and theory, while his *The Compelling Image: Nature and Style in Seventeenth-century Chinese Painting*

(Cambridge, Mass., 1982) is a more dialectical account of major artists and competing values. J. Cahill, ed., *Shadows of Mt. Huang: Chinese Painting and Printing of the Anhui School* (Berkeley, 1981) is a multidisciplinary catalogue of local pictorial culture. T.-k. Cheng, T.-i. Jao, and J.C.Y. Watt, eds., *Proceedings of the Symposium on Paintings and Calligraphy by Ming I-min* (Hong Kong, 1976) is a valuable compendium of studies on loyalist artists, with an accompanying exhibition catalogue. V. Contag, *Chinese Masters of the 17th Century* (Rutland, Vt., 1970) surveys loyalist and orthodox school painters; her article "The Unique Characteristics of Chinese Landscape Pictures," *Archives of the Chinese Art Society of America* 6 (1952): 45–63 is a classic exposition of Confucian aesthetics. J.-h. Chou and C. Brown, *The Elegant Brush: Chinese Painting under the Qianlong Emperor, 1735–1795* (Phoenix, 1985) offers detailed studies of court patronage and production. Among in-depth studies of individual artists are: W.-k. Ho, *The Century of Tung Ch'i-ch'ang* (Kansas City, 1992); W.-g. Weng, *Chen Hongshou: His Life and Art* (Shanghai, 1997); F. Wang, R.M. Barnhart, and J. G. Smith, eds., *Master of the Lotus Garden: The Life and Art of Bada Shanren (1626–1705)* (New Haven, 1990); R. Edwards, ed., *The Painting of Tao-chi* (Ann Arbor, 1967). Qianlong-era court collecting and patronage are part of the larger survey in W.C. Fong, J.C.Y. Watt et al., eds. *Possessing the Past: Treasures from the National Palace Museum, Taipei* (New York, 1996). R.L. Thorp, *Son of Heaven: Imperial Arts of China* (Seattle, 1988) is a multifaceted account of the arts of the imperial courts. C. Nie, *Gugong bowuyuan cang Qingdai gongting huihua* (Court Painting of the Qing Dynasty) (Beijing, 1992) offers excellent illustrations and newly published material.

W.-g. Weng and B. Yang, *The Palace Museum, Peking: Treasures of the Forbidden City* (New York, 1982) discusses palace architecture among other arts; a richly illustrated record appears in *The Illustrated Catalogue of the Architecture and Decoration of the Imperial*

Palace: Interior Design (Beijing, 1995). L.C. Johnson, ed., *Cities of Jiangnan in Late Imperial China* (Albany, N.Y., 1993) includes discussion of Ming–Qing urban spaces. Architectural discourses are the subject of K. Ruitenbeek, *Carpentry and Building in Late Imperial China: A Study of the Fifteenth-century Carpenter's Manual Lu Ban jing* (Leiden, 1993). F. Bray, *Technology and Gender: Fabrics of Power in Late Imperial China* (Berkeley and Los Angeles, 1997) and R. Knapp, *China's Traditional Rural Architecture: A Cultural Geography of the Chinese House* (Honolulu, 1986) offer anthropological perspectives on residential architecture.

O. Impey, *Chinoiserie: The Impact of Oriental Styles on Western Art and Decoration* (London, 1977) provides an overview of this multifaceted phenomenon. J. Rawson, ed., *The British Museum Book of Chinese Art* (London, 1992) includes a concise account of trade art among discussions of other social and cultural functions of art and much useful reference material. M. Sullivan, *The Meeting of Eastern and Western Art* (Berkeley, 1989) surveys cross-cultural impacts of visual arts. T.H.C. Lee, ed., *China and Europe: Images and Influences in Sixteenth to Eighteenth Centuries* (Hong Kong, 1991) and J.D. Spence, *The Chan's Great Continent: China in Western Minds* (New York, 1998) take a broad cultural perspective on China–Europe interactions.

Specialized studies

On woodblock illustrations see: R.E. Hegel, *Reading Illustrated Fiction in Late Imperial China* (Stanford, 1998); K. Carlitz, "Social Uses of Female Virtues in Late Ming Editions of Lieh Nu Chuan," *Late Imperial China* 12/2 (Dec. 1991): 117–48; D.H. Delbanco, "The Romance of the Western Chamber: Min Qiji's Album in Cologne," *Orientations* 14/6 (June 1983): 12–23; R. Vinograd, "Private Art and Public Knowledge in Later Chinese Painting," in *Images of Memory: On Remembering and Representation*, ed. S. Küchler and W. Melion (Washington and London, 1991): 176–202; K.B. Tsang, "A Case Study: The Influence of Book Illustration on Painting as Viewed in the Work of

Hua Yan," *Oriental Art* 33 (Summer 1987): 150–64. On arts of desire and memory see: J. Hay, *Kernels of Energy, Bones of Earth: The Rock in Chinese Art* (New York, 1985); H. Kohara, "An Introductory Study of Chen Hongshou, Parts I and II," trans. A. Burkus, *Oriental Art* n.s. 32/4 (Winter 1986–7): 398–420; n.s. 33/1 (Spring 1987): 67; A. Burkus-Chasson, "Elegant or Common? Chen Hongshou's Birthday Presentation Pictures and His Professional Status," *Art Bulletin* 76/2 (June 1994): 280–99; J.T. Zeitlin, *Historian of the Strange* (Stanford, 1993). M. Weidner, ed., *Views from Jade Terrace: Chinese Women Artists 1300–1912* (Indianapolis and New York, 1988). On loyalist artists see: F. Wakeman, "Romantics, Stoics, and Martyrs in Seventeenth-century China," *Journal of Asian Studies* 43/4 (Aug. 1984): 631–66; W.J. Peterson, *Bitter Gourd: Fang I-chih and the Impetus for Intellectual Change* (New Haven, 1979); Q. Bai, "Fu Shan (1607–1684/85) and the Transformation of Chinese Calligraphy in the Seventeenth Century" (New Haven: Ph.D. Dissertation, Yale University, 1996); J. Hay, "The Suspension of Dynastic Time," in *Boundaries in China*, ed. J. Hay (London, 1994): 171–97; M. Fu and S. Fu, *Studies in Connoisseurship: Chinese Paintings from the Arthur M. Sackler Collection* (Princeton, 1973); J.-h. Chou, *The Hua-yu-lu and Tao-chi's Theory of Painting* (Tempe, Ariz., 1977); R. Vinograd, "Origins and Presences: Notes on the Psychology and Sociality of Shih-t'ao's Dreams," *Ars Orientalis* 25 (1995): 61–72; W.C. Fong, "Stages in the Life and Art of Chu Ta: AD 1626–1705," *Archives of Asian Art* 40 (1987): 7–23.

On hardwood furniture see: C. Clunas, *Chinese Furniture* (London, 1988); S.-h. Wang, *Masterpieces from the Museum of Classical Chinese Furniture* (Chicago, 1995); N. Berliner, ed., *Beyond the Screen: Chinese Furniture of the 16th and 17th Centuries* (Boston, 1996); S. Handler, "The Elegant Vagabond: The Chinese Folding Armchair," *Orientations* 23/1 (January 1992): 90–6. On craft objects from the Suzhou region see: R. Kerr, ed., *Chinese Art and Design:*

The T.T. Tsui Gallery of Chinese Art (London, 1991); D.P. Leidy, W.-f. A. Siu, and J.C.Y. Watt, *Chinese Decorative Arts* (New York, 1997). On export ceramics and other crafts see: C. Clunas, ed., *Chinese Export Art and Design* (London, 1987); S. Little, *Chinese Ceramics of the Transitional Period, 1620–1683* (New York, 1983); T. Volker, *Porcelain and the Dutch East India Company as Recorded in the "Dagh Registers" of Batavia Castle, those of Hirado and Deshima and Other Contemporary Papers. 1602–1682* (Leiden, 1971); C.L. Crossman, *The Decorative Arts of the China Trade* (Woodbridge, Suffolk, 1991). On court crafts see: R. Kerr, *Chinese Ceramics: Porcelain of the Qing Dynasty 1644–1911* (London, 1986); V. Wilson, *Chinese Dress* (London, 1986). On Buddhist arts at court see: *Cultural Relics of Tibetan Buddhism Collected in the Qing Palace* (Beijing, 1992). On court painting see: H. Wu, "Beyond Stereotypes: 'The Twelve Beauties' in Early Qing Court Art and the Dream of the Red Chamber," in *Writing Women in Late Imperial China*, ed. E. Widmer and K.-i.S. Chang (Stanford, 1997); K.B. Tsang, "Portraits of Meritorious Officials: Eight Examples from the First Set Commissioned by the Qianlong Emperor," *Arts Asiatiques* 47 (1992): 69–88; A. Zito and T.E. Barlow, eds., *Body, Subject, and Power in China* (Chicago, 1994). On international arts see: S. Aoki and H. Kobayashi, eds., *"Chugoku no yōfu ga" kan* (An Exhibition of Chinese Western-Style Pictures) (Tokyo, 1995). On European images of China see: A. Kircher, *China Illustrata: With Sacred and Secular Monuments, Various Spectacles of Nature and Art and Other Memorabilia*, trans. C.D. van Tuyl, (Bloomington, Ind., 1987); D. Lion-Goldschmidt, "Ming Porcelains in the Santos Palace Collection, Lisbon," *Transactions of the Oriental Ceramic Society* 49 (1984–5): 78–93; J.D. Spence, *The Memory Palace of Matteo Ricci* (New York, 1984); R. Wittkower, "English Neo-Palladianism, the Landscape Garden, China, and the Enlightenment," *L'Arte* 6 (June 1969): 18–35.

CHAPTER 10

Source references

For the translation of Zhao Zhiqian's inscription on *Cactus and Oleander* see C. Brown and J.-h. Chou, *Transcending Turmoil: Painting at the Close of China's Empire, 1796–1911* (Phoenix, 1992): 262–63. The translated manifesto of the League of Left-Wing Artists is from J.F. Andrews and K. Shen, *A Century in Crisis: Modernity and Tradition in the Art of Twentieth-century China* (New York, 1998): 216. The translations of Mao Zedong's remarks on literature and art are from E.J. Laing, *The Winking Owl: Art in the People's Republic of China* (Berkeley, 1988): 3–4. The criticism of Shi Lu's painting is from M. Sullivan, *Art and Artists of Twentieth-century China* (Berkeley, 1996): 250. For Lin Fengmian's program for art education and the Storm Society manifesto see Sullivan, *Art and Artists of Twentieth-century China*: 62.

General studies

J.D. Spence, *The Search for Modern China* (New York, 1990) provides a helpful overview of the complex issues and history of the last several centuries. C. Brown and J.-h. Chou, *Transcending Turmoil: Painting at the Close of China's Empire, 1796–1911* (Phoenix, 1992) is a useful catalogue of painting history and schools during China's long nineteenth century. Further explorations of nineteenth-century painting and printmaking appear in J.-h. Chou, ed., *Art at the Close of China's Empire*, in *Phoebus Occasional Papers in Art History*, 8 (Phoenix, 1998). Excellent photographic illustrations of Shanghai school work are found in G. Shan, ed., *Shanghai bowuguan cang Hai Shang ming huajia jingpin ji* (Masterpieces by Famous Shanghai School Painters from the Collection of the Shanghai Museum) (Hong Kong, 1991). R.H. Ellsworth, *Later Chinese Painting and Calligraphy, 1800–1950* (New York, 1986–88) is a richly illustrated catalogue of art from this long era. Extensive and thoughtful accounts of twentieth-century developments are found in J.F. Andrews and K. Shen, *A Century in Crisis:*

Modernity and Tradition in the Art of
Twentieth-century China (New York,
1998); M. Sullivan, Art and Artists of
Twentieth-century China (Berkeley, 1996);
C.-t. Li, Trends in Modern Chinese
Painting: The C.A. Drenowatz Collection
(Ascona, Switzerland, 1979). M. Kao,
ed., Twentieth-century Chinese Painting
(Hong Kong and Oxford, 1988) offers
an anthology of essays on major topics.
J. Clark, Modern Asian Art (Honolulu,
1998) is an Asia-wide survey.
Contemporary developments are
documented, with accompanying critical
essays, in V. Doran, et al., ed., China's
New Art, Post-1989 (Hong Kong, 1993);
M. Gao, ed., Inside Out: New Chinese Art
(San Francisco and New York: Berkeley,
1998); J. Noth, W. Pohlmann, and
K. Reschke, eds., China Avant-garde:
Counter-currents in Art and Culture
(Berlin and Hong Kong, 1994, 1993);
H. Wu, Transience: Chinese Experimental
Art at the End of the Twentieth Century
(Chicago, 1999).

Specialized studies

M. Kao, ed., The Art of Su Liupeng and Su
Renshan (Hong Kong, 1990) is and in-
depth study of two nineteenth-century
artists. A discussion of Shanghai school
portraiture is included in R. Vinograd,
Boundaries of the Self: Chinese Portraits,
1600–1900 (Cambridge, 1992). B. Smith

and W. Weng, China: A History in Art
(New York, 1972) includes paintings
illustrating nineteenth-century battles.
M. Rudova and L. Menshikov, eds.,
Chinese Popular Prints (Leningrad, 1988)
includes detailed explications and
excellent color illustrations of a broad
range of popular woodblock prints.
H. Li, Chinese Woodcuts (Beijing, 1995)
concentrates on the modern woodcut
movements in which the author was
both observer and major participant.
T. Tse Bartholomew, I-Hsing Ware (New
York, 1977) offers a concise and
thoughtful account of this ceramic type.
Arts Council of Great Britain, Peasant
Paintings from Hu County, Shensi Province
(1976) documents this movement.
T. Chen, H. Pan, and B. Lu, Zhongguo
minju (Chinese Vernacular Architecture)
(Shanghai, 1993) offers excellent
photographic documentation of
residential architecture in the Fujian-
Guangdong region. The Yu Gardens are
placed within a long lineage in
R.S. Johnston, Scholar Gardens of China
(Cambridge, 1991). The interplay of art
and politics in the PRC has produced an
extensive, richly documented literature,
including J.F. Andrews, Painters and
Politics in the People's Republic of China,
1949–1979 (Berkeley, 1994);
R.C. Croizier, Art and Revolution in
Modern China (Berkeley, 1988);

R.C. Kraus, Brushes with Power (Berkeley,
1991); E.J. Laing, The Winking Owl: Art
in the People's Republic of China (Berkeley,
1988).

A specific case study of urban
literary and visual modernity is
Y. Zhang, "The Texture of the
Metropolis: Modernist Inscriptions of
Shanghai in the 1930s," Modern Chinese
Literature 9 (1995): 11–30. G.R. Barmé,
In the Red: On Contemporary Chinese
Culture (New York, 1999) offers a
knowing guide to the intersections of
popular mass media, literary, and visual
cultures. Specific aspects of
contemporary and avant-garde practice
are addressed in catalogues focused on
public spaces, and arts of cultural
critique and protest, including
M. Brouwer, ed., Heart of Darkness
(Otterlo, 1997); H. Hou and
H.U. Obrist, eds., Cities on the Move
(Ostfildern-Ruit, 1997); C. Basualdo et
al., ed., Cream: Contemporary Art in
Culture (London, 1998). The
increasingly important contemporary
mode of installation art is documented
in C. Driessen and H. van Mierlo, eds.,
Another Long March: Chinese Conceptual
and Installation Art in the Nineties (Breda,
1997). For Xu Bing, see B. Erickson,
"Process and Meaning in the Art of Xu
Bing" in Three Installations by Xu Bing
(Madison, Wis., 1991): 2–23.

PICTURE CREDITS

Calmann & King, the authors, and the picture researchers wish to thank the institutions and individuals who have kindly provided photographic material. Collections are given in the captions alongside the illustrations. Sources for illustrations, additional information, and copyright credits are given below. Numbers are figure numbers unless otherwise indicated.

Every effort has been made to contact the copyright holders, but should there be any errors or omissions, Calmann & King would be pleased to insert the appropriate acknowledgment in any subsequent printing of this publication.

American Museum of Natural History, Laufer Collection, courtesy of the Department of Library Services: 9-17 (#116303); Art Museum, Chinese University of Hong Kong: 10-25, 10-39, 10-43; Chion-in, Kyoto: 8-16; The Art Museum, Princeton University, N.J.: 8-26, © 1985 Trustees of Princeton University, Edward L. Elliott Family Collection. Museum Purchase, Fowler McCormick, Class of 1921, Fund (#y1984-13) (photo: Clem Fiori); Asian Art Museum, San Francisco: 8-25 Avery Brundage Collection (#B60 P784+), 9-26 Avery Brundage Collection (#B60 P2349), 9-36 Gift of the Walter and Phyllis Shorenstein Fund (#1989.4); The British Museum, London: 0-2 (#1946.7-13.5, 6, 11 & 12), 5-25 (#1903,04-08.0,1), 6-24 (#1919.1-1.0163), 6-25 (#1919.1-1.080); Karen Brock: 4-4, 4-26, 5-14, 6-6; Cincinnati Art Museum, Cincinnati, John J. Emery Endowment and Fanny Bryce Lehmer Endowment (#1948.79): 7-28; Cleveland Museum of Art, Cleveland: 8-36 (#64.94), 9-8 (#80.10), 9-10 (#61.89), 9-15 (#53.247), 9-29 (#79.72); Cultural Relics Publishing House, Beijing: Front Cover, 1-1, 1-5, 1-6, 1-9, 1-11, 1-12, 1-13, 1-14, 1-15, 1-16, 1-17, 1-18, 1-19, 1-20, 1-21, 1-22, 1-23, 1-24, 2-1, 2-4, 2-9, 2-12, 2-13, 2-14, 2-17, 2-19, 2-20, 2-21, 2-23, 2-24, 2-25, 2-26, 2-27, 2-28, 3-1, 3-8, 3-9, 3-11, 3-12, 3-15, 3-17, 3-18, 3-19, 3-21, 3-22, 3-25, 3-27, 4-1, 4-7, 4-8, 4-10, 4-11, 4-12, 4-13, 4-14, 4-15, 4-16, 4-17, 4-18, 4-19, 4-20, 4-22, 4-23, 4-24, 5-1, 5-4, 5-5, 5-6, 5-8, 5-10, 5-11, 5-15, 5-16, 5-18, 5-19, 5-20, 5-21, 5-22, 5-27, 5-30, 6-1, 6-5, 6-7, 6-8, 6-9, 6-14, 6-15, 6-16, 6-17, 6-18, 6-19, 6-20, 6-21, 6-22, 6-23, 6-27, 6-28, 6-36, 6-37, 7-2, 7-3, 7-4, 7-7, 7-12, 7-15, 7-18, 7-21, 7-23, 7-29, 7-32, 7-39, 8-2, 8-6, 8-8, 8-10, 8-12, 8-13, 8-17, 8-18, 8-19, 8-20, 8-23, 8-24, 8-31, 8-32, 8-40, 9-1, 9-2, 9-7, 9-9, 9-14, 9-23, 9-24, 9-34, 9-35, 9-40, 9-41; Elvehjem Museum of Art, University of Wisconsin-Madison: 10-47 © Xu Bing (courtesy of the artist); Britta Erickson: 10-7 © Zhang Hai'er (courtesy of the artist), 10-10 © Zhan Wang (courtesy of the artist), 10-15 © Chen Shun-chu (courtesy of the artist), 10-41, 10-44 © Huang Chih-yang, (courtesy of the artist), 10-46 © Cai Guo Qiang (courtesy of the artist); Freer Gallery of Art, Smithsonian Institution, Washington, DC: 2-7 (#40.10), 2-18 (#30.54), 3-20 (#15.103); Fujii Yurinkan, Kyoto: 7-27; Don Hamilton: 0-3; Hanart TZ Gallery, Hong Kong: 10-1, 10-27 & Back Cover; Hong Kong Museum of Art: 9-31; Institute of Archaeology, Beijing: 2-22, 5-7; Instituto Português de Museus, Lisbon (courtesy of the French Embassy, Lisbon): 9-46; Hebei Provincial Museum: 6-29; The Metropolitan Museum of Art, New York: Frontispiece, Dillon Fund Gift, 1977, (#77.78), 5-11 Kennedy Fund 1926 (#26.123), 6-35 Dillon Fund Gift, 1977 (#77.78), 7-13 from the P.Y. & Kinmay W. Tang Family Collection, partial & promised gift of Oscar L. Tang and Jack C. Tang (#1996.479a), 7-14 Rogers Fund, 1930 (#30.76.293), 7-42 Frederick C. Hewitt Fund, 1921 (#21.76), 8-1 Purchase, Lila Acheson Wallace Gift, 1993 (#1993.15), 8-5 Dillon Fund Gift, 1989 (#1989.141.3), 9-8 Purchase, Douglas Dillon Gift, 1977 (#1977.80), 9-25 Gift of Lily and Baird Hasting, 1989 (#1989.99.1); Musée Guimet, Paris (photo: © Réunion des Musées Nationaux – Michel Urtado): 9-33; Museum für Ostasiatische Kunst, Cologne (#R62, 1 [10]) (photo: Rheinisches Bildarchiv, Cologne): 9-4; Museum of Fine Arts, Boston. Reproduced with permission © 1999 Museum of Fine Arts, Boston. All rights reserved: 6-26 (#31.643), 7-31 Denman Waldo Ross Collection (#28.65), 7-43 Gift of Denman Waldo Ross (#06.289), 8-14 Chinese and Japanese Special Fund (#12.902); National Palace Museum, Taipei: 6-33, 7-5, 7-8, 7-16, 7-17, 7-19, 7-20, 7-24, 7-33, 7-35, 7-41, 8-7, 8-11, 8-27, 8-28, 8-29, 8-30, 8-33, 8-35, 8-37, 8-38, 8-39, 9-11, 9-32, 9-43; Nelson-Atkins Museum of Art, Kansas City: 3-13 Purchase Nelson Trust (#33-81), 5-17 Purchase Nelson Trust (#40-38), 5-29 Purchase Nelson Trust (#33-1543/1), 7-10 Purchase Nelson Trust (#35-116), 7-36 Purchase (#F80-5), 7-40 Purchase Nelson Trust (#34-10), 8-34 Purchase Nelson Trust (#46-51/2), 9-22 Purchase Nelson Trust (#68-1), 9-27 Purchase Nelson Trust (#59-24/45), 10-6 Purchase Nelson Trust (#67-19/1); Osaka Municipal Museum of Art: 10-16; Percival David Foundation, London: 7-1 (#PDF 4), 8-21 (#PDF 255); Palace Museum, Beijing: 0-5, 2-16, 5-28, 6-34, 7-37, 8-4, 10-4, 10-20, 10-33; Ann Paludan: 6-10; Philadelphia Museum of Art, Philadelphia: 9-37 Purchase, Temple Fund (#1961-46-5); Rietberg Museum, Zürich, Charles A Drenowatz Collection (photo: Wettstein & Kauf): 9-28; Mary Ann Rogers/Kaikodo, Hawaii: 8-22; San Francisco Museum of Modern Art: 10-3 © Zhang Xiaogang, 10-37 © Wang Guangyi, 10-38 © Lin Tian-miao (courtesy of the artist), 10-45 © Song Dong (courtesy of the artist); Seikado Bunko Art Museum, Tokyo: 7-11; Shanghai Museum: 9-21; Spencer Museum of Art, University of Kansas, Lawrence: 10-35 Gift of William P Fenn (#1977.101); Sumitomo Collection, Sumiyoshi: 9-16; Ssu-hua Collection, Birmingham: 9-18; Stanford Rare Book Collection, Stanford University: 9-45 (#KB1667.K5 f), 10-14 (#915.1.T4831 F); The State Hermitage Museum, St. Petersberg: 10-24; Michael Sullivan, Oxford: 10-36 © Wang Keping (courtesy of the artist), 10-42 © Liu Kuo-sung; Tokyo National Museum: 7-22 (#TA 161), 7-45 (#TA), 7-46 (#TA 143), 9-13 (#TAB1397), 9-30 (#TA 207), 10-17 (#TA 237); Victoria and Albert Museum, London: 8-9 (#FE.6-1973), 9-42 (#C.457-1918); Xu Beihong Memorial Museum, Beijing: 10-34; Wan-go Weng, Inc. (courtesy of the Chaoying Fang Collection, Englewood, N.J.): 10-28; Zhejiang Provincial Museum: 10-2.

INDEX